MAIN TRENDS IN AESTHETICS AND THE SCIENCES OF ART

MAIN TRENDS IN AESTHETICS AND THE SCIENCES OF ART

Mikel Dufrenne

HOLMES & MEIER PUBLISHERS, INC.

NEW YORK • LONDON

Published in the United States of America 1979 by
HOLMES & MEIER PUBLISHERS, INC.
30 Irving Place, New York, N.Y. 10003

Reprinted from MAIN TRENDS OF RESEARCH IN THE SOCIAL AND
HUMAN SCIENCES—Part II
Copyright © Unesco 1978

Library of Congress Cataloging in Publication Data

Main entry under title:

Main trends in aesthetics and the sciences of art.

 (Main trends in the social and human sciences ; 3)
 Originally published as chapters 4 and 5 of Main
trends of research in the social and human sciences,
pt. 2.
 Bibliography: p.
 1. Aesthetics, Modern--20th century--Addresses,
essays, lectures. 2. Communist aesthetics—Addresses,
essays, lectures. 3. Art—Philosophy--Addresses, essays,
lectures. I. Dufrenne, Mikel. II. Series: Main
trends of research in the social and human sciences.
Selections ; 3.
BH201.M32 1979 700'.1 79-12758

ISBN 0-8419-0507-X (pbk.)

FOREWORD

At the outset of this double chapter, and in order to justify the choices im-
plicit in its ordering, we must refer to the difficulties which awaited us and
to the recommendations which were made to us by the group of experts con-
vened by Unesco in July 1967 to launch the Second Part of the Study on
Trends in Research. The difficulties were due both to the ambiguity of the·
concept of art and to the diversity of current studies on art: we could hardly
make a balance-sheet of these studies without asking ourselves what their
purpose was, especially as more often than not, they too raise this very
question.

The semantic field of art is in fact very uncertain: How can it be de-
limited? On the one hand, it so happens that art does not have, always and
everywhere, the same status, content and function. This is true even today.
Our work should take account of this vital fact, which is determining in both
artistic production and in the study of that production: the diversity of po-
litical, social and ideological backgrounds results in very considerable differ-
ences in the situation and meaning of art from one society to another. On the
other hand, quite apart from any socio-cultural presupposition, it so happens
that today the word 'art' is highly suspect and that the extent of the concept
is very vague: between masterpiece and rough sketch, between a mature
artist's drawing and that of a child, between song and shout, sound and
noise, dance and gesticulation, object and happening, art and non-art, where
does one set the boundary, and are boundaries necessary? For it is not only
the 'theories' of art which hesitate to determine its essence; it is also the
practice of artists, who continually give the lie to any definition. Throughout
this study it will be seen that we have been careful not to put forward any
definition of art which might run counter to the spirit of self-questioning and
invention which prevails and which wrests it from any firm grip.

And if art, strictly speaking, is elusive in this way, what is the position
with the arts, with each particular art? Here again the boundaries are shift-
ing: where does one place a paraph, a mobile, a piece of sculpture designed
for living with, a kinetic work? But it is hard to discredit entirely the tradi-
tional classifications of the arts and the choice of material and praxis on
which these classifications are based: the idea of a particular art cannot be
discounted altogether and we have given it its due in the second chapter. A
decision had still to be made concerning literature: should it be included
with the other arts or given a separate position from the start? The latter
solution was tempting, for the twofold reason that literature has by right a
specific relationship with language and that its study can therefore benefit
from the remarkable current development of linguistics. Nevertheless we
have not assigned a special status to literature, except in the second chapter.
For this again there are two reasons: the first is that certain general problems
arise in the same way in literature as in the arts: these problems involve
what might be called the 'phases' of the aesthetic phenomenon: creation,
dissemination, reception and appraisal of the works. We have devoted the

first section of the second chapter to research on this subject. The second reason was put forward by the group of experts: it is that research aimed at the various arts and research dealing with literature have too many common characteristics and are also sometimes too closely combined – for instance, in research covering a whole period, style, school, culture, etc., as well as in comparative studies – for research trends to be analysed in isolation: in artistic expression each 'approach' has to be examined on its own merits with its guiding principles, methods, limitations and relations with other approaches as a general phenomenon, whatever the art to which it is applied.

This brings us to the second major difficulty in our undertaking, which involves not the nature or meaning of art and literature, but the studies which are devoted to them and which were to be reviewed. In the first place, in order to discover prevailing trends in this research, should one stress critical appraisal or scientific study? According to the original project, the subject of this section of the work was to be 'the critical study of literature and the critical study of art'. The group of experts, however, considered that strictly 'critical' appraisal of forms of artistic and literary expression could no more be divorced from their 'scientific' study (taken in the sense of any systematic inquiry governed by the ideal of objectivity and strict accuracy) than it could be dissociated from basic philosophical or para-philosophical reflexion on the phenomenon of art. It became clear forthwith, in fact, that one of the most striking trends in contemporary artistic and literary studies was to be seen in the close alliance, or even merger, in different forms and by reference to different basic assumptions, of critical appreciation, positive research and often radical questioning. 'Criticism', maintained the group of experts, 'nevertheless occupies an essential place in this body of research because, taken in the widest sense, it is only its end-product and culmination, but also exemplifies the attitude through which creative works are approached *as such* – from the angle of their value. It is in this sense that the critical attitude may be regarded as *qualifying* the various forms of the study of art and literature which are to be included in this chapter.' We felt that we were respecting this desire to do justice to the sciences of art without divorcing them from criticism or philosophy in choosing as the title for this work: *Aesthetics and the Sciences of Art*.

It remains that the scientific approaches had to be given special treatment if we were to be faithful to the spirit of the project. How could this be done? We chose to present them from several angles, even if it meant inflicting some repetitions on the reader: we first refer to these approaches in their own right, before showing them at work, on the one hand in the study of the phases of the aesthetic phenomenon, and on the other hand in the study of each particular art.

The arrangement adopted in this book will therefore be understood. It opens with a tentative general description of the present situation with regard to art and literature. In this description special attention is paid, on the one hand, to the changes which are now affecting both the life of the arts and

their study, and on the other hand to the depth and complexity of the differences in approach and attitudes linked with the existing diversity of social and cultural contexts.

This is followed, after a brief review of the major philosophical currents which govern the study of art today, by a section of central importance containing a series of accounts of the current trends in each of the principal scientific approaches to which art, viewed as a general phenomenon, gives rise.

In this way the main trends in the study of art are identified 'in intension'. This general picture needed to be supplemented by an examination 'in extension', centred on the trends to be observed in the application of research to more specific aspects of art. One section therefore deals with research trends in the study of problems connected with the different phases of the artistic phenomenon: creation, reception, appraisal. A final section surveys trends in all types of research, focusing on each of the arts separately.

The structure of the report as a whole is thus four-dimensional, in that it involves four planes of vision which not only supplement one another but also intersect at right angles: human, historico-social and cultural *situations*; intellectual, philosophical and scientific *approaches; phases* in the artistic phenomenon; *modes* of artistic expression.

Whatever the claims of this form of presentation, it seemed that the text would be clearer if it were divided into two separate chapters, the first entitled 'Art and the science of art today', grouping the three sections in which the study of art is considered in intension, and the second, entitled 'Contemporary study of the principal problems in aesthetics and the various arts', grouping the two sections in which it is considered in extension.

A bibliographical annex – which, in order to avoid numerous repetitions, had to be common to the whole of this survey – gives, for each work cited in the text or in the footnotes of the two chapters, all the data that could be assembled. It was considered appropriate to include in addition some advice regarding the main contemporary sources of bibliographical information which can be consulted in various fields.

One more remark is called for: the study of all forms of artistic and literary expression taken as a whole can scarcely be treated as one *discipline*; it is far rather one *sector* of research to which many disciplines contribute, each seeking to achieve an all-embracing whole. The unity of aim which could inform these manifold approaches as yet exists only as an ideal or ultimate programme, only partially achieved at each attempt and on a basis which is always specific. For this reason, the question of interdisciplinary co-operation had to be taken into account throughout the report, instead of being discussed in a final section. We have nevertheless mentioned it in its own right by way of conclusion to the first chapter. As for the conclusion of the second chapter, it deals with the humanist significance of the practice of art and also of an undertaking such as this, which is aimed at surveying all reflexions on that practice.

The report which we are presenting is the outcome of a series of collective

studies for which the aid of a large number of contributors has been enlisted on as broadly international a basis as possible.

In the first place it was clear that while the rapporteur, with the help of the associate rapporteurs [1] could undertake, in the light of suitable consultations, to deal with developments of the most general bearing, on the other hand, both the trends of research relating, for example, to certain specialized scientific approaches, and those focusing on each of the arts taken separately, would need to be described by qualified specialists possessing the necessary direct experience, in terms they considered suitable, and on their own responsibility.

Furthermore, owing to the complexity of the field to be covered, the large number of points of reference and the wide range of variations in the cultural context, it was decided that the preliminary outline of the report, intended to provide a frame of reference for the work of the contributors, should itself be drawn up on the basis of broad consultations, occupying a preliminary phase. In August 1968, a preliminary draft outline drawn up by the rapporteur was accordingly submitted for comments and suggestions to the 56 National Commissions for Unesco which had notified their intention of taking an active part in the elaboration of the study, and to international non-governmental organizations interested in it.[2] It was also sent to 94 scholars or critics in 26 countries in different parts of the world, who were asked to make comments and suggestions with a view to the preparation of a revised outline, and to indicate whether they were willing to assist at a later date in the preparation of the report itself.

The outline, recast in the light of the results of these consultations, was suggested, as from December 1968, as a general frame of reference to the 90 specialists from 29 countries who had been personally invited to provide analyses – 'synthetic notes', 'special contributions', or 'additional essays' – intended either to provide material and guidance for the writing of the different sections of the report, or to be inserted under their own signatures. The outline was also forwarded to the National Commissions for Unesco and to interested international non-governmental organizations, which were asked to assist in the drafting of the report, either by submitting summary reports, or by collecting individual essays. It was understood, however, that

1. Professor Terukazu AKIYAMA, Institute for Study of Cultural Exchange, Faculty of Letters, University of Tokyo (Japan).
 Professor (Mrs.) Soheir AL KALAMAWI, Faculty of Arts, University of Cairo, Ghiza (Egyptian Arab Republic).
 Professor Béla KÖPECZI, Professor at the Faculty of Letters, Budapest University, Secretary-General of the Hungarian Academy of Sciences.
 Professor Peter E. LASKO, Department of Visual Arts, University of East Anglia, Norwich (United Kingdom).
2. European Writers' Community; International Association of Art Critics; International Council of Museums; International Council for Philosophy and Humanistic Studies (and its member federations); International Music Council; International Musicological Society; International PEN; International Social Science Council; International Theatre Institute; International Union of Architects; Society of African Culture.

this outline was intended only as a guide and that it would have to be further remodelled when the text was written up in the light of the material and observations received by the rapporteur.

Lastly, the outline and certain preliminary drafts of parts of the study were discussed at length at the meeting of consultants held by Unesco in June 1969, the members of which were for the most part responsible for the various chapters in the Second Part of the Study on Trends in Research. During this meeting the rapporteur was able to have working sessions with two of the associate rapporteurs. The other two were unable to attend.

In writing this work the rapporteur was able to draw on the following contributions, some of which, edited to a greater or lesser extent, constitute, under the direct responsibility of their respective authors, the actual text under certain headings,[3] while others, not inserted in full for lack of space, are quoted extensively or reflected in the present text:

(a) *Contributions obtained through National Commissions:*

BELGIUM	Special Commission set up by the two Royal Academies	Rapport schématique sur les tendances actuelles de la recherche dans l'étude des arts et des lettres en Belgique.
CUBA	National Commission	Various information.
Arab Republic of EGYPT	Prof. Shucry AYYAD	National *versus* international inspiration in modern Egyptian poetry.
	Prof. Ali EL-RAI	The novel and the drama in Egypt: products of national sources, or fruits of foreign influences?
	Prof. Shawki DEIF	Influence of historical methods upon literary studies.
FINLAND	Prof. (Mrs.) Annamari SARAJAS and Mr. Kai LAITINEN	Studies in Finnish literature.
INDIA	National Advisory Committee	(i) Minutes of panel meeting. (ii) Report on Fine Arts (Dr. Mulk Raj ANAND). (iii) Report on Literature (Dr. Prabhakar MACHWE).
ITALY	Prof. (Miss) Anna-Maria BRIZIO	Aspetti della ricerca storico-artistica in Italia.
JAPAN	Prof. Shuichi KATO	The main trends in the study of Japanese literature after the Second World War.

3. See Tables of Contents at the beginning of the two chapters.

POLAND	National Commission	Bibliographical information with notes.
SWEDEN	Dr. Teddy Brunius	Report on study of artistic and literary expressions.
TANZANIA	Dr. Godwin Z. Kaduna	Dance and theatre in Tanzania.
UKRAINIAN S.S.R.	National Commission	Razvitie iskusstvovedenija v Ukrainskej S.S.R. (= Development of the sciences of art in the Ukrainian S.S.R.)
	Prof. E. S. Šabliovskij	Ukrainskoe literaturovedenie za poslednie desjatiletija (= Literary studies in Ukraine over the last ten years).
S.F.R. of YUGOSLAVIA	Inter-academic Committee specially set up by the Academies of Sciences and Arts	1. Critical study of literature; 2. Musicology (D. Cvetko); 3. Fine Arts (Vinko Zlamalik); 4. Architecture and town-planning (André Mohorović); 5. Theatre (Stanislav Batić); 6. Ballet (Branko Dragutinović); 7. National music and dance (Radmila Petrović and Milica Ilijin); 8. Film (Milutin Colić).

(b) *Contributions from international non-governmental organizations*

| INTERNATIONAL ASSOCIATION OF ART CRITICS | International survey on 'Art criticism and the development of societies and cultures'. |

(c) *Individual contributions*[4]

H. E. Mr. Ferdinand N'sougan Agblemagnon (Togo)	Approche sociologique des expressions artistiques et littéraires en Afrique noire.
Mihail V. Alpatov (U.S.S.R.)	1. Značenie hudožestvennogo nasledija dlja sovremennogo čeloveka i problemy istorii istorii iskusstv (= The significance of the artistic heritage to contemporary man and the problems of the history of art); 2. La création artistique et l'étude de l'art en U.R.S.S.
Mulk Raj Anand (India)	Main trends of research in the study of artistic expressions in India.

4. Some of the persons consulted individually were approached on the recommendation of National Commissions or of international non-governmental organizations.

Giulio Carlo ARGAN (Italy) — Main trends of research in the study of the visual arts today (in Italian).

Rosario ASSUNTO (Italy) —
1. Current research on aesthetic creation as a form of play (in Italian);
2. The categorization of the history of the arts by styles; the so-called formalistic systems (in Italian).

Marie-José BAUDINET (France) — *Gestalt* et arts plastiques – problèmes de perception.

René BERGER (Switzerland) — La mutation actuelle des moyens de présentation, de production et de diffusion et ses conséquences pour l'étude des expressions artistiques, vues dans les conditions actuelles de l'expérience esthétique.

Gianfranco BETTETINI (Italy) — Principali tendenze attuali della ricerca nello studio del cinema.

Iván BOLDIZSÁR (Hungary) — The rôle of mass media and their significance for art, literature, public participation in culture, and the relevant scientific research.

Pierre BOURDIEU (France) — Tendances actuelles de la recherche dans l'étude statistique des publics: le public des musées.

Virgil CÂNDEA (Romania) — Principales tendances actuelles de la recherche en histoire littéraire.

Daniel CHARLES (France) — Tendances de l'esthétique musicale récente de langue française.

Françoise CHOAY (France) — Les principales tendances actuelles de la critique en architecture et en urbanisme.

Alain DANIÉLOU (France; International Institute for Comparative Music, Berlin) — Notes sur quelques thèmes:
(a) Critique de l'intérieur et du dehors;
(b) Le poids du passé et de l'histoire et son influence sur la culture vivante;
(c) Les emprunts philosophiques interculturels;
(d) Les composantes psychologiques des jugements d'appréciation esthétique, notamment au niveau des structures perceptives;
(e) L'étude de la création comme exploitation des virtualités des systèmes d'expression préexistants;
(f) Primat de l'écrit et primat de la communication sonore directe.

Gillo DORFLES (Italy)

1. The secularization of art and the loss of mythical and ritual values (in Italian);
2. Industrial design and graphic art regarded as forms of popular art (in Italian);
3. Current research on the arts of communication and the mass media (radio, television, advertising, graphic arts, etc.) (in Italian).

ÉTIEMBLE (France)

Note de synthèse sur le comparatisme.

Robert FRANCÈS (France)

Principales tendances actuelles de l'étude expérimentale des expressions artistiques.

Mason GRIFF (United States of America)

The commercialization of art and its consequences for the creator, as a problem of empirical sociology.

Shuichi KATO (Japan)

National *versus* international creation in art and literature, with special reference to Japanese cultural life.

Béla KÖPECZI (Hungary)

1. Le point de vue marxiste sur l'étude des expressions artistiques et littéraires;
2. Principales tendances actuelles de l'étude historique des expressions artistiques et littéraires;
3. Situation et signification de l'art dans les pays socialistes.

G. LANUZA (Argentina)

Crítica de la crítica contemporánea.

P. E. LASKO (United Kingdom)

Present trends in the historical study of the visual arts in the West.

Jacques LEENHARDT (France)

1. Principales tendances actuelles de la sociologie de la littérature et de l'art;
2. Les variables sociologiques du jugement d'appréciation esthétique;
3. Sociologie de la création;
4. L'étude sociologique de la réception des oeuvres artistiques et littéraires.

Jean-François LYOTARD (France)

Principales tendances actuelles de l'étude psychanalytique des expressions artistiques et littéraires.

Louis MARIN (France)

Etude des expressions artistiques et littéraires: approche sémiotique.

Elizar M MELETINSKIJ & Dimitri M. SEGAL (U.S.S.R.)

Strukturalizm i semiotika v sovremennom literaturovedenii i fol'kloristike v S.S.S.R. (= Structuralism and semiotics in current research on literature and folklore in the U S.S.R.).

A. S. MJASNIKOV (U.S.S.R.) Literaturovedenie i sovremennost' (= The science of literature and the present day).

Abraham A. MOLES (France) L'approche informationnelle dans l'étude de l'art et de la littérature.

Zaghloul MORSY (Morocco) Attitudes de pensée et conscience esthétique au Maroc.

Claude V. PALISCA (United States of America)
1. Main trends of research in the study of music;
2. Some recent trends in the historiography of music.

José Antonio PORTUONDO (Cuba) Crítica marxista de la estética burguesa contemporánea.

Etienne SOURIAU (France) Le fait artistique considéré du point de vue économique.

Jean STAROBINSKI (Switzerland) Principales tendances actuelles dans l'étude de la littérature – considérations sur l'état présent de la critique litteraire.

Jerzy TOEPLITZ (Poland)
1. (a) Quelques remarques sur les arts de l'information,
(b) Les principales voies de recherche dans le domaine des arts de l'information;
2. Création collective artistique et littéraire: incidences sur la recherche;
3. Déplacement et disparition des frontières traditionnelles entre les arts: le rôle du cinéma.

TRÂN VAN KHÊ (Viet-Nam; Institut de musicologie, Paris) Les tendances actuelles de l'ethnomusicologie.

André VEINSTEIN (France) Tendances principales de la recherche dans le domaine des arts du spectacle.

Dr. Claude WIART (France) Principales tendances actuelles de l'étude psychopathologique des expressions artistiques et littéraires.

Albert WELLEK (Federal Republic of Germany) The psychological study of literary and artistic expression and creation (in German):
1. The psychological approach to literary expression and creation;
2. The psychological approach to musical expression and creation;
3. Perspectives of the psychology of art.

Anna Zador (Hungary)

Tendances de la recherche sur les arts et la littérature en relation avec les questions de diffusion et d'éducation.

Leopoldo Zea (Mexico) and Carlos Horacio Magis (Argentina)

Variación de los puntos de vista y de los criterios en que se fundan el estudio y la apreciación de las expresiones artisticas y literarias: situación y punto de vista de la América latina.

Advantage was also taken of certain 'auxiliary contributions' which had been assembled for the First Part of the Study.[5] One of them, the essay by Professor A. A. Gerbrands (Netherlands) on 'The study of art in anthropology', provided the text for the passage dealing with 'The anthropological approach' in Section III of the first chapter.

The nature of the present work and the limits imposed on its size made it impossible to reflect in detail all the wealth of material contained in the analyses of many contributors, on which the rapporteurs were able to draw. Wherever we have pruned, summarized or simplified, we have done so with regret. But it is at least satisfactory that arrangements have been made with a number of periodicals for the publication, as articles, of some of the texts.[6]

5. In particular:
A. J. Greimas: Les relations entre la linguistique structurale et la poétique; G. Osgood: On the strategy of cross-national research into subjective culture; N. Ruwet: Musicologie et linguistique; etc.

6. René Berger, 'Une aventure de Pygmalion', *Diogène*, No. 68, special issue, *Communication et culture de masse*, Oct.-Dec. 1969, pp. 32-56 (English translation, 'A Pygmalion adventure', *Diogenes*, No. 68, special issue on *Mass Communication and Culture*, Winter 1969, pp. 29-52).

Jerzy Toeplitz, 'Le cinéma et l'éclatement du système des arts', *Diogène*, No. 72, Oct.-Dec. 1970, pp. 122-141 (English translation, 'On the cinema and the disruption of the arts system', *Diogenes*, No. 72, Winter 1970, pp. 112-133).

Zaghloul Morsy, 'Profils culturels et conscience critique au Maroc', *Journal of World History* XII (4), 1970, pp. 588-602.

Mikhail V. Alpatov, 'Patrimoine artistique de l'homme moderne et problèmes d'histoire de l'art', *ibid.*, pp. 643-654.

José Antonio Portuondo, 'Critique marxiste de l'esthétique bourgeoise contemporaine', *ibid.*, pp. 655-669.

Trân Van Khê, 'Les tendances actuelles de l'ethnomusicologie', *ibid.*, pp. 682-690.

E. Meletinskij & D. M. Segal, 'Structuralism and semiotics in the USSR', *Diogenes*, No. 73, Spring 1971, pp. 88-114 (also in French in *Diogène*, same ref.).

Jean Starobinski, 'Considérations sur l'état présent de la critique littéraire', *Diogène*, No. 74, April-June 1971, pp. 62-95 (English translation, 'Considerations on the present state of literary criticism', *Diogenes*, No. 74, Summer 1971, pp. 57-88).

Ferdinand N'sougan Agblemagnon, 'Sociologie littéraire et artistique de l'Afrique', *Diogène*, same ref., pp. 96-115 (English translation, 'The literary and artistic sociology of Black Africa', *Diogenes*, same ref., pp. 89-110).

In addition to the associated rapporteurs Messrs. F. N'sougan AGBLE-MAGNON, M. ALPATOV, Mulk Raj ANAND, G. C. ARGAN, C. V. PALISCA and J. STAROBINSKI perused the first version of the whole of the present work and made valuable comments and suggestions which were taken into full account in the definitive version.

The rapporteur's heartiest thanks go to the institutions and persons that have at every stage of this work and in various ways afforded him very valuable assistance.

Among the associated rapporteurs whom he thanks for having been willing to share his general tasks and responsibilities he wishes to express his special gratitude to Professor Béla KÖPECZI who, with unfailing devotion, constantly took a close interest in the elaboration of the report as a whole and himself drafted the portion relating to the situation of artistic activity and its study, and the doctrinal bases thereof, in the Socialist countries (Section I, Part B of the first chapter) and put into final form, incorporating the specialized reports brought together for the purpose, the key section III, in which the various scientific approaches are presented and in which he also performed the difficult task of producing a comprehensive general view of the 'historical approach', on the basis of a number of fractioned contributions.

Finally, the rapporteur wishes to express his appreciation to the General Rapporteur, Mr. Jacques HAVET, who has been so closely and completely associated with his work at every stage of its preparation and execution and has continually afforded him his intellectual assistance and support, while arranging the consultations and constantly maintaining the most effective liaison with all the contributors to this collective effort. Without him, this undertaking could never have been begun or pursued.

Mikel DUFRENNE

ART AND THE SCIENCE OF ART TODAY

Contents

Art and the science of art today

*On the basis of an essay by René Berger.
**A synopsis based on a number of contributions and first-hand accounts.

Contemporary study of the principal problems in aesthetics and the various arts

***With a note by Etienne Souriau on the economic study of art.

SECTION ONE: THE SITUATION AND MEANING OF ART TODAY

If we are to understand the development and the interest of theoretical re-
search on art, we must first take a look at the ever-increasing volume of re-
search carried out *by* art, as evidenced in the proliferation of styles and
fashions. Emphasis will be laid on the most conspicuous and most violent
aspects of the change taking place in the arts, because we feel that these
aspects give rise to the studies which we shall attempt to survey, and even
influence their findings. In respect of previous art forms also, they spur us
to take a fresh look and to attempt new approaches.

This change is doubtless not radical: the old continues to exist alongside
the new, sometimes contesting, sometimes stimulating it. In Japanese archi-
tecture, for instance,[1] especially over the past ten years, traditional forms
and even materials have been employed to produce decidedly modern works.
Tradition, thus placed at the service of invention, ceases to be constraining
and becomes inspiring. This dialectic of continuity and discontinuity may
also appear in some countries of the Third World, if tradition there becomes
a source of innovation instead of serving as a pretext for stereotyped prod-
ucts intended for export. Mrs. El Calamawy, for example, reminds us that in
the Arab world the Koran, sung five times daily, is still held up as the high
model of literary style for contemporary writers.

However this may be, the art scene is rarely peaceful and in any event
varies considerably from country to country, as do the attitudes of the public
and scholars. This diversity must be taken into account. In dwelling for a
moment on the more startling and aggressive aspects of the change in the
arts, we give precedence to a certain practice and experience in aesthetics
which is more peculiar to the Western countries. This experience may per-
haps be tending to spread to all countries where art is alive. It may also help
us to grasp certain features of art which are universal, even if they are not
equally clear everywhere. The fact remains that this experience is not ac-
quired in an identical fashion all over the world and that outside the West,
art can traverse different adventures and acquire another meaning. Accord-
ingly, after reviewing the situation of art in the Western countries, we shall
examine the situation in the Socialist countries on the one hand, and on the
other in those countries which are neither Western nor Socialist, at least
officially, and which, as Mrs. El Calamawy suggests, might be called socie-
ties in transition.[2]

1. This observation I owe to T. Akiyama.
2. We are aware that this threefold partition is arbitrary, since the socio-cultural
dividing line does not always coincide with the geographical. The West includes
Europe, but also North America: it is not defined by mere geography, but by prac-
tice. The Western societies are the so-called advanced societies where, as a result of
technological development, a consumer society becomes established. The U.S.S.R.
and the peoples' democracies are also industrial societies, which in this respect can
be identified with the West, especially as they are geographically contiguous, but
their economic and political régimes forbid us to regard industrialization as tanta-

A. IN THE WESTERN COUNTRIES, *by Mikel Dufrenne*

1. THE PRESENT STATE OF ART

One hundred and fifty years ago Hegel announced that art was dying: the
world's prose, in which the absolute mind acquired self-awareness, was
bound to kill art. And perhaps art is in fact dead. Perhaps that which we call
art today, and which shows signs of such exuberant vitality, is another art,
designed for other purposes and endowed with another meaning. Traditional
art was neither self-conscious nor institutionalized. It was entangled with
scholarship, religion and social life. It offered the immediate expression
– immediately accepted and understood – of a culture which was experienced
as a whole by the totality of the people: a culture which was really a second
nature granted to Nature herself. Given over to divine worship, it celebrated
the sacred element which pervaded the whole life of the community, uniting
it and making it meaningful. This embodiment of art – an art which did not
regard itself as such, which is only recognized by us now – finds expression
chiefly in archaic societies. It gradually loses its characteristic features when
culture divides itself into various institutions and society breaks up into
classes, violently opposed in various degrees. It wins its autonomy when the
totality of which it was unwittingly the soul disintegrates. Then are the words
'art' and 'artist' invented, and art becomes reflected through the artist and
affirms itself as art, refusing to serve any cause except its own. Is this to be
regretted? We know how strongly nostalgia for this wonderful totality was
expressed by Lukács in his youth, as it had been by Hegel too – who was
thinking of Greek art rather than spontaneous or uncultivated art (*art sau-
vage*) –, and it is perhaps expressed in contemporary art today. It is easy to
see what art lost when it won its autonomy.

 In the first place it has ceased to be sacred: it has lost its mythical and
ritual force, as Gillo Dorfles expresses it.[3] There are no more summits or
privileged moments to which it might give access. Our heroes – champions
or stars – no longer in the main belong to the world of art. Our myths are
caricatures of real myths, placed at the service of advertising or propaganda.
When the viewer or the listener becomes a consumer, when broadcast music
becomes the background for prosaic activities, when the open space before
a church becomes a parking area, listening and viewing are deprived of any
ritual character.

 Next, art has become depersonalized: it too seems to be prey to the curse
of alienation brought upon man by technological civilization. Certainly tradi-

mount in their eyes to Westernization. As for the countries which we are calling
non-Western, some may be technologically Western, like Japan, but most are dis-
tinguished from both the Western countries by their degree of development and
from the Socialist countries by their political and cultural régimes.

 3. This is taken from a very interesting contribution by G. Dorfles on 'La dé-
sacralisation de l'art et la perte des valeurs mythiques et rituelles'.

tional art was not dedicated to the exaltation of subjectivity and the promotion of freedom, but, in worship, ceremony or festivity the individual, who was at the same time spectator and actor, at least had the feeling that he was recognized and belonged. When a work passed through the hands of a single artisan, that artisan felt that he was an instrument of the culture that inspired him. Art was truly 'popular'. By participating in the festivity or the particular event, both the individual and the creative artist had an opportunity of self-expression. Today the very meaning of the term 'popular art' has been debased: it no longer designates art of the people for the people, but one or the other – either art *of* the people, that is, a certain type of spontaneous handicraft,[4] as opposed to genuine art, that of artists, or else art *for* the people, more frequently called art for the masses and to some extent tied up with the mass media. For the very concept of the people has given way to that of the mass, a mass no longer integrated and informed, that is, cultured, through information, because, as Dorfles says, three forms of culture are readily distinguishable – 'high-brow, middle-brow and low-brow' – and mass culture is referred to as 'mid-cult'. With this middle culture, just as people are reduced to mass, art is reduced to pastime. The 'art consumer' is alienated thereby, but the creative artist, who was still able to assert his individuality within a collective style, may very well be obliterated by impersonal forms of art such as those produced by the mass media. In the eyes of a public accustomed to mass-produced films and television serials, the identity of the author has lost practically all significance. While we know a book by its author, we know a film or a stage performance by the most outstanding name, the easiest to identify. It may be that of an actor; more often than not it is merely that of the leading rôle; sometimes it is that of the organizer or 'host' of the programme.[5] In this way the individuality of the created work is called in question, as is its uniqueness.

However, this picture of the death of an art is too gloomy. Let us not succumb too readily to nostalgia for the past, unless it gave rise to a new art, which would not be just a revival of the old, because a return to the origin would wish to be more radical. Until we revert to this possibility, let us move a little further forward with G. Dorfles, whom we have taken as a guide. 'I think I can say', he writes,[6] 'that the loss of the mythical, ritual and poetic character of art was a necessary stage, enabling art to acquire a new tech-

4. This expression and the following remarks are taken from another contribution by G. Dorfles on 'L'esthétique industrielle et l'art graphique considérés comme formes d'art populaire'. See also his essay, 'Sociological aspects of industrial aesthetics' (1971).

5. Here we refer to an interesting contribution by Jerzy Toeplitz on artistic and literary works by more than one author. The same remarks were moreover made by G. Dorfles. Toeplitz adds: 'the modern art which uses the mass media is comparable to folklore in certain respects. It too becomes anonymous and the names of the authors and co-authors of these works are readily forgotten'. We would make a reservation concerning this comparison with folklore: it will become more apparent, further on, that archaic cultures can have their artists.

6. This conclusion is supported by his book, *Nuovi riti, nuovi miti* (1965).

nological dimension specific to our own civilization. But I also think that in the next stage man will be in a position to draw on mythical and poetic elements for new artistic purposes ... and that creative art will no longer be deprived of the irrational fantastic.' It may be that such reloading with meaning or poetry is occurring today in what would be 'a genuine popular art': not the 'degenerate art of the mid-cult', but graphic art and industrial design: arts which are perhaps both from the people and for the people, if it is true that there is in them 'a common ground – too subtle to be completely analysed as yet – where actual participation of the masses is united with a kind of spontaneous germination of the object'. Pop art seems to have realized this inasmuch as it recognizes the provoking and demystifying effects of the products of the consumer society which it has taken over.

To this I have just one remark to add (which will be developed and explained when I come to the attitude of the artist and also to research based on psychoanalysis): by emancipating itself from an all-embracing culture, by breaking its connexions with religious, ethical or social values, art has gained the power to express a deeper, more fundamental relation, which one might venture to call pre-cultural or pre-historical, of man with the world, anchored in a time when seeing and desiring, the imaginary and the real, arise simultaneously. In this sense art today has a function and force which make it irreplaceable.

Let us look a little more closely, however, at the position accorded to art by a technological civilization which is at the same time investigating it. Paradoxically, the most striking phenomenon, which we shall therefore mention first, is related not to creative activity but to the distribution of works of art – although it is true that the means of reproduction, through a form of feedback, end by affecting production itself.

(a) *The transformation of the means of presentation, reproduction and distribution* [7]

We are familiar with the new means of presentation, reproduction and distribution made available to art by modern technology: the extension of transport facilities both for the public and for the works of art – sometimes entire travelling exhibitions – the development of art books, photography, diapositives and the film, in turn reproduced *ad infinitum* by popular newspapers and television. These means, obviously bound up with the commercialization of art, make the works available to a vast public, at least in the form of what Malraux calls the *Musée imaginaire*. By these means art is spread all over the world and this fact cannot be overemphasized. What we are concerned with here, however, is the consequences of this worldwide diffusion of art.

Firstly, some of these means of distribution – those which are properly

7. Here we follow very closely a remarkable paper by R. Berger which was published in the review *Diogenes* (No. 68, 1969) with the title, 'A Pygmalion adventure'. The quotations are extracted from it.

called the mass media – themselves give rise to new arts. Even if we have difficulty in believing with McLuhan [8] that the medium is the message, it is an incontrovertible fact that new media give rise to new messages, those put out by the 'information arts'. The television film, for instance, becomes a particular genre within the art of film. Similarly, '. . . one believes that recording methods serve above all to conserve, to imprint, to perpetuate "high fidelity" ', writes Pierre Schaeffer (quoted by René Berger). 'The real importance of electro-acoustics is that it permits one to *make* sounds or again to fix natural sounds, to *repeat* them, to *perpetuate* and to *transform* them.' Research on these emerging arts will be referred to at the end of this chapter.

Secondly, as a result of technological resources, the public has adopted a new approach to the arts, or, if one prefers to say, the works have acquired a new presence, considerably magnified. It is a twofold phenomenon: either we move ourselves, thanks to ever-increasing travel facilities, or the works are brought to us, either directly as live music over the air, or as art works in exhibitions travelling across continents, or by means of reproductions. Of the latter it has often been said that they are untrue to the originals. Malraux showed, however, that they also reveal unnoticed aspects – for example, details or new angles – to the extent that they constitute new aesthetic objects. In this connexion Berger says: 'Our strongest ideas lose their hold. Reproduction is no longer simply . . . a phenomenon of repetition, as the belief would have it, which draws its tenets from etymology or habit; it corresponds to a group of operations as numerous and complex as the techniques which it uses, the ends that it pursues, the functions that it sets up and which make it a *production* It is thus, to take a single example, that is born the "multiple" of which the importance is, not only that it does not refer to an original but also that it abolishes the very idea that such an original can exist, each example including, in its singularity, a reference to the other examples, uniqueness and multiplicity ceasing to oppose each other, just as "creation" and "reproduction" cease to be antinomic.'

The characteristic feature of reproduction, however, it not just that it metamorphoses the work, but that it suggests to the public a new approach: in essence this involves replacing a verbal relay by direct contact, or at least backing the former by the latter. When stained-glass windows were seen only by a few privileged people, everyone else having to be content with descriptions or black and white photographs, the emphasis was placed on the iconographic aspect of their study. They were regarded as a language, which could be given a conceptual explanation. When they are ressuscitated in all their glory by reproduction, no scientific study can ignore their light and colour; it must deal with what impinges on the senses as much as with their concept.

What is more, a new field of vision is opening before us: instead of being occupied by things which can be identified and rendered intelligible by a pattern of words and the pre-eminence of the concept, this field, according to Rauschenberg (quoted by R. Berger), appears as 'part of a close and un-

8. Cf. McLuhan & Fiore, *The Medium is the Message* (1967).

controlled continuity that has neither beginning nor end, depending on a decision or an action on the artist's part'. For the public the domain of art takes on the same aspect; it ceases to be the *pleroma* of works to which Etienne Souriau refers and becomes a variegated and effervescent medley. 'That is why', again according to Berger, 'teaching, traditional instrument of the elaboration and the transmission of knowledge, appears to us under a new guise, in particular as a *slow system of diffusion* that the parallel exist-ence of multiple circuits of information, fast and massive, often shows up as inadequate'. Reflection is unable to keep up – is it still possible to define the essence of art or of the arts? 'The corpus of art works on which one exercises reflection cannot without difficulty establish itself outside the concept of "art in the process of being created", and of the means of presentation, of repro-duction and of distribution; it follows that that corpus not only remains open, but that it can always be called in question and then that every attempt to reduce it to a norm is revealed as equally abortive.'

Such finally is the new approach imposed by the multiplication of infor-mation. The public itself is multiplying fast, and, confronted with an experi-mental art, can no longer exercise its sovereign judgement based on immu-table criteria such as those traditionally taught. Even judgement becomes experimental and it can only be based on studies which are also multiple, as we shall see. Thus 'the new dimensions of experience transform *both* the *object* and the manner of knowledge'.

Thirdly, another implication of the massive dissemination of art may be expressed in the form of a question: when art is distributed all over the world does it become international? Must one conclude that art can only be handled and exported when it has ceased to be rooted in a local culture and a tradi-tion and when its universality is not that of the concrete single object but that of an abstraction? Art is international in the same way as science, but while it is conceivable that there are no such things as Kansas mathematics or Soviet biology, can we so readily accept that Polynesian fetishes or Span-ish baroque no longer exist? Do we not know that poetry – and also certain philosophical writings today – are in fact untranslatable? In this sense cer-tain nationalistic reactions are legitimate and seem to serve the cause of art, provided of course that the particular they exalt is capable of being raised to the universal. As Marx has already said, the miracle of Greek statues is that they speak a language we still understand. Precisely; and therefore we should doubtless not lay too much stress on the conflict between an international style and national cultures. On the one hand, the singular object may find expression in a medium which is foreign to it. While it is true that poetry is untranslatable, it is also a fact that African bards (*les Orphées noirs*) have succeeded in extolling *négritude* in French and Le Corbusier did not use sandstone from the Vosges to sanctify Ronchamp. Furthermore, interna-tional art is an art which has internationalized itself, but one would have to distinguish between two modes of internationalization. One is the expansion of technical processes and economic constraints: for example, stereotyped multi-storey buildings have spread like a disease all over the world, but so

has also a certain art of information. The other may arise through the prestige of a certain style, which is then truly a style. Now this style originated somewhere and it has not disowned its origins. Nevertheless it has also been capable of receiving and assimilating the messages of other cultures, as for example in Picasso's Negro masks and Messiaen's Hindu rhythmic patterns.

This worldwide spread of an art capable of transmuting cultural characteristics also implies the universalization of taste. Taste is always 'our taste', but it is all the more that *sensus communis* detected by Kant, as sought by the ever-widening experience of the *Musée imaginaire*. If the dialectic of the singular and the universal is at work in creative art, this is because it is at work in us too, because the concrete object that has become universal is a part of our consciousness. Cuban poets extol the Cuban revolution; Xenakis writes music which is as Greek as Plato's *Parmenides;* Pollock danced in front of his canvas like an American pioneer treading virgin soil; but their works do not lose their meaning or their power to inspire other works when they go abroad, any more than the ancient works did when they left their own times. The gradual evolution or metamorphosis of meaning does not entail loss of meaning: a Negro mask has a new magic when it becomes an aesthetic object in an ethnological museum, in the same way as a Greek or Khmer temple deprived of its original setting and ceremonial, reduced to an illustration in an art book. Art when exported or reproduced is not completely uprooted; through it the public, and artists in the first place, establish roots in remote worlds. This does not mean that we become Negroes at the sight of Negro art, any more than the proletariat becomes bourgeois by contact with an art which was previously the prerogative and expression of the dominant class. Discovering a new world does not mean inhabiting it but widening one's horizon – and perhaps, for the artist, a prospect of new adventures.

(b) *The means of production and new fields*

Let us now see first what this vaster if not unanimous world has to offer today in terms of artistic production. First, new means. We are well aware that the gradual evolution of the arts is governed as much by changes in techniques as by the mysterious mutations in *Weltanschauung*. This change is multiplied and hastened by industrial civilization. Its impact on art is such that a certain form of music can be called electronic, while architecture, painting and the film bring to mind innumerable examples which it is unnecessary to enumerate. Two consequences of this development of techniques should, however, be noted. The first is that the relation of art to technique is not unilateral: technology does not offer art new, more economic or more effective means of attaining pre-established and immutable ends (at least for the time being); it creates new ends or, if one prefers, new styles. For example, the standardization and pre-fabrication of architectural ele-

ments may suggest a new conception of homes, or groups of buildings. Similarly the technique of animated cartoons may suggest a new conception of the art of photography. Then again the technical object may have recourse to aesthetics. This brings in the whole problem of design, of the henceforth deliberate and no longer spontaneous cultivation of the aesthetic element in everyday objects; at the same time we witness the meaning taken on by poetry when it becomes part of the world's prose.

In the second place, this is also a problem for the artist: What conception is he going to have of his activity, or of his vocation, when he associates with an engineer or himself becomes a technician? What kind of initiative can he take, or what control can he claim over his work, or his part of the work, when he has recourse to a computer? Does he want to be ousted like a musical performer condemned to unemployment because of concrete music? Certainly not; but it is not easy to analyse the rules invented by the conscious mind (or indeed by the unconscious) when creation is left to mechanical devices or when it relies on chance, where once it invoked inspiration. Perhaps in this familiarity with the technical device, a new mentality is developing which makes the artist akin to the engineer as much as to the odd-job man. It may also happen, however, that the artist reacts with some violence to the invasion of our lives by technology, that he turns technology against itself by parodying it, or that he promotes an aesthetic of the waste product with the dustbins of our civilization. As we shall go on to say, everything depends on the way in which he regards this civilization – at least in Western societies.

At all events, we must admit that our civilization offers art not only new media but also new fields – opened up by these same media, moreover, and assured of a new audience. Reference will be made later to the information arts which have sprung up as a result of the development of the mass media. An allusion has already been made to the demand of industry, which is considerable today, and in which Dorfles sees the promise of a new popular art. One might also refer to the advertising arts brought into being by a competitive economy, or the propaganda arts exercised under authoritarian régimes. Is it enough to say that advertising or propaganda have made use of pre-existing arts without converting them? By no means: this is no more the case than it was for architecture to go on decorating skyscrapers with Corinthian pillars or Gothic gargoyles. On the contrary, new art forms or new styles were invented which in turn influenced the traditional forms. Aphorisms, to which certain poets resort, were probably an established practice in pre-Socratic times, but they may also be an unconscious effect of advertising slogans. Some of the graffiti which were to be seen on the walls of Paris in May 1968 and which perhaps heralded a new style owed something to the poster and something to René Char. There is also scope for art in the environment itself, and the public took up this idea before town-planning was even thought of. In fact the dream of metamorphosing our surroundings, at least our urban surroundings, into a kind of *Gesamtkunstwerk* or permanent opera is not new, but it is perhaps today that the means, if not the clear realization, appear to be within our reach.

What constraints are imposed on the artist by reason of these new powers? He claimed his independence at the same time as the specificity of art. What economic and social status does he possess in a capitalist society?

(c) *The economic status of art and the freedom of the artist*

Let us first consider the economic status of art. Despite official commissions or subsidies, art is essentially a private business, subject to the laws of competition. Its commercialization involves the works themselves, their sale, their execution, their performance, or their distribution.

Masterpieces consecrated by time are sound investments which give lustre to museums, those new sites of pilgrimage. Even with the more recent works, however, the market remains steady once an artist has acquired a certain reputation among the connoisseurs. When a new name or a new school comes up, it does not banish the others, except perhaps after many years. Falls in market prices have never been spectacular except in the case of the painters of the Second Empire. Speculation is confined in practice to unknown artists or outsiders, of whom the vast majority never manage to make a name for themselves, or a living except by expedients. As for the film industry, while it provides a living for large numbers of workers, it only enriches a few stars and of necessity there are not very many well-known film producers. Nor should it be forgotten that there are probably just as many amateur cameramen as there are amateur painters or unpublished novelists. It is not, however, this anonymous multitude which assures art's economic vitality; it is rather the prestige of those who are talked about and who have their followers – clients who are not only collectors, for even in wealthy countries where a degree of luxury is within everybody's reach, this clientèle is restricted. Nevertheless, just as there exists a mass of unknown producers, there is in all developed societies an anonymous mass of consumers – all those who attend museums, read art books, go to the theatre or the cinema and listen to recordings. Even if art does not penetrate the world's prose to the point of metamorphosing it as the prophets of anti-art or non-art would have it, art infiltrates the leisure activities of the masses. Even if it is not a people's art, it has been brought to the people, just as it has spread all over the world.

The ever-increasing place which art occupies in our daily lives has attracted the attention of the State, which is tempted to press it into the service of ideologies or politics and to keep a constant check on it. Hence the question: to what extent is the artist free or does he feel free *vis-à-vis* the State? The standards and checks officially imposed on him are a measure of this freedom. Censorship exists everywhere, but it does not have the same force and the same functions everywhere. One may think that the artist is less free in countries where there is a State religion or a State aesthetic, that he is freer in countries where the State merely has interests and does not have doctrines or recommends a style. Things are not so simple, however, for we

must be careful to distinguish between being free, feeling free and wanting to be free. An artist who conforms to standards and accepts supervision may feel free (without therefore ressembling Spinoza's weather vane). The artist who identified himself with his city and with his culture did not even ask himself whether he was free. Similarly, in some countries, artists who are particularly sensitive to social problems see themselves as defenders of the policy pursued by the State, and even prophets of the future which the State has in view, to the point of censoring themselves. On the other hand, in a country where censorship is mild, an artist may be affected by all manner of insidious constraints imposed by the world around him and feel alienated to the point of despair or revolt. If there is any criterion of an artist's freedom at a time like our own, when freedom is a subjective requirement, it must be sought in the vitality and quality of his art, and perhaps too in its liberating power.

(d) *The world around us*

To an artist the world in which we live may appear as 'the other', with the fateful quality of the strange and the foreign. The inhumanity of our civilization is due in the first place to the fact that civilization, when it becomes universal, crushes all the distinctive and meaningful landmarks which were native ground, and is known and placed at a remove by the conscious mind. Instead of being lived naturally as a tradition or a *habitus*, it ceases to be a comfortable suit of clothes made to measure and becomes a uniform, mass-produced by the workings of impersonal laws, imposed on everyone. Furthermore, this world turned upside down by the technological revolution and by social revolutions is full of doubts and contradictions: it is a torn world of which no one feels a citizen, for nationalism has not disarmed. The system of production and consumption, which might tend to unify it, actually accentuates the scandalous inequality of development and the contrast between wealth and poverty, between waste and famine. Within each society also, the gap is widening between those institutions which are on the move and those which are stagnating. Then again this world is oppressive or hostile: the vast machinery which man invents to increase his organic powers is turning against the individual. It is not surprising that certain philosophies assert that man is dying: he is being enslaved by material or intellectual systems. It is no longer merely the Church or the State which thinks for him and forces him to accept its reasons; it is reason itself, in the hands of all those who have the monopoly of discourse (and certain writers re-invent preciosity in order to terrorize masochist readers).

Can the artist be said at least to feel sustained by a public with which he has bonds and to which he is responsible? In his approach to the world does the artist experience loneliness or does he feel given away to others, to a public, or even to a people? Then again, in his production, is he affected by public demand or does he follow only his own impulses or a certain logic in

the gradual unfolding of a style? The answer to these questions should of course take into account not only the artist's personality and the rôle he assigns himself, but also historical situations, social régimes and systems of art production. The size of the audience and its fastidiousness vary according as the people are less divided socially and more unanimous ideologically, and *vice versa*, while the constraints of the market or the State will also vary in their intensity.

At all events, whether or not they are supported by a public, most artists, at least in the Western countries, do not usually react to the world around them without unease or rebelliousness. Their works bear testimony to this. When creative art is not an escape for them, as speculative thought or erudition are for others, it is an opportunity for decrying everything that mystifies, oppresses or alienates the individual – including sometimes the very idea of creative art. For artists have also lost their *naïveté*: in the past they were able to identify themselves with the city or the prince who embodied it; at the dawn of history they could be the artisans of an immemorial culture and celebrate a world in which everything had meaning. Today this is no longer possible: what was formerly spontaneous consent would be complicity. They cannot help but be accomplices, and know it, when in order to live, and also to gain a hearing, they must take their place in the commercial circuit. If they do this, can they at least claim their freedom? Yes, but they may be drawn back into the net. Every society has its safety-valves to prevent explosions. Bourgeois society has its *enfants terribles, monstres sacrés* or *maudits*, which do no one any harm. No surrealist has yet run into the street shooting at random, and Salvador Dali is a multimillionaire. Protest is emasculated once it becomes a fashion, pending its inclusion in histories of art.

Conversely, in countries which distrust it, it seems to be taken more seriously when it does occur. The aesthetic character of innovations, in particular, seems to be more attentively studied and appreciated.[9] In countries which find protest diverting, the game may become dangerous for the ruling class at the stage when art finds a wider audience, even among those who are ruled. It may then produce unforeseen effects and instead of being a safety-valve become a detonator.

For art today seems to be fundamentally revolutionary – at least in Western societies. Not just in face of industrial society, established order and accepted values and technocratic rationality, but more profoundly because it represents diversion and transgression: the rebellion of sentiment and fancy over logical discourse, nature getting her own back on culture. As we have suggested, art did not have to be revolutionary when culture, still untamed, was close to nature and in tune with it, when the laws created and preserved a certain demographic, economic and psychic equilibrium, when they found expression in myths, in a natural language which gave meaning even to things. Art becomes revolutionary when, as Rousseau found, culture is con-

9. We received this comment from Béla Köpeczi.

trary to nature, when the imaginary and the Utopian are repressed, when seeing is an aid to knowing and feeling its enemy, when the ear is trained, when needs are manipulated, when desire finds expression only in empty signs and caricature, as for instance love in sex and justice in legalism.

Let us, however, look a little more closely at the way in which art reacts to this civilization and to the position accorded it.

2. THE ARTIST'S REACTION

Of course the artist's reaction varies considerably from one society to another. While it is easier for us to describe the artist in revolt, or the revolutionary artist – sometimes unaware of the fact – who is often in the forefront in capitalist societies and sometimes in the Third World, we must not forget the humanist artist [10] to be found in the Socialist countries.

At all events, wherever he is free, the artist reacts by impassioned and fascinating research. The first explanation which comes to mind is of course the great variety of means made available to him by industrial civilization and also the demands it makes on him. Research is then truly technical, as it always has been. No trade can be plied, even in eventless societies, without thought being given to the skills involved and without invention being called into play. When technological progress is stepped up it is not surprising that the call made on invention should be more pressing. However, this frenzied research is partly accounted for by commercialization and competition. In a madly competitive market, setting sound investments apart, only the latest fashion sells well – the product which is most blatantly advertised or shocks the public. This is a sufficient explanation for those who are put off by novelty and who are apt to decry it as imposture. It is not sufficient for those who want to understand.

Actually this research is stimulated by ceaseless thought, so radical that it may go so far as to negate art and, first of all, the artist. Pondering on his status, the artist today seems to be retracing the path followed from Cennini to Vasari, from the state of craftsman to that of artist – perhaps because he is tired of being regarded as an exceptional being, probably also because he has come into contact with important styles in other cultural areas which are unconnected with the religion of art and the canonization of the artist, and finally because Western civilization is rehabilitating technique and inviting the artist to become a technician. But the artist contests his being even more radically when he contests the very idea of art. Not that he necessarily abandons the quest, as Rimbaud or Marcel Duchamp did; but he assigns another object to it than the beautiful, and he pursues it elsewhere. No doubt any creation is a transgression, any invention is a challenge to tradition, any style a challenge to the medium, even when, on closer investigation, the arts and the societies they reflect seem free from problems. Today, however, the

10. The expression is borrowed from Béla Köpeczi.

transgression takes on violent forms: it exalts anti-art, *l'art brut* or *l'art sauvage*, and it is not easy to discern the artist's motives and intentions. It certainly displays a degree of aggressiveness, but against what? First, against traditional values: putting a moustache on the Mona Lisa, perverting music by adding noise to it, painting by affixing objects normally cast away and choreography by introducing everyday gestures, are all ways of rejecting the seemly by declaring it conventional. They are ways of profaning beauty – because it is oppressive once definitions or models of it are imposed, because it goes hand in hand with other values now suspect as a result of their manner of establishment or their antecedents – even the defining of beauty was once the privilege of a social class – perhaps also because this officially-accepted beauty has masked or excluded other forms of beauty. Aggressiveness is then turned against the object, not just against the aesthetic product, as when some painters slash their canvases, but against the prosaic objects depicted in distorted form and devoid of practical significance in surrealist works. It may also be turned against the beholder, who may be given a bottle-rack to contemplate or a problematical assemblage of monemes to read. Is this not mocking his lack of sophistication? Perhaps too this tacit interruption of the connexion between transmitter and receiver paralyses the artist and prevents him from issuing his message. He is thus reduced to silence, if it is true that creative art is never a one-way process, like the expression of the fantastic in a dream, that it is always directed at some other person: to deny that other person, to set one's face against the universal, is to deny oneself.

Refusal of values and of the works in which they are invested, refusal of the world we know, controlled and policed, refusal of a public which can be domesticated at pleasure: we have the impression that the artist wants to play and appeals to us to play with him. This has often been said and there are countless studies on art and play.[11] Art, play, life – this was the slogan of the Futurists. It re-echoes in Tzara's *Le manifeste de M. Antipyrine*: 'L'art n'est pas sérieux'. Today 'happenings', Césaire's assemblages of automobile parts, Tinguely's machines, Cage's music, and kinetic works, invite us to take part in a game. R. Oxenaar, presenting Constant Nieuwenhuis's project for a 'new Babylon' at the Venice Biennale in 1966, wrote: 'This is a city for *homo ludens*, a city where man does not work in order to eat, but eats in order to play, a city for people who are truly free and can devote themselves to giving free rein to their creative instincts'.[12] We know, however, that the game can be serious by reason of the motivations it stirs up, the commitment

11. Let us cite only the special issue of the review *Diogenes*, No. 50, Summer 1965, devoted to the theme *Art and Play*. The following remarks are inspired by a very interesting paper by Rosario Assunto. On the importance of game in all avenues of social life HUIZINGA's work *Homo Ludens* (1938) (English translation, 1949), remains of course a classic.

12. The project for a city of this kind would seem to be inspired by nostalgia for a long past during which the whole community foregathered to celebrate in carefree communion. In this connexion D. Segal mentions in his observations that 'carnival culture', before being the subject of many contemporary works, was studied by Mihail BAKHTIN (BAHTIN). Two capital works by this author are avail-

it presupposes and the effects it produces. Such is art: when it claims to be play it most urgently needs to be taken seriously.

Then again we might well ascribe to systematic nihilism the extreme forms taken by the mutation of artistic and literary expression in the capitalist industrial societies. This would, however, mean disregard of the more peaceful forms of this mutation, and above all, an underestimation of its affirmative aspects. For *Thanatos* never finishes with *Eros* and if the refusal of traditional values liberates desire, it is in order that desire will be unashamed and at the same time discover new values. We believe that in contemporary art, we are concerned with a liberation movement, brought about in the first place by the repressive and inhuman character of our civilization and later by the weight of all that artifice has added to nature. This art intends to do in its way what a certain phenomenology proposes to do: remove the clothing of ideas which covers the world in order to regain a native familiarity, a happy connivence, with it.[13]

There are three aspects to this liberation movement:

1. First, the world must be liberated by being peopled with new, startling objects which are not a comforting rehash of the already-known. Lifting an everyday object from its normal setting and putting it, sometimes in numerous examples, in a museum, as Arman does, is making of it not so much an aesthetic object as an unwonted object, like those unexpectedly revealed by 'objective chance'. It is also a way of taking us out of our usual setting, of surprising us into letting go of the object, inviting us to do justice to it at last – perhaps because previously undiscovered beauty has been brought to light. Why not? Could not even our civilization be rehabilitated in this way? By constructing a caricature of a machine, Tinguely gives the machine over to nature, and perhaps to poetry. In the works where Rauschenberg accumulates the obsessive symbols of the American way of life is there not tenderness as well as irony? At all events it is in this manner that poetry sets words free, by lifting them out of prosaic syntagms and that Cage's music sets sound free. But are we not then invited to take part in a game of fools? Are we not abandoning solid ground for the delights of the imagination? While we think we are changing the world, have we not merely changed our outlook on it?

2. Before answering this question we must admit that contemporary art, instead of merely taking its audience to witness, provokes it and makes it take sides more imperiously than ever. It wants to free its audience as well as the art object, even if this demands shock treatment. How? In the first place, by enabling it to discover new horizons, freeing it from the bonds of tradition and prejudice, inveighing against the values which enslave it. If the traditionalists accuse art of mystifying the public, it is precisely because it is endeavouring to demystify it. To the point of 'deculturing' it, if we can use

able in English: *Rabelais and His World* (1968; Russian original, 1965) and *Problems of Dostoevsky's Poetics* (1973; Russian original, 1963). See also Kristeva, 'Bakhtine, le mot, le dialogue et le roman' (1967).

13. This theme of reconciliation must obviously be treated with caution. It is contested in the present survey by J. F. Lyotard.

the word, Dubuffet for instance rejects outright 'stifling culture' and the teachers who transmit it and demand deference to masterpieces. Today's works do not claim supremacy or deference. They treat the beholder as a friend. What they ask of him is that he should associate himself with the creation as an actor, as does a performer, as does the rambler who experiences the architecture of a town, as does an audience when it joins in the singing of a chorus. If such works sometimes appear precarious or roughly-assembled, it is in order that the partner can finish them. Execute, finish – these words have a double meaning: this is the risk run by contemporary art, the risk of dying in order to become something else and also in order that the public may live. Let us note in passing that the champions of culture, despite Dubuffet, are moving in the same direction: immanent iconological or semiological analysis, for instance, by teaching us to read the works, engages us actively, and familiarity takes the place of respect. It is precisely in connexion with Shakespeare that Freud shows us the liberating power of poetry when it goes back through the sedimentations of culture to the immemorial myth and allows us to experience our own fantasies without scruple or shame. What art liberates without our knowledge is the hidden. Why hidden? Repressed, forgotten, *a priori* inaccessible? Here philosophies diverge, as they diverge on what attaches us to the hidden: desire for the lost object, care for Being, the call of the 'wholly other'. But they concur in seeing in art what Freud previously saw in dreams, the power to express something that haunts us and that it is forbidden to name. Art invites us to a festival where prohibitions are lifted, but on condition that the festival is given by us and not for us, because the cathartic virtue of art is the reward of this game, of this free work which, like that of dream, 'does not think'. According to Dubuffet, the sin of culture is that it holds that a work of art is something to contemplate instead of something to experience or to make. Art only frees us if it is our own, and the mission that certain artists have assigned to themselves is to appeal to our creativeness, not so much by giving us a model to imitate, as a master does to a disciple, that is, to a prospective master, as by giving us an example of freedom to be lived.

3. The ruse of culture is that the most provocative work is soon commercialized, the gesture of revolt institutionalized, the appeal ignored. At least the artist was able to free himself. For this is what he is seeking in the third place, sometimes alone, without recruiting companions to share his adventure, without claiming that his freedom calls for that of others. Freeing himself always means expressing himself, but it does not mean making a confession or an exhibition, complacently alienating himself in the contemplation of his own image. More deeply it means coming out of himself and getting rid of the self. He must gamble to lose himself, and his authenticity is proportionate to his abnegation. Hence these strange, inscrutable, anonymous works produced by automatic writing, gestural painting and also perhaps aleatory music. The Ego comes in not in the place of the Id but as 'other', because it has freed itself from itself, from all the signs, all the habits, all the constraints which gave it personal identity. To 'de-create' oneself was

the expression used by Simone Weil. It is conceivable that many people are inclined to assimilate this adventure to a mystic quest. Did not Pollock take up the study of Buddhism? There are, however, certainly other ways of expressing oneself than making one's mind a vacuum and working under mescaline, for example. The music of Xenakis, which celebrates 'beings' (*les étants*), gives voice to Eros rather than Thanatos, in the same way as neo-figurative painting or lyric poetry. But in any event the artist does not talk about himself for all that; he expresses himself by opening up a whole world to us – his world – for it is the world in which he is living even when he is living his own death, a world in which he is himself because this world is in his image, or rather is his image, even when he wants every image of himself to be effaced.

The word Image brings us to the question which we had put on one side, that of the seriousness of art. This world which the artist inhabits and which he opens up to us, is it not a hallucinatory world, a refuge from harsh realities? When we think that we are freeing ourselves and freeing the world, are we not exchanging the real for the unreal, thought for reverie, freedom for caprice? Is not art a mirage and a luxury? Here certain artists throw light on the subject by invoking something that goes beyond the real – and all contemporary art is surrealistic in some way. Their works do not set the imaginary against the real: they disclose a being in the state of nature (*un être sauvage*), not torn by this opposition because the subject has not yet broken away from the object in order to domesticate it by means of concepts or tools. The main point made in the first surrealist *Manifesto* is a primary one: it springs from the threshold of consciousness, at the stage where the pleasure principle and the reality principle are not yet antagonistic, because an hallucination reveals not only a desire, but the aspect of the world which gives rise to the desire and at the same time responds to it. Then the world is what we dream, but our dreams reflect the world: the world dreams with us and it is the world's dreams which art records until science denounces them. *Our* dreams only exist because desire disarms us and throws us on the mercy of the world. They represent the possibilities which haunt reality; the art which reveals them expresses the power of Nature. That is why it breaks down the defences that we have built up, the systems by which we endeavour to regulate life and civilize nature. It invites us to the freedom of a game which we win by losing ourselves. In this it does not abolish thought but instigates it to start on another adventure. It may, however, also happen that thought instigated art, as also reflexion on art. For this reason we must briefly survey the contemporary scene in philosophy before going on to scientific research proper. Meanwhile let us glance at the situation of art in other socio-cultural settings.

Here the foregoing emphases may be displaced or may change. For instance, a certain desire for continuity, a certain attachment to tradition may be more perceptible. Then again, while in the Socialist countries the most extreme forms of contemporary art are decried as symptoms of decadence, in the Western countries themselves these productions are not always sym-

pathetically received. Evidence of this is provided, as M. Alpatov remarked, not only by the public which continues to frequent museums of classical art, but also by many critics or specialists in aesthetics, like Herbert Read and Hans Sedlmayer. We said at the outset that the old always continues to exist alongside the new. We must not forget this as we proceed to emphasize the new in an attempt to determine its true place and to understand it.

B. IN THE SOCIALIST COUNTRIES, *by Béla Köpeczi**

Although the evolution of literature and art presents certain common features all over the world, their situation assumes special characteristics in the Socialist countries. The changes that have occurred in means of presentation, reproduction and dissemination influence art and its function in these countries as elsewhere, but do not necessarily lead to the same results as in capitalist society. The radical changes that have affected the economic, social, political and cultural structure play a decisive part from the triple standpoints of the development of artistic and literary production, the education of the public and the use of the mass media. In view, however, of the nature of this study, it is on questions of theory that our attention will be focused.

1. THE CULTURAL REVOLUTION AND THE PUBLIC

In the Socialist countries art has its place in that great undertaking that Lenin called a cultural revolution, the characteristics of which are as follows: extinction of the cultural monopoly of the former ruling classes; raising of the cultural level of the worker and peasant masses; creation of a new intelligentsia; support from the State for the development of the sciences and the arts; conscious activity of the Communist Party and of the Socialist State, aimed at achieving these objectives. This programme implies the existence of an art which appeals to the broad masses and the democratization of its dissemination.

Under these conditions, a work of art cannot be regarded as an article of trade even if, in the present stage of evolution, it does retain some of the characteristics that this term implies. Guided by the principle of the educational rôle of art, socialist cultural policy endeavours to disseminate and to make accessible, through the grant of considerable subsidies, the loftiest values of past and present. This conception of culture can lead to an oversimplified didacticism, but, even in that case, it is hardly possible to deny the advantages offered by selection based on value judgements. The results obtained at the level of the dissemination of classical literature and art are

* Professor at the Faculty of Letters, University of Budapest. Secretary-General, Hungarian Academy of Sciences.

undeniable; in this connexion there has been much talk of a 'conservative' policy, but we consider, on the contrary, that the 'rebirth of the classics' had led to a raising of cultural standards and to the human enrichment of the broad masses. The difficulties of choice arise especially in connexion with current production, where the demands of politics, aesthetic concepts or simple questions of taste may lead to erroneous judgements. Thus products marred in varying measure by excessive schematism, insignificance or bad taste can be disseminated, especially in the field of light entertainment, where we find certain features of a 'consumer culture' inherited from the past or imported or imitated from Western Europe. The raising up of the cultural level of the masses, and conscious action from the critics and cultural institutions are apt to thwart those tendencies.

2. THE POSITION OF THE ARTIST

Whereas in Western Europe the artist, even if he regards himself as 'committed', frequently lives on the fringe of society, in the Socialist countries he takes part in the life of the community. The commitment of socialist writers and artists does not mean in any way that they are obliged to take a stand on matters of current political interest, and it does not necessarily involve the production of illustrative works, as certain opponents would have it. Nevertheless, if one approves of the aims of socialism one cannot adopt the same opposing attitude which, within a society dominated by capitalism, would necessarily stem from one's attitude as an opponent of that particular social order. The commitment of the socialist artist is no more than a conscious identification with the cause of the working class, and this stance implies the creation of an art that is democratic and humanistic in character. That being said, it must nevertheless be recognized that this new attitude of the intellectual in the community is not easily achieved, for it is subject to the misunderstandings of politics as well as to those of the artist, and it is often at the mercy of conflicts of an objective nature that arise between these two spheres of human activity. Moreover, it does not necessarily follow that an artist living in a Socialist country is a Marxist: the problems that we have touched on naturally assume a different light for those who are not Marxist, and the nature of the contradictions that these artists have to contend with is also different.

It is primarily by their creative activity that the writer and the artist take part in the building of the new society. In this task they are assisted by the State, which places orders through the intermediary of the cultural institutions, establishments or factories and which, through the same network of organizations, undertakes to disseminate their works. Government bodies promulgate laws aimed at ensuring effective protection of the author's rights, thus enabling a considerable body of writers and artists to live solely from their profession. The State subsidizes artists' funds which pay out advances and grants to their members, deal with problems of social security, maintain

homes for rest and creative work and in some countries they may even have their own publishing houses, sales networks and so forth. Creation and dissemination alike receive public support, so that creation is encouraged both directly and indirectly. Thus, the artist finds himself in an unprecedented situation: he is assured that he will be enabled to address a very wide audience and to exert influence on the public at large.

3. WORKS

Under the influence of social reality and Marxist theory various literary and artistic trends of a socialist character have come to light during the past hundred years. Some consider as 'socialistically realistic' only those works which extend the classical tradition, whereas others refer only to tendencies originating in the *avant-garde* of the beginning of the century. Looking beyond this quarrel between schools, we believe that it is the co-existence of these movements which, from the beginning, has characterized the evolution of the new art. The novels of Gorky, A. Tolstoy or Sholokhov, the theatrical school of Stanislavsky, the paintings of Deineka, Sarian or Favorsky, the statues of Mukhina, the symphonies of Shostakovich and the ballets of Prokofiev prove that it has been possible to keep faith with a certain realistic tradition of the nineteenth century and to achieve undeniable successes. The poems of Mayakovsky, the films of Eisenstein and the theatrical innovations of Meyerhold, to mention only these, are there to show that the movement which borrowed from futurism, expressionism or constructivism was also capable of creating durable works.

We find the same tendencies, with national variants, among the other peoples of the Soviet Union, in the other Socialist countries of Central Europe, Asia and America, and in the works of Marxist writers and artists in non-Socialist countries. In some countries, like France (Aragon, Eluard) or Czechoslovakia (V. Nezval), it is the *avant-garde* that has been predominant; in others, like Germany, we observe the co-existence of several trends (B. Brecht, J. R. Becher, Anna Seghers); lastly, in some others we note an early attempt at synthesis (as, for example, in the poetry of the Hungarian A. József).

While admitting the importance of tradition in the formation of the new art, it should not be forgotten that its representatives are seeking to assert not only continuity but, above all, discontinuity in the evolution of art. The socialist artist is searching for novelty in themes and forms and, at the present stage, we are witnessing experimentation in every sector of art and literature.

In a note that he was kind enough to send to us on literary and artistic developments in the Soviet Union, M. Alpatov describes the present situation as follows: 'It was towards the end of the fifties that a new wave of artistic research began to develop, especially among the younger generation of artists and poets. They were beginning again to show an interest in the post-impressionists and to rehabilitate the Russian art of the beginning of the

century. Attempts are being made to link up with folklore traditions and those of ancient Russia. It cannot be said that all these searchings have been crowned with success. There always remains a danger of eclecticism. By imitating fine examples one risks losing one's originality and one's national character. But however that may be, the faults of the preceding stage are disappearing in every realm of art and above all in architecture and in the decorative arts.'

Let us add that in the other Socialist countries we are witnessing a return to certain manifestations of the *avant-garde* in the twenties and an increase in the interest aroused by current literary and artistic trends in Western Europe.

True innovation, however, resides not in the search for new forms, but above all in the search for a new content. During revolutionary periods socialist art has presented man in his struggle to bring about a radical change in society. Today, at least in some Socialist countries, the forms of the combat have changed: writers and artists are seeking to define the characteristics of socialist personality in conditions of peaceful construction. What is on the agenda is the expression of a real humanism – one that takes into account the individual and that goes against alienation, depersonalization and nihilism.[1]

4. FOUNDATION AND DEVELOPMENT OF THE MARXIST THEORY OF ART

As to their basic aims, art and cultural policy in the Socialist countries are determined by Marxist philosophy. The two basic ideas that govern Marxist doctrine in this matter can be summarized as follows: art is a reflexion of reality and, accordingly, a means of knowledge; secondly, art has a social function, namely, it must help to change the world and to change man himself. These basic notions have been interpreted in very many different ways under the influence of social, political and cultural developments. For an understanding of the present debates we have to go back to the sources and compare what they convey to us with the different interpretations that have appeared over more than a century.

(a) *Art as a reflexion of reality*

(i) According to the Marxist view [2] the various forms of social conscience are the reflexions of objective reality, of which the knowledge, understanding

1. A. Mjasnikov, 'Literaturovedenie i sovremennost'' (= The science of literature and contemporaneity), unpublished contribution to the present study. Cf. TUGARINOV, *O cennostjah žizni i kul'tury* (= Concerning the Values of Life and Culture) (1960); PRACHT, 'Sozialistischer Realismus und ästhetische Masstäbe' (= Socialist realism and aesthetic criteria) (1966).

2. *Works by the theorists of Marxism on literature and art*: MARX-ENGELS, *Sur la littérature et l'art* (1936, 1954) and LÉNINE, *Sur la littérature et l'art* (1957) (selected texts in a French translation). Cf. LIFŠIC (LIFSHITZ), *K voprosu o vzgljadah*

and change 'for us' (*'für uns'*) are the aims of all human activity. Reflexion (*Abbild, Widerspiegelung*) does not mean photographic reproduction, but rather the building of a model serving to bring out – by strictly artistic means – the essence of human phenomena.

(ii) The founders of Marxism consider that in literature as in art it is *realism* that corresponds to their philosophical view. 'Realism, writes Engels,[3] supposes, in my view, in addition to accuracy of detail, the exact representation of typical characteristics in typical circumstances.' Plehanov (Plekhanov), Mehring or Lafargue cite this same realism when they criticize naturalism or formalism.

Realism thus conceived is not one artistic tendency among others – it is considered as a *method* that makes it possible to understand the complex relationships that lie behind changing reality, a method that postulates the castings of images and therefore the sensual presentation of characteristic

Marksa na iskusstvo (= Contribution to the Question of Marx's Views on Art) (1933); LUKÁCS, *K. Marx und Fr. Engels als Literaturhistoriker* (= K. M. and Fr. E. as Historians of Literature) (1948); MEILAH, *Lenin i problemy russkoj literatury* (3rd edn., 1956) (French translation, MEILAKH, *Lénine et les problèmes de la littérature russe*, 1956); SÁNCHEZ VÁSQUEZ, *Las ideas estéticas de Marx* (1966).

Fundamental expositions of Marxist aesthetics: PLEKHANOV (= PLEHANOV), *L'art et la vie sociale* (French translation, 1960); MEHRING, *Gesammelte Schriften* (1961); LAFARGUE, *Critiques littéraires* (1936); LUNAČARSKIJ (LUNACHARSKY), *Sobranie sočinenij* (= Selected Works) (1963-67); CAUDWELL, *Illusion and Reality* (1950); GRAMSCI, *Letteratura e vita nazionale* (1952); DELLA VOLPE, *Critica del gusto* (1960, 1966); LUKÁCS, *Die Eigenart des Ästhetischen* (= The Specific Nature of the Aesthetic) (1963, 1965).

On the history of Marxist aesthetics: LUKÁCS, *Adalékok az esztétika történetéhez* (= Contributions to the History of Aesthetics) (1953) (German version, *Beiträge zur Geschichte der Ästhetik*, 1954).

Handbooks: KAGAN, *Lekcii po marksistko-leninskoj èstetikoj* (= Lessons in Marxist-Leninist Aesthetics) (1963-64-66) (German translation, *Vorlesungen zur maxistischen-leninistischen Ästhetik*, 1969); PAVLOV, *Osnovni vyprosi na estetikata* (= Basic Problems of Aesthetics) (1958); BERESTNEV & NEDOŠIVIN (eds.), *Osnovy marksistko-leninskoj èstetiki* (= The foundations of Marxist-Leninist Aesthetics) (1960); KOCH, *Marxismus und Ästhetik* (1962); SZIGETI, *Bevezetés a marxista-leninista esztétikába* (= Introduction to Marxist-Leninist Aesthetics) (1964-66); FEIST, *Prinzipien und Methoden marxistischer Kunstwissenschaft* (= Principles and Methods of the Marxist Science of Art) (1966).

In the essay written as a contribution to this study, 'Crítica marxista de la estética burguésa contemporánea' (published in French translation, 'Critique marxiste de l'esthétique bourgeoise contemporaine', 1970), J. A. PORTUONDO, of the University of Havana, describes the main trends in Marxist criticism, stressing the ideas of M. S. Kagan, Lukács, Ivan T. Pavlov, Galvano Della Volpe and Adolfo Sánchez Vásquez. He discusses the controversies of certain Marxists with the existentialists and with the structuralists.

Concerning the present trends of Marxist philosophy as applied to art, especially in the non-Socialist countries, see below in Section II, *The Philosophical Scene*, the survey by M. Dufrenne, 'Marxism'.

3. Letter in English dated April 1888 to the young English novelist Margaret Harkness, quoted in French translation in MARX-ENGELS, *Sur la littérature et l'art*, 1936 edn., p. 148, 1954 edn., p. 317.

human phenomena linked to one another in an intensive totality. It is thus that the problem of the method leads to the theory of reflexion. This conception was applied by critics and historians of art and literature in the Soviet Union in the twenties and in particular by A. V. Lunačarskij (Lunacharsky).

In the application of the theory of reflexion to the realm of art the philosophy of György Lukács [4] is particularly notable on account of its content and of the widespread interest that it has evoked. In Lukács' philosophy the influence of Hegel's aesthetics matches in addition that of the ideas of Marx and Lenin on literature. According to this theory artistic *mimesis* consists in an 'imitation' of reality, made possible by a subjectivity pushed to its extreme, which brings into relief the essential moments of the phenomena from the point of view of the evolution of humanity considered in its generic aspects. Lukács distinguishes between artistic and scientific knowledge, stressing the anthropocentric character of the former and the process of dis-anthropo-morphism which is inherent in the latter. The aim of science is to present a reality independent of the knowing subject, whereas art achieves unity of the subject and of the object, which ensures its specificity. Lukács attributes great importance to the search for this specificity (*Eigenart*) in order to answer the reproach that he has a somewhat epistemological conception of literature and art. According to him it is that which is *typical* that achieves the dialectical unity of the subject and of the object, of the abstract and of the concrete, of the particular and of the general, of the phenomenon and of the essence – i.e., the specificity of an art that exerts its influence on man and, consequently, on society. The work of art produces an affective and mental shock that Lukács – taking the old term used by Aristotle and re-interpreting it in his own way – calls *catharsis*. *Catharsis* enables man to go beyond the stage of individuality to reach that of the generic, that is to say, to identify himself as an individual with the cause of mankind.

In the thirties, writers and theorists discussed the correctness of this conception. Bertolt Brecht among others took the Hungarian philosopher to task for the over-passive character – inherited from Hegelianism – of his theory of reflexion. Instead of stressing, as Lukács does, the unity of the essence and of the phenomenon, the great German playwright stresses the contradictions that exist between them. He contrasts the 'typical' of Lukács with what he calls *Verfremdung*, i.e., a form of representation in which one recognizes the object while making it appear as 'foreign'. Moreover, he attributes great importance to creating distance and to *Einfühlung* (empathy)

4. The ideas are expounded in the fundamental work of LUKÁCS, *Die Eigenart des Ästhetischen* (1963, 1965). A summary account of this aesthetics will be found in HELLER, 'Lukács's aesthetics' (1965) and, by the same author, 'L'esthétique de György Lukács' (1967). See again ARVON, *Georges Lukács, ou le Front populaire en littérature* (1968), and LICHTHEIM, *Lukács* (1971). Also worth consulting is a slightly earlier work by LUKÁCS, *A különösseg, mint esztétikai kategória* (1957) (Italian translation, *Prolegomeni a un'estetica marxista. Sulla categorie particolarità*, 1957; French translation in preparation, *Prolégomènes à une esthétique marxiste*).

in the reception of a work destined to contribute towards changing the world, thus opposing Lukács whose catharsis constitutes – according to him – an eternal ethical feeling. 'Realistic art is an art of combat. It combats false conceptions of reality and impulses that go against the real interests of mankind. It makes possible the formation of correct views and strengthens productive impulses.' [5]

Although the majority of Marxist thinkers accept the theory of reflexion, the epistemological, aesthetic and historic aspects of the problem continue to be discussed. The representatives of the 'great realism', such as Lukács or M. Lifšic (Lifshitz), while combating, and correctly so, sectarianism, set up as an ideal the works of the classical writers of the nineteenth century and of their followers, the works of, say, Balzac, Tolstoy or Thomas Mann. The thesis that contrasts this realistic art with anti-realistic art – a label under which it was intended to include not only bourgeois decadent art, but also innovating trends of the revolutionary *avant-garde* (German expressionists, Russian futurists, surrealists of central Europe, and the like) – implied an unduly simplified vision of the true historical process. At the present time there are various contending philosophies, varying from the theory of realism considered as a general trend, illustrated by the works of the great classics, to the theory of '*Réalisme sans rivages*' ('unbounded realism'), which is meant to include all the trends of the twentieth century and any work of value. This discussion touches on the very foundations of the theory of reflexion, since some theorists contrast with it, in one way or another, myth, activity and subjectivity.[6]

(iii) Marxist aesthetics postulates the *primacy of the content*, while declaring its dialectical unity with form. Here *content* and *form* should be taken to mean two aspects of the work of art that cannot exist independently of each other: the content is the reflexion of the essential relationships inherent

5. BRECHT, *Schriften zur Literatur und Kunst* (1966), Vol. II, p. 361; cf. MITTEN-ZWEI, 'Die Brecht-Lukács Debatte' (1967) and, more recently, in French, 'Brecht et la tradition littéraire' (1973).

6. For the debate on the subject of realism see: LUKÁCS, *Probleme des Realismus* (1955); by the same author, *Die Gegenwartsbedeutung des kritischen Realismus* (1958, 1971), originaly published under the title of *Wider den missverstandenen Realismus* (= Against Misunderstood Realism) (French translation, *La signification présente du réalisme critique*, 1960); studies published in issues 3, 4, 5 and 6 of 1957 of *Voprosy literatury* (= Questions of Literature); GARAUDY, *D'un réalisme sans rivages* (1963, 1968); FISCHER, *Von der Notwendigkeit der Kunst* (1959) (English translation, *The Necessity of Art*, 1964); by the same author, *Zeitgeist und Literatur* (= Spirit of the Times and Literature) (1964); MORAWSKI, 'Le réalisme comme catégorie artistique' (1963); SUČKOV, 'K sporu o realizme' (= On the debate over realism) (1965), and reply by GARAUDY (1965); the collection of essays *Sovremennye problemy realizma i modernizm* (= Current Problems of Realism and Modernism) (1965); MACHEREY, *Pour une théorie de la production littéraire* (1966); SUČKOV, *Istoričeskie sudby realizma* (= The Historic Fate of Realism) (1967); 'Of socialist realism – A basis for further discussion' (conclusions of the Panel on Cultural Theory attached to the Central Committee of the Hungarian Socialist Workers' Party) (1965); KÖPECZI, 'Socialist realism – The continuing debate' (1966); by the same, 'Réalisme socialiste: légende et vérité' (1971).

in a subject; form is, in the last analysis, the image that expresses these relationships and ensures communication between the creator and the receiver. Generally, a distinction is made between the inner and the outer form. In the novel, for example, the inner form is made up of the characters and composition,[7] the external form is reduced to technique. Marxist aesthetics has given little attention to analysis of questions of form, which has certainly harmed its development and suggested the idea that it is only concerned with the content of works of art, especially their political or ideological content. For some time now, Marxist specialists in aesthetics have been trying to make use of the results achieved by the former Russian formalist school, by the different structuralist trends, by semiotics, by the theory of information and by cybernetics.[8]

(b) *Art and society*

(i) In *The German Ideology*, Marx and Engels already stated that 'it is not consciousness that determines life, but life that determines consciousness'.[9] One of the forms of this consciousness is the aesthetic form which is linked by a series of transitions to the material basis. 'Whether an individual like

7. As an example of concrete analysis of one *genre* see LUKÁCS, *A történelmi regény* (1938) (English translation, *The Historical Novel*, 1963).

8. On the Russian formalist school – R. Jakobson, B. Ejhenbaum (Eikhenbaum), Ju. N. Tynjanov (Tynianov), etc., – see: ERLICH, *Russian Formalism* (1955), and, in French, *Théorie de la littérature – Textes des formalistes russes* [B. EIKHENBAUM, V. SHKLOVSKY (= ŠKLOVSKIJ), R. JAKOBSON, V. V. VINOGRADOV, J. TYNIANOV, O. BRIK, B. TOMASHEVSKY (= TOMAŠEVSKIJ), V. PROPP] (1965).

On the new structuralist trends see: MUKAŘOVSKÝ, *Kapitoly z české poetiki* (= Chapters from Czech Poetics) (1948); ŠKLOVSKIJ (SHKLOVSKY), *Hudožestvennaja proza* (= Literary Prose) (1959); GŁOWIŃSKI, OKOPIEŃ-SŁAWIŃSKA & SŁAWIŃSKI, *Zarys teorii literatury* (= Outline of a Theory of Literature) (1962); SŁAWIŃSKI et al. (eds.), *Z dziejów form artystycznych w literaturze polskiej* (= On the Evolution of Artistic Forms in Polish Literature) (series of works published since 1963 and giving an overall view); LOTMAN, *Lekcii po struktural'noj poetike* (= Lectures in Structural Poetics) (1964); by the same, *Tezisy k probleme v rjadu modelirujuščih sistem* (= Theses relative to the Problem of Model-productive Systems) (1967); FILIP'EV, *Tvorčestvo i kibernetika* (= Creation and Cybernetics) (1964); *Poetics/Poetyka/Poética, First International Congress of Work-in-Progress devoted to the Problems of Poetics, Warsaw, 1960* (ed. by DAVLE et al., 1961); *Idem, Second Congress . . ., Warsaw, 1964* (edited by JAKOBSON et al., 1966); MELETINSKIJ (MELETINSKY) & SEGAL, 'Strukturalizm i semiotika v sovremennom literaturovedenii i fol'kloristike v SSSR' (= Structuralism and semiotics in current research into the literature and folklore of the U.S.S.R.), written as a contribution to the present study, published in English under the title 'Structuralism and semiotics in the U.S.S.R.' (1971). See also below in Section III, *The Scientific Approaches*, the sub-section 'The semiotic approach' by Louis Marin.

9. *Marx-Engels Gesamtausgabe* (MEGA), Vol. V, 1932 edition, p. 16; quoted in French translation in MARX-ENGELS, *Sur la littérature et l'art, op. cit.*, 1936 edn., p. 27, 1954 edn., p. 142; see MARX-ENGELS, *The German Ideology* (English translation, 1947).

Raphael', write Marx and Engels,[10] 'is able to develop his talent depends entirely on the demand, which in turn depends on the division of labour and the consequent condition of men's education'. The demand therefore depends on the division of labour, i.e., on the separation of the various activities that lead to one another, which separation gives rise to the birth of classes and social strata. Marx and Engels are not content with mentioning this essential factor of evolution, they also speak of the 'conditions of men's education', although the latter stem from the division of labour. This means that in the definition of the demand they attribute an important rôle to the cultural situation of each society and of each class or stratum of this society. P. Francastel, speaking of Diderot and Marx, recognizes that they have 'introduced the problem of the relations existing between art and society considered in its entirety, forming the framework in which the artist is active'.[11] This is therefore a vital gain for Marxism in the realm of theory – a gain that constitutes the foundation not of a sociology of art, but of aesthetics itself.

(ii) Marxist aesthetics recognizes that the relations between the artist's class affiliations, his vision of the world and his creative activity are very complex. Writing about Balzac, Engels already underlined the contradictions that may exist in this connexion: 'The fact that Balzac was forced to go against his own class sympathies and political prejudices, that he *saw* the inevitability of the end of his beloved artistocrats and that he described them as not deserving any better fate; the fact that he *saw* the true men of the future only where they were to be found at the time (i.e., among the Republicans of the Cloître-Saint-Merri, 5-6 June 1832), *that* I regard as one of the greatest triumphs of realism and one of the most striking characteristics of Balzac in his later years.'[12] With regard to Leo Tolstoy, Lenin detects similar contradictions, but he does not explain them solely by the writer's individual vision of the world. 'The contradictions in Tolstoy's views', he writes,[13] 'are not those of his strictly personal thinking; they are the reflection of the social conditions and influences, of the historic traditions – complex and contradictory to the highest degree – that determined the psychology of the different classes and different strata of Russian society at the time *following* the reform but *preceding* the revolution.'

Some Marxist critics have used Engels' remark on the subject of the

10. *L'Idéologie allemande, MEGA*, Vol. V, p. 372, quoted in French translation in MARX-ENGELS, *Sur la littérature et l'art, op. cit.*, 1936 edn., p. 55, 1954 edn., p. 175.

11. FRANCASTEL, 'Problèmes de la sociologie de l'art', p. 287 in GURVITCH (ed.), *Traité de sociologie*, Vol. II (1960). We find the same idea in MUNRO, 'The Marxist theory of art history' (1959, 1963).

12. Letter written in April 1888 to Margaret Harkness, quoted in French translation in MARX-ENGELS, *Sur la littérature et l'art, op. cit.*, 1936 edn., p. 149, 1954 edn., p. 319.

13. 'Leo Tolstoy' (16 (29) Nov. 1910), 4th edn. in Russian of the *Works*, Vol. XVI, pp. 293-297; quoted in French translation in LÉNINE, *Sur la littérature et l'art, op. cit.* (1957), p. 129.

'triumph of realism',[14] to introduce, in the interpretation of the contradictions of the author's personal vision of the world and of his work, the notion of direct intuition of reality without casting any light on the place of the latter in the creative process. This question gave rise to repeated discussions leading to the adoption of quite different attitudes which have determined the cultural policies of the working class movement.

(iii) While stressing the determining rôle of society, Marx did not deny the relative autonomy of art in relation to economic and social developments. In his *Contribution to the Critique of Political Economy* we read: 'In the cast of art we know that specific periods when art has flourished are in no way related to the general development of society nor, consequently, to the material basis or, in a way, the framework of its organization'. And Marx wonders – without, however, giving us any answer – about the causes of the survival of the great artistic monuments of antiquity: 'The difficulty does not consist in understanding that Greek art and the epic are linked to certain forms of social development. The difficulty consists in understanding that they can still cause aesthetic enjoyment and are considered in some respect as a norm and as inimitable models.' [15]

In taking this standpoint Marx draws our attention to the dialectics of the relationship existing between the evolution of art and the evolution of society; he warns us in advance against any attempt to reduce these complex relations to a simple automatism.

(iv) Inspired by the general lessons of Marxism and by the ideas of the Russian democratic critics, such as Belinskij (Bielinsky), Černiševskij (Chernyshevsky), Dobroljubov, and of the French positivists like Hippolyte Taine, G. V. Plehanov (Plekhanov) attempted to prove, in a consequential manner and with the aid of concrete analyses of certain works and certain trends in French and Russian literature, that 'any ideology – including art and what is called *belles-lettres* – expresses the tendencies and inspiration of a given society, or, in the case of a society divided into classes, of a given social class'.[16] This conception, which disregards Marx's warnings, profoundly influenced Marxist aesthetics for quite a long time and gave rise to a school of vulgar sociologism.[17] The sociologists who adhered to it established too direct a link between the artist's class affiliations and his work, and above all they stressed the political and ideological importance of literature and art. Invoking the radical change in society the representatives of the organization *Proletarskaja Kul'tura* ('Proletkult'), as also those of revolutionary fu-

14. Cf. POSPELOV, 'Metodologičeskoe razvitie sovetskogo literaturovedenija' (= Methodological development of Soviet literary science) (1967); FRIDLENDER, 'Osnovnye ètapy sovetskogo literaturovedenija' (= Essential stages in Soviet literary science) (1968); KÖPECZI, 'Balzac and the Human Comedy' (1968); by the same, 'L'histoire des idées – histoire de la littérature?' (1969).

15. See MARX, *Contribution to the Critique of Political Economy, in fine* (new English translation, 1970).

16. PLÉKHANOV, *L'art et la vie sociale*, p. 237 in edn. under reference (1950).

17. Cf. MACA (ed.), *Sovetskoe iskusstvo za 15 let* (= 15 Years of Soviet Art), documents (1953); see also ERMOLAYEV, *Soviet Literary theories, 1917-1934* (1963)

turism, rejected the heritage of the past and advocated the need to create an absolutely new art, a proletarian art. 'As regards the questions posed by culture, we are immediate socialists,' declare the proponents of *Proletkult*. 'We declare that the proletariat must forthwith and without delay create in its image socialist forms of thinking, feeling and living.'[18] The former futurist V. Majakovskij (Mayakovsky) did not say anything different, even if he contested the Proletkult thesis whereby proletarian culture can be created only by writers and artists with a working-class background.[19]

Lenin attacked this idea vehemently, defending the principle of continuity in the realm of culture and rejecting the utopianism and illusionism of the 'leftists'. 'Marxism', he states,[20] 'has acquired world-wide historic importance as an ideology of the revolutionary proletariat due to the fact that, far from rejecting the most precious conquests of the bourgeois era, it has on the contrary assimilated by transformation everything precious in the development of human thinking and culture over a period of more than 2,000 years. Only subsequent work on this basis and in this direction, animated by the practical experience of dictatorship of the proletariat, which is the final struggle against all forms of exploitation, can be recognized as constituting the development of a truly proletarian culture.'

He was thus defending the fundamental positions of Socialist cultural policy, but abstained from intervening in aesthetic matters. In conformity with the standpoints of the central committee of the Communist Party of the U.S.S.R., A. Lunačarskij (Lunacharsky), who for a long time was in charge of Soviet cultural policy, favoured in the twenties the development of, and competition between, the various movements.

The defence of the heritage of the past was a just cause; dogmatic policy, however, made use of it in order to condemn *avant-garde* trends, even revolutionary ones, thereby limiting freedom of creation.[21] Marxist theory, at the

18. In the journal *Proletarskaja kul'tura*; quoted in French in FRÉVILLE, 'L'action de Lénine sur la littérature et la culture', introduction to LÉNINE, *Sur la littérature et l'art, op. cit.* (1957), p. 40.

19. Referring to the futurist manifesto of 1912, MAJAKOVSKIJ (MAYAKOVSKY) declared in 1923 that it was necessary to 'combat the application of the working methods of the dead to modern art' (*LEF*, No. 1, Mar. 1923). In 1928 he attacked the worshippers of the past who 'under the pretext of education take us in the cemeteries to the tombs of the classics' (*Novyj LEF*, No. 1, Jan. 1928).

20. In Point 4 of the 'Draft resolution for the Proletkult Congress', 8 Oct. 1920 (*Works*, 4th edn., Russian, Vol. XXXI, pp. 291-292; quoted in French translation in LÉNINE, *Sur la littérature et l'art*, p. 167, under the title 'Thèses sur la culture prolétarienne').

21. It was with a party resolution of 1932 that the struggle against leftist tendencies in the RAPP and against *avant-garde* trends began. The proposed aim was to organize single associations of writers and artists, instead of having extremely restive small-size movements, and to promote a drawing together of creators considered as 'fellow travellers'. In the beginning, this change seemed likely to favour cultural development. Later it was realized that unity meant uniformization in the service of a dogmatic policy. See in this connexion the explanations of LUKÁCS in *Müvészet és társadalom* (= Art and Society) (1968).

present time, lays stress on continuity, but assigns a more important rôle to innovation.

(c) *The function of art*

(i) According to Marxist aesthetics, a work of art is not solely an instrument of knowledge (some critics of Marxism are wrong when they criticize those writers for maintaining such a view): it serves, in a complex way, the conscious awakening of man and thereby influences his activity. Within the workers' movement there was very early evidence of a utilitarian trend that wanted to attribute to literature and art a direct educational rôle, above all in political matters. The utopian and petit-bourgeois socialists like Proudhon formulated this requirement without taking into account the specificity of art.

While defending the reason for the existence of 'political' *genres*, Marx and Engels rejected any kind of over-didactic conception of art. 'In my view', Engels writes,[22] 'a novel that is socialist in character, perfectly fulfils its mission when, through the faithful depiction of real relationships, it destroys conventional illusions as to the nature of these relations, shakes the optimism of the bourgeois world and forces people to doubt the lastingness of the existing order, even if the author does not directly indicate any solution and even if, as the case may be, he does not ostensibly take any side.'

In 1905, in an article entitled 'The organization of the Party and party literature', Lenin defined the function of socialist literature in the following terms: 'Literature should become *part* of the general cause of the proletariat, a small cog and a smal screw in the great social democratic machinery, one and indivisible, set going by the whole of the conscious *avant-garde* of the entire working class. Literature must become an integral part of the organized, methodical and unified work of the Social Democratic Party.' [23] Let us point out in this connexion that in the same article Lenin underlined the specific character of literature in relation to politics.

Much has been said about the meaning that Lenin attributed to 'the party spirit', i.e., Marxist commitment in the realm of art. There are some (including Lukács) who claim that this article relates solely to the press and that it has nothing to do with literature proper; others insist that this theory should be applied literally in every situation. It is certain that Lenin, in 1905, had in mind socialist literature in general, including *belles-lettres*. After the October Revolution, the party spirit meant for him the acceptance of Marxist ideology and service in the cause of the proletariat; but he no longer insisted that all creators should belong to the Party and he no longer

22. Letter dated 26 Nov. 1885 to Minna Kautsky, in MARX-ENGELS, *Letters to A. Bebel, W. Liebknecht, L. Kautsky and others*, Vol. I, p. 414, quoted in French translation in: MARX-ENGELS, *Sur la littérature et l'art*, 1954 edn., pp. 314-315.

23. 'The organization of the Party and party literature' (13 (26) Nov. 1905), *Works*, 4th edn., Russian, Vol. X, pp. 26-31, quoted in French translation in LÉNINE, *Sur la littérature et l'art*, p. 87.

demanded, as he did in 1905, that literature should be rigorously subordinate to the demands of the current political struggle.

The relationship between literature, art and politics is therefore complex and cannot be examined solely on a theoretical plane. At any rate, both on the aesthetic plane as in the realm of the cultural policy of Marxism, there are a great many contending standpoints. Some insist on the autonomy of literature and art in relation to politics, while others remain faithful to utilitarianism and even to the dogmatism of the past, two extremes rejected by the majority of theoreticians.[24]

(ii) Serving the cause of the proletariat by artistic means signifies addressing oneself to the great mass of the population and contributing to its conscious awakening. This requirement must have as a consequence the birth of a literature and of an art of a democratic or popular character. But how can this objective be attained? After the discussions of the twenties, dogmatic cultural policy imposed a certain cultural model, the formation of which was also linked with the social and cultural realities of the Soviet Union, and later of the other Socialist countries. The changes that took place after 1956 made possible a more refined view of the public and of the 'folk' character of literature.

(d) *Socialist realism*

In the theoretical discussions of the twenties the different trends in socialist literature and art – including the *avant-garde* – hailed realism as their authority. People spoke of a proletarian realism, a dialectical realism, romantic realism, etc. Finally, the expression *socialist realism* [25] was adopted at the First Congress of the Writers of the Soviet Union in 1934. Socialist realism as an artistic method regards as its aim the reflexion of the essential part of reality in a historically concrete way. It implies on the part of the artist adherence to a materialist and dialectical conception of the world and the undertaking to serve the cause of the proletariat and of socialism. Socialist realism, illustrated by a considerable number of works of value, is an artistic phenomenon and not a figment of the mind nor the object of a simple political directive, as some people think.[26] It is true that dogmatic policy deformed this theory and that, by its 'aesthetic norms', it helped to reinforce

24. Cf. BEYER, *Die Künstler und der Sozialismus* (= Artists and Socialism) (1963). See the debates on these matters in several periodicals: 'On the artist and politics' (*Marxism Today,* Jan. and Feb. 1960); 'Débats sur les problèmes idéologiques et culturels' (*Cahiers du communisme,* May-June 1966); *Wort in der Zeit* (1966 issues).

25. See ROST & SCHULZE, 'Der sozialistische Realismus' (1960).

26. We think we have proved that socialist realism is a historical phenomenon and that it should be examined as such; see our paper 'Le réalisme socialiste en tant que courant littéraire international' (1967, publ. 1969). Cf. aussi MORAWSKI, 'Les péripéties de la théorie du réalisme socialiste' (also in English, 'Vicissitudes in the theory of socialist realism') (1961).

academic and schematic tendencies. The ravages that were thus caused were serious but the theory of socialist realism is beginning to benefit from the lessons of this evolution, as well as from those of the development of twentieth-century literature and art. The recent debate on socialist realism is evidence of this.[27]

The literary and artistic trends, the aesthetic debates and the attitudes adopted in cultural policy have given rise during this half century, within the socialist world and primarily in the U.S.S.R., to an abundant theoretical literature that is very badly known in general and specially in Western Europe. During a certain period writings stamped with the mark of dogmatism received fairly wide circulation; for some time now we have been witnessing in Western Europe a renaissance of the so-called Russian formalist school, confrontations with the works of Lukács or Brecht, etc.; the other aspects of this activity seem, however, to be overlooked.

In a recent article,[28] Academician N. Konrad reviewed the results obtained in the Soviet Union, after 1917, by the so-called 'philological' sciences, and drew attention to the positive contribution of trends which have tended to be condemned out of hand. Thus, the RAPP school, which considered literature as a form of ideology, as well as the sociological school, despite its well-known simplifications, combated successfully certain dogmas with which cultural history was overburdened, as well as a one-sided psychological approach ('psychologism'). As regards the Russian formalist school, it had the merit of drawing attention to the importance of questions of language and style, even if its approach was unilateral. Later the increased interest in the classics made possible the introduction of the notion *'narodnost''* (folk character) in the interpretation of literature; this does not mean to say that the class character was denied, but that a more general view of the history of literature was obtained. Similarly, the horizons were expanded for the study of the literatures of all the nations of the U.S.S.R., of the other Socialist nations and of world literature.

Let us add that in other aspects of art the same trends in regard to theory have been observed. At the present time, thanks to the social, cultural and, in particular, artistic development, we are witnessing a flourishing of a great many movements and the development of very open discussions between their spokesmen in the various Socialist countries, where the lessons of the past – international and national – have their place alongside the emerging forms of new trends in literature and art.

27. For the recent debate on the topic of socialist realism see: *Problemy socialisticeskogo realizma* (= Problems of Socialist Realism) (1961); Ivanov, *U sučnosti socialisticeskogo realizma* (= On the Essence of Socialist Realism) (1962); Mehnert, *Aktuelle Probleme des sozialistischen Realismus* (1968); Mjasnikov, 'Sovremennye spori po voprosam socialisticeskogo realizma' (= The current debate on the subject of socialist realism) (1968); the collection of essays *Socialisticeskij realizm i problemy èstetiki* (= Socialist Realism and the Problems of Aesthetics) (1967); and our own article, 'A Marxist view of form in literature' (1971-72).

28. Konrad, 'Oktjabr' i filologiceskie nauki' (= October and the philological sciences) (1971).

C. IN THE NON-WESTERN COUNTRIES, *by Mikel Dufrenne**

We now propose, on the basis of the contributions we have received, to make a brief review of studies of literary and artistic expression in the 'non-Western' countries. We are, in fact, going to exceed the limits of the plan that we had set ourselves, for the contributions that have been received deal at least as much with the practice itself of literature and art – and primarily with its underlying ideology – as with the study of such practice; as much with art – essentially literature – as with the sciences of art. This is easily understood if, among these countries, we make a distinction between those that previously – i.e., prior to achieving independence or turning to a policy of development – possessed a tradition (mainly in universities) of critical and scientific reflexion, as in the case of Japan, India, the Latin-American nations and certain Arab countries,[1] and those which did not, because of the prevalence of oral tradition, as in the Black African countries. Literature and arts have of course existed in such countries, doubtless from time immemorial, but they have not, up to now, become the theme of aesthetic reflexion or scientific study. What is more – we have already mentioned this in passing – they existed without awareness of their existence, without asserting any claim to specificity or independence: they were completely integrated with a culture which itself had an integrating force, and the 'aesthetic' purpose was indistinguishable from religious, social and utilitarian purposes. Even in the West, it is not very long since art became defined and institutionalized (even though we may now question its specificity and its privileges in the light of its most recent developments). And it is undoubtedly in following the Western example that today, throughout the world, art seeks to identify and define itself; as yet it is not, however, the subject of systematic study everywhere.

But there is at least consciousness of it, and consciousness that does not remain neutral; for, as we shall see, art immediately becomes a sensitive area in the confrontation of western societies with those of the East or with the Third World countries. It also becomes a cultural policy issue, for this consciousness extends to the political authorities as well as to the artists. Consequently, although the practice of art has outdistanced theory, awareness of this practice does at least give rise to what we may term an ideology which, as we shall clearly see, is both lucid and impassioned, since the issues that it arouses relate in every case to the life and the meaning of the national culture. But since within this ideology desire and will are constantly reacting on knowledge, it cannot be regarded as a really scientific approach – all contemporary epistemology disallows this. We shall, therefore, present it first as

* A synopsis based on a number of contributions and first-hand accounts.

1. To this list we should add China. We must express our regret at our inability, in the absence of authorized evidence, to include reference to the studies being carried out in that great country.

our contributors have expounded it, following this by positive studies where these have been carried out.

Another word, this time of warning. We must not believe that this ideology, common to all non-Western countries, does not concern the West. In the first place it is the West that allowed it to gain strength by focusing attention on art in the sense of a specific 'institution' within culture. Second, the issues which provide the fuel for this ideology are problems *for* the West and *of* the West, since it is the West that invented nationalism – in the guise of imperialism in the first instance – and it is also for the West to ascertain whether the universal can be reconciled with the particular and to contribute, for its part, to furthering the universal without any suspicion of imperialism – we observed this a little earlier.

1. THE IDEOLOGY

As we experience awareness of the specificity of art, so we become conscious of the reality and distinctiveness of cultures. And it is always in its relationship with culture – of which it may equally be the expression, the effect or the driving force – that art is about to be considered. Now in the developing countries culture is being challenged. The basic influence affecting all reflexion on art is, in fact, the confrontation of cultures between the West and everything that is not Western. This confrontation has been a particularly bitter experience not only in the former colonies which have had to fight for their independence and which have not yet eliminated the after-effects of a traumatic encounter, but also in those countries whose dynamic relationship with the West assumes the aspects of peaceful competition. How, in such countries, are the cultures in this confrontation regarded?

The national culture, first of all, is no longer experienced, as it might have been, in a kind of happy innocence. Because it has been threatened, disqualified, often half destroyed, it is henceforth *thought out* and *desired* as the instrument of an intransigent and impassioned self-assertion. If we consider this culture as a value, the West may, all unwittingly, have contributed to it, not simply because it has illustrated the value of its own culture, but because – after the devaluing of the indigenous culture by its conquerors, missionaries and teachers – it has, through its artists and scholars, succeeded in revaluing it. When Picasso becomes an enthusiast for Negro art, when ethnological museums accommodate it and ethnologists pore over it, the African rediscovers his art. He sees it with a stranger's eyes but not as a museum exhibit regarded with lukewarm interest or requiring, if it is to be understood, a special effort of adjustment: he sees it as his own art and that is what he wants it to be.

This is a point on which all contributors agree: awareness of art is linked to what Mulk Raj Anand calls 'the search for national identity', and Leopoldo Zea and Carlos Magis 'the quest of one's own originality'. This search assumes a scientific form in countries which are adequately equipped for this

purpose, as in India where, says Mulk Raj Anand, 'the most enlightened students have been concerned to relate the art expression of the past and the present to the practice of the arts. This has entailed detailed studies of the archaeological, anthropological, sociological and formal aspects of our understanding within the context of art expression. Most of these studies are devoted to the search for national identity.'[2] Even when this identity is not defined by scientific methods it is no less passionately asserted. Thus Zea and Magis refer to the 'search for Latin-American genius and for its ability to express itself' in Latin America at the beginning of the century. F. Agblemagnon reminds us of the reception that the theme of *négritude* developed by Senghor, Césaire and Sartre has found in Africa. Again, Ali El-Rai alludes to the literary forms that 'particularly suit the aspiring Arab soul'.[3]

This unanimous assertion of a distinctive spiritual identity is sometimes all the more intransigent because it is difficult to visualize it clearly and its reality is clouded by ambiguity. Do the roots of the South American peoples lie in Europe or in America? At the dawn of the twentieth century, according to Zea and Magis, they 'demanded a return to that reality which was previously regarded as an obstacle: the particular Creole synthesis (the indigenous basis remodelled by the Iberian peoples)'. Furthermore, national identity cannot be asserted pacifically – it can only define itself by *opposition* – by opposition to the western culture which always risks alienating it, since it feels challenged and menaced in its depths. In regard to art the menace is even more distinct, since art is more closely integrated with daily life; this is certainly so (as we have said elsewhere) in respect of archaic cultures and is, in any case, exemplified by Black Africa. This 'mixing' of art and life is very well described by F. Agblemagnon:

It is not solely in grandiose events or exceptional circumstances that artistic expression in Black Africa is produced or becomes apparent. It lies in the rhythm of daily life, in the desire to maintain a constant relationship between the cosmic and the real, between the exceptional and the banal, and the art expressed in everyday objects is the most pertinent and striking illustration of this. We see, in objects of common use – ranging from chairs to scales for weighing gold – a series of signs and geometrical figures which, apart from their scriptural value, represent a geometrical and architectural expression sought solely for artistic purposes. To lose the secret of these – seemingly modest – sources of expression would be deliberate estrangement from the great traditional schools of apprenticeship in artistic expression.[4]

2. Special contribution. In addition, M. R. Anand draws our attention to the following works, which he considers specially representative of Indian conceptions in aesthetics: AUROBINDO, *The Significance of Indian Art* (1947); MARDEKAR, *Arts and Man* (1960); PANDAY, *Comparative Aesthetics* (1957); TAGORE, *Rabindranath Tagore on Art and Aesthetics*, edited by P. Neogy (1961). An important essay by Mulk Raj ANAND, 'The birth of Lalit Kala', to be published in the periodical *Cultures*, issued by Unesco, resumes and develops in broader perspective the themes which he has tackled in his contribution to the present Study.

3. Contribution provided by the National Commission for Unesco of the United Republic of Egypt.

There is a danger of this secret becoming lost as soon as the West stamps a new pattern of everyday life. What has a particularly corrupting effect on the genuineness of art is its commercialization or, we may venture to say, its prostitution. Mulk Raj Anand has noted this clearly in respect of India:

But, whereas in the days of the village republic, the craftsman was an integral part of society, paid for and recognized for his service for the community, the artist today is not producing material goods of a specific marketable value but cultural goods of which the value has yet to be recognized. . . . Therefore the artist turns to film poster work or commercial design for a living, or he paints pretty pictures with plenty of local colour in them which may appeal to a certain kind of foreign tourist or procure him a patron among the diplomats; or he paints decorative pictures for the more sophisticated drawing rooms of the big cities. There are a very few artists who are immune to these peculiar social conditions and who seek to answer the challenge of their vision.[5]

Thus national culture feels itself threatened, even when it is marked out for a new life – which will only really be its own if it accepts the challenge that the West has issued.

How, in turn, is western culture seen? The attitude it produces is basically ambivalent – and we know that ambivalence means, even when it does not provoke it, anxiety. This culture is seen first of all as something foreign: it is the 'other', and this 'otherness' is even more keenly felt since the 'other' has too often imposed himself by force. But this culture is also regarded as possessing prestige – it is allied to the spectacular advance of technology, and neither the distrust or the resentment that it may arouse can hide the fact of its vitality and power of expansion from shrewd eyes. What is more, it appears as an inevitable line of advance; just as, in the developing countries, the economy must assume the harness of industrialization, so the black Orpheus must, as Sartre has stressed, sing in French if his voice is to carry across frontiers. But the voice is then no longer entirely his own: 'Africans', observes F. Agblemagnon, 'including grammarians, admit the impossibility of translating certain emotions for which words exist in the vernacular language The privileged persons who succeed in a complete break-through of the language barrier are few and far between.' [6]

noire. C'est dans le rythme quotidien, dans cette volonté de maintenir un dialogue permanent entre le cosmique et le réel, entre l'exceptionnel et le banal, et l'art des objets quotidiens en est l'illustration la plus pertinente et la plus éclatante. Depuis les objets communs comme les sièges jusqu'aux poids pour peser l'or, nous saisissons une série de signes, de figures géométriques qui, outre leurs valeurs scripturales, sont des recherches géométriques et architecturales uniquement liées à une préoccupation artistique. Perdre le secret de ces sources apparemment modèles d'expression, c'est s'éloigner délibérément des grandes écoles traditionnelles de l'apprentissage de l'expression artistique.' – Special contribution.

5. Special contribution.

6. 'Les Africains, y compris les agrégés de grammaire, reconnaissent ne pas pouvoir traduire certaines émotions pour lesquelles ils ont des mots dans la langue vernaculaire de leur village. . . . Rares sont les privilégiés qui arrivent complètement à franchir ce Rubicon de la langue.'

This culture, furthermore, is seen as an imperialist weapon of the ruling societies, directed primarily against national cultures. It is not simply the 'other', it is also the enemy. Must we allow ourselves, then, to be haunted and fascinated by it? It sometimes happens, in fact, that its prestige is denied and its purpose denounced, mainly by Marxist militants in the Third World. Particular evidence of this is provided in the well-informed and lively essay, 'Crítica marxista de la estética burguesa contemporánea', sent to us by J. A. Portuondo, of Havana. There are many critics and specialists in aesthetics in the non-Western countries who base their arguments on Marxism. Is it not then paradoxical that it should be the West which again provides its opponents with ammunition? But these opponents do not use the Marxist doctrine in the sense of a Western or foreign contribution; they assert it as a progressive philosophy, capable of expressing the universal and of promoting a truly international culture. It is this desire for universality that they set against western culture, and not a national culture belonging to a past from which, even though they do not reject it, they believe the new culture can only be saved in so far as it can be excelled.

It is, in fact, here that the problem – or the hope of a solution – lies. The majority of our contributors observe, in regard to this confrontation of cultures, that three solutions are proposed and three attitudes adopted in their respective countries. The first and the most passive, if one may say so, consists in accepting or even sanctioning a division which tends to impose itself naturally. 'No developing country can escape a cultural dichotomy', says Shuichi Kato, who describes the situation as exemplified by Japan at the beginning of the century:

After the Meiji Reform (1868), Japan adopted western political institutions (parliamentary monarchy), retaining however the traditional authoritarian values of military dictatorship. Western technology was systematically introduced and heavy industries developed in urban areas without modification of rural life (e.g. the continuation of the exploitation of tenants by land-owners), without much change in the production of a large part of consumer goods (e.g. food consumption and clothing). Around the turn of this century, the educated Japanese, living in the rapidly growing cities, worked during the daytime in the westernized industrial and governmental offices and went home to spend the evening in the traditional way: wearing the kimono, sitting on the mat, eating rice. Efficiency in western technology during the day and a delicate aesthetic life of traditional values in the evening: indeed a precarious balance for a person. Dr. Köbel, professor of philosophy at Tokyo Imperial University, was among the first to note this sharp contrast between the Japanese working life and Japanese private life.

Accordingly, the architecture in Tokyo of that time was divided into two categories: all public buildings, such as governmental offices, banks, railway stations, schools, and large department stores, were constructed in the 'western style' with bricks, stone, concrete and steel; while practically all living quarters were houses built of wood in the traditional 'Japanese style'. This split was also evident in the cultural and educational facilities. The National Academy of Music was composed of two separate departments which were totally independent of each other: one strictly for traditional music and the other for western music. The same was true of the National Academy of Arts: a department for 'Japanese painting' and another for 'western painting'. As a matter of fact the Japanese painter of the time was

obliged to specialize either in working in Indian ink and the traditional water-colours or with oil on canvas.

Also in the theatre one either specialized in the traditional Kabuki, Nô and Kyôgen or in the 'new Theatre'. The masses were rarely attracted by the Kabuki, while the young intellectuals of Tokyo were witnessing performances of Shake-speare, Chekhov and a few Japanese plays written in the 'western' style. Except for rare instances, actors of the Kabuki never performed in the 'new Theatre' and, accordingly, actors of the 'new Theatre' did not play in the Kabuki.[7]

This situation, which was that of Japan yesterday, prevails today in countries which, simultaneously with the achievement of independence, have set about the process of modernization. But, because it is artificial and difficult to tolerate, it will not last any longer than it has in Japan. One cannot exist for long on two levels, torn between a native ego and a western super-ego. And as, in particular, this dual system has repercussions on social stratification, it is also unacceptable. Participation in western culture is the privilege of an élite, while the people remain necessarily faithful to tradition; and this élite – because it is sensitive to this fact and feels itself to be responsible – experi-ences a feeling of guilt and a sense of treachery: can one deny one's people and one's past? And so, says F. Agblemagnon, 'black French-speaking writ-ers, whether they are literally exiles or exiles on the spot, regard themselves as cut off from the masses and from traditional society. They have a sense of guilt at living within another culture and no longer feel exactly like their illiterate brothers who are still in the village; this mass becomes, for them, the symbol of traditional society.' And he adds: 'This new African literature asks itself: is it only of significance in Paris, London or Washington? It de-plores being completely unknown in Africa itself. Does the artist really a-chieve his goal when the people for whom the work is intended ignore its very existence?' [8] For an artist, furthermore, playing the western game does not mean that he is sure of winning. Zea and Magis have seen this quite clearly in Latin America during the second half of the nineteenth century:

In Mexico, Chile and more especially Argentina, leaders of the literary and artistic movement sought integration with European culture beyond the Pyrenees, but this integration encountered particular obstacles, due to the circumstances in which the Latin-American peoples were living and the deep imprint of the culture in which they had been brought up. For this reason the tendency for culture to become the privilege of the minority was, unfortunately, to grow more marked while, at the same time, the past inspired only a feeling of aversion because of its symbolic identification with the colony in the sense of a synthesis of structures imposed by

7. Special contribution.
8. '... les écrivains noirs de langue française, qu'ils soient des exilés au sens littéral, ou des exilés sur place, se considèrent comme coupés de la masse, coupés de la société traditionnelle. Ils ont mauvaise conscience d'être dans une autre cul-ture, de ne plus se sentir exactement comme leurs frères analphabètes demeurés au village; cette masse devient à leurs yeux le symbole de la société traditionnelle. ... La jeune littérature africaine s'interroge. N'a-t-elle de signification qu'à Paris, Londres et Washington? Elle déplore d'être complètement ignorée en Afrique même. L'artiste atteint-il vraiment son but puisque le peuple auquel l'œuvre est destinée oublie jusqu'à l'existence de cette œuvre?'.

the mother-cities of the Peninsula. As a substitute for this past an attempt was made to model trends of thought, as well as literature and art, on the pattern of trans-Pyrenean Europe. But this substitution failed to solve the problem, for the results of this adherence – so-called integration with the western world – were regarded by the European artists themselves as poor imitations of their own creative works. And indeed they were right, because the Latin-American artists did no more than reproduce the same themes and use a similar technique; these themes were in fact completely alien to their world, the world of the artists who sought to absorb them.[9]

There is, then, a second solution which, although finding supporters everywhere, will also be seen to be impracticable. This is the defence and illustration of the indigenous culture against western temptations and its glorification or even resurrection where, in countries which have experienced colonial rule, it has been at least partially destroyed. This project implies the return of the creative artist to his people and almost always his political commitment to the struggle of the people, in which the stake is often both independence and socialism. We quote F. Agblemagnon again here:

This commitment has differing degrees and depths according to authors. There is the commitment of the artist in regard to everyday life which means accepting the lot of the writer or artist today. Then there is the personal, political commitment. Following this trend of thought, we can set side by side men who, both in origin and destiny, are extremely different: we think of Frantz Fanon who became the protagonist and the hero of the Algerian revolution; Stéfan Alexis, killed during the internal struggle in Haiti; Christopher Okigbo, the Nigerian poet, assassinated during the Nigerian war; Léopold Sédar Senghor, the poet-president who is ever mindful of his political commitments when he tries to reconcile his theory of *négritude* with his country's imperatives of economic development; Mario De Andrade, head of a revolutionary party engaged in the struggle for the liberation of Angola; Jomo Kenyatta, who was a prisoner under the colonial régime, and so on.[10]

Commitment in aesthetic terms – the terms which concern us here – may also be total. It is accepted today, or has been in the past, by a proportion of the nation's intelligentsia. In India, for example: 'Some part of it consciously fought back the alien culture in defence of chauvinist nationalism and tried deliberately to revive the ancient ("spiritual") tradition of culture and its artistic expressions as against the "material" forms of the West.' [11] In Morocco, the appeal for a return to the wellsprings is expressed in polemical

9. Special contribution.
10. 'Cet engagement a des dimensions et des profondeurs diverses selon les auteurs. Il y a l'engagement de l'artiste dans la vie de tous les jours qui est l'acceptation de la condition de l'écrivain ou de l'artiste aujourd'hui. Puis il y a l'engagement personnel, un engagement politique. Dans cet ordre d'idées nous mettons côte à côte des hommes extrêmement différents tant par leur origine que par leur destin: tel F. Fanon qui s'est fait l'interprète et le héros de la révolution algérienne, S. Alexis qui a trouvé la mort dans les luttes intérieures à Haïti, C. Okigbo, poète nigérian, assassiné au cours de la guerre du Nigéria, L. Sédar Senghor, le poète-président qui n'oublie pas ses engagements politiques lorsqu'il tente de réconcilier sa théorie de la négritude avec les impératifs du développement économique de son pays, M. De Antrade, chef d'un parti révolutionnaire engagé dans le combat de la libération de l'Angola, J. Kenyatta qui a connu la prison sous le régime colonial, etc.'.
11. Mulk Raj Anand, special contribution.

terms by Allal al-Fassi, whose words Z. Morsy reproduces: 'I address my appeal to the writers of this country, who spend their time analysing aspects of human problems in the light of foreign creative works I address my appeal to research workers so that they may study our Islamic society, its civilization, thought, philosophy and literature and no longer follow the path of what they learned at their French lycée I am not forgetting those who sing of the achievements of the socialists and others, and of the sacrifices of Guevara and Lumumba I ask them to glorify our national struggle and Moroccan, Arab and Moslem sacrifices.' [12] In Black Africa we are aware of the reception that the theme of *négritude* has obtained – sometimes expressed in violent terms since it represents, says F. Agblemagnon, 'a kind of cry for liberation'.[13]

He adds, however: 'For some time Blacks and non-Blacks have been asking themselves about the value and ambiguity of this theme and we have heard a kind of *anti-négritude* theory put forward.' [14] Why this change of opinion? The reason lies in the fact that the search for one's identity cannot be reduced to the glorification of the ancestral past. It must look towards the future and have due regard for the sense of history. Marxist thinkers, even if anxious to safeguard national identity, refuse to adopt any line that runs counter to internationalism. Non-Marxist thinkers, such as Laroui in Morocco, are just as sensitive to the demands of historical circumstances, the study of which argues against any idea of Utopia. The reality of the West is a fact which cannot be ignored: 'Whether we try to refute it, liberate ourselves from it or assent to it', says Z. Morsy in his comments on Laroui, 'the West is here with us as a prime fact, and ignorance or imperfect knowledge of it has a nullifying effect on all serious reflexion and genuinely artistic expression'[15] Furthermore, the future of the non-Western countries lies along the path of westernization. To reject western culture *en bloc* is to reject development of science and technology as well; and what country can expand today without industrialization? If it accepts this industrialization while resolved to maintain the purity of its traditions, will it not lapse into the dichotomous state described by Kato?

12. 'J'adresse mon appel aux écrivains de ce pays qui passent leur temps à analyser partiellement les problèmes humains à la lumière de la production étrangère. . . . J'adresse mon appel aux chercheurs pour qu'ils étudient notre société islamique, sa civilisation, sa pensée, sa philosophie, sa littérature et qu'ils ne restent pas dans le sillage de ce qu'ils ont appris dans les lycées français. . . . Je n'oublie pas ceux qui chantent les réalisations des socialistes et autres et les sacrifices de Guevara et de Lumumba. . . . Je les invite à glorifier notre lutte nationale et les sacrifices marocains, arabes et musulmans.'
13. '. . . une sorte de cri vers la libération.'
14. 'Depuis un certain temps, les Noirs et les non-Noirs se sont interrogés sur la valeur et l'ambiguïté de cette théorie, et nous avons pu entendre une sorte de théorie anti-négritude.'
15. 'Qu'on entende la réfuter, s'en libérer ou y consentir, l'Occident est d'abord là, dont la méconnaissance ou la connaissance approximative sont dirimantes à toute pensée sérieuse et à toute expression véritablement artistique.' – Special contribution.

The sole alternative to intolerable duality is synthesis, and it is towards a solution of this kind that our contributors see national ideologies heading today, in full awareness, moreover, that it is easier to name it than to define and introduce it. Synthesis is, however, the very word that Mulk Raj Anand uses:

The study of important problems in relation to artistic expression in traditional societies, which have received the impact of modern industrial cultures, can only be fruitful if we consider the clash between traditionalism and modernity as part of a new emergent synthesis rather than as research into two fundamentally opposed attitudes of East and West, which have nothing to do with each other.

In the case of India Mulk Raj Anand later observes:

After half a century of affirmation of a false myth and the revival of ancient and mediaeval Hindu culture, on the parallels of a political myth, the intelligentsia has recently begun to awaken to the fact that the new industrial civilization, which it has accepted on the social plane, must be absorbed.

He adds:

And yet very few members of the top hierarchy wish to confront the contemporary human situation openly because the problems of technology versus human survival in the West have made a good many ideologies of the West, from Schopenhauer and Max Muller to the Neo-Yogis, consider Indian mysticism to be the answer to everything.

This illustrates the phenomenon to which we have already drawn attention, namely that it is sometimes western thinking that reveals the indigenous culture to itself and gives it value. But it still remains for the indigenous culture itself to achieve the synthesis of the East and the West. Mulk Raj Anand draws our attention to the fact that:

India has made a distinctive contribution in the synthesis of the European forms of the novel and the content of Indian life, in the works of Indian-English novelists, Raja Rao, Mulk Raj Anand, R. K. Narayan, Namala Mardandaya, Attia Hussain, Bhabhani Bhattacharya and several others.

In another form of artistic expression, the dance-drama, the acceptance of a certain aspect of European choreography has made various new contributions possible from Mrinalini Sarabhai, Shirin Vajifdar, Krishna Kutty, Parvati Kumar, Shanti Bhardan and Maya Rao.

Another key-word that we find in all writers is the 'universal'. To overcome antagonism or contradiction is to promote the universal, as Hegel has taught us. But we must realize that this process cannot be achieved without sacrifices. Shuichi Kato is very alive to this:

With the changing of values, the divorce from tradition has become a serious problem. Gone are the days when people differentiated between western ability and the Japanese soul. Western ability has become Japanese ability. The dichotomy has disappeared. But where can one find the Japanese soul when the people are driving automobiles to air-conditioned offices, tractors in the fields or watching a 'Western' on television? The Japanese clothes of today are the same styles as those of Western Europe. The Japanese now eat the same amount of animal protein as most Europeans. Most households no longer harbour miniature shrines of traditional deities or souls. It is true that girls sometimes wear kimonos, perhaps on Sunday, but this

is an international phenomenon: Christians too find their Christian soul only on Sunday. The problem for Meiji Japan was the dichotomy of the culture; the problem for Japan today, especially for artists and writers, is one of regaining national identity.

Thus Kato demonstrates, not without a hint of mockery, that the sacrifices are reciprocal – in its modernization, providing the example of industrialization, the West itself has not remained unchanged. The advice to the developing countries reads thus: to follow the West is not westernization but rather 'planetarization'. And it is in this way that what Hegel termed the 'concrete universal' can come to pass.

But, here again, insufficient attention is paid to this demand for universality. Kato warns us about this again: if an attempt is made, in order to save national character, to reduce the synthesis to a more or less illegitimate compromise, beware of monsters!

In the 1930's, simulataneously with the rising of nationalism, politically-inspired architects who had already mastered the construction techniques started designing buildings with the conscious purpose of emphasizing the Japanese national character. . . . The conscious search for national identity in architecture in the Japan of the 1930's resulted in the production of architectural monsters.

From which he concludes:

There is no other way out of this technological age. Those who continue to speak a local dialect will fall into regionalism. Nationalism as a major motivation of artistic creation will produce only monsters.

Does this mean, however, that the sacrifice of a particular identity must be pursued until its complete disappearance? By no means, and Kato helps us here, again to understand this:

Contemporary architects are no longer striving for emphasis of Japanese character but are simply trying to solve problems within the framework of the international architectural grammar of the post-Bauhaus era. Yet often enough there appears something in their works which could be called a sensibility of Japanese perception: sense of colour, of form, of surface, of line. This Japanese character of architecture when it appears does so in response to the influence of the climate, natural surroundings and the temperament of the designer and not as something conceived as the target of creation. If the works of Tange Kenzo are Japanese, they are so only in the same sense that the works of Le Corbusier are French.

Hence his final remarks:

The search for national identity should not be a conscious motivation for artistic creation. National identity is something which results through the unconscious tradition in the artist from his search for the art beyond national borders.

In western language we should express it differently – 'whosoever will save his life, shall lose it', but he who does not persist in seeking his soul will find it and his works will reveal it to all.

This acceptance of the demands of the technological age is certainly less clearly admitted among other contributors to this study. But all express the

hope that the universal will not absorb the particular, but can itself be particularized.

'Planetarization' of culture can thus promote a humanism which will not be a form of Westernization. Zea and Magis express this forcibly, they themselves commencing by placing the West in its proper relative position:

European culture is one culture among others: like all cultures it has drawn its nourishment by absorbing other cultural forms, since, however different it may be from the culture of other groups of humans, it does not reach the point of ceasing to be human. 'Perspectivism', the *raison vitale*, 'historicism', 'existentialism', are all manifestations of a philosophical expression and a new cultural attitude, in Europe or the West, which will give support to the new trend in Latin-American culture; their models and prototypes belong to universal history. The Latin-Americans will continue to explore their own being without servility or prejudice, not from any deliberate attempt to seek originality, exoticism or singularity, but to show in what way they are men, ordinary men, and to reveal what it is that links them to the universal as the expression of mankind of which they form an integral part. ... In other words, the issue is to express the way in which the different national groups in Latin America are gradually awakening to a consciousness of themselves, of their own reality, not as worlds in isolation, but as manifestations of much wider realities and as particular forms of universal reality.

This desire to foster a human universality is just as much the Marxist approach. J. A. Portuondo, quoting at the end of his essay a remark of Gillo Dorfles – 'as the mirror of the situation in which we are placed, and at the same time, as the means of improving and surpassing it, art, even in our era, should be the most sensitive and effective instrument in revealing its own *becoming* and in guiding the *becoming* of mankind' – has the following comment to make: 'Despite the excellent intentions reflected in these few lines, the elements of the problem are reversed in it. It is not the mirror that should guide the hand; it is the *revolutionary becoming* of mankind that should guide and govern *aesthetic becoming*.'

2. THE WORKS

The reader will have been conscious of varying emphases in the texts that we have quoted. Between one country and another and, of course, between one thinker and another, the interpretation of the notions of synthesis or the universal, which seem today to find majority support, is not one-voiced. And we can well imagine that works deriving from this ideology themselves constitute an amalgam in which very little homogeneity is to be found. It is not our intention to explore this amalgam any more than we did when considering western art in order to identify the mutations it has undergone. Two points must, however, be made:

In the first place art in every country is driven by a great number of currents. Two examples will suffice. Mulk Raj Anand has identified five such currents in India:

The phenomenon we see, therefore, and which has been termed mutation of artistic expression, displays several remarkable eccentricities:

1. The search for influence from the more fashionable styles of Paris, London, New York and Rome.

2. The research into the academic realism of the West, borrowed by the artists of the late nineteenth century.

3. The persistence of the revivalists of the early twentieth century who had sought to achieve spirituality in art by borrowing the romantic forms of sixth-century Ajanta and Bagh Buddhist art but within the framework of the seventeenth century Mughal miniature.

4. The return to naive and primitive expression as a more dynamic form of revival.

5. The search for a synthesis between the relevant inheritance of myth, love, nature and human conflict in new contemporary human forms, this itself forming an inner content and thus exploding into a new expression. This becomes fused into the search for personal authenticity.

In Egypt, Ali El-Rai distinguishes, for his part, three schools of poetry:

It is worth noting, before concluding this summary, that the actual literary scene in Egypt presents all three schools: the traditionalist, represented by older poets such as 'Aziz Abaza and 'Ali al-Guindi; the romantic, by Mahmoud Hasan Isma'il and Saleh Gawdat among others; while a varying blend of social realism and modernistic trends characterizes such younger poets as 'Abdel Mu'ti Higazi, 'Afeefi Matar and Kamel Ayyoub, to mention a few names. With varying intentions, forms and techniques, we may safely conclude that all the above-mentioned trends concur in attemtping to realize what Al-'Aqqad and Al-Mazini stated (half a century ago) as their goal: the creation of a literature that is Arabic in language (we may now add: and tradition), Egyptian in character, and universal in appeal.

Furthermore, emerging everywhere in this diversity, we find a subject of major concern reflected in the approach of creative artists: as Ali El-Rai has pointed out and as F. Agblemagnon states in regard to African literature, art is, everywhere, 'the search for self and for genres'. He adds: 'The search for self arises inasmuch as it is necessary to rediscover the ancient personality that will provide the prop for the emergence and full blossoming of the new; a search, likewise, for genres and styles, because the new language has not been totally mastered.' [16] It is not surprising that it is to literature that this reflexion refers. In the practice of the non-Western countries everywhere, literature is the preferred medium, no doubt because it facilitates expression of the ideology underlying creative work. Furthermore, even within literature one genre seems, in turn, to have a privileged place both because it attracts a really popular audience and because it enables traditional themes to be transposed into a modern form, the theatre. Ali El-Rai notes: 'Drama in Egypt presents an even clearer case than that of the novel of the way a new form is transplanted into a country's rich soil, to become, before long, a natural product of the land.' This observation is corroborated by Agble-

16. '... recherche de soi et de genres. ... Recherche de soi, car il faut redécouvrir cette personnalité ancienne qui servira de béquille à l'éclosion, à l'épanouissement de la personnalité nouvelle; mais recherche de genres et de styles également, parce que le langage nouveau n'est pas encore entièrement maîtrisé'.

magnon: 'We believe that the new African literature and the new African art will owe much to the theatre and it would seem that this genre has a considerable contribution to offer. We find in it all the elements usually grouped in the traditional story which is a continuous way of interpreting and acting out life. We are thus not at all surprised to see that the African language theatre is winning over a public whose existence was unsuspected.' [17]

But this obviously does not mean that other arts, such as architecture in Japan or painting in Mexico, are not displaying remarkable vitality. Indeed, the contributions which we are using testify that art and literature are everywhere very much alive. The fact that they may hold aloof from tradition or become temporal rather than sacred, as Mulk Raj Anand says – corroborating Dorfles' diagnosis of western art – does not weaken their vigour. The western-inspired status that the artist has acquired, coupled with the individualization of aesthetic experience, is giving art a new stimulus and what Mulk Raj Anand has to say in regard to India is no doubt applicable to a number of countries: 'The realization by the individual of his potential in the autonomous arts has introduced a completely new factor of struggle into a society through and within which the fine arts had previously been part of ritual'.

3. SCIENTIFIC STUDY OF LITERARY AND ARTISTIC EXPRESSION

We must now take a glance at the study of literature and art. This glance will be brief since, as we have indicated, the information available to us is limited and inevitably patchy. Since we are dealing not merely with criticism but with research which is scientific in purpose, a distinction must be made between countries with what we may venture to call a developed university system, and those whose universities are still quite new. In the latter countries, such as those of Black Africa, all that is so far expressed – by a few critics but mainly by the creative artists themselves – is the ideology underlying their creations. In the first category of countries scientific research, where it is highly institutionalized and widely undertaken, as in Japan for example, uses the same conceptual methods as in the West. What is being thought and done in Tokyo today is hardly distinguishable from what we see in Europe or North America – for science is international. We see here, very precisely, that to adopt western schooling – and even to enter into competition with it – is not so much to become Westernized as to raise oneself to the universal level. And the fact that science is not utilized to an equal extent everywhere is due, above all, to lack of resources and not because those who

17. 'Nous croyons que la nouvelle littérature africaine, le nouvel art africain devront beaucoup au théâtre, et il semble que ce genre pourra beaucoup apporter. Nous y trouvons réunis tous les éléments habituellement rassemblés dans le conte traditionnel, qui est une manière continue d'interpréter et de jouer la vie. Nous ne sommes donc pas étonnés de voir aujourd'hui le théâtre, en langue africaine, reconquérir un public que l'on ne soupçonnait pas.'

champion national art would repudiate its use for the sake of ideology.

Our contributors have, in fact, pointed to a number of weaknesses in certain countries, affecting 'critical' discourse more than 'scientific' discourse. Thus, observe Zea and Magis, 'in Latin America every intellectual of middling stature is a potential critic. The work of such critics suffers, practically always, from a series of characteristic faults: lack of sensitivity, "dilettantism", vagueness of thought and expression, aesthetic, political, moral and religious prejudices, linked with a tendency to put in a good word for friends and fellow sympathisers.' But who would dare throw the first stone at the Latin-Americans? Does the European critic never yield to the temptation to lapse into gossip and amateurism? And are scientific standards themselves always as strict as they claim to be? Can science be completely divorced from ideology? Zea and Magis later add: 'Contemporary criticism has gradually changed its approach; it has come out today in favour of "internal" criticism, rejecting improvisation and firmly resolved to apply strict standards. It is important here to stress with what dignity many front-rank creative artists are carrying out their work of criticism, guided by a deep aesthetic feeling and by an unerring intuition that makes up for the lack of what we may term the technical training and *apparatus criticus.*'

As in the West, a variety of doctrines and approaches are used – the same, on the whole, as in the West. They are more inclined to deal with literature than the arts, for the same reason, that literature is more flourishing – its study can relate more closely to ideology, whereas study of the arts requires stricter technical standards. Zea and Magis take note first of the studies dealing with literature in the South-American countries, in which they identify 'four trends which have developed more or less successively, but which have remained inter-connected'. They specify them as follows:

1. 'Social literature', a school deriving from the old positivism and whose younger adepts 'remain too firmly bound to non-aesthetic criteria such as committed and alienated literature';

2. a more modern school, 'whose representatives show special interest in the creative process, taking full account of the cultural tradition of the [Iberian] Peninsula and of the transformation it underwent in America, and in the work itself, studying this by means of stylism, formal analysis, philological techniques and, occasionally, the historico-thematic method';

3. the group of critics who 'attempt to ascertain how writers and their works are placed in a typically American (i.e., national) context', and of whom 'the most developed strive to identify the socio-cultural structures in which American man lives and how these are reflected in his works without lapsing into extremes of chauvinism';

4. lastly, the 'chief group', already large, 'of the most modern critics whose interest lies in study of works which express a "being-in-the-world", of the fundamental problems of man and of nothing more. Hhis school does not defend any viewpoint, but simply points to the universality of Hispano-American literature. Even when it seems that these critics are carrying out an exclusively thematic or ideological study, the real basis of their criticism

lies in aesthetic values, and it is not surprising that several representatives of this new trend have successfully ventured into study of samples of non-Hispanic works or have based their concrete analyses on speculation concerning the literary phenomenon itself. They are, moreover, carrying out studies – with the same efficacy – on the plastic arts.' In the study of these arts, Zea and Magis note the same trends as in the study of literature, as well as the same uneven display of interest in social commitment and in technical aspects.

In India, Mulk Raj Anand observes that 'the theory of art as an autonomous discipline has invited a good deal of attention in those seats of learning where Faculties of Fine Art and Literature exist, as in the Universities of Baroda, Calcutta, Benares and Punjab. But the absence of such faculties (elsewhere) and the relative neglect of discussion of art problems in the newspapers and the periodical press have led to the neglect of any precise formulations of the rôle of criticism, the teaching of the history of art, or high-level competition in creative art.' Here again we find research inspired by national ideology as opposed to a more neutral and scientific form of research:

The critical philosophies, which deal, on the other hand, with the problems of art, do not concentrate on the predicaments of the contemporary artist and do not help him to evolve a new aesthetic. They are mostly concerned with rediscovering past systems of aesthetics which, in fact, did not exist. Tradition must be resurrected, somehow, to support a lingering traditionalism.
As against this, a few artists and art critics have tackled the basic controversies in relation to art in the modern world.
The important critics have tried, in recent years, to adopt a comprehensive approach towards appreciation, combining thus the historical, comparative, sociological, economic, psychological, anthropological, semiotic and experimental aspects. Unfortunately in our emerging society there is, as yet, little possibility for the publication of papers in aesthetic theory.

The same situation prevails in Egypt – and no doubt in all the Arab countries – where interest is also mainly directed towards literature and where the various western schools find an echo today, as Shawki Deif observes:

The establishment of other universities in Egypt has brought forth various trends in the study of literature. A number of scholars follow the 'natural' method which studies literature in the light of race, environment and time. Others follow the 'psychological' method which looks for psychological elements in literary products. The 'social' method links literature with the economic and political circumstances in which it grew. The 'aesthetic' method seeks to point out the elements of beauty and how far they may be appreciated. The 'historical' method stands on firmer ground; the facts of history are not a matter of dispute and literature, in fact, is an independent part of history.[18]

In short, we see the conceptual and methodological systems of western research tending to penetrate everywhere, gradually forcing out research that

18. Contribution provided by the National Commission for Unesco of the United Republic of Egypt.

is subservient or reduced to nationalist ideology. Their use does not, however, condemn such ideologies in so far as the universal can embrace the particular and the neutrality of science be used to serve the cause of the particular. This is why the Marxist countries of the Third World are developing research with such keenness. The work being carried out in Havana provides an excellent example of this, as presented in the report submitted by the Cuban National Commission for Unesco. So the issue – corroborated, moreover, by J. A. Portuondo in his contribution – is no longer between nationalism and universalism, but between bourgeois aesthetics and Marxist aesthetics, continuing, thus, a debate that is prominent in the West.

But this, perhaps, is going to happen in all countries. Whereas at the political level the effective gap between industrial societies and the Third World, between rich and poor, has not been eliminated – far from it – in the realm of art the poor countries have realized that they are no poorer than the rich and in so far as reflexion on art is concerned, they are taking over the apparatus of the rich countries to serve their own ends, which they regard, at times as those of mankind.

Let us now examine this structure – first of all the philosophical concepts, and then the instruments which are scientific in the strict sense.

SECTION TWO: THE PHILOSOPHICAL SCENE

In introducing the conceptual machinery employed today in the study of forms of literary and artistic expression we make a distinction between philosophy and science. It would take too long to explain our reasons for doing so. We will merely say that alongside the objectifying thought which takes art as its subject, in the same way as science does in any other sphere which it selects and determines to explore, there is another thought, less determining, less legislatorial, more deeply associated with life, which might be called, according to the exactness of its formulation and perhaps also to the value attached to it, *Weltanschauung,* ideology or philosophy. This thought may of course inspire the scientific study of art as well, being in the first place close enough to that study to give rise to it or penetrate it; for it holds its own in praxis as well as in reflexion. Hence if we now refer to the philosophies in which it is expressed today this is not just because when their aims are epistemological, they orientate research in the study of artistic and literary expression, but because they conspire with this expression to the extent of sometimes laying claim to it in their own right. They say in their fashion, which sometimes verges on the poetic, what the arts say. They evoke the same thought. There is of course no question here of elaborating that thought: we are mainly concerned to recall briefly the fascination which art has for it, how it is in league with art, even when it is not setting out to establish an aesthetic, and how in exchange it can lead art into certain adventures. As for the countries where philosophy is not currently practised, it is precisely art which no doubt has the mission of expressing their particular *Weltanschauung.*

The philosophies to which we refer are therefore the ones nearest to us and most alive in our midst. But amongst these must also be included some old doctrines which seem to have taken on new life. To quote just one, Thomism, not because it still holds sway in established religion, but because the works of Maritain and Gilson have made it applicable to our contemporary situation. It is a notable fact, moreover, that Maritain and Gilson have drawn from it two very different philosophies of art, although both philosophies are in accordance with decisive aspects of contemporary art. The former defines art as a spiritual adventure akin to mystic experience,[1] and sometimes a prelude or a substitute for it. The latter defines art as 'doing' as opposed to 'knowing' and thus justifies both the formal analysis of works and the abandoning of figurative art.[2] Let us now turn to the more provocative forms of current thought.

1. J. MARITAIN, *Art et scolastique* (1927) (English translation, *Art and Scholasticism,* 1930); *Frontières de la poésie* (1935); *Situation de la poésie* (in collaboration with Raïssa MARITAIN, 1938) (English translation, *The Situation of Poetry,* 1955); *Creative Intuition in Art and Poetry* (1953).
2. GILSON, *Painting and Reality* (lectures, 1955, publ. in 1957, 1958; French version, *Peinture et réalité,* 1958); *Introduction aux arts du beau* (1963) (English trans-

1. THE DEMYSTIFYING PHILOSOPHIES

This thought may first take the form of a rejection of order and of established values. Among the living philosophies of our time, some owe their audience to their demystifying power: Nietzsche first of all. Not only does he point out, by giving an account of the origin and history of values, the weakness and resentment which lead to nihilism. He also reveals the contradiction which is at the heart of tragedy: the opposition between truth and life. Truth is mortal when it teaches us that the *Grund* is the *Abgrund*; and 'we have art so as not to die of truth'. Does this mean that art is merely a diversion and a lie? No, provided Apollo does not reduce Dionysus to silence. For art may then be true itself: it imitates the duality of human beings, of which Dionysus is the symbol; it plays as human beings play 'in the innocence of their becoming'; it invites us to play and, in that carefree, happy affirmation, to exercise the will to power which moves us, as it moves that exemplary artist, Nature. If no dialectic can overcome the opposition of life and knowledge, perhaps art suggests that we live according to the truth, without dying of it, by triumphing over death. However, it will be realized that such an art does not require Schopenhauer's contemplation, which is the negation of the will to live; rather does it appeal to us to create and at all events it gives the advantage to that creative power which is common to the artist, the conqueror and the legislator. But is not this power ready to develop in any man who shakes off the yoke of culture? Perhaps Dubuffet [3] is only democratizing Nietzsche. Whether they know it or not, there are many followers of Nietzsche among contemporary artists, particularly among those who announce the 'return of tragedy', of which Domenach has written.[4]

Then there are the Freudians: André Breton was one of the first of the creative writers to refer to Freud. Psycho-analysis is another way of accounting for origins, another attempt to demystify. It is not inspired solely by a therapeutic concern: medical investigation goes hand in hand with a theory of culture which would have us to understand civilization and the prevailing 'malaise' as stemming from the vicissitudes undergone by desire once it is repressed. The archaeology of the individual mind is a reflexion of the archaeology of mankind. Both bring out the tragic character of the human condition: the seat of conflicts opposing, under the banner of *ananké*, man and his other self, wish and reality, individual and society, life and death. Torn and frustrated from the moment he draws his first breath and is forced to embark on the adventure of life, is there any salvation for man? What concerns us here is the meaning and function which Freud assigns to art. For he does not merely suggest an explanatory approach to art by psycho-

lation, *The Arts of the Beautiful*, 1965); *Matières et formes* (1964) (English translation, *Forms and Substances in the Arts*, 1966).

3. DUBUFFET, *Prospectus et tous écrits suivants* (1967); *Asphyxiante culture* (1968.)

4. DOMENACH, *Le retour du tragique* (1967).

analysing the artist, as do some of his disciples, as we shall see [5]: he ponders over the fate of art. Culture, which represses the impulses, proposes three outlets: religion, but it only overcomes desire by humiliating man and finally by perpetuating his neurosis; science, which certainly frees him from fantasies and myths and upholds the principle of reality, but not without a sacrifice, for it entails the inhibiting of the emotions or cutting them off; and art, which cannot be the one and only solution, but which is probably the best because it alone reconciles pleasure and reality. For art expresses desire, as dreams do, without appeasing it, for desire is insatiable, but by liberating it, and, unlike night-dreams which become blurred in the heat of the day, art creates an object, which imposes on the creative artist the obligation to overcome the resistence of his material and which assumes reality in the eyes of the beholder. This object has a cathartic function beyond what Aristotle foreshadowed: the pleasure which we find in it is not just that disinterested pleasure, harbinger of ethics, described by Kant. This pleasure is but an 'additional attraction' which 'makes possible the liberation of a greater pleasure emanating from much deeper psychic sources'. This greater pleasure is due to the fact that we recognize ourselves in the work ('the fate of Oedipus moves us because . . . the oracle placed the same curse on us before we were born') and can contemplate our own fantasies without scruple or shame. What is more, this disclosure, which takes place without our knowledge, may point a moral, again unknowingly to us. The deeper meaning – deeper in ourselves – of the myth which art reactivates, as Shakespeare writing King Lear, is that we must consent to necessity: we must accept death, but without renouncing our love of life. This moral may even – although Freud does not say so – lead us into the practice of art, a practice which would have the seriousness of play and the efficacy of praxis. If the creative artist comes back from fantasy to reality, for us and through us, if we are associated with his creation, the world may indeed be changed. This aesthetic transformation of reality and its relationship with political action perhaps constitute the most important problem with which we are confronted by the evils of our civilization.

The thinking of Nietzsche and Freud, as we see, deals chiefly with the meaning of artistic creation and it has concerned and inspired artists just as much as theorists. Other philosophies, because they tend to foster reflexion on the nature of the aesthetic object and its relation to the intaker, have been the chief influence on the study of art. As artists today are highly sensitive to intellectual developments, however, these philosophies have had some influence on the practice of art as well. All the more so when the philosophy in question comes to power in certain countries, as in the case of Marxism.

2. MARXISM

The importance and effectiveness of Marxist thought and its impact on the practice and study of art cannot be overemphasized. Béla Köpeczi demon-

5. See later in this chapter the sub-section 'The psychoanalytical approach', by J. F. Lyotard.

strated this well when describing the situation of art in the Socialist countries. But since Marxism, as we shall see, also inspires in every country many works in which it is invoked as an authority while their authors are not necessarily politically committed, we must pose here, very briefly and in general terms, the problem of Marxism on a world scale.

This is a difficult undertaking, for Marxism gives rise to much discussion, even on its own ground. The reader is no doubt aware of the disputes going on almost everywhere, but especially in France and Italy, which actually give proof of the vitality of this philosophy but which also prevent the observer from defining it otherwise than by approximations, always debatable.

First let us say, however, that Marxism could be and has been regarded as a demystifying philosophy. It is materialistic. What it condemns in the name of that materialism is, first, the idea of a sovereign subjectivity, sure of itself in splendid isolation. In this it is echoed by a considerable body of thought to which we shall be referring shortly. It next condemns idealism: materialism is often defined as realism, in relation to its rejection of idealism. These ideas are, however, rather vague and we find it striking that certain Western Marxists now no longer stress materialism as such, at least not when they are defending conceptual philosophies as opposed to the philosophies of perception. The fact remains that while expressing themselves differently, they agree that the material conditions of production play a preponderant part in the development of the superstructures of society and personality.

Second, this materialism is specified in all cases as being *historical* and *dialectical*. Nevertheless, the alliance which certain Marxists sometimes form with structuralism leads them to pay just as much attention to synchrony as they do to diachrony, so that the historical involves insertion in a social totality as well as the evolution of that totality. As for the notion of dialectic which is used for thinking this evolution through, it seems that despite the place which it occupies in Sartre's latest philosophical work,[6] it has less authority at present, at least in the sense that the notion of *Aufhebung* is less relevant than the notions of contradiction and struggle or over-determination, perhaps because it may have teleological associations, perhaps also because, in so far as one is referring to a non-Hegelian meaning of the concept, this concept tends to be thought of in terms of reciprocal or over-determination. The fact remains that wherever history is not positivist or concerned merely with events but leads on to sociology, Marxism has its say; and it is quite remarkable that many works on the sociology of art are inspired by it, often explicitly.[7]

Third, if the themes of contradiction and struggle are still in the forefront of Marxist thought, it is probably owing to what is perhaps the most original feature of that thought: the establishment of an indissoluble bond between *theory and practice*. It sometimes happens, however, that this feature, with-

6. *Critique de la raison dialectique* (1960).
7. See, in particular, subsequent sub-sections entitled 'The historical approach', by Béla Köpeczi, and 'The sociological approach', by Jacques Leenhardt, etc.

out ever being abjured, fades into the background when the emphasis is placed on the epistemological contribution of Marxism and when practice is studied mainly as the practice of theory rather than productive or political practice. Marxism is then put forward as a science and as a philosophy of science. A distinction is drawn within Marx's works between those which were still 'anthropological' and hence ideological, and the scientific works. The concepts of 'socialist humanism', together with those of 'alienation', 'scission', 'fetishism' and 'total man' are rejected, while it is agreed that they refer to practical and real problems, though in an ideological form, therefore 'without theoretical value'.[8] The question is then: how to bring together theoretical practice and political practice? While political action must of necessity have recourse to science, are its ends determined solely by science? And can commitment be brought about by purely scientific motivations? It must be observed that in the countries which have to combat certain ever-threatening imperialistic pressures, attention is turned, on the contrary, to Marx's early writings, and to the concepts whose 'humanistic' character is decried elsewhere in the name of science. It is then stressed that Marx's early works fit into the true evolution of his thought, in which there was no break. The relation between theory and practice is therefore conceived differently in accordance with the urgency and violence of political practice. However, this observation itself is a Marxist theme.

In point of fact, throughout these divergencies and inflexions, adopted to suit the philosophical context and the political situation, Marxist thought preserves its unity. What is specific throughout all the works that are based on it is the attention paid to historical situations and, in the analyses of the latter, the emphasis placed on the material conditions of production (of whatever kind) and on the ever-fluctuating relationships established between the forces of production, which determine their development. Now art it-self is a product. Hence Marxist thought is unremittingly investigating the modes and circumstances of its production, its relation to social structures, its relation to the ideologies which the created work may defend or contest, its 'objective' function in the historical process. At the same time the pro-ducer is asked to take stock of his situation and responsibilities, for he is not allowed to believe that his activity can be innocent. On the contrary, in every society it is always both acted upon and acting. In point of fact we shall see that Marxist thought makes an irreplaceable contribution to the study of literary and artistic expression.

3. PHENOMENOLOGY AND EXISTENTIALISM

Phenomenology is a dual philosophy which looks at art from two angles. In the first place it is eidetic – at least according to its founder, Husserl – and unlike empiricism it demands that thought should have access to the essence

8. Cf. in particular, by ALTHUSSER, 'Marxisme et humanisme', in ALTHUSSER, *Pour Marx* (1965) (English translation, *For Marx*, 1970).

and be able to define those regions which are pivotal in Being *qua* known. It can therefore investigate the essence of art, as it investigates the essence of inanimate and living things, of social groups, etc., and discern therein the essences of the pictural, the musical, the literary, etc. This form of research cannot be suspected of dogmatism: having recourse to the method of imaginative variations in order to arrive at the essence, it encourages the concrete experiments by which artists test the boundaries of art or the boundaries dividing its provinces, respecting them or crossing them, as when anti-art transgresses art or when the calligram refuses to respect the boundary between the literary and the plastic arts. This means that not only may essences refer to historical objects or facts, but they are affected by historicity in our awareness and our use of them, because they can only be grasped subjectively. Hence the second undertaking of phenomenology: the complex of the problems of subjectivity and the subject-object correlation. Is this a return to Kantian criticism? Yes and no, depending on the status assigned to subjectivity. We do not have to enter into these difficulties; we have only to mention that it is on this transcendental phenomenology rather than on eidetic phenomenology that the post-Husserlian school of existentialism took shape: Heidegger (who has, however, refused to be ranked with the existentialists), Sartre and Merleau-Ponty.

With very different emphases and intentions these philosophers all set out with the idea of exploring man's being-in-the-world. We cannot follow them on their respective paths, which led Heidegger to a meditation on Being and on the difference between the *Sein* and the *Seiende*, Sartre to a resumption of dialectical materialism, Merleau-Ponty to an ontology of the flesh. We can at least observe, however, that these various paths all involve reflexions on art, demonstrating that artistic expression forces itself upon the attention today as a fundamental aspect of human experience. Just as remarkable as this convergence are however the divergencies: each set of reflexions spontaneously gives the advantage to a particular form of expression: in Sartre it is literature, which he is careful to distinguish from art,[9] in Heidegger it is poetry,[10] in Merleau-Ponty it is painting.[11] These choices are by no means a matter of indifference. Not only do they bear witness to the affinity between philosophical discourse and artistic expression, to the extent that Heidegger may be said to be a poet and Merleau-Ponty a painter; they influence and shed light on the meaning of philosophical discourse. If poetry takes precedence in Heidegger, it is because he thinks of *being* as residing in language and perhaps because the difference between the *Sein* and the *Seiende* is suggested to him by the difference between the word and the thing, by the

9. SARTRE 'Qu'est-ce que la littérature?' (1948, 1970; English translation, *What is Literature?*, 1949), and other essays in the series *Situations I, II*, etc.

10. Cf. in particular, HEIDEGGER, *Erläuterungen zu Hölderlins Dichtung* (1951); 'Der Ursprung des Kunstwerkes' and 'Wozu Dichter?' (1952); '. . . *Dichterisch wohnt der Mensch*' (1954).

11. MERLEAU-PONTY, 'Le doute de Cézanne' (1945, 1948); *L'œil et l'esprit* (1961, 1964); *Le visible et l'invisible* (posth. work, 1963) (English translation, *The Visible and the Invisible*, 1969).

play of disclosure and dissimulation, by the evanescent and ambiguous character of poetic expression. If Merleau-Ponty ponders over Cézanne, it is perhaps because in the silence of an originary vision there is not yet that distance which speech places between the thing and the word, because *being* retains in the pictorial appearance the solid and rough presence of the tangible, because the invisible is always immanent in the visible. In all cases, however, art is regarded as committing us profoundly: by Sartre, in ethical or political action; by Heidegger, in going back to the foundational, that is, meditation on being; and by Merleau-Ponty, in a quest for the originary. That is why these philosophies make such a point of recommending art to our vivid attention, just as much as Freud did.

They invite us to reflect on our experience – unique and irreplaceable – of art. But do they set out to control this experience and to elaborate a 'science of art'? This is not the intention of Heidegger or Merleau-Ponty. But it could be – it *was* with Conrad,[12] Geiger [13] and Ingarden [14] – the intent of that phenomenology which purports to be an exact science, as with Husserl in 1910.[15] For the eidetic may be aimed at defining the essence of art, the arts and art forms, even in terms of their historical evolution. Similarly, noetic analysis of aesthetic perception may adopt the methods of psychology without necessarily rejecting its transcendental inspiration; and above all noematic analysis may become immanent analysis of the aesthetic object and practice, if not initiate, a scientific reading of the works. At all events we must now say something about the philosophies which take a systematic interest in art as a subject of scientific study.

4. NEO-POSITIVISM

Positivist philosophies have been recommending a science of art for a long time, and some of the scientific approaches which will be examined subsequently were encouraged if not inspired by them. We should like to describe here, however, as being not without implications for the study of art, a new and more particularly French aspect .of Positivism – an anonymous one, moreover. It is made up of somewhat different features. Its fundamental theme is that of the 'epistemological break' (*la coupure épistémologique);* science draws a boundary line, between percept and concept, and it is not enough to say that it constructs its object; it is the concept itself, substituted for the *thing,* which it takes as its object. In the last resort it is itself the object of its discourse. This is the prestige of logic: we see that the empirical

12. CONRAD, 'Das ästhetische Objekt' (1904, 1905).
13. GEIGER, *Beiträge zur Phänomenologie des ästhetischen Genusses* (1922); *Zugänge zur Aesthetik* (1928).
14. INGARDEN, *Das literarische Kunstwerk* (1931); *Studia z Estetyki,* 2 vols. (1957, 1958). See also the Bibliographical Annex at the end of the following chapter, under INGARDEN and KALINOWSKI.
15. HUSSERL, 'Die Philosophie als strenge Wissenschaft' (1910) (English translation, 'Philosophy as rigorous science', 1965).

sciences are conceived after the manner of the formal sciences, by an epistemology with an idealistic bent. The method advocated by this epistemology is structuralism, which is scarcely a method, moreover, but rather a concern with the systematic relating of elements, as illustrated in linguistics and in a certain school of anthropology. Because it subordinates elements to the way in which they are combined, and the individual to the system, structuralism accords with the idealistic bias of this philosophy. The interest taken in language, an interest aroused by the prestige of linguistics, fosters this bias, for language appears as a system which seems to exist *in se* and *per se,* independently of speech and also of reality; for signs, which the object replaces in speech, replace objects in language, just as concepts replace objects in the theory if not the practice of science.[16]

Can this positivism, so wary of perception and so keen on concepts that it empties them of reality, be interested in art? Some of its partisans are assuredly interested, but only because they are seeking to counterbalance their scientism by lyricism and ecstatic transports. For within the limits of positivism, logical or otherwise, one can have only one opinion of art, that of Carnap: art is a gesture or a cry and it only expresses emotions (direct, as a symptom: against which Susanne Langer, as we know, set the symbol).[17] Does this mean that art is not amenable to positive study? It is, for sure, but on the condition that its expressiveness is left on one side, along with anything on account of which it might claim to have a symbolic function or pretend to veracity and also with anything on account of which it might give rise to a value judgement. The work of art will therefore be considered as an object among other objects, as a product in the production circuit, as an effect and hence as evidence in a particular historical situation. If one is more concerned with the specificity of artistic production, one will regard the work as a representative example of a genre or a style which has its own history, just as language has, but a history always bound up with the history of culture and society. So it is always in relation to something else, to the place where it belongs and which determines it, that the work unwittingly takes on meaning. If the work is eventually studied in its own right it will be regarded less as an individual case than as a system of intrinsic relations whose analysis involves linguistic concepts.[18] This is what semiology sets out to do, as we shall see [19] – at least a certain school of semiology, not the American semantic school, nor the school which phenomenology might have inspired, a school whose keyword is structure and whose original feature is strict obedience to linguistics. Actually this school of semiology is well established in one sense and less well established in another. Well established, for

16. This movement of thought embraces a considerable literature. We may quote one title: WAHL, F. (ed.), *Qu'est-ce que le structuralisme?* (1968).

17. LANGER, *Philosophy in a New Key* (1942); *Feeling and Form* (1953); *Philosophical Sketches* (1962); and LANGER (ed.), *Reflections on Art* (1958).

18. Cf., for example, BLACK, *Models and Metaphors* (1961); HUNGERLAND, I. P., *Poetic Discourse* (1958); WHEELWRIGHT, *Metaphor and Reality* (1961); etc.

19. See later in this chapter the sub-section 'The semiotic approach', by Louis Marin, and its comprehensive bibliography.

it can readily be demonstrated that the structural method was applied long before structuralism – by Viollet-le-Duc or by Vincent d'Indy, for example. Not so well established because the young research workers who take up semiology do not for that reason turn their backs on phenomenology: they do not abandon the perceiving or deciphering subject; they combine noetic with immanent analysis; nor are they indifferent to the expressiveness of the work, that second sense which can be explored by psycho-analytic criticism, and finally to the philosophical problems raised by the work.

For philosophy, once again, does not turn to art solely in order to foster its study, but is concerned with art for its own sake.[20] Consequently philosophy can inspire artists as much as scholars and is instigating that astonishing mutation in the world of art which we have outlined: art and philosophy today have gone a long way to meet each other. It is perhaps science which is most inclined to hold aloof from philosophy. It will be seen later that even if philosophy sheds light on certain scientific procedures, justifies them and perhaps originates them, as we have attempted to demonstrate, and as further study will confirm, other approaches among those which we are now going to describe have been made without reference to it. Let us now come to the essential part of this chapter.

One further word, however: It may seem surprising that we have barely mentioned aesthetics, whose official existence nevertheless cannot be denied; many universities in different parts of the world have chairs of aesthetics, many countries have societies of aesthetics and seven of them have a review of aesthetics, while hundreds of participants attend international congresses on aesthetics every four years. But the status of aesthetics in the world of learning is not so certain. It is everywhere and nowhere. It was first introduced as a philosophical discipline and indeed when we alluded to certain philosophies, it was also with aesthetics – *their* aesthetics – that we were dealing. Aesthetics may wish to be regarded as a science, however. At all events it cannot be indifferent to scientific procedures: so that when we come to refer to those procedures we shall still be talking about aesthetics or what inspires it.

Then again, if aesthetics is elusive in some respects, the problems it tackles could be identified and surveyed even if the angle from which they were viewed has varied in the course of history according to the prevailing systems of thought. These problems relate in the first place to the very nature of the aesthetic fact: to what in accordance with a long tradition is known as the beautiful and to the other aesthetic categories which may accompany it, to the place of the beautiful in an axiological system, to the judgement of taste, its conditions, structure, validity, to the object – nature or work – predicated by the beautiful, to the mode of being of the work and the meaning and

20. Witness, for example, the double issue of the *Revue internationale de Philosophie* (1964) on *L'art et le jeu*; the collection *Philosophy Looks at the Arts*, edited by J. MARGOLIS (1962); or the works devoted to art by 'general philosophers' like the ones we have just mentioned, or again, in the U.S.A., the 'metaphysician' Paul WEISS (cf. his *Nine Basic Arts*, 1961, and *The World of Art*, 1961); etc.

function of art. They then lay weight on the twofold relation of the aesthetic object to man and to history – the creation of the object and its reception, which leads on to an infinite number of considerations. All this we shall reduce to three terms: axiology, creation and reception, and shall attempt to determine the position with regard to research along these three lines and thus to give a picture of aesthetic practice today. Before doing so, however, and in order to shed light on the way in which these problems are dealt with, we shall have to enumerate, as we did with the philosophical approaches, what are properly speaking the scientific approaches to art.

SECTION THREE: THE SCIENTIFIC APPROACHES

Art (including literature, for we are not attempting here to measure the specificity of literature or to enter into its relations with art) is today an activity mobilizing many people – producers and consumers – and a separate institution, if we adopt a functional standpoint, in the system of culture. It is therefore not surprising that it calls for the attention of the sciences – of practically all the sciences known as human and/or social sciences. We shall see this when reviewing as completely as possible the various approaches to art. Each approach is described by a specialist, whose signature appears under the title. To these specialists we express our heartiest thanks.

1. THE HISTORICAL APPROACH, *by Béla Köpeczi**

I. CURRENT PRODUCTION IN THE HISTORY OF LITERATURE AND ART

There has been much talk for some time about the crisis in the history of literature and art, a subject that some are inclined to equate with a positivist type of purely academic research, compared with an immanent analysis and criticism of works of art.

Formerly, writers and artists were the first to deny the need for this discipline, in the belief that it contributed nothing to aesthetic understanding. Some, like T. S. Eliot, even maintained that the concept of history is alien to the essence of art: 'The whole of the literature of Europe from Homer has a simultaneous existence and composes a simultaneous order'.[1] All works are therefore contemporaneous and their simultaneous perception renders any historical approach superfluous.

There are now some writers and artists, as well as theorists of art, who would limit the validity of the historical approach or question its usefulness. While maintaining the specific characteristics of art, they regard the historical approach as more or less 'extraneous', and in any event superfluous. Some seek to explain literary and artistic phenomena – particularly their thematic aspects – by factors of a psychological nature. Others dwell exclusively upon the form of the work of art, conceived as a system of signs designed for an aesthetic finality.[2]

* See note *, page 19.

1. 'Tradition and the individual talent', p. 42 in ELIOT, *The Sacred Wood* (1920).

2. We need only recall that W. KAYSER excludes literary history from the *'Literaturwissenschaft'*: cf. *Das sprachliche Kunstwerk* (1948). Less emphatic on this question, René WELLEK & A. WARREN, in their *Theory of Literature* (1949), consider that literary history – as an extrinsic approach to literature – should reappraise its aims and methods, to be applied moreover to a very limited field. For the points of

In spite of attacks by the dissidents, production of this type is abundant.[3] Various classical styles of history of literature and art have not only survived but have taken on a new dimension as a result of the findings of the historical sciences and other disciplines, such as psychology or sociology. Consequently, in recent years, the production of biographies, histories of forms and genres, histories of various periods and movements, national or universal histories of literature and the arts, has been increasing steadily. Apart from these traditional approaches, mention should be made of some more modern trends that attempt a synthesis. In this connexion, V. Cândea identifies two trends, one leading to horizontal synthesis, the other to vertical synthesis.[4]

The first trend would seem to derive from an ambition that is quantitative in nature, that of discovery of the whole, an exploration reaching out in time and space: the least known regions of literary geography are being explored, so that soon not a single manuscript, item of correspondence or literary document will be left unturned. To the numerous treatises devoted to obscure aspects of history and literature that have only recently come to light – a case in point is the work of George Graf on Christian-Arab literature[5] – should be added the works of a synthetic nature that set out to portray a complex of literary phenomena, such as the *Histoire des littératures* published in the 'Encyclopédie de la Pléiade' under the direction of Raymond Queneau (1956-59, 3 vols.), or the *Dictionnaire Laffont-Bompiani des œuvres de tous les temps et de tous les pays* (1955), and in the same line of thought, the dictionnaries of personalities and authors compiled with the same intention of providing exhaustive information.

V. Cândea defines the second trend – aiming at vertical synthesis – in the following words:

The entire body of literary data that is being mastered in all its aspects is explored, dissected and questioned in many varied ways, reflecting the same urge to isolate and classify the motives, feelings and phenomena 'of all times and all countries' (...) Every theme is the object of a study in the form of a monograph, beginning with

view on history in discussions concerning the 'new criticism', see DOUBROSKY, *Pourquoi la nouvelle critique?* (1966).

3. A list of the main universal and current bibliographies is contained in the Bibliographical Annex at the end of the following chapter.

For the history of various disciplines and the current state of research, see: *Actes du I^er Congrès international d'Histoire littéraire, Budapest, 1931* (1932), particularly VAN TIEGHEM, 'La question des méthodes en histoire littéraire'; ESCARPIT, 'Histoire de l'histoire de la littérature' (1958); POULET *et al., Les chemins actuels de la critique* (1967); WELLEK, R., *A History of Modern Criticism, 1750-1950* (1955- , 4 vols. to date); *New Literary History. A Journal of Theory and Interpretation* I (1), Oct. 1969; JAUSS, *Literaturgeschichte als Provokation* (1970); KUTSCHER, *Grundriss der Theaterwissenschaft* (2nd edn., 1949); *The Transactions of the International Conference of Theatre History* (1957); CHASTEL, 'Problèmes actuels de l'histoire de l'art'/'Current problems in the history of art' (1953); ZEITLER, 'Kunstgeschichte als historische Wissenschaft' (1967); KULTERMANN, *Geschichte der Kunstgeschichte* (1966); WESTRUP, *An Introduction to Music History* (1955); BLUME, 'Historische Musikforschung in der Gegenwart' (1968).

4. An unpublished contribution to the present work, 'Note sur l'histoire de la littérature'.

5. *Geschichte der christlichen arabischen Literatur* (1944-53).

its genesis and following the entire evolution of one literature or of all. The focus of these works plainly reflects current trends of research in literary history: enriched by points of view and methods of science as varied as psychology, sociology or the history of ideas, the historical approach to literature has reached a hitherto unparalleled complexity. This is confirmed by the titles, and even more clearly by the subtitles, of recent works. Raymond Trousson traced the impact of the Promethean theme on European literature,[6] studying the genesis of the myth, its treatment in literature and its successive ideological functions: a Christian argument to combat the mythology of the Middle Ages, a symbol of knowledge during the Renaissance, of peoples for Herder, of man for Goethe. Erich Wimmer traces the evolution of the theme of the 'Mater dolorosa' in the German literature of the Middle Ages,[7] Max Milner the devil in French literature,[8] and Robert Mauzi the idea of happiness in that literature throughout the eighteenth century.[9] For André Dabezies, an examination of the 'aspects of Faust in the twentieth century'[10] calls for an analysis of the relevant literature, ideology and mythology, since the theme goes beyond a literary or cultural creation: the author is thus interested in a commentary that is the product of a concept peculiar to an individual or social group, and which pertains to the history of psychology, the history of religion and anthropology. Added to the problems of the research worker is the quantity of material to be studied, since between 1900 and 1955 ninety-five new *Fausts* had been written in German (plays, novels, short stories, libretti, scenes for puppet theatre or film scenarios, etc.), over sixty in other languages, and more than eighteen silent films had been made on the subject.

The study of other forms of artistic expression reveals similar features,[11] with certain differences associated with the specific characteristics of the different arts and the diversity of national traditions. This is illustrated by P. E. Lasko, who, in stressing that the historical point of view plays a somewhat less important rôle in the study of literature in the English-speaking world,

6. *Le thème de Prométhée dans la littérature européenne* (1964).

7. *Maria im Leid. Die Mater dolorosa, insbesondere in der deutschen Literatur und Frömmigkeit des Mittelalters* (1968).

8. *Le diable dans la littérature française depuis Cazotte jusqu'à Baudelaire (1772-1861)* (1960).

9. *L'idée du bonheur dans la littérature et la pensée françaises du XVIIIe siècle* (1967).

10. *Visages de Faust au XXe siècle. Littérature, idéologie et mythes* (1967).

11. To mention a few works of synthesis in different fields of art: QUENEAU (ed.), *Histoire des littératures* (1956-59); FAURE, *Histoire de l'art* (1927, reprinted, 1939 and later); CHENEY, *A World History of Art* (1937); HAMANN, *Geschichte der Kunst* (1955) and *Allgemeine Geschichte der Kunst* (1957-69); AL'PATOV, *Geschichte der Kunst* (1961-63); DEVAMBEZ, BABELON, DORIVAL (eds.), *Histoire de l'art* (1961-65-66-69); GOMBRICH, *The Story of Art* (1965); COMBARIEU & DUMESNIL (eds.), *Histoire de la musique des origines à nos jours* (1955-60); ROLAND-MANUEL (ed.), *Histoire de la musique* (1960-63); SACHS, REESE, BUKOFZER, EINSTEIN, AUSTIN, volumes of the *Norton History of Music* (1940-66); WESTRUP et al. (eds.), *The New Oxfod History of Music* (1957-); HITCHCOCK (ed.), *Prentice-Hall History of Music Series* (volumes by SEAY, PALISCA, PAULY, LONGYEAR, SALZMAN, NETTL, MALM, HITCHCOCK, etc., continuing publication); DUMUR (ed.), *Histoire des spectacles* (1965); MAC-GOWAN & MELNITZ, *The Living Stage. A History of World Theatre*, (1955); BERT-HOLD, *Weltgeschichte des Theaters* (1968) (English translation, *A History of World Theatre*, 1972); KINDERMANN, *Theatergeschichte Europas* (1957-68); SADOUL, *Histoire du cinéma mondial* (1966).

points to the fact-finding approach to research in the field of the fine arts, and particularly to the importance of what he calls 'connoisseurship' – the science and art of the expert:

In its narrower sense, Connoisseurship involves the study of an individual work or a group of related works, and the placing of such work accurately into time and place. At its most obvious, it is the need of any historical discipline to establish the correctness and genuineness of its primary data. The tools of this basic research in the subject continue to be refined. Not only the more sophisticated study and interpretation of documents, but an increasing stylistic sensibility based on a growing and interrelated body of information, and the discovery of new material, perhaps more especially by excavations, lies at the root of this essential work. Also modern technological advances in the chemical and physical examination of individual works, like x-ray, infra-red and including such fundamental breakthrough techniques as fluoride and carbon 14 tests in the field of prehistory, play a significant rôle in the re-examination of the body of material on which any synthesis depends.[12]

We may recall that in the Socialist countries, under the influence of Marxism, the historical approach is considered basic to any literary or artistic study, not only from the fact-finding point of view, but also as the basis for a comprehensive aesthetic perception of the work of art.

II. GENERAL PROBLEMS AND MAIN STARTING-POINTS OF RESEARCH

All the foregoing statements prove that in the study of literature and of art, history plays a living rôle. And yet this discipline is searching for a path, both as regards the conception of historicity and the tools that may be employed.

What are the questions to which the history of literature or of art must find valid scientific answers? The work of art is placed in time and space and its significance cannot be determined without reference to its relationship with its antecedents, and above all to what it owes to the circumstances of its genesis. For this reason the text of the work must be examined with the help of every means of *learning*, both classical and modern, to achieve as scientific a reading of the text as possible (connoisseurship exists both in the history of the visual arts and in the study of other forms of expression).[13] The next step is to determine how the work is related to the author, the public, the culture and more generally to the society of the times in which it originated. Implicit in the search for laws or trends in creation and reception is

12. Lasko, 'Trends of art historical research', an unpublished contribution to the present work.
13. In the issue of the *Revue d'Histoire littéraire de la France* entitled *Méthodologies* (1970), several authors summarize the experiments carried out and results obtained with the new techniques in the field of criticism and analysis of texts: see in particular LAUFER, 'La bibliographie matérielle dans ses rapports avec la critique textuelle, l'histoire littéraire et la formalisation'; PROUST, 'De l'usage des ordinateurs dans l'édition des grands écrivains français du XVIIIe siècle'; DUCHET, M., 'L'informatique au service de l'analyse des textes'; DUCHET, C. & LAUNAY, 'La lexicologie au service de l'histoire et de la critique littéraires'.

the problem of determining *periods, movements* and *styles* [14] and that of discerning *national* or *regional* characteristics and outlining the author's *personality*. Clearly, *evolution* in the context of art is not seen in the same light as in the general context of history, but it is hardly possible to deny the existence of historical processes in this sphere – processes that are linked with changes in society, but also with movements occurring within literature and art. At the present time, the principal concern of research workers is to formulate an explanation of the historical aspect of the work of art without losing sight of its specific aesthetic characteristics.

Opinions regarding the historicity of a work of art are primarily determined by the philosophical position adopted. They also stem from differences in the methods used in history, the social sciences and the human sciences. Furthermore, they are closely linked with the evolution of literature and art during the historian's own life-time. Meyer Schapiro is quite correct in stressing the importance of the latter factor, with reference to his personal experience:

The changes in artistic practice had a great effect on art historians and critics in their conception of formal structure as the main object of study. I say this with some conviction since my own first studies of Romanesque sculpture (my doctor's thesis on Moissac (written in 1929, published in 1931) owed their formal analytic approach to my intense interest in Cézanne, Seurat, Matisse and the Cubists.[15]

By weighing these different factors, it is possible to identify and place the various movements and schools that are in evidence in the history of art and literature.

Despite the existence of a few early works recording literary and artistic data and the Renaissance interest in antiquity, the true history of literature and art only emerged as a discipline dedicated to the examination of the relations between history and the arts towards the end of the eighteenth and the beginning of the nineteenth centuries. The notion of the grandeur of the past, an optimistic view of national and human progress, the cult of the genius expressing the aspirations of country and mankind, the didactic attitude, are all features of this *romantic historiography*,[16] which mainly produced biographies and national histories. It would be a mistake to think that this type of history has completely disappeared today: manuals and works of popular science are still frequently written in the same spirit.

In the second half of the nineteenth century, under the dual impact of the

14. For discussions relating to periodization anl literary movements, see: *IIème Congrès international d'Histoire littéraire, Amsterdam, 1935*, 'Les périodes dans l'histoire de la littérature depuis la Renaissance' (1937); TEESING, *Das Problem der Perioden in der Literaturgeschichte* (1949); *Actes du Vème Congrès de l'Association internationale de Littérature comparée, Belgrade, 1967* (1969); the issue of *New Literary History* entitled *A Symposium on Periods* (1970).

15. Letter to the rapporteur, Mikel Dufrenne, dated 23 Oct. 1968, at the time of the first consultations that preceded the drafting of this double chapter.

16. On romantic literary history, see WELLEK, R., *A History of Modern Criticism, 1750-1950* (1955-); LUKÁCS, *Adalékok az esztétika történetéhez* (1953) (German version, *Beiträge zur Geschichte der Ästhetik*, 1954).

development of natural science and the philosophy of Auguste Comte, **positivism** became the dominant mode of thought in the human sciences. It was reinforced by the school of H. Taine,[17] by the German *Kulturgeschichte* and H. T. Buckle's *History of Civilization.* His contemporary and his modern opponents are both quite right in criticizing positivism – which is far from being a dead letter – as a fact-finding process that delights in the accumulation of insignificant data, in self-evident determinist explanations, often biological in nature, or in simple illustrations of the history of civilization through literary and artistic facts. On the other hand it should be remembered that insistence on a scientific approach to the study of works of art, the search for laws in the evolution of literature and art, the identification of relations between such expressions of the mind and society, are all valid objectives which should not be discredited merely on account of the failings of positivism.

In Germany, under the impact of the neo-Kantian philosophy of Wilhelm Dilthey, the *Geistesgeschichte* school developed in opposition to positivism. It sought an explanation for art and its changes in the forces of the mind, in other words, primarily in the creator's world view as determined by the philosophical concepts respected by each age and individual.[18]

Whereas the *Geistesgeschichte*, particularly in Western Europe, became and is still the dominant current in the history of literature, in the *history of fine arts* the theme of styles predominates, as defined by H. Wölfflin in the light of formal criteria peculiar to various artistic movements.[19] This discovery led several historians to visualize some sort of union between the *Geistesgeschichte* and the history of styles. This gave rise to an attempt at

17. Here we should recall the bases of TAINE's method, at a time when a certain form of neo-positivism is being revived: 'The new method that I am attempting to apply entails the consideration of man's works in particular as facts and products, of which it is necessary to know the characteristics and seek the causes, no more. Seen in this light, science neither condemns nor forgives: it merely observes and explains. It proceeds in the same way as botany, which examines with equal interest the orange tree, the pine tree, the laurel, the ash, it is itself a sort of botany that is applied not to plants, but to man's works.' ('La méthode moderne que je tâche de suivre consiste à considérer les œuvres humaines en particulier comme des faits et des produits dont il faut marquer les caractères et chercher les causes, rien de plus. Ainsi comprise, la science ne proscrit ni ne pardonne: elle constate et elle explique. Elle fait comme la botanique qui étudie avec un intérêt égal tantôt l'oranger et tantôt le sapin, tantôt le laurier et tantôt le bouleau, elle est elle-même une sorte de botanique appliquée non aux plantes, mais aux œuvres humaines.' – *Philosophie de l'art*, Paris, 1885, pp. 14-15).

18. Dilthey's typology is highly suspect when one considers that for him Balzac and Stendhal represent positivism, Goethe objective idealism and Schiller idealistic dualism. Cf. in particular Vol. II of DILTHEY's *Gesammelte Schriften, Weltanschauung und Analyse des Menschen seit Renaissance und Reformation* (1914, 1944). Dilthey's ideas have been taken up again both in R. Unger's *Problemengeschichte* and in H. A. Korff's *Ideengeschichte.*

19. Cf. WÖLFFLIN, *Kunstgeschichtliche Grundbegriffe* (1915) (English translation, *Principles of Art History*). These questions are examined in detail by R. Assunto in an unpublished contribution to the present work: 'La catégorisation de l'histoire des arts par "styles": les systèmes dits "formalistes"'.

synthesis by O. Walzel,[20] who for literature established categories based on certain relations between *Weltanschauung* and form. Thus Goethe and romanticism are classified as the expression of an objective idealism, literature of the second half of the nineteenth century as realism, while the expressionists represent dualist personal idealism.

Some fine arts historians have sought to explain the evolution of art by what A. Riegl, under Hegel's influence, termed *Kunstwollen*, namely, an immanent form that becomes manifest in works of art. Another exponent of the same 'Vienna School', M. Dvořak, focused on the history of civilization, seeking a more objective interpretation of historical development. The 'Vienna School',[21] composed of members whose opinions often changed considerably in the course of their career, has not only influenced the history of fine arts (the early work of such scholars as H. Sedlmayr and E. H. Gombrich, for example, bears the imprint of this influence) but also that of other modes of expression, particularly with regard to the study of relations between content and form initiated by the various movements active at a given time.

Towards the end of the nineteenth century the interest aroused by immanent criticism engendered an historical trend (represented chiefly by K. Fiedler, A. von Hildebrand, B. Croce, Fry, Bell and Focillon) that P. E. Lasko describes in these words: 'The significance of this trend is that it emphasizes the work of art itself, and its own development in form and colour.' [22] This then represents a new conception of historicity, limited to the study of the internal development of art, which eventually leads to an anti-historical formalism.

Historical and dialectical materialism, represented in this field at the end of the nineteenth and the beginning of the twentieth centuries by V. G. Plekhanov, Fr. Mehring and others, in contrast to these idealist theories, propounded an explanation that sought to discern the true causes of the genesis of art works, to expose major trends in evolution and to analyse the influence of literature and art on society. In an earlier section dealing with the theory of art in the Socialist countries, we outlined the chief characteristics of Marxist aesthetics.[23] We now intend to explore the criteria of historicity as applied by the first Marxist historians of literature and art. 'The products of art are phenomena or facts that are the result of social relations. A change in social relations will alter the aesthetic tastes of the public and

20. Cf. his *Gehalt und Gestalt des Dichters* (1929, reprinted, 1957). The typology resembles that forming the basis of STRICH's *Deutsche Klassik und Romantik, oder Vollendung und Unendlichkeit* (2nd edn., 1924).
21. On the Vienna School, see in particular: RIEGL, *Historische Grammatik der bildenden Künste* (posthumous work, 1966); and DVOŘAK, *Kunstgeschichte als Geistesgeschichte. Studien zur abendländischen Kunstentwicklung* (1924). And for a similar orientation in musicology, see ADLER, *Methode der Musikgeschichte* (1919) and ADLER (ed.), *Handbuch der Musikgeschichte* (1924, reprinted 1930, 1961).
22. 'Trends of art historical research', unpublished contribution.
23. See above, Section I, B.

consequently the products of the artists.'[24] That is how Plekhanov defined
the link between the development of art and that of society. This conception
had the merit of bringing out the importance of the socio-economic factor
and of social psychology in the evolution of literature and art, but it also led
to a mechanistic determinism with regard to the interpretation of relations
between the social background of the author and his work, between the
genesis of the work and the social environment, and between the taste of a
particular public and the emergence of various trends. Despite these distor-
tions, the notion that certain features recur regularly in the development of
art and that this is determined, in one way or another, by changes of taste
in society, has been widely accepted.

III. THE NEW TRENDS

In the past few decades the evolution of the natural sciences, discoveries in
linguistics, the appearance of new philosophies, changes in historical con-
ceptions and methods and the evolution of art itself have given rise to new
schools of thought, or at least contributed to a regeneration of traditional
methods and approaches.

(A) *History of art – history of ideas and civilization*

The placing of a work in a clearly defined historico-cultural context and the
detection of the relations between this environment and the work, both from
the angle of its genesis and of its reception, is a more or less general ten-
dency. V. Cândea,[25] citing a few examples, summarizes the characteristics of
this approach: 'Ezio Raimondi, author of a work on the techniques of liter-
ary criticism,[26] rejects *ad hoc* criticism as hypothetical and evanescent, and
makes a case for a complete historical examination of a literary work, which
in his view is a twofold historical reality: on the one hand as a social product,
on the other as a creation which, although it transcends the historical plane,
must take its place in history through its readership. Sometimes the research
worker regards adherence to the historical approach as a return to good
method, sometimes as an innovation. This is Erwin Wolff's position in his

24. PLEKHANOV, *L'art et la vie sociale* (French translation, 1949). In defining the
tasks of materialist criticism Plekhanov underlines the need for a twofold approach,
sociological and aesthetic: 'In seeking to identify the social equivalent of certain
literary phenomena, this criticism betrays itself if it fails to realize that it is not
enough to discover this equivalent and that sociology must not shut the doors on
aesthetics, but on the contrary, should open them wide' (*ibid.*, p. 238). LUNAČARSKIJ
has accepted the fundamental elements of Plekhanov's conception and expresses his
ideas in *Osnovi pozitivnoj èstetiki* (= Basic principles of positivist aesthetics) (1923).
25. 'Note sur l'histoire de la littérature', unpublished contribution.
26. RAIMONDI, *Techniche della critica letteraria* (1967).

study of the English novel of the eighteenth century.[27] He asserts that fictional creation does not merely describe the historical and literary situation of a period but embodies it (*verkörpert*): as a consequence the research worker must reconcile 'the objectivity of the world' – enemy of the individual – and the 'experience' that helps man in his attempt to conquer the world. The historical perspective underlies classical works,[28] treatises and attempts to explain local literary phenomena. In his *Panorama of contemporary Spanish literature*,[29] T. Ballester stresses the social and political conditioning of literature. R. E. Spiller, in his work on the American literary revolution, 1783-1837,[30] highlights his subject by drawing on political and cultural history and on the history of ideas in the United States of America: his well-documented study seems to demonstrate that the literary revolution would not have been possible in the United States without a genuine political revolution. Most contemporary authors consider that a description of the social and political context is essential if the literature of a period is to be treated in a satisfactory manner.'

V. Cândea concludes that 'this method, then, is no longer the sole prerogative of literary historians who invoke a particular ideology. *To interpret the work and the writer's every activity, to explain literary movements, the entire development of a national literature in the light of social causes, of the image of society reflected in all these facts . . .: to place a writer within the history of a culture, to associate him with a definite moment of that culture, to pinpoint the philosophical, artistic and scientific influences that converge in his work* [31]: this was recommended by the Romanian author, T. Vianu, in 1964 as the essential methodology for research in literary history. Issuing from an essentially Marxist sphere of research, is not such a method utilized by a good many Western authors who would certainly not include themselves in the ranks of Marxist research workers?'

With the limits of this brief survey it is quite impossible to describe the wealth and diversity of the work done in Latin America or in other countries not attached to European traditions. We must, however, record a remarkable convergence: the analyses submitted by our colleagues from these countries confirm that the views we have just set out have in general a universal validity. This shows that, taking into account the characteristics peculiar to the cultural evolution of each single country, a historical study of the arts and literature shows the same basic tendencies in other regions as in Europe or North America. We will cite a few examples *inter alia*. Shuichi

27. WOLFF, *Der englische Roman des 18. Jahrhunderts: Wesen und Formen* (1964).

28. See, for example, BARBI, *Dante. Vita, opera e fortune* (1940) (English translation, *Life of Dante*, 1954).

29. BALLESTER, *Panorama de la literatura española contemporánea* (1965).

30. SPILLER (ed.), *The American Literary Revolution (1783-1837)* (1967).

31. VIANU, 'Materialismul istoric si dialectic în studiul istoriei literare' (= Historical and dialectical materialism in the study of literary history), in *Teorie şi metode în ştiinţe sociale* (1965).

Kato informs us [32] that in Japan, since 1945, partly under the influence of Marxism, special attention is being paid to the historical study of origins; in recent years close co-operation has been built up between history and the **history of literature**, the latter in particular resorting ever more systematically to the history of ideas. Similarly in Egypt, Shawki Deif [33] mentions the growing influence of the historical method on literary studies, adding that research workers regard literature as an integral part of the larger process of human revolution, or as an expression of the characteristics of a people, or as the outcome of the geographical situation of a country, or yet again as a manifestation of class struggles. In Latin America, according to Leopoldo Zea and Carlos Horatio Magis,[34] the historical study of literature is divided into two types of movement: positivism and the movement which groups research workers 'who concentrate on the interpretative type of historical study under the influence of historicism', one of their most notable tendencies being, in their view, the study of 'relations between the various forms of Hispanic art'.

It is therefore safe to say that the need to 'place' art in historical perspective is felt all over the world; however, it should be remembered that the content of the explanation may differ widely, depending on whether it is formulated by an idealist or a materialist, by a conservative or a revolutionary, by an expert in classical art or one in modern art. To mention only the non-Marxist philosophy of history, very different answers to the question of relations between art and history would be propounded by P. Hazard, A. O. Lovejoy, E. R. Curtius, J. Huizinga, E. Panofsky or Lucien Febvre.

To take a few examples from the context of the history of ideas: P. Hazard, in his work on the consciousness of Europe,[35] has examined literature and other intellectual outputs principally from the viewpoint of political ideas reflecting the desire for stability and that for change in the various strata of society at the end of the seventeenth and early eithteenth centuries. In his *History of Ideas*, A. O. Lovejoy [36] draws on literature to illustrate the evolution of philosophical thinking. E. R. Curtius,[37] wishing to introduce more precise methods – in other words philological methods – concentrated on the Latin literature of the Middle Ages, considered as the prevailing tradition of European letters, with a view to bringing out the *topoi,* the commonly accepted ideas. J. Huizinga,[38] to whom we are largely indebted for a better

32. Excerpt from a note on the current evolution of literary studies in Japan, submitted by the Japanese National Commission for Unesco.

33. 'Influence of the historical method upon literary studies', contribution submitted by the Unesco National Commission of the Republic of Egypt.

34. 'Variación de los puntos de vista y de los criterios en que se fundan el estudio y la apreciación de las expresiones artísticas y literarias: situación y punto de vista de la América Latina' – Survey prepared as a contribution to this study.

35. HAZARD, *La crise de la conscience européenne, 1680-1715* (1935) (English translation, *The European Mind. The Critical Years: 1680-1715*, 1953).

36. Cf. in particular LOVEJOY, *Essays in the History of Ideas* (1949).

37. CURTIUS, *Europäische Literatur und lateinisches Mittelalter* (1948) (English translation, *European Literature and the Latin Middle Ages*, 1953).

38. HUIZINGA, *Wege der Kulturgeschichte* (1930).

understanding of the Middle Ages and the Renaissance, set himself the task of deciphering the various forms and functions of culture from the history of peoples and social groups; he wished to apprehend and elucidate the process whereby these expressions became 'cultural figures', in other words motifs, themes, symbols, ideas, mentalities, ideals, styles and modes of the sensibility, which can nowhere be discerned better than in literature and in art.

In the field of the history of the fine arts,[39] the iconological school (centered in the Warburg Institute) and on a personal basis E. Panofsky, made their influence most keenly felt. Beginning with E. Cassirer's theory of 'symbolic forms' Panofsky distinguishes, from the point of view of the object, three levels of interpretation: the level of meaning as phenomenon (*Phänomenonsinn*), that of meaning as significance (*Bedeutungssinn*) and that of meaning as document or 'meaning as essence' (*Dokumentsinn, Wesensinn*). The sources of the interpretation may be classified as subjective and objective. The former brings into play three categories: the category of life experience (*Vitale Daseinserfahrung*), that of literary knowledge (*Literarisches Wissen*) and that of a particular archetypal vision of the world (*Weltanschauliches Urverhalten*). As to the objective sources, they relate to the history of the *Gestaltung* (*Gestaltungsgeschichte*), to that of types (*Typengeschichte*) and to the general history of the intellect (*Allgemeine Geistesgeschichte*).[40] G. C. Argan draws our attention [41] to the fact that 'Panofsky's iconological research carries further the study of relationships in time and extends them in space, but above all it endows the study of the genesis of art with the unlimited dimension of unconscious motivations.' This is how Panofsky, who at the beginning was more of an exponent of *Geistesgeschichte*, came close to explanation by psycho-analysis.

While accepting some elements of the iconological school, E. H. Grombrich, influenced by Karl R. Popper's philosophy of relativist history, in his *Art and Illusion*,[42] seeks to provide a psychological explanation to the history of the form of vision which is peculiar to art.

In the history of literature, movements invoking psychology or psycho-analysis are gaining in strength. All those wishing to study images, themes, 'obsessive metaphors', seek to explain the work with reference to the author's unconscious. J.-P. Weber, an exponent of thematic analysis, defines the subject as follows: 'An event or a situation (in the widest sense of the word) occurring in infancy, is likely to reappear – usually unconsciously – in a work or group of works of art'.[43] Viewed from this angle the theme is studied in

39. On recent trends in the history of art, particularly in the United States of America, see ACKERMAN, 'Western art history' (1963).

40. PANOFSKY, *Aufsätze zu Grundfragen der Kunstwissenschaft* (1964), p. 95.

41. See following chapter, Section II, *The Study of the Various Arts*, I, 'Visual arts'.

42. GOMBRICH, *Art and Illusion* (1959; rev., 1962); see also, by the same author, *In Search of Cultural History* (lecture, 1967; published, 1969).

43. Cf. WEBER, *Néo-critique et paléo-critique* (1966).

the light of the theories of Freud, Jung and Adler, based on the writer's biography, with particular reference to his childhood.

Whereas the trends described above are mainly derived from idealist philosophies of history (above all of *Geistesgeschichte)* and psychology (*Gestaltpsychologie* included), others seek an explanation of literary and artistic phenomena in economic and social factors, and consequently draw on sociology and economic history. The history of mentalities, as conceived by the exponents of the school of the *Annales*, proposes to study the cultural model of a given society with a view to the subsequent placing of various intellectual manifestations, among them literature and art. In his work on unbelief in the sixteenth century,[44] L. Febvre provides an example of the application of these principles to Rabelais, regarded as a representative of Christian humanism. More recent studies – under the influence of Marxism – attempt, by painstaking research into all kinds of documents, to reconstitute the intellectual equipment of a period and the changes in the mentality of various social strata, and of readers in particular (R. Mandrou's works are a case in point).[45]

In the history of the fine arts the sociological approach has made an important contribution to an understanding of social demand. On the basis of a wealth of documentation and strict classification, in his well-known work on Florentine painting and its social background,[46] F. Antal succeeded in formulating some general considerations on the impact of demand on the development of art. Antal concentrated on a specific subject. A. Hauser, in his social history of art and literature,[47] attempted to make a synthesis and thereby, despite some simplifications, exerted a considerable influence on the history of art and literature. In his philosophy of the history of art,[48] he affirms that stylistic changes cannot solely be explained by formal elements but primarily by the evolution of society. In his view, art forms are not only forms that have been experienced and defined visually and acoustically, but they are also forms of expression of a certain world view, determined by the social environment. In the history of literature a *history of taste* (L. L. Schücking, E. Auerbach),[49] namely, a historical study of the public is also required. Under the influence of Hegel and Marx, Th. W. Adorno formu-

44. FEBVRE, *Le problème de l'incroyance au XVIe siècle. La religion de Rabelais* (1942; reprinted 1962). For the ideas of Lucien Febvre on the history of collective mentalities, see his *Pour une histoire à part entière* (1962) and, in English, *A New Kind of History* (1973).

45. Cf. MANDROU, *De la culture populaire en France aux XVIIe et XVIIIe siècles. Bibliothèque bleue de Troyes* (1964), and 'Histoire littéraire et histoire culturelle', in the issue of the *Revue d'Histoire littéraire de la France* already cited (1970). The method of the history of mentalities is described by Georges DUBY in SAMARAN (ed.), *L'histoire et ses méthodes* (1961); cf., more recently, by the same author, *Des sociétés médiévales* (Inaugural lecture at the Collège de France, 1971).

46. ANTAL, *Florentine Painting and Its Social Background* (1948).

47. HAUSER, *Sozialgeschichte der Kunst und Literatur* (1953) (English translation, *The Social History of Art*).

48. HAUSER, *Philosophie der Kunstgeschichte* (1958) (English translation, *Philosophy of Art History*, 1959).

49. SCHÜCKING, *Die Soziologie der literarischen Geschmacksbildung* (1931) (Eng-

lated his sociology of music which seeks to identify the human content – historically determined – in the structural and technical elements of the work of art.[50]

And yet, despite these attempts at regeneration, the history of literature and art, conceived as an integral part of the history of ideas or of civilization, is under fire chiefly because it tends too often to neglect the strictly aesthetic aspects of the problem.

(B) *History of art – history of forms and structures*

The end of the nineteenth century saw, in the study of literature and art, the beginning of a school of thought that stressed the immanent interpretation of a work of art. This trend has gained ground in recent years under the impact of neo-positivist philosophy and of certain trends in modern art. Members of this school are either entirely opposed to any historical conception of the work of art or else, more often, are concerned with an intrinsic historical approach which precludes any recourse to so-called external factors.

In the study of the fine arts – with antecedents going back to K. Fiedler – H. Focillon initiated the method that can be termed history of form. He drew a logical distinction between *form* and *sign* in protest against content-form dualism and refused to recognize any but a *formal* content understood as the *essential content* of the form. He said: 'A sign signifies an object, form signifies only itself'. The form may lend itself to the expression of several different meanings: 'The great network of ornament in which the successive divinities and heroes of Mesopatamia are caught fast changes its name without even changing its shape'. The 'life of forms' in time should be considered from two points of view: 'First it is internal, i.e., what is the position of the work of art in its formal development? Second, what is the relationship of this development to other aspects of human activity?'[51] In this way he attempts to achieve a synthesis of studying formal development and its relation with other activities. But since he was primarily concerned with 'formal development', he has been considered to represent a certain ahistorical trend.

Nevertheless, it seems that the study of the fine arts is hostile to all anti-historical pressure, even when it is structuralist in form. In the course of discussions on structuralism P. Francastel formulates his conception of form and its development. He tells us:

lish translation, *The Sociology of Literary Taste*, 1966); AUERBACH, *Das französische Publikum des XVII. Jahrhunderts* (1933).

50. ADORNO, *Einleitung in die Musiksoziologie* (1962).

51. 'Le signe signifie, alors que la forme *se* signifie. ... Le réseau d'ornements où viennent se prendre les dieux et les héros successifs de la Mésopotamie change de nom sans changer de figure. ... C'est d'abord un problème d'ordre interne: quelle est la position de l'œuvre dans le développement formel? un problème externe: quel est le rapport de ce développement avec les autres aspects de l'activité?' – FOCILLON, *Vie des formes*, pp. 10, 11, 83 in 1947 edn. (English translation, *The Life of Forms in Art*, pp. 3, 4, 56 in 2nd edn., 1948).

It is inconceivable for a work of art to exist without its structure, but it does not follow that the structure will have the same rôle or the same attribute in each case. Consequently, it is equally important when considering each particular case to question both the degree of originality and the degree of integration of the structure, and also to remember that analyses concentrating on structures – or forms – fail to embrace all the points of view that are valid or even useful for a precise knowledge of the object in question.[52]

Applying these ideas to an interpretation of the linear perspective of the Quattrocento, he defines his method as follows:

I have attempted to show the origins (of perspective); then the slow build-up of a system which, little by little, eliminates many other possibilities fleetingly glimpsed, while on the other hand applying to man's activities in general the practical and philosophical results of a certain collective attitude towards the outside world and towards action.[53]

Marc Le Bot summarizes the historical characteristics of this conception as follows:

Genuine historical events in the field of art are first of all what Pierre Francastel calls mutations in the prevailing system; within it, individual and collective styles produce what may be termed innovations; individual works in the same style produce variations on it. None of these ideas implies the slightest opinion concerning aesthetic value.[54]

With this study of forms finally leads to a history of styles which also uses some of the teachings of sociology to advantage.

Furthermore, a certain scepticism with regard to the *history of styles* is growing in the study of the fine arts and other fields. Reflecting this scepticism, Claude V. Palisca, in connexion with the history of music, stresses a method which seeks to examine changes in structures that have been more or less fixed in the course of time within an interdisciplinary context:

52. 'L'existence d'une œuvre d'art est impensable sans structure, mais il ne s'ensuit pas que dans chaque ouvrage la structure possède le même rôle ni la même qualité. Il est aussi important, par conséquent, de se demander devant chaque cas particulier quel est aussi bien le degré d'originalité et le degré d'intégration de la structure que de ne jamais oublier que les analyses qui prennent pour objet les structures – ou les formes – n'épuisent pas les points de vue valables et même utiles pour une connaissance précise de l'objet considéré.' – FRANCASTEL, 'Note sur l'emploi du mot "structure" en histoire de l'art' (1962), pp. 50-51; see also, by the same author, 'Art, forme, structure' (1965).

53. 'J'ai essayé de montrer ses origines; puis la lente élaboration d'un système qui, peu à peu, élimine toute une série d'autres possibilités fugitivement entrevues, tout en étendant, d'autre part, à l'ensemble des activités de l'homme les conséquences pratiques et philosophiques d'une certaine attitude collective par rapport au monde extérieur et à l'action.' – FRANCASTEL, *Peinture et société* (1964, 1965), Preface, p. 7 in the 1965 edn.

54. 'Les véritables événements historiques, en matière d'art, sont d'abord ce que Pierre Francastel nomme les mutations dans l'ordre du système; les styles individuels et collectifs y produisent ce qu'on pourrait nommer des novations; les œuvres particulières qui relèvent d'un même style, des variations; sans qu'aucune de ces notions implique d'abord le moindre jugement de valeur esthétique.' – LE BOT, 'Art, sociologie, histoire' (1967), pp. 486-487.

In recent years there has been a growing suspicion of the evolutionary view of musical change in which the succession of musical practices and styles of composition are seen as an internally generated process independent of social and intellectual forces. Studies in depth of certain musical cultures and organizations have shown that there are many non-musical factors influencing musical practice and changes in public taste and manners of composition. Concomitantly historians have grown sceptical of the notion of *Weltanschauung*, an intellectual climate that was once thought to determine artistic and cultural style. Such period concepts as baroque, romanticism, classicism, and all that they imply are being questioned. They are found often to be alien to the self-concepts of the period they are proposed to describe and to gloss over many skeins of conflicting directions. Here too more concrete relationships between manifestations in the various arts and between the arts and intellectual and social history are being investigated. Alfred Einstein[55] has set an example in his reconstruction of the social, literary and political context of the Italian madrigal, and younger men are now examining with a close lens certain areas of this large landscape, such as the madrigal in Ferrara and Florence. Interdisciplinary studies are thus losing some of their dilettantish character, and central figures, problems, or localities that are in themselves webs of musical and cultural relationships are being probed with the support of intensive archive work, analyses of local repertories, liturgies, customs, systems of patronage and the like.[56]

In P. E. Lasko's opinion, the interdisciplinary approach to research is typical of a recent trend which, in his view, lays claim to an autonomous interpretation of the work of art, regarded as a *non-verbal means of communication*:

As yet, relatively little work is done in this direction, and its impact is perhaps greatest in the area of 'contemporary' history – in the area of study where the history of art and art criticism overlap. Here research is being undertaken in non-verbal communication and psychology of perception, both in the contemporary and the historical field. In this area, it is artists themselves, with an increasing awareness of their historical position and a sense of Apollinaire's *'Eternel Présent'*, rather than art historians (or even contemporary critics), who are making the more fundamental contribution. It may almost be said that the creative work of some artists is a non-verbal historical commentary in its own right. What contributions there are by academics in this field, may be said again to transgress the established boundaries of art-historical research, and to spread into the fields of psychology, behavioural science and even psycho-analysis and physiology. What is of concern to this general trend of research is the re-examination of the whole concept of 'Art', its function in society, and the roots of individual artistic creativity. Such ideas must seem almost inevitable in the light of certain developments in the art of the twentieth century, when it is conceded that the history of any creative activity of man, must in the end be nourished by the same roots as the creative activity itself. It is not surprising that such aims must range over a wider area of scholarship than a purely historical approach commands, although it ignores the lessons of history only at its peril.[57].

If, in the study of the fine arts, a purely diachronic conception failed to prevail, in the study of literature we are witnessing (and, above all, we have witnessed) trends which, in order to bring out the literary character of a text,

55. EINSTEIN, *The Italian Madrigal* (1949).

56. Palisca, 'Some recent trends in the historiography of music' (unpublished contribution to the present work).

57. 'Trends of art historical research', unpublished contribution.

are content with an approach that is purely synchronic. Influenced by Husserl's phenomenology, Roman Ingarden defined the literary work by its structure – a structure of which the various strata can in his view only be subject to an intrinsic explanation, in other words without bringing in the conditions of the work's genesis.[58] Husserl also influenced Martin Heidegger and his follower E. Staiger, the latter being the first literary critic to associate phenomenology and existentialism. In opposing *Geistesgeschichte,* Staiger, in his major work on the fundamental notions of poetics,[59] attempts to go beyond historicity by substituting existentialist time for real time. This 'anthropological philosophy' really only takes cognition of a single question to which the work must supply an answer: what is man? However, in his later works, Staiger 'reconsiders' his method, and in addition to the *interpretation* he includes a *commentary* to provide the 'historical background' for it.[60]

An ahistorical trend can also be discerned in the *New Criticism* (John Crowe Ransom, Allen Tate, Cleanth Brooks and others) which seeks for an 'ontological', 'contextual' or 'formalist organic' interpretation of poetry.[61]

The current mode of literary structuralism that claims a quasi-monopoly over synchronic analysis[62] derives partly from phenomenology, partly from the Russian formalist school – V. Shklovsky, B. Eikhenbaum, I. N. Tynianov – but mainly from the new linguistics initiated by Ferdinand de Saussure and the Linguistics Circle of Prague. One of its noted members, Roland Barthes, proposes to elucidate the 'tragic world' of Racine 'without a single reference to any existing source (derived for example from history or biography)'.[63] According to this conception, a work of art is not a product, but 'a sign of something beyond itself', and criticism chiefly consists in deciphering the meaning, understanding the terms – mainly the concealed terms – and the semantic content of the sign. In the case in point, Barthes wishes to reconstruct 'a sort of anthropology of Racine that is both structural and analytic: structural as regards its base, because tragedy here is treated as a system of unities (the figures) and functions; analytic in form, because only a language prepared to record the world's fear, as I believe is the case for

58. INGARDEN, *Das literarische Kunstwerk* (1931).
59. STAIGER, *Grundbegriffe der Poetik* (1968).
60. STAIGER, *Stilwandel* (1963).
61. On this movement and its development, see WELLEK, R., *Concepts of Criticism* (1963).
62. On the relations between structuralism and history, see: WACHTEL, 'Structuralisme et histoire' (1966); PARAIN, 'Structuralisme et histoire' (1967); GREIMAS, 'Structure et histoire' (1966, 1970); SZABOLCSI, 'Possibilité d'une unité des méthodes génétiques et structuralistes dans l'interprétation des textes' (1968); KAGAN, 'I tak, "strukturalizm" i "antistrukturalizm"' (= And so, 'structuralism' and 'antistructuralism') (1969); ANDERSON, 'Art history?' (1967); RODER, 'Art and history' (1967). See also the works mentioned below by Louis Marin in the footnotes of 'The semiotic approach'.
63. '... [de mettre à jour le] monde tragique [de Racine] sans aucune référence à une source de ce monde (issue, par exemple, de l'histoire ou de la biographie).' – BARTHES, *Sur Racine* (1963), Foreword, p. 9.

psycho-analysis, seemed to me suitable for an encounter with a man in confinement'. Implicit in this structural criticism, then, is a psycho-analytic approach stressing the subjective without being able to disregard its contextual surroundings. In fact, the psycho-analytical study necessarily leads to a biographical study, and from this point of view it is certainly historical, even if it only concerns the history of a tragic individual living in a divided world in which he cannot act except through language. Such men '*make* their own language, they voice their divided state, this constitutes the reality and bounds of their condition'.[64] Clearly, this conception of Barthes goes beyond the framework of typical, formal analysis undertaken by more orthodox structuralists who are content with a quantitative description of certain elements in a work of art, or attempt to expose the relations between these elemens within a given structure.

While adopting some of the elements of Lukács' first aesthetic and the teachings of sociology from the structuralist angle, Lucien Goldmann wishes to achieve more than a history of subjectivity. His initial focus is the social group pinpointed in history: 'The group represents a process of structuration which in the conscience of its members conduces to affective, intellectual and practical tendencies embodying a coherent answer to the problems that arise in their relations with nature and their inter-human relationships.'[65] To

64. '... le signe d'un au-delà d'elle-même ... [reconstruire] une sorte d'anthropologie racinienne à la fois structurale et analytique: structurale dans le fond, parce que la tragédie est traitée ici comme un système d'unités (les figures) et de fonctions; analytique dans la forme, parce que seul un langage prêt à recueillir la peur du monde, comme l'est, je crois, la psychanalyse, m'a paru convenir à la rencontre d'un homme enfermé. ... [Ces hommes-là] *font* leur langage, ils parlent leur division, c'est la réalité et la limite de leur statut.' – BARTHES, *ibid.*, pp. 157, 9-10, 66. Barthes attempts to define his method with reference to those of Goldmann and Mauron: 'Goldmann's and Mauron's criticisms are always haunted by two phantoms, usually extremely hostile to meaning; in Goldmann's case, the signifier (the work, or more exactly the relay precisely introduced by Goldmann, which is the world view) is always in danger of appearing to be the *product* of the social conjuncture, the meaning finally only serving to mask the old determinist pattern; and with Mauron, the same signifier can barely be distinguished from *expression*, so dear to traditional psychology (this no doubt is the reason why the Sorbonne has just swallowed literary psycho-analysis so easily, in the form of Mauron's thesis).' ('Les critiques de Goldmann et de Mauron sont sans cesse menacées par deux fantômes, d'ordinaire fort hostiles à la signification; dans le cas de Goldmann, le signifiant (l'œuvre, ou pour être plus exact le relais que Goldmann introduit justement et qui est la vision du monde) risque toujours d'apparaître comme le *produit* de la conjoncture sociale, la signification servant au fond à masquer le vieux schéma déterministe; et dans le cas de Mauron, ce même signifiant se dégage mal de l'*expression* chère à l'ancienne psychologie (ce pour quoi, sans doute, la Sorbonne vient d'ingérer si facilement la psychanalyse littéraire, sous les espèces de la thèse de Mauron).' – BARTHES, *Essais critiques* (1964, p. 268). While stressing the specific characteristics of literature, does not Barthes – in his conclusions – come close to some of his opponents? The latest studies of Barthes do, however, reveal a keener interest in history: cf. BARTHES, 'Drame, poème, roman', pp. 25-40 in *Théorie d'ensemble* (1968).

65. 'Le groupe constitue un processus de structuration qui élabore dans la conscience de ses membres des tendances affectives, intellectuelles et pratiques, vers

illustrate his method, we will quote his words in connexion with the works of Pascal and Racine: 'To reveal the tragic structure of the *Pensées* of Pascal and Racine's theatre is a process of understanding; to place them in the context of extremist Jansenism while defining its structure is a process of understanding in relation to the latter, but a process of explanation in relation to the writings of Pascal and Racine; to place extremist Jansenism in the overall context of the history of Jansenism is to explain the former and understand the latter. To place Jansenism, as an ideological movement in the historical context of the "robe" nobility of the seventeenth century, is to explain Jansenism and understand the "robe" nobility. To place the history of the "robe" nobility in the overall historical context of French society is to explain the former while understanding the latter, and so forth.' [66] Thus, works of art are the expression of the world view of particular social groups, and their value depends on the structure, which may be remote from or close to the 'rigorous coherence' of a certain totality determined historically.

Trends attempting to highlight the specific characteristics of art from the point of view of form necessarily encounter problems of history: a purely immanent criticism of the work of art is impossible. Exponents of some of these approaches are aware of this fact and are looking for ways of achieving a synthesis, others regard the purely synchronic nature of the interpretation (which is, moreover, impracticable) as the criterion of modernity.

(C) *History of art – the comprehensive approach*

A history of art that attempts to explain the aesthetic phenomenon by external factors, or a history of art that only attempts to examine its 'interior development', are fragmentary, since they fail to resolve the problem of the relationship between the work of art and the history of mankind from which it cannot be dissociated. At the present time we can observe only two attempts to overcome this antagonism: one has its origins in subjective idealist philosophy, particularly in existentialism, the other in dialectical and historical materialism.

une réponse cohérente aux problèmes que posent leurs relations avec la nature et leurs relations inter-humaines.' – GOLDMANN, *Pour une sociologie du roman*, p. 218 in 1st edn. (1964) or p. 346 in 2nd edn. (1965).

66. 'Mettre en lumière la structure tragique des *Pensées* de Pascal et du théâtre racinien est un procédé de compréhension; les insérer dans le jansénisme extrémiste en dégageant la structure de celui-ci est un procédé de compréhension par rapport à ce dernier, mais un procédé d'explication par rapport aux écrits de Pascal et de Racine; insérer le jansénisme extrémisme dans l'histoire globale du janénisme, c'est expliquer le premier et comprendre le second. Insérer le jansénisme, en tant que mouvement d'expression idéologique, dans l'histoire de la noblesse de robe du 17e siècle, c'est expliquer le jansénisme et comprendre la noblesse de robe. Insérer l'histoire de la noblesse de robe dans l'histoire globale de la société française, c'est l'expliquer en comprenant cette dernière et ainsi de suite.' – *Ibid.*, pp. 223-224 (1964) or p. 354 (1965).

(a) *The work of art explained through biography*

In his 'Considerations on the present state of literary criticism', J. Starobinski notes:

No one can claim that a literary work is created *ex nihilo*; it is always *preceded* by something; it is, if not pre-formed, at least prefigured in the mind of its author and in the historical moment.[67]

According to him it is an 'existential' decision that determines transition to literature and materialization in a work, and the task of literary history is not to grasp the conditions surrounding its genesis, but to compare, on the basis of the text, these conditions and the final objective.

'The most specific study', he continues, 'will be seen to consist not of identifying residues of the antecedent impulsion in the work, but of perceiving the original character of the final intention as embodied in the closed form of a text. Critical examination will at least have to make a distinction – it will have to take note of the divergence, the contrast, the distance that may separate the work from its original conditions: it proceeds from them in order to differ from them; it expresses them by being untrue to them. It moves history forward, if only in an infinitesimal way, and can no longer be reduced to the balance of forces of the preceding moment.'[68]

These ideas are close to those of Sartre who, in *What is Literature?*, states:

One cannot write without a public and without a myth – without a *certain* public which historical circumstances have made, without a *certain* myth of literature which depends to a very great extent upon the demand of this public. In a word, the author is in a situation, like all other men. But his writings, like every human project, simultaneously enclose, specify, and surpass this situation, even explain it and set it up *Being situated* is an essential and necessary characteristic of freedom. To describe the situation is not to cast aspersion on freedom.[69]

67. 'Nul ne peut prétendre ... que l'œuvre littéraire naît *ex nihilo*; celle-ci est toujours *précédée*; elle est, sinon préformée, du moins préfigurée, dans la conscience de son auteur et dans le moment historique.' – Cf., in the following chapter, Section II, *The Study of the Various Arts*, sub-section II, 'Literature'.
68. 'L'étude la plus spécifique ... ne consistera pas à répertorier dans l'œuvre le résidu de l'impulsion antécédente, mais à percevoir le caractère de l'intention finale telle qu'elle s'inscrit dans la forme close d'un texte. A tout le moins, l'examen critique devra se faire différentiel, attentif à l'écart, à l'opposition, à la distance que l'œuvre peut marquer par rapport à ces conditions originelles: elle en procède pour en différer, elle les exprime, en les trahissant. Fût-ce d'une façon infinitésimale, elle fait bouger l'histoire et ne peut déjà plus se réduire aux rapports des forces de l'instant précédent.' – *Ibid.*
69. 'On ne peut écrire sans public et sans mythe – sans un *certain* public que les circonstances historiques ont fait, sans un *certain* mythe de la littérature qui dépend, en une très large mesure, des demandes de ce public. En un mot, l'auteur est en situation, comme tous les autres hommes. Mais ses écrits, comme tout projet humain, enferment à la fois, précisent et dépassent cette situation, l'expliquent même et la fondent. ... C'est un caractère essentiel et nécessaire de la liberté que d'*être située*. Décrire la situation ne saurait porter atteinte à la liberté.' – *Qu'est-ce que la littérature?* (1947), p. 188 in SARTRE, *Situations, II* (1948) or p. 184 in separate edition in volume form (1970) (English version, p. 150 in B. Frechtman's translation, 1949).

In the case of existentialists and historians of literature influenced by this philosophical trend, description is primarily psycho-analytical. Here of course we are dealing with existential psycho-analysis, as defined and practised by Sartre in his writings on literature and art, for example in his *Baudelaire,* of which the philosophical foundations were already laid in preliminary form in a chapter of *L'être et le néant*.[70]

Influenced by Sartre, but also by Gaston Bachelard and by phenomenology, J. Starobinski, G. Poulet, J.-P. Richard and others recommend the use of a method that could be called *thematic* (sight, time, space, distance, feeling, etc.) but which claims to be 'comprehensive criticism'. G. Poulet defines his method as follows:

Contrary to what is supposed, criticism should guard against concentrating on one particular *object* (whether the person of the author, considered as another being, or his work considered as an entity), for what should be attained is a *subject*, in other words a spiritual activity that can only be understood by putting oneself in its place and adopting its point of view, in short by making it once again play the subject rôle within us.[71]

The explanations of these critics in connexion with Jean-Jacques Rousseau, Proust or Mallarmé [72] testify to an intuitive approach founded on a certain psychological conception of the work of art, even when they take into account the importance of literary language or of a particular historical context. However, Starobinski, as shown in his new book on criticism,[73] reveals an increasingly evident trend towards the development of a more complex method that also takes into account the sociological aspects of literature. Sartre himself, in connexion with his study on Genet, realizes that the subjective explanation is not sufficient. Dialectical and historical materialism gave him the idea of seeking for a broader interpretation of what he has lately called the *lived experience*. In connexion with his new book on Flaubert, he states that he wants the reader 'to feel Flaubert's presence the whole time'. He adds: 'My ideal would be for the reader to be able all at once to feel, understand and know Flaubert's personality, as wholly individual but also as wholly representative of his period. In other words, Flaubert can only be understood by what differentiates him from his contemporaries'.[74] Thereby he rejects the 'individualist' study of the work of art and its author. In his

70. Pages 643-708 (1943 edn.).

71. POULET, 'Réponse' (1959).

72. STAROBINSKI, *Jean-Jacques Rousseau. La transparence et l'obstacle* (1957, 1971); POULET, *L'espace proustien* (1963); RICHARD, *L'univers imaginaire de Mallarmé* (1962).

73. STAROBINSKI, *L'œil vivant, II. La relation critique* (1970).

74. '. . . [que le lecteur] sente tout le temps la présence de Flaubert. . . . Mon idéal serait qu'il puisse tout à la fois sentir, comprendre et connaître la personnalité de Flaubert, comme totalement individuelle, mais aussi comme totalement représentative de son époque. Autrement dit, Flaubert ne peut être compris que par ce qui le distingue de ses contemporains.' - Interview in *Le nouvel Observateur du monde* (Paris), No. 272, 26 Jan.-7 Feb. 1970; cf. p. 114 in *Situations, IX* (1972).

preface to *L'idiot de la famille* [75] we read: ' . . . a man is never an individual; it would be better to call him a "singular universal": totalized and thereby universalized by his epoch, he re-totalizes it by reproducing himself within it as a singularity'. As for the method used to study Flaubert 'from both sides', he refers us to his Introduction to the *Critique de la raison dialectique*.[76] But if Sartre failed to propose a satisfactory philosophical solution to the question of the relations between the individual and society, it is permissible to ask how he could solve the same problem on the plane of historical or literary criticism.

We are thus forced to conclude that these more or less subjective interpretations are restricted to a psychological or psycho-analytical type of individual history – recently with overtones of phenomenological or structuralist conceptions – a history that fails to identify the dialectical relations between the work of art, its author and society in a given period.

(b) *The work of art and the history of man*

While asserting that what is human is *ipso facto* historical, the Marxist interpretation attempts to go beyond a certain scientism in which is implicit a mechanistic determinism, and beyond any form of psychological subjectivism. In *The Specific Nature of the Aesthetic*, Lukács brings out the *objective* historical character of the aesthetic phenomena, remarking:

A work of art never comes into being without the artistic representation of the historical *hic et nunc* of the moment depicted. It is a matter of indifference to us whether the respective artists are conscious of this or not, whether they believe that they are producing something outside time, whether they are utilizing an earlier style, or whether they are pursuing an 'eternal' ideal drawn from the past; their creations are only authentic in so far as they are fathered by the most deep-seated trends of the period of their genesis; the content and form of truly artistic creation cannot be dissociated, precisely from the aesthetic point of view, from their genesis. The historicity of objective reality takes its subjective and objective form from artistic creation.[77]

Through elaboration of the theory of reflexion, Lukács is able to establish a dialectical relation between subjectivity and historical objectivity. His category of realism implies the existence of a certain totality within which the particular, historically determined, succeeds in expressing one moment of the generic. Goethe, Balzac or Thomas Mann express the essential trends of

75. ' . . . un homme n'est jamais un individu; il vaudrait mieux l'appeler un "universel singulier": totalisé et, par là-même, universalisé par son époque, il la retotalise en se reproduisant en elle comme singularité. . . . [Etudier Flaubert] par les deux bouts' – *L'idiot de la famille* (1971) constitutes the first part of a study on Flaubert, in course of preparation.
76. First published as an article (1957), with the title 'Questions de méthode', then as the opening section of his *Critique de la Raison dialectique* (1960), finally as a separate volume (1967), with its original title (English translation, *Search for a Method*, 1968).
77. LUKÁCS, *Die Eigenart des Ästhetischen* (1963), Introduction.

their periods, thereby becoming spokesmen for mankind; and their best works remain valid for all periods in history.

Other Marxists, who also accept the reflexion theory as a basis, seek a more precise definition of the historical reality that influences the creation and reception of the work of art. In order to do this, they endeavour to elucidate the factors of mediation that exist between it and its economic and social base. Discussions concerning periodization, the history of styles and artistic periods have demonstrated the relative nature of 'styles'. However, some Marxist historians consider that 'periods' do not exist as chronological units in which a single style or school of thought predominates, but as complex groups which must be defined from an anthropological point of view, in other terms examined as an expression of the essence and nature of man mentioned in Marx's *Economic and Philosophic Manuscripts of 1844*, by placing them in a *more concrete historical context* while taking into account possible different *types* of evolution.[78]

In Marxist works on the history of literature and art, more and more emphasis is being placed on the need to establish the specific characteristics of the work of art, which should be considered as the indispensable starting-point for any study. According to Mihail Alpatov:

The historian should not lose sight of the work of art itself. His main task does not consist in discovering a philosophy which might serve as a key to the work of an artist, or which may have influenced the latter at one time or another. It is more important to discover, in the work of an artist, how he succeeded in solving, by artistic means, questions that were the concern of the philosophers and aestheticians of his time. Literary sources are not the only means of deciphering works of art, although they do provide a point of departure for an interpretation of art for the

78. For discussions regarding the interpretation of trends in the evolution of literature, see FOHT, 'Zakoni istoričeskogo razvitija literatury' (= Laws of the historical evolution of literature) (1963) and ŠČERBINA, 'O prirode literaturnyh zakonomernostej' (= Concerning the nature of literary regularities) (1966).

For questions of 'style', see KLANICZAY, 'Styles et histoire du style' (1964); KÖPECZI & JUHÁSZ (eds.), *Littérature et réalité* (1966).

Some works that combine concrete historical research with a very subtle analysis of form are: BAHTIN, *Problemy poetiki Dostoevskogo* (1963) (English translation, BAKHTIN, *Problems of Dostoevsky's Poetics* (1973) and *Tvorčestvo Fransua Rable i narodnaja kul'tura Srednekov'ja i Renessansa* (1965) (English translation, *Rabelais and His World*, 1968); SCHIRMUNSKI (= ŽIRMUNSKIJ), *J. G. Herder* (1963); ALEKSEEV, *Iz istorii anglijskoi literatury* (= Outline of the History of English Literature) (1960) and *Šekspir i russkaja kul'tura* (= Shakespeare and Russian Culture) (1965); LIHATSCHOW (= LIHAČEV), *Die Kultur Russlands während der osteuropäischen Frührenaissance vom 14. bis zum Beginn des 15. Jhdts.* (1962).

For a descriptive bibliography of Soviet works on literary history see: *Sovetskoe literaturovedenie za 50 let* (= Fifty Years of Soviet Literary Science) (1968).

The following may be mentioned as works representative of the application of Marxist methods to the history of music: KNEPLER, *Musikgeschichte des XIX. Jahrhunderts* (1961); GRUBER, *Istorija muzikal'noj kul'tury* (1941-53); ZONTAI, *Ethos und Affekt. Geschichte der philosophischen Musikästhetik* (1970); MARÓTHY, *Zene és polgár, zene és proletár* (= Music and the Bourgeois, Music and the Proletarian) (1966).

'iconologist' of the Panovsky school.[79] It is more important to find in art itself the artists' new and unique contribution to the culture of their time. We agree in considering that the rôle of alchemy in the sixteenth century is important for an understanding of Dürer's conception of the theme of his 'Melancholy'. But we must not forget what engraving, as a form of graphic art, represented and especially the clear and concise formula enunciated by Wölfflin, who saw in it 'the artistic expression of unrest'.[80]

Now we must seek to achieve a scientific and critical analysis of works of art, and above all an analysis that succeeds in embracing in their totality all the elements and all the special characteristics that distinguish them.[81]

While also stressing the specific characteristics of art in the study of its history, some Marxist research workers are influenced by the teachings of the 'Russian formalist school' of the twenties and by various structuralist trends. A comprehensive survey carried out by E. M. Meletinsky and D. M. Segal [82] describes the activity of the centre at Tartu where semiotics is studied in combination with a structuralist historical concept of culture. This school, like others in the Soviet Union and other socialist countries, rejects any form of ahistoricism or anti-historicism, to strive for some form of synthesis between the so-called genetic approach and the structuralist approach.[83]

Historicity does not involve the postulate of a rectilinear evolution: it refers to a dialectical movement which takes into account both the trends of the general evolution and the specific character of the work of art. Alpatov makes this very clear:

The historical nature of our method can in no way be compared to the classification of works in space or time, nor to classification by style. Our approach cannot be likened to that of the botanist who assigns each new species its place in the Linnaean system.

79. By PANOVSKY, see in particular *Meaning in the Visual Arts* (1955). See also DITTMANN, *Stil, Symbol, Struktur. Studien zu den Kategorien der Kunstgeschichte* (1967).

80. WÖLFFLIN, *Die Kunst A. Dürers* (1905) (English translation, *The Art of Albrecht Dürer*, 1971).

81. 'Znacenie hudožestvennogo nasledije dlja sovremennogo celoveka i problemy istorii iskusstv', a contribution to the present study, published in French translation: 'Patrimoine artistique de l'homme moderne et problèmes d'histoire de l'art' (1970): see pp. 648–649 for our quotation. Apart from his major work *Geschichte der Kunst* (1961–62) already referred to (footnote 11), we will mention another title in the important output of M. AL'PATOV: *Ètjudy po istorii zapadnoevropejskogo iskusstva* (= Studies in the History of Western European Art) (1963), in particular the essay 'Titian's *Christ crowned with thorns*'.

82. 'Strukturalizm i semiotika v sovremennom literaturovedenii i fol'kloristike v SSSR' (= Structuralism and semiotics in current research on literature and folklore in the U.S.S.R.), contribution to the present study, published in English translation under the title 'Structuralism and semiotics in the U.S.S.R.' (*Diogenes*, No. 73, 1971).

83. For the bibliography of these studies, see in *Diogenes* the article by MELE-TINSKY & SEGAL referred to in the preceding footnote and, following our survey, the accounts of other scientific approaches, particularly 'The semiotic approach' by Louis Marin. See also the chapter on *Social and Cultural Anthropology* by Maurice Freedman in *Main Trends in Social and Cultural Anthropology* (1979).

Art is largely fluid and this historical fluidity determines the *forces of evolution* that are specially remarkable in post-Renaissance European art. However, there are forces in art that tend towards *permanence*, but which cannot be considered as forces of stagnation, conservatism and reaction. They reflect a trend that is natural to creativity, namely to halt at a point of perfection once that point has been reached. Very recently even, European authors disdainfully criticized the action of these forces in the art of ancient Egypt. And yet these were the very forces that made possible the creation of masterpieces until the Saite epoch.

To these forces may also be attributed the relative permanence of some *national schools* of which characteristic traces may be found in several countries in Europe in the course of the centuries. This of course does not mean that these schools are unaware of trends towards universality. The classicism of the eighteenth and nineteenth centuries is the best expression of these tendencies, later reflected in so-called *avant-garde* production. Despite this, a certain national particularism, curiously mixed with universalism, has come to light in various countries. There is no need to make special mention of these characteristics, but it is impossible to be unaware of them.[84, 85]

A genuine history of art cannot stop at the description of a work, a trend or a period, it must recognize direct relations between phenomena and identify examples of convergence. We will once again quote Alpatov:

It has been observed that works of art created at different times and in different parts of the world are related in a surprising way in many essential features; sometimes they resemble each other more closely than do works pertaining to the same school or period. Proponents of chronological classification deride such links, which 'transcend barriers'. They only admit relationship where there has been actual contact between schools and artists or the positive influence of one school on another. However, affinities between Pierro della Francesca and the painting of ancient Egypt, between sculptures at Chartres and early Greek sculpture, between Russian ikons and the portraits in the Fayum, between the landscape painting of Vermeer and that of his predecessors and successors, with whom he had no direct contact,[86] are undeniable and tangible facts which art historians should take into account. Hitherto this inexplicable relationship between remote phenomena has been observed by only a few authors.[87] It is perhaps due to the fact that art is subject to the same intrinsic logic and the same laws as those which cause men at all times and in all places to find an identical solution to the same mathematical problem. In any case, a study of these internal relationships makes it possible to enlarge the horizon of our historical surveys. Perception of such similarities helps us to understand and visualize the history of art not only as a long progression, as a series of links in a chain, but also as a brotherhood of artists of genius, as a unique whole,

84. On these questions see in particular: *Interrelations of Cultures. Their Contribution to International Understanding* (1953); HAGEN, *Patterns and Principles of Spanish Art* (1936); FREY, *Englisches Wesen im Spiegel seiner Kunst* (1942); AL'PATOV, *Russian Impact on Art* (1950).

85. AL'PATOV, 'Značenie hudožestvennogo ...', *op. cit.* (p. 653 in published French translation).

86. See the exhibition organized at the Orangerie Museum in Paris in 1966: *Dans la lumière de Vermeer.*

87. See GOLDSCHEIDER (ed.), *Towards Modern Art, or King Solomon's Picture Book: Art of the New Age and Art of Former Ages Shown Side by Side* (1951); and MALRAUX, *Le musée imaginaire* (1947, 1965) (English translation, *Museum without Walls*).

in which classical and barbarian artists of Africa, Asia and Europe have been able to co-exist in peaceful rivalry.[88]

Such a history of literature and the arts, inserting itself in the history of mankind, will take into account the place, the time, the dialectical relationships and mediations that link the basis and the superstructure, as well as the characteristics of its own evolution. Accepting as its scale of reference man and the full development of his personality, it will by necessity have an aesthetic dimension.

We have attempted to show that different movements, schools and approaches are not isolated from one another but have a reciprocal influence. Furthermore, there is pressure everywhere for the interdisciplinary approach: the strictest 'close reading' does not justify exclusion of the historical background when interpreting a work of art; conversely, in a genuine historical study of a work, a purely 'extrinsic' explanation would not be adequate.[89] Moreover, the purpose of the history of literature and art should not be to reconstruct the past as such, but to carry out a study that leads up to the present, in other words, that helps the contemporary public to understand the work of art as a totality.

2. THE COMPARATIST APPROACH, *by Étiemble**

Although 'comparatism' was not born in the twentieth century, for both Voltaire and Montesquieu practised it (incidentally or systematically) and since the very notion of *Weltliteratur* was first conceived by Goethe, the first periodicals devoted to this discipline appeared only at the end of the nineteenth century – and then often disappeared soon afterwards. It is only in the twentieth century that comparatism has become, in many countries, a subject for teaching and research. As a result, periodicals have become numerous, as have the languages in which they are published. The socialist world which in the time of Stalin, condemned comparatism as 'cosmopolitan' and 'bourgeois' has finally, since 1956, been according it the attention it deserves. In 1962 the Congress of Budapest, to which were invited a small number of scholars from the bourgeois world, provided confirmation of the resurgence of comparative literature in the popular democracies, with the exception of Albania and China. At the present time the International Com-

88. AL'PATOV, *op. cit.* (p. 654 in published French translation).

89. See for example, for the history of literature, the latest special number, *Méthodologies* of the *Revue d'Histoire littéraire de la France* (1970), already referred to (footnote 13), and particularly the text introducing the work by René POMEAU, 'L'histoire de la littérature et les méthodologies', pp. 769-775.

* [René Étiemble], Professor of General and Comparative Literature, University of Paris-III.

parative Literature Association is directed by a committee which comprises members from the United States of America and the Union of Soviet Socialist Republics, Japan and Hungary, Poland and Denmark, Yugoslavia and India, East Germany and Holland, Czechoslovakia and France. A number of research projects bring together scholars from two worlds which, only yesterday, were separated by a reciprocal *non possumus*. The time has therefore come to attempt to define the problems and the prospects of comparatism.

At a time when the aeroplane, symposia and 'peaceful co-existence' are providing a discipline whose sole claim must be to attain universality every chance of stating its aims and defining itself, specialists are nevertheless spending their time analysing an obvious crisis.

What exactly is at the centre of it?

When Goethe christened *Weltliteratur*, although he backed it up, curiously, with the songs of Béranger on the one hand and, on the other, with some Chinese novel vaguely translated from an edifying and stultifying original, this supposedly 'world' literature was hardly anything of the kind. Half a century later, when a Hungarian disciple of Goethe defined the *Dekaglottismus* necessary to every comparatist, the only languages to be taken into consideration, according to him, were Dutch, English, French, German, Hungarian, Icelandic, Italian, Portuguese, Spanish, Swedish and, for good measure, Latin. But the comparatist of 1969-1970 receives professional reviews and original works written in Russian, Romanian, Polish, Serbo-Croat, Bengali and Japanese. The *Cahiers algériens de Littérature comparée* are published by M. Bencheikh in French, but university graduates trained in Arabic will very soon use that language to express themselves. And although M. Mohammed Ghunaymi Hilāl still published in English, in Cairo, *The Rôle of Comparative Literature in Contemporary Arabic Literature Study* (1965), his general work on comparative literature, *Al Adab al-muqâran* (1953, 1962), was written in Arabic. Once the Government of Pekin has abandoned its cultural isolationism, it will not be long in producing reviews and books in its own language. Firstly, then, comparatism is undergoing a crisis of expansion; the number of working languages is already considerable – tomorrow it will be excessive; the volume of work being carried out and the number of professional periodicals are growing; bibliographies are paltry or deficient. Such, in general terms, is the situation. Although there may be grounds for hoping that an association of comparatists that is at last truly international will be capable of establishing and keeping up to date a central index of the work being carried out in the world's universities, how, solely by its own means, will it be able to draw up and publish a complete annotated bibliography, without which the future of a fast-expanding discipline can only be jeopardized? Whereas there is no shortage of money for mathematicians, physicists, chemists and biologists, since no great perception is needed to recognize the beneficial results that ensue, public opinion, which is ill-informed, does not yet appreciate the value of literary and artistic

studies, nor that of comparatism which has to make do with a meagre and scarcely noticeable allowance. At present there only appears to be Unesco which, through the National Commissions of its Member States, has the means to compile and publish the indispensable bibliography.

Paradoxically, however, whenever the crisis of comparatism is being discussed, scarcely a thought is given to the threat which looms over this discipline, in the form of the abundance of information which exists and of the difficulty of obtaining or of reading it.

Attention is paid above all to another 'crisis', one which is admittedly serious since it revolves around knowing whether comparatism is possible, whether it has its own field of investigation, whether it has at its disposal one or several methods and, consequently, whether it has a research programme.

The hesitations over terms express the uncertainty which torments more than one comparatist. Sometimes the subject-matter of comparatism is considered to be Goethe's *Weltliteratur* (*World Literature,* or *littérature universelle, or littérature mondiale,* or *mirovaja literatura*); it is then discovered that there already existed a notion of world literature but that it was hardly comparatist at all; in fact, all the concepts of world literature (Prampolini's, for instance, in *Storia universale della letteratura,* published in 1938) are no more comparatist than the *Allgemeines Lexicon der bildende Künstler,* by U. Thieme and F. Becker (1907-1950). These works are nothing but monographs placed side by side. At best, they contain cross-references. But if the comparatist's field really is the whole body of literature and the whole body of the arts, this field cannot consist in a juxtaposition of separate pieces. Guillermo de Torre is quite right in asking 'whether the only field which bears a resemblance to the half-glimpsed domain of *Weltliteratur* is not that of comparative literature'.[1] Let us go even further and say that comparatism is a method, if not the only method, which sets itself the goal of studying every kind of relation which exists between all the arts and between all literatures, or the relations between the whole body of literature and the whole body of the arts.

This, however, does not solve anything since an agreement must be reached as to exactly which method or methods will make it possible to study these relations between two or several literatures, two or several arts, between one moment in this or that art and one moment in this or that literature.

One person will speak of *vergleichende Literaturgeschichte;* another will refer to *vergleichende Literaturwissenschaft;* one will talk of *littératures comparées* or *letterature comparate,* another of *littérature comparée,* of *letteratura comparata,* of *comparative literature,* and some may wonder whether there is not a contradiction *in terminis* between the singular term

1. '... si el único territorio que se acerque al dominio entrevisto de la *Weltliteratur* no sería él de la Literatura comparada' – DE TORRE, 'Diálogo de Literaturas' (address to the International Congress of Comparative Literature held at Chapel Hill, North Carolina, in 1958, publ. in 1959).

(*littérature, letteratura, literature*) and the very notion of comparison or comparatism. Others would like to know exactly how to distinguish general literature from comparative literature (in the singular); others deny the legitimacy of comparing a verbal art and a plastic art or a musical work.

This uncertainty with regard to terminology is, as always, one of the causes and one of the effects of the uncertainty in the study itself.

As a result, an excessive proportion of comparatist activity over the last ten years or so has consisted in investigating the very notion of comparatism, its field of study and its methods. Since Professor René Wellek spoke, in 1958, of the crisis of comparatism,[2] H. H. H. Remak has published 'Comparative literature at the crossroad. Diagnosis, therapy and prognosis' (1960), Mrs. Neupokoeva an essay on 'Metodologija komparativizma S.Š.A. i ee sviaz' s reakcionnoj sociologiej i èstetikoj' (1963), Corn. de Deugd *De eenheid van het comparatisme* (1962), and myself, in 1963, *Comparaison n'est pas raison. La crise de la littérature comparée;* after which M. Simon Jeune brought out *Littérature générale et littérature comparée. Essai d'orientation (1968),* Claude Pichois and A.-M. Rousseau *La Littérature comparée* (1968) and Al. Dimă *Principii de literatură comparată* (1969), not to mention numerous other essays.

What conclusion is to be drawn from all this work?

Firstly, that the terms in which the question was posed ten years ago have fortunately been superseded. To historical and even historicist comparatism 'French-style' ('the word *comparative* must be stripped of all aesthetic value and must be accorded an historical value' – Paul Van Tieghem [3] – or again: 'comparative literature is not literary comparison', but the study 'of the *actual* relations which existed between Byron and Pushkin, Goethe and Carlyle' – J.-M. Carré [4]), writers for long delighted in opposing comparatism 'American-style', a comparatism of which the primary concern was criticism and aesthetics and which did not shrink from comparing literary *genres* 'even when the possibility of direct influence is ruled out', as the American sinologist, James Hightower has said.[5] But at the Budapest Congress, in 1962, it was discovered that the expert Neupokoeva, from the U.S.S.R. Academy of Sciences, upheld 'French' or allegedly French theses, whilst a Frenchman who was present at these discussions, the author of this paper, defended supposedly 'American' positions; and René Wellek, allegedly the champion of the 'American' position, wrote in 1968 that 'we need both literary history and criticism',[6] thus confirming what I myself wrote in 1963: 'Those like René Wellek in the United States and many others elsewhere are not wrong who think that the study of the history of compared literatures is not the same as

2. Cf. WELLEK, R., 'The crisis of comparative literature' (address to the Congress mentioned in the previous footnote) (1958, publ. 1959).
3. *La littérature comparée*, p. 21 in the 4th edn. (1951).
4. Preface to GUYARD, *La littérature comparée* (1st edn., 1951), p. 5.
5. Quoted by ÉTIEMBLE, *Comparaison n'est pas raison*, p. 66.
6. WELLEK, R., 'The name and nature of comparative literature' (in NICHOLS & VOWLES (eds.), *Comparatists at Work*, 1968).

the comparative history of literatures, that literatures are systems of forms that man adds to his natural language, and that the study of *actual relations* should be made with a view to discovering values, and even to bringing to bear value-*judgements* and perhaps, as I believe, should go so far as to contribute to the formulation of values which are slightly less arbitrary than those which sustain our thinking or which are causing our downfall'. Simon Jeune also considers that comparatism, 'which is extremely prone to give way to the historical approach', should not give up the attempt to formulate a theory of literature nor cease to inquire into the causes of aesthetic pleasure by way of textual analysis; Pichois and Rousseau also hold the view that comparative literature is a 'methodic art' which makes it possible to 'describe, understand and appreciate' writings belonging to different literatures, or literary texts and works of art (music or painting, for instance). Corn. de Deugd celebrates the rediscovered unity of the comparatist method. Like Pichois and Rousseau, this Dutch scholar refers to *Mimesis* by Erich Auerbach (*Linguistics and Literary History* by Leo Spitzer would serve the same purpose), to illustrate the method; in other words, he favours textual analysis. The same reference to *Mimesis* is to be found in a work by Professor Dimă of Bucharest who, whilst not foregoing the indispensable historical investigations, considers that the proper task of comparatism is to study the beauty of the works which are being compared. Such is also the view of more than one Japanese comparatist.

Nor should we forget Jurgis Baltrušaitis and his *Moyen Age fantastique* (1955) which demonstrated that influences originating in Eastern Asia came into contact with Islam in Iran and were transmitted from the furthest point of Asia far into Gothic Europe. With regard only to those themes and forms which were imported from China and which may have had an effect on the Italian Renaissance, we could refer to dozens of worth-while articles and works.[7] The Russian scholar Mikhaïl Alpatov has made a skilful study of the influences not only of Byzantine art (which are evident) but also of classical Greek art on the themes and forms figuring in the work of Roublev and various painters of Russian icons. Nor should we fail to mention Hilde Zaloscer, who explored the Indian and therefore 'Pagan' origins of numerous decorative themes in Coptic, i.e., Christian art.[8]

And it is more than thirty years since Paul Maury showed, in *Art et littératures comparés* (1934), that the arts and literature cannot be studied separately, and more than forty years since Louis Séchan's essays on the relations between Greek tragedy and ceramics [9] proved in advance that Maury's sug-

7. To quote only a few examples: SOULIER, *Influences orientales dans la peinture toscane* (1925); PLENGE, 'Die China Rezeption des Trecento und die Franziskaner-Mission' (1929); POUZYNA, *La Chine, l'Italie et les débuts de la Renaissance* (1935); or APPLETON, *A Cycle of Cathay. The Chinese Vogue in England during the Seventeenth and Eighteenth Centuries* (1961).

8. ZALOSCER, *Quelques considérations sur les rapports entre l'art copte et les Indes* (1947).

9. SÉCHAN, *Etudes sur la tragédie grecque dans ses rapports avec la céramique* (1926).

gestions were well-founded. There still remains a great deal to be done; almost everything, in fact. Nevertheless, from those detailed monographs which already exist, there may and should emerge syntheses and outlines of aesthetics such as are to be seen in Th. Munro's *The Arts and their Interrelations. An Outline of Comparative Aesthetics* (1949), or Henri Focillon's *La vie des formes* (1943). The remarks of the latter with regard to 'sculptors who see as painters', or 'painters who see as sculptors', should often be applied to writers who describe as painters, writers who describe as sculptors, etc. No less worthy of interest for the comparatist are the works of C. S. Brown, *Music and Literature* (1948), Léon Guichard, *La musique et les lettres en France au temps du wagnérisme* (1963) and Thérèse Marix-Spire, *Les Romantiques et la musique* (1955).

All this at least proves that even in an apparently barren period for French music, the comparatist is able to find sustenance. He would therefore fail in all his duties if he limited himself to studying each of the arts in isolation (and this, even if his object was to compare the Japanese music of *Noh* theatre with that of the Peking opera).

After Emile Mâle who, as early as 1898, taught that French religious sculpture of the thirteenth century cannot be understood without constantly referring to written works – *Bestiaires, Encyclopédies, Miroir* by Vincent de Beauvais, *Noces de Mercure et de la Philologie* by M. Capella, not to mention Prudence's *Psychomachie* – Panofsky has proved that numerous paintings of the Renaissance will reveal nothing, their themes and forms will remain mute, if we do not know that they are merely illustrating a celebrated literary text or even a less celebrated text by the neo-platonists of Florence. For Mâle as for Panofsky the painting can be explained once the text has been explained. And as for *aliterature, acriticism* or those poems called 'à délire' (to be 'unread' – or *deliria* . . .) which are now in fashion, whoever wishes to fathom them cannot neglect to look at Chapter XVII of Jacques Chailley's book on *40,000 ans de musique:* 'Musique pour le papier' (1961) – music not to be performed . . .

One may well have heard the melodies composed by Francis Poulenc for so many poets, but I doubt whether it is possible to come to grips with them if one has not read his *Journal de mes mélodies*. In this book the musician reveals that before trying to sing the melody, a singing-master's pupils should 'read the poems attentively';[10] in other words they should perform a textual analysis. For this reason the poems of Apollinaire or the texts of Jules Renard which have been set to music by Poulenc will doubtless never be better rendered than they have been in the recordings made by Pierre Bernac, for the latter, simply by means of diction, comments on and elucidates the text. It follows from this that all musico-literary comparatism will be nothing but foolishness unless it is the work of a man who has been trained in both music and poetry. To quote Poulenc again: 'I never transpose, in order to make my task easier, the key in which the music of a verse suggests itself to

10. POULENC, *Journal de mes mélodies* (1965), p. 2.

me when I take a random look at a poem. As a result, my modulations are sometimes allowed as little margin as a mouse in a mouse-hole.

'Here, having begun this melody at the first verse and knowing what the music of the last one would be like, I exercised control over the modulations, allowing them to be directly shaped by the words. Two arabesques of seven verses going from C to C, with the key of D as the highest point (reached each time by different degrees) form, so I believe, a logical whole." [11] This is true comparatism; no other kind exists: it is both technically-minded and informed by sensibility.

We are not always so lucky as to have someone of the stature of Poulenc providing comments on himself. As to knowing whether the poetic song of the troubadours imitated Arabic poetry and music, the question is far less easy to determine, and national passions only serve to complicate the matter vastly. Nevertheless, who would dare claim to be interested in minstrels and troubadours without being familiar with the origins of non-liturgical monody, the forms of which were later to inspire Lulli and the *opéra-comique?* Like the lay, the *chanson de geste* is linked with the history of music; we should wish to know in what exact way. Likewise, in China, the history of the *ts'eu*, which originated in the eighth century, is that of a poetic *genre* of which music is an inseparable part; the melodies indicate the precise type of versification to be used. If the melody of a *ts'eu* is not known, the poem cannot be sung.[12]

Certain fears still need to be allayed: in the capitalist and in the socialist worlds some persons are still concerned about, or even explicitly condemn, 'cosmopolitan' deviationism. On the one hand it will be feared that an allegedly 'bourgeois' science might glorify large-scale or small-scale chauvinism; on the other, that this 'cosmopolitanism' may blunt a patriotism which, as statesmen and intellectuals are aware, represents a force to be reckoned with, whether in socialist, 'bourgeois' or Third World countries. Nowhere, however, does comparatism set out to destroy the notion of 'national identity'. Its object, rather, is to facilitate greater comprehension of every literature and every national art, whilst doing justice to the literature and arts of other countries. But when an attentive reader discerns in the work of some German comparatists something like nostalgia for the Hitlerian dream of a Pan-Germanic Europe, it is not to be wondered at that, whether they be socialists or capitalists, scholars from other nations begin to remember events and to express their concern. In condemning the liberal cosmopolitanism of Henri Peyre, a Frenchman who practised comparatism in the United States, Neupokoeva is fortunately only expressing her own opinion and not that of the comparatists of the Moscow school nor those of the Leningrad school, nor all those who, in Georgia, Armenia and elsewhere, model themselves on Vesselovsky. It is certain that the various works published by the Leningrad school, on international relations between literatures, or the Polish periodical *Zagadnienia Rodzajów literackich*, published in Łódź, which deals with

11. *Ibid.*, p. 70.
12. See in this connexion FENG Shu-lan, *La technique et l'histoire du ts'eu* (1934).

problems relating to literary *genres*, express very different points of view from those of Mrs. Neupokoeva. The same could be said of the studies in comparative literature published in Budapest in 1962 and 1964 under the auspices of the Academy of Sciences.[13] The bibliography of these works alone proves that theoretical questions, the history and theory of *genres*, comparative stylistics and metrics, literary parallels, relations between central European literatures, difficulties of translation, trends in world literature and relations between literature and the arts are also discussed. It is no less encouraging (or amusing) to note that Paul Van Tieghem's book, which first appeared quite some time ago and which is in no way Marxist or even progressive (it might even be considered out of date) has just been translated and prefaced by Professor Dimă, in Bucharest under the title of *Literatură comparată* (1966).

The existence of so many different attitudes and methods gives us grounds for hoping, therefore, that the best comparatists will, under every political system, succeed in going beyond the artificial distinction between *national* and *cosmopolitan* and in dealing correctly with the most important questions raised by their discipline from a point of view now historical, now sociological and now aesthetic.

Having thus defined the field and the general method of comparatism, it still remains to draw up research programmes and to carry them out in a manner which will make comparative literature as a teaching subject at last worthy of the name.

Whether 'socialist' or 'capitalist', all scholars agree that there exist different areas of civilization and that, naturally, men from Slav, Romanic, Germanic, Sino-Tibetan or Semitic areas, for instance, will be likely to choose, and to benefit from, the exploration, initially, of questions which arise (diachronically or synchronically) in each of these linguistic fields. The most open-minded, the most ambitious and the most Utopian comparatist will never condemn studies within a linguistic field which deal with the relations between literature and the arts or between two allied literatures or arts. But our planet being what it is now, a few comparatists are beginning to gain an inkling of the possible value that might accrue to them from studies concerning the most apparently varied field: Rolf A. Stein's research on the bards of Tibet [14] makes it indispensable for the European comparatist to think again about the ill-founded objections of those who, some decades ago, condemned Bédier's theories concerning the genesis of epic legends; likewise, Zhirmunsky's work on the heroic folk-epic in central Asia [15] deserves our attention. If anyone wishes to understand why China never produced any epic poetry, he should read Georges Dumézil's work on the Indo-European epic, when everything will become clear. While it is necessary, therefore, to

13. La *littérature comparée en Europe orientale* (1963) and *Littérature hongroise – Littérature européenne* (1964).

14. STEIN, *Recherches sur l'épopée et le barde au Tibet* (1959).

15. Cf. especially CHADWICK & ZHIRMUNSKY, *Oral Epics of Central Asia* (1969); and, in German, SCHIRMUNSKI (= ŽIRMUNSKIJ), *Vergleichende Epenforschung* (1961).

accept and to hope that certain comparatists specialize in one linguistic or geographic area (Romanistic studies in the German manner, Danubian Europe, Latin America, etc.), it is important for the future of this discipline that others take on the task of adding to the list of familiar languages those belonging to an area as remote as possible in time and in space: the study of Pharaonic theatre leads to a fuller understanding of the mystery plays of the European Middle Ages; the study of the *karagheuz* and *taziehs* of Iran and the shadow-theatre of Kelantan adds a little more light to what we knew about the absence of theatre in Sunnite Islam until the rise of French influence in Egypt and Lebanon at the end of the nineteenth century. Whoever has not studied the influence of the Chinese, Turkish or Japanese worlds on the development of liberal ideas in Europe from the Middle Ages to the French Revolution will never quite understand the humanism of the Renaissance and the spirit of the Enlightenment. Conversely, those Chinese who refuse to study the influence of English and French poets on twentieth century Chinese poetry and those French who know nothing of the rôle of the *haiku* and the *tanka* in twentieth century European and Ibero-American poetry will never have the opportunity of understanding our present dread of rhetoric, eloquence and discursive writing.

Since everything, or nearly everything, remains to be done, it would appear to be a matter of some importance for international associations of comparatists (in literature and in art) to draw up a world research programme, to endeavour to create study groups and even to assign subjects to willing and competent comparatists. If there is one discipline which requires work in common and collaboration between all departments dealing with languages, art, philosophy, the history of ideas, and aesthetics, that discipline is comparatism. In this connexion, would it not be fitting to do everything possible to place comparatists in better-equipped departments or teaching and research units, since they are too often isolated and without adequate means? According to their tastes, some would devote themselves to those annotated and critical bibliographies of which we are so badly in need; others would embark on definite programmes involving one period or one *genre*; some would tackle a movement of ideas in a particular country at a carefully-selected period; others would develop their theories concerning *genres*; and some would devote themselves to studies of *Stoffgeschichte* (provided that European-centred ways of thinking are abandoned and that dictionaries of *Stoffgeschichte* published in Europe no longer omit the Buddha or Yang Kouei-fei, as was always the case, nor the myth of Madame Roland in China). Studies could also be undertaken of the brutal ways in which languages have come into contact with each other in the twentieth century, for this phenomenon is entirely new and cannot be resolved by means of traditional linguistics; of comparative stylistics and poetics; and of the art of literary translation, which is still so badly treated in our educational system. Detailed studies could also be carried out on the use of the vocabulary of one art in that of another art, whereby misunderstandings are produced and undesirable modes become established. If comparatists who

concern themselves with literature were better acquainted with Austrian baroque, the Churriguera school or the work of Aleijadinho, they would not misuse the word 'baroque' as they do now; nor would they use it improperly in music: 'If, writes P. Billard,[16] a concerto by Vivaldi, a fugue by Johann-Sebastian Bach and Haendel's *Messiah* are considered to be monuments of baroque art, it would appear that the word "baroque" has been invested with a very particular significance in music, as far removed from the popular meaning as from the technical meaning which is given to it by historians of the plastic arts.' And P. Charpentrat holds up to scorn the 'baroque mirage' [17] and 'the passion for seeing the baroque in everything during the period 1950-1960' [18] a passion which would quickly have cooled off if comparatists from every field (literary, musical, architectural, etc.) had worked together and criticized their own language.

It follows from this that one of the essential tasks of comparatism at the present time is to establish for itself an historical, annotated, critical and, if possible, standardized dictionary of all the terms necessary to the practice of this discipline. This dictionary should be discussed by specialists from every nation involved and each term should be approved by every scholar. Each should agree to refer to the dictionary in his work in the following manner: 'I take the word "realism" in Sense A 1 of the annotated and critical dictionary.' This would prevent 'the adoption of a concept of baroque poetics on the basis of a concept of baroque in the plastic arts which has itself been formulated with implicit reference to literary criteria'.[19] The same applies to notions such as classicism, romanticism, symbolism, etc.

The title of a collection published by Skira in Switzerland, *Arts, Idées, Histoire*, gives an approximate idea of what the ideal of comparatism might become: for everything is connected in the city of man. After numerous partial syntheses have been carried out, an attempt will have to be made, but at a much later date, to establish more ambitious syntheses. And who knows, perhaps one fine day we shall find ourselves equipped with a comparative world literature. It is possible even now to move beyond the study of actual relations and to inquire why, for instance, given the vast number of bottles and vegetables which exist, Egyptian painters under the Pharaohs, Dutch painters of the sixteenth century or French painters of the eighteenth invariably arranged them in one particular way. André Vigneau once began illustrating in this manner Plato's treatise on the beautiful, the *Hippias major;* it has always been a source of regret to me that he was unable to complete this work. And rather than compare Molière's *L'Avare* with *The Aulularia* of Plautus, why not compare some of the scenes in Molière with those to be found in the Chinese playwright who also wrote an *Avare*, which Molière

16. BILLARD, 'La musique baroque', p. 1097 B in *Encyclopaedia Universalis*, Vol. II (1968).

17. CHARPENTRAT, *Le mirage baroque* (1967).

18. CHARPENTRAT, 'Le baroque littéraire', p. 1096 C in *Encyclopaedia Universalis*, Vol. II (1968).

19. CHARPENTRAT, *art. cit.* (1968), p. 1096 B.

certainly had not read and yet which seems to have inspired him? It is in this way that comparative literature might help to make it possible to settle the dispute of 'anthropologists' and 'humanists', to distinguish between what is contingent in man and that which is universal or necessary; to restore the notion of aesthetic constants or values; in short, to use all that we may learn from literature and the arts for the purpose of founding upon the ruins and wreckage of the various humanisms that new humanism of which we are so cruelly in need and for lack of which not only comparatism, literature and the arts, but also the human sciences and science itself in its relation to man [20] will perish.

3. THE SOCIOLOGICAL APPROACH, *by Jacques Leenhardt**

We can identify two main streams in research on the sociology of art and literature. On the one hand is the sociology of the work of art, a book, picture, film, etc., when the sociologist traces its existence in society. This leads him to investigate the components of the creator's social environment, its rules and internal laws.[1]

Secondly, the work of art itself may be treated as a subject, considered in its sociological context and therefore viewed in the making. In this case it is no longer its existence in society which is investigated, but rather the sociological conditions of its creation. A different approach to the environment will therefore be called for.

As soon as it leaves the hands of its maker, the art object is launched on a long pilgrimage through the meanders of society, and every moment provides an opportunity to analyse the social conditions surrounding the existence of the object in question.

This sociology is sub-divided into many branches and is first defined as a sociology of art, music, literature, cinema, etc. Each type of cultural object is therefore examined as a finished product and traced throughout its existence in society. Let us retrace this path. Since the Church lost its quasi-monopoly in commissioning works of art, every work on completion is absorbed in the market circuit. From the days of the great patrons, artists have been fought over and their products have passed from hand to hand.

20. I make no mention here of the question of the languages which might be used in comparative studies, since this raises too many serious political and linguistic problems. I have written at length on this question in *Comparaison n'est pas raison* (1963).

* Ecole pratique des Hautes Etudes, Paris. With a note by Etienne Souriau, emeritus professor of the Sorbonne, on the economic study of art.

1. It will be worthwhile to refer to the annotated bibliography of L. LÖWENTHAL, 'Literature and society', in the collection *Relations of Literary Study*, ed. THORPE (1967), particularly, but not exclusively, focused on American works.

This is where sociology of the art market, and also the study of its strictly economic aspects, commence.[2] Etienne Souriau vindicates this approach in a valuable contribution from which we quote:

> The economic point of view carries great weight in evaluating the aesthetic needs of a given society. Art from the economic point of view may be defined as follows: *in a given society, the aggregate of effort aimed at satisfying the aesthetic needs of that society*. These aesthetic needs can be evaluated by the signs of social disquiet displayed in the absence of aesthetic values, in other words the ugliness of the life environment and the failure to satisfy the aesthetic instinct both in the private dwelling and in the city. Knowledge of the expenditure of each social stratum to obtain such satisfaction makes it possible to evaluate the total aesthetic need. It would be of great interest to establish the aesthetic budget of the various social strata, and also to observe the incidence of this subject in teaching. For aesthetic education should primarily seek not to form creative artists, but to teach men how to fulfil their aesthetic needs.

E. Souriau indicates the lines of research to be followed up in order to 'evaluate' the position and economic function of art.

Let us quote him again:

(a) *Direct estimate of the movement of funds*

It is at present very difficult to make a direct estimate of the movement of funds in connexion with art and literature. A large part of these deadlines cannot be identified. Of course the number of theatre and cinema admissions can be estimated and reliably checked. To take France as an example, for music, the records maintained by the *Société des Auteurs et Compositeurs de Musique* (SACEM) and for literature and the theatre by authors' associations, as well as by the *Caisse des Lettres*, provide a solid basis for assessment. But with painting, for example, an excellent book like Raymonde Moulin's *Le marché de la peinture en France* (1967) shows clearly how difficult it is to establish the annual total of the economic wealth created by the production of pictures.

(b) *Estimate of the population living on art*

There is a major piece of research to be undertaken, aimed at making an indirect assessment of the place of art in the national income of a given society. It would require an estimate of the sector of the population engaged in satisfying the aesthetic needs of this society. We deliberately avoid the term artist. In the first place it would provide an entirely misleading idea of the art budget if the survey included only artists and their means of existence. Such an enumeration would not be very difficult to make, as the professional organizations could provide precise figures on the subject. The following factors should, however, be taken into account:

1° In some respects amateur production plays a large part. This is striking in literature: there are no professional poets (legally, a professional is one who derives at least 51% of his income from the activity in question).

2° Some authors who spend a large part of their time on such activities should technically qualify as professionals but they do not, because they cannot make a living

2. BONNAFÉ, *Le commerce de la curiosité* (1895); CROZET, *La vie artistique au XVIIe siècle, 1598-1661. Les artistes et la société* (1954); HASKELL, *Patrons and Painters. A Study in the Relations between Italian Art and Society in the Age of the Baroque* (1963).

from their art and derive most of their earnings from a second profession, such as teaching.

But the most important fact in this field is that a great number of specialized workers who do not qualify as artists live from art. For example in the music field, in addition to composers and musicians, those engaged in branches of the music trade must be included, such as printers and publishers of music, music sellers, instrument makers, purveyors of instrumental accessories (for example, rosin manufacturers); the officials at the SACEM, manufacturers and sellers of records, radio technicians, music critics and musicologists. Similarly in the theatre: the artists named in a stage production are few: an author (alive or dead), the actors (frequently non-permanent staff members, including only those listed in the 'cast' of possibly no more than five or six characters and their understudies); in addition to the actors and the musicians, a designer and producer may perhaps form part of the company. But the non-artist personnel could well number some forty people, from the secretary-typist of the administrator to the theater attendants and duty fireman (see the organigram in Ph. Van Tieghem, *Technique du théâtre* (1960), p. 105). Clearly the entire staff pertains to the budget for art, and their earnings as well as the artists' must be deducted from the total receipts that finance stage performances.

If a total count of all this personnel were made, bearing in mind their minimum earnings, it would be possible fairly accurately to gauge the size of the budget for art, which is at present unknown.

It should be remembered that there are some social groups in which the artistic function is barely exercised by any but amateurs: for example in ancient Greece or in Europe in the Middle Ages there were no professional actors. Yet at the time, dramatic art was extremely important in social terms. At the present time indeed there are towns and villages where theatre and even music performances are only given by amateurs. It would be useful to find monographs devoted to amateur artistic activities in various social or geographical environments, such as musical associations among workers, for example the miners in Wales or Northern France. In such cases, the estimate would have to be based on findings concerning the amount of time spent on these activities, this time being assessed in accordance with the hourly wage normal in the same circles.

An economic approach to the study of art could also attempt to establish the relations between currency fluctuations or the stock market and the value of art works.[3] In this case art is considered as an investment.[4] Although such a definition of art may shock, this type of analysis is not often without interest for the knowledge of art itself and of changing tastes. It will be found that there are sudden fancies or 'discoveries' that could be very instructive on analysis. An example is the English Eighteenth century portrait, of which the prices rose dizzily between 1950 and 1960 (the fact that a Gainsborough rose from $10,000 to $100,000 speaks for itself).[5] The value of painted works, however, does not always increase, and even if many early talents are 'dis-

3. REITLINGER, *The Economics of Taste, 1760-1960* (1963).

4. RUSH, *Art as an Investment* (1961). Following Rush, one could try to interpret the phenomenon by the desire to 'create a past for oneself' which in the aftermath of the war was manifested by part of the American bourgeoisie recently enriched, i.e., ennobled, by economic expansion. It is a fact that the numerous purchases of this middle class brought about a concomitant rise in prices.

5. According to R. Heinemann, the value of a collection of El Greco and Rembrandt had risen by 100,000% during the last century.

covered', just as many are consigned to oblivion. The best-known example in France is the fall of Meissonier on the disappearance of academism.[6]

On the subject of discoveries, it is interesting to refer to the remarks made by Berne-Joffroy in his book on Caravaggio:

If one is justified in thinking that the successes of Courbet, then of Manet, were a prelude to the resurrection of Caravaggio this is due to the general law that associates evolution in the history of art with the evolution of art itself. Thus, as Lionello Venturi has pointed out, it is in relation to Michelangelo that Vasari admired Giotto, in relation to Carrache and Poussin that Bellori revealed Raphael. Who revived Vermeer, then completely unknown? It was Toré, a fervent admirer of Rousseau and Corot, and later, the first admirer of Monet and Renoir. Would the frescoes of Arezzo have been praised to the skies if Cézanne and Seurat had not gone before? Hermann Voss, in drawing attention to Georges de la Tour, pointed to his connexion with various artistic speculations of our period, and André Lhote concurred. The better to praise Chardin, Malraux refers to Braque. It is therefore permissible to suppose *a priori* that the resurrection of Caravaggio, who although he was not unknown was profoundly misunderstood, was associated with the success of his grand-nephews.[7]

This is to say that through such objective data as prices at public sales, an entirely new dimension emerges that provides the key: taste, deeply rooted in the modern artistic and social atmosphere.[8]

The environment can equally well refer to the chain of galleries, circles of connaisseurs, critics, or friends, even including spectators or readers. Concerning the latter, works by the *Institut de Littérature et de Techniques artistiques de masse* (ILTAM) of Bordeaux [9] have considerably clarified the situation, while research carried out by P. Bourdieu in his survey on *L'amour de l'art* [10] shows how this 'love', all too frequently believed to be independent and free, is determined by social conditions. A more descriptive type of study will be found in R. Moulin's book describing the social and economic conditions of the paintings' market in France.[11]

The diversity of these approaches clearly shows the difficulty of trying to grasp a reality of any kind under the concept of *environment*. If one were tempted to try, the study of contemporary society would quickly and clearly

6. Between 1860 and 1960, Meissonier must have lost 90% of his market value: Cf. WAGENFÜHR, *Kunst als Kapitalanlage* (1965) (French translation, *L'Art, valeur de placement* (1967), p. 154).

7. BERNE-JOFFROY, *Le dossier Caravage* (1959), pp. 11-12.

8. SCHÜCKING, *Die Soziologie der literarischen Geschmacksbildung* (1931) (English translation, *The Sociology of Literary Taste*, 1966); GUÉRARD, *Literature and Society* (1935).

9. ESCARPIT, *La révolution du livre* (1965) (English version, *The Book Revolution*, 1966); ESCARPIT & ROBINE, *L'atlas de la lecture à Bordeaux* (1963). Cf. also DUMAZEDIER & HASSENFORDER, *Eléments pour une sociologe comparée de la production, de la diffusion et de l'utilisation du livre* (1962); HOGGART, *The Uses of Literacy* (1957); WEBB, *The British Working Class Reader* (1955).

10. BOURDIEU, DARBEL & SCHNAPPER, *L'Amour de l'art. Les musées et leur public* (1966).

11. MOULIN, *Le marché de la peinture en France* (1967). Attention should be given to its full bibliography.

show why this concept is not applicable unless it is considerably defined.

In our society we can see that there is a sharp cleavage in this environment, dividing it into two areas that were formerly one: production and demand. In the past writers and readers, who frequently were one and the same, came together in 'salons'. Nowadays, owing to the vast distribution and nature of the *media*, the communication of cultural objects is a *one-way* flow. Consequently a sharp distinction must be made between a producer and a consumer of culture. The creative or producer milieu is therefore encased in an infinitely vast environment, that of the consumer. A. Moles has devoted his book *Sociodynamique de la culture* to studying the latter. He traces the path followed by the cultural message through all the mass transfer channels (radio, television, the press, books) and draws up an ingenious 'basic socio-cultural cycle'.[12] This outline, however, provides nothing more than an understanding, couched in broad and general terms, of the specific products of the creative environment. We will therefore revert to this matter again.

Lastly, we should still take account of a branch of research which, although somewhat traditional in principle, succeeds at times in identifying interesting phenomena, namely the sociology of the content of literary or artistic works.[13] It is certain, for example, that the advent of the portrait as a subject is of interest to sociologists of Western culture. Furthermore it should show how the concept of the portrait as a portrayal of the personage represented evolved gradually, not so much from the subject depicted – the human head which art had been painting for some time past – as from the manner of depicting this image, the care with which the artist portrayed the specifically individual aspects of a face rather than its common or universal characteristics. The subject of the picture is therefore less important than the manner of reproduction which determines its existence as a portrait or as something else.

This shows how little trust can be placed in the apparent objectivity of the content.[14] In most cases it refers to a complex unity with a graphic expression of which it would be vain to attempt to dissociate the components. Proof of this is found in a book by E. Sereni, *Storia del paesaggio agrario italiano* (1961), of which several passages imply that the allusive purpose of the painting has been transcended. True, Sereni considers painting primarily as historical evidence and judges it with reference to its fidelity in portrayal. But at times he abandons his view-point and rightly shows that painting could be realistic without being a copy of reality. In this event it becomes a

12. Moles, *Sociodynamique de la culture* (1967), pp. 94-95. Cf. also Jacobs, N. (ed.), *Culture for the Millions?* (1960, 1961).

13. Through an examination of notaries' records, such as G. Wildenstein performed ('Le goût pour la peinture dans le cercle de la bourgeoisie parisienne autour de 1700', 1956), it is possible to discern trends in the taste of certain social classes. The question of the existence of a bourgeois patronage in the eighteenth century, for example, finds a very guarded answer. Cf. on the other hand Crozet, *La vie artistique en France au XVIIe siècle* (1954).

14. Cf. Albrecht, 'Does literature reflect common values?' (1956).

true portrayal, an interpretation of the real, transcending an illusory fidelity
to the subject referred to:

> The landscape painters of the seventeenth century were to discover their true voca-
> tion and lofty inspiration when they deliberately adapted their methods and style
> to the new conditons, breaking away from a hidebound classicism, to transfer to the
> canvas, in moving, realistic terms, the forms of the damaged and tormented country-
> side before their eyes. An untended landscape of which man is no longer in com-
> mand but which overawes human beings and makes them savage, no longer a back-
> cloth for nymphs, heroes or court beauties, but a place where renegade monks and
> tramps, peasants and brigands, horsemen and soldiers of fortune roam, lost on
> rocky mule-tracks among tufted trees and mysterious valleys.[15]

Here Sereni shows how after a long period of painting landscapes to serve as
settings for scenes from mythology, painters reverted to realistic subject-
matter, and points out how this return was revealed as much by the mode of
representing as by the object represented. This again touches on something
other than a sociology of content.

The time has now come to focus on other types of sociological research,
those that examine the sociological conditions of artistic creation. Since we
have already touched on the subject and do not think it necessary to dwell
on it further, we will not enter here into the sociology of the content of written
or painted works. We will rather attempt to highlight the studies based on a
synthesis of what tradition has blindly termed form and content: hence a
structural analysis, but nevertheless not formalistic. What does this mean? To
repeat a formula utilized by B. Teyssèdre in his excellent introduction to
Wölfflin's *Renaissance und Barock*, we will seek for the evidence of those
who discern 'a *formal structure based on its concrete genesis*'.[16] In the field
of art, this type of research can be traced back to the Circle of Warburg.

For a better understanding of the background to this problem, a dual tra-
dition must be called to mind: first, a Kantian tradition, passing through H.
Cohen and E. Cassirer in particular, which gave instruction on the reading
of forms and already spoke about the meaning of forms, even if for Cassirer [17]
this reading remained abstract and general; and secondly, a tradition of
historical study, personified by A. Warburg, whose contribution led to the
creation of a method of concrete interpretation of forms. At the convergence
of these traditions, E. Panofsky's work made its appearance, in particular
his *Idea. Ein Beitrag zur Begriffsgeschichte der älteren Kunsttheorie* (1924).
The group that gathered around Warburg represented a considerable step

15. SERENI, *Storia del paesaggio agrario italiano* (1961) (pp. 172-173 in French
translation, *Histoire du paysage rural italien*, 1964).

16. TEYSSÈDRE, 'Présentation' (from the French translation of WÖLFFLIN's *Re-
naissance und Barock* (1888): *Renaissance et Baroque*, 1967), p. 14. In our opinion
B. Teyssèdre is quite right to ascribe a 'modern' interpretation to *Renaissance und
Barock*, deliberately ignoring the systematism of Wölfflin's later works.

17. CASSIRER, *Der Begriff der symbolischen Formen im Aufbau der Geistes-
wissenschaften* (1921-22); and his *Philosophie der symbolischen Formen* (3 vols.,
1923-29) (English translation, *The Philosophy of Symbolic Forms*, 3 vols., 1953-57).

forward in the study of art. Here for the first time a change in the mode of representation was no longer interpreted as improvement or decline, in any event as the evolution of a former technique or manner, but rather as a sign of change in cultural aptitude, in mental habits associated with an epoch. This link is clearly shown in *Gothic Architecture and Scholasticism* (1951), a work in which Panofsky establishes a rigorous correspondence between the structure of scholasticism and the structure of gothic buildings, a correspondence that is founded on a common mental habit. That we should follow Panofsky's reasoning to the point where the genesis of this habit would be revealed in social practice is surely what he is inviting us to do when he writes:

But [the builders of Gothic structures] were *exposed* to the Scholastic point of view in innumerable other ways, quite apart from the fact that their own work automatically brought them into a working association with those who devised the liturgical and iconographical programs.[18]

It would, however, be necessary to study the nature of the channels of mediation, which Panofsky has failed to identify clearly. He speaks of builders 'exposed' to scholasticism; elsewhere he explains the correspondence by 'the way in which this reality is viewed under special conditions', all this creating a habit which is expressed at the level of the *modus operandi* of the various creative techniques. While unreservedly accepting Panofsky's hypothesis and findings, it may be regretted that he did not himself explore the theoretical problem of the constitution of the *modus operandi*. This is a severe stumbling block: does it, as we think, refer to a correspondence based on a social reality preceding any creation, or is it a construction superimposed *a posteriori* by the research worker, thus being entitled to no more than the status of an analogy? The reply to this question is determinant.

Lastly we must mention the work of P. Francastel. His intention is not so much to formulate a sociology of art as to demonstrate the indissoluble links uniting painting with society.[19] But is it so different? Let us hear what he has to say:

Works of art are not purely symbolic, but genuine objects vital to the life of social groups
 I believe it necessary to examine it [the visual function] in relation to the overall activity of man at a given time.[20]

He sums up his endeavour as follows:

The fundamental hypothesis of this work then is that from the Fifteenth to the Twentieth centuries a certain group of men built up a mode of pictorial representation of the universe in the light of a particular psychological and social interpreta-

18. PANOFSKY, *Gothic Architecture and Scholasticism*, p. 23 (my italics); see also his *Studies in Iconology* (1939).
 19. FRANCASTEL, *Peinture et société. Naissance et destruction d'un espace plastique. De la Renaissance au cubisme* (1964, 1965).
 20. 'Les œuvres d'art ne sont pas de purs symboles, mais de véritables objets nécessaires à la vie des groupes sociaux. . . . Je crois qu'il est nécessaire de l'étudier [la fonction visuelle] par rapport à l'activité totale de l'homme à une époque donnée.' – *Peinture et société, op. cit.*, p. 8.

tion of nature, based on a certain sum of knowledge and practical rules of action.[21]

We are therefore concerned with painting as a plastic language, pertaining to and elaborated by the group, 'based on the deepest physiological and mental structures.' [22] But to say that painting is a language does not mean that this language is intended to express a certain fact known beforehand. On the contrary, Francastel denies any connexion between the figurative sign that constitutes language and the symbol of some pre-existing reality.

A form of thought, an art never constitute a system of signs intended to give material form to acquired knowledge; they pertain to the level of speculative thought and the problematics of the universe.[23]

The sign, then, refers to nothing other than itself; it alone is the constituent of the figurative discourse. But also, throughout history, the same treasury of signs becomes ever richer without at any time disappearing. How then, by means of this relatively stable common fund, have the various social groups exhibited such contradictory conducts and values? [24] It is the structure of the figurative discourse that must then be investigated as being the structure of utopias visualized by social groups endeavouring to grasp reality by making use of every available practice.

Clearly, Francastel's work closely corresponds to our idea of sociology, in other words as the correspondence between forms of art and forms of social practice.[25]

In the field of literature, Lukács's theory of the novel was also founded on the convergence of a Kantian line of thought and a blend of historical, Hegelian and Marxist thinking.[26] Lukács is primarily concerned with the identification

21. 'L'hypothèse fondamentale de cet ouvrage est donc que, du XVe au XXe siècle, un certain groupe d'hommes a édifié un mode de représentation picturale de l'univers en fonction d'une certaine interprétation psychologique et sociale de la nature, fondée sur une certaine somme de connaissances et de règles pratiques pour l'action.' – *Peinture et société, op. cit.*, p. 9.

22. '. . . fondé sur les structures mentales et physiologiques les plus profondes'. – *Ibid.*, p. 209.

23. 'Une forme de pensée, un art, ne se constituent jamais comme un système de signes destinés à matérialiser des connaissances acquises; ils sont du niveau de la spéculation mentale et de la problématique de l'univers.' – FRANCASTEL, *La figure et le lieu. L'ordre visuel du Quattrocento* (1967), p. 30.

24. *Ibid.*, p. 183.

25. It is opportune to mention a book containing a wealth of ideas and information: HAUSER, *Sozialgeschichte der Kunst und Literatur* (1953) (English version, *The Social History of Art*). Standing at the junction between the plastic arts and literature, this synthesis provides some very enlightening demonstrations of changes in style and their connexion with society.

26. Since the nineteenth century, Marxism has provided an effective stimulus to sociological research in the field of literature. Regardless of the criticisms to which these works of research lie open, the work of the heterodox F. MEHRING (*Die Lessing-Legende*, 1893) and the very orthodox G. V. PLEKHANOV (cf., in English, *Art and Social Life*, 1953; and in German, *Kunst und Literatur*, 1955) had at least

of specific *forms*, of the novel, the essay, and tragedy for example.[27] Later, the Kantian procedure gives way to a thesis according to which these forms originated and found their meaning in their relationships with the concrete social groups which formulated them.

That leads us to what Lucien Goldmann calls a structuralist-genetic method [28]: structuralist because it is concerned with form, in other words with groups of structured elements; genetic because it attempts to discern some meaning in the functional purpose of these structures, of these different world views,[29] for a given group or social class.

Much research has been carried out on the basis of these premises.[30] We shall not here embark on an exposition of their various contents, but will identify the problems they have broached, with particular reference to the problem of the novel.[31] Nothing comprehensive or authoritative has yet appeared on this subject. A few issues, however, emerge relatively clearly,

the undeniable merit of having attempted a concrete application of Marxist theses. We are familiar with the difficulties and dead-ends into which disciples foundered and with the ensuing critical discussions. What was then known as 'popular Marxism', even if it still survives, today belongs to history and has little infuence on current thought (see above, 'In the Socialist countries', by Béla Köpeczi); nor do we reserve it any space here.

27. LUKÁCS, *Die Theorie des Romans* (1920).

28. GOLDMANN, *Le dieu caché. Étude sur la vision tragique dans les Pensées de Pascal et dans le théâtre de Racine* (1956). See our article, 'Pour une esthétique sociologique: essai de construction de l'esthétique de Lucien Goldmann' (1971).

29. Nearly every research worker adopts a different terminology in this connexion, which reflects the difficulty to which we drew attention earlier as regards Panofsky. There is a terminological uncertainty regarding the concepts of mediation and of vision. One can, like GOLDMANN, adopt the term 'world-view' (*Weltanschauung*) with his definition: 'A world-view is a *coherent and unified viewpoint on reality as a whole*' ('*Une vision du monde est un point de vue cohérent et unitaire sur l'ensemble de la réalité*' – *Recherches dialectiques* (1959), p. 46), specifying that the world-view is never produced by an individual, but by a social group. Thus study of world-views relates to group or class sociology. H. WÖLFFLIN, who followed in Dilthey's wake, suggests as a unifying concept the life awareness (*Lebensgefühl*) of a given period (*Renaissance und Barock* (1888), French translation (1967), p. 171). E. PANOFSKY speaks of the 'mental habit' spread by diffusion (*Gothic Architecture and Scholasticism*, p. 83). P. FRANCASTEL links 'figurative systems' ('*les systèmes figuratifs*') to the 'changes in mental behaviour of a certain social milieu' ('*transformations des conduites mentales d'un certain milieu*' – *La figure et le lieu*, p. 256). G. LUKÁCS, in *Die Theorie des Romans*, uses the term 'cast of mind' (French translation, p. 31) to explain the appearance of new types of creation, of new arrangements for which the 'empirical and sociological conditions' will have to be identified (*ibid.*). J. P. VERNANT, in *Mythe et pensée chez les Grecs* (1965), associates the *structures of thought or patterns of mental organization* ('*structures de pensée*' *ou* '*organisations mentales*') with sets of institutional practices (p. 140). Further on he points out that the 'mental mutation' seems to be 'part and parcel of the changes that occur in society' (p. 313), or rather in the city. Although these terms are extremely diverse, there is an undoubted similarty of inspiration and theory to be discussed.

30. See our article 'The sociology of literature. Some stages in its history' (1967).

31. Cf. SPEARMAN, *The Novel and Society* (1966).

spread over the long history of this literary *genre*. On a general level and apart from Lukács' book, Goldmann has put forward a global hypothesis. He writes:

The novel form in fact appears to be *the transposal to the literary plane of the substance of everyday life in an individualist society that is the result of market-oriented production.* There is *strict correspondence* between the literary form of the novel and the everyday relationship of men with property in general, and, by extension, of men with other men, in a producer society geared to the market.[32]

We should also specify the form of novel to which we are referring. In the steps of Lukács and Girard, Goldmann states:

The novel may be defined as the story of a search for genuine values using degenerate means, in a degenerate society, which degeneration, as far as the hero is concerned, is manifested principally by the displacement, the reduction of genuine values to a tacit level and their disappearance as manifest realities.[33]

From this it can be deduced that he based his concept of the novel essentially on the great French novels of the nineteenth century, those of Stendhal or Flaubert for example. One of the most interesting tasks in studying the sociology of the novel today would be to isolate other novel forms traditionally grouped under the heading of 'novel' which could be identified with different groups or social classes. It can be observed for example that the heroes of the English novels of the eighteenth century, e.g., by Defoe or Fielding, are not given to self-questioning. On the contrary the novel is an expression of a triumphant individualism that has come to grips with the world.

I. Watt's book, *The Rise of the Novel* (1957), clearly shows how this type of novel is linked with philosophical realism. But beyond the realism of the content, Watt perceives a more profound realism underlying the representation, which gives the content of the novel in a strict sense its whole meaning.[34] Thus the origin of this realism would throw light on any studies of novels by Defoe or Fielding. Watt traces these origins to English society, and more specifically to the groups fairly closely associated with political power. In fact Locke, Addison and Steele were on the public payroll; Granville was a member of the House of Commons, Prior and Defoe were entrusted with diplomatic missions. Exposure of the links between the Bill of Rights, Locke's

32. 'La forme romanesque nous paraît être en effet *la transpositon sur le plan littéraire de la vie quotidienne dans la société individualiste née de la production pour le marché*. Il existe une *homologie rigoureuse* entre la forme littéraire du roman et la relation quotidienne des hommes avec les biens en général, et, par extension, des hommes avec les autres hommes, dans une société productrice pour le marché.' – *Pour une sociologie du roman* (1964), p. 24.

33. 'Le roman se caractérise comme l'histoire d'une recherche de valeur authentique sur un mode dégradé, dans une société dégradée, dégradation qui, en ce qui concerne le héros, se manifeste principalement par la médiatisation, la réduction des valeurs authentiques au niveau implicite et leur disparition en tant que réalités manifestes.' – *Ibid.*

34. Cf. AUERBACH, *Mimesis. Dargestellte Wirklichkeit in der abendländischen Literatur* (1946) (English translation, *Mimesis. The Representation of Reality in Western Literature*, 1953).

philosophy and nascent business capitalism spotlights the sociological sub-
strata on which an individualist and victorious world view could build up
the biographical novel form with its positivist hero.

This reveals the present need to distinguish between various types of novel
structures. Studies of the modern novel only make this need for redefinition
more pressing. On all sides commentators vie with one other in expounding
the formal processes of the contemporary novel, of which they fail to grasp
the significance except rarely and then only at too general a level. Will the
study of social circles such as the 'the intellectuals' succeed in throwing light
on the phenomenon? Are present-day novel structures still linked to a world-
view? No decisive answers have been given to these questions up to the
present.[35]

As we conclude this brief general survey, our concept of what is worthy of
the name of sociology of literary or artistic creation must emerge. This back-
ground sketch alone suggests a definition. If sociology wishes to enter the
field of creativity, it must forge the necessary weapons to understand and
explain a strictly social aspect, that of the mental structures at work in any
creative activity. The substance of literary and artistic works may be subject
to unconscious conditioning; but the structures for the perception of the uni-
verse, the categories in which it is conceived, the moulds in which the crea-
tor casts the elusive substance, all these belong by right to the domain of
sociological entities, groups, and social classes. These structures acquire
meaning in relation to their existence and their activities within society as a
whole and in confrontation with the world. By studying this relationship the
sociologist can understand and explain the forms of cultural production.[36]

35. Cf. our attempt: *Lecture politique du roman: 'La jalousie' d'Alain Robbe-
Grillet* (1973).

36. In addition to the references given above, from the copious literature on this
subject, see in particular the following works and collections:
 ALVAREZ, *Under Pressure: The Writer in Society – Eastern Europe and the U.S.A.*
(1966); AMOROS, *Sociología de una novela rosa* (1967); BELVIANES, *Sociologie de
la musique* (1949, 1950); BERELSON, *Who Reads What Books and Why?* (1957);
BYSTRON, *Socjologia literary* (1938); DAICHES, *Literature and Society* (1938);
DUNCAN, 'Sociology of art, literature and music' (1957); DUVIGNAUD, *Sociologie de
l'art* (1967); ELSBERG, 'La sociologie dans l'étude bourgeoise contemporaine de la
littérature' (1967); ENGELSING, 'Der Bürger als Leser. Die Bildung der protestan-
tischen Bevölkerung Deutschlands im 17. und 18. Jahrhundert am Beispiel Bremens'
(1960); FRANCASTEL, 'Problèmes de la sociologie de l'art' (1960) and *Etudes de
sociologie de l'art* (1970); FRYE, 'The critical path. An essay on the social context
of literary criticism' (1970); FÜGEN, *Die Hauptrichtungen der Literatursoziologie
und ihre Methoden* (1964); GODOY, *El oficio de las letras* (1970); GOLDMANN, 'La
sociologie de la littérature: situation actuelle et problèmes de méthode' (1967)
(parallel publication in English version, 'The sociology of literature: status and
problems of method'); HOGGART, 'Literature and society' (1966); HONIGSHEIM,
'Soziologie der Kunst, Musik und Literatur' (1958); HUACO, *The Sociology of Film
Art* (1965); LEAVIS, Q. D., *Fiction and the Reading Public* (1932); LEENHARDT, J.,
'Sémantique et sociologie de la littérature' (1969); LÖWENTHAL, *Literature, Popular
Culture, and Society* (1961); MEMMI, 'Cinq propositions pour une sociologie de la
littérature' (1959) and 'Problèmes de la sociologie de la littérature' (1960); MOUNIN,
Poésie et société (1962); MUKERJEE, *The Social Function of Art* (1948); POSPELOV,

4. THE EXPERIMENTAL APPROACH, *by Robert Francès**

Some introductory remarks

(1) The experimental approach to aesthetic phenomena clearly places research in this field in the category of the so-called nomothetic social and human sciences. Such research embraces a very broad range of experiments, from the laboratory treatment of 'purified' variables, or the presentation of genuine works of art, to experiments or surveys on the spot (in schools, entertainment halls, hospitals, etc.). In all cases this type of study aims at establishing relations and invariables, usually tested by a statistical process for which initial hypotheses, alternative or not, had been formulated.

(2) The experimental approach, thus defined as regards its diversity, is radically different from art criticism – although it can provide basic information for certain philosophical considerations or simple generalizations, which could be termed criticism.

In fact this approach is centred entirely on phenomena of a 'public' rather

'Literature and sociology' (1967); SILBERMANN, *Introduction à une sociologie de la musique* (1955), 'Kunst' (in KÖNIT (ed.), *Soziologie*, 1958), and 'A definition of the sociology of art' (1968); THODY, 'The sociology of literary creativity. A literary critic's view' (1968); ZÉRAFFA, *Roman et société* (1971); etc.

Art et société (Revue d'Esthétique, 1970); *The Arts in Society/Les Arts dans la société (International Social Science Journal*, 1968); *Critique sociologique et critique psychanalytique* (Symposium, 1965; publication of the Institut de Sociologie, Brussels, 1970)l *Littérature et société. Problèmes de méthodologie en sociologie de la littérature* (symposium, 1964; *Revue de l'Institut de Sociologie*, Brussels, 1967); *Littérature, idéologies, société (Littérature*, Paris, 1971); *La Politique culturelle (Communications*, Paris, 1970); *Problèmes d'une sociologie du roman (Revue de l'Institut de Sociologie*, Brussels, 1963); *Psychanalyse et sociologe comme méthodes d'étude des phénomènes historiques et culturels* (= Vol. II of *Critique sociologique et critique psychanalytique, op. cit.*, joint publ. of the Institut de Sociologie, Brussels, and the Ecole pratique des Hautes Etudes, Paris, 1973); *Sociology of Literary Creativity / Sociologie de la création littéraire (International Social Science Journal*, 1967); *Sociologie de la littérature. Recherches récentes et discussions (Revue de l'Institut de Sociologie*, Brussels, 1969); etc.

Collective extracts from important works may be found in ALBRECHT, BARNETT & GRIFF (eds.), *The Sociology of Art and Literature. A Reader* (1970); see also ESCARPIT (ed.), *Le littéraire et le social. Eléments pour une sociologie de la littérature* (1970); FÜGEN (ed.), *Wege der Literatursoziologie* (1968); etc.

See also, in the next chapter, in Section IV, the bibliographical references of 'Artistic creation' (*sub* 'The sociological approach') by Mikel Dufrenne and of our own contribution, 'Reception of the work of art'; and in Section V, the sociological works referred to in the essays devoted to the different arts, in particular by Jean Starobinski (Cf. items listed under 'Criticism with a sociological bias' in the bibliography forming an annex to his essay on 'Literature'), Claude V. Palisca ('Music'), Gianfranco Bettetini ('The art of cinema'), Gillo Dorfles ('The arts of information and the mass media'), etc.

* Institut d'Esthétique et des Sciences de l'Art. Paris. President of the International Association of Empirical Aesthetics.

than a 'personal' or introspective nature: it is based on expression that can be readily checked by any research worker, such as direct observations (sales statistics, numbers of visitors to museums, or tickets sold for entertainment; the analysis of works in the light of explicit criteria; the analysis of verbal or other reactions as evidence of appreciation). Whenever the object of the research is 'mental', representative and affective, it is always the identity of another person that is under scrutiny and never that of the observer. These two principles are borrowed from operationalism or logical positivism, on which the social and human sciences are based today, whether explicitly or not.

This does not in the least hinder interdisciplinary co-operation between criticism and experimentation. But such co-operation cannot take the form of indiscriminate fusion or interpenetration. Philosophical thought or criticism can focus on a particular branch of learning, but strict observance of methodological requirements limits freedom of affirmation.

This report is centred on four points that are considered fundamental [1]:

1. *Aesthetic judgements and values.*
2. *The conditions for intercultural artistic communication.*
3. *Form conceived and form perceived in contemporary art.*
4. *The creative actions of artists and automatic art.*

I. AESTHETIC JUDGEMENTS AND VALUES

The first major problem to which much experimental research has been devoted concerns the aesthetic value of works. In the first place many seem to agree that in the framework of a culture, the value of a work should be conceived independently of any critical opinions – particularly in matters of taste – that may be expressed. It matters little what my neighbour says about the Ninth Symphony on leaving the concert hall. It will always be one of the most solid monuments of the art of music.

But it is not easy to remain content with this straightforward affirmation of transcendence. Phenomenologists have quite rightly stressed the notion that a work of art does not exist until it is viewed, apprehended, constituted or reconstituted by a person. Thus its value could depend on nothing other than the consensus of judgements relating to it. This consensus alone gives it its human dimension as a fact of civilization – like altars, venerated the more on account of the offerings that surround them, as the philosopher Alain remarked.

Such opinions constitute the raw material of many experiments in which respondents are asked to rank in order, by artistic merit or according to their preference, sets of plastic or musical works, chosen so that through comparison significant data can be obtained.

1. The subject of this report was submitted in essence to the Fourth International Congress on Aesthetics (Uppsala, 1968). See also FRANCÈS, *Psychologie de l'esthétique* (1968).

To bring out the importance of realism in representation, which is thought to vary according to the age or culture of the respondents, they are asked to rank in order reproductions of paintings with a common theme, of the same period, each with a more or less sharply marked difference in degree of realism.

Sometimes, in order to identify the criterion or criteria which determined their preferences, respondents are questioned on the reasons for their choice.

It is worth mentioning some of the results relating to the statistical configuration of these judgements:

(a) There is significant agreement between adults with advanced training in art when asked to rank in order to merit prints of paintings by masters and by less-known painters and of chromos. Burt, one of the first research workers, demonstrated that despite objections to the very principle of the experiment, these adults considered as experts, gave ordered series with ranks showing an average correlation of 0.90 which in statistical terms indicates a very high degree of agreement between the rankings.

But this agreement is largely due to the heterogeneous nature of the set, and to the fact that some of the painters were recognized and some were not. Agreement between experts is considerably reduced when the set is entirely made up of prints of canvases by great masters whether old [2] or modern.[3] It is also considerably reduced if the set is made up entirely of contemporary painters, whether representative or not. Gordon [4] showed ten original untitled oil paintings for judgement, each from a different modern and contemporary school of art. The average correlation between the ten experts (painters and critics) asked to give an opinion was very low. The comments accompanying the classifications of each expert make it possible to identify three factors emerging from the intercorrelations between classifications. These factors are: (A) a more or less pronounced negative attitude towards modernism or the absence of representative intent; (B) interest in a specific technique (drawing, colour, composition); (C) interest in stylistic qualities in a broad sense, without reference to specific technical aspects. These factors show certain interrelations which are worth mentioning: thus an aversion for modernism goes hand in hand with relative indifference to technical and stylistic qualities.

(b) The same series are then shown to adults with no artistic speciality (employees, workers, or even under the procedure used by Gordon, adults selected by chance from the telephone directory). The result of their ordered series shows a much higher degree of unanimity between laymen than be-

2. CATTEL, GLASCOCK & WASHBURN, 'Experiments on a possible test of aesthetic judgement' (1918).

3. FRANCÈS, 'Limites et nature de l'effet de prestige. II: Notoriété de l'auteur et jugement de l'œuvre' (1963).

4. GORDON, 'Individual differences in the evaluation of art and the nature of art standards' (1956).

tween experts. The fact was established both by Gordon[5] with original paintings, whether figurative or not, and by myself in 1964 with reproductions of modern figurative paintings. This high degree of agreement is, however, accounted for by the utilization of criteria other than those used by the experts. It is less a question of reference to a well-known painter or school than to qualities unrelated to knowledge: the search for faithful representation and the rejection of originality, a judgement based on the qualities of the model or object depicted, regardless of its expressive merits.

In brief, the consensus of experts is high when they have to compare in order of merit the works of established authors with those of less-known or unknown artists. This consensus diminishes when the comparison relates solely to works of masters and disappears when works by unknown painters are shown. At this point the individual preferences of the expert for a particular painter or school come into play. The greater consensus of the slightly educated or uneducated respondents is explained partly by their lack of cognitive roots, as shown by their judgement and the reliance on simple criteria easily applied to one school or another.

(c) Is there any predictable agreement between adult art specialists and more or less informed respondents? Such agreement is usually low and insignificant, amounting to no more than a chance. This is not quite true in a case where works of very heterogeneous value in the same group are to be compared, as in Burt's experiment: here agreement between the experts and a group of adults of varying educational level was appreciable. With a more homogeneous group of masters, J. Cattel, already mentioned, found a fairly close correlation between classification by experts and by students trained in art appreciation or history, but there was almost no correlation when students of the same university level but without any art instruction were surveyed. As in many other types of research the consensus between different groups lessens not so much according to age or general cultural level but according to the specific culture. We confirmed this statement in our 1964 experiment, made with four sets of five reproductions each based on a common theme.[6]

On the whole these experiments tend to prove that within the framework of a culture, the scale of aesthetic values, if one agrees to associate it with a consensus of judgement, is not perceptible except when those concerned share a common fund of knowledge or traditions, or at least have received similar instruction in art appreciation. Furthermore the scale must consist of widely-spaced rungs if agreement is to be reached between experts. As soon as the space between rungs is reduced, disagreement increases. This is also true when experts are shown contemporary works from different schools. The diverse aesthetic currents preferred by each expert disrupt the consensus just as much as personal preference for one master among others.

5. *Art. cit.*
6. FRANCÈS & VOILLAUME, 'Une composante du jugement pictural: la fidélité de la représentation' (1964).

II. THE CONDITIONS FOR INTER-CULTURAL ARTISTIC COMMUNICATION

The research mentioned so far seems to indicate that aesthetic values depend on cultural norms that are current in a given civilization, and that only with the acquisition of these norms is a well-founded judgement possible, either by experts or by persons specifically instructed in them.

From this it is possible to infer that the aesthetic values of one civilization would not be apprehended by those trained or educated in the norms of another civilization, removed in time or space from the former. Thus inter-cultural relativism is a consequence of intra-cultural relativism.

Well-designed experiments in fact bear out this conclusion: Lawlor [7] showed decorative designs taken from materials, pottery, or other artefacts from West Africa to two groups of respondents from different cultures: British students and students from what was then known as the Gold Coast. These adults, with no special knowledge of the plastic arts in their own countries, were asked to select from the group the two designs they most preferred and the two designs they least preferred. The results show that, *within each national group*, there was very clear agreement, both regarding the preferred designs and the least preferred. But *between* the groups the disagreement was very marked. The English and the Africans judged the same objects according to criteria that were probably quite different. Experiments of this type were made before and after Lawlor with similar results.

It should be noted, however, that they all used respondents who had apparently little inclination for art or did not specialize in art. What happens when experts of two different cultures are questioned? The most likely hypothesis is that the divergences between them would increase. In fact, repeated experiments consistently show the contrary.

Several intercultural experiments have recently been carried out by I. L. Child and various collaborators. They invariably bore on subjects selected within each ethnic group for their artistic qualifications. In 1955 [8] Child and Siroto compared the judgements of advanced art students in New Haven (United States of America) and those of Bakwele experts (a Bantu-speaking people living in the Congo and Gabon); the latter were either sculptors, witch doctors, or wise men who had lived in their villages, sheltered from Western influences. On their side, the American students were not qualified to judge African sculpture. The two groups were asked to judge separately some 40 photographs of African masks carved for decorative or ritual purposes. The statistical procedure used to compare these judgements (by ordered series) was complex: it took into account both the consensus of each group and the existing correlation between the two ethnic groups. The result was as follows: there was a very high degree of correlation between the ordered series of the Africans; and there was a certain degree of agreement between their ordered series and those of the Americans, higher than it

7. LAWLOR, 'Cultural influences on preferences for designs' (1955).
8. CHILD & SIROTO, 'Bakwele and American aesthetic evaluations compared' (1965).

would be in the case of random coincidence (there would be only one chance in a hundred of obtaining this degree of agreement, expressed by correlation, merely through the play of chance).

Similar research has been carried out among American art students and Japanese potters highly skilled in the art of decoration. Here the material to be evaluated was of Western origin and included pairs of *objets d'art* and pairs of abstract paintings in colour prints. Ignorance of Western art was verified in the Japanese potters. Despite this, there was significant agreement between the judgements of the two ethnic groups (lower, however, than the agreement within the American group).

Lastly, a similar experiment attempted to compare the artistic judgement of Americans and of artists from the Fiji Islands. It related to mixed material: both Western paintings and drawings and Bambara carvings. Here again the judgements of the two ethnic groups were fairly closely correlated although neither group could have knowledge of the aesthetic norms applicable to objects belonging to the other culture.

In the field of music, A. Tamba (a Japanese composer) and myself are currently engaged in a research project.[9] It relates to extracts of traditional Japanese music which are to be judged in Tokyo by students of that type of music and in Paris by French students (non-musicians, music students and professional musicians) none of them qualified in this *genre*. But the results do not lead to the same conclusions as those reached by I. L. Child in the field of plastic arts. In the case of simple works (instrumental solos), musical knowledge does not increase the degree of agreement of the French respondents with the judgements of Japanese experts. It would seem that music, perhaps because it is entirely governed by socio-cultural norms, is in a category distinct from the other arts. However, the results of this project will need to be corroborated by others before they can be considered definitive.

From all this research the following conclusion can be drawn: if there is a higher degree of agreement between expert respondents from two cultures that are remote one from the other and where there is no known diffusion, than between non-expert respondents, this indicates that in each of these cultures, artistic professions or studios select individuals having a particular type of sensibility, who are capable of perceiving in the works of another culture qualities that do not depend directly on the norms, but on more general variables associated with form, proportions, colour or tonal relations. Moreover, this sensibility has been established by research on the general factor of taste, established in particular by Eysenck by means of numerous tests each based on works pertaining to a well-defined *genre,* some of the non-western works.

Of course this 'area outside the norms' only takes into account one part of the variety of aesthetic judgements; it is but one aspect of value, that transcends cultures. But it is important that on completion of his efforts the experimenter should have established a limit to cultural relativism.

9. FRANCÈS & TAMBA, *Les préférences musicales. Recherche interculturelle* (in preparation).

III. FORM CONCEIVED AND FORM PERCEIVED IN CONTEMPORARY ART

In the art of our civiliations, in particular at their present stage of evolution, a work, as we know, is a construction of psychological initiative and a structure offered to perception. It can even be a conceived form which has to be rediscovered by perception. Communication of the formal intent of the artist is clearly a primordial factor in the aesthetic function of a work of art: all meanings, all connotations of value or other inherent qualities are connected with it.

At a certain level of complexity the processes of this conception are no longer easily perceived. The artist, who is so to speak at the heart of the work, has no trouble in performing this feat. But the spectator, the listener for whom these works are intended, often grasps but a limited part of such wealth, offered to him in an enigmatic and concealed manner.

The aesthetics of various contemporary artists, particularly composers, is frequently constructivist; it leans on mathematics, presents us with products of elaborate design that we can only, assuming that we are capable of it, discern on reading the score or even, up to a certain point, the programme notes.

This hiatus between the work conceived and the work perceived has been brought to light by experiment, particularly in connexion with music.

In fact two aspects of the hiatus should be distinguished:

(a) In many works, up to the eighteenth or nineteenth century, an audience with no instruction in music, or average performers, experienced great difficulty in perception, in recognizing the overall structure of a sonata movement based on the development of two themes; in identifying variations on a theme when they are somewhat subtle; in following the subject of a fugue in polyphonic music. But at least these difficulties are minimal for well-trained listeners (students or professors of music, highly-skilled executants or composers).

This is what I was able to demonstrate in repeated experiments with Bach's fugues [10]: we requested adult respondents of three levels of musical training to indicate, in the course of play, the subject of the fugue when it appeared in one voice or another in the different registers of the keyboard. Even on a second hearing the elementary-level listeners were unable to identify more than half of these fugal entries, whereas on a first hearing the qualified musicians were able to pick out more than 80%. A similar disparity was established with regard to the thematic structure of a sonata movement, the identification of variations, etc. In short, it is obvious that in music, until the nineteenth century, formal articulations, whether simultaneous or successive, were barely comprehensible to a slightly educated listener, but that they were easily recognized by musicians with some degree of training.

 10. FRANCÈS, *La perception de la musique* (1958); by the same author, *Psychosociologie du public musical. Enquête sur les choix de musique 'classique' d'une population résident à Paris et dans la région parisienne*, Institut d'Esthétique et des Sciences de l'Art, Paris, 1963 (unpublished survey).

(b) This is far from being the case with more recent works, particularly contemporary works, in which the extremely subtle and rigorous constructional effort can no longer be identified even by extremely qualified listeners specialized in this technique.

In fact the experiments that are generally carried out on twelve-tone scale works consist of simple and more general tasks of perception than the preceding category. In 1958 I merely asked my respondents to identify short fragments some of which were composed on the twelve-note scale, others on a scale in which the last six notes were different. The fragments were either melodic, harmonic, or polyphonic. The respondents, after listening four consecutive times to both sets had to decide in which scale each fragment was composed. In fact this amounted to asking them to recognize the unity inherent in this type of composition. The results showed that composers who had produced, conducted or analysed dodecaphonic works for years failed to identify the fragments in a proportion of more than 50% of the cases, in other words the error percentage was greater than if they had replied at random.

Experiments on complete serial works were made by Albert Wellek.[11] In one of them in particular, the scale was completely altered by dividing the octave into thirteen tempered notes. The respondents were all future professors of music or musicologists. They first listened twice in succession to a piece by Webern constructed on a scale of 13 tempered notes and twice using the usual scale of twelve; or, to a piece by Schoenberg played twice correctly and twice with changes in the last three bars. Respondents had to decide whether they heard any difference between the correct and the altered versions and wherein lay the difference.

Of the 42 respondents, only one-third or one-quarter noticed the complete change in the sound relationships that had been introduced (whereas when they heard pieces by Dussek or by P. E. Bach similarly changed they usually answered correctly).

Such research would not of course be relevant if the disciples of the twelve-tone school had not themselves claimed (like Schoenberg) that the serial concept was a unifying principle. It would appear that this unity is entirely conceptual without any concomitant and perceptible impression of unity.

To sum up on this point, let us say that the unity or structure of certain products of contemporary art is often conceptual in character and is not translatable on the plane of perception. It is important to show that this is true even for the experts, for it alters the existential status of works of art and puts an end to some of the illusion of the public and of critics.

11. WELLEK, A., 'Expériences comparées sur la perception de la musique tonale et de la musique dodécaphonique' (1966).

IV. CREATIVE ACTIONS OF ARTISTS AND AUTOMATIC ART

The act of artistic creation has only seldom been the subject of experimental study.

In the first place the study of exceptionally creative individuals, of persons of great talent and genius, cannot be carried out in this fashion. It pertains to biographical analysis and monographs, as in another domain does the study of the geniuses of science. But research on average talents is possible, for example on the process of pictorial creativity in pupils in a classroom. It would be equivalent to the classical experiments made by Gottschaldt, Maier or Piaget in the field of intelligence.

A few experiments on this type of respondent have been attempted. They are less concerned with creative activity itself than with the psychological functions on which it depends. Thus Dreps [12] sought to differentiate the psycho-physical and mental capacities of students of an advanced graphic and plastic arts school having, in the opinion of their teachers, varying degrees of talent. The tests taken by the respondents are many and varied. Some tests prove to be classificatory, that is to say they correspond to the degrees of artistic talent – a test to recognize proportions or reproductions of visual forms briefly shown, an interpretation of ink blots, an outline judged for its originality. On the other hand purely sensory or perceptual texts (recognition of colours, analysis of perspective) do not clearly distinguish the respondents, no more than do precision or stability tests for manual movements. This disparity is confirmed in another research project carried out in the same year on children whose talent or graphic skill was variously rated by their masters. In brief, the functions on which creative activities at each level depend are not sensory or motor, but are related to the perception of complex forms, particularly imagination and originality in either perceptive interpretation or graphic performance.

But creativity can be studied by analysing its products – and here the choice of samples makes it possible to approach the highest levels. This is a classic method in aesthetics. It takes on an experimental character when precise hypotheses are tested, not by examples that can always be found to bear out a thesis, but by statistical analyses of random samples selected according to certain criteria applied to the variables in question.

This was the method used by J. Cohen in recent tests on the language of French poetry.[13] The hypothesis is that any poetic language is a 'deviation' from the balance of the mother tongue. The deviation may be phonic, metrical or semantic. The semantic deviation in particular is a violation of the language code from the paradigmatic angle, which creates 'metaphoric' forms in a general sense. The number of such deviations is always greater in poetry than in prose and increases as one moves from classical to romantic or symbolist poetry, including for example impertinent or redundant terms,

12. DREPS, 'The psychophysical capacities and abilities of college art students of high and low standing' (1933).
13. COHEN, J., *Structure du langage poétique* (1966).

or unco-ordination (juxtaposition of semantically unrelated phrases). To demonstrate this, J. Cohen selects random samples of a hundred lines of scientific or literary prose and a hundred lines from Racine; Lamartine or Vigny; Rimbaud or Mallarmé. From these samples he notes the number of epithets which are impertinent, redundant, etc. He first verifies the quantitative homogeneity of each type of linguistic unit, either in prose or poetry samples of different periods. Next he determines the existence of statistically significant differences between the various categories of samples. As regards impertinent epithets, for example, they are non-existent in scientific prose. They attain a certain level in novels (8%). In poetry they vary from about 4% in classical works to 23% in romantic writing and 46% in the symbolists.

Another mode of study of creativity is to identify any analogies between the output of electronic machines under certain conditions and that of an artist in the form of works of art. This is in reference to *simulation* research carried out with computers and not to experimental works that can be obtained with such machines; the latter are more innovatory and require a greater degree of creativity on the part of the machine than of the artist who is operating it.

Research in simulation with classical harmony has been carried out by P. Barbaud,[14] among others: a few pairs of common chords, their position and mode of progression are fed into the memory of the machine. The tonal function of each of these connecting chords is controlled by the input programme, which is derived from an analysis of musical texts in which tonal harmony was used and from which a stochastic matrix was prepared.

In this way the machine is equipped with a chord repertory and with qualitative and quantitative rules of progression prepared in the light of statistics compiled from works of a particular period. The resulting output is in this case extremely banal and resembles class exercises in harmony. The slightest note of originality is excluded, whereas any composition normally contains some, even if only a few.

The programme fed into the machine can, however, be enriched to obtain a more modulated harmonic product, a repertory with a greater range of chords, thus running through stages similar to those of the history of harmonic language in the eighteenth and nineteenth centuries.

But the control of rhythmic and melodic variety, as well as of harmony, soon outstrips the machine's capabilities.

On the other hand, the creation of an entirely new harmonic style is very easy to achieve: it suffices to feed in a programme that is entirely different from that derived from textual analysis. By analogy one might say: *nothing is harder to achieve than originality in a work, once a style, or rather a language, is established; nothing is easier than to invent an original language, without achieving any originality in the work.* The machine is devoid of epochal assumptions or prejudices. It can easily innovate in the linguistic field, but it can seldom invent anything unique in form. In this its work – if

14. Cf. BARBAUD, *Initiation à la composition musicale automatique* (1965).

one may use this term – resembles either that of writers who use a language to produce nothing but entirely predictable works; or of inventors of a language in which they were unable to express anything personal.

These are a few examples of experimental research in aesthetics chosen from the great number of those known to us. It seemed useful to orient this selection towards the problems with which aestheticians are usually concerned, to show that our endeavour, despite appearances, is not a discipline apart, notwithstanding its alien vocabulary which links it to psychology, sociology and linguistics.

In its way, I believe that the experimental approach to aesthetics cannot fail to promote the unification of the human sciences.

5. THE PSYCHOLOGICAL APPROACH, *by Mikel Dufrenne, with the collaboration of Albert Wellek and Marie-José Baudinet*

Innumerable works are nowadays devoted to 'the psychology of art' (as we know, this is the title of a book by Malraux), of the arts or of artists. No doubt at one time such an approach from psychology was held suspect by those influenced by phenomenological criticism of psychologism. Was this criticism based on a misunderstanding? A. Wellek* believes so.

The essential point is that the polemic surrounding Husserl aimed at what was termed 'soulless psychology', in other words the pure psychology of the phenomenalist (and not phenomenological) conscience of Wundt's days, and when shorn of this hypothesis it lost its purpose.

It is a fact that 'structural psychology', as initiated by F. Krueger, E. Spranger and their disciples is rightly directed against – and in this it is in accord with Husserl – phenomenalism and psychologism; it leads to a renovation of the science of the soul', in the words of A. Wellek, who also calls for a rehabilitation of the psychological approach:

It is time to cast off the burden of prejudices that have outlived their time, to allow a fresh wind to blow and to set psychology in its median position, acting the rôle of mediator which is its own today, much to the benefit of the aesthetics of literature.

In fact, the psychologists have worked tirelessly. If it is impossible for us to cite all their works, how can we at least catalogue them? No doubt in the first place, for any art, we should separate the psychological study of the creator from the psychological study of the recipient. In dealing with the problems of creation we will attempt to draw up a broad enough inventory of the related research to include that based on psychology. Therefore this sub-section will be deliberately limited to the psychology of reception.

But even limited to this approach, psychology is not homogeneous, and extremely diverse enterprises, as regards both purpose and procedure, can be

* We adhere very closely here to the essay Albert Wellek was kind enough to send to us.

ascribed to it. Of such enterprises, we will allot a special place to information theory – as we have just done for the experimental approach, although of course any positive psychology has the right to have recourse to experiments, since the experimental approach to art today is sufficiently assured of its concepts and methods to claim autonomy. We will therefore leave these two branches aside, and more especially the psycho-sociological study of opinions on art and judgements of taste, which is most frequently, as we have just seen, pursued by the 'experimentalists'.

The scope of this sub-section having been mapped out, which is the path to follow? Would it be possible to detect a sufficiently clear affinity between the various arts and the various psychological doctrines to provide a principle as a basis for the organization of our inventory? Assuredly not, because in the first place it is not possible to define and differentiate doctrines so easily, and secondly because they do not specialize in the study of a particular art. We propose, however, to base our examination of research projects on three distinct families of art: the musical arts that require hearing, the visual arts that require viewing, and the literary arts that require reading; we will then outline the recent developments in the psychology of these three activities.

I. THE PSYCHOLOGY OF MUSIC HEARING, *by Albert Wellek*[**]

The study of hearing presents what may be termed two a priori problems. The first, that concerns both the sociology of taste and experimental psychology relates to the competence of the listener.

Hegel made a distinction between the common man's comprehension of art and his acquired knowledge, favouring the former. The music-lover with no formal training in music has as much right to music as the musicologist. The aesthetics of music should therefore be valid both for the specialist who follows the music from the score and for the lay listener. This task becomes ever more difficult, as contemporary aspirations to a musical 'absolute' become increasingly demanding. But even with regard to the effect of repetition, which was carefully analysed by L. B. Meyer in the United States of America,[1] a theory of music psychology should take account of both the 'first impression' and the final impression, of both intuition on first hearing and analysis, whether it relates strictly to the analysis of forms and phrases or simply to the gradual discovery of details by the amateur.

The second problem relates to the audibility of the music; this arises, in A Wellek's view, in 'modern' music; but perhaps it also arises in 'exotic'

** Mainz University.
N.B. *Unfortunately the limited scope of the present work made it impossible to include the entire text of the substantial and erudite study which we owe to Albert Wellek. The presentation will enable the reader to identify immediately the connecting texts and summaries that we have inserted, and that cannot be attributed to him. M.D.*
1. MEYER, 'On rehearing music' (1961).

116 *Mikel Dufrenne et al.*

music, in which case the cultural context of the hearing is more apparent, a fact to which psychology does not always pay sufficient attention. In this connexion A. Wellek refers to the work of R. Francès [2] (whose statement appears earlier in this chapter) [3] on the hearing of twelve-tone music.

R. Francès came to the conclusion that the understanding of dodecaphonic music was only possible through cognition, not through perception, and that it had no immediate auditive effect: '... such understanding is not perceptive in nature. The organization is thought out, but it is only very rarely felt on being heard. The conceived order does not engender the perceived order'.

Apart from this type of research, Hellmut Federhofer and I decided to attack the problem on a broader front. At the first International Symposium on Experimental Aesthetics, held in Paris in 1965, I submitted our early results for discussion. In 1967 Federhofer published a brief analytical study on 'hearing problems associated with modern music' [4] in which he referred, as I had myself,[5] to a wide-ranging survey of some 250 people in different musical centres in Germany and abroad, particularly Zürich and Copenhagen, of which the results by and large confirm and expand Francès' findings. In so far as the music in question is not directed solely to a score-reader but, as has been the case so far, to a listener, a discordance is revealed between the composer's intent and the 'hearing capacity' of the listener, even when highly trained, and the composer is victim of the 'intentional fallacy', as defined by William Wimsatt [6] (and by René Wellek [7] as regards literary criticism).

The contrary argument postulating that the history of music had already known 'music for the eye', which only exists on paper, and that it is impossible to listen directly to a 'canon by inversion' which has to be read, i.e., followed on the score, has no substance. There is in fact a difference between cases where such subtleties of construction are incorporated in the work which one may fail to grasp, without losing the whole work's artistic value and meaning, and cases where the entire composition is made up of elements that escape the ear and are devoid of meaning as a group of audible and heard sounds.

This is the general view *inter alia* of the masters of contemporary music aestheticians, Ernest Ansermet,[8] Friedrich Blume [9] and Jans Rohwer.[10]

We will now follow A. Wellek in his examination of some specific problems.

2. See in particular FRANCÈS, *La perception de la musique* (1958) and *Psychologie de l'esthétique* (1968).
3. Cf. above, 'The experimental approach'. See also in the following chapter, 'Music' by Claude V. Palisca, in particular pp. 296-297.
4. FEDERHOFER, 'Hörprobleme neuer musik' (1967).
5. WELLEK, A., 'Expériences comparées sur la perception de la musique tonale et de la musique dodécaphonique' (1966).
6. WIMSATT, *The Verbal Icon* (1954).
7. WELLEK, R., *Concepts of Criticism* (1963).
8. ANSERMET, *Les Fondements de la musique dans la conscience humaine* (1961).
9. BLUME, 'Das musikalische Kunstwerk in der Geschichte' (1967).
10. ROHWER, *Neueste Musik* (1964).

1. The psychology and typology of hearing

A psychology of the hearing of music should begin with the psychology of hearing or of sounds in the strict sense. In musical psychology in the strict sense, classical psycho-physics and psycho-physiology of hearing, as developed to a high degree of perfection from the time of Helmholtz [11] until Stevens and Davis [12] and G. von Békésy,[13] have no immediate relevance. Authentic musical psychology arose with the phenomenological analyses of musical phenomena, in particular those of G. Révész [14] and E. M. von Hornbostel,[15] for which Ernst Kurth [16] formulated the theory; it is a very young discipline even in the context of modern psychology, which has only been in existence for a hundred years as an 'independent science'. Certain attempts have been made to 'objectify' this discipline in the spirit of the natural sciences or of neo-behaviourism by deviating from the orientation set by Kurth, but these attempts, such as those made by R. W. Lundin, a pupil of Skinner,[17] have so far had no success, and were greeted with total incomprehension, even by musicologists. The latter are inclined to regard the situation as completely confused.[18]

Psychological studies on auditive abilities, in particular those made by C. E. Seashore (from 1910),[19] by Révész again (from 1920),[20] then by A. Wellek (from 1938), have proved to be more relevant and have exerted a greater influence. The two basic works of A. Wellek, *The Absolute Ear and Its Types* and *Typology of the Musical Gift*,[21] have just been supplemented and republished. It is true that the very complex notion of absolute pitch that emerges has once more been called into question in the meantime, particularly as concerns its hereditary form ('genuine') by A. Bachem,[22] and with due regard to what distinguishes it from the simple estimate of relative pitch

11. HELMHOLTZ, *Die Lehre von den Tonempfindungen als physiologische Grundlage für die Theorie der Musik* (1863).

12. STEVENS & DAVIS, *Hearing. Its Psychology and Physiology* (1938, 3rd edn., 1948).

13. Von BÉKÉSY, *Experiments in Hearing* (English translation, 1960); cf., by the same author, 'Zur Theorie des Hörens' (1929-30).

14. RÉVÉSZ, *Zur Grundlegung der Tonpsychologie* (1913).

15. Von HORNBOSTEL, 'Psychologie der Gehörserscheinungen' (1926).

16. KURTH, *Musikpsychologie* (1931, 2nd edn., 1947).

17. LUNDIN, *An Objective Psychology of Music* (1953).

18. For example, Ingmar Bengtsson.

19. SEASHORE, *The Measurement of Pitch Discrimination* (1910); *The Psychology of Musical Talent* (1919); 'A base for the approach to quantitative studies in the aesthetics of music' (1927).

20. RÉVÉSZ, 'Prüfung der Musikalität' (1920); 'Gibt es einen Hörraum?' (1937); *Inleiding tot de muziekpsychologie* (1944, 2nd edn., 1946; German translation, *Einführung in die Musikpsychologie*, 1946).

21. WELLEK, A., *Das absolute Gehör und seine Typen* (1938, 2nd edn. 1969); *Typologie der Musikbegabung im deuschen Volke. Grundlegung einer psychologischen Theorie der Musik und Musikgeschichte* (1939, 2nd edn. 1969).

22. BACHEM, 'The genesis of absolute pitch' (1940); 'Note on Neu's review of the literature on absolute pitch' (1948).

(D. Morgan Neu, René Chocholle and M. Matzawa).[23] Nevertheless all the previous findings of Wellek have recently been re-stated, confirmed and supplemented in the thesis submitted to Mainz University by Ursula Engelhardt.[24] In a chapter entitled 'The nature of musical abilities',[25] P. R. Farnsworth has *inter alia* set forth a critical appreciation of tests on the musical gift. Frequently these studies go no further than the early works of Révész and Seashore, as is the case with Hardi Fischer and Ch. Butsch.[26]

The validity of phenomenological scales (scales of phenomena), that were largely perfected in particular by S. S. Stevens and his collaborators, has lately been called into question; the same is true of the scale of phons and particularly of sones, as regards the loudness of sound and also to some extent for the very useful mels scale applied to frequency differences. Sader has just outlined the problem of the loudness of sound and noise, in a doctoral thesis presented at Mainz.[27]

The interest in typology, which was active in the twenties and thirties and at that time was mainly applied to problems of rhythm (particularly by J. and O. Rutz, E. Sievers and G. Becking [28]), dwindled after the Second World War, but reappeared in slightly different form in the most up-to-date factor analyses, in particular those by Raymond B. Cattell and his collaborator, D. R. Saunders.[29] In this field, factor analysis seeks to attain essentially the same objectives as typology, using more formalized methods, but in which hypotheses also play an important part.

2. *Musicotherapy and musical expression*

The growing interest shown in recent years in what is termed musicotherapy is more closely connected with individual psychology than with typology, both in theoretical and in applied psychology. Musicotherapy goes beyond the strict technique of psychotherapy with the use of music, and in particular attempts to restore mobility, ease and flexibility in cases of motor disorder by the direct action of music and/or rhythm according to the Carpenter effect (ideomotor law), whether these disturbances are neurological in origin or solely neurotic (psycho-somatic) . . .

In fact general experience has for some time past shown that musicality

23. NEU, 'A critical review of the literature on "absolute pitch"' (1947); 'Absolute pitch – a reply to Bachem' (1948); CHOCHOLLE, 'Das Qualitätssystem des Gehörs' (1966).

24. ENGELHARDT, *Beiträge zur Entwicklungspsychologie des absoluten Gehörs und seiner Typen* (1968).

25. In FARNSWORTH, *The Social Psychology of Music* (1958).

26. FISCHER & BUTSCH, 'Musikalische Begabung und Intelligenz' (1961).

27. SADER, *Lautheit und Lärm* (1966).

28. See in particular BECKING, *Der musikalische Rhythmus als Erkenntnisquelle* (1928).

29. Cf. CATTELL & SAUNDERS, 'Musical preferences and personality diagnosis' (1954).

and affective memory often remain intact in cases of brain damage. Sometimes preservation of the musical motor abilities is in striking contrast with the almost total destruction of nearly all the other faculties. We must conclude, then, that purely reproductive musical activity, up to a certain general level of structuration, is or could be located in one of the deeper regions or layers of the central nervous system and the psyche, i.e., that it pertains to a lower level of development than those governing other and higher activities, which in such a case had remained blocked at the level of the *'Vorgestalt'* in the sense of Sander [30] or Conrad. In fact, music is a factor of affective enrichment or integration (which is the same thing) at the level of Scheler's 'middle psycho-vital layer', as demonstrated by the Carpenter effect and consequently by elementary musicotherapy, as we have seen. The patient follows the integrational-emotional line, that acts as the motor and stimulus for the pieces of music he has learnt – which moreover he could not learn except by following this course – and when the beginning is played for him he can pick up and continue to play correctly the pieces he has learnt.

These experiments throw significant light on the central problems of music and on the musical phenomenon as a whole. They provide neuro-physiological and psychological confirmations (which are in some ways complementary) of the basic idea of Schopenhauer's philosophy of music, in which music alone of all the arts reaches beyond the realm of ideas and is a direct expression of the universal will.

3. *Taste in music and classifications of musical impressions*

From the psychological-aesthetic point of view, absolute music (independent of language and literature) has precisely this advantage that in the framework of a given musical culture, in particular the 'Western-American culture', and almost since the beginning of modern times, it is possible to determine with precision the prevailing hierarchy of values on which there is a universal international consensus, and this is more obvious than with the other arts. In this connexion, Paul R. Farnsworth in particular has collected some very convincing statistics in a work entitled *The Social Psychology of Music*; [31] we must also mention a study by John H. Mueller (Bloomington) compiled in collaboration with Kate Hevner, based on concert programmes in North America,[32] and those that the writer has compiled from announcements in international catalogues of long-playing records (particularly Schwann's).

For another attempted systematization using statistics, mention should be made of the applications of the 'Semantic Differential' (Polarity Profile) according to the concepts of Charles Osgood and his collaborators,[33] to which

30. SANDER & VOLKELT, *Ganzheitspsychologie* (1962, 1967).
31. *Op. cit.* (1958).
32. MUELLER & HEVNER, *Trends in Musical Taste* (1943).
33. OSGOOD *et al.*, *The Measurement of Meaning* (1957).

several theses have been devoted in recent years at Hamburg University. This method only provides simple classifications and, at best, factor analyses of the pleasurable or expressive qualities of music. Direct phenomenological analysis of music, on the other hand, does not attempt to achieve precision in the sense attached to this word in the natural sciences, but it bears on the fact itself and not on its indirect effects, without taking into account certain 'formalized' intermediaries as is the case with semantic differentials.

4. *The aesthetics of form and expression and the aesthetics of heteronomy*

The idea of interpreting the affective and expressive effects of music as pure-ly symbolic and semantic in the logistic sense was formulated some time ago in the United States of America by Susanne Langer,[34] but she encountered a contradiction on the psychological aesthetic plane relating to the personal nature of aesthetic feelings.[35] The controversy which, in the realm of music, has for over a century opposed the aesthetics of form and the aesthetics of expression has finally been resolved, in a dialectical synthesis that achieves an 'aesthetics of form and expression' which shows that any form, no matter how 'pure', has an expressive quality and that any expression is transmitted solely through the intermediary of form. Such an interpretation of the aes-thetics of expression therefore differs radically from the 'aesthetics of heter-onomy' defined by F. Gatz,[36] since felt emotion communicated in this way stems directly from the musical form as such and is not extraneous (hetero-nomous) to the music. Such are the arguments that have recently been formu-lated by A. Wellek [37] and by C. Dahlhaus.[38]

Apart from this, since the initial research made by G. Anschütz on 'com-plex coloured hearing',[39] musical synesthesia (coloured hearing) has become the scientific basis for 'colour music', which postulates musical heteronomy in quite a different way, opening up the possibility of a new *genre* of artistic synthesis, either stated or disguised.

It is nonetheless typical of our times that the elaboration of classifications and of so-called objective scales of musical judgement meets with universal approval. In this connexion mention should be made of an article published by Ulaza Kuno and Yayoi Suga in the review *Japanese Psychological Re-search*.[40] The authors of this article examined eleven works by composers

34. LANGER, *Philosophy in a New Key* (1942): see Chap. VIII.
35. Cf. WELLEK, A., from 'Gefühl und Kunst' (1939) and in a summary form in *Musikpsychologie und Musikästhetik. Grundriss der systematischen Musikwissen-schaft* (1963).
36. GATZ, *Musik-Ästhetik in ihren Hauptrichtungen* (1929).
37. In *Musikpsychologie und Musikästhetik, op. cit.* (1963).
38. DALHAUS, *Musikästhetik* (1967).
39. ANSCHÜTZ, *Kurze Einführung in die Farbe-Ton-Forschung* (1927); *Farbe-Ton-Forschungen* (3 vols., 1927-36); *Das Farbe-Ton Problem im psychischen Ge-samtbereich* (1929); 'Zur Frage der "echten und unechten *audition colorée*"' (1930).
40. KUNO & SUGA, 'Multidimensional mapping of piano pieces' (1966).

ranging from Scarlatti to Debussy, who are analysed in two dimensions which may be considered more or less perpendicular to each other, in other words independent: sensed beauty and formal beauty, coloured (or chromatic) beauty and 'gothic' beauty. None of this is new of course, but the epithet 'gothic' is surprising and should certainly be replaced by a more suitable term. It would seem to have been suggested by the title of the last of the eleven works considered: '*La cathédrale engloutie*' by Debussy – although this precise work would seem to be much nearer the opposite pole, that of 'coloration'.[41]

II. THE PSYCHOLOGY OF VISION, *by Marie-José Baudinet**

The psychology of vision, which we shall now consider in relation to the study of the arts sometimes termed visual, can be approached in many different ways. In particular, it can be studied from the point of view of physiology and psycho-physiology: we will not here mention the extensive research undertaken in this field, except where it has in its turn inspired strictly psychological research specifically related to art. In fact, we will confine our survey to the work of the Gestalt *school, which for the study of works of art seems to be the most substantial and the most open to the other approaches. We will now let Mme. M.-J. Baudinet, to whom we are indebted for this section, speak for herself.*

If it had not been for *Gestaltism*, any meditation on art today would still consist of the metaphysics of the beautiful, the philosophy of criticism or the psychology of contemplation. We are indebted to it for having substituted a methodical reflexion on perception, an experimental analysis of the genesis of forms and their effects, for vague or theoretical speculation on art. It has illumined the work of art and shown it to be no more than a single event, al-

41. Apart from the references given in preceding notes, the following works can be consulted:
ARNHEIM, 'Information theory. An introductory note' (1959); BENSE, *Aesthetica* (1954-60); BLUME (ed.), *Die Musik in Geschichte und Gegenwart* (14 vols., 1949-68); BOULEZ, 'Musique traditionelle – un paradis perdu?' (English version, 'Traditional music – a lost paradise?') (1967); EIMERT, *Grundlagen der musikalischen Reihentechnik* (1964); FRANK, *Grundlagenprobleme der Informationsästhetik* (1959); FUCKS, *Mathematische Analyse der Formalstruktur von Musik* (1958) and 'Mathematische Musikanalyse und Randomfolgen' (1962); FUCKS & LAUTER, *Exaktwissenschaftliche Musikanalyse* (1965); GEHLEN, *Zeit-Bilder* (1960, 1965); HEINEMANN, *Untersuchungen zur Rezeption der seriellen Musik* (1966); JAUSS (ed.), *Die nicht mehr schönen Künste* (1968); KNEUTEN, 'Eine Musikform und ihre biologische Funktion' (1969); MOLES, *Théorie de l'information et perception esthétique* (1958) (English translation, *Information Theory and Esthetic Perception*, 1966); PICKFORD, 'The psychology of ugliness' (1969); WELLEK, A., 'The relationship between music and poetry' (1962) and 'Grösse in der Musik' (1963). An abundant classified bibliography of works previous to 1963, including a list of works by the writer, will be found in WELLEK, A., *Musikpsychologie und Musikästhetik* (1963).
* University of Paris – VIII.

beit more triumphant than others, in the succession of produced and perceived forms. 'No longer can we consider the artistic process as self-contained, mysteriously inspired from above, unrelated and unrelatable to what people do otherwise'.[42] Art is an act and a means of identifying ourselves in relation to a given environment. Any act of looking at a work of art infers a play of relations between the ordered system of the object and that of the viewer. Looking then consists in grouping significant formal complexes; art introduces a specific form of significant formal validity; hence *Gestaltpsychologie* requires us to make both a noematic and a noetic analysis. Furthermore, in its initial stages, it postulates isomorphism between the structure of the object and the structure underlying the viewing process – a notion admittedly difficult to elucidate, but that seems to be relegated to second place nowadays, no longer being needed, doubtless, on account of the new models of perception based on computer science. For this reason we will concentrate essentially on the psychology of the subject as it views the visual form.

The form produced is not an objective imitation of external reality. Nor is it the immaterial fruit of a form-aligning intellect. It is there, physically present, its living quality derived from meaningful texture.[43] Is there a general law governing the appearance of forms in the world and in consciousness? *Gestalt* experiments are based on a fundamental principle, that of balance. The ideas of balance and pattern are fundamental to all analysis.[44] From a strictly physical point of view, balance is 'the condition of the object subjected to compensated forces'. In this sense the object is the result of a system of forces in equilibrium. From the psychological point of view, perception of the object is more strongly subject to the 'appearance' of equilibrium. The laws governing the equilibrium of the model are not the same as those that govern the equilibrium of the representation. In art, equilibrium will be invoked to designate the distribution of masses and directions appearing in space or on the canvas, in such a way that the whole of the objective structural complex is seen as a meaningful organization: that is the very essence of the meaning of pattern. Reading of the work and, more specifically, of a work of art will make constant reference to this law of equilibrium, of which it will be necessary to demonstrate the objective conditions and subjective need at every level of the analysis.[45]

We will now discuss a few of the subjects basic to *Gestalt* psychology and to the plastic arts in order to elucidate what is meant by this constant search for a pattern.

42. ARNHEIM, *Art and Visual Perception* (1954), Introduction, p. viii.
43. ARNHEIM, 'The *Gestalt* theory of expression' (1949).
44. ARNHEIM, '*Gestalt* psychology and artistic form' (1951).
45. ARNHEIM, *Art and Visual Perception* (1954); RASHEVSKY, 'Perception of visual pattern and visual aesthetics' (1948).

1. *Limits . . .*

What relationship is there between the notion of *pattern* and the facts of line and contour? Is the delimitation between the interior and the exterior of a particular form, the threshold that marks off the perimeter from the periphery identical with the physical and psychological structure of the meaningful equilibrium? The contour does not exist in reality. It is only the perception that organizes a limitative reading, an epiderm around the creative object, by the dynamic choice of significant elements: the reduction of the object to its *essential traits* makes it possible to perceive the presence of a pattern. But then is the pattern identical with the schema? In so far as it is a simple form governed by the double principle of economy and purpose, the schema does indeed function as a pattern,[46] with this difference that the technological or scientific schema constitutes an autonomous whole in itself, containing its own meaning and carries an intellectual characteristic in the form of memory. So it is that the line in plastic art is the result of a system of stresses. We should not be deceived by its apparent simplicity.[47] In physics, simplicity refers to the totality of the system and to the intellectual facility of assimilating it. In art, simplicity refers to the economy – even the paucity – of means but where a work of art is concerned the effect is always *complex*. It always calls into place a system of stresses. Similarly this simplicity betokens the aptitude of the conscience to perceive, more or less directly and more or less rapidly, the resolution of such stresses. The perceptive conscience brings about groupings and elementary divisions that enable it to identify the initial patterns. A schematic contour cannot alone constitute the *basic form* of the representation, it must also act as a significant stimulus.

2. *Form*

More is implied in *form* than in *contour*. Beyond the mere delimitation of the object, form visualizes the space occupied by the object, its fullness. What are the internal characteristics of the object? What part do they play in the representation? The plastic form is supported by the space of the representation in which it is located. The figure emerges from the ground.[48] The perception takes on the significant structure of the affirmation and the negation as it appears in a given area, in which it is possible to distinguish the place occupied by the object from the area it does not occupy. The background can become a figure if the balance can be organized also in reverse. The dynamism of the figure means that it weaves an illusory space in its relations with the other figures.[49] Just as when we were speaking of the contour or line, here form as an object will never be exactly the same as its concept. The

46. GAFFRON, 'Right and left in pictures' (1950).
47. GIBSON, J. J., *The Perception of the Visual World* (1950); by the same author, 'What is form?' (1951).
48. ARNHEIM, 'Perceptual abstraction and art' (1947).
49. GOMBRICH, *Art and Illusion* (1959).

features of the object are selected not as a substitute for knowledge but to create a system of stimulations and allusions of which the equilibrium and meaning will only be established by the consciousness that perceives it.[50] For this reason art will never be formalist. As soon as artistic form comes into existence, formalism is itself treated dramatically. By this we mean that it is no longer a cold combination which is objectively valid, but an event for the consciousness that perceives a meaningful system of tensions between form, the environment, and the subject's mode of existence. Briefly, all form in plastic art is the equivalent of, or a material substitute for, a certain relationship with the world. Art by material and stylistic media creates original systems of tension, visual patterns that function for the perception as manifestations of existence and balanced contradictions.[51]

3. *Genesis*

Gestalt analysis of artistic perception is not restricted to form. The search for origins is built on it.[52] How are patterns born and how do they develop?

The work of art has its roots in the most creative period of life, in childhood. Then it is that form, the treatment of materials, expresses the subject's relations with the world in the most direct manner. In this period fundamental solutions to conflicts between reality of perception and the imagery of desire are built up. The child's drawing appears to be a rudimentary and clumsy representation of the world he perceives. But clumsiness does not explain everything: let a right-handed person draw with the left hand and the result would in no way resemble a child's drawing. Nor yet does ignorance: the child knows infinitely more than he reproduces. The analysis must be based on real elements: the material existence of the object, its psychological function.[53] The desire to produce and express oneself is conditioned by the material and cultural media. The products of a child are in the first place the very gestures of creation. The patterns are as much biological and muscular as psychological.[54] The whole body is engaged in the act of creation, as it is in the act of perception. The more matter is mastered, together with the body, the more the pattern is linked with the meaningful structures of the cultural environment. By and large the child's product is not a general or special concept of an object, nor an imitation of what is perceived. It is rather a way of expressing a perceived and meaningful experience that is determined by the constraints imposed by matter, the tool, the environment, etc. The child records what he perceives in a form expressive of existing internal tensions.[55] He finds a means of successively constituting equilibrium

50. BORNSTEIN, 'Structurist art – Its origin' (1960-61), and other articles by the same author.
51. KEPES, *Structure in Art and in Science* (1965).
52. PIAGET & INHELDER, *La représentation de l'espace chez l'enfant* (1948) (English translation, *The Child's Conception of Space*, 1956).
53. GOMBRICH, *Meditations on a Hobby Horse* (1963).
54. GOMBRICH, *Art and Illusion* (1959).
55. BRUNER & KRECH (eds.), *Perception and Personality* (1950).

by relating himself to his creations. 'Child art' leads to the recognition of primary schemata of tensions and biological and psychological resolutions in their production.[56] Therein we may perhaps find the matrices of all our patterns. Perhaps this explains the wish (or feeling) for regression that more than ever haunts artistic creation.

To rediscover the key to simplicity and unity in an expressive basic vocabulary, that is what fascinated Klee and still fascinates Vasarely.

4. *The material components*

To the analysis of form and genesis a factual demonstration should be added, in other words, with regard to plastic art, a demonstration based on the materials and procedures employed. The work of art exists as matter. One of the first physical problems is the question of space. How is an imaginary space constituted and perceived? In the graphic arts that use two dimensions, how does depth appear? How do the various elements that indicate it operate? Here the problem of form and background reappears in a dynamic and ordered system of planes and perspective.[57] Similarly in sculpture, space will be seized in the imagination and in that space volumes and voids, convexities and concavities will provide the components of the work's expressive structure.[58] At this point the pattern becomes a complex in space that stands before the totality of the observer. By means of a plastic vocabulary intended to translate the feeling of space, the observer is led to penetrate the inner meaning of the object. Perspective is only one of the possible solutions. What is important is that the observer should be able to identify the spatial proportions of the image and locate the position of his own vision in relation to this space. This relationship implies that what he perceives has meaning for him. Comforting or vertiginous, continuous or discontinuous, the apparent space of the work becomes a possible mode of being for the subject perceiving it. The means, the code used to translate the imaginary space, become meanings, in other words a system of correspondences between the appearance of the object and the consciousness of the percipient.[59]

What is the situation with regard to light and colour? Light and colour are not treated as one, because physically as well as psychologically they relate to different although inseparable experiences.[60] Light perception and its consequent psychological impact presumably precede colour differentiation.[61]

In the first place light and shadow are experienced in childhood as two contradictory entities loaded with biological meanings. Light is both revealed and revealing. It is not shape and line that alone create space. Light

56. LÖWENFELD, *Creative and Mental Growth* (1947).
57. ARNHEIM, *Art and Visual Perception* (1954).
58. ARNHEIM, 'The holes of Henry Moore' (1948).
59. ARNHEIM, '*Gestalt* psychology and artistic form' (1951).
60. HILER, 'Some associative aspects of color' (1946).
61. BURCHARTZ, *Gleichnis der Harmonie* (1941).

creates the visible. The very structure of space would not appear if it were not for a distribution of light and dark. Regardless of the stylistic materials and means used, every work of art reveals a pattern expressing perception. In other words the artist organizes a particular solution based on the structural determinants of the appearance of the visible. Whether the light is there to show up relief, depth or opaqueness, whether it expresses transparency or spirituality, its function is always to weave the visual pattern.[62] The spectator will find that he is caught in the web which links the object and the vision, and just as in his earliest experience of darkness he will perceive in the treatment of light the schemata expressing day and night, life and death, appearance and disappearance. In the course of history, art seems to have attempted an ever-more faithful depiction of the distribution of sunlight or artificial light on objects, in order to create a reassuring space.[63] Later the light source was no longer an observed fact but rather a systematic creation. Light no longer reveals objects but is identical with things themselves. The slightest line, the smallest touch of paint becomes a light stimulus, an expressive pattern. Light is the mode of existence of the observer who, remote from the physical model, will discover through the light of the work that his eye is the ultimate source of luminosity, as the work is the source from which meaning derives its energy.[64]

But we have yet to discuss colour. We are on firm ground when speaking of contour: there at least we can relate the expression of specific patterns to the general properties of other patterns such as space, balance or the geometrical properties of a figure. This is not the case with colour.[65] There is as yet no scientific theory on the differential perception of colour. What is known of the physical phenomenon in no way renders any account of the physical mutations in the subject that perceives it. But *Gestalt* theory also offers its own hypotheses, again based on its structural principles of meaningful equilibrium: it suggests that the psychological patterns of colour are the result of a combination of stresses; a homogeneous colour field in isolation is equivalent to a neutral field and produces no reaction in the observer's consciousness. For the coloured object to be perceived as a meaningful shape, an underlying pattern must be perceived through chromatic tensions. A certain colour will have a certain meaning in a situation because it appears in a certain chromatic context, but it may take on an opposite meaning in a different context. Here the context is the expressive pattern reflecting the cultural and material media. The metaphors describing colour in terms of hot and cold clearly show how closely the experience of colour is associated with the kinesthesis of the observer,[66] and to his metabolism. The same remarks also apply to light. But our metaphors go still further; there are colours that attract and others that repel, that 'turn the stomach', like the effect of a

62. RASHEVSKY, 'Perception of visual pattern and visual aesthetics' (1948-49).
63. GOMBRICH, *Art and Illusion* (1959).
64. GAFFRON, *Die Radierungen Rembrandts* (1950).
65. ARNHEIM, *Art and Visual Perception* (1954).
66. KÖHLER & HELD, 'The cortical correlate of pattern vision' (1949).

surfeit of sugary confections. This type of association led Gombrich to think that our perception of art and more specifically our interpretation of form and colour were closely associated with our elementary biological life (and perhaps with oral stimulations?).[67] But the recognition of universal chromatic patterns is all the more impossible since every cultural and historical group has built up its own lexicon and meaningful associations.[68] We are not in possession of an objective colour key. Colour is studied in relation to its chromatic environment and in the symbiosis of the forms within which it is distributed. It is part of the form's very aggressiveness. Undoubtedly, Vasarely undertook the most 'gestaltist' project when he attempted to compile a formal chromatic lexicon of plastic units capable of an infinite number of combinations.

5. *Movement*

What can be said briefly about perceived movement? [69] In this context there is an immense difference between the so-called instant space arts and time arts in which the creative gesture continues to move with the clock. In a painting or statue, the permanent balance of the pattern is contained in the immediate overall action of forces. The dance or the play offers a process of constant making and unmaking. Arnheim wrote: 'Thus one kind of artistic medium defines acting through being, the other defines being through acting. Together they interpret existence in its twofold aspect of permanence and change.' [70] In the visual arts, forces can be recognized by the very presence of their resultants, and their time of perception is equal to the time required to capture the balance of forces in a single spatial relationship. The same applies to movement as well as to form: it acquires its specific expressiveness from the space or time from which it becomes isolated. The kinetic pattern is established by the visual relay between the dynamic force of the tensions in the object and the kinesthetic impressions of the observer. All visual shape is dynamic, and to the subject his body appears as posture.[71] Then occurs the illusion of motion within the significant perception. 'Perception reflects an invasion of the organism by external forces, which upset the balance of the nervous system.' [72] No pattern is static. All that has been said regarding the balance of formal and material patterns is true only on the understanding that equilibrium is never achieved objectively. The observer creates the balance. This tendency to create an equilibrium is projected on to the work itself, as if its own components were constantly striving to complete it, to achieve stability. But a work of art can only attain fulfilment in the percipi-

67. GOMBRICH, 'Psycho-analysis and the history of art' (1954).
68. GREENOUGH, *Form and Function* (1947/1948).
69. ARNHEIM, 'Perceptual and aesthetic aspects of movement response' (1951).
70. ARNHEIM, *Art and Visual Perception*, p. 309.
71. MERLEAU-PONTY, *Phénoménologie de la perception* (1945), p. 116.
72. ARNHEIM, *Art and Visual Perception*, p. 337.

ent through the act of imbuing it with meaning. As Arnheim points out, the dynamic elements of a composition will come to nothing unless the move- ment of each detail contributes to build up the movement of the whole.[73] If movement is lacking, the word is still-born. This movement of the whole, recognized in the work by perception, is fundamentally linked with the in- tentionality, which should be expressed by all its elements and can only be apprehended by the eye of the observer. In *Gestalt* terms there is symbolic meaning in every work of art, and it is expressed by movement in the rela- tions between sign and symbol.[74]

Conclusion

As Arnheim writes: 'If art could do nothing better than reproduce the things of nature [. . .] or to delight the senses, there would be little justification for the honourable place reserved to it in every known society. Art's reputation must be due to the fact that it helps man to understand the world and him- self, and presents to his eye what he has understood and believes to be true.' [75] Thus *Gestalt* philosophy finds its theoretical culmination in the two opposite poles of its analysis: on the one hand it tries to identify simple, formal and objective patterns that, if not universal, are at least valid for a whole civiliza- tion; on the other, from the patterns and their aesthetic combinations, it tries to define expressive intentionality that would also be of universal value. Such an enterprise would seem to provide a fecund heuristic structure and also to be typical of the ideology of an industrial civilization in the space age. In- deed, at the furthest stretch of the imagination, it would be a magnificent vision to compile a universal lexicon of simple forms using combinatory analysis and electronics to produce formal and significant totalities for all men. But this exaltation of perception completely obliterates what classical thinking called *imagination*. By continually discovering that in the last in- stance the observer is the creator, creation itself is reduced to almost nothing. The artist plays with the observer; at present they play one against the other, but the chess pieces of the game are often missing. Arnheim wrote ' "Ab- stract" art does in its own way what art has always done. It is not better than representational art, which also does not hide, but reveals the meaningful skeleton of forces.' [76] Certainly, but is it in fact this skeleton which we appre- ciate?

In this short survey we have not been able to give their due place to all the philosophers and aestheticians who, although they have not adopted the principles or even the ideas of *Gestaltism*, have taken its findings into ac- count in their own research. Yet they are many, quite apart from major or-

73. Cf. ARNHEIM, *Art and Visual Perception*; 'Gestalt psychology and artistic form' (1951); 'Perceptual and aesthetic aspects of movement response' (1951); etc.

74. ARNHEIM, *Art and Visual Perception*, in particular pp. 370-376.

75. ARNHEIM, *Art and Visual Perception*, p. 374.

76. *Ibid.*, p. 376.

thodox *Gestaltists* such as Arnheim. For instance, the novel approach of psycho-analysis to the work of art takes *Gestaltist* conclusions into account and even tries to reconcile two trends in research (Gombrich, Erhenzweig).

Or again the phenomenologists construct an entire philosophy of intentionalism and meaning on the as yet very tenuous findings of *Gestalt* theory regarding relations between form and meaning (M. Merleau-Ponty, M. Dufrenne, R. Klein).

The sociology of art has also stressed the importance of analysis of cultural patterns, which are now taken up as a level of significance in iconological analysis (Panofsky, Gombrich, Schefer).

It would seem that *Gestalt* thinking has imposed a fundamental task on all forms of aesthetic research: to undertake a formal analysis of the work of art. Even leaving aside the postulates of equilibrium and of psycho-biological isomorphism the impetus to constitute and apply a scientific methodology to art has definitely come to life.[77]

III. THE PSYCHOLOGY OF READING, *by Mikel Dufrenne*

A few words must be added about the psychology of reading. The act of reading is not precisely one of seeing or of hearing. What is it, then? In

77. Apart from the references in the preceding footnotes with regard to the psychological study of the visual arts, the following works may be consulted (suggestions made by Mme. M.-J. Baudinet and Albert Wellek).

ARNHEIM, 'The priority of expression (1949), *Toward a Psychology of Art* (1966) and *Visual Thinking* (1970); BERLINER, *Lectures on Visual Psychology* (1948); BIRKHOFF, *Aesthetik Measure* (1933) and 'Structure and communication' (1965); BLAKE & RAMSEY (eds.), *Perception. An Approach to Personality* (1951); BORNSTEIN, 'Conflicting concepts in art' (1963), 'Transition toward the new art' (1958) and 'Sight and sound – Analogies in art and music' (1964); BURT (Sir Cyril), 'The psychology of art' (1933); FROMM, *The Forgotten Language* (1951); GEHLEN, *Zeit-Bilder* (1969); GOMBRICH, *Norms and Forms* (1966); HILL, 'Programme, paragrammes, structure' (1968); HOGG (ed.), *Psychology and the Visual Arts* (1969); HUNGERLAND, H., 'Consistency as a criterion in art criticism' (1948); KATZ, *Gestalt Psychology* (1950/1951); KEPES, *Language of Vision* (1944); KÖHLER, *Gestalt Psychology* (1947); LE RICOLAIS, 'Introduction à la notion de forme' (1966, 1968); LORENZ, 'The rôle of *Gestalt* perception in animal and human behaviour' (1951); McLUHAN, *Understanding Media* (1964); MALRAUX, *La psychologie de l'art* (1947-50); MOLNAR, 'Towards science in art' (1965, 1968); MORGAN, 'Psychology and art today' (1950); MÜHLE, *Entwicklungspsychologie des zeichnerischen Gestaltens* (1955); MUNRO, 'Methods in the psychology of art' (1948); OGDEN, *The Psychology of Art* (1938); PEPPER, *Principles of Art Appreciation* (1949); SCHULTZ, 'Epistemology, science and structures' (1952); SCHRICKEL, 'Psychology of art' (1955, 1968); SIDDIQI & THIEME, 'Die verloren Botschaften. Über die Urteilsstruktur bei Künstlern . . .' (1969); VÁNDOR, *Zeichnungen und Malereien von in Hypnose hervorgerufenen visuellen Erlebnissen* (1965, 1970); VIGOTSKIJ, *Psihologija iskusstva* (= Psychology of Art) (1965); WELLEK, A., 'Das Farbenhören und seine Bedeutung für die Bildende Kunst' (1966); WERTHEIMER, *'Gestalt* theory' (1944); WESTRICH, 'Die Entwicklung des Zeichnens während der Pubertät' (1968); WHYTE (ed.), *Aspects of Form* (1951); WINKLER, *Psychologie der modernen Kunst* (1949); WOLLHEIM, *Art and Its Objects* (1968).

contemporary usage, at least in France, the word 'reading', like the word 'writing', has become inflated: there is a tendency to regard any object that can be looked at, especially a plastic object, as a text, even where texts commenting on it do not take its place. There is a predominance of a certain type of semiology, of which the conceptual structure will be described below. Indeed, there is no doubt that the most painstaking analyses of reading, of its operation or function, are today made by linguists and semiologists: witness the recent book by Barthes on reading a story by Balzac.[78] But the considerable expansion of the connotations of reading is due not only to the prestige of semiology but also to the fact that the phenomenon of reading can be studied on its frontiers, where the written word and the plastic object come into contact, sometimes even fusing. Frequently a literary work assumes an artistic form requiring contributions from the other arts at least for its typography, and also for the illustrations: this is where the problem of the correspondence of the arts arises.[79] For instance, in illuminations, the drawing blends with the letters, and in calligrams the letters can become drawings: we know that Mallarmé in his day was deeply interested in this convergence.[80] Conversely, the text can enter into a painting, not only through the title which may, as in Klee's work, be as 'poetic' as it is in Debussy's Preludes, or when words or figures are introduced in the painted object, as in collages or certain works by Klee. On the other hand, Butor, the very author who wrote 'Le livre comme objet' in *Répertoire I* (1960), can devote a work to *Les mots dans la peinture* (1969). This opens a vast field for research in which textual study can be contrasted with the study of the figure, the study of reading with that of vision, consequently to some extent justifying the ambiguity of the word 'reading' on the ground of the actual object of research.[81]

It is enough for our purpose to draw attention to this field of interest, and we will now confine the word 'reading' to the act of perceiving and understanding a literary text, either hand-written or printed. One might expect the psychology of this act to be integrated in *Gestalt* terms, to the extent that reading implies seeing; in fact certain works inspired by this school are concerned with the comprehension of writing, the form of letters, the pregnance and stability of their groupings. But in fact the psychology of reading does not seem to have given rise to as much research as the psychology of vision or hearing. This is perhaps because the phenomenon of understanding is complex, and its mechanism difficult to discern. In any event it is much easier to analyse what is read than to analyse the reader.

Precisely, the first works that call for mention – numerous because their purpose is practical – concern the object to be read. In this connexion re-

78. BARTHES, *S/Z* (1970).
79. *La correspondance des arts* is the title of a book by Etienne SOURIAU (1947), and also the subject of many recent works.
80. Cf. *Divagations* by MALLARMÉ (1897) and 'Le coup de dé' by VALÉRY (1920); also *Bâtons, chiffres et lettres* by QUENEAU (1965).
81. Here we will only refer to two authors who have made contributions to this Study: Jean François LYOTARD, *Discours, figure* (1971) and Louis MARIN, *Etudes sémiologiques* (1972).

search, generated by advertising in particular, on the legibility of printed signs, their expressiveness and force of aesthetic attraction, comes to mind. In fact, such research borders on the psychology of the reader, in whom it is hoped to introduce unconscious motivations through the expressiveness of the printed image. In this case the aesthetic pleasure does not cross the threshold of comprehension: the text does not have to be accepted nor to procure the same effect as a literary text; as Freud would have said, its aesthetic quality is no more than a seductive premium; it is intended to induce certain behaviour, and for that purpose it must arouse fairly strong motivations.

Equally practical, but more impartial, is the research carried out on learning to read. This research is of course psychological, sometimes psychopathological, for the study of alexia and aphasia are equally significant in the study of speech,[82] but we shall not consider them further, since they are not particularly relevant to the specific nature of the literary text and the mode of reading it calls for.

The true function of psychology in the present context is to study reading from the angle of what is read, reading that does justice to the text, that is not content with the mere deciphering of signs but sets out to understand and appreciate them: i.e., informed or 'aesthetic' reading. Its first task is to discern the 'literary' value of the text; to do so it must compare it to texts in which literary qualities, as Barthes and Todorov have remarked, are wholly absent, 'writing degree zero',[83] including the wording, precisely like the texts from which one learns to read, their only merit being their legibility. How can the presence of this literary quality be determined? By what the authors of *Rhétorique générale* call the *métabole*, namely any type of change in any aspect of the language, and chiefly but not exclusively in the code, any transformation governed by non-literary usage that produces any deviation whatsoever from the norm.[84] But here again research workers are tending once more to focus on the object rather than on the subject, on the poetical or rhetorical processes rather than on the perception of their effects. Nevertheless the authors of the treatise we have just mentioned make a passing reference to the reading processes, e.g., namely, to use Chomsky's term, to the competence of the reader. To quote them in full:

It is clearly the relation between the norm and the deviation that constitutes style and not the deviation as such. The principle in question has been criticized as incorrect from the psychological point of view, the reason being that the reader never makes a comparison with an undetermined zero degree, but so to speak consumes the material directly. Once again a distinction must be made. That there exists a naïve form of reading, more attentive to the content of the message than to its form, to the story line in the novel than to its structure, is well known. Conversely who would dream of denying that informed reading – which only occurs, it may be

82. Cf. HÉCAEN & ANGELERGUES, *La cécité psychique. Etude critique de la notion d'agnosie* (1973).
83. Cf. BARTHES, *Le degré zéro de l'écriture* (1953) (English translation, *Writing Degree Zero*, 1967).
84. DUBOIS *et al., Rhétorique générale* (1970).

conceded, on re-reading – is not in fact always constituted by the inter-play between the deviation and the norms? Furthermore it is one of the characteristics of a work of art that it imposes its particular truth as an absolute truth. The charm of the rhetoric usually has the effect of dimming the critical faculty, that is necessarily comparative. But when it is a question of identifying stylistic features (informed reading) or of appreciating them (aesthetic reading) *reference* mechanisms will come into play: the pattern of the argument will become plain, choice and preference will replace simple savour. Furthermore, we should bear in mind that such comparisons already take place on an automatic and spontaneous level.

But whether informed or not, reading is not confined to recognizing and judging the literary quality of the written word. It is equally attuned to the content of the message, it enters the world of the work – an imaginary world. How can a psychological study of this act be made? In this context, Sartre turned to phenomenology to analyse what he termed: 'The consciousness of reading, [. . .] a consciousness *sui generis*, which has its structure'.[85] In the specific instance of reading a novel, 'The sphere of objective meaning' (*la sphère de signification objective*), thought of 'in terms of things' (*pensée à la façon des choses*), 'becomes a world of unreality' (*devient un monde irréel*), in other words, 'meaningful knowledge' (*le savoir signifiant*) becomes 'imaginative knowledge' (*savoir imageant*), because a certain attitude of consciousness makes the word-sign play the rôle of representative, like an 'analogue': likewise, in the theatre, imaginative consciousness 'apprehends' (*réalise*) the characters *on* the actors and the place *on* the set. 'The phrases of the novel have become filled with imaginative knowledge' which tries to portray things as presences: in Bergson's words, it is 'an expectation of images' (*attente d'images*) that do not in fact materialize. 'Images appear when we cease reading or when our attention begins to wander. But when the reader is engrossed there are no mental images.' (*Elles apparaissent aux arrêts et aux ratés de la lecture; . . . quand le lecteur est bien pris, il n'y a pas d'images mentales.*) [86]

The theory of reading leads to thoughts on understanding and communication of the work: Sartre, we know, has given much thought to the relationship between the writer and the public. His point of view is associated with both sociology and the ethics of commitment. At times it also veers from psychology to philosophy, to an ontology that is more or less derived from the thinking of Heidegger. We must here say a word about Blanchot's thought.[87] In his turn he has inspired some more recent works. Blanchot believes that the part played by the reader is already present in the work's genesis; because a work 'is made up of tattered shreds of the personal experience of irreconcilable and inseparable moments' (*est l'intimité déchirée de moments irréconciliables et inséparables*); for him, it is not a question of the contact between Apollo and Dionysus, but of revelation and concealment.

85. SARTRE, *L'imaginaire* (1940), pp. 87 sqq. (English translation, *The Psychology of the Imagination* (1948), pp. 77, 90 sqq.).

86. *Ibid.*, p. 86 (English translation, p. 90).

87. Cf. in particular *L'espace littéraire* (1968), from which the following quotations are taken.

opening and closing, light – what the reader expects – and darkness – the writer's source of inspiration and the process through which he writes and releases himself of his burden. The same contrast exists between the book and the essence of the work: as Blanchot puts it, 'between the book that exists and the essence of the work that is never there beforehand, between the book that conceals the essence and the work that can find no outlet except in the density of such concealment' (*[l'opposition] du livre qui est là, de l'oeuvre qui n'est jamais là d'avance, du livre qui est l'oeuvre dissimulée et de l'oeuvre qui ne peut s'affirmer que dans l'épaisseur de cette dissimulation*) (p. 284). The true reader must assume the absence of the work, or acknowledge the blind spot in his own heart.[88] To this end, reading should not strive to understand or interpret (and here Blanchot ignores the semiology inspired by Panofsky: he believes that 'a book originating in art' (*qui a son origine dans l'art*) cannot achieve existence as a work except 'in the space opened up by a single reading, each time the first and each time the only reading (*dans l'espace ouvert par une lecture unique, chaque fois la première et chaque fois la seule*).[89] This kind of reading must accept the text as it stands; it does not argue or question, it is not the act of a man telling himself that he knows how to read; for Blanchot it is 'an unqualified affirmation that blooms in the immediate . . ., a delicate and innocent "yes" ' (*un pur oui qui s'épanouit dans l'immédiat . . ., un oui léger, innocent*), in direct contrast to 'the grim struggle of the creator with the chaos into which he plunges in an effort to overcome it' (*la sombre lutte du créateur avec le chaos où il cherche à disparaître pour s'en rendre maître*) (p. 206). In this sense, reading 'is more positive than creation, more creative, although it produces nothing' (*plus positive que la création, plus créatrice, quoique ne produisant rien*): since it releases the work in the book, by its own self-effacement and even irresponsibility, maintaining inviolate its distance from the work; in this way it puts us into communication with the secret life of the work, 'its unending genesis and unfolding' (*sa constante genèse et son déploiement*) (p. 215), rather than with its worldly history and objective content, familiar to the specialists.

Here we find ontology drawing away from science. But as we have seen, thinking on art in general is committed to this oscillation between science and philosophy, also evident in other scientific approaches.[90]

88. There is a commentary on this analysis in the survey by J. F. Lyotard on 'The psychoanalytical approach' below, pp. 141 sqq.

89. A comparison could be made between this conception of Blanchot's and the defence by Gaston Bachelard of a 'first reading' (*lecture première*), the only reading that treats poetry correctly because it 'co-dreams' (*elle 'co-rêve'*) with the poem (cf. DUFRENNE, 'L'art et le sauvage', 1970).

90. For the psychological study of literature the following works may also be consulted (list drawn up by Albert Wellek): BATESON, 'Linguistics and literary criticism' (1968); BERGER, B., *Der Essay* (1964); BERGLER, *Laughter and the Sense of Humor* (1956); BOLLNOW, *Die Methode der Geisteswissenschaften* (1950); CROCE, *Estetica* (1902, republ. 1958) (English translation, *Aesthetic*, 1967); DEMETZ, GREENE & LOWRY (eds.), *The Disciplines of Criticism* (1968); DRÜE, *Husserls System der phänomenologischen Psychologie* (1963); *Enzyklopädie der geisteswissenschaftlichen Arbeitsmethoden* (THIEL, ed., 7 vols., 1969); ERTEL, *Eine psychologische*

6. THE PSYCHOANALYTICAL APPROACH, *by Jean-François Lyotard**

The request that prompted these notes only seemed to be simple; in appearance, it required a survey of the research carried out in a specific scientific field; in fact it demands no less than the constitution of its subject-matter.

Indeed, there is no hope of complying with this request unless the concepts of 'expression' and 'psychoanalytical study (of literary and artistic expressions)' are defined; on examination of the 'principal trends' in question it appears that the definition and scope of these terms are the cause of divergences between current trends that for the most part are not explicit. Rather than produce a 'scientific' evaluation which would be a fiction, it seems to us more appropriate to steer a course through the maze of those current trends, in the wake of the problem created by the terms 'expression' and 'psychoanalytical study (of literary and artistic expressions)'.[1]

Theorie des Komischen (1968); FLEMMING, 'Das Problem von Dichtungsgattung und -art' (1959); FRIEDRICH, *Die Struktur der modernen Lyrik* (1956) (English translation, *The Structure of Modern Poetry*, 1974); GALINSKY, 'Literary criticism in literary history' (1964); GRAUMANN, 'Zur Psychologie des kritischen Verhaltens' (1959); GRIFFIN, 'The uses and abuses of psychoanalysis in the study of literature' (1951); HARDING, *Experience into Words. Essays on Poetry* (1963); HOLLAND, *The Dynamics of Literary Response* (1968); *Imago. Zeitschrift für Anwendung der Psychoanalyse auf die Geisteswissenschaften* (S. FREUD, ed.) (1912-37, republ. 1969); JAUSS (ed.), *Die nicht mehr schönen Künste* (1968); KERENYI and MANN, *Romandichtung und Mythologie* (1945); KOESTLER, *The Act of Creation* (1964); LAIBLIN (ed.), *Märchenforschung und Tiefenpsychologie* (1969); LANGE-EICHBAUM & KURTH, *Genie, Irrsinn und Ruhm* (1967); *Literature and Psychology* (MANHEIM, ed., since 1951); LUCAS, *Literature and Psychology* (1951); MANHEIM, *Hidden Patterns. Studies in Psychoanalytic Criticism* (1966) and 'Psychopathia literaria' (1960); MIKO, *Estetika výrazu* (= Aesthetics of Expression) (1969); MUHLE & WELLEK, A., 'Ausdruck, Darstellung, Gestaltung' (1952); MUKAŘOVSKÝ, 'Kunst als semiotisches Faktum' (1968); MÜLLER-VOLLMER, *Towards a Phenomenological Theory of Literature. A Study of W. Dilthey's Poetik* (1963); OSGOOD *et al., The Measurement of Meaning* (1957); PICKFORD, 'Factorial studies of aesthetic judgments' (1955, 1968); SÁNCHEZ RUPHUY, *Witzverständnis bei Psychotikern und Normalen* (1967); SEBEOK (ed.), *Style in Language* (1960); SIDDIQI, *Experimentelle Untersuchungen über den Zusammenhang von Sprachgestalt und Bedeutung* (1969); SKINNER, *Verbal Behavior* (1957); SPITZER, 'A new synthetic treatment of contemporary Western lyricism (Hugo Friedrich)' (1957); TRILLING, *The Liberal Imagination. Essays on Literature and Society* (1951); WELLEK, A., 'Die Struktur der modernen Lyrik. Betrachtungen ... zu Grundsatzfragen einer Literaturkritik und systematischen Literaturwissenschaft' (1963), *Ganzheitspsychologie und Strukturtheorie* (1955, 1969), *Die Polarität im Aufbau des Charakters* (1966), *Der Rückfall in die Methodenkrise der Psychologie und ihre Überwindung* (1959), *Psychologie* (1963), Chap. 5, 'Das Genie', and *Witz-Lyrik-Sprache. Beiträge zur Literatur- und Sprachtheorie* (1970); WELLEK, R., *A History of Modern Criticism* (1955 sqq.), *Concepts of Criticism* (1963) and 'Literaturkritik und Literaturwissenschaft' (1961); WELLEK, R. & WARREN, *Theory of Literature* (1949); WHORF, *Language, Thought and Reality* (1956).

* Faculty of Letters and Human Sciences, University of Paris-Vincennes.

1. For the bibliography of these studies, reference should be made to the following works: KIELL, *Psychiatry and Psychology in the Visual Arts and Aesthetics.*

1. It is a twofold (yet single) question because the problem of expression and that of research based on a psychoanalytic interpretation of a literary or visual work of art share the same basic set of issues. It seems possible to construct this set of problems in the Freudian manner by contrasting *expression* with *meaning*, and the relationship between expressing and expressed with the relationship between one text and another. The meaning of a statement presupposes the existence of a common code, the language in which it is produced. To understand a text written in a foreign language, once the writing has been deciphered, requires its *translation* into the language of the reader; to understand a text written in the language of the reader gives rise to a *commentary* or *interpretation* made in the same language ('meta-language').

Expression also calls for interpretation or commentary; but where visual form of expression is concerned, it is evident that the work and its spoken or written commentary do not pertain to the same frame of reference: the former belongs to a space with properties quite other than those appropriate to linguistic space. In the case of literary expression, despite the apparent sameness of the signifier for both the work and its interpretation (both being articulated speech), one may postulate that they are profoundly different owing to the extent to which the written work is laden with *'figure'*. At least three types of 'figure' can be identified, each with its specific place and mode of existence in the work: the image induced in the reader's mind, the *trope* governing the order of linguistic signifiers and the form or configuration of the narrative. Owing to the presence of figure in literary work it pertains in part to a space that could be termed topological, it borrows operations from a realm of the signifier that is different from that of the language of communication. This enables it to oppose a certain density to the commentary, comparable with that of a painting or carving, in this respect at least.[2]

A *Bibliography* (1965); by the same author, *Psychoanalysis, Psychology and Literature. A Bibliography* (1965); KOFMAN, *L'enfance de l'art. Une interprétation de l'esthétique freudienne* (1970); KRIS, *Psychoanalytic Explorations in Art* (1952); STERBA, 'The problem of art in Freud's writings' (1940). See also: Centre international de Documentation concernant les Expressions plastiques (CIDEP), *Liste des acquisitions de la bibliothèque*. A bibliography of works in French, unfortunately not by groups, will be found in an excellent essay by Gilbert LASCAULT, 'Esthétique et psychanalyse', in SEMPE *et al., La psychanalyse* (1969).

2. In this connexion see some linguists' research, for example:
– for the structuralist school, FÓNAGY, 'Form and function of poetic language (1965) and 'Der Ausdruck als Inhalt' (1965);
– for the semiological school, TODOROV, 'Les anomalies sémantiques (1966). Here we see the build-up of a concept, that of transgression, which is the anti-concept of structuralism just as expression (or style, in Roland BARTHES' terminology – *Le degré zéro de l'écriture* (1953), translated into English in 1967 as *Writing Degree Zero*) is anti-literature (anti-writing); and which falls squarely in the 'logic' of desire, itself anti-logical. In philosophical literature, the idea of expression – meaning a sense of immanence in the perception, and thereby also opposed to meaning – is at the heart of the aesthetic of Mikel DUFRENNE (cf. *Phénoménologie de l'expérience esthétique* (1953), and *Le poétique* (1963), *passim*). This phenomenological

One might agree that expression is present when the signifier of the work cannot be translated into the language that provides the interpretive commentary, that is, the strict meaning: for example, a painting by Van Gogh is not a translation of his description of it in his letters to Théo.

Expression in this sense is at the heart of the Freudian concept of repression, and perhaps of the unconscious. In *The Interpretation of Dreams* (1900), in particular in Chapter VI,[3] there is a list of the operations that take place when what was initially a 'text' (the *Traumgedanke* – dream-thoughts – that are fragments of daytime speech) is transformed into a 'scene' or dream-sequence: displacement, condensation, means of representation, secondary elaboration. The interpretation does not examine a text, or rather the text (manifest content of the dream), it is itself a heavily 'figure-loaded' (with the above connotation) composite which confronts the interpreter with problems similar to those inherent in a literary or plastic work. The operations which constitute dream-work are not linguistic, and the product of such work (the manifest content of the dream) cannot by its very nature be grasped in a network satisfying the requirements of intelligibility that pertain to rational discourse; [4] the interpretation cannot therefore consist in unravelling what has been done, since in principle it is governed exclusively by the conditions of articulate discourse and can only proceed under such conditions. To 'decondense' a dream expression, or to relocate a stress, are not operations that can be effected logically if nothing at all is known about either the elements that have undergone condensation and displacement or about their original order. Freud never mentions any such attempts. In fact, the language of the psychoanalyst is not a language of *study*.

This is not the place to define it positively. It is enough to observe that in psychoanalysis, the relation to the object is no longer a relation of *knowledge*, that in this context language undergoes a mutation which liberates it from both poetry and learned discourse. The language of analysis is not itself expression, nor is it knowledge of expression. The difficulty inherent in the psychoanalytical 'study' of 'expression' is that it would seem at first sight that the rôle of speech in treatment cannot be sustained, since reactivation of the traces of unconscious wish and their 'construction', which represent the function of speech in treatment, appear impossible in connexion with a work

conception of expression is formulated and discussed in our own work, *Discours, figure* (1971), pp. 292 sqq.

3. Cf. in English, Standard Edition, Vol. IV, pp. 277-338.

4. G. LASCAULT, in the above-mentioned essay, derives from this set of problems the same methodological difficulty as we encounter here: 'to constitute a theoretical discourse that goes beyond the metaphors of aesthetics without disregarding them'. I agree with him that 'psychoanalysis makes it possible to define this project' (*op. cit.* (1969), p. 272).

On the question of interpretation see in particular: LAPLANCHE, 'Interpréter [avec] Freud' (1968), and, relating to Paul RICOEUR's book, *De l'interprétation. Essai sur Freud* (1965), the articles by Michel TORT, 'De l'interprétation ou la machine herméneutique' (1966) and by RICOEUR, 'Une interprétation philosophique de Freud' (1967).

of art that is itself a secondary trace, an elaborate amalgam of traces of unconscious wishes. Yet by following the trail of this difficulty, research has succeeded in breaking new ground and has discovered the existence of a space where there is some free play and mobility, a *void* thanks to which the work of art is not a symptom.

This difficulty brings us back to expression. The operations that constitute dream-work pertain, as we observed, to topological space, of which the operative rules violate linguistic space. A poet like André Breton, who is undoubtedly aware of the mechanisms of the dreams, but is determined to make no concessions to the demands of the unconscious in the rules of language, provides us with a simple example of the impingement of the former upon the latter in 'Mot à Mante' (in *Signe ascendant*), with such expressions as *nuagenouillé* or *oumyoblisoettiste*, fairly simple condensations or 'collages', yet sufficient to hinder the signifying and introduce the depth *pertinent to the meaning*. I cannot provide further examples here, but they all come under the heading of transgression.

It is obvious that 'figurative' operations reveal the same traits as those used by Freud in locating the 'unconscious', i.e., 'absence of contradiction, primary process (mobility of cathexis), timelessness and a substitution of psychical reality for external reality'.[5] He describes the same operations carefully in *Jokes and their Relation to the Unconscious* (1912), perhaps the most important text, as A. Ehrenzweig observed, regarding the psychoanalytic theory of art, because it is the only one in which the operations that form the object (in this case witticisms, but also works of art) are analysed and related to the workings of the unconscious.[6] Expression is the presence, in the secondary process, in speech and in realistic representation, of operations pertaining to the unconscious system. The introduction of such operations always consists in the formation of a *figure* (in one or several of the connotations mentioned earlier); this figure comes from 'another scene',[7] not that of the language, picture or sculpture in which it appears. It is the expression of a different kind of meaning, and the meaning it expresses is not present in the work in the same way as is its immediate significance.[8]

The primacy of the figure, of an arrangement of the parts of an object which cannot be deduced from the laws of the structure to which it belongs,[9]

5. 'Das Unbewusste' ('The unconscious') (1915): *Gesammelte Werke* (hereinafter indicated by the initials *G.W.*), Vol. X, p. 286. (N.B. We give references to that edition; for English translations of Freud's works, see the Bibliographical Annex at the end of the next chapter).

6. See EHRENZWEIG, *The Psychoanalysis of Artistic Vision and Hearing. An Introduction to a Theory of Unconscious Perception* (1953) and 'Une nouvelle approche psychanalytique de l'esthétique', in BERGE *et al.*, *Entretiens sur l'art et la psychanalyse* (1968). Cf. LYOTARD, 'Le travail du rêve ne pense pas' (1968).

7. '... ein anderer Schauplatz' – FREUD, *Die Traumdeutung (The Interpretation of Dreams)*, Chap. VII.

8. I am here using, with a different vocabulary, the research of A. Ehrenzweig. He characterizes this figure as *Gestalt-free* and *thing-free*, liberated from good form and from the realism of things.

9. Here it would be possible to discuss form as expounded by Vl. PROPP in his

was related by Freud, as we know, to the constitution of the wish. The hallucinatory nature of the image produced is due to 'helplessness',[10] a state in which an overflow of energy finds no outlet in real life and revives the traces of past satisfaction through a process of regression. Hallucination, whether dreamlike or not, constitutes the basic datum of art: the manifestation of a 'reality' other than perceptual. This 'reality', which Freud terms psychical, is related to the pleasure principle; it avoids the twofold requirement imposed by the normal reality principle: the association of psychical energy with the linguistic system and 'reality-testing' of a representation.[11]

But the figure in which the wish is gratified is not limited to the hallucinatory image. This image is itself an expression: it is the fleeting coincidental expression of a more primitive figurative force, the *original fantasy*.[12] This fantasy also deserves to be called a figure for several reasons: it avoids the logic of perception and language; it is a sort of form or configuration which will order the perceptions, speech and affects of the subject throughout his life; it is the imprint in psychical reality of the wish and of the forbidden, in other words the trace left on the subject by the withdrawal of the signifier, the mark of a want.[13] For Freud, art must be considered with reference to fantasy.[14] Not only did he attempt a direct demonstration on Leonardo da

Morphology of the Folktale (Russian original, 1928, 1969; English translation from the first edition, 1958, 1968; French translation from the second edition, 1970), and as contested by strict structuralism: cf. Lévi-Strauss, 'La structure et la forme' (1960).

10. *Hemmung, Symptom und Angst (Inhibitions, Symptoms and Anxiety)* (1926): *G.W.*, Vol. XIV, p. 113.

11. 'Entwurf einer Psychologie' (1895); *Die Traumdeutung* (1900), Chap. VII; 'Formulierungen über den zwei Prinzipen des psychischen Geschehens' (1911).

12. *Aus den Anfängen der Psychoanalyse*, Heft M (1897); works from the 1907-1909 period dealing with the relation between fantasy and origin; 'Mitteilung eines der psycho-analytischen Theorie widersprechenden Falles von Paranoia' (1915); 'Ein Kind wird geschlagen' (1919); *Drei Abhandlungen zur Sexualtheorie*, note 72 (1905);.*Zur Geschichte der psychoanalytischen Bewegung* (1914); cf. Laplanche & Pontalis, *Vocabulaire de la psychanalyse* (1967); and more especially, by the same authors, 'Fantasme originaire, fantasmes des origines, origine du fantasme' (1964).

13. It is on the basis of this withdrawal of the signifier that emotional space is constituted, the support of literary or visual space; such is the thesis maintained by P. Kaufmann in his remarkable book, *L'expérience émotionnelle de l'espace* (1967) of which the close correspondence with the reading of Freud made by J. Lacan will be apparent. See also P. Kaufmann's contributions to Berge *et al.*, *Entretiens sur l'art et la psychanalyse* (*op. cit.* 1968), *passim*. Cf. Laplanche, *Hölderlin et la question du père* (1967). For Lacan's interpretation one will find in 'Le séminaire sur "La lettre volée"' (1957) an easily available summary, useful as an example of the whole of the work of this French psychoanalyst (who himself placed it at the beginning of his *Ecrits* (1966) with supplements), and at the same time decisive with regard to our problem since it bears on a literary work, Edgar Allan Poe's tale, 'The purloined letter'. Far from saying that literature should be treated as a field for interpretation, as a symptom, it produces a representation-text which shows that 'the unconscious means that man is inhabited by the signifier' (*l'inconscient, c'est que l'homme soit habité par le signifiant*) (p. 35). It is vain to put it aside, to *purloin* it, it will always reach its destination, as the tale teaches.

14. *Der Wahn und die Träume in W. Jensens 'Gradiva'* (1907); 'Der Dichter und

Vinci, and provide an involuntary illustration with Michelangelo's *Moses*, but in his texts on theory he describes the artist 'as a man who evades reality because he cannot reconcile himself to renouncing the satisfaction of impulses, as is demanded by reality from the beginning – a man who in a fantasy life gives free rein to his erotic desires and ambitions ('Formulierungen', Chapter 6). But the artist *does not hide* his fantasies, he puts them into the shape of real objects and furthermore he renders their representation a source of aesthetic pleasure ('Der Dichter und das Phantasieren', p. 223). According to Freud the aesthetic object is made possible because a similar want exists for art lovers, in other words *in reality*, as well. 'The dissatisfaction produced by the substitution of the reality principle for the pleasure principle is itself a part of reality.' ('Formulierungen', Chapter 6.) Thus it is in the gap left free for wish-fulfilment by the withdrawal of the signifier that the work of art finds its place. As for aesthetic pleasure, Freud interprets it in economic terms as a *seductive reward (Verlockungsprämie)*, as the permission given the reader or the art lover 'to gratify his own fantasies without reproach or shame' ('Der Dichter und das Phantasieren', *ibid*). The pleasure of art is the same as the pleasure of the game: it is announced that *in reality*, reality will be put aside in favour of pleasure. Paul Ricoeur [15] believes that he can build up his hermeneutic interpretation of Freud on the basis of the specific nature of aesthetic pleasure in relation to the libido, as characterized by the term 'reward', that enables released emotion to find its catharsis.

2. We can now understand what Freud meant when he stated that art is a 'reconciliation (*Versöhnung*) of the two principles' (of pleasure and reality), and in what sense this thesis must be taken as a starting-point. Play does not reconcile fantasy and perceptual reality by rendering one immanent in the other; rather it proceeds from the realization of their dissociation, while affirming the rights of the former in the enclaves that it creates in the latter. Art, an offshoot of childhood play ('Der Dichter . . .') is also in no sense a fusion of 'realities' which in Freud's view must remain for ever separate. Admittedly the artist brings about a much closer interpenetration of the two processes, the seizing of the elusive in the actual configuration of his game; a work of art, however, let us repeat, only belongs to reality by reason of the gap opened up by the want, which (for Freud) rules out any hope that the wish will ever become the actual world, that reality will ever become a game

das Phantasieren' (1908); *Eine Kindheitserinnerung des Leonardo da Vinci* (1910); 'Formulierungen über den zwei Prinzipen des psychischen Geschehens' (1911).

15. RICOEUR, *De l'interprétation. Essai sur Freud* (1955). Originating in this same question of external inwardness, of unreal reality, but still in line with the Freudian approach, is the theory of the transitional object formulated by WINNICOT, 'Transitional objects and transitional phenomena. A study of the first not-me possession' (1953). An artistic or literary object would seem to play the same rôle as a transitional object (thumb, comforter, teddy bear, later toys): while preceding the reality test, it would not be an internal object in Klein's sense of the word either. In connexion with this object, an adult never asks a child 'Did you think of it yourself?' or 'Where did you get that idea?'. There reigns between them a sort of convention of illusion. André Green (see below) applies this concept to the nature of tragedy.

(here we see how the path chosen by H. Marcuse [16] conflicts with Freudian theory). Above all this is perhaps the point where the anaclasis of art and sickness breaks down: the function of art is not to provide a true likeness of wish-fulfilment but to show by the arrangement of its figures which deconstructions should be achieved, in the field of perception and language (in other words in the preconscious field), so that a figure of an unconscious order can be – I will not say recognized, since deconstructions in which the 'figures' dwell are themselves obstacles to lucid perception and intelligence – but rather guessed at through its very hiding: the beating of wings, Nietzsche's doves' feet, etc. The purpose of art is to reveal the unfulfilled wish (to which the artist's impatience and dissatisfaction are living witness). Due recognition must be given to all that *differentiates* the function of the figure in art from its function in dream or symptom: in the work of art the *same operations* of condensation, displacement, figuration, which in the dream or symptom have no purpose but to *disguise* the wish because it is intolerable, in artistic expression are used to set aside the harmonious, the reassuring, the familiar, the 'good form' (A. Ehrenzweig), in other words the secondary process, the preconscious, in order to expose the ugly, the disquieting, the strange, the formless, which represent the 'chaos' of the unconscious. One merit of Klein's school was to expose the fundamental purpose of 'ugliness' in great works.[17] Analyses carried out by A. Ehrenzweig, albeit made from a completely different angle (that of *depth psychology*) and bearing on a different aspect (no longer the relations of objects but the operations that produce the work) reached the same conclusions with regard to the presence of the 'horrible' ('horrible beauty' as Baudelaire wrote) in aesthetic emotion. The work that results from this approach must be situated *beyond* the beautiful and the ugly. This is not to say that aesthetic emotion should be identified, as Ehrenzweig suggests, with that produced by the orgasm, in which terror is similarly mixed with pleasure.[18] If this were so, the 'figure' in art could not fulfil the function of *catharsis*. Freud always firmly postulated this function. Associated with it is the entire enigma of the difference between the symptom and the work of art, between disease and expression.[19]

16. MARCUSE, *Eros and Civilization. A Philosophical Inquiry into Freud* (1955): see in particular Part II.
17. On this question, see: KLEIN, 'Infantile anxiety situations reflected in a work of art and the creative impulse' (1929); SHARPE, 'Certain aspects of sublimation and delusion' (1930); by the same author, 'Similar and divergent unconscious determinants underlying the sublimation of pure art and pure science' (1935); PRICKMANN, 'The nature of ugliness and the creative impulse' (1940); SACHS, *The Creative Unconscious* (1942); SEGAL, 'A psycho-analytical approach to aesthetics' (1952). GOMBRICH, 'Psychoanalysis and the history of art' (1954), stresses this aspect by comparing in particular nudes of official French art with the *Demoiselles d'Avignon* of Picasso; with deforming glasses the aesthetic image of the former is improved; from this he concludes that 'ugliness' restores the onlooker to activity, whereas the best of official art makes him revert to passivity.
18. 'Une nouvelle approche psychanalytique de l'esthétque', p. 90 in BERGE *et al.*, *Entretiens sur l'art et la psychanalyse* (1968).

To identify this difference it is useful to refer to the central figure of M. Blanchot's thinking; [20] it will be apparent that these are the meditations of an expert. Orpheus goes down into the night of hell to rescue Eurydice on the condition, imposed by Hades and Cora, that he would not look at her until they had reached the upper world; however at the gates of hell he turns around to look at her and loses her; nevertheless a song rose from the dismembered body of Orpheus.

What the artist is expressing is the 'figure' of the unconscious (the original fantasy) which is that both of his wish and of his death; he knows that in its bareness this figure cannot be endured, and that if it is to be made manifest, it will be at the cost of first being brought near the light, reconciled with the laws of daylight, remodelled in line with good form and 'thingness'. Stop the tale here, and you will find yourself in the same position as Klein's school on fantasy and art: the reconciling function of fantasy (even that of adapting to reality), the need for the artist to go into *mourning* (not look at Eurydice) for the interiorized object if he wishes to be able to resurrect and exhibit it in the category of the beautiful.[21] But the legendary tale goes on: Orpheus turns round. His desire to *see* the figure overcomes his desire to bring it to the light. Orpheus wants to see in the night, to see night. By trying to see Eurydice he loses all hope of making her be seen: the figure is that which has no face, it kills the one that looks at it because it fills him with its own night; if the Ego should come to take place where the Id is,[22] it would immediately cease to be Ego. There is no 'reversible regression'.[23] It was for the sake of this back-

19. See *Eine Kindheitserinnerung des Leonardo da Vinci* (1910); 'Das Unheimliche' (1919); Freud's writings on Hamlet and Oedipus collected by STAROBINSKI in the Preface to the French translation (*Hamlet et Œdipe*, 1967) of JONES, *Hamlet and Oedipus* (1949).

20. BLANCHOT, *L'espace littéraire* (1955).

21. See note on p. 130 above and ISAACS, 'The nature and function of phantasy', in *Developments in Psychoanalysis* (1952). Mauron's theory of creation has developed in the same direction: cf. 'L'art et la psychanalyse' (1949); *Introduction à la psychanalyse de Mallarmé* (1950); (English version, *Introduction to the Psychoanalysis of Mallarmé*, 1963) and *Des métaphores obsédantes au mythe personnel. Introduction à la psychocritique* (1963).

22. 'Wo Es war, soll Ich werden' (Where it was, there ego shall be) are the last words of the IIIrd Conference of the *Neue Folge der Vorlesungen zur Einführung in die Psychoanalysis* (1932), *G.W.* XV. Freud himself had given a fair idea of the measure of success that may be expected from this 'sollen' by writing in 'The unconscious' ('Das Unbewusste') in *Metapsychologie* (1915), that in themselves the unconscious processes are unknowable.

23. The thesis of such reversibility is maintained by KRIS, *Psychoanalytic Explorations in Art* (1952), particularly in Chapter I, 'Approaches to art', for example on p. 25: 'The relationship familiar in dreamwork is reversed: we are justified in speaking of the Ego's control of the primary process ..., the capacity of gaining easy access to Id material The most general, one might say the only general hypothesis advanced in this respect came from Freud, who speaks of a certain "flexibility of repression" in the artist'. (Freud's book in question is the *Vorlesungen zur Einführung in die Psychoanalyse* (1917), *G.W.* XI, pp. 390-391). Again, in p. 302 of the same *Psychoanalytic Explorations in Art*: 'In states of inspiration it leads to

ward look that Orpheus went to fetch Eurydice, and not to create a work of art; the artist did not plunge into the night to put himself in a condition to compose a harmonious song, to reconcile night and day, to become re-nowned for his art. He went in search of the figural agency, the 'other' of his *very work*, the unseeable or death itself. The artist is one in whom the desire to see death even at the price of dying is stronger than his desire to create. We must stop looking at the problem of art in terms of *creation*. And as to the wish to look at the night, a work is never more than the proof of a failure to fulfil it. To contrast a work of art with a symptom, as one would success (or reconciliation, peace, even victory . . .) with failure (or hostility or dualism), is to adopt the same attitude with regard to 'expression' as academism, it is to tolerate only 'art' that is reassuring, that reconciles, that is *separate*, as

active elaboration in creation. The process is dominated by the Ego and put to its own purposes – for sublimation in creative activity'.

In the *Vorlesungen*, Freud does not use the term 'flexibility' but *Lockerheit*, 'laxity' or 'laxism', in repressions which normally put an end to conflict. He as-sociates this laxity with the capacity· to sublimate. Yet neither one nor the other gives grounds for the idea that the Ego should dominate the process of 'creation', let alone control the primary process. E. Kris compares artistic production with scientific thinking (*ibid.*, p. 296); this goes quite against Freud's consistently main-tained differentiation between knowledge and expression; flexibility of repression would bring the artist closer to the pervert than to the scientist. This thesis of Kris appears also in MOSSE, 'Psychological mechanisms in art production' (1951); in GOMBRICH, 'Psycho-analysis and the history of art' (1954), mentioned earlier; in BELLAK, 'Free association: conceptual and clinical aspects' (1961); and in MAURON, *Des métaphores obsédantes au mythe personnel* (1963), from which I have bor-rowed the expression of 'reversible regression' (*op. cit.*, p. 234). Everything becomes clear when Mauron describes the moment of the backward look in the following terms: 'He takes Eurydice back from Hell only to lose her again through a mistake which is curiously reminiscent of that made by Lot's wife' (*ibid.*). And even more plainly: 'Poetry is here conceived as an attempt at a synthesis of different elements – the conscience and two alien universes: the external and the unconscious This effort should be made by another agency. I have called it the "Orphic ego"'' (p. 221).

As for E. Kris, he defines (*op. cit.*, pp. 26 sq.) sublimation under two charac-teristics: displacement to a socially acceptable aim and 'neutralization' of libidinal energy. He conceives this neutralization as a 'liaison of energy'. But Freud had always taught that such a liaison constitutes not a neutralization of the primary process, but the secondary process. How then to reconcile it with 'flexibility of repression' and in general with visual or poetic creation, which cannot occur with-out transgression of the secondary order? In his approach to sublimation, Freud always related it to *Lockerheit* (laxity) of repression: compare the text of the *Vor-lesungen* with that of 'Das Ich and das Es' (*G.W.* XIII, pp. 272-275), in which sublimation is once again considered in relation to the existence of an uncommitted quantity of energy, displaceable (*verschiebbare*) and endowed with *Lockerheit*. A few lines before the passage quoted from the *Vorlesungen*, Freud wrote, in con-nexion with the decisive character of the quantitative factor in resistance to the process: 'All depends on the *quantity* of unemployed libido that a person is able to maintain in abeyance (*in Schwebe*) and the size of the fraction of his libido that he is able to direct away from sexual purposes towards sublimation' (p. 389). It is clear that far from depending on the control of the Ego over the Id, sublimation derives from the floating nature of energy, therefore from the distress of the Ego.

examplified in the semblance of 'life', in official alienation.

Some observations of the school of Klein will help us to grasp the purpose of expression, provided they are divorced from the concept of 'ego-gratification' or the equilibration of object-relations, in which they are frequently enmeshed. This purpose is neither *knowledge* nor *beauty*, but *truth*. Knowledge and beauty are charms, temptations that attract the poet and the painter, that incite them to soften, to make intelligible and loveable, to render logical and attractive the rough sketch extracted from the night. They urge him to create a work. But truth appears where it is least expected. Its emergence is sufficient to make a work of art, but a work of art will not make it emerge. The power of a literary or pictorial expression does not lie in its harmony (nor in the 'victory' of the ego), it is that which holds and maintains open and 'free' the field of words, lines, colours, and values, so that truth can 'figure' itself therein. When guilt and fear assail the sick painter his work closes in, it no longer houses truth, it becomes the stereotyped exteriorization of the hallucinations that haunt him.[24] This type of exteriorization is quite different from expression. Obsession and schizophrenia in themselves no more make it possible to disclose the figure than does 'health'. If it is Eurydice who flings herself in front of Orpheus and obliges him to look at her, there has not been in the subject that desire to see, that transgression of the frontier between day and night, that chink between the eyelids where the figure pauses for a second, leaving behind it a trace which is truth. A work that is forced upon its author does not disclose the trace of fantasy as a force of deconstruction, as a primary process marked by 'free cathexis', but rather the imprint of a defence mechanism, an unchanging matrix, a work showing anxiety in the face of desire against which all defences are raised. The truth-bearing power does not derive from the fact that the nameless terror is 'overcome', 'left behind', 'pacified' or 'known', but that the field should be left free for the elusive to leave its trace. Joanna Field is closest to the essential when she states that the voluntary work of the artist is only 'to plan the gap, to provide the framework within which the creative forces could have free play', and W. R. D. Fairbairn is right in recognizing that this effort is identical to that required of the subject by the basic rule of analysis.[25] In this enlarged and sustained vacuum the primary process can leave a trace of its operations without this trace being instantly ordered and repressed by the secondary process. Disease is not just the bursting-in of the unconscious, it is both that bursting-in *and* a furious struggle against it. Genius may plumb the same depths in search of the figure as does sickness, but does not fight against it; it desires it.

24. See Heimann, 'A contribution to the problem of sublimation and its relation to the process of internalization' (1952). After an 'acting out', the subject (a woman painter) compulsively produced a painting in a Victorian style which was quite the opposite of her usual *genre*.

25. Field, *On Not Being Able to Paint* (1950); Fairbairn, 'Critical notice on J. Field's *On Not Being, etc. . . .*' (1950); Winnicot, 'Critical notice on J. Field' (1950).

The artist is not a 'victorious' neurotic; it is not true to say that the greatness of his work is in inverse proportion to the intensity of the psychic disorder from which he suffers. The poems of madness of Hölderlin, the canvasses Van Gogh painted at Arles and Auvers, the writings of A. Artaud, the inmate of Rodez asylum, are there to testify to the credibility of the principle that from the depths of madness truth may be uttered. The converse is not true: intensity of internal disorder is not sufficient to produce poetry.[26] It is conceivable, and has been observed, that a single subject may harbour both terror of the nightly figure along with aberrant fantasies, repeated ceremonial, reliance on a mental straightjacket, the products of this secret terror, and at the same time the wish to share it in the fact and the strength to leave open some terrain for poetic or plastic expression on which it could leave a trace. No doubt this type of coexistence is unendurable and can drive the subject to the breaking-point, suicide, or to repression of the urge for truth (like Rimbaud), or to the vain confusion of the final state.

3. As long as the psychoanalytical approach to literary and artistic expression fails to give due recognition to this urge for truth, this desire to see, it will be condemned to extending the shameful list of 'diagnoses' of works, of the subject-matter of these works or of their authors.[27] In 1941, G. Kraus was able to count 18 diagnoses of the Van Gogh 'case' since 1920 (they alternated between schizophrenia and epilepsy). Ch. Mauron [28] adds his version: castration trauma. In 1954, D. E. Schneider corroborated [29]: 'He lives under the constant overpowering threat and masochistic passive homosexual unconscious wish for castration' (p. 230). In a recent article, Marthe Robert [30] also noted the ambivalent feeling towards the father in the clinical picture (the father a priest, religious vocation of the son, replacement of preaching by painting); but finally she cannot resist making her own diagnosis (tendency to narcissistic neurosis with melancholia). In this study, however, the question of building a relationship between the 'case' and the 'creator' is mooted.

One of the methodological conditions for such a construction should be the establishment of a relationship of an intelligible nature between the par-

26. On this subject see the preface by BLANCHOT, entitled: 'La folie par excellence', to the French translation (1953) of JASPERS' *Strindberg und Van Gogh* (1949). It seems to me that this study suffers from making too many concessions to the idea of 'the dialectic of mental aberration', of 'mediation' of the poet between the excesses of (unconscious) desire and the common measure. See also DERRIDA, 'La parole soufflée' (1965, 1967).

27. And it will be necessary, like LASCAULT ('Pour une psychanalyse du visible', p. 84 in TEYSSÈDRE *et al., Les sciences humaines et l'œuvre d'art*, 1969), to compare the encounter of psychoanalysis with art to the ridiculous dialogue of a 'blind analyst suffering from logorrhea' with a 'deaf and dumb' aesthetician.

28. MAURON, 'Note sur la structure de l'inconscient chez Van Gogh' (1953).

29. SCHNEIDER, D. E., *The Psychoanalyst and the Artist* (1954). The author does not scruple to conclude his study of Van Gogh with these words: 'Nothing is so obscene as self-torture which almost always flows from the sick distrust that underlies pathologic self-love'. But 'obscene' is not in the Freudian vocabulary

30. ROBERT, 'Vincent Van Gogh, le génie et son double' (1968).

ticular *style* of the artist under study, i.e., the new set of literary or pictorial problems initiated by him as 'creator', and the unconscious set of problems associated with his 'case'. It is of no interest whatever to conjecture whether Van Gogh suffered from narcissistic neurosis, schizophrenia or epilepsy: firstly, in the absence of the subject, the psychoanalyst declares a prescriptive dispensation; next, such a conjecture would assume that the secret of the forms produced by the painter or the writer are within the scope of clinical analysis and that clinical discourse is the whole of critical discourse. Even supposing that it were possible, by means of documentary processing (which moreover is extremely difficult), to identify those expressive forms which are in significant correlation with symptoms, and ultimately with clinical cases, no light would be thrown on the relationship of expression to the neurosis or psychosis.[31]

The painstaking exposure of themes and their unconscious foundations in literary works have been the object of research by Ch. Mauron and the psycho-critical school. Both from the psychoanalytical angle and from that of the theory of creation, this trend is related to M. Klein's school, as we have seen. But it includes considerable innovations with regard to literary criticism. Far from purporting to establish immediate correlations between the supposed initial *trauma* and the manifest content of a given work, it interposes between the two extremes intermediate formations corresponding to superposed layers of forms, the sedimentation of which would, in short, represent the genesis of works in their plurality, originating in a deep-seated matrix. This implies a sort of generative set of fantasies which, in connexion with literary figures, would be comparable to generative grammars dealing with the immediate constituents of speech, while avoiding the error of the semiologists (in the view of the psychoanalysts) of treating figure as if it were speech.

It is impossible here to give an account of the subtle analyses made by Ch. Mauron, which both illustrate and justify his method – a method which can in no way be criticized as being simplistic. The arrangement in tiers or layers of figures, and their internal organization, correspond to the arrangement of meaning revealed by the analysis: withdrawal (primal repression) by way of deconstruction and freezing in uncontrollable forms. But psychological criti-

31. On this subject see the recent clarification by MARINOW, 'Der malende Schizophrene und der schizophrene Maler' (1967): there is no psycho-pathological art (Volmat) but there is a psycho-pathology of art (a schizophrenic painter) and a psycho-pathology of pictorial activity (a schizophrenic who paints). SCHNEIDER (*op. cit.* pp. 197-205) attempts to establish on certain canvasses by M. Chagall a relationship between the subject pictured and a supposed aggressive compulsion against male authority. But this relationship is established in an unmediated way, the strictly pictorial properties being neglected in proportion to their abstraction in relation to the traumatic scene in Schneider's hypothesis: the analysis bears by preference on the subject of the picture; it finds it more difficult to relate to the aggressive compulsion in the palette and colour scale used by Chagall; finally, it fails to account for the spatial organization itself, other than to say that it is of the dream type (condensation and juxtaposition of heterogeneous elements – see p. 197).

cism perhaps omits a fundamental element from the literary work (as from
the artistic work): namely, the element of want or dispossession *(dessaisisse-
ment)* (Kaufmann). In his analyses of the origin of the 'personal myth' and
of the figures it arouses, Mauron doubtless admits the postulate of a want of
being, of a withdrawal of meaning which is variously revealed by the authors
under study; but this dispossession is then solidified on the fantasmatic
scene, it is identified as a figural *theme* in such a way that an empty space is
at play, so to speak, only *within* the work, in its *content*. But the question
posed by literature, painting or music to criticism inspired by psychoanalysis
concerns the space *in which* the works appear, in which they become possi-
ble. Any set of fantasies is due to some dispossession, but its operation also
consists in 'enclosing', in an inaugural and constant figuration the vertigo
which it arouses; thus, it makes this sort of want its *content-area* (as revealed
by Mauron). Artistic or literary work reverses the relation between expres-
sion and the area opened up by the withdrawal of meaning. It is not content
to exteriorize its deep-seated figures in symptoms; it exposes, if not the set
of fantasies itself, at least its traces, by making available an open, 'decon-
structed' space, that even goes so far as to distort the laws of language and
perception in such a way that the formative *operations* of the figures of the
unconscious and of their traces can, in this unencumbered space, produce
other figures, new figures, which can then be either poetic or plastic.

To consider Mallarmé as a man whose unconscious was haunted by the
figure of a dead maiden must not prevent one from studying the movement
that clears a space for this figure, in which the play of forms, by multiplying
operations of segmentation and combination, will be able to produce new
expressions. I would say that unconscious figures, in so far as they are *con-
stituted* and have the value of a *fate*, the value of meaning born of dispos-
session, will find in the secondary process as a bound process (linguistic
constraints, constraints of connotation of good form, of reality, etc.), an ally
which will put all its own constraints at their service. It is through endeav-
ouring to break through these constraints and to prevent their freezing into
an ice-barrier of established meanings that the artist will yield positive con-
sent to that which, in the unconscious, is mere dispossession, and will elimi-
nate any defensive rigidity. That this dispossession should thus be desired
(where it is dreaded in morbid exteriorization), that is the very essence of in-
spiration; there lies the principle of its truth-bearing function.

Transgression of the rule constitutes the visible aspect of this *work* which
may, admittedly, be assimilated to dream-work and in general to the opera-
tions of the primary process, but which repeats these operations only by re-
versing them, inasmuch as it applies them to the very outcome of that proc-
ess, namely the figures produced by fantasy.[32] Due precisely to this effort at

32. See, on the importance of transgression, Lascault, 'L'art contemporain et
la "vieille taupe"' (1968). The reversing is ignored, for example, in the classical
study by Marie Bonaparte on Edgar Allan Poe: 'Both [the dream and art] in fact,
act as safety valves to humanity's over-repressed instincts Thus works of art,
like dreams, reveal themselves as phantom presences which tower over our lives,

transgression which is characteristic of the desire to write or paint, the works of Mallarmé, Cézanne, Joyce or Picasso are associated with that advent of desire which constitutes the history of the West, and which leads it towards an ever more radical criticism of constraints in poetry or the plastic arts, a criticism that finds its counterpart in revolutionary criticism of economic, social and political constraints.

Assuredly 'modern art' is particularly revealing in this connexion and it can inspire some thoughts on the validity of the function of catharsis that Freud, after Aristotle, recognized in artistic and literary expression: for that opening-up of a free space in which the operations producing the deepest figures can become manifest, that 'let-be' attitude, that dizziness and that active passiveness, are its principal concern. Nevertheless, every great expression has been 'modern' in this respect, and continues to be so; a particularly valuable proof of this assertion, because it lies at the heart of Freud's work, is to be found in the rôle played by expressions of the art of tragedy (particularly in Sophocles and Shakespeare) in the very institution of psychoanalysis. This rôle is neither *illustrative* nor *didactic*; in no way can it be considered to pertain to what may be termed 'applied psychoanalysis'; nor is it solely heuristic, but truly *constituent* in the sense that it was by reference to the tragic scene where the dramas of Oedipus and of Hamlet take place that Freud was able to assign a place for the coming-together (the 'recognition', as Starobinski calls it, echoing Aristotle) of the results of his self-analysis as well as of those of his clinical practice, thus establishing their universal relevance.[33] For the

with one foot in the past and one in the present'. – BONAPARTE, 'Poe and the function of literature', pp. 83 and 86 in PHILLIPS (ed.), *Art and Psychoanalysis* 1957). Marie Bonaparte in particular states that the artist is subject to compulsive repetition just like anyone else. I acknowledge that he is subject to it, but not in the same manner. The interpretation of Marie Bonaparte is based on the 'drive' theory of works of art. The remark also applies to the attempt at a psychoanalytical study of the novels of Robbe-Grillet by ANZIEU ('Le discours de l'obsessionnel dans les romans de Robbe-Grillet', 1965). In an article printed immediately after the foregoing, 'L'œuvre et l'analyste', PINGAUD pinpoints the essential, maintaining that even if the written work actually addresses itself to its reader as to an impersonation of the psychoanalyst, then the 'writing appears to be the opposite (and the refusal) of the cure', because it sets speech in 'a place beyond space, a moment outside time, where no one speaks to anyone else any more' – a place in which one recognizes the representational scene. 'Instead of disarming fantasies and obsessions by bringing them forth to the light of consciousness', Pingaud adds, 'writing seeks to maintain their force intact, to use their wealth to its own benefit . . .'.

33. I follow here STAROBINSKI, Preface (1967) to the French translation of JONES, *Hamlet and Oedipus*; cf., by the same author, 'Psychanalyse et critique littéraire' (1966). There are also some thoughts on the truth-bearing function of the theatre in an article by O. MANNONI, 'Le théâtre du point de vue de l'imaginaire' (1959, 1969): 'The theatre is perhaps not so much an illusion as the reduction of illusion. By evoking them, after having incited them, the stage puts back in their place (in other words, concentrates on the scene of the dream) the classic, imaginary pity and terror' (*op. cit.* p. 215). Marthe ROBERT, in 'Raconter des histoires' (1970), takes up a similar viewpoint on the relationship between the *genre* of the novel and what

twofold operation to succeed, enabling Freud to situate the patient and himself as analyst, each in relation to the other, it is essential to call on the drama – canonical so to speak – of unconscious desire in *Oedipus-Rex* and of neurosis in *Hamlet*. Still obscure and unrecognized in writings such as 'Entwurf einer Psychologie' (1895), all the effort being concentrated on building up a system of knowledge, the Oedipus complex, the universal starting-point of psychoanalysis, has never been the subject of a full-length study, perhaps owing to the eminent truth-value achieved through its expression in tragedy.[34]

If tragedy is apt to provide a springboard for the psychoanalytical scene, it is because the inversion has already taken place whereby the space of desire, the primal fantasy space centred on the want which is basic to it, is represented in the scenic space, which is the space opened up by the desire to see the desire. It is not only through the element of fate in it that tragedy will inspire the theme of psychoanalysis: the position as expression-giver, which calls upon the same dispossession in the artist as in the hero (but to a dispossession that is sought after, not merely encountered as in the case of Oedipus, or inhibiting as in the case of Hamlet), this position prefigures the relationship of speech in analysis with the desire that is its object. Is not the

Freud has called the 'family novel of neurotics' ('Der Familienroman der Neurotiker' (1909), *G.W.* VII, pp. 224 sqq.): 'It may be said that that novel of the origins, the novel of neurotics, not only reveals the psychological origins of the *genre* (. . .) but is the *genre* itself' (*op. cit.*, p. 77).

34. Particularly in a book by André GREEN, *Un œil en trop* (1969), we find the bridge between the truth-bearing function of theatrical representation (examined principally in connexion with the *Oresteia* and the Theban plays of Sophocles, in other words, the dramatization of parental relations, and the thesis of the withdrawal of the signifier, formulated by Jacques LACAN (cf. his *Ecrits*, 1966), that bears out P. KAUFMANN's work (1967) referred to above. Here is in condensed form the formula of this conjunction: 'Briefly, it is because the problem of the relationship to the Other manifests itself as representation that the drama appears in its turn as a representation of that very relationship to the Other' (p. 98). This should be understood as follows: the relationship to the Other, that is to say to the parents in the Oedipean triangle, is always *representation* in the sense of its hallucinatory form: the absence of the Other constitutes the space of desire where the representation opens. What is represented is always the relationship to the Other, the relationship of consanguinity as the place where dispossession occurs, since it is in the latter that the wish represents that which is absent. Green rightly stresses the element of separation and alienation: the tragedy in no way provides a spectacle of reconciliation, but of non-recognition: 'The chief signifier . . . is the death instinct'; and Green (pp. 268 sq.) praises Hölderlin for having considered the presentation of the tragic as the impossible union of 'God-and-man' purified by their unlimited separation (HÖLDERLIN, *Remarques sur Œdipe*, p. 63 in the French translation by François Fédier, 1965). The only reservation to be made in my opinion relates to Green's identification of dream-work with the work of tragedy, or of the order of drives as *repraesentans* with theatrical representation. Here he ignores the function of the *double inversion* inherent in a work of art; yet, as we have seen, he is perfectly able to situate it: inversion of content (the absence of the progenitor opens a space for dispossession and alienation) and container (the space of alienation, of representation, opens itself to the want of the signifier). In this connexion see LYOTARD, 'Œdipe juif' (1970).

twofold rule that obliges the subject on the one hand to practice free association, and the analyst on the other to listen to the patient's remarks with '(evenly) suspended, poised attention' tantamount to holding open, free of secondary constraints, a region in which the figural forms can reveal their presence? Once this area is freed, the difference between art and analysis is perhaps not so wide as is the hiatus between the desire to see the desire and the desire to give it expression.

We can understand how at this point rôles are exchanged and how expressive or representative practice serves as an introduction of psychoanalytic practice to itself.

In short, current trends may be broken down as follows:

1.1 Reading a work as an expression of drives (of the author or subject), in other words as a symptom.
1.2 The same reading corrected by introducing a theory of sublimation, which is most often a theory of the formation of the Ego.
1.3 An interpretation of the literary or artistic creation as a process of mourning for the interiorized object and of exteriorization of fantasy in an empty space.
2.1 A theory of literary or plastic space as the counterpart of unconscious space.
2.2 A reading of the work as a process of spatialization reacting back on a constitutive emotional dispossession, that of the want of the word of the Other.
2.3 A reflexion focused on the truth-bearing function of literature and the arts, and on the rôle that the *space* in which works of art come to being can fulfil in the very process of self-constitution of psychoanalysis.

Post-scriptum: The reason why I have not mentioned in this survey the works of Gaston Bachelard or of Sartre [35] is that the only thing they have borrowed from psychoanalysis is the name that it bears (a borrowing the meaning of which has yet to be interpreted). In both cases, this represents an effort by philosophies of consciousness to *avoid* the dimension of the unconscious. An idea of the difference between existential psychoanalysis and psychoanalysis proper may be obtained from the closing words of Sartre's *Baudelaire* (1947, 1963) [36]: 'The free choice made by man of himself is absolutely identical with what is called his fate' (*Le choix libre que l'homme fait de lui-même s'identifie absolument avec ce qu'on apelle sa destinée* – p. 224 in the 1947 edition). Existential psychoanalysis is contained in *L'être et le néant* (1943),[37] on pp. 643 sqq. *Les mots* (1964) [38] is probably the most 'Freudian' book written by Sartre.

35. For the critical conceptions of Bachelard and Sartre and their influence, see above, in the same chapter, 'The historical approach', by Béla Köpeczi, pp. 579-581.
36. English translation, same title (1964).
37. English translation, *Being and Nothingness*.
38. English translation, *Words* (1964).

As for Bachelard, he himself has finally dropped the word 'psychoanalysis' (in *La poétique de l'espace* (1958),[39] explicitly), which he had previously used in an anti-Freudian sense, even though – or, rather, inasmuch as – in *La psychanalyse du feu* (1938),[40] the question of 'sexuality' assumed some prominence. On this subject see the issue of *L'Arc* (1970) devoted to Bachelard. The same remark applies to 'Bachelardian' literary criticism: cf. Weber, Guiomar.

7. THE ANTHROPOLOGICAL APPROACH*, by *A. A. Gerbrands***

In the period between the two world-wars an important change took place in our conceptions about 'primitive art'. Until then it was generally assumed that this art was anonymous. Admittedly, any particular piece of such art must have been made by someone; but that author was usually presumed to have been an unknown somebody, a devoted servant of his people, submerged in their totality. His personality and his identity as an artist were supposedly of no importance – only his works counted and they could count only as the fulfilment of an essential function in the religious system pervading the community. In this largely religious context the creator of the object was assumed to be an irrelevant factor. We are slowly coming to see, however, that this alleged anonymity is a misconception, the result of lack of information and understanding of the rôle of the individual in societies in which this kind of art is made and used. Gradually we are coming to the realization that this art is anonymous to us only because we do not know its makers, yet in their communities there is no doubt whatever as to who they are. They are certainly not the nameless individuals that they might seem to be to the superficial observer, obliterated in the vague mass of strange faces in a forgotten village. The idea that the artist is nameless, lost in an undifferentiated mass, is a misconception to be traced back, in the first place, to our incapacity to distinguish as soon as we are faced with human types whose appearance seems very unlike our own. Man always feels insecure when familiar physical characteristics are absent or seem blurred under another skin colour. This lack of discernment has played us false ever since we first began to form collections of curiosa and to establish ethnological museums. There is rarely more than a vague indication of provenance attached to the older collections, supplemented in rare instances by hardly less vague indica-

39. English translation, *Poetics of Space* (1964).
40. English translation, *The Psychoanalysis of Fire* (1964).
* See also in *Main Trends in Social and Cultural Anthropology* (1979) by Maurice Freedman, the subsections 'Visual Art', 'Music', and 'Literature', pp. 54–67. To avoid duplication, what is offered here is meant as more detailed illustration of a specific aspect of current research.
** Institute for Cultural Anthropology and Sociology of non-Western Peoples, State University, Leiden, Netherlands.

tions about use or function. Information, however, about the individual background, i.e., the man or woman who made the object, who used it, and through whom the object came to life, until fairly recently was virtually non-existent. It is not difficult to understand why just this point was never recorded. In the past that man or woman always seemed to hide behind a wall of unknown faces in a stray village or to disappear in the ostensible chaos of a city crowd. Even the experienced anthropologist of today needs time to become sufficiently familiar with the amorphous mass of a strange community before he can distinguish one individual in it from another. Under such circumstances it is not surprising that it was often taken for granted that the separate individual in the unfamiliar community was of little importance. That made it all the easier to see the community as a kind of supra-individual unit, leading its own existence more or less independently of the individual, or at least determining the behaviour pattern of the individual to such an extent that he could do little more than undeviatingly follow the well-worn path of tradition. There is no question that in the communities usually labelled 'primitive' the power of tradition is very great. But even in the most conservative societies the margin of freedom which is allowed the individual in practice is much greater than ethnological theory was formerly willing to accept.

There is still another reason why the power and influence of the community could be overrated so easily. At first glance the behaviour of the people of an unfamiliar community seems to the outsider to have very little if any system. Obviously no human community could exist however without a more or less extensive system of rules, provisions or agreements. To grasp this system it is necessary to substract the personal element from a profusion of individual acts. For this the individual must first be dissolved, as it were, in the community, the community has to be de-individualized. This approach is justified, and may even be indispensable, when such abstract elements as the kinship system, the social organization or religious ideas are involved. But however much such aspects of a community appear in a sense to lead their own lives, in reality the mechanism of the community runs much less smoothly than the theoretician would like to think, as the gap between the ideal and reality is often far from negligible. This is hardly remarkable because that reality can only be the sum of the acts of individuals who often have far less desire to conform than theory would require. All this is certainly also true about art, where we are concerned on the one hand with an individual as a tractable member of the community, but on the other hand with that same individual as an artist who in any society, by the very nature of his gifts, must be to some degree the non-conformist.

The bent to overrate the power of the community is not the only factor we encounter in evaluating a work of art from an alien culture. There is also the legacy of nineteenth-century materialism, with its tendency to approach a work of art primarily from the technical angle: the material it was made of, the tools that were used and the way it was made. These are obviously very important questions as material, tool and technique do much to determine

the final form of a work of art. Overlooking the human aspect of the strange work of art this technical approach originally completely dominated the study of so-called primitive art in both Europe and America. Understandably so if we remember that until the 1950's this study had to be based for the most part on objects in museums – dead, sterile objects whose contact with the human community that had used them was severed. So it seemed obvious to restrict oneself to the analysis of form, and its complement, the classification of characteristics of form in stylistic areas or evolutionistic sequences, because neither the maker nor the human or cultural background of the work of art is of much importance to technical dissection. It even could be put that the exclusive study of the technical aspect of works of art from an alien culture originated more or less inevitably from museum conditions.

If it is put in general terms one could say that these two approaches towards 'primitive art' have been in existence until today: the one a basically materialistic approach, or a technological one, and largely accountable for as a heritage of museum techniques; the other which could be labeled the humanistic or sociological approach, or perhaps better the cross-cultural approach after Melville Herskovits, who in 1945 pursued the point that 'the study of African art should be thought of as the analysis of a cross-cultural phenomenon which cannot be adequately understood unless its aesthetic values are fully related to its cultural background.' [1]

The historical development up to 1955 or thereabout of the two approaches sketched in broad outline in the foregoing is discussed in detail by Gerbrands in Chapter II of his *Art as an Element of Culture, especially in Negro Africa* (1957). As could be expected, the development since then shows signs of cross-fertilization though there are clear indications that the pure technological approach is becoming rarer and rarer and in all likelihood in a not too distant future will merge into the more universal cross-cultural or structural approach. The following may serve to bring Gerbrands' original survey up to date.

Shortly after the last war, in 1946, a pioneering work in the field of the technological approach appeared, i.e., F. M. Olbrechts's *Plastiek van Kongo*. Actually it was based on a large retrospective exhibition of Congolese art held in Antwerp in 1937-1938, but the war had delayed its publication. As it was originally published in Dutch, it remained nearly inaccessible for students of non-European art until 1959 when, after the death of the author, a French translation was published: *Les arts plastiques du Congo belge* in commemoration of the author who during his lifetime had been indeed 'le maître incontesté de la science de l'art african'. Olbrechts was the one who gave the technological study of non-European art its sound scientific base in that he for the first time applied to this kind of art the method of stylistic analysation well known from European art history. With great care and a keen eye for significant details he analysed a large number of Congolese sculptures. He thus was able to formulate the characteristics of a number of

1. HERSKOVITS, *The Backgrounds of African Art* (1945), p. 59.

art styles in the Congo Basin with a precision until then never achieved, nor strictly speaking ever pursued before. One has to do Olbrechts justice however in pointing out that he himself was not really satisfied with the results thus obtained. One of the aims of the 1937-1938 Antwerp exhibition had been to clarify what Olbrechts at that time called the 'social function' of a work of art, i.e., the relation between a work of art and religion, social institutions, symbolism and the artist. The results had been so meagre due to a lack of pertinent information, that it was decided to organize a special expedition 'to investigate into the origin of the work of art, integrated as it is in the social, the religious and the economic life of these communities'.[2] For this, the artist would be the starting-point: the motives which drive him to create, his sources of inspiration, the way in which he obtains his training, his technique, the economic or other factors which set him to work, his social position within his group – in short, a general examination of the artistic activity in the widest sense.[3] Or, as it would be put nowadays: a structural examination of artistic activities. The area choosen for the investigation was the Ivory Coast. Here in 1938-1939 Vandenhoute worked among the Dan/Diomande and the Gere/Wobe, and Maesen among the Senufo. It is most disappointing that neither of them up to the present has made the results of his investigations accessible in print, though admittedly part of it has been made use of by A. A. Gerbrands [4] and Robert Goldwater.[5]

The technique of stylistic analysis as it had been used by Olbrechts also was used more or less successfully by scholars like Th. P. van Baaren,[6] T. Bodrogi,[7] H. Burssens,[8] A. A. Gerbrands,[9] S. Kooijman,[10] D. Newton,[11] P. J. L. Vandenhoute,[12] and P. Wingert.[13] Basically it is the same technique as used in systematic botany and zoology, i.e., to select objects with an accurate and reliable statement of the place of origin and to use these as type-specimens, assuming that objects having the same formal characteristics (i.e., 'style') have the same origin. As Olbrechts did, they used this technique to define art areas which in their turn could then serve as a starting-point for

2. OLBRECHTS, *Les arts plastiques du Congo belge* (1946), p. 12.

3. OLBRECHTS as quoted in GERBRANDS, *Art as an Element of Culture, especially in Negro Africa*, p. 78.

4. Vandenhoute's investigations were partly published by GERBRANDS in *Art as an Element of Culture . . .*, pp. 78-93.

5. The results of Maesen's research were used by GOLDWATER in *Senufo Sculpture from West Africa* (1964).

6. VAN BAAREN, *Korwars and Korwar-Style* (1966).

8. BURSSENS, *Yanda-beelden en Mani-sekte bij de Azande* (= Images of Yanda
7. BODROGI, *Art in North-East New Guinea* (1961).
and Sect of Mani among the Azande) (1962).

9. GERBRANDS, 'Kunststijlen in West Nieuw-Guinea (= Artistic styles in Western New Guinea) (1951).

10. KOOIJMAN, *Ornamented Bark-Cloth in Indonesia* (1963).

11. NEWTON, *Art Styles of the Papuan Gulf* (1961).

12. VANDENHOUTE, *Classification stylistique du masque Dan et Guéré de la Côte d'Ivoire occidentale (A.O.F.)* (1948).

13. WINGERT, *American Indian Sculpture. A Study of the Northwest Coast* (1949).

154 Mikel Dufrenne et al.

investigations into cultural relations in space or occasionally in time, or simply to bring some kind of order in a museum collection. The latest in this field is R. Schefold's stylistic study of suspension hooks from the Middle Sepik River region in New Guinea, in which he used statistical techniques to establish the relative chronological relationship of forms within the region of study in order to recognize foreign influences within a style and also to characterize the specific tendency ('*das Wesen*') of the style.[14] More or less of the same kind as the above is a stream of more general publications dealing with larger areas or even with whole continents, with which the book market has been flooded since the 1950's.[15] What characterizes the above publications and many others of the same sort is that they all start from existing collections and take their interpretations and explanations from already available sources, i.e., the literature and the data accompanying the objects studied. For a structural study of the so-called 'primitive arts', however, the information one can take from existing sources in nearly all cases is so very poor that indeed the most obvious decision a man like Olbrechts could come to was to have the pertinent data collected in the field and from the people who made and used the works of art themselves.[16]

Not in all cases, however, did the existing information allow for only superficial conclusions about the cultural background of a work of art. An outstanding example of what could be achieved by patient analysis and carefully piecing together of small bits of information is W. H. Rassers and his interpretation of the Javanese *wayang* and *kris*. Originally his studies appeared in four publications between 1922 and 1945, and they were reprinted in English translation in 1959.[17] The same emphasis on the interdependance of objects and the other aspects of a culture is found in the publications of G. W. Locher, *The Serpent in Kwakiutl Religion* (1932), H. Schärer, *Die Gottesidee der Ngadju Dajak in Süd-Borneo* (1946),[18] and C. A. Schmitz, *Wantoat* (1963). It is also very strong in the work of Cl. Lévi-Strauss.[19]

Franz Boas, in his classic work *Primitive Art*, had already stressed the

14. SCHEFOLD, *Versuch einer Stilanalyse der Aufhängehaken vom Mittleren Sepik in Neu-Guinea* (1966).
15. To mention only a few of the more important publications of this kind: LINTON & WINGERT, *Arts of the South Seas* (1946); LEENHARDT, M., *Les arts de l'Océanie* (1948; BODROGI, *Oceanian Art* (1959); GUIART, *Océanie* (1963); GRIAULE, *Arts de l'Afrique noire* (1947); PAULME, *Les sculptures de l'Afrique noire* (1956); ELISOFON & FAGG, *The Sculpture of Africa* (1958); WINGERT, *Primitive Art. Its Traditions and Styles* (1962); and, finally, the series 'Kunst der Welt', which contains several volumes by well-known specialists.
16. Thus another student of Olbrechts, Miss M.-L. Bastin, was able to collect very useful information among the Tshokwe in Angola: see BASTIN, *Art décoratif Tshokwe* (1961).
17. RASSERS, *Panji, the Cultural Hero. A Structural Study of Religion in Java* (1959).
18. Re-issued in English translation under the title: *Ngaju Religion. The Conception of God among a South Borneo People* (1963).
19. LÉVI-STRAUSS, *Tristes Tropiques* (1955); *Anthropologie structurale* (1958).

point that for a clearer understanding of the history of art styles we would need a knowledge of the attitude and actions of the artist. 'Unfortunately, observations on the artist are very rare and unsatisfactory, for it requires an intimate knowledge of the people to understand the innermost thoughts and feelings of the artist.' [20] When Boas wrote these lines in 1927 he was quite right to say so, for at that time virtually nobody paid any attention to the individual behind the 'primitive' work of art. 'We have to turn our attention first of all to the artist himself' Boas quite rightly remarked.[21] The first to do so, even before Olbrechts, and in all likelihood independently from Boas, was H. Himmelheber who already in 1934 had studied the artist among the Baulé, the Atutu and the Guro in the Ivory Coast.[22] He also studied the artist among the Yaka, the Tshokwe and the Kuba in Congo,[23] and in 1938 among the Eskimo on Nunivok Island.[24] He went back several times to the Ivory Coast to study the artist among the Dan – Kran. The results were published in 1960 in an important publication *Negerkunst und Negerkünstler*. His steps were followed by E. Fischer who in 1960 studied the personality and the work of the artist among the Dan.[25] The increased attention to personality studies in cultural anthropology was reflected in a number of studies dealing, like Himmelheber's and Fischer's, with individual artists: W. L. d'Azevedo in 1956-1957 studied the artist archetype in Gola culture in Liberia and Sierra Leone.[26] Kupka went to study the artist in Arnhemland in 1959-1960,[27] Wm. Fagg collected, during several trips to Nigeria, information about well over a hundred carvers whose personal styles are now established by examples or photographs in the British and Nigerian museums,[28] and Gerbrands studied in 1960-1961 the artist, his personality and his work among the Asmat Papuans on the Southwest Coast of New Guinea.[29] Dark is presently engaged in a long-term ethno-aesthetic research project in the Kilenge area of Western New Britain where Gerbrands was to join him early in 1967. Lastly in the United States africanists are seriously engaged in the preparation of several research projects which will deal not only with the plastic arts, but with music, dance and the verbal arts as well, using the latest techniques to record sound and movement. The new structural approach to aesthetics and to the conception of art in anthropology shows a clear tendency towards an individualization of an art which until not so very long ago was generally considered to be an anonymous art. What William Fagg wrote a few years ago about African art in fact applies to all the arts hitherto

20. Boas, F., *Primitive Art* (1927), reprint (1955), p. 155.
21. *Ibid.*
22. Himmelheber, *Negerkünstler* (1935).
23. Himmelheber, 'Les masques Bayaka et leurs sculpteurs' (1939).
24. Himmelheber, *Eskimokünstler* (1939).
25. Fischer, E., 'Künstler der Dan, die Bildhauer Tame, Si, Tompieme und Sön – ihr Wesen und ihr Werk' (1962).
26. Azevedo, *The Artist Archetype in Gola Culture* (1966).
27. Kupka, *Un art à l'état brut* (1962).
28. Fagg, *Nigerian Images* (1963), p. 120.
29. Gerbrands, *Wow-ipits. Eight Woodcarvers from Amanamkai* (1966).

lumped together too conveniently under the one denomination of primitive art:

> That [African] art is made up of the works of individual [African] artists is a simple fact which somehow largely escaped notice until after the Second World War. In traditional ethnography there had seemed no more reason to inquire into the authorship of a dance mask or an ancestor figure than of a bow or a cooking pot; while the writers on 'primitive art' – that appendage of modern art – often seemed to regard African sculpture through a kind of mystical haze, almost as though it were a product of the collective unconscious – and this in the face of the most tangible evdence of individual originality. [. . .] In the study of art, information can never be properly ignored because it is too detailed; this is well established in European art and individual differences are at least as great and at least as signifi- cant in African art. We cannot be satisfied to identify a work as Yoruba, or even as from the Egba or Ekiti Yoruba; we must classify it if we can with the works of a particular village and a particular family of carvers, and if we can progress so far we shall usually be able to discover the carver's name.[30]

– which, in fact, was exactly the outcome of Gerbrands's research among the Asmat Papuans in the village of Amanamkai where he was able to identify and to describe the work and personality of eight woodcarvers.[31]

8. THE SEMIOTIC APPROACH, *by Louis Marin**

It is undoubtedly a hardy enterprise to try to describe the approach adopted by a science of art – namely the semiology of art – which, as yet, does not exist but which is feeling its way towards a methodology and trying to find its feet. But although, put in these terms, the task is hopeless, it may be inter- esting at least to try: there is so much and such varied research going on under this label in different countries that an overview of the subject may help to map out the lines of force and the divergencies, the various strata of ideas, ancient or more recent, thus encouraging those working in this field to indulge in that self-examination which leads to deeper understanding.

(a) The word semiology goes back to ancient Greek, and the Stoic philos- ophers' inquiry into signs, their strict linkage of the concepts of the signifier (*sêmainon*) and the signified (*sêmainomenon*), combining to form the sign (*sêmeion*), may well be regarded as being already a semiology in its own right, seeing that their introduction of the double dichotomy between 'per- ceptible' signifier and 'intelligible' signified and between referent and mean- ing clearly anticipates recent work.[1] Thus we are not concerned with writing the history of semiology, since it would be hard to distinguish from philo-

30. FAGG, *Nigerian Images*, pp. 119-120.
31. GERBRANDS, *Wow-ipits*
* University of Paris-X and University of California at San Diego.
1. JAKOBSON, 'Quest for the essence of language' (1965), pp. 21, 22. As will be

sophical thinking, which, since its earliest days in ancient Greece, has applied itself to the consideration of the connexion between sound and meaning, a fundamental problem in the science of language. What we should note is the reactivation [2] of the term *semiology* or *semiotic* concurrently by Ferdinand de Saussure in a famous section of his *Cours de linguistique générale* [3] and by C. S. Peirce in his classification of signs.[4] Thus, at about the same time, the term was revived and a programme sketched out for a general science of signs. But, from the outset, there was a certain ambiguity about semiology, and even the most recent discussions in the field of art still bear the traces of that ambiguity: Saussure, having defined the characters of *langue*, in relation to *langage*, as being its social, objective, homogeneous and concrete part, defined the institution of *langue* in its specificity as 'a system of signs expressing ideas and therefore comparable to writing, to the deaf-and-dumb alphabet, to symbolic rights, to the forms of courtesy, to military signals, etc. It is therefore possible to conceive of a science that studies the life of signs within the life of society; such a science would be part of social psychology ... We shall call this science semiology. It would tell us what signs consist of and what laws govern them.' [5] In Peirce, semiotic is identified with logic. 'Logic, in its general sense, is ... only another name for semiotic (*sêmeiôtikê*), the quasi-necessary, or formal, doctrine of signs ... By a process which I will not object to naming Abstraction, we are led to statements ... as to what *must be* the characters of all signs used by a "scientific" intelligence, that is to say, by an intelligence capable of learning by experience'.[6] Peirce's semiotic is divided into three main branches which correspond each to one of the three characteristic components of any sign, the ground, the object, and the interpretant.[7] The first branch is pure or specula-

seen in our conclusions, however, semiology, by a backlash effect which is in itself significant, is now uncertain about this point.

2. It would be useful, from the point of view of epistemology, to undertake an analysis of the notion of reactivation: see on this question certain pointers in CHOMSKY, *Cartesian Linguistics. A Chapter in the History of Rationalist thought* (1966), pp. 1-3.

3. Cf. 5th edn. (1955), pp. 32 sqq.

4. To be found in Volume II of his *Collected Papers*.

5. '... un système de signes exprimant des idées et par là comparable à l'écriture, à l'alphabet des sourds-muets, aux rites symboliques, aux formes de politesse, aux signaux militaires, etc. On peut donc concevoir une science qui étudie la vie des signes au sein de la vie sociale; elle formerait une partie de la psychologie sociale ... Nous la nommerons sémiologie. Elle nous apprendrait en quoi consistent les signes, quelles lois les régissent ...'.

Do all linguistic or extra-linguistic signs in fact express an idea? This is a very important question, too easily lost sight of in semiotic thinking.

6. P. 98 in BUCHLER (ed.), *The Philosophy of Peirce. Selected Writings* (1940) (Chap. 7, 'Logic as semiotic: the theory of signs').

7. We ought perhaps to avoid translating or transposing this into the Saussurian term *signified*, as Jakobson does in the above-mentioned article. Peirce – and here his writings leave us in no doubt – thought of the interpretant of a given sign A as another, equivalent or more developed sign B, created by the sign A in the mind of the person whom it addresses.

tive grammar, the task of which is to ascertain what determines the meaning of signs.[8] The second branch is logic proper which ascertains the conditions of the truth of signs, that is, whether they hold good of their objects, or, as Peirce says, it is 'the formal science of the conditions of the truth of representation'.[9] Finally, the third branch, or pure rhetoric, ascertains the 'laws by which ... one sign gives birth to another'.[10] These references to both Peirce and Saussure, at the very beginning of the modern rediscovery of semiology, situate that subject within a characteristic triangle of forces constituted by three poles – the linguistic, the sociological and the logical; and perhaps these different poles, which thus define the subject, by a recurrent epistemological 'effect', cause tensions within the field which it covers, tensions which we think may account for the divergencies of approach met with in the semiology of art.

(b) The linguistic pole on which Saussure lays such emphasis is characterized by the fact that, although hypothetically and programmatically linguistics is a specific area within semiology, to the extent that the set of linguistic signs does not constitute the whole set of signs, nevertheless linguistics will be the basic model, epistemologically and methodologically, for semiology.[11] Non-linguistics signs – but how are signs to be defined? – will be studied by processes, methods and concepts of operation extrapolated from linguistics. If semiotics is to attempt to deal with the arts which do not employ language, it will have to start from the basic premise that they should be treated as languages, or better still it should project the Saussurian dichotomy of *langue* and *parole* on to works of art – a dichotomy, be it said, without which there could, for Saussure, be no such thing as semiology – and study the complex relationships between the two levels, using studied, careful extrapolations from linguistic concepts. Nevertheless, strong emphasis needs to be laid on the following point, sometimes forgotten in criticisms of this type of semiology: the extrapolation of concepts and methods from linguistics to an extra-linguistic field, and the application of a linguistic model outside its own field has the essential operative advantage of marking the differences, contrasts and incompatibilities between disparate areas, such marks having an appreciable heuristic value.[12] Nevertheless, though it takes these differences into account, the linguistic model, when applied to extra-linguistic material, introduces an approach to problems, conceptual patterns and semantic structures,

8. This definition should be read alongside the works of HUSSERL, particularly his *Logische Untersuchungen* I and II (1901, 1913) (English translation, *Logical Investigations*, 1970), in which he redefines pure general grammar in a very similar fashion.

9. PEIRCE, p. 99 in BUCHLER (ed.), *op. cit.* (1940).

10. *Loc. cit.*

11. 'Rien n'est plus propre que la langue à faire comprendre la nautre du problème sémiologique' ('Nothing makes us better aware of the nature of the semiological problem than the language') – SAUSSURE, *op. cit.*, p. 34.

12. See, on this point, JAKOBSON's programmatic pointers in 'On linguistic aspects of translation' (1959) and 'Linguistics and poetics' (1960).

which it might perhaps be as well to challenge, even if it means casting doubts upon the original linguistic model.[13]

The sociological or, to use Saussure's expression, 'psycho-sociological pole', comes out in the distinction between *langue* and *parole*. In a sense, therefore, it is dependent on the theoretical approach to problems which we owe to Saussure. If language seen as a system of signs is a social institution, might not other social institutions be considered to be systems of signs to which the same procedures of analysis, the same methods and theoretical hypotheses would, *mutatis mutandis*, then be applicable? [14] At the end of his chapter on semiology, Saussure refers to rites, customs and forms of courtesy. Might we not take our sociological viewpoint further and perceive and conceptualize as a social institution something which at the outset seemed to relate only to individual initiative or some universal categorization? Might we not take an overall 'sociocentric' point of view on the arts employing language, image, sound or gesture, and descry in the work of art under consideration – or in the perception by a given society, or a given class or group within that society, of that work of art – a codification or codifications which constitute regular institutions with their own stereotyped or diffuse norms which would thus be the structural basis of one or more sign systems? [15] Taking this point of view, there can be no question of thinking that semiological analysis exhausts at least hypothetically the work being studied, but such objective, scientific and rigorous procedures could be used to get an in-depth grasp of the work much more often than impressionistic and subjective 'criticism' would have us think. Works of art of all kinds could then be considered as the complex symbolic or symptomatic manifestations of a time, a place, a society or group, as variations on social institutions or social sign systems.[16]

13. On this subject, see DERRIDA, 'Sémiologie et grammatologie' (1968) and SCHEFER, 'Lecture et système du tableau' (1968). On the semiologie of music, apart from pages 22 to 38 of LÉVI-STRAUSS's *Mythologiques *: Le cru et le cuit* (1964) (English translation, *The Raw and the Cooked* (1970), pp. 14-30), also relevant are RUWET, 'Musicology and linguistics' (1967), MOUTARD, 'L'articulation en musique' (1972) and in particular a recent issue of the journal *Musique en jeu* (Paris), edited by NATTIEZ, entitled *Sémiologie de la musique* (1971). See also the sub-section 'Music', by Claude V. Palisca, in the next chapter of this work.

14. This is reminiscent of one of the most productive hypotheses in structuralism as applied to sociology or ethnology See for instance RADCLIFFE-BROWN, *Structure and Function in Primitive Society* (1952) and LÉVI-STRAUSS, *Anthropologie structurale* (1958), pp. 63 sqq. (English translation, *Structural Anthropology* (1963), pp. 55 sqq.).

15. On this point see BOAS, *Primitive Art* (1927) and LÉVI-STRAUSS, *Anthropologie structurale*, pp. 269-294 (English translation, *Structural Anthropology*, pp. 245-268) or else BOURDIEU, *Sur les conditions sociologiques de la perception esthétique* (1968).

16. Cf. the definition of a history of cultural 'symptoms' in PANOFSKY, 'Iconography and iconology' (1939, 1955): '. . . those underlying principles which reveal the basic attitude of a nation, a period, a class, a religious or philosophical persuasion We interpret all these elements as what Ernst Cassirer has called "symbolical" values. . . . This means what may be called a history of cultural symptoms

Finally, Peirce's definitions bring out clearly the third of the poles of attraction which influence semiology – logic, which was also dealt with at the same period in Husserl's *Logische Untersuchungen*, although in fact the term 'semiotics' does not occur in it. The general, abstract and formal science of signs: that is how semiotics is seen by Peirce, who aims to establish the universal laws governing the symbolic functioning and the interrelationships of signs, according to their various classes and types, wherever, in whatever forms and at whatever levels these general structures may manifest themselves. Is it possible to construct formal semiotic models of which works of art would be, as it were, the surface outcrops, at once complex and particular, the generative, selective and combinatory processes and rules of transformation which would be described and analysed by general semiotics? [17] There is no need to emphasize what a vast and difficult undertaking it would be to apply such a working hypothesis, the verification of which would require an immense amount of research. Just as, within the limited field of a particular institution, but one which is perhaps central to human culture as it exists and as it develops – i.e., kinship – it was possible to isolate 'the logical atom of kinship' [18] which, by transformations and combinations, gives the whole set of possible kinship systems, similarly we can speak, hypothetically, of the possibility of 'a logical atom of meaning', a general semiotic form the abstract universality of which would in no way prevent it from being specifically manifested in various cultural products.[19]

– or "symbols" in Ernst Cassirer's sense – in general.' (pp. 30, 31 and 39 in *Meaning in the Visual Arts*, 1955).

17. This recalls the relationship between research on grammatical acceptability and formal logic. The task of the mathematical analysis of syntaxes is to ascertain 'the possibility conditions for syntax in general', a revival of the idea of a general grammar, a natural universal design underlying any language, such as was developed in the seventeenth and eighteenth centuries. Noam Chomsky thus aims to construct abstract models as an approach to the workings of actual syntaxes. See CHOMSKY & MILLER, 'Introduction to formal analysis of natural languages' (1963), and CHOMSKY, 'Explanation models in linguistics' (1962) and, naturally, CHOMSKY, *Syntactic Structures* (1957) or again HALLIDAY, 'Categories of the theory of grammar' (1961).

18. 'L'atome logique de la parenté' – Cf. LÉVI-STRAUSS, *Anthropologie structurale*, pp. 56 sqq. (English translation, *Structural Anthropology*, pp. 46 sqq.).

19. We really do mean 'form': if the aim of semiotic research, in this view, does consist in the working out of a generalized scientific semantics, we must be quite clear that this subject will be, as Roland BARTHES says in his 'Eléments de sémiologie' (1964, 1965), § II, 2. 3, 'classement des *formes* du signifié verbal' (English translation, *Elements of Semiology* (1967), p. 45: 'a classification of the *forms* of the verbal signified'); or alternatively, a system of the signifiers taken as such, and not a system of the *signifiés* which, as Gilles-Gaston GRANGER so rightly says, 'both constitutes the object itself, the theme of a first-degree science and not a science of *langage* (we would say science of modes of expression), and, as meaning, refers back to a totalizing experience the interpretation of which is philosophical' (*d'une part constitue l'objet lui-même, thème d'une science du premier degré et non pas science du langage (nous dirions science des expressions), d'autre part, en tant que signification, renvoie à une expérience totalisante dont l'interprétation est philosophique –*

To conclude this initial overview of the semiological field based on the pointers supplied by the first thinkers who attempted to foresee the ground covered by semiology and draw up a programme for it, we should emphasize quite clearly that these three epistemological poles, as we have called them – the linguistic, the sociological and the logical – stand in a relationship of strict interdependence one to the other. Indeed, none of them exists except in its relationship with and distinction from the other two, and in fact semiology, to the extent that it is animated by the differential relationships between these three disciplines, should define itself as the interplay of the differences, contradistinctions and correlations between them. This interplay does not exclude feedback processes; as a result of these processes, certain challenges, changes or questionings which start out in semiology may come to affect also the sciences which constitute its borders, and between which it occupies the intervening space.

However, if these introductory pointers, which are so many necessary preconditions for a semiology of the artistic and literary modes of expression, have enabled us to recognize the 'transcendental' which establishes the right of a science in general to exist, we must now leave this level of the basis, which we have identified in its initial form and move on to examine semiological research itself, bearing in mind the epistemological tensions mentioned above.

(c) We must start with two preliminary remarks:

(i) With the artistic and literary modes of expression, we come up against highly developed and integrated sets of elements, which strictly speaking do not belong on the logical level on which we have so far moved. Literary or artistic works exist on a hierarchically higher plane, that of meaningful totalities. Semiological analysis, then, will be ineffective and worthless unless it is capable of decomposing such totalities into their constituent elements. But this process will itself fail to achieve its aims unless each constituent element is recognized in the function of integration which it fulfils within that totality. Analysis, to summarize, must 'delimit the elements through the relationships which unite them'. Thus each sign stands in a dual relationship – that of constituent and that of integrator – in respect of the other signs and of the totality. Situated at the point of articulation of *form* and *sense*, the sign, by virtue of its 'capacity for breaking down into lower-level constituents' and 'its capacity to integrate a higher-level unit',[20] is the object of semiotic analysis

Essai d'une philosophie du style (1968), p. 127). For this reason, semiotic analysis is constantly in danger of side-slipping from the study of the signifier to that of the signified. One must define scientific semantics as the theory of lexical patterns and at the same time acknowledge its close relationship with the phenomenology of cultures, i.e., with an interpretation of the substance of the signified. Distinguishing the respective areas or levels of research does not mean isolating them one from the other.

20. BENVENISTE, 'Les niveaux de l'analyse linguistique' (1962, publ. 1964, 1966): pp. 126-127 in BENVENISTE, *Problèmes de linguistique générale* (1966).

and is at the same time constituted by that analysis, to the extent that the lower and higher levels by which it determines both its form and its sense are not external to the analysis but are in the analysis itself, as its operators.[21] But the semiotic objects – the artistic and literary modes of expression – are sets of signs of which, to use a linguistic expression, the sentence on the one hand and the discourse on the other would constitute the hierarchical analytical levels. Is there any discontinuity between signs and sets of signs? Must semiotic analysis radically alter its procedures when it moves on from the structures and systems of signs to those sets of signs manifested in living communication? [22]

(ii) The second remark is just as basic: it is undoubtedly necessary – at least if we are to make the analysis as safe as possible – to distinguish between the modes of artistic expression which employ language, or literary modes, and others which do not and which relate to a substance other than the linguistic substance. Not that the premise which requires us to consider non-linguistic expressive objects as signs is inadmissible; since the beginning of human thinking about signs, the distinction between natural signs and conventional signs, typical examples of which are pictures and words, has maintained its validity, and we find this distinction once again in the concept of the motivated or arbitrary nature of the sign.[23] However – and this is where linguistics fully serves as a model for semiology – it is certainly the case that the literary modes of expression, as they are primarily linguistic in nature, can have linguistic procedures applied directly to them, whereas images, gestures and sounds, considered as signs, will, because of their independence and purity, be immensely more complex and perhaps in the long run impenetrable subjects of study – unless objects, images and patterns of behaviour can never signify autonomously and unless 'every semiological system [had] its linguistic admixture'. Perhaps the fate of substances other than linguistic substances is sealed by the fact that 'there is no meaning which is not designated', and that 'the world of signifieds is none other than that of language'. But this is also an advantage, inasmuch as objects, sounds and images are relayed or re-articulated in discourse which can no doubt be analysed by means other than linguistic analysis, which bears on first-order language; this other form of analysis would be based on linguistic analysis but would develop it and go beyond it.[24]

21. *Ibid.*, p. 122.
22. *Ibid.*, pp. 129-130.
23. Or alternatively the intrinsic or extrinsic quality of the seme, to use the terminology of E. Buyssens, *La communication et l'articulation linguistique* (1967), pp. 63-64; also by the same author, *Les langages et le discours. Essai de linguistique fonctionnelle dans le cadre de la sémiologie* (1943). For a discussion of the problems raised in semiological analyses by the distinction between motivated and arbitrary signs, see Mounin, 'Communication linguistique humaine et communication non linguistique animale' (1960, 1970) and 'Les systèmes de communication non linguistiques et leur place dans la vie du XXe siècle' (1959, 1970); also Barthes, 'Eléments de sémiologie' (1964), §§ II.4.2 and 3 (in English, pp. 51-54 in *Elements of Semiology*).
24. '... tout système sémiologique se mêle de langage [... il n'y a] de sens que

One noteworthy instance of this predominance of the linguistic pole in semiology is given by R. Barthes in 'Eléments de sémiologie'. 'Where there is a visual substance, for example, the meaning is confirmed by being duplicated in a linguistic message (which happens in the case of the cinema, advertising, comic strips, press photography, etc.), so that at least a part of the iconic message is, in terms of structural relationship, either redundant or taken up by the linguistic system. ... In more general terms, it appears increasingly more difficult to conceive a system of images and objects whose *signifieds* can exist independently of language: to perceive what a substance signifies is inevitably to fall back on the individuation of a language.' However, R. Barthes distinguishes between the relay-language of the non-linguistic substance and language as studied by the linguist. 'It is a second-order language, with its unities no longer monemes or phonemes, but larger fragments of discourse referring to objects or episodes whose meaning *underlies* language, but can never exist independently of it. Hence the idea of "*translinguistics*" of which semiology would be a part "covering the *great signifying unities of discourse*".' [25] This is the working hypothesis used by R. Barthes in his *Système de la mode*, or in his seminal observations on architecture, furniture, cars and posters. Here the basic problem is the following: when signifiers stand in an analogical relationship with the signifieds, i.e., when one is dealing with intrinsic semes, is it possible to articulate them n a discontinuous way, since discreteness is necessary for meaningfulness, and then to construct paradigmatic series made up of few and finite terms? The close relationship between signifier and signified is such that in this case it would seem impossible 'to dismember the signifier without cutting up the signified itself into isomorphic sections, hence the impossibility of the second articulation.' [26]

nommé ... le monde des signifiés n'est autre que celui du langage ...'. – BARTHES, 'Eléments de sémiologie', Introduction, development included only in the new edition with *Le degré zéro de l'écriture* (1965), pp. 80-81 (in English, *Elements of Semiology*, p. 10). [N.B. The translators of this work, Annette Lavers and Colin Smith, explain that they have 'preferred English to Latin in translating *signifiant* and *signifié*, even at the cost of the inelegant plural "signifieds"'.]

25. 'La substance visuelle, par exemple, confirme ses significations en se faisant doubler par un message linguistique (c'est le cas du cinéma, de la publicité, des comics, de la photographie de presse, etc.) en sorte qu'au moins une partie du message iconique est dans un rapport structural de redondance ou de relève avec le système de la langue. ... D'une manière beaucoup plus générale, il paraît de plus en plus difficile de concevoir un système d'images ou d'objets dont les *signifiés* puissent exister en dehors du langage; percevoir ce qu'une substance signifie, c'est fatalement recourir au découpage de la langue. ... C'est un langage second dont les unités ne sont plus les monèmes ou les morphèmes, mais des fragments plus étendus du discours renvoyant à des objets ou des épisodes qui signifient *sous* le langage, mais jamais sans lui ... une *trans-linguistique* ... la sémiologie ... cette partie qui prendrait en charge les *grandes unités signifiantes du discours*.' – BARTHES, *ibid.*, pp. 80-81 (*Elements of Semiology*, pp. 10-11).

26. '... de découper le signifiant sans que le signifié soit lui-même débité en tronçons isomorphes: d'où l'impossibilité de la deuxième articulation.' – METZ, 'Le cinéma: langue ou langage?' (1964). Christian Metz's works contain relevant and

But it is naturally in relation to literary expression that the attraction of the linguistic pole is most strongly felt, and particularly in the approach to the problem of style in the poetic process, which constitutes the archetypal model of semiotic analysis in literature and thus opens the way to a rigorous aesthetics of language. Perhaps it is worthwhile recalling here a possible definition of an aesthetics of language: 'we may call aesthetic anything which bears on the relationship between a structure and its contents, as soon as one considers the object as an object of possible contemplation', writes G.-G. Granger; and, in this sense, he is right to point out that 'the concept of style is not originally an aesthetic category'.[27] In a chapter in a collective work,[28] which marks the awakening of interest by American structural linguistics in poetic language – in particular under the distant but decisive influence of the Russian formalists [29] – R. Jakobson distinguishes six factors involved in verbal communication, each of which determines a different function of language: the poetic function is defined by its set towards the message as distinct from the code, the contact between addresser and addressee, and the context to which the message refers.[30] However, before we mention this 'canonical' analysis we should note that the general pattern on which it is based is that of the communication and transmission of a message from an

forceful thinking about the theoretical and methodological problems of the semiology of the cinema, in its relationship with the linguistic model. 'The linguistic and grammatical phenomenon', writes Metz, 'is infinitely vaster, and concerns the great fundamental figures used in the transmission of any information. Only general linguistics and general semiology ... can furnish the study of the cinematographic language with appropriate methodological models'. ('La grande syntagmatique du film narratif': p. 124 in *Communications*, No. 8, 1966). His discussion of the concept of double articulation is highly subtle: 'We must carefully distinguish two assertions: the first ... is that the cinematographic language in itself has nothing resembling the linguistic double articulation. The second, which we by no means wish to endorse, is that "the cinema has no articulations".' Metz goes on to distinguish, within the message of the film, five major levels of coding, each of which is a sort of articulation (*op. cit.*, p. 67, no. 2). See also Eco, 'Appunti per una semiologia delle communicazioni visive' (1967, 1968), pp. 139-152, or Lévi-Strauss, *Le cru et le cuit* (1964), p. 31 (in English, *The Raw and the Cooked*, pp. 22 sq.); cf. Marin on Lévi-Strauss, 'Récit mythique, récit pictural – A propos de Poussin' (1968, publ. 1969). Concerning the possibility and limits of a semiology of art, see Dufrenne, 'Art et sémiologie' (1967) and Benveniste, 'Sémiologie de la langue' (1969), especially on homology and interpretance.

27. Granger, *Essai d'une philosophie du style* (1968), p. 188.

28. 'Linguistics and poetics', in Sebeok (ed.), *Style in language* (1960).

29. In *Théorie de la littérature* (ed. Todorov, 1965) there is a collection of Russian formalist texts. On the problem under consideration, we recommend especially Eikhenbaum (= Ejhenbaum), 'La théorie de la méthode formelle' (1925) particularly pp. 38-40 etc.; Chklovski (= Šklovskij), 'L'art comme procédé' (1967); Tynjanov, 'La notion de construction' (1923), and Tynjanov & Jakobson, 'Les problèmes des études littéraires et linguistiques' (1928). On Russian formalism, see Erlich, *Russian Formalism* (1955).

30. 'The set (*Einstellung*) toward the message as such, focus on the message for its own sake, is the poetic function of language.' – Jakobson, p. 356 in Sebeok (ed.), *op. cit.*

addresser to an addressee. It follows that any message presupposes a code and a context. Concerning the code, Jakobson observes that 'for any speech community, for any speaker, there exists a unity of language, but this overall code represents a system of interconnected subcodes; each language encompasses several concurrent patterns which are each characterized by a different function.' [31] In this sense any use of a language predicates the employment of a multiplicity of codes within the overall code, this articulated multiplicity being itself a phenomenon of style.

But what exactly is the poetic function of language? What is the empirical linguistic criterion of the poetic function? Recalling the two basic modes of arrangement used in verbal behaviour, selection and combination, which themselves refer back to the metaphoric and metonymic poles of language,[32] Jakobson states that '*the poetic function projects the principle of equivalence from the axis of selection into the axis of combination*'.[33] Roland Barthes develops the same idea when he talks about transgression of the usual syntagm/system division: the paradigm (axis of selection) extends on to the syntagmatic plane (axis of combination); [34] according to Jakobson, 'equivalence is promoted to the constitutive device of the sequence'.[35] It is by exploiting this double interplay of syntagm and paradigm in the concept of 'coupling' that S. R. Levin manages to define the processes of poetic creation more exactly, while identifying the concept of style itself with precision: for him, poetic structure is 'a structure in which semantically and/or phonically equivalent forms occur in equivalent syntagmatic positions, the forms so occurring thus constituting special types of paradigms'.[36] These creative transgressions of the syntagm/system contradistinction come in the category of what have been called implicit or *a posteriori* codes of language,[37] that is to say codes which are worked out in the course of actual work of the message upon itself, in poetic works. Levin gives this excellent definition of the poetic code: 'In reading a poem we find that the syntagms generate particular paradigms, and these paradigms in turn generate the syntagms – in this way leading us back to the poem The poem generates its own code, of which the poem is the only message.' [38]

However, as Levin is the first to point out, there exists a third type of equivalent functions, those which are so in relation to the genre, the body of conventions, the positions equivalent with respect to the meter or the rhyme-

31. *Ibid.*, p. 352.
32. JAKOBSON, 'Two aspects of language and two types of aphasic disturbances' (1956), pp. 60, 76.
33. JAKOBSON, 'Linguistics and poetics', p. 358 in SEBEOK (ed.), *Style in Language*.
34. BARTHES, Eléments de sémiologie' (1964), § III.3.7 (in English, p. 86 in *Elements of Semiology*).
35. 'Linguistics and poetics', p. 358 in *Style in Language*.
36. LEVIN, S. R., *Linguistic Structures in Poetry* (1962), § 2.5, p. 18. See also the article by RUWET, 'L'analyse structurale de la poésie' (1963), pp. 38 sqq., and the same author's 'Analyse structurale d'un poème français' (1964).
37. GRANGER, *Essai d'une philosophie du style* (1968), p. 191.
38. LEVIN, S. R., *op. cit.*, § 4.9, p. 41.

scheme of a poem. This introduces another form of code, an explicit, *a priori* code which initially governs the use of a particular language for poetic purposes. Whilst the semiotic structural analysis of the poem must undoubtedly decipher the unique code of the poem of which it is the only message, it must do so within those *a priori* codes which are the general, conventional, explicit constraints determining the poetic use of language in general. And is it not a rule of analysis, a rule of thumb at least, which Levin gives us when he notes 'a rather consistent correlation between semantic couples and the syntagmatic axis and phonic couples and the conventional axis'?[39] The effects of style result therefore, it would seem, from an overcoding or from a multiple coding; and one can perhaps go along with Voegelin,[40] Levin or Ruwet when they suggest constructing a grammar of poetry which could 'describe the structure of a poem in terms of transformations effected on a nucleus or nuclei', and generating lexical relationships as well as poetic tropes.[41] But it should be realized – and preserved as one of the greatest benefits of semiotic analysis in poetry – that in the final analysis the poem which I read creates by its unique diction its own code, of which the poem itself is the only message. This is what G.-G. Granger might regard as analysis being drawn towards recognition of the individuation of the message, while offering to the addressee a general form, a general appearance, a discursive figuration which he will be able to apprehend intuitively, but which the semiotic analyst will have to break down into its techniques and its devices.[42]

(d) We have just mentioned discursive figuration as an intuitive mark of stylistic redundancies in poetry. We may ask – and here we come back to the beginning of this analysis – if visual figures or figures employing gesture, in so far as they are aesthetically expressive, are not susceptible of similar analytic procedures. R. Jakobson, in the paper quoted above, is strict on this point: 'Poetics deals with problems of verbal structure, just as the analysis of painting is concerned with pictorial structure. . . . It is evident that many devices studied by poetics are not confined to verbal art. . . . In short, many

39. LEVIN, S. R., *op. cit.*, § 5.1, p. 42.
40. VOEGELIN, 'Casual and noncasual utterances within unified structure' (1960).
41. RUWET, 'L'analyse structurale de la poésie'.
42. GRANGER, *Essai d'une philosophie du style*, pp. 200 sqq. There is an extremely large bibliography on the semiological analysis of style in poetry and in general: we find critical information on the application of information theory to the problem of style in TODOROV, 'Procédés mathématiques dans les études littéraires' (1965); here Todorov assesses the book by Max BENSE, *Theorie der Texte. Eine Einführung in neuere Auffassungen und Methoden* (1962) and the Soviet works inspired by cybernetics, especially *Strukturno-tipologičeskie issledovanija* (= Structural-typological Research) (1962-1963), or the stylistic theories of V. V. VINOGRADOV, *Sjužet i stil'* (= Subject and Style) (1963). See also V. V. VINOGRADOV, *Stilistika. Teorija poetičeskoj reči* (= Stylistics. The Theory of Poetic Language) (1963) and also *Problema avtorstva i teorija stilej* (= The Problem of Authorship and the Theory of Styles) (1962); and I. M. LOTMAN, *Struktura hudožestvennogo teksta* (= The Structure of the Literary Text) (1970). See also the recent work by GREIMAS and others, *Essais de sémiotique poétique* (1972).

poetic features belong not only to the science of language but to the whole theory of signs, that is, to general semiotics'.[43] This programmatic statement could be taken up and continued in several directions: the first, which is the one indicated by Jakobson, would be to study the figurative transpositions – pictorial, choreographic and musical – of various texts, in order to identify the structural constants of the action.[44] Research of this type is to be found right outside the field of semiology, in the work of P. Francastel [45] for instance, or in the works on iconography or iconology by the representatives of the School of Warburg, Panofsky [46] or Wind,[47] although the methodology they employ is not made entirely explicit.

Another direction could be that indicated by Jakobson when he writes: 'When handling the surrealistic metaphor, we could hardly pass by Max Ernst's pictures or Luis Buñuel's films *The Andalusian Dog* and *The Golden Age*'.[48] This remark echoes indications which he gives, in connexion with the metaphoric and metonymic poles of language, on the contrast from this point of view between surrealist and cubist painting, or between the films of Griffith and those of Chaplin. It would probably be possible, in this connexion, to return to the definition of the poetic function and apply it to the study of pictorial transgressions of the syntagm/paradigm contradistinction: the theoretical writings of painters like André Lhote, Kandinsky, Paul Klee and Mondrian could, from this point of view, provide a real proto-semiotics of painting.[49] The whole problem, here, seems to be that of ensuring a strict balance between analysis of formal relationships and semantic construction of the picture, a correlation of lines, colours and figures constituting a meaningful correlation.

A third avenue of research would be to treat Levin's third type of equivalent positions, those of the genre or convention which, in music, paintings, etc., constitute *a priori* codes which are just as binding as those which weigh

43. JAKOBSON, 'Linguistics and poetics', pp. 350-351 in SEBEOK (ed.), *Style in Language*.

44. See on this subject WALLIS, 'Mediaeval art as a language' (1968) and 'La notion de champ sémantique et son application à la théorie de l'art' (1966); also BENVENISTE, 'Sémiologie de la langue', 2nd part: cf. p. 129 *sub* No. 3 in *Semiotica*, I, 2.

45. FRANCASTEL, most recently in *La figure et le lieu* (1967): cf., for example, pp. 34 sqq.

46. PANOFSKY, for instance in *Studies in Iconology* (1939, 1962).

47. WIND, *Ästhetischer und kunstwissenschaftlicher Gegenstand* (1923, later reprinted in part in 'Zur Systematik der künstlerischen Probleme', 1925) and 'Some points of contact between history and natural science' (1936).

48. JAKOBSON, 'Linguistics and poetics', p. 351 in SEBEOK (ed.), *Style in Language*; cf. also 'Two aspects of language . . .', p. 78.

49. LHOTE, *Traité du paysage et de la figure* (1939-50, 1963); KANDINSKY, *Über das Geistige in der Kunst, insbesondere in der Malerei* (1912) (English translation, *Concerning the Spiritual in Art, and Painting in particular*, 1972); KLEE, *Das bildnerische Denken* (posthumous collection of essays, 1956) (English translation, *The Thinking Eye*, 1961); MONDRIAN, 'Réalité naturelle et réalité abstraite' (1957). On all these points, see the present author's 'Eléments pour une sémiologie picturale' (1969).

so heavily upon the poetic use of language, and on which the individual painter's, musician's, etc., implicit codes are superimposed. Particularly, instructive and productive is the semiotic analysis of the techniques of attribution of authorship in painting and music, studied both in synchrony and diachrony: semiotic analysis brings out in such cases not only implicit and explicit codes, but also the code of those codes, i.e., the institutional, codified forms of knowledge of those codes at various points in history, and in various civilizations, social classes and social groups.[50]

With this last question, as earlier with the concept of genre or convention, we appear to come back to the sociological or cultural polarization of semiotic analysis. If the symbolic function is a universal characteristic of man and his culture, the diversified human usages of this function are characterized by differences of time and place, giving cultures in their different forms.

From this point of view, present research on literature and folklore might seem to offer tentative guidance on the relationship between semiotic analysis and sociology in general. The importance of the 'Copernican revolution' represented by Propp's *Morfologija skazki* [51] is well known: his structural descriptions of the fantastic folktale opened the way to modern research on the narrative structures of the novel, the short story, and even of historical discourse.[52] But, from there onwards research work was faced with the choice between two alternative paths. The first was to make use of the synchronic study of the folktale for paradigmatic and logical purposes;[53] the other was to regard it only as an introduction to a historical and ethnographic study.[54] Lévi-Strauss, particularly in his criticism of Propp, took the first of these courses.[55] The second is characteristic of semiotic analysis in the Soviet Union, starting with the work of those who have, perhaps wrongly, been called 'formalists',[56] e.g., M. Bakhtin who, in his studies of the semantic structure of great literary works, uses the concept of 'world image' and P. G. Bogatyrev, who, with his more folklore-oriented approach, studies the hierarchized sys-

50. BERNE-JOFFROY, *Le dossier Caravage. Psychologie des attributions et psychologie de l'art* (1959). See also BOURDIEU, *Sur les conditions sociologiques de la perception esthétique* (1968); BOURDIEU *et al.*, *Un art moyen. Essai sur les usages sociaux de la photographie* (1965) and *L'amour de l'art: les musées et leur public* (1966).

51. PROPP, *Morfologija skazki* (1928, 2nd edn., rev., 1969) (English translation from the 1st edn., *Morphology of the Folktale*, 1958, 1968; there is a French translation based on the 2nd edn., *Morphologie du conte*, 1970).

52. Much writing on this, including, among the first theoretical studies: GREIMAS, *Sémantique structurale* (1966) and *Du sens* (1970); BREMOND, 'Le message narratif' (1964); TODOROV, *Littérature et signification* (1968) and *Poétique de la prose* (1971); and GENETTE, *Figures I, II* and *III* (1966-69-72).

53 MELETINSKY (= MELETINSKIJ), 'The structural-typological study of folklore' (1971): cf. especally, pp. 69-70. Contains extensive up-to-date bibliography.

54. MELETINSKY & SEGAL, 'Structuralism and semiotics in the U.S.S.R.' (1971) (written as a contribution to the present work): cf. pp. 89-90.

55. Cf. LÉVI-STRAUSS, 'La structure et la forme' (1960, 1973).

56. Cf. the above-mentioned articles by MELETINSKY and MELETINSKY & SEGAL, with extensive bibliographies; see also PROPP, *Istoričeskie korni volšebnoj skazki* (= The Historical Roots of the Fairy Tale) (1946).

tems of functions in folktales.[57] We can thus understand why E. Meletinsky and D. Segal can say that basically there is no clash between the genetico-historical method and synchronic description.[58] This is why folklore studies are particularly interesting from the point of view of the semiotic analysis of the literary and artistic modes of expression. Folk literature, with its strong patterning, its immediate semioticity and, at the same time, the way in which it has developed through various stages, not only allows concepts and methods for the study of the structure of subject and of the system of characters in verbal narrative art to be developed but also enables correlations with the historical and cultural context to be established.[59] Admittedly, the transfer from folklore to literature raises considerable epistemological problems: as both Lévi-Strauss and Meletinsky stress, the utmost caution should be shown in applying the models used for folklore to the complex aesthetic forms of literature: the work of Greimas, for instance, which follows lines indicated by Lévi-Strauss and Propp, and other work by E. Meletinsky, D. Segal, S. Neklyudov, E. Novik, to name only a few, demonstrate this line of approach and the difficulties which it encounters.[60]

(e) From another point of view, we should note that a considerable proportion of semiotic analysis can be traced back to the phenomenology of culture as developed by Cassirer, for instance in his *Philosophy of Symbolic Forms*.[61] The problem can be rated as follows: if the forms of art and other forms of cultural expression are to be regarded as similar to the constituents of knowledge and experience, are we not bound to fall inevitably into the errors of 'sociologism' or 'psychologism' which would block the way to any genuinely scientific approach? Symbolic 'culture-forms' are in fact 'types of creative activity and expression': it is the symbolic forms themselves which, in their emergent evolution are 'the true principle of organization for a phenomenology of spirit' inasmuch as a type of form 'is not to be thought of as a "substantial" thing but rather as a "function" of the human spirit', a universal function, always identical, but manifesting itself variously through time and in many places.[62] No doubt Lévi-Strauss has something similar in mind when

57. Cf. BAHTIN, *Problemy poetiki Dostoevskogo* (1963) (English translation, BAKHTIN, *Problems of Dostoevsky's Poetics*, 1973) and *Tvorčestvo Fransua Rable i narodnaja kul'tura Srednevekov'ja i Renessansa* (1965) (English translation, BAKHTIN, *Rabelais and his World*, 1968); BOGATYREV & JAKOBSON, 'Die Folklore als besondere Form des Schaffens' (1929).

58. MELETINSKY & SEGAL, 'Structuralism and semiotics in the U.S.S.R.', pp. 90-91.

59. Cf. on this point MELETINSKY, 'The structural-typological study of folklore', pp. 71 sqq.

60. See also the special issue of *Tel Quel* on *La sémiologie aujourd'hui en U.R.S.S.* (1968), with an introduction by KRISTEVA, an article by Viat. V. IVANOV, and studies centred around 'number in culture'.

61. CASSIRER, *Philosophie der symbolischen Formen* (3 vols., 1923-29) (English translation, *The Philosophy of Symbolic Forms*, 3 vols., 1953-57).

62. See HENDEL's Introduction to the English translation of the last-mentioned work, Vol. I, pp. 35 sqq.

he says: 'In the same way we may be able to show that the same logical processes operate in myth as in science, and that man has always been thinking equally well; the improvement lies, not in an alleged progress of man's mind, but in the discovery of new areas to which it may apply its unchanged and unchanging powers.' [63] If semiotics is to set itself up as the science of signs, i.e., as the general theory of the symbolic function in its products, it is undeniable that the phenomenology of cultural forms as conceived by Cassirer and as developed, in their different ways, by Panofsky and Susanne Langer [64] for instance, has made powerful efforts in that direction.

Hence the importance, in the semiotic analysis of the artistic and literary modes of expression, of an operative methodological synthesis, such as that carried out by Panofsky in *Meaning in the Visual Arts*, in which it would not be difficult to rediscover, on a higher plane and in a different field, that articulation of form and sense already noted above at the levels of linguistic analysis; as Bourdieu says, 'a work of art may yield various meanings on different levels, depending on the interpretative grid that is applied to it and ... the low-level meanings, i.e., the most superficial meanings, remain partial and mutilated, and thereby erroneous, as long as the high-level meanings which encompass and transfigure them are not captured'; [65] 'factual meaning' and 'expressional meaning',[66] the 'meaning of the *signified*',[67] in which we need to have at our disposal 'truly descriptive concepts' which constitute a genuine 'interpretation' of the work of art,[68] and, finally, 'intrinsic meaning or content' [69] at which level iconographical meanings and methods of composition are perceived as 'cultural symbols', expressions of the culture of a nation, a period, a class [70]: this methodological approach, which sees 'the

63. 'Peut-être découvrirons-nous un jour que la même logique est à l'œuvre dans la pensée mythique et la pensée scientifique et que l'homme a toujours pensé aussi bien. Le progrès ... n'aurait pas eu la conscience pour théâtre, mais le monde, où une humanité douée de facultés constantes se serait trouvée au cours de sa longue histoire continuellement aux prises avec de nouveaux objets.' – LÉVI-STRAUSS, *Anthropologie structurale* (1958), p. 255 (English translation, *Structural Anthropology* (1963), p. 230).

64. See especially LANGER, *Feeling and Form* (1953).

65. BOURDIEU, Postface to PANOFSKY, *Architecture gothique et pensée scolastique* (French translation, 1967, 1970), p. 137.

66. 'Both the factual and the expressional meaning may be classified together: they constitute the class of primary or natural meanings.' – PANOFSKY, 'Iconography and iconology' (1939, 1955), pp. 26-27 in *Meaning in the Visual Arts* (1955) (referred to by BOURDIEU, Postface, *op. cit.*, p. 138).

67. PANOFSKY quoted by BOURDIEU, *ibid.*, who refers back to 'Zum Problem der Beschreibung und Inhaltsdeutung von Werken der bildenden Kunst' (1932).

68. PANOFSKY quoted by BOURDIEU, *ibid.*, who refers back to 'Über das Verhältnis der Kunstgeschichte zur Kunsttheorie' (1925). See also 'Iconography and iconology', pp. 30 sqq. in *Meaning in the Visual Arts*: here PANOFSKY distinguishes (p. 33) 'three levels, pre-iconographical description, iconographical analysis, and iconological interpretation'.

69. PANOFSKY, 'Iconography and iconology', pp. 30 and 31 in *Meaning in the Visual Arts* (quoted in French by BOURDIEU, Postface, *op. cit.*, p. 139).

70. PANOFSKY, 'Iconography and iconology', pp. 30, 31 and 39 in *Meaning ...* (referred to by BOURDIEU, *ibid.*); cf. note (16) above.

ultimate truth of a style' as having no existence except in the continuous ex-
change between the framework, the conceptual and technical tools available
to a given mind and the solutions that that mind invents through such sche-
mata while transforming the original tools,[71] has been compared in a most
thought-provoking way by P. Bourdieu with the workings of N. Chomsky's
generative grammar 'as a system of internalized schemata by means of which
all the characteristic thoughts, perceptions and actions of a culture can be
generated, and only they'.[72]

Perhaps, from this point of view, we should analyse the codes underlying
the factual and emotional, or according to E. Panofsky, pre-iconographical
levels. Already at this primary level of the meaning of the work, even before
the eye sees the first image or the outline of the most primitive figure, semi-
otic analysis would then be able to show the part played by non-mimetic
elements in the make-up of the sign, and to show how, and within what
limits, such elements are arbitrary or dependent on the organic conditions of
the perception and formation of images.[73] This is why semiotic analysis can
find support in the enormous amount of material collected by *Gestalt* psy-
chology and sociology.[74] In such analyses, it would be possible to see, once
again, how form and sense are articulated, and how form and concept merge
in the hierarchized totality of the work as deciphered at all its levels of
meaning.[75]

We should now take a quick glance at the third, or logical polarization of
the epistemological field of semiotics. Like the other two tendencies, it seems
to us to be inseparable from semiotics itself; if semiotics claims to be scien-
tific and is seeking its scientific identity, it has no alternative but to try to
formalize and axiomatize itself so as to provide a rigorous basis for its many
activities. But efforts in this direction are by no means external to the make-
up of semiotics itself, since the founding of a science is one and the same
thing as the truly scientific practice of that science. However, as we said
with regard to the risk of 'sociologism' in semiotic analysis, the theory of

71. Cf. BOURDIEU, Postface, *op. cit.*, p. 161, which we summarize here.
72. BOURDIEU, *ibid.*, p. 152.
73. See, on this particular point, the paper read by Meyer SCHAPIRO at the Inter-
national Preparatory Conference on the Problems of Semiology (Kazimierz, Poland,
1966), 'On some problems of the semiotics of visual arts: field and vehicle in image
signs' (publ. 1969); see also, by the same author, the article 'Style' in KROEBER (ed.),
Anthropology Today (1953) and, for the methodological problems raised therein,
his essay 'The Joseph scenes on the Maximianus throne' (1958).
74. ARNHEIM, *Art and Visual Perception* (1954); it is of some interest to note the
significant areas of convergence between the research in *Gestalt* psychology and
the works of WÖLFFLIN, especially in *Kunstgeschichtliche Grundbegriffe: das Pro-
blem der Stilentwicklung in der neueren Kunst* (1915) (English translation, *Prin-
ciples of Art History: the Problem of the Development of Style in Later Art*). See
also some passages of GOMBRICH, *Meditations on a Hobby Horse* (1963), especially
p. 12 and p. 56, and in *Art and Illusion* (1959, 1962). For a criticism of Gombrich
on the problem of linear perspective as a 'natural code', see GOODMAN, *Languages
of Art* (1968), particularly p. 16.
75. On this point we should mention the noteworthy efforts of A. J. GREIMAS
and Julia KRISTEVA.

culture-forms, and the analysis of codes or of genres in the processes of creation and communication, rest, in the works of Cassirer and of Lévi-Strauss alike, on a general theory of symbolic function, though for completely different reasons in the two cases. These metaphysical horizons which can be glimpsed in the background of semiotic theory may to some extent be given scientific shape in an essentially logical, abstract theory of the sign and of meaning. Susanne Langer has shown that whereas arts and science on the one hand and mathematics and logic on the other both employ processes of abstraction, the forms of abstract art are not those of rational discourse 'which serve us to symbolize public facts, but complex forms capable of symbolizing the dynamics of subjective experience, the pattern of vitality, feeling and emotion'.[76] But it is understandable that some semioticians, particularly in the wake of neo-positivism and the work of Carnap, for the sake of strict scientific method, limit the logical base of semiotic analysis to those communication mechanisms which use vocal signs made up of discrete recurring units, which have a grammar and are used for interpersonal communication, i.e., to 'real' languages. This would make it possible to describe all discourse as 'either having the semiotic form "$Of(x)$" or deviating from it in *specified* ways',[77] the whole aim of the exercise being to define semantic universals, in particular, the essential logical structure of all human language. Do these theoretical requirements enable us to arrive at the universal of meaning by virtue of their extreme rigour? Or ought one not rather to remark with Jakobson, that 'the particular and the universal emerge as two correlated moments, and their synthesis reaffirms the irresolvable unity of the outer and inner side of any verbal sign'?[78] If linguistics is to be able to assert relationships of interdependence with the other sciences of thought, communication and language, it must, so Jakobson says in substance, define both the individual characteristics of language and its affinities with other systems of signs: the problem here is that of universal semiotic constances which make it possible to carry out intersemiotic translation, a 'transmutation [which] is an interpretation of verbal signs by means of non-verbal sign systems')[79] and *vice-versa*, which brings us back to the poetic function and the discourse which enables it to be said: formal research on the elementary

76. LANGER, 'Abstraction in science and in art': p. 180 in HENLE, KALLEN & LANGER (eds.), *Structure, Method and Meaning* (1951).

77. '... we would rule out, as non-language, systems which use other than vocal sign-vehicles; systems whose sign-vehicles are not composed of discrete recurring units (phonemes); systems which have unrestricted combinability of signs (i.e. no grammar); systems whose signs are iconic; perhaps even such systems – to add a pragmatic criterion – as are not used for interpersonal communication ... it will be assumed that it is possible to describe all discourse as either (a) having the semiotic form '$Of(x)$' or (b) deviating from it in specified ways.' – WEINREICH, 'On the semantic structure of language', pp. 142 and 148 in GREENBERG (ed.), *Universals of Language* (1963).

78. JAKOBSON, 'Implications of language universals for 'semantics', p. 276 in GREENBERG (ed.), *Universals of Language*. See the interesting bibliography at the end of Jakobson's contribution to this work.

79. JAKOBSON, 'On linguistic aspects of translation', p. 233 in BROWER (ed.), *On*

structures of meaning, and the construction of very general models,[80] of which works would be the manifestations obtained and selected from a set of alternatives hierarchized by rules of transformation etc., seems to us to be absolutely essential, in that it defines the transcendental conditions of possibility of any signifying system, thus enabling us to situate the semiotics of different regions in their interrelations, i.e., primarily in terms of their potential for reciprocal transposition or transmutation.[81]

We began by referring to the hopelessness of this overview of the semiology of artistic and literary modes of expression. The difficulty of the enterprise was due both to the diversity of the work and research undertaken on this subject, and – perhaps the most important factor – to the fact that since western thinkers have begun looking into signs and symbols, an implicit, latent semiology has emerged, with two aspects, one fundamental and one regional.

The difficulty of such an inquiry into the semiology of artistic and literary modes of expression becomes even more obvious when one realizes what a far-flung empire is covered by this tentative science of signs, the linguistic, sociological and logical elements which, by their interdependence and inter-connexions, constitute the domain of this science being themselves widely dispersed. Admittedly, linguistics opens and polarizes the semiotic field, but semiology emerges where there are gaps in the linguistic system, in the spaces left between the different uses of linguistics: some of these overlap and enclose others, and the semiology of artistic and literary modes of expression is referred back to symbolic manifestations codified by institutions and conventions of an irreducibly literary, artistic and social nature, but at the same time and in contrast, the breaking or upsetting of the codes of the particular language of a class or a group, at a given moment in time and in a particular place.

This means that semiology is operating on two levels: that of the latent, gradual building-up of symbolic objects and of significant systems in experience; and that of the conscious, rigorous building-up of such systems into structural objects, increasingly general, formal and abstract, culminating in the structure of the symbolic function in general.

Finally, it is possible that this task, with its elements at once far-flung and closely articulated, may throw up queries and challenges affecting the research programme and its basic premises. The main effects of this would be: the definition of significant systems as systems of communication and ex-

Translation (1959); see also p. 238 of same, and BENVENISTE, 'Sémiologie de la langue' (1969).

80. In this connexion, see the works of A. J. GREIMAS, *Sémantique structurale* (1966) and his articles on narrative structures collected in *Du sens* (1970).

81. Here we should mention the second issue (1960) of the journal *Langages* (Paris), bearing the title *Logique et linguistique*, which is devoted to the relationships between the two subjects, and includes articles by DUCROT, BAR HILLEL, CHOMSKY, QUINE, etc.

change; the challenging of the definition of signs as representations by a perceptible signifier of an intelligible (i.e., according to Jakobson, trans-latable) signified, '*concept pensé en lui-même dans sa présence simple à la pensée*'; the challenging of the very concept of communication as transmission having the function of passing on from one subject to another the identity of the thing signified; the concentration of attention in semiotics on significant non-expressiveness, on gesture and on *deixis* as a productive practice.[82] It is perhaps characteristic of a science which is still finding its feet that it should forge ahead with its theory and its research programme, and at the same time with heuristic practice, with the result that, as it advances, its basic premises are laid open to questioning. At all events, this is a sign of its fertility, even if the results do not yet fit together into a stable and strictly coherent system – but then, will they ever?

9. THE INFORMATIONAL APPROACH, *by Abraham A. Moles**

INTRODUCTION

What is today called informational aesthetics is based on the observation that all works of art and, generally speaking, any form of artistic expression can be considered as a *message* transmitted by a creative individual or micro-group, i.e., the artist, called the *transmitter*, to an individual *receiver* chosen from a given socio-cultural group, by means of a transmission *channel*, which may be a system of visual or aural sensations, etc. Starting from Shannon's [1] general communication theory based on mathematics (1948), informational aesthetics aims at an objective identification of the physical characteristics of the message and of their statistical properties. The approach is thus based on a formal theory similar to that of the physical and psychological sciences; it begins by deliberately *ignoring* the transcendental values of a work of art, though it may reintroduce them later on in the study as *capacities* inherent in the individual transmitters or receivers, which can be statistically demonstrated and experimentally controlled. In fact, following the usual practice of the natural sciences, it substitutes for the variability of the human being a model which psychologists would call a human operator, i.e., a model having a certain number of standard capacities, and then extends this model by examining variants thereof, using the algorism which Piéron calls that of *differential psychology*.

82. See on this subject the works of the *Tel Quel* group, and partcularly of Julia KRISTEVA, in particular 'Pour une sémiologie des paragrammes' (1967), 'La productivité dite texte' (1968), etc., published otgether in her essay collection, $\Sigma\eta\mu\varepsilon\iota\omega\tau\iota\kappa\eta$. *Recherches pour une sémanalyse* (1969), and her more recent essay, 'La mutation sémiotique' (1970).
* Professor at the University of Strasbourg.
1. Cf. SHANNON & WEAVER, *The Mathematical Theory of Communication* (1949).

Briefly, informational aesthetics appears as a branch of empirical psychology which comprises:

(a) a theoretical part: the drawing up of patterns and doctrines by means of reasoning, and possibly also by mathematical calculation;

(b) an experimental part: the study of the characteristics of the message, the creator or the receiver.

It developed in France between 1952 and 1958, also in Germany between 1955 and 1962, and its ideas subsequently spread in a variety of forms to all major countries. In the view of its founders, A. Moles and M. Bense,[2] it is of a primarily statistical and general character. It purports to be a science, the limits of its validity being *in fact those of statistical theory*, particularly Shannon's theory of information. Informational aesthetics thus represents a mental attitude which contrasts sharply with traditional philosophical aesthetics, and which has resulted in the adoption of categorical positions in favour or against.

It recently became apparent that the combined corpus of doctrine and experience in this field was directly linked with problems of a more general nature, such as for example that of the mechanisms of intellectual creation,[3] which appear, in *statu nascendi*, to be common to both the artistic and scientific fields; or to the production of 'works of art' by computer, the machine-writing of meaningful texts, the elimination of ambiguities from a mechanical translation, and generally speaking, to all the problems involved in simulating creative processes. In principle, informational aesthetics provides methods of structuring, rules and techniques for programming, and the statistically-based numerical data to be introduced into the process.

These theories are thus no longer purely academic; they are applied in laboratories and computer centres, sometimes under a great variety of names, and are the subject of an impressive total volume of scientific activity, a brief account of which is given in the Annex.

1. SUBSTANCE OF THE THEORY

The essential element in the discussion of the communication process is the *quantity of novelty* or *originality* transmitted by the message from the *Umwelt* of the creator to the *Umwelt* of the receiver. Shannon's major contribution [4] was to measure this in mathematical terms, taking a quantity known as information, or negative entropy, linked by a simple formula to the individual probability of the occurrence of elementary signs placed indiscriminately in a pre-existing *répertoire* and known in advance of the act of communication, both to the transmitter and to the receiver, with probabilities of occurrence which can be defined.

2. MOLES, *Théorie de l'information et perception esthétique* (1958); BENSE, *Einführung in die Informations theoretische Ästhetik* (1960).

3. MOLES, *Art et ordinateur* (1971).

4. Cf. SHANNON & WEAVER, *op. cit.* (1949).

This supposes that the message can be objectively *broken down* by an external observer who does not participate in the act of communication – in this case the student of aesthetics – into a series of elementary signs which can be identified and enumerated in a *répertoire*. This leads us directly to the structuralist hypothesis, with the postulate of the existence of atomistic phenomena; a fairly obvious example is linguistics,[5] where the 'atoms' are the words or letters of a poetic or literary text; a less obvious but acceptable example is music, where the traditional score reduces the musical message to a series of operational elements (notes taken from a répertoire, the sol-fa system); much less obvious is the example of the visual arts, where the notion of *Gestalt*, or form, is obvious from their very nature.[6] It fell to the early theoreticians in this field to surmount these obstacles by showing that the information concept was the meeting-place of atomistic, structuralistic doctrines and dialectical *Gestalt* doctrines, based on the *opposition* between a single *form* and a *background*, and also on the idea of *totality (Ganzheit)*.

With a deliberate disregard for the notions of meaning and significance in a work of art, informational aesthetics has concentrated in recent years, on the one hand on developing an increasingly close correspondence between the basic theory and real situations as regards the material nature of the message, the preparation of *répertoires* at the different levels of information, the investigation of probabilities of occurrence, the laws of arrangement, known as *assembly codes*, etc.; and on the other hand, on adding the concept of *Gestalt* to a number of other concepts taken as a starting-point, which are new contributions to computer science, and somewhat remote from the initial study of discrete messages made up of objectifiable signs, transmitted with an eye to maximum *economy* in the duration of communication or cost of *occupation of the channel*, which was Shannon's original concern. Informational aesthetics does, however, retain the *distinction* between *container* and *content*, and the temporary refusal to concern itself with content ('meaning', aesthetic emotion) or indeed with anything but the container (packing, coding, signals, forms) expressed in purely objectifiable terms. This is for example the attitude adopted today by content analysts, and it is not surprising that content analysis is largely based on informational doctrine.

Information is thus measured by the quantity of novelty; and it has been shown [7] that the *quantity of information* is merely a way of expressing the *complexity of a message*, a concept which appears to be fundamental. A message is considered as a sequence of signs, or possibly an assembly of parts, in the same way as an organism is an assembly of *parts* or *organs* subject to certain rules. One of the basic affirmations of the theory is that complexity, or information, a numerical magnitude linked to the message, is one

5. Cf. CHERRY, *On Human Communication* (1957).
6. Cf. ARNHEIM, *Art and Visual Perception* (1954, 1965).
7. Cf. von NEUMANN *et al.*, 'The general and logical theory of automata' (1951); MOLES, *Les musiques expérimentales* (1960); ASHBY, *An Introduction to Cybernetics* (1956).

of the vital objective units of measurement of perception, a point which was clearly established recently in a factorial study by Noll [8] at the Bell Laboratories. The complexity, or quantity of novelty provided by an aesthetic message is thus one of the *predominant units of measurement of perception.*

It then follows that one of the bases on which the work of art is adapted to the individual is the *optimization* of this complexity or information, bearing in mind the fact that the human receiver is in any case capable of apprehending only a *limited quantity of originality in a given unit of time*; this was first established empirically – with widely-scattered values – by industrial and experimental psychologists,[9] and then strongly confirmed by the work of physiologists on brain structures and corresponding cybernetic models.[10] Communication between human operators is in fact motivated less by the desire to reduce to the minimum the cost of occupying the transmission channel (time, in the case of speech; the surface of a gramophone record, when music is listened to; in reading, the number of printed signs read, etc.), than by the desire to produce a message having the *maximum impact* on the receiver. It is the idea of *intelligibility* which appears as a dialectical phenomenon linked with the originality of the message: the greater the information, the greater the novelty for the receiver; the greater the novelty, the less the receiver is capable of achieving perception, which dominates the totality on the heterogeneous signs received, of assembling them in a global pattern (*Gestalt*), or in other words, projecting his previous knowledge on to the message, and, briefly, understanding it. Thus the intelligibility of a message varies in inverse proportion with the information, and informational aesthetics claims that a large part of a work of art is based on a dialectical exchange, more or less sophisticated and more or less conscious, between originality and intelligibility; there is an optimum value for the typical human operator (differentially variable), which is more or less satisfied by a given message. *If* the message is entirely 'original', in the sense of the arrangement of its elements, it is merely a heterogeneous and completely unforeseeable assembly of all the signs in the *répertoire*; the operator can do nothing with it, is overwhelmed and gives up. *If* the message is entirely intelligible, it is at best entirely banal, wholly expected and entirely devoid of interest, since the operator already knows all that it contains.

Real messages are experiments, situated somewhere within these extremes, which, based on the subjective probabilities of elementary signs registered by culture in the memory of the human operator, introduce a subtle *dialectical* interplay between the *expected* and the *unexpected*, the known and the unknown, which explains one of the fundamental aspects of the work of art, considered as a special example of transmission in which the act of communication is gratuitous, in the philosophical sense of the term. Let us note in

8. NOLL, 'Computers and the visual arts' (1967).

9. Cf. HICKS, MILLER, BRUNER in ATTNEAVE (ed.), *Application of Information Theory to Psychology* (1959).

10. Cf. FRANK, *Grundlagen Probleme der Informationsästhetik und erste Anwendung auf die Mime pure* (1960).

passing that the purpose of a remarkable number of essays in contemporary art, both visual and sonic, is the almost systematic exploration, without any particular regard for the possible receiver, of the whole field between total order and total disorder, between the complete predictability of a blank wall, a blue square or uninterrupted noise in an oscillator, and the complete unpredictability of a group of chance splashes or a noise presented to the attention of the observer.[11]

2. DEVELOPMENT OF CONCEPTS

Based originally on physico-mathematical theory of communications constructed with the purpose of reducing the cost of transmitting original stimuli from one point to another (telecommunication), informational aesthetics thus gradually moved away from its starting-point as it reached a clearer understanding of communication between *human operators*, which is characterized by a kind of saturation as regards the flow of originality such operators are capable of apprehending. The measurement which is of most concern to it is not, as before, the quantity of information (measured in *binary digits*, *bits* or binary questions), but rather what it calls *redundancy*, which is in fact the number of signs in *excess* of that strictly necessary to convey the same quantity of originality by an unforeseeable assemblage, i.e., one which has no 'order' for the receiver. Redundancy is linked to intelligibility. It expresses the receiver's capacity to project global forms (*Gestalten*) on to the assemblage of signs which constitute the message. It is this measurement which is the most relevant to communication between human beings.

As summarized above, the informational theory of aesthetic perception may appear somewhat over-simplified. The refusal to consider questions of significance, the atomization, into elements in a répertoire, of forms which are visibly global – even if technical operations such as the scanning performed by television cameras are literal examples of this practice – the rôle of the cost concept,[12] even a generally-stated psychological cost, are crude arguments which have produced much controversy.

3. FIRST ADJUNCT TO THE BASIC DOCTRINE: THE IDEA OF LEVELS

Two additional observations enlarge considerably the scope of the informational approach by enumerating the many stages through which the work of art must pass, including the chain transmitter-channel-receiver, which forms the basic situation in communication.

The first is the banal observation that most messages are a ranking order of *levels* which the observer can separate more or less objectively, but which

11. Cf. MEYER-EPPLER, *Grundlagen und Anwendung der Informationstheorie* (1959).
12. See, in particular, the work of Zipf and Mandelbrot.

are closely intermingled in the global fact constituted by the aesthetic message. A musical work requires a large number of communication systems, which can be distinguished objectively by the observer and even subjectively by a painstaking receiver. There is a microscopic structure of *sonic elements* coming within the field of psychophysics (different perception threshold), a structure of assembled *notes* in a sol-fa register, culturally arbitrary but clearly established, a structure of *sonic objects* in the sense of a musical phenomenology which has been well tested by experiments in concrete [13] and electronic music, structures of assembled *culturally-familiar patterns* (melodic phrases, harmonic chords, etc.) and many others. At each of these levels of perception it is possible to discover elementary *signs* which can be 'expressed', a *répertoire* with groups of subjective probabilities, assembly or code laws, and consequently, a quantity of information for that level, from which can be deduced the approximately 'optimum' redundancy which the receiver can expect to take in, given his cultural equipment (*signs expectancy*). There thus exists an *order of levels*, which can in principle be separated experimentally, and among which the receiver's attention can shuttle or oscillate, in accordance with a *strategy of perception* which has been little studied to date.

In this connexion, systematic studies are in hand,[14] based chiefly on the construction of messages in which the levels of the *répertoire* are clearly separated and their interference with each other can be experimentally controlled. At each level are to be found *super-signs*,[15] which are in fact constituted by a standard stereotyped assemblage of signs from the next level below, thus coded into a 'sub-routine', to borrow a term from programming theory.[16] If it is admitted that a large number of informational levels react on each other, it will be seen that the idea of *pleasure*, which information theory links to the predominating sensation felt by a receiver in the case of a *Gestalt* problem easily resolved for a given stimulus, can be accommodated in a much more subtle manner.

4. SECOND ADDITION: THE IDEA OF THE ECTO-SEMANTIC OR
AESTHETIC MESSAGE

The second observation also gives a more general character to the range of discussion on information theory. It is what Moles calls [17] the opposition between *semantic* and *aesthetic* types of information, arising primarily from the *dual mode of apprehension* of the message received, and which has been taken up, more or less independently, by all authors concerned with the message or with semiology (Barthes's dispersion-field, Martinet's dual articu-

13. Cf. SCHAEFFER & MOLES, *A la recherche d'une musique concrète* (1952).
14. By SELLUNG, RONGE, HASELOFF and others.
15. Cf. MOLES, in RONGE (ed.), *Kunst und Kybernetik* (1968).
16. Cf. HARMON & KNOWLTON, 'Picture processing by computer' (1969).
17. *Théorie de l'information et perception esthétique, op. cit.* (1958).

180 *Mikel Dufrenne et al.*

lation, Bojko's artistic plane, Meyer-Eppler's ecto-semantic message, the content analyst's opposition between denotative and connotative, etc.). It is based on the idea that the message transmitted between transmitter and receiver, even if it appears as a single message to the receiver, will almost always appear to an external observer as two separate superimposed messages, the first of which is a semantic message constituted by signs that are *explicitly known and can be expressed*, not only by the external observer (the student of psycho-aesthetics or the linguist) but also by the *creator* and the receiver of the message, who are able to spell out clearly the signs of the code they assemble and perceive. It is thus an inherent property of this semantic message that it would be possible, at least in principle, to change the starting and finishing *répertoires*, provided that they are common to both communicators in advance, and to translate the message into another 'language' without impairing its substance. Examples are short stories, narratives, musical works which 'tell a story' or offer invariant melodic patterns that can be translated into any other language *exhaustively*, without any loss.

It is, however, entirely obvious that the messages normally transmitted between human operators extend considerably beyond semantic messages of this kind, in which each communication can be reduced to a system for recognizing signs; for example, the form of the sonic signal is not finally fixed once the score has been transcribed, however carefully, nor even when the receiver is able to recognize or read the score in its entirety. The real message goes beyond the semantic message. Moles [18] suggests for consideration that the semantic message is overlaid by an *aesthetic* message, composed of the aggregate of the variations, fluctuations and changes undergone by the *Gestalt*, or form, of the message while continuing to be recognizable, since signs can admit of tolerances or variations from a standard without ceasing to be recognizable as signs. A musical note may, without departing from the composer's written indications, vary slightly in pitch, duration or intensity, in a manner which is quite perceptible to both the performer and the listener, without either of them ceasing to recognize it as a specific note in the scale. A phoneme can preserve the same distinctive features [19] while varying appreciably in a large number of the numerical value characterizing it (Meyer-Eppler's ecto-semantic elements); a typographic character may undergo variations in form which are clearly perceptible and at the same time irrelevant to the recognition of the character, etc.

The aesthetic message is formed by the totality or sequence of all these variations – which are *perceptible*, i.e., above the differential perception levels making up what the psychophysicist considers to be the elementary 'grain' of the message – and at the same time *cannot be broken down* explicitly by the receiver. The way in which a musical message is actually performed in relation to a score read by, or familiar to, a conductor and his orchestra, the details of the brushwork of a painter in building up a figura-

18. *Théorie de l'information et perception esthétique, op. cit.*
19. Cf. Roman JAKOBSON, for example 'Phonology and Phonetics' (in collaboration with HALLE, 1956).

tive picture, remain by and large unformulated even if they have statistical characteristics which can be objectified by an external observer, in this case the student of aesthetics expressing himself in his own 'meta-language'. They include regularities to be found in different performances of a work, or throughout several types of different works produced by the same creator; they are grouped together under the collective term of 'style', or manner of execution, and can certainly be studied. In other words, there are varying degrees of originality in the manner of using the field of liberty or 'dispersion-field' [20] available to the creator in relation to the standard, basic, semantic message, i.e., a quantity of aesthetic information which can in principle be measured by an external observer studying the sonic or visual document on the basis of the determination of fluctuating elements and the probability of their occurrence. This is a differential system. The informational interpretation of the idea of style, or manner of execution, in relation to a fixed skeleton form, offers a precise definition of this concept of style in a given situation, once the basic semantic message has been clearly defined.

5. LIMITS TO THE CAPACITY OF THE RECEIVER

This method of reduction also implies that *if* the human receiver's capacity to apprehend the information is in some way *limited*, he will continually find himself faced with a *choice* regarding the different aspects of the message assailing him. If the basic semantic message is too rich or complex it will monopolize his attention, and he will be forced to neglect the wealth of the fluctuating aesthetic message superimposed thereon. Should this not be the case, he will 'request' or desire that it be reduced, thus suggesting a *rule* of composition to the creator whose object is to be heard and fully accepted. The semantic and the aesthetic messages would then be contrapuntally offset, an argument which has been supported by a number of recent developments in contemporary music.

Furthermore, in accordance with what has been noted above, the enlarging of the theory of the message to include a series of levels, each possessing its *répertoire*, code and measurable quantity of originality or information, produces a kind of plan, or *informational architecture*, which holds the message fast in a series of numerical characters. It also implies for the spectator, listener or reader a constant choice between *levels of attention*. The receiver may interest himself in the interplay of chords, the timbre of the instruments, the ornaments, the sequence of melodic patterns, the overall structure of the work to which he is listening as the sound comes and goes; he may turn to the details of the picture, the play of the geometrical masses or forms, the major splashes of colour, or examine the print, the choice of words, the originality of expression, the development of the action in a novel, all of them to a varying extent original or conventional, but each time differ-

20. Cf. the works of Roland BARTHES, especially 'Introduction à l'analyse structurale des récits' (1966).

ent. It is the problem of choosing between levels which faces the receiver at each moment of the performance as it unfolds, and which in certain cases can be objectified. Informational aesthetics stimulates the experimenter to elucidate the modes of apprehension of a picture, or a sonic or literary form by, for example, systematically producing multiple structures having clearly characterized separate levels, with widely varying quantities of information, in order to study the behaviour of the average individual receiver. This has been done, for example, with purely artistic aims in mind, by Vasarély, in educational studies by G. Sellung, and by scientists such as Harmon and Julesz at the Bell Laboratories.

6. THE RÔLE OF AESTHETIC MEASUREMENT

Thus the informational theory of aesthetic perception, with its many variants and recent elaborations, proposes in the first place the adoption of an objectivistic position which temporarily sets aside the notion of value; a complex terminology, borrowed partly from computer science and achieving what Wertheimer calls a 'recodification of thought'; and a *system of measurement*, which at least in theory casts a close architectonic network round what used to be called the work of art, while at the same time *refusing to measure beauty* by only one index, which had long been the cherished dream of students of aesthetics, and was expressed in its most concrete form by G. Birkhoff around 1930. The theory seeks to define the nature of the aesthetic stimulus, to give it a *structure*, to apprehend the reactions of individuals to it and to predict their behaviour. Like all theories having a structuralist basis, it does not claim to provide the sole description of the work, but is in the philosophical category 'it is as if . . .'; it constructs a model and claims to produce results from its 'operation'. It is therefore judged by operational criteria and the quantity of new findings it contributes to contemporary aesthetics and art, and incidentally to other fields of the human sciences such as linguistics, the theory of creativity, etc.

7. CRITIQUE AND PRACTICAL DRAWBACKS

The theory nevertheless comes up against a number of basic difficulties:
 1. The concept of information is defined on the basis of probabilities of occurrence of the elementary signs which constitute the message. These signs must, in the first place, form a sufficiently large aggregate for the notion of 'probability' to be meaningful. Information theory supplies numerical values for the degree of correspondence between the novelty *proposed* by the message transmitted to the receiver and the quantity of novelty *acceptable* to the latter – but only in the case of messages comprising a large number of elements. At the present time it *says nothing* about the information, or the novelty or pleasure value, of a simple message comprising few elements,

such as the curve of a Greek vase or a very brief melodic theme. Here it is more appropriate to refer to other notions such as Birkhoff's concepts of quantity of symmetry (m = O/C), or the intrinsic characteristics of *Gestalt* theory. Max Bense [21] and the Stuttgart school showed that as the number of elements involved in a message increased, Birkhoff's well-known technique for measuring beauty based on the number of architectural rules in proportion to the total number of elements present in the field of perception, amounted only to the expression of a quantity of redundancy in relation to the variety of signs in the message, as suggested by informational theory. Thus these two aspects lead into each other.

2. A second objection to information theory is that the *set of probabilities* of the signs, and of the transmissible combinations where applicable, ought to be *stable* in the particular message proposed in relation to the aggregate of all the previous messages transmitted by the same channel (Boltzmann's ergodic theorem). In fact this is not the case, precisely for the reason that the transmission of a particularly original message, superadded to the preceding message, modifies the distribution of the frequency of occurrence of signs in the human or social group under consideration, and consequently the probabilities for the next message. Generally, however, it is justified to assume that these variations are slight and continuing, and that they represent a *cultural evolution*, if by culture is meant the way in which signs, symbols ('culturemes') and rules of assemblage *sediment* in the memory of individual members of a social group.

3. A third objection, which is more serious, is the relationship maintained between objective probabilities of occurrence of a group of signs at a given moment in a finite *répertoire* and the concept of measurement of the information provided to a given individual, based on a *subjective probability* of expectation of a sign or element of perception, or of a group thereof (*set of expectations*). This problem has exercised all those concerned with the theory of probability.[22] In addition, subjective probabilities are a function of individual culture, being different for the creator and the receiver; this implies that if the analysis is to be correct, one must introduce into the basic communication situation the concept of the *independent observer* expressing himself in a *meta-language*, or scientific language dealing with the communication language studied.

4. Further, informational aesthetics comes up against considerable experimental difficulties in the breaking down of the *ordered levels* of perception. We have seen that the majority of works or messages contain several levels, and that the attention of the receiver oscillates from one to another, depending on the quantity of information they convey and the structure of subjective probabilities which the receiver has retained from his culture. When classifying *répertoires* it is, however, frequently difficult to avoid randomness in

21. The reader may wish to consult the following works by BENSE: *Einführung in die Informations theoretische Ästhetik, op. cit.* (1960); *Aesthetica* (4 vols., 1954-56-58-60); *Theorie der Texte* (1962); and *Bestandteile des Vorüber* (1964).
22. For example, Paul Lévy.

allocating signs, supersigns, super-supersigns, etc. to clearly separate levels; hence there is uncertainty as to the scope and content of *repertories*, and consequently as to the value of the statistical conclusions which may be drawn therefrom. A number of recent studies making use of the concept of self-correlation (Julesz, Moles, Mathews[23]) to express numerically the difference between *near order* and *remote order*, and above all attempts at simulating, by computer, perception processes with several overlapping levels, should clarify this point, probably in correlation with a computer synthesis of aesthetic stimuli. For the time being, most scientists have been content to construct or study stimuli at a single level of signs which is defined as clearly as possible; in particular, they have set aside the *strategy* of the receiver when reading messages at several levels.

5. Lastly, the concept of the 'value' of a work, considered as an absolute, is entirely eliminated from informational theory. It is replaced by the concept of correspondence to an objectifiable *optimum* of *informational flow*, or redundancy, at several levels, linked to subjective probabilities, i.e., in the last resort, to social criteria, taking a typical standard human operator and his variants. This approach may be considered as fundamentally opposed to traditional aesthetics. It appears to prove its operational value precisely when the creator desires to communicate with the greatest possible number of members of the society (Max Bense's *Aesthetics of Men*), i.e., as a theory of applied aesthetics providing the creator with rules for communicating in *the best possible way* with the *largest possible number* of individuals in a given socio-cultural layer (by means of posters,[24] decoration, etc.). But it is much less operative when the creator refuses to consider that the purpose of the work of art is to give the greatest pleasure to the greatest number, and instead addresses himself to the problem of constructing new rules in the absolute (*Aesthetics of the Gods*).

8. EXPERIMENTAL WORK

A series of experiments has been conducted on the basis of informational aesthetics, using the same approaches. Many of them have been concerned with works of literature and music, since their message is concrete, objective and already recorded in a form such as a magnetic tape or a printed text which can be studied at leisure. Music is one art among others which in the West has long been based on the idea of a *score*, i.e., a 'programme of operations' made up of signs which can be isolated and reproduced in a performance; the concepts of semantic and aesthetic messages thus follow on naturally.

Recently, however, particularly since the computer invasion of the human

23. Cf. MATHEWS *et al., The Technology of Computer Music* (1969), and studies by Julesz, Mathews, Harmon, 'Picture processing by computers' (a brief account of these studies is to be found in MOLES, *Art et ordinateur*, 1971).

24. Cf. MOLES, *L'affiche dans la société urbaine* (1969).

sciences, the quantification and storage of signals, and the scanning of pictures by technical devices such as television cameras, etc., the basic arguments propounded by the founders of the theory have gradually acquired greater operational value and systematically enlarged their scope.

A large part of the early studies dealt with the constitution of *répertoires*. They linked up with statistical investigations pioneered by Yule, Zipf and Herdan, who studied the statistical organization of signs in a *répertoire* (Zipf's law): Guiraud [25] applied the same principles to the vocabulary of poetry. These authors were responsible for a school of *statistical linguistics* and for the preparation of critical studies on the 'historical falsity' or 'authenticity' of works, on the basis of the distribution of probabilities in their *répertoires* and an analysis of the entropy or information in a given message. Since then work has been carried over into other fields, particularly music, by Mol in Leiden and especially Fucks [26] in Aachen. Fucks has elucidated the stylistic, evolutionary laws governing the quantity of information in the history of music throughout the ages. The findings of these authors, in particular the 2-2, 3-3, etc. probabilities of assemblage of signs (Markoff's di-grams, tri-grams) expressed in so-called *transition matrices*, have already been used directly in composing machine music (Hiller,[27] Barbaud [28]) and in machine writing (Baudot,[29] Montreal; Lutz, Stuttgart school, Stickel, Bense, etc.).

Other studies have been carried out, chiefly as regards the separation of levels of perception, either for purely artistic ends (Vasarély, the 'Groupe d'Art visuel'), or for purely scientific ends (the emergence of forms constructed from supersigns which are entirely independent of their component signs (Noll, Harmon, Knowlton, etc.)). The measurement and separation of quantities of aesthetic and semantic information have been continued experimentally by Moles in the musical field, using various methods for *perturbing* or destroying the message, which affect the semantic and aesthetic parts in different ways (inversion, clipping, filtering, cutting, masking, etc.). Moles has also produced graphs showing the distribution of aesthetic and semantic information as a function of the different parameters of the sonic signal (frequency and levels). These methods are now being used in the study of visual stimuli such as pictures or posters, which have many possible industrial applications. Following on the work of Buswell, Molnar [30] has tried to establish the laws governing the movement of the eyes when looking at a picture, and to use them as a basis for constructing ordered rankings of signs and supersigns. Berlyne [31] has presented test cases with stimuli of increasing

25. GUIRAUD, *Problèmes et méthodes de la statistique linguistique* (1960).

26. FUCKS, *Mathematische Analyse von Sprachelemente, Sprachstil und Sprachen* (1955) and *Nach allen Regeln der Kunst* (1968).

27. HILLER & ISAACSON, *Experimental Music* (1959).

28. BARBAUD, *La musique, discipline scientifique* (1968) and *Initiation à la composition musicale automatique* (1965).

29. BAUDOT, *La machine à écrire* (1964).

30. MOLNAR, *Sur l'art abstrait* (1963).

31. BERLYNE, 'The influence of complexity in visual figures on orienting responses' (1958).

complexity in order to verify experimentally the law of *optimization* of complexity at a given level, described qualitatively by Moles in 1958.[32]

9. GENERAL FEATURES OF THESE STUDIES

Thus informational aesthetics as it develops gives a strong impression of constituting *unity*. In accordance with the principles of information theory and cybernetics, it is concerned with what is common to phenomena that are physically heterogeneous but can all be reduced to a *law-giving pattern* of communication, admittedly comprising many variants, but based on the idea of the transmission of a certain amount of novelty to an individual or mass group, measured by the abstract unit of magnitude called 'information'. It considers sonic, visual, literary or typographic messages, motion pictures or stills, the graphic arts or painting, artistic messages by way of scent or palate, merely as varying physical sensory channels to which it always applies the same methodology, as follows:

(1) description of the channel, the transmitter and the receiver, and formal and structuralist description of the message;
(2) study of the separable and expressible elements at the level under consideration, at the most elementary level (differential psychophysical thresholds);
(3) establishment of a *répertoire* of signs, study of their probability of occurrence in the cultural context of the act of communication;
(4) study of the laws of constraint governing the assemblage of these signs, which taken together constitute the *structure* as such;
(5) reconstruction of a model and its operation;
(6) critique of the inadequacies of the model, followed by further study either at another level of supersigns or from another angle with an improved model.

We have here a kind of thought algorism, which is extremely fruitful and is used systematically by a large number of scientists, whose experiments can easily be classified under these process headings.

On the other hand, informational aesthetics is not always so apposite when the communication mechanism of a system of elements that can be combined is not the essence of the artistic process. For example, it has very little to say about a large number of recent events in contemporary art such as the outcry provoked by surrealism, the *reductio ad absurdum* of the work of art brought about by 'pop' art or Klein's *Salon du Vide*, certain aspects of tachism (abstract expressionism) and formless painting, where the student of aesthetics gains much more insight from the sociological approach or from that of Husserl's eidetic reduction, etc., than from informational aesthetics.

It is specially at home with the elaborately-constructed systems of optical and kinetic art, new forms of computer art which are all more or less pro-

32. MOLES, *Théorie de l'information et perception esthétique, op. cit.* (1958).

duced by a process of combination, and what may be called 'permutational art'.[33] It is in very close agreement with much of the arts linked to *language*, since it revives the age-old metaphor of art as language in a concrete and operational form.

A high proportion of its most significant results, lying closest to practical application, i.e., 'works of art' which are introduced into the consumer society and commercialized, is to be found in the musical field, which by its very nature was predisposed to the manipulation of operational signs through the concept of a *score* (music for films, plays, ballet, etc.) It appears, however, that developments in this field will shortly be transposed to the *visual* arts, now that the basic manipulative element is the computer, linked to an interface system easily handled by the artist.

Abandoning its original highly atomistic character based on Shannon's work on discrete sequences of signs, informational aesthetics has developed towards an increasingly satisfactory recognition of what may be called the 'syntactic structures' of the *work* of art, considered as the generalized or generalizable form of a *copy* belonging to an imaginary museum, i.e., an element of a 'multiple whole', rather than as the expression of the transcendental uniqueness of a *chef-d'œuvre*, copies of which are no more than imperfect approximations, mass-produced and non-authentic.

10. PRESENT APPLICATIONS AND TRENDS

In fact, informational aesthetics is preparing the way for one branch of contemporary artistic development. It experiments with technical methods, elucidates syntactical structures and suggests *programming rules* in all matters concerned with the use of computers in the creation of aesthetic works. Moving further, it proposes 'thought experiments' dealing with the creative act, such as the idea of an 'imaginary machine' (Philippot) involving a series of simple actions carried out with inflexible precision, possibly without the use of machines, and aimed at producing a structured whole. It is in fact based to a large extent on the use of large-scale facilities for manipulating numerical data, which codify, for example, musical notes (cf. the work of Hiller,[34] Tenney and Beauchamp at the University of Illinois on the empirical simulation of the process of composition, the work of Barbaud [35] on algorithmic serial music as the result of a combination of elements, etc.). Similarly, it combines the literary experiments conducted by experimental literature groups (Lescure's S + 7 method for modifying the nouns in a text following a given rule, while retaining the syntactical structure as conceived by Chomsky) with experiments in the programming of a literary synopsis on

33. MOLES, 'Structure du message poétique et niveaux de la sensibilité' (1961) and 'Die Permutations Kunst' (1962).

34. HILLER & ISAACSON, *Experimental Music, op. cit.* (1959).

35. BARBAUD, *La musique, discipline scientifique, op. cit.* (1968); *Initiation à la composition musicale automatique, op. cit.* (1965).

the basis of the studies by Propp, Lévi-Strauss and Todorov; the direct construction of a sonic musical signal without any kind of score, using the graphic command facilities of computer subprogrammes (Music IV and V by Mathews, Gutmann and Risset at the Bell Laboratories); the construction of animated cartoons on related principles (work of Harmon, Knowlton and Mezei [36]; the systematic study of variants in a computer programme controlling a drawing machine (work of Nees, Francke and Nake in Stuttgart), creation by computer (Tokyo, Montreal), etc. From the general aesthetic point of view, most of these experiments should be regarded as the exploration of new media to be made available to the artist rather than as 'works' in the conventional sense of the term, even if, in a mass society, the 'work of art' is now a less rigorous concept. They have, however, already brought about international competitions and regular exchanges between different centres, conferring on these artistic or para-artistic transpositions a *production* aspect reminiscent of the great studios of Renaissance painters (the concept of 'multiple' works adapted to a mass society interested in promoting aesthetics for the masses). For the time being, given the extensive material resources necessary and the level of technological qualifications required, they remain concentrated in a few large centres which are chiefly concerned with recruiting talented young artists prepared to master the necessary new techniques. Here there lies a problem for the future, that of disseminating these new media and providing instruction in their use, which might well engage the attention of large international cultural bodies. One of the major obstacles to the development of these branches of informational aesthetics applied to the production of 'works of art' is the small number of artists, generally young, who have surmounted the barrier of the technical training required from the outset. Consideration is at present being given to the creation of artistic centres, to be responsible for either, or both, research into informational aesthetics and the production of works, comprising a number of special workshops or laboratories (sound, literature, pictures, stagecraft and film-making) grouped together around a few important basic facilities which are pooled (computer, studios, etc.), with an appreciable per capita investment, say of the order of $2,000 for a total of 50 to 200 artists, scientists, students of aesthetics and producers.

Growing interest has been shown in this field in most countries since the early work of Moles and Bense (1954-1956), as witnessed by the snowballing of instruction courses, research groups, an intense flow of publications, and the appearance of a number of journals dealing in whole or in part with informational or linguistic aesthetics. This interest is linked with:

(1) the progressive adoption of limited but fruitful approaches to the study of a communication process rejecting any kind of transcendent vision as defying scientific definition at a stage when the aesthetics of philosophical disciplines are being transferred to scientific disciplines;

(2) the emergence of a large number of applications of aesthetics in adver-

36. Cf. MEZEI & ROCKMANN, 'The electronic computer as an artist' (1964).

tising texts, industrial design, architecture, etc. (applied arts), where the users of technicians consult psychologists as to the effectiveness of their texts;

(3) the creation of computer centres which translate into concrete achievements a large number of theories which go beyond the scope of theoretical doctrine;

(4) the exploratory trend of using the same facilities to produce socially utilizable works.[37]

11. INVESTIGATION CENTRES, PERSONALITIES, PUBLICATIONS

Below is a list of some of the centres known to be active in this field, including the names of those associated with them. Boldface type indicates individuals who are well-informed on the whole range of activities:

ARGENTINA
Centro de Arte y Comunicación (GLUSBERG). Computer visual arts: ROM-BERG, DUJOVNY.
Instituto Torcuato di Tella. Electronic sounds: REICHENBACH.
Instruction and courses in informational theory and composition: KRÖPFEL.

CANADA
Toronto. Programming: MEZEI.
Experimental psychology and aesthetic perception: BERLYNE.
Summary of texts: BAUDOT.
CYGRA Group (University of Montreal): GHEERBRANT, POULNARD.

FRANCE
Groups in Paris:
Institut d'Esthétique expérimentale (FRANCÈS, PHILIPPOT, **Moles**)

37. In addition to the reference works quoted in previous notes, the reader may consult the following works: ALSLEBEN, *Ästhetische Redundanz* (1962); ALSLEBEN, MOLES & MOLNAR, *Probleme der Informations-Ästhetik* (1965); ARNHEIM, *Entropy and Art. A Study of Disorder and Order* (1971); CAMPION, *Computers in Architectural Design* (1968); DAVIES, *International Electronic Music Catalog* (1968); ECO, *Opera aperta* (French translation, *L'œuvre ouverte*, 1965); FERENTZY, 'Computer simulation of human behaviour in music composition' (1965); GARNICH, *Konstruktion, Design, Ästhetik* (1968); GUNZENHAUSER, *Ästhetisches Mass und ästhetische Information* (1962, 1971); HILL (ed.), *DATA. Directions in Art. Theory and Aesthetics* (1968); KIEMLE, *Ästhetische Probleme der Architektur unter dem Aspekt der Informations-Ästhetik* (1957); KUPPER, 'Computer und Musikwissenschaft' (1966); MOLES, 'Cybernétique et œuvre d'art' (1965) and *Sociodynamique de la culture* (1967); PIERCE, *Symbols, Signals and Noise* (1961); PRIEBERG, *Musica ex Machina* (1960); PUZIN, *Simulation of Cellular Patterns by Computer Graphics* (1969); RECKZIEGEL & MIX, *Theorien zur Formalanalyse mehrstimmiger Musik* (1967); Music Centre of the University of Ghent, 'Seminarie voor Muziekgeschiedenis' (1967); SIMON, *Patterns in Music* (1967); XENAKIS, *Musiques formelles* (1969)

Empirical aesthetics: FRANCÈS. Pattern processes: ESTIVALS.
Laboratory studies: MOLNAR.
Literary studies: BARTHES, TODOROV, **Queneau**, LESCURE, LAMBERT and the *Groupe du Nouveau Roman*: ROBBE-GRILLET, BUTOR, SAPORTA.
Laboratoire d'Acoustique musicale of the Sorbonne (LEIPP). *Radiodiffusion française* (SCHAEFFER). *Bull-Honeywell Centre* (BARBAUD). Synthesis of sound.

GERMANY (Federal Republic)
Stuttgart Group. Informational aesthetics: **Bense**, GUNZENHAUSER, von CUBE, ALSLEBEN, FRANK.
Poetry and literature: STICKEL, WALTHER, LUTZ.
Computer graphics: NAKE, NEES, FRANCKE, GARNICH.
Aachen and Düsseldorf Group: Stylistic and statistical analysis: FUCKS, GÖTZ.

HUNGARY
Budapest Group. Poetical analysis, computer music: FERENTZY, **Fónagy**.

NETHERLANDS
Interactive Computer Graphics Group, Delft University of Technology: MEULDIJK, STRUYCKER.

SPAIN
University of Madrid Group. Modulating computer compositions: **Camarero**, BARBADILLO, GREENHAM, YTURALDE.

UNITED STATES
Bell Laboratories Group. Computer synthesis, aesthetic analysis, films and visual arts: **Mathews**, NOLL, RISSET, HARMON, KNOWLTON.
University of Illinois. Computer musical composition, musical theory, informational aesthetics: **Hiller**, BEAUCHAMP, TENNEY, CAGE, etc.
Universities of Columbia and Princeton Group. The aesthetics of sound, electronic synthesis: **Ussachevsky**, BABITT (linked with the Bell Group).

U.S.S.R.
Moscow Group. Stylistic analysis: PLOTNIKOV, KOLMOGOROV, Kinetic art: NUSBERG. Musical synthesis: MURZI.

YUGOSLAVIA
Zagreb Group. Optical and kinetic art, industrial design, experimenting with the computer: PUTAR, **Kelemen**, PICELJ.

Journals dealing with problems of informational aesthetics:
Grundlagen Studien für Kybernetik, Hamburg (FRANK, ed.);
Leonardo, Paris/New York (MALINA, ed.);

Bit International, Zagreb (KELEMEN, ed.);
Journal of Computer Graphic, Toronto (MEZEI, ed.);
Sciences de l'art, Paris (FRANCÈS, MOLNAR, eds.);
Journal of Music Theory, Yale University, New Haven (CLIFTON, ed.);
Journal of Computer Science, Toronto (MEZEI, ed.);
Gravesaner Blätter, Scherchen (MOLES, ed.): 26 issues, publication discontinued;
Rot, Stuttgart (WALTHER, ed.).

Professor MEZEI publishes annually in Toronto *A Bibliography of Computer Art* available on request addressed to the author.

CONCLUSION, *by Mikel Dufrenne*

We hope to have covered the ground as thoroughly as possible with regard to the various approaches to literature and art that are open today. Some of these approaches have been available for a considerable time, whereas others are based on comparatively recent sciences such as psychoanalysis, computer science or semiology. It is, however, not the age but the diversity of these approaches which we propose to consider in concluding this first Chapter.

The approaches are certainly diverse: an historian's comments on a work of art in no way resemble those of a psychoanalyst or a semiologist. But this diversity is typical of all the human sciences: compare for example the comments of an economist or a historian regarding the movement of prices, or of a demographer or a psychologist concerning population movements. And surely it also applies to the natural sciences, depending on the changes in perspective adopted by research. It is, indeed, characteristic of every science to circumscribe its own territory and to determine its own conceptual apparatus, as if it were alone in the world. Scientific research progresses by the delimitation of those areas of rational inquiry that define new disciplines.

Then arises the problem of plurality against interrelation of disciplines. We are not here concerned with the pedagogical aspect of this problem, if it merely consists in providing students with several strings to their bow so as to increase their prospects on the labour market, i.e., with a *pluri-disciplinary* qualification. But it could also mean enlarging their field of competence in one single sector of knowledge and/or practical application, which would be measured precisely by their mastery of a variety of approaches to that main subject. The problem is therefore that of convergence of approaches, a co-operation of disciplines: of *inter-disciplinarity*.

This problem does not arise when specialists in the applied sciences are required to collaborate in a common enterprise, as for example in the construction of a rocket or in determining the economic potential of a region, in other words when it is necessary to *act together* (co-operate), not *think together* (in other words, to co-theorize). In this case the sole difficulty lies in the choice of a foreman who will organize and co-ordinate the team; this choice may depend not only on extrinsic considerations of prestige, but also on considerations of theory, that is, according to specializations. But there immediately arises the temptation of empire-building by each discipline, particularly at times when it is charged with the impetuosity of youth.

Such an 'imperialistic' attitude is the chief obstacle to genuine inter-disciplinarity. It may derive from reasons other than the will to power of a discipline that seeks to be recognized and established: it may be based on strictly scientific grounds. In this case the model constructed by the discipline is postulated as the truth of the subject to which it applies: the entire subject is in the last analysis explained by this model, because all elements can be reduced to its terms, and consequently the other figures of the object based on other models seem to be superficial or false, in any event useless,

compared with this explanation, then regarded as ultimate. For example, such and such a discipline affirms that a painting can be reduced to language, or a book to calligraphy; consequently the author, if he does not efface himself, should be effaced by the science of art or literature: in this way psychology or phenomenology are excluded, and even sociology to the extent that it is concerned with the relation of the creative product to a branch of intellectual activity. Each discipline may purport to deal with determinants that emerge 'in the last analysis', that is after the initial datum has been sufficiently distilled, when the accidental and uncertain elements have been excised, with the result that these determinants can claim to bear on the essential.

But imperialism may be less conquest-seeking when it takes the form of a policy of negotiation and exchange, and here no doubt is where the best prospect of inter-disciplinarity lies. At this point one discipline can offer its services to others, thereby acknowledging their rights in the kingdom of science, even if such an offer dissimulates an attempted annexation. It may also, in a less ambiguous manner, request the services of other disciplines. So it is that Jean Laplanche can write [1]: 'If psychoanalysis is by its nature *interdisciplinary*, this does not imply that it should meddle in everything without having to render an account to anyone. We cannot today conceive of psychoanalytic research unable and unwilling to learn from the contributions and points of view of the other human sciences'. He goes on to call for 'the integration [as against "a mere confrontation"], in a common work, of the joint efforts of specialists of several disciplines: *psychiatrists, anthropologists, linguists, logicians, specialists in aesthetics, biologists, ethologists*'. The *raison d'être* of such a team is the project in hand, and Laplanche specifies: 'We would above all emphasize that such groups cannot work effectively unless they are concentrated on a specific subject, what the psychoanalyst calls the "material" and other specialists the *corpus . . .*'

But what then constitutes co-operation? This question leads to another: is there one discipline that may benefit particularly from it? Laplanche for example says: 'When we approach a linguist . . . we request him to enlarge his point of view, for our benefit, into semiotics or the general science of signs, even if at times the unconscious "text" consists of a system of images (dream), gestures or behaviour'. Similarly, help from a logician would enable the psychoanalysts to follow up the 'effort to isolate the laws which Freud broadly indicated as deriving from a partial axiomatics (absence of negation, for example) inherent in the unconscious *logos*'. Clearly this is where psychoanalysis benefits from the light thrown by other sciences. Are the benefits reciprocal as a matter of course? This is doubtful: logic certainly has nothing to lose nor yet to gain by illuminating the laws of the fantastic, nor has rhetoric anything to gain by learning that metaphor equals condensation, and metonymy equals displacement. Let it be understood that these remarks are in no way intended to discredit inter-disciplinary collaboration, but merely to

1. 'La recherche psychanalytique', pp. 151-152 in *Revue de l'Enseignement supérieur* (Paris), special issue (No. 2-3, 1966): *La Psychologie*.

point out that it cannot be disinterested: there is – perhaps always – one discipline that exploits another; but what does it matter if each progresses in its turn?

Let us add in this connexion that co-operation need not go so far as the constitution of a working group and that it can be limited to the dissemination of information: each discipline obtains information for its own purposes and can therefore utilize findings or concepts formulated elsewhere. Such exchanges are obviously most useful as a means of introducing new material into research, while avoiding any likelihood of overstepping the limits of the speciality that makes use of it; more probably, the specialist will feel less isolated and better motivated by the release of information. In other words, if knowledge is then unified, it is so only within the thinking of a given scholar. In this case research is pluri-disciplinary rather than inter-disciplinary in the strict sense. There is, however, one prerequisite, that is, unless the stimulus comes from unforeseeable and distant analogies, that the subject of such research must itself be multi-dimensional.

And precisely, as Laplanche points out, if an inter-disciplinary team is to be constituted it must be for a specific project: the purpose is not to make an abstract comparison of methods or concepts, but to increase knowledge of a particular subject. The question then arises as to whether this subject pertains strictly, or at least primarily, to one discipline, or whether it is common to all the associated disciplines. If the topic, to pursue our example, is the unconscious, it must pertain to psychoanalysis, and the other disciplines will only be concerned to the extent that psychoanalysis decides to refer to them for its own purposes. If on the other hand the topic is, let us say, myth, or relationships within the family, or signs in general, then each discipline is equally concerned because each has something to say in its own right. This implies that the topic itself is subject to consideration through several different approaches because it presents a number of aspects. The whole difficulty resides in deciding whether plurality is irreducible or is simply seen in terms of these approaches. Is it possible to determine the essence of a topic that only one science could claim as being within its own competence, while the others no more than seize, so to speak, on inessentials? We shall revert to this question below.

But it must first be stated that art, including literature, seems to lend itself particularly well to a diversity of approaches, and by the same token if not to inter-disciplinarity, at least to pluri-disciplinarity. Firstly, it is multi-dimensional, especially when considered as a single, autonomous totality. Here no doubt the dialectics of the multiple and the one can be applied. For thinking about this totality does not only imply collection in an imaginary museum of all forms, all *genres* and the whole succession of works of art through history; it also implies an effort to define the essence of art, vainly sought after throughout history, and which can perhaps be more nearly reached through the movement of withdrawal or dissimulation which may constitute it, at a time when anti-art, or non-art, or *a-art*, have raised doubts about art; or through the works of those so fascinated by art that they are

reduced to helplessness, silence, or madness. Thoughts on this experience led Blanchot to the shores of a philosophy of absence. But this search for the essence of art may also call on science; and although it is true that it has not yet brought into being a science of music or painting, a science of litera- ture (or of as we say today of *littérarité*) initiated by the formalists is being formulated before our eyes and it is certainly an eidetic science in Husserl's meaning of the term. But this science cannot remain in the splendid isolation of formalism, for to reflect upon itself it must refer to its own history: the very idea of the essence of art or literature is located in a certain era, even if the exact date of birth is difficult to fix. Furthermore, it must introduce the diachronic dimension into its conception if, in order to grasp the essence linked to existence, it has to refer to the historical *corpus* of works of art; and with history all the human sciences come into play: how can the essence of art be understood as it was actualized in history, unless the meaning and function of art, its place in a culture, its relation to other institutions, the way in which it is experienced by the *psyche*, are explored?

It is therefore necessary to move into the area of empirical knowledge. All the more does this justify a multi-dimensional approach. In the first place this science is applied to different arts, the study of which may give rise to different disciplines, as literature calls on linguistics, plastic arts on the psy- chology of vision; or it may be giving rise within the same discipline to dif- ferent theories, as music calls on psycho-physiology, and painting on psy- chology of form.[2] Secondly, because one art object may pose different prob- lems depending on whether it is considered from the producing or the re- ceiving end, particularly because the very nature of this object, as presented to us, is ambiguous: it is situated, as E. Souriau well demonstrated, on several levels of existence, as an object to be perceived, and therefore subject to the phenomenology of perception; it is also an object to be known, which brings us to the dimension of meaning. The meaning, embodied in the felt experi- ence, is itself ambiguous and may give rise to various interpretations: Bache- lard's phenomenology, Panofsky's semiology, Mauron's psychoanalysis, the structural analysis of Lévi-Strauss, or many others. It may no doubt be said and has frequently been said after Valéry, that meaning constantly eludes us by its very diversity, and that there is no absolute meaning: not only to each man his own preferene, but to each his own truth! Which is the justification for a plurality of both interpretations and approaches.

Even if the proposition 'each his own truth' is correct, if the meaning of the work is manifold and its being is ambiguous, each discipline maintains its own view of this complexity and its own way of accounting for it; thereby

2. But account must be taken also of a fact peculiar to contemporary art, which is that the arts themselves, as in former times the *genres*, tend to break down the partitions that separate them until sometimes they intermingle: painting integrates sculpture and in some way becomes sculpture, music integrates speech or phono- logical articulation; the film sets abstract painting in motion. Are we not justified in thinking that such pluriproduction requires pluridisciplinarity? Yet this is not self-evident. On the other hand, one may rest assured that it obliges each discipline to rethink the definition of art in general, or of the particular art that it favours.

claiming to grasp the essential, even if it dwells in an undetermined essence. So we come back to the same problem: is there a character or truth of the object which is one and is open to adequate study by a single branch of knowledge? With regard to an artistic object, we may perhaps suggest a reply: negative, if it is true on the one hand that this object may be perceived on several planes of reality, and on the other hand that its interpretation and even its use are always open. This would be sufficient justification for the pluri-disciplinary nature of its study. But could not this pluri-disciplinarity be oriented towards inter-disciplinarity, in other words, towards genuine cooperation between disciplines? This chapter (and the following) gives us a further opportunity to attempt to answer this question which now relates to scientific practice. On the one hand, each specialist will add to the fund of knowledge of his own discipline only if he pursues his own line of approach and stresses its specific characteristics, if, far from being ashamed of his specialization he adheres to the chosen course; failing this, he will drift into eclecticism, which is never fruitful. Yet, on the other hand, the same specialist may learn from the other disciplines. Not gratuitously, through somewhat frivolous curiosity, but because he is led there by his own research, precisely because he perseveres with it: in questioning the situation or social function of art he may want to know how the work of art is perceived within one culture, and what fantasy it evokes; conversely, interpretation of a work of art as the translation of an unconscious text leads to investigating the chosen form and perhaps to determining which are the forms favoured by a given culture. To formulate a semiology of art imposes the need to differentiate between various readings, some of which are conditioned by the unconscious as much as by the culture and the structure of society. Investigation on '*littérarité*' would lead to research on how the concept of literature and literary practice has emerged and undergone change in the course of history. In short, we have seen a thousand examples of the way one approach leads to another. The important point is that this follows from the logic of research, and is only imperative on the student who remains faithful to his original purpose. One meets the other disciplines within the confines of a certain discipline, because one is seeking solutions to problems they too are investigating, having visualized their own limitations.

Should we use the dialectics of the individual and the universal? More down to earth, should we say that unique knowledge becomes unified knowledge, that a speciality becomes a polyvalent discipline, the crossroads of disciplines? Not absolutely, because this conjunction of disciplines is only effective, we repeat, when each pursues its own line of inquiry. A student who calls on their assistance and notes the findings obtained elsewhere, sometimes promoting research elsewhere, is primarily stimulated by his own investigations, which he will pursue: 'imperialism' is here simply loyalty to the cause; but such loyalty means that for each specialist, collaboration is to some extent one-way: he utilizes the other's services, but conversely, since the other may utilize his services, there is a give and take which promotes inter-disciplinarity.

May one not go still further and speak of *trans-disciplinarity*? If one discipline seeks information or suggestions from the others, it will be to the extent that it feels some affinity with those disciplines from which it obtains relevant material. In fact what brings them together in this way is a certain philosophy in common: at least a similar attitude towards science, the same desire for lucidity and accuracy, and at times the same ideology: for example that of historical materialism; also that of what has been termed, not without some ambiguity, structuralism, in which topics such as man's death, or the primacy of language predominate. Let there be no mistake: these topics can certainly be the subject of rigorous philosophical thought, but it is not in this form, it is in a vulgarized and polemical form that they enter epistemology; and it is very frequently as a result of misunderstandings that they are transferred from one science to another. When on occasion they are precisely defined, it is only because they have given rise to specific research by one discipline. Furthermore, rather than a trans-disciplinary subject-matter, it is a pre-philosophical *doxa* that is here involved. By devoting a programme of scientific work to it, many aspects of the aesthetic object or experience, indeed whole sectors of research, would be eliminated. A *doxa* of this type can provide a common language for different disciplines, but it cannot provide a language for their operations. On the other hand, inter-disciplinarity can emerge in the course of the work, but only because pluri-disciplinarity exists and, if one may say so, *uni-disciplinarity*. For there are *several* sciences of art, not *one* science of art. However if *one* truth of art may be said to exist, it is that the ideal of knowledge, like the transcendental idea for Kant, is not known. But is there anything like 'art' *per se*?

CONTEMPORARY STUDY OF THE PRINCIPAL PROBLEMS IN AESTHETICS AND THE VARIOUS ARTS

Section Four: The Study of General Problems
Section Five: The Study of the Various Arts:

INTRODUCTION

In the previous chapter we attempted to discern the movement of both con-
temporary art and literature and, at the same time, the intellectual climate in
which the study of the movement is carried out. We considered in turn the
ideology, the philosophy and the sciences which, each in its own way, con-
tribute towards determining the direction taken by such a study and the way
in which it is pursued. Naturally, when mentioning the scientific approaches,
in the main section, we could not draw any radical distinction between the
theory and practice of research and it would have been wrong to do so;
choice of method, the determination of the field of study, and the positive
application of the procedure are too closely interdependent. That is why we
have already considered a certain number of examples of positive research
undertaken under the banner of such or such a science. We must still, how-
ever, try to arrive at a clearer picture of what has been done, concerning our-
selves now with the object rather than with the method of such research. But
this does not mean that we shall be able to omit any further reference to
methodological options, although we shall, as far as possible, avoid unneces-
sary repetition. We have chosen two different subjects for discussion in the
two sections of this second chapter, namely, in the first place, the problems
which can be described as general and which, as we suggested earlier, are
traditionally encountered in aesthetics and, secondly the problems that arise
in regard to each of the arts considered individually.

SECTION FOUR: THE STUDY OF GENERAL PROBLEMS

INTRODUCTION

Of these problems, we have selected three which seem to us to be impossible to ignore: the problem of the creation of the work of art, the problem of its reception, and the problem of its evaluation. The selection is doubtless limited, but not, we think, arbitrary. In the first place, because aesthetics has traditionally been concerned with these problems, long before resorting to the positive sciences to which it has bequeathed them; and next, because these problems arose also before art claimed its independence, before artists were distinguished from craftsmen and claimed for their works the special status of aesthetic objects. It is sufficient for an object to be produced which appeals to our taste, that is to say, which does not serve any exclusively practical or conceptual purpose, for us to ask ourselves in what circumstances and with what intention it was produced, and what reception is expected for it and is received. Depending on time and place, various ideologies may distort the sense of these questions, and that is something to be borne in mind in a history of cultures. The fact remains that such questions cannot be dismissed on that account, and they still call for an answer from those who think about these matters today. We shall now see what is being done to answer them.

A. ARTISTIC CREATION, *by Mikel Dufrenne*

At the outset of this section, we must warn the reader that the account we shall try to give of the research done on the creation of works of art will be somewhat fragmentary. Many aestheticians, particularly those concerned with aesthetics in France – Alain, Valéry, Bayer, Gilson, E. Souriau – do, indeed, and rightly so, stress the creative activity of art. Such a study cannot be burked, but it may be incorporated in a formal study of the completed work, and it may be concerned more with the craft than with the psychological and social circumstances of its practice. It is in his canvas that Van Gogh's touch can be identified, and it can be studied within the framework of a system of pictorial writing without our knowing anything of the artist's intentions or motivations. This is the direction in which the most recent research is mainly directed and it is more appropriate for a constructive approach. Moreover, though many articles are written on writers or artists, the authors are usually philosophers rather than scientists. Again, it is through their work that philosophers investigate creative artists; they are less concerned with trying to discover the strange secret of creation than with understanding its impersonal sense, less concerned with knowing a man's destiny than with 'poetic destiny'.[1]

Truly, it is the very idea of creation that is devalorized today. Why? And, in the first place, by whom? It is challenged as much by artists as by theorists, both in their practice and in their ideology, which last is often dependent upon currently accepted ideas (in this connexion, mention might be made of an aesthetic field similar to the epistomological field explored by Foucault, and in harmony with it). Although artists have at times raised the standard of the wondrous secrecy surrounding the act of creation, it is a striking fact that today many of them, among the greatest, refuse to lead the lives of stars; they work in the shade and in silence, they reveal to the public only their works (sometimes also their reflexions, for they readily turn to writing as well, thus forging a further link between discourse and art), but not their innermost thoughts. Let us say in brief how, divesting themselves of their robes as creators, they tiptoe slowly from the stage. With the public they establish another relationship, which is both more discreet and more fraternal. They offer the public (if it still wants it) the dignity of co-creator, for they have come to realize that the act of creation is not complete until a work is received, with the necessary perception, in a manifestation of sensibility. And sometimes, they go farther still. Just as certain musical compositions leave it to the interpreter to choose the order of the pieces, or allow him to improvise in accordance with his 'reflexes' (G. Tremblay), so certain kinetic works look to the audience to 'perform' them. The creator then stands aside, delegating to his audience the task of pulling the strings. But he may also give way to other partners, when he works as part of a team, more democratically than formerly in the studies of the masters and in the mediaeval corporations. For example, the members of the Living Theatre sometimes join together to compose and stage their productions. But the artist may withdraw still farther; he may, in the course of his own work, lose control and even the consciousness of what he is doing, leaving everything to the sheer spontaneity of voice or gesture. Here the appeal launched by the Surrealists has been heard by Pollock, by Michaux, by Artaud, and by so many others. It comes, perhaps, from farther off; for to divest oneself of everything is at the same time to achieve a state of grace, as did all those who invoked the Muse in other than set phrases, as did all those who found inspiration – the very breath of life – in the exaltation of the fête, all the more violent the sharper its sentiment of 'powerlessness'. In such a case, anonymity must be attributed not to an unsigned work, but to the very being of its creator, who no longer belongs to himself, for whom in truth 'I' is 'another'.

But this passionately sought absence from self, this annihilation of a reason enslaved to discursive language, and this abandonment to indiscriminate chance, mean also the death of the work, or the anguished awareness of its impossibility – an awareness that may, on the other hand, become joyous, ironical or sacrilegious in others: as, for instance, the artist who signs ready-mades, or frames tattered posters, or hawks his canvases about in the rain.

1. BLANCHOT, 'La folie par excellence' (1953), quoted by DERRIDA in *L'écriture et la différence* (1967).

Despair, resentment, irony: the uselessness of the creative act is made manifest by the uselessness of the object created. What is denounced at the same time as the myth of the creator is the myth of the work created: the idea of a masterpiece, the respect for such a unique irreplaceable object, self-contained, carried to the summit of fulfilment and materiality by a certain inner necessity. If art is the pursuit of that fulfilment to the point at which it is accomplished the idea of it will have to be finished off as the wounded are finished off – and long live non-art! And, for example, long live kinetic art, where the object demonstrates its precarious nature and the unpredictability of the happening! In this way, the artist refuses to be God, but is that in order to affirm his humanity or because it seems to him impossible to achieve it?

If this question has a meaning and calls for an answer, they must be sought among those who reflect the experience of art instead of living it. Why is the notion of creation nowadays so suspect in their eyes? In the first place, because it carries with it a theological connotation, ill-received by a certain school of thought since the 'death of God' was announced. The primary meaning of 'to create' is indeed a strong one wherein creation is divine and occurs the *ex nihilo: fiat lux*! We see here, on the one hand, that the idea of creation implies the idea of a creator and takes its meaning from him: creation in this case is merely a product intended to show creation to be an act and celebrating the glory of the creator. That glory, of which the world is evidence, is connected with the liberty and absolute efficiency of the creator. The world, in an instant outside time at which time begins, emerges from the void. And since the idea of creation thus calls for a genesis rather than a description, that which devalorizes it is also its sterility. For if such genesis occurs in the mystery of subjectivity, how can it be grasped and mastered? It can only be celebrated, like the jealously guarded secret of that minor god, genius: *ne, sutor, ultra crepidam*! If, nevertheless, we violate this taboo, we encounter a fresh difficulty: the ambiguity of the notion. For the primary strong meaning of the word can indeed be offset by a secondary weak meaning, which becomes a vague meaning: it can be said of a theatre producer equally well as of a writer, that he 'creates a comedy', the same can be said of all those actively involved in the production of the work on the stage, behind the scenes, or even in the auditorium itself. Creation becomes anonymous when it is said of an industrial firm that it creates a new model; it becomes uncertain when it is said that a child creates when it scrawls on a sheet of paper.

To the problems raised by this ambiguity of the word – the ideological connotation of which can easily be criticized at the same time – a radical solution may be proposed: eliminate all that is problematic in creation by, for example, replacing the word creation by the word production. In this way, those artists who tragically confess their sterility are taken at their word. It is decided both that the work, far from being self-sufficient as a finished object, does not carry its meaning within itself, says something different from what it wants to say, and that no shred of originality and no shred of

merit can be attributed to its author. Thus a certain sociology of art, Marxist or not, comes into being. But this vigorous rejection of the concept – or pseudo-concept – of creation is not to be commended only for the guarantee that it offers a science of art by freeing it from a certain ideology, for it is expressed also in meditations such as those of Blanchot or Derrida which have nothing positivist about them. In fact, positivism is here in harmony with a whole movement of thought which has recently made its appearance in the field of Western philosophy: an anti-humanist way of thinking that tends, for a wide variety of reasons that are sometimes incompatible with one another, to deny the individual the privilege of thought, initiative and the control of his own actions. Death of man, death of the work of art: this inflation of the theme of death is the means by which contemporary thought dramatizes the old Kantian idea of the finitude of the subject, interpreted in an epistemological context as the resorption of the individual into the system. In this way, research on creation inevitably takes on a philosophical dimension.

No doubt the concept of creation had to be challenged, if only to encourage scientific research; and it is no doubt equally true that purely and simply to substitute man for God is to fall from one mystery into another. But is not the anti-humanist rejection of this concept still likely to mystify us if it is proclaimed unreservedly? It does in fact elude two problems which are linked to that concept, and which we have no right to dismiss too peremptorily.

(1) While the word 'create' may be used in many ways, some order should be introduced into this diversity, and, in the first place, the word should be defined more strictly: 'to create' means to produce an object which obviously does not spring from nothing, but which is nevertheless new. This very simple definition does not oblige us to pronounce those judgements of value to which contemporary thought is so strongly allergic; it merely invites research to turn away from the creator and towards creation, in the sense of the created object, and to appreciate the newness of it. Wherein lies this newness? The answer to such a question entails a formal analysis of the work, that is to say, a technical approach to creation. In relation to what is the newness manifested? In relation to a certain given state of artistic *praxis* – grammar of forms, types of action which are also types of thought – where technical and aesthetic questions emerge of which some artists become aware even before the public perceives them. How does newness prove its quality? The new work of art, the one which brings an answer at once unpredictable and inevitable to the questions raised at a certain moment of *praxis*, is the starting-point of a history; it gives meaning, in retrospect, to the preceding works and it opens the way for other works which will make it possible to understand it by dint of harking back to it, and which will end up by breaking free from it. The work, once created, is itself pregnant with a future which sheds light on the past. It is for history and sociology to measure this creativity of creation by its retrospective and prospective effects.

(2) But newness and its effects are produced through men: for a public, and by artists. Are men to be denied the power to produce them? No men-

tion has yet been made of a feature of our epoch that is nevertheless some-what remarkable, namely, that, at the very moment when it denounces the idea of creation, it proclaims its praise of the idea of creativity from the house-tops. The artist who refuses for himself the dignity of creator recog-nizes it in the spectator or wants to confer it upon him and, if the spectator does not claim it for himself, he claims it for every man. Here anti-humanism is given the lie. Perhaps the ideology implied in the verb 'to create' is mysti-fying only for those who decree the death of man, for it may well be that 'to create', in the same way as 'to learn', is man's self-assigned vocation: not only to grasp the world and explain it, but to seize hold upon it for the pur-pose of humanizing it by reshaping it, and adapting it to new objects which are for him like a new revelation. To create is the finished form of '*to do*', a *to do* that possesses an ontological significance, which in *naturata* is found to be *naturans*. Doubtless such a statement is as ethical in character as it is metaphysical, but it also calls for positive research: in the first place, for a form of anthropology, and especially psychology. Can we, by empiricism, get closer to this idea of creativity? Can we discover the conditions, aims and machinery of creative activity? Can we establish a pedagogy of this activity? Can we determine, if not govern, its social conditions? But is there also, in man's individual nature or destiny, something indomitable? Must we admit that there are exceptional beings, or must we assume that there is no differ-ence in nature between the actions or personalities of creators, even if they are children, primitives or madmen, but only differences of social standing which determine the absorption of culture and the powers of invention? In this matter, anthropology can learn from formal analysis and from the hier-archy which it introduces among works of art.

We see, then, that devalorization of the idea of creation does not mean that all the problems raised by creation have been settled. The mistake in this idea was more that it offered itself as a solution rather than a problem, for exam-ple, by invoking genius, or that it discouraged all research by substituting a mystery for the problem. Whatever name is given to creation in order to 'demythicize' it – production, fabrication, emission – it is a fact that in all societies men produce works of art. More cautious and more objective ap-proaches to that fact are now being made. In mentioning them, we can at least group them under the two headings we have adopted here: those con-cerned with the subject who creates, and those concerned with the object that is created.

I. THE STUDY OF THE CREATOR AND CREATIVITY

The studies concerned with the creator will be briefly mentioned. Naturally, they cannot deal exclusively with the creative act; they must refer also to its product. A tree is judged by its fruit, and in most cases the personality of the maker is reconstituted or interpreted in the light of his work. There still re-mains the question of how the tree bears its fruit. What is the mechanism of

creation and in what conditions is that mechanism exercised? The subject must be studied psychologically to begin with, then historically and sociologically.

1. *The psychological approach*

(a) *Philosophical psychology*

Since the days of Plato, philosophy has unceasingly meditated upon the creation of works of art, and, very roughly speaking, it can be asserted that two doctrines have been constantly opposed to one another: one exalting the miracle of genius, the spontaneity of unpredictable inspiration, and the other exalting sobriety and patient labour. At the beginning of the present century, for instance, there were, on the one side, theorists of the *Einfühlung* such as Lipps or Volkelt and of intuition-expression such as Croce and on the other, Valéry and Alain. The former describe a certain attitude, a spiritual adventure as Maritain says, but without being able to explain it by referring it to dispositions or traits of personality. The latter deny the need to evoke a differential psychology; the creator does not exist prior to his act of creation; in his work he does not express a pre-existent personality; in creating he creates himself; in setting man's seal on matter by dint of work, he marks himself with that seal, he becomes truly man – even in his body, which he disciplines and informs. That is why Alain places the dance in the foremost rank of the arts. Although Alain would have denied it, is there not in this an echo of Nietzsche? The handsome appearance of the dancer is the truth concerning man; art is that serious game through which man already affirms himself as superman, through which he liberates himself by assuming self-given rules – and that is why a work of art is always amenable to formal analysis. Others will say, on the contrary, that man is lost because in his very work he suffers the greatest possible anguish, what Artaud calls his 'powerlessness' (*impouvoir*), the impossibility of the work and the impossibility of being, the harsh realization that 'inspiration is, in the first place, that fine point where it is lacking'.[2] This theme is readily developed by contemporary philosophy in so far as it announces the death of man and as its strategy consists of conceiving man as the instrument rather than the agent of what he produces, and consequently of subordinating him to powers which have a logic or life of their own, of measuring his finitude – which implies his end – by that subordination. The artist is in this way placed at the service of art, obliged to bear witness that he is irresponsible and unequal to his task; inspiration abandons him, his words are constantly snatched from him, as Artaud says again; his work escapes him, not only when it is delivered to the public or when it becomes an anonymous element in the corpus of works, but at the very moment of its conception. Creation confirms the saying of Hegel that

2. BLANCHOT, *Le livre à venir* (1959), p. 52.

the birth of the child is the death of the parents. Creative consciousness is a consciousness so unhappy as to amount sometimes to madness. In this way the Dionysism of Nietzsche may be turned against himself: denunciation of the too-human may signify the effacement of man rather than the coming of superman, and the morose delectation of mourning rather than the joyous manifestation of the fête. Orpheus loses Eurydice, and the Maenads tear him to pieces. This theme, first introduced by Rilke, is the subject of very important essays in French literature, but it has hardly caught the attention of the psychologists. What have they to say for themselves?

(b) *Positive psychology*

As we said earlier, psychologists have done relatively little work on this subject because creation is viewed, if not as a secret, at least as a fact that is not easily accessible to empirical investigation, especially in its most authentic manifestations, which are also the most unpredictable. Authentic: for it is a remarkable fact that positive science does not hesitate to pronounce judgements evaluating both the quality of the product and the personality of the producer. Experimental psychology does the same thing, for its own purposes, when it divides the subjects it is testing into different groups: higher, lower, and control, for example, in referring back to the teachers in order to evaluate the talent of the pupils; and the same is true of psycho-pathology when it appraises works of art in its raw state. Such axiology is perfectly justified, in the first place because artistic *praxis* does in fact call for a judgement of taste and, secondly, because it is itself guided – as is also the practice of the investigators themselves – by the judgements prevailing at a given time and place. Psychology invariably draws upon a sociology of the cultural environment which affects both the investigator and the subject of investigation. A distinction is therefore made; in the name of this axiology, between the study of 'average talents' which alone lend themselves to experimentation, and the study of 'creative individuals' (who do not lend themselves to experiment and come within the field of biographical analysis and the monograph) [3] with whom also philosophical criticism is concerned.

Creation is therefore studied with reference to personality. In general, three points may be considered: operations, dispositions, motivations.

The creative operation comes essentially within the sphere of the psychology of behaviour but frequently this branch of psychology is concerned with 'intellectual operations' or 'intellectual activities' (the title of a book by Oléron) without special reference to what are properly artistic operations. The theories of learning therefore go no further than simplified tasks and restricted processes. Works on intelligence study mainly the way in which problems are resolved, but the solution of such problems lies rather in articulating a reasoning or inventing a strategy than in fabricating an aesthetic object. In the same way, factorial theories hardly ever invoke factors that the

3. FRANCÈS, *Psychologie de l'esthétique* (1968), p. 154.

creation of works of art would reveal. Besides, if psychologists hardly look for intelligence in art, that is not only because a rejection of the theory of the faculties leads to neglect of imagination and taste, but because, for lack of a formal analysis of the work, activity in the arts has rarely been interpreted as confrontation with a series of problems. But we can at least adopt from that psychology certain notions which will be verified by formal analysis. For example, that 'newness is a characteristic lying outside the subject . . . (who) does not approach the task in a state of total innocence, otherwise he would never be able to complete it'.[4] Originality, therefore, is never absolute; and it must not be thought that the newness of the result invariably implies newness of means. While it is true that the most important inventions are concerned with methods or procedûres, in most cases new results are obtained by methods which are already familiar.

It is doubtless not easy to classify artistic activity as one of the intellectual activities; but although it is uncommon, we can at least try to discover what it is that predisposes the subject to practise it. Such a study of dispositions comes within he field of experimenal psychology, which is dealt with elsewhere,[5] and all that need be said here is that the investigations are concerned less with the emission of the message than with its reception; that is to say, with individual tastes, in the first place with their persistence and consistency, and then with their relationship to the previously revealed variants of the personality. The stûdy of creation requires not only the determination of tastes, but that taste itself should be put to the test, for the creator not only shows preferences in selecting, but taste in producing. Thus the Meier-Seashore or Mac Adry tests are tests of taste which shed light on an aptitude rather than on an attitude. This study requires also the establishment of the psycho-physical capacities needed for the practice of the arts. For example, precision and stability of hand movements, exactness and discriminating capability of observation, accuracy of visual memory, a lively imagination. Such research has been pursued for some time – that of Tiebout and Dreps as reported by Francès, goes back to 1933 – and is still being carried on. The reason is that such research served a practical purpose, namely that of selecting young persons of talent, directing them to art schools, and providing education for their development. It is therefore with an educational object, which is itself justified by ethical and sociological considerations, that the psychological investigation is undertaken.

It is in the United States in particular that a great deal of work is being done today on the theme: *'The Art and Science of Creativity'*. Such is the title, assuredly an ambitious one, of a little book by G. Kneller. Such work is quite recent, since Guilford reports that up to 1950 only 0.2% of the titles of

4. 'La nouveauté est une charactéristique extérieure au sujet . . . (lequel) n'aborde pas la tâche dans un état d'innoncence totale, sans quoi il ne pourrait jamais en venir à bout'. – OLÉRON, *Les activités intellectuelles* (1964), p. 107.

5. Cf. in the preceding chapter the sub-sections entitled, 'The experimental approach', by Robert Francès, and 'The psychological approach', by Mikel Dufrenne, Albert Wellek and Marie-José Baudinet.

Psychological Abstracts were concerned with creativity. The very notion was suspect: creativity implies non-conformity; and 'creative thinking' may produce the best and the worst. Thus Torrance notes that 'many aspects of our educational and social system actively discourage and inhibit such thinking' [6]: many teachers, for instance, see a disturbing element in this. Margaret Mead also points out that 'Our present way of rearing children does prepare them to work on teams – but not to the necessary individual work which makes it worthwhile to have the team'.[7] That is why Torrance, before considering how creative behaviour can be encouraged by rewards, proposes to find out how the social milieu receives and appraises that behaviour. Conformism dies hard! It is somewhat remarkable that, whereas creativity is in most cases defined by contrasting it with conformity,[8] J. Getzels and P. Jackson, in their book *Creativity and Intelligence* (1962), entitle Chapter 4 '*The highly moral and the highly adjusted adolescent: exploration in psycho-social excellence*'. There are therefore prejudices to denounce and habits to be overcome; for – and it is with this that almost all the research is concerned – there is a new kind of education to promote: mass education will have to be replaced by 'creative' education based on inter-personal relationships, the aim of which is expressed by Kneller in the following terms, 'Much of the disorder of contemporary youth, we now know, is an explosion of potentially creative energy that can find no other outlet. In the schools this energy is frustrated by regulations destined to keep masses of young people in order by making them behave in unison. ... How much delinquency would vanish if one teacher – superbly trained, superbly rewarded – would, like a physician, take responsibility for the education and general personal guidance of ten or twelve youngsters'.[9]

The truly psychological study of creativity has led to the invention of a very large number of batteries of tests, most of them devised to manifest, measure and correlate certain traits of behaviour, such as intelligence, lucidity, ability to express, flexibility, originality, self-confidence. In determining these traits recourse is had to the psychologies of personality, and at times to extremely precise models. I shall mention only one of these by way of example: the model established by J. B. Guilford of 'the structure of the intellect', a three dimensional model defining respectively the operations ('*cognition*', '*memory*', '*divergent*', '*production*', '*convergent*', '*evaluation*'), the contents ('*figural*', '*symbolic*', '*semantic*', '*behavioral*') and the products ('*unit*', '*class*', '*relation*', '*system*', '*transformation*', '*implication*'), containing, therefore, 120 'intellectual factors' amenable to specific tests. American psychologists vie with one another in ingeniousness in organizing experi-

6. Torrance, *Rewarding Creative Behaviour* (1965), p. 13.

7. Margaret Mead, 'Bringing up children in the space age', p. 72 in *Space Digest*, Feb. 1959.

8. Cf. for example, Crutchfield, 'Conformity and creative thinking', in Gruber, Terrel & Wertheimer (eds.), *Contemporary Approaches to Creative Thinking* (1962).

9. Kneller, *The Art and Science of Creativity* (1965), p. 99.

ments and handling the results statistically, but conceptualization does not seem to be on a par with experimentation: the notion of creative thinking continues to be rather vague. What happens when research is concerned with creative practice in the arts?

Investigation is then concerned, on the one hand, with individuals: with their special aptitudes and also with personality; thus it often distinguishes between 'spontaneous highs', 'spontaneous lows', 'deliberate highs' and 'deliberate lows'.[10] On the other hand, it is concerned with educational methods that can develop talents. Thus Torrance proposes to recompense creative behaviour: curiosity, initiative, originality. Many stress the need to encourage what in France would be called the critical mind (*esprit critique*); self-evaluation, as some call it, self-reflectiveness in Beittel's terminology. Some more truly pedagogical surveys contrast two educational methods which Mattil calls 'depth' instruction and 'breadth' instruction, the one calling for concentration on a specific expression (in this instance, painting), and the other on variety and dispersal.[11] The results are in favour of the first method, which proves to be more stimulating on four points: continuity in productivity, self-evaluation of art products, aptitude for a variety of tasks and for changes in orientation, self-reflection characteristic of intuitive and flexible thought.[12]

But while students offer a ready-to-hand and practically inexhaustible human material for these numerous surveys, it is not so easy to mobilize adult creators. Mention must be made, however, of a survey conducted by D. MacKinnon and W. Hall at Berkeley on 'the creativity of architects'. There is no room here to describe its strategy, which was complicated – and costly. Let us mention merely a few of the conclusions. This is how the architects see themselves: 'It is clear that creative architects more often stress their inventiveness, independence and individuality, their enthusiasm, determination, and industry. Less creative architects are more often impressed by their virtue and good character and by their rationality and sympathetic concern for others'.[13] This is how they are seen by psychologists that is to say, what

10. Such is BEITTEL's classification in his essay 'Creativity in the visual arts in higher education', p. 394 in TAYLOR, C. W. (ed.), *Widening Horizons in Creativity* (conference, 1962; publ. 1964).

11. Cf. MATTIL *et al.*, 'The effect of a "depth" vs. a "breadth" method of instruction at the ninth grade level' (1961), quoted by BEITTEL, *op. cit.*, p. 384, who comments as follows: ' "Depth" here refers to sustained concentration in the curriculum (in this instance, painting), as opposed to dispersal, variety, and coverage ("breadth")'.

12. 'There are four dimensions of depth related to the development through art of the capacity for creative action, as we can deduce them from our present evidence:

A. *Continuity in productivity:*
B. *Self-evaluation of art products:*
C. *Divergent tasks:* . . . changed orientation;
D. *Process self-reflection:* . . .; symbolizes flexibility and intuitive thought; . . .'.
 – BEITTEL, *op. cit.*, p. 394.

13. MacKINNON, 'The creativity of architects', p. 365 in TAYLOR, C. W. (ed.), *Widening Horizons in Creativity*.

their psychological profiles are in relation to creativity as revealed by the replies to the questionnaires:

On the first cluster of scales, which are measures of poise, ascendance, and self-assurance, creative architects reveal themselves as dominant (Do); possessed of those qualities and attributes which underlie and lead to the achievement of social status (Cs); poised, spontaneous, and self-confident in personal and social inter-action (Sp [= social presence]); though not of an especially sociable or participative temperament (low Sy [= sociability]); intelligent, outspoken, sharp-witted, de-manding, aggressive, and self-centred; persuasive and verbally fluent, self-confident and self-assured (Sa [= self-acceptance]); and relatively uninhibited in expressing their worries and complaints (low Wb [= sense of well-being]).

But it is on the second cluster of scores, those having to do with responsibility, socialization, and self-control, that creative architects differ most widely from their less creative colleagues. Their scores reveal the creative architects to be relatively free from conventional restraints and inhibitions (low So [= socialization] and Sc [= self-control]), not preoccupied with the impression which they make on others and thus perhaps capable of greater independence and autonomy (low Gi [= good impression]), and relatively ready to recognize and admit self-views which are un-usual and unconventional (low Cm [= communality]).[14]

These surveys are clearly of interest, linking as they do creativity to individual natures or, in the case of young people, to the development of their psychological personality. In particular, the lessons they teach concerning education should not be neglected, even though they have often been adumbrated by naïve pedagogy. But we also see what they presuppose or neglect: on the one hand, on the psychological plane they leave in the shade the motivations that can be revealed by depth psychology. On the other hand, in trying to establish the psychological conditions and modalities of creativity, they presuppose that its manifestation may be subjected to objective criteria, and that in the long run it is possible to distinguish genuine creativity from imitations of it. In that respect they rely unthinkingly on the judgement of experts, teachers or critics; but there still remain to be studied both the socio-cultural conditions of such a judgement, such as could be undertaken by a sociology of taste, and the justification of that judgement, which calls for the immanent analysis of the objects created. From this it can be seen that other approaches to the act of creation must be co-ordinated with those just mentioned, and, in the first place, to complete this discussion of psychology, the study of motivations. But we must first say at least a few words about the special approach made through data processing.

(c) *The informational approach*

The data processing approach to creation is in fact very like the psychological approach, from which it has in particular borrowed the notion of *Gestalt*. As it has been dealt with in the preceding chapter by one of its most outstanding experts, Abraham Moles, we shall here say of it only what can be said by a layman and we shall follow very closely another text by A. Moles

14. *Ibid.*, p. 366.

himself.[15] The problem of creation lies at the heart of cybernetics, for it postulates that in man's mental structure there is 'only one function which creates forms' (or 'messages' – the form of the object is the message transmitted by the phenomenon to the receptor), this same function being at work in the sciences as in the arts. And as Moles says, its unavowed aim is the construction of a Creating Machine. Art and science are therefore conspiring together. Moles would doubtless reject the prudent distinctions made by Kant between arts or sciences and fine arts, or by Francastel between 'plastic thinking' and 'logical thinking'. For him, art, which always combines a semantic dimension and an aesthetic dimension, 'supplies us with *subjects for thought*' (*nous fournit en objets à penser*) and 'the artist is an amplifier of intelligence' (*l'artiste est un amplificateur d'intelligence*). That is why – in addition to proof of that reflectiveness of contemporary art referred to in our introduction – the production and study of a work of art may in the end be merged into one another: the experimental art of today is of itself experimental aesthetics. And such art does not wait for the creating machine to be created before it has recourse to machines; as we know in the case of contemporary music.[16]

The example of music enables us to determine forthwith the function, if not the structure, of the creating machine: 'the experimenter who produces a composing machine programme is led on, ipso facto, to an exhaustive, precise and thorough study of the very rules of music and of its various styles, which makes him an eminent musicologist and, by reaction, suggests to him a multiplicity of creative ideas which he hands over to machinery to try out. The rôle at present assigned to the machine is that of overcoming complexity and exhausting combinatorial possibilities'.[17] Thus, the machine does not *replace* the artist or the scientist, it supplements him by, as it were, multiplying his power of conceiving and exploring the imaginary. By programming the machine, it is he, and he alone, who determines the style or the norm of his works. The machine takes over from him by producing the elementary

15. 'Création artistique et mécanismes de l'esprit', an essay which is published only in a Romanian translation (1970), and which we quote from the original manuscript in French, kindly lent by the author. The first quotations given below are taken from pages 1 to 4 of the manuscript (pp. 173 to 175 of the Romanian publication). See, with reference to these questions, the recent work by MOLES, *Art et ordinateur* (1971).

16. Many names could be given here, it will suffice to mention four titles: XENAKIS, *Musiques formelles* (special number of the *Revue musicale*, 1963); MOLES, *Les musiques expérimentales* (French version, 1960); SCHAEFFER, *Traité des objets musicaux* (1966); *Musiques nouvelles* (special number of the *Revue d'Esthétique*, 1968).

17. 'L'expérimentateur qui actualise un programme de machine à composer est conduit, ipso facto, à une étude exhaustive, précise, approfondie, des règles mêmes de la musique et de ses différents styles, qui fait de lui un musicologue éminent et, par réaction, lui suggère une multiplicité d'idées créatrices qu'il donne à la mécanique le soin d'éprouver. Le rôle assigné actuellement à la machine, c'est de vaincre la complexité, d'épuiser la combinatoire.' – MOLES, *art. cit.*, p. 8 of manuscript (p. 178 of the publication in Romanian).

forms of composition, as the computer takes over from the research worker by doing his calculations. In other words, the rôle of man is not nullified, but *shifted elsewhere* by the machine. To quote Moles once agian: 'Man's rôle is *shifted elsewhere* by the advent of the creating machine: (a) a link is created between the aesthetician who defines, elucidates and transcribes the rules of style and the artist who implements them: resulting in an exchange that promotes experimental aesthetics to the rank of a utilizable technique; (b) the creating machine will, in the first place, be a machine to test combinations, laying open to the field of art the dimensions of structural complexity at the various levels of perception'.[18]

Furthermore, the machine, by presenting them helps us to understand the 'basic mechanisms' (*les mécanismes de base*) of creativity. It puts itself at the service of that key faculty – the imagination that creates forms. For the artist, in this very like the scientist and the research worker, 'sets out in search of forms, of patterns, which attract him. He is an inventor only in so far as he is a discoverer of new forms: his act of creation is *first and foremost* an act of choice'.[19] But the imagination must still come to terms with the 'reasoning faculty' (as in Kant with the understanding). For the originality of what is new must be reduced to a proportion acceptable for the public, or at any rate, for the artist; it must therefore be rectified by a certain *redundancy* which guarantees a necessary minimum of intelligibility. Perception of the message demands that order and disorder – we might equally well say the norm and the transgression of the norm – should be mingled in it in the right proportions. It is this balance which determines 'the extent to which the work a-chieves its purpose of communication and, consequently, its social value' (*l'adéquation de l'oeuvre à son but de communication et donc de valeur sociale*). Thus the notion of newness lies, in any case, at the heart of such research, and as a quality which can be measured and the measuring of it sends us back from the study of creativity to the study of what is created, of which

18. 'Le rôle de l'homme est *déplacé* par l'apparition de la machine à créer: (a) une liaison est créée entre l'esthéticien qui définit, élucide et transcrit les règles du style et l'artiste qui les actualise: un échange en résulte qui promeut l'esthétique expérimentale au rang de technique utilisable; (b) la machine à créer sera d'abord une machine à essayer les combinaisons, ouvrant au champ artistique les dimensions de la complexité structurelle aux différents niveaux de la perception'. – *Id.*, p. 14 (p. 183).

19. '... part dans le monde à la recherche de formes, de *patterns* qui le séduisent, il n'est l'inventeur qu'en tant que découvreur de formes nouvelles: son acte créateur est *d'abord* un acte de choix'. – *Id.*, p. 9 (p. 179).

The constant recourse of cybernetics to the notion of form could raise here an interesting problem of psychological aesthetics: is *material* imagination, which Bachelard contrasted so forcefully with *formal* imagination, really different or does it necessarily require the creation of forms in order to express itself? It would no doubt be necessary to go more fully into the notion of form by comparing it with that of representation. That is why the problem mentioned here in passing could doubtless find elements of a solution in current research on the semiotics of representation, and also on the relationship between the presentation and the text, and where psycho-analysis, as we shall shortly see, has something to say.

we shall speak briefly later.

As regards creativity, we see that the creator is not only helped by the machine; he is to a certain extent explained by the model supplied by the machine. Can we proceed further along these lines and transfer the explanation from the mechanical to the physiological? Can we regard the nervous systems as a machine? The data theory is increasing the amount of research in that direction, but it would seem that the investigations being made are not so far concerned with the psycho-physiology of creation.

And since all machinery requires a certain amount of energy to operate, the motor processes of creation, that is to say, motivations have still to be studied. Here, the data theory can give place to psycho-analysis.

(d) *Psycho-analysis*

There is nothing surprising about the fact that psycho-analysis is being directed towards the study of creation. Dreams occupy a great deal of its attention, but do not works of art resemble dreams in that they are spontaneous, imaginary, impenetrable? And although psycho-analysis consists largely in understanding the process of dreaming, not only the images it produces but the impulses which produce it, will it not be extended to cover the work of the artist, not only the work he creates, but also the desire which urges him to create and which is expressed through the act of creation? What we have called motivation is given its true name and true visage by psycho-analysis which calls it libido. Freud himself has, in fact, considered the nature of the work of art and the artist. And soon after him came many works on the psycho-analysis of art, the extent and diversity of which are sufficiently shown in the text by J. F. Lyotard in the preceding chapter. They are too numerous for me to list them here, the more so as they are generally not limited to the specific problem of creation and not without reason, for it has already been suggested that the analysis of creation could be carried out only when reference could be made to a prior analysis of what was created.

As for creation in itself, has psycho-analysis anything to say about it? Freud suggests that it is doubtful. As to what makes Leonardo a great painter, that is to say a true painter, psycho-analysis has nothing to say. And who has anything to say? We speak of a gift, or of genius, to say that we admire certain works; and we can justify that admiration only by revealing, with reference to the product, the technical procedures followed for its production. Analysis then operates in the context of the principle of reality, and with reference to the creator's ego, to that element in him that is concerned with reality, with a world than can be known and mastered. But psycho-analysis is primarily interested in the id, and the pleasure principle in accordance with which the id expresses itself, the world of phantasm in which desire is fulfilled. Concerning that libido, its origin, its operation and its manifestation, psycho-analysis has perhaps something to say.

But with what libido are we concerned here? Doubtless a distinction must be made between the libido by which all men are haunted, which is the un-

conscious itself in every individual psyche, and the desire, itself uncon-
scious, to express the libido, or rather, to let it express itself. Contemporary
thinking (Blanchot, Bataille) and also the testimony of many artists, warn us
that the libido is not a project, a free decision, but truly a desire; and that, as
in the case of all desires, the more inaccessible the goal the more violent the
desire. That goal is not the work of art, otherwise the artist would come to a
stop as soon as his work was completed; and what creator has ever had the
feeling of being finished with his work? Of course, the desire to create must
indeed be expressed and relaunched by means of creations, which, however,
are never the last word that can be said. If the libido remains unsatisfied,
that is because fundamentally it is a desire for the impossible: the desire to
express the desire as it expresses itself in the dream, and so fulfil it. It is that
desire, which cannot be reduced to aptitudes and *savoir faire*, although it
always needs them in order to become operative, that is doubtless the dis-
tinguishing work of the true creator. That is why we must above all make sure
of its existence and of its energy. What assures us of this, is paradoxically the
work itself, and that is why our first duty is to examine it and pronounce that
judgement of value that is the measure of its authenticity; for only the work
can tell us whether the libido which gave rise to it was genuine, whether it
possessed the strength needed to fulfil it.[20]

Let us dwell for a moment on this point. We see that psycho-analysis en-
tails a judgement of value, and consequently an examination of the work.
Only by means of such an examination is it possible to answer the irritating
question which it is eternally asked, which also it asks itself, and which we
are shortly going to meet in this paper: how can we distinguish true creation
from pseudo-creation, the creative work from the symptom-work, genius
from madness? To this question there is no ready-made answer, each case
being individual and ambiguous. Let it be said at once and very firmly that
only a formal study of the work can suggest any answer, one that will doubt-
less be invariably cautious and uncertain. That is why psycho-analysis, which
purports to be an analysis of the subject, and let us add, of his motivations, is,
in reality, in the first place an analysis of the work. Let us return, however,
to the analysis of the libido, but well aware that only the work can testify as
to its authenticity and its strength.

'Strength' is the word which is used by Hölderlin, and which is taken up in
modern studies such as those of Blanchot, Rousset and Derrida, to describe
poets, those who remain upright under the shafts of heaven – that is, who
are not afraid to speak of the libido, or rather, to express what the libido
arouses in them, and what they are forced to describe, almost unconsciously
and without ever knowing it, as strange, disquieting, invisible. When that
strength is lacking ... through excess, they are struck down; they become
mad; when it is lacking through insufficiency, we have academism or dilet-
tantism. In both cases, creation founders in silence, or in idle talk; not that
the desire has disappeared, but the desire for desire has proved to be without

20. In writing this, I have drawn upon *Discours, figure* by J. F. LYOTARD (1971).

strength, reduced to impotence by the disintegration of the ego, or by its socialization, as may happen, but in another way, by the choice of an ego which is converted to the reality-principle and turns towards science.

Whence comes this desire? The concept introduced by Freud to deal with artistic activity (and moreover, with intellectual activity also) is that of sublimation: the particular way in which the sexual impulse comes to an end and which presupposes that that impulse has been assigned the property 'of being able to switch to another goal without losing its essential intensity' (*de pouvoir déplacer son but sans perdre, pour l'essentiel, de son intensité*), and consequently 'of exchanging the original sexual goal for another which is no longer sexual, but which is psychologically akin to it'.[21] To which Freud was later to add a change in the object of the impulse. But he says also that the suppression and sublimation of desires are processes 'of which we know absolutely nothing as regards their internal mechanism'.[22] Ricoeur observes that 'in Freud's work, the notion of sublimation is both fundamental and episodic' (*dans l'oeuvre de Freud la notion de sublimation est à la fois fondamentale et épisodique*).[23] Similarly, in their *Vocabulaire de la psychanalyse* (1967), Laplanche and Pontalis say: 'the absence of a coherent theory of sublimation continues to be one of the lacunae in psycho-analytical thinking'.[24]

Though unable to discover the mechanisms of the sublimation which produces the desire to create, we may at least try to find out how that desire operates, that is, how art can succeed in expressing that desire. But first, and as a guide for our observations, let me point out that psycho-analysis has been dogged by a temptation. Or rather, a twofold temptation, to which it gives way as soon as it is no longer attentive enough to the specificity of the work of art, and also to its authenticity. Giving way to the first leads to the assertion that creation, in so far as it calls in fact for *savoir faire*, control and vigilance, establishes the domination of the ego over the unconscious; so that art is placed on the same level as science, technology or philosophy, that is to say, the activities by means of which the ego liberates and affirms itself. Art will be used even for therapeutic ends, as we are reminded by Dr. Wiart in a contribution to the present study. But the cathartic function of art is not that of science. Apart from the fact that it has recourse to release rather than to repression, the work of the ego entailed by it implies a relationship with reality that is different from that of science. On the other hand, by yielding to the second temptation, and because often it is as much a theory of sickness as it is a therapeutic, psycho-analysis treats art as a neurosis just as it does religion, for instance; in this way it considers a work of art as a symptom and attempts to explain its production as being actually due to sickness. It thereby ignores all the positive work of creation, which definitely rules out any identification of the work of art as a symptom, that is to say, as a direct expression

22. *Gesammelte Werke*, V, p. 140.
21. *Gesammelte Werke*, VII, p. 150.
23. *De l'interprétation* (1965), p. 467 (English translation, *Freud and Philosophy*, 1969).
24. At the end of the article 'Sublimation'.

of desire. It ignores the desire to create which is peculiar to art. It is conse-
quently necessary to accept, and possibly intensify, the ingenious distinction
established by Marinow between the schizophrenic who paints and the
painter who becomes a schizophrenic.[25] It is indeed true that, to the experi-
enced eye, both express themselves in their productions, which are in that
case 'pictographic symptoms'. It is also true that both are treading the same
paths towards the same collapse into psychosis. But these paths, and the ex-
pressions which mark out the stages, run nevertheless in opposite directions:
the schizophrenic who turns to painting when discourse has become im-
possible for him, invents a new technique for communicating and for bring-
ing order into the chaos of an exuberant world. Hence the surprising mixture
of contraries observed by Navratil,[26] excessive formalism and arbitrary de-
formations. In this way the schizophrenic invents his 'style'. What Marinow
observed in the painter who becomes a schizophrenic is, on the contrary, a
'change of style', in the form of a deterioration of technique before the
painter finally gives up. The painter ceases to be a creator, whereas the other
becomes one for a moment, and very relatively. For 'not all human activity is
creative, and not all the results of creative activity can be regarded as works
of art'. It may even be that some works created under the influence of schizo-
phrenia are genuine works of art; which does not mean that it is possible to
replace the notion of a psycho-pathology of art by that of a psycho-patho-
logical art. This is where Marinow disagrees with the many psychiatrists
(Lombroso, Bader, Navratil, Bleuler, etc.) who have the romantic idea that
sickness brings out new and unpredictable possibilities in man, and that the
way of genius lies through madness.[27]

What is expressed in the work of a madman is madness. That being so, the
work can certainly be regarded as a symptom, and very usefully so, as Dr.
Wiart attests. But in this particular case the expression is too intelligible, and
to the point of paradox that intelligibility attests that, even if there is a desire
to communicate, there is no desire to express the desire – that desire, secret
and subtle in its operation, that belongs to the creator. Rather, desire is ex-
pressed spontaneously, not only unconsciously, but, as it were, mechanically.
How, in fact, is desire generally expressed? By a phantasmic form, what
Freud sometimes calls a matrix. The phantasm is that image, for which the
unsatisfied desire provides the impulse, and in which the desire is fulfilled
in imagination, the energetics of desire being always linked to the plastic
quality of a form. But where the work is a symptom, desire has lost its avail-
ability and has become linked to a rigid and obsessive form which expresses
itself in almost univocal fashion. On the contrary, where desire is not scle-
rosed by sickness, the form is in motion and not easy to decipher. It is pre-

25. Marinow, 'Der malende Schizophrene und der schizophrene Maler' (1967).
26. *Schizophrenie und Kunst* (1965).
27. A problem to which contemporary thinking, whether prompted or not by
psycho-analysis, is constantly returning; as one proof of which (among many) see
the article in which Derrida questions the interpretations proposed by Laplanche
and Blanchot for the 'Artaud case': 'La parole soufflée' (1965, 1967).

cisely such a form that is produced, or prepared, in a genuine work of art, by the desire to create. Let us recall, in the first place, an observation of H. Sachs; he contrasts daydreams and poetry (just as Freud contrasts '*der Dichter und das Phantasieren*,' and curiously enough, without any reference to Freud). What characterizes poetry (in the broad sense of the term) and makes it different from dreaming, from ordinary phantasm, is the care with which desire is there disguised.[28]

But what is the reason for this disguise? We must not suppose – Lyotard so warns us on this very point – that it is merely due to the unconscious self, and that the desire to create is also evident to itself. On the contrary, creative activity is unaware of the matrix form which represents desire, even when it is shaping an object wherein such a form will 'set'. The same happens here as with the receptor: the conscious pleasure experienced from the form of the object is merely an 'enticement' which both releases and conceals a deeper pleasure, which is an unconscious one: the pleasure we take in 'enjoying our own phantasms without scruple or shame', as Freud said.[29]

What, then, is consciously done in the act of creation? Joana Field describes this for us by examining the vicissitudes of creation in a woman patient. What makes it impossible for this patient to paint is the conscious effort either to follow the technical procedures which enslave her to authority, or else to produce the exact resemblance which encloses her to the object: anxiety then inhibits creation. On the other hand, activity is liberated precisely when the patient is willing that her hand should move freely and that the result should be unpredictable, that she should then exercise her will to 'maintain the kind of attention which created a gap ahead of time and a willingness to wait and see what was emerging to fill the gap', in other words, 'to provide the framework within which the creative forces could have free play'.[30] Is it not this same effort that psycho-analysts demand of their patients? We see, then, that the part played by consciousness is merely – but it is considerable – to arrange, in what actually follows from the reality-principle and imposes formal constraints – language, material, the world perceived – an imaginary space which could be called primary because it is homologous with the processes of the unconscious, in which the unconscious figure will be able to exhibit its traces. This is what is now called a work of deconstruction: it is a matter of going beyond the bounds of writing – all forms of writing: verbal, pictorial, musical – a matter of turning the codes against themselves and putting them at the service of a message which will never be formulated in plain language. This theory of creation seems, no doubt, to be very greatly inspired by contemporary art, but perhaps it is really in our epoch – let us say, in the last hundred years – that aesthetic creation has won its independence by breaking free from all politeness, all ritualism, all ideology. Perhaps Western art prior to the nineteenth century, and still more so ancient art, was aimed primarily at interpreting the subject in a cul-

28. SACHS, *The Creative Unconscious* (1942).
29. *Gesammelte Werke*, VII, p. 223.
30. FIELD, *On Not Being Able to Paint* (1950).

ture which was not exposed to challenge, rather than at expressing the transports of desire. Perhaps also the art of today helps us to see the art of the past more clearly, to understand that the violence and fantasy of creative transgression are not the monopoly of our epoch, and that all true art, in spite of, and above and beyond the religious or social functions that it has been able to assume, acts as the herald of an impossible message, concerning which we do not know whether its meaning should be ascertained by reference back to the fantasy of the transmitter or of the receptor.

May not this message, however, be attributed to the creator and deciphered by the psycho-analyst? Among much recent work, mention must be made at least of the remarkable achievements of Mauron's psycho-criticism. Mauron does not yield to the temptation mentioned earlier, but declines to regard a work of art as a symptom, immediately decipherable, of a trauma. By superimposing texts, by comparing figures of speech, he detects 'obsessing metaphors' articulated in networks beneath which he uncovers 'mythical figures', which themselves point to a 'personal myth', the status of which, as Lyotard very rightly says, is analogous to that which Freud assigns to the original phantasm. 'The same dream is continued in several works, which might be merely that dream in different disguises'.[31] Analysing the dream implies looking for 'an unconscious structure', articulating 'an internal dramatic situation' which, moreover, is not easy to locate; for 'the deep-lying imagination does not assemble, as thematic consciousness and criticism too easily suppose, merely sensations and memories or ideas scarcely touched by sentiments; it commands movements of desire or fear, the search for or the flight from contact'.[32] In any event, creation springs from the unconscious, it constitutes a form of 'reversible regression' (*régresion réversible*), similar to what is found in analysis or self-analysis: 'art demands, as a preliminary gesture, an affective withdrawal both to the experiences we have had, our past as living beings, and our reserves of energy ... What is needed is the inner light of the blind, sensitive to all the shades and presences of the night'.[33] The look that Orpheus casts on Eurydice. But this is where the operation of the ego begins, which Mauron has chosen to call orphic; for 'regression represents merely a first stage' (*la régression ne représente qu'un premier temps*); we must still 'effect synthesis at the level of language' (*opérer la synthèse au niveau du langage*). But is there really a question of synthesis? Does creation reconcile the unconscious and the conscious? Is it not rather an activity which

31. 'Un même rêve se poursuit sous plusieurs œuvres qui pourraient n'en être que des déguisements divers'. – MAURON, *Des métaphores obsédantes au mythe personnel* (1963), p. 65.
32. 'L'imagination profonde n'assemble pas, comme le croient trop aisément la conscience et la critique thématiques, que des sensations et des souvenirs· ou des idées à peine colorés de sentiments; elle ordonne des mouvements de désir ou de crainte, des recherches ou des fuites de contact'. – *Ibid.*, p. 195.
33. 'L'art exige, comme geste préalable, un repli affectif à la fois sur nos expériences vécues, notre histoire d'être vivant, et sur nos réserves d'énergie ... il faut un regard aveugle, sensible à toutes les nuances et les présences de la nuit'. – *Ibid.*, p. 239.

is unaware of what it does, which at any rate does not know that it allows the unconscious to rise to the surface without ever becoming visible as in sickness? An activity which, the more lucid it is the more it pretends to be unaware of itself; leaving the initiative to words, as Mallarmé says, to those words which are 'the germs of a poem' (*germes de poème*), as Valéry says.

The analyses of Mauron should in any case be supplemented by those of the plastic arts by Pierre Kaufmann, who takes up in his own way the theme of creation as a regression in the direction of an original. He analyses creation less as the production of an object than as the invention of an imaginary spatiality (rather like the topological space revealed by Francastel in contemporary art) typical of phantasmatic objects, a vacant space, open between 'the unspace' ('*inespace*') of enjoyment and the mundane space guaranteed by the reality test, whose vectors are lived in the emotions in which the anguish of desire is specified. For desire is anxious: the law is that its object should be inaccessible to it, and that consequently 'the subject should be deprived of its identity' (*le sujet soit dessaisi de son identité*).[34] Creation is a retroaction provoked by that anxiety: 'the function of art is to confer existence on what has never been, on what is in so far as it has been withdrawn'.[35]

It is at any rate noteworthy that for the authors just mentioned, the study of creation leads to the study of the object created, and the study of the meaning of that object to the study of its formal structures; which is proof that the technical work of creation cannot be neglected, even if it is inspired by and placed at the service of phantasm in order to offer it a place of refuge. But there is a final point, which the reference to Kaufmann impels us to mention, and which moreover goes beyond the field of psycho-analysis; for in fact in Kaufmann, as in Lacan, we find that psycho-analysis is associated with a whole school of thought based on the contemplation of absence (or dissimulation, or difference). Psycho-analysis brings grist to this particular mill in so far as it discovers that children have their first experience of exteriority through what is missing; when the breast, the 'good object' ('*bon objet*') of enjoyment moves away and will become truly an object only by turning into a 'bad object' ('*mauvais objet*'); the other is other only by being absent. And, at the same time, the other is also the incomprehensible authority of the father and, through him, of culture. Whence the idea that desire can never be satisfied, even if the need dies down or if the impulse slackens, both because its object eludes it, being other and non-supplementary, as Pradines said, of the object of need, and because the Other imposes on the ego the régime of prohibition. Whence also the anxiety, 'which is not only the result of experience, but original expression, all emotion being a protection against anxiety', as Kaufmann says, in this case citing Heidegger.[36] Otherness is therefore thinking based on both the lack of the lost object and

34. *L'expérience émotionnelle de l'espace* (1967), p. 241.
35. 'La fonction de l'art est de prêter une existence à ce qui n'a jamais été, à ce qui est en tant que soustrait'. – *Ibid.*
36. '... qui n'est pas seulement l'expérience, mais l'expression originaire; et toute émotion est une défense contre l'angoisse'. – *Ibid.*, p. 125.

the constraint exercised by authority – the father, language, the law. No doubt. But a capital letter hypostatizes it by uniting its meanings; whether this Other be named – Father, Phallus, Signifier or Law – it is always carefully distinguished from the *alter ego* and from the social institution. Finally, the father is understood by the Father, language by the Word, as the penis is understood by the Phallus. We do not explain what is sacred, we postulate it as a principle of explanation, or as man's destiny. Is not this in the end, a justification of religion, since even if we undertake to psycho-analyse it, we accept the principle of it in the basis of psycho-analysis? Psycho-analysis would demystify only if it laid all its cards on the table and if it stated clearly that the withdrawal of the signifier (and why call it the signifier?) was sometimes the withdrawal of the breast which governs the individuation of the child, and sometimes the cultural system which existed before him and imposes itself upon him.

But what matters to us here concerns creation or, if the term is preferred, inspiration. No doubt it is true that creation offers phantasm a gap to be filled wherein it can express itself, and that consequently its operation is, in the first place, to smash constraints or transgress norms; invention is indeed recognized by its ability to provoke rupture. But that does not imply the 'dispossession of the subject' (*le dessaissement du sujet*), or that the creator is another, absent to himself and to the outside world, so as to be linked to the Other. Why should the phantasm which inspires the creator not be inspired itself by the outside world? Freud always sought in the outside world the origin of the original phantasm; it may possibly manifest a structure that cannot be reduced to individual experience. As Laplanche and Pontalis very rightly say, 'The notion of the original phantasm combines the need to discover what might be termed the bedrock of experience (and if that is fractured and, as it were, weakened, and finally fades away in the history of the individual, we shall go further back as far as the history of the species), and the desire to base the structure of phantasm on something other than experience'.[37] That structure must be filled in or animated by experience, that is to say by a certain experience; in other words, what is imaginary cannot be cut off from what is real. If it seems to be operating in unreality, it is reality that is being hollowed away, that is giving place to nullity, to absence, as well as necessity; and it is perception, wise or unwise, which experiences the hollowness of absence, as it experiences the indistinctness of the horizon. What inspires the desire to express and liberate desire is the outside world. Rather than express the dispossession of the subject, art testifies to the way in which the subject is caught up by reality, possessed rather than dispossessed. And in aesthetic experience, if the subject fails to master the object, he will, by

37. 'Dans la notion du fantasme originaire, viennent se rejoindre l'exigence de trouver ce qu'on pourrait appeler le roc de l'événement (et si celui-ci, réfracté et comme démultiplié, s'efface dans l'histoire de l'individu, on remontera plus haut, jusque dans l'histoire de l'espèce), et le souci de fonder la structure du fantasme elle-même sur autre chose que l'événement'. *Vocabulaire de la psychanalyse* (1967), p. 158.

dint of communicating, be mastered by it, he will experience presence and not absence.

2. *The historical approach*

History, like the human sciences, comes into contact with art, and consequently with the fact of creation. Of course, within the bounds of history regarded as a discipline, the histories of art, in general highly specialized, occupy a well defined place. But it could be shown that the various doctrines of history each have an effect in the study of creation. It will suffice, in this paper, to discuss two clearly opposite trends.

The first of these, which could be called traditional, is above all sensitive to the individuality of the creator and to the uniqueness of his work; in this it is adopting for itself the notion that history's task is to show the unique aspect of events. Here, the event is in the unique act of creation, the advent of the work of art. We shall therefore concern ourselves more with its origin than with a description of it; we shall study the theory of production rather than of the product. The study of the origin will itself deal mainly with the creator, with what he himself has that is unique; and what we shall seek to gather about the work will be the style, conceived not as a code or as a system of values peculiar to a group or a school, but as the expression of a personality. Of course the study of style entails an immanent analysis of the work; the more so as the historian is at the same time the expert to whom the problems of attribution and dating are entrusted. Among so many others, Berenson and Venturi spring to mind. But formal study is not in this case taken as an end. The historian seeks to account for facts of style by reference to the creator. He therefore gives priority to biography, and also to the creator's psychology. However, if this kind of history is really to be history, it cannot be limited to psychology; it explores the circumstances surrounding the act of creation, and in particular the cultural situation which inspires and directs it. In general, it takes little account of the social and economic situation, except, of course, in so far as that situation has a direct influence on the creator; talking of Florentine art, mention of Lorenzo and his court can hardly be avoided. It tends to analyse an historical context by dealing with the particular rather than the general, that is to say, with reference to events, individuals or works. In proof of this we may mention the argument, brilliantly developed by Malraux, that a painter becomes a painter by looking at paintings and not at landscapes, and that, for example, El Greco responds to the direct challenge addressed to him by Tintoretto. While, however, history of this kind states the general, it is in terms of schools rather than of genres, because schools are connected with intersubjectivity, whereas genres are connected with structural typology. We see, therefore, the concepts involved: personality (genius), source, influence, inheritance, anticipation. The creator is the man who pursues a dialogue with other creators, past, contemporary and sometimes future; sometimes also with other men: princes, popes, pa-

trons, critics. He assumes a tradition; he is subjected to influences; he imitates great masters. If he has genius, he innovates and may be forerunner of later work: Signac, for example, hails in Delacroix a precursor of neo-impressionism. These concepts have been criticized quite recently by Michel Foucault.[38] Their explanatory capacity is indeed limited so long as they are unable to offer either an exact analysis of what is new in the object created, or a study of the many technical, social and political conditions of creation. Influence exercises merely a magical causality. And the notion of a history as a relationship between discontinuous units is suspect. Although Signac justifies himself by evoking Delacroix, it is nevertheless true that the handling of colour has not the same meaning or the same purpose in both. Similarly, as Todorov writes, 'it matters little that such and such a device in Racine is already to be found in Corneille. In the work of each it has a different significance, which alone counts in the description of such and such a tragedy. As early as in 1926 Tynianov said: "I reject categorically the method of making comparisons by means of quotations, which makes us believe in a *tradition* being handed on from one writer to another. According to this method, the constituent terms are taken out of their functions, and in the end we are faced with incommensurable units".' [39]

However, not everything in this approach is to be condemned. In the first place, it makes reasonably clear what artists experience and their spontaneous ideology. It is true that they have personal relations with works of art and with men, that they sometimes despise and sometimes admire, that they would like to be thought faithful to certain examples, that they wish, on the contrary, to break with certain traditions or challenge certain authorities, that they group to form a school or sever their connexions; in short that they feel themselves to be creators in an anecdotic history of intersubjectivity. The value of a biography is that it relates their experiences, or at least the superficial aspect of them. This historical approach has further the merit of dealing not only with the individuality of the creators but also with the special features of the works. It can, therefore, do them justice, not only by appreciating their quality (and consequently by admitting a judgement of taste), but also by finding in them a province of history. For while history is concerned with what is impersonal, a genre or a collective style, historical fact certainly belongs to what is singular: it is the work of art that is historical, in the sense in which Heidegger understands it with reference to the Greek temple which expresses a culture and an age, a moment of history; and also

38. Cf. *L'archéologie du savoir* (1969), *passim* (English translation, *The Archaeology of Knowledge*, 1972).

39. 'Peu importe que tel procédé de Racine se trouve déjà chez Corneille: dans l'œuvre de chacun, il reçoit une signification différente qui seule compte pour la description de telle ou telle tragédie. Tynianov déclarait dès 1926: "Je refuse catégoriquement la méthode de comparaison par citations, qui nous fait croire à une *tradition* passant d'un écrivain à l'autre. Selon cette méthode, les termes constitutifs sont extraits de leurs fonctions, et finalement on confronte des unités incommensurables".' TODOROV, 'Poétique', p. 153 in WAHL, F. (ed.), *Qu'est-ce que le structuralisme?* (1968).

in the sense that it initiates a history in the history of art, in so far as it establishes a new perception and proposes a new form of action. It is somewhat remarkable that when the history of societies – and of arts which appear at the outset to have no history – begins to take shape, ethnologists begin to take note of the creativity of artists, even if the latter continue to be shrouded in anonymity, and of the uniqueness of works of art. Thus, Jean Laude, studying negro art, not only exercises his taste, but discovers a similar taste for works of art in negro societies. They also, because they are sensitíve to quality, turn certain works into historical facts.

It is nevertheless true that this power of initiating, or punctuating, a history can be found only within a genre and with reference to a certain state of culture. History dealing with the events and persons involved in creation seeks support from an impersonal history in which creation continues to have meaning, but is no longer associated with a creator – anonymous history, an intimation of which is to be found among historians who are still traditional like Wölfflin, the outstanding figures among them being Panofsky, members of the school of Warburg, Francastel, Meyer-Schapiro, from whom most of the young historians draw their inspiration today. History of this kind aims at being more scientific, without measuring scientific value by exactness of detail and wealth of erudition. It is in two ways more scientific. On the one hand, by resorting systematically to formal – nowadays called structural – analysis, but in order to deduce from it general characteristics, special features, systems of value and significance, in short, structures which define a genre. This method is all the more necessary since the description of a work always involves other works, and it is the only one on which the analysis of a history, or rather of an evolution, can be based. To quote Todorov once more: 'In writing a history of *literature* (and not biography or social history), it is necessary to follow the evolution of the special features of the literary discourse, and not of the works. It is literature that evolves, not the works'.[40] The same could be said of painting or music, and of the genres properly so called that belong to each art: short stories, novels, still lives, landscapes, sonatas, oratorios, and even of sub-genres: in the case of novels, the form of dialogues and monologues. But with this reservation, I repeat, that it is always works that cause art to evolve.

Subject to that reservation, such an approach does not reject the idea of creation. On the contrary, it embraces it more firmly. True creation is what Francastel calls mutation, and in a work of art, this is innovation: the appearance of a new theme (for example, the one Panofsky presents in the representation of the Nativity: the Virgin kneeling before the Infant Christ instead of holding Him in Her arms) or of a new form which is not merely a variant of a traditional one (for example, the one Francastel reveals in Impressionism: the dissociation of line and colour, because colour is attributed to light and not to objects).

40. 'Pour faire de l'histoire *littéraire* (et non de la biographie ou de l'histoire sociale), il faut suivre l'évolution des propriétés du discours littéraire, et non des œuvres. Ce ne sont pas les œuvres qui évóluent mais la littérature'. – *Loc. cit.*

Furthermore, this concept of history can claim the support of science, in that, after having studied it, it undertakes to explain creation; not by the creator's psychology, but by placing the object created in its context, the history of art in general history. The historian does not extend his grasp over psychological events; his grasp is over historical events, just as over the discoveries of technology, the facts of social life or ideological movements. To explain creation means, in this case, to explain how it is called forth not only by a certain state of the problems of art, but by a certain state of social circumstances or of ideology. In matters of theory, this undertaking raises more problems than it solves, as Marxism can bear witness: how can we understand the influence of infrastructures on superstructures, that is to say, the influence of the 'specific conditions' of creative work? Are we to invoke a causality – whether dialectic or not – which after all would hardly be clearer than the notion of influence, or should we merely look for correspondence (as Baudelaire uses the word), or more strictly, a homology between social structures and the structures of the work of art, as Lévi-Strauss has so ingeniously done in the case of the Caduveo tattoos? However, even if the concepts remain imprecise, in practice the results are undeniable: the history of art helps us not only to a better understanding of the work, but to a better understanding of society as well, by showing how the institutions or *habitus* peculiar to a culture are reflected in art, and how breaks or mutations in style signify the advent, or the perpetuation, of a crisis of régime or of culture. We see, then, that this conception of the history of art leads on to sociology. Thus Francastel, for example, regards himself as a sociologist of art, and many contemporary historians could claim the same title.

3. *The sociological approach*

The sociological approach, like the historical approach, is by now long established [41] and tends to ignore the project and the *praxis* of the creator subject, the stress in this case being laid on the social conditions of creation. Confining ourselves here to the process of creation (since the sociology of art and of literature in general is discussed elsewhere), we may observe that society intervenes in this process at several stages [42]:

1. It is society, in the guise of the public, which urges on the creator. Sartre has made a remarkable analysis of the relationship between the writer and his public.[43] This relationship can be examined in the case of all the arts. It is, therefore, society which creates a certain demand for art goods.

41. Of pioneer works, I shall mention only: Guyau, *L'art au point de vue sociologique* (1889); Lalo, *L'art et la vie sociale* (1921); Plekhanov, *Art and Social Life* (English edition, 1953).
42. At this point, I follow very closely the invaluable indications given in a synopsis prepared by Jacques Leenhardt.
43. In 'Qu'est-ce que la littérature?' (1947, 1948, 1970) (English translation, *What is Literature?*, 1949).

2. It is society which offers to, or imposes on, the creator the intellectual and technical means established within it – a system of thinking and of values, art codes, styles.

3. It is society which directs these goods along various channels and offers them to the consumers.

4. It is society which judges them through the agency of those on whom it has conferred the power to judge.

These theses, which can be accepted without difficulty, are as yet very vague, and they are not made more precise by an attempt like that of the *Geisteswissenschaften* at the start of this century, to show that creation reflects and expresses the spirit, the vision of the world or of a society or an epoch; [44] in other words, that the creator is at the service of the prevailing ideology. Current trends in research are therefore directed towards determining objects and concepts with greater precision.[45] On the one hand, those who follow these trends are no longer content merely to refer to society, they try to discern the various social groups which may bring an influence to bear on creation, particularly, under the impact of Marxism, the social classes, according to the situation they occupy and the power they exercise in society as a whole. It is obvious, for example, that the demand for art goods differs in quantity and quality according to the social groups and it is also evident that the systems of thinking and writing from which the works draw their inspiration vary according to these groups. On the other hand, they are not any more content, for the purpose of defining the relationship between the work and the ideology, to evoke so uncertain a notion as that of reflexion – nor, for the purpose of defining the relationship between the various social sectors, as between infra-structures and supra-structures, to invoke the notion of linear causality and determination, which Marx had already found oversimple. Here again, Marxist thinking – in the works of Lukács, and quite recently in those of Althusser – is adapted to the complexity of social fact, and considers causality as a relationship that is not limited to the two terms that it unites, but is mediatized by the structurized whole of the relationships in which they are located.

We may mention at least two expressions from this new sociological approach. The first is 'genetic structuralism', which is employed by Goldmann who himself draws upon the work of Lukács. Goldmann's approach could also be paralleled with that of Hauser,[46] and even with that of Panofsky, of whom enough has been said in these two chapters for us not to add much more at this point.[47] It aims at establishing a homological relationship that

44. *Zeit-Bilder*, which is also the title of a recent work by GEHLEN (1960, 1965).
45. For a general picture of this research cf. BARNETT. 'The sociology of art' (1959); see also the special number (XX (4), 1966) of the *International Social Science Journal,* entitled *The Arts in Society*. For the sociology of literature and literary creation, the master-work is still WELLEK, R. & WARREN, *Theory of Literature* (1949): the remarkable bibliography contained in it should be consulted.
46. HAUSER, *Sozialgeschichte der Kunst und Literatur* (1953) (English translation, *The Social History of Art*).
47. Panofsky's originality lies not only in linking an iconological tradition which

is at once comprehensive and explicative between two 'significant structures' (*structures significatives*): that of a social group and that of a work. The first task is therefore to 'cut up the object' *(le découpage de l'objet)*[48]: to arrange the many facts in 'natural units' (*unités naturelles*) which make it possible to understand the activities taking place therein. These units must be determined in two orders of fact: at the social level, where they represent certain specific configurations where a certain social practice is located; at the level of intellectual and art productions, where once again cutting up is not just a matter of course; for while it is probable that a major work in itself constitutes a coherent structure, as a unit it is liable to disappear when we consider the complete works of its author (Goldmann, for example, considers that, in Pascal, the *Provinciales* and the *Pensées* are 'expressions of two structures that are separate although in certain respects related',[49] and it would be still more arbitrary to constitute a significant structure of such an entirety as the novel which would include both the *Roman de la Rose* and the '*nouveau roman*'. The second task is to define the relationship uniting the two types of structure – an intelligible relationship of homology, we are told; we must 'seek in the intellectual, political, social and economic life of the age, structurized social groups in which the works studied can be integrated as partial elements by establishing between them and the entirety, intelligible relationships and, in the most favourable cases, homologies'.[50] Of course the notion of homology brings us back to such terms as to *correspond*, to *reflect,* to *express*; but is that to be regretted? What has to be determined is indeed the coexistence of the structures through which the same practice and the same ideology are manifested in a group or class.

For the purpose of reflecting on creation, this operation is also useful in measuring the originality of a major work and apportioning the responsibility for its creation. Here, creativity is not measured by the novelty of the procedures or the violence of the transgression, but by the coherence of the imaginary universe offered by the work. As regards the *content* of that universe, the 'creator enjoys total liberty'.[51] But as the *structure* governing that content 'corresponds to the one towards which the entire group is headed' and which is represented by the creator, it may be said that 'it is the social group which – through the intermediary of the creator – *in the last resort*

is closely related to hermeneutics and contemporary semiotics with a sociology of creation, but also in looking for the mediations which operate between individuals and groups.

48. GOLDMANN, *Pour une sociologie du roman* (1964, 1965), p. 229 in 1964 edn.

49. '... expressions de deux structures distinctes bien que, par certains côtés, apparentées.' – *Ibid.*, p. 230.

50. '... rechercher dans la vie intellectuelle, politique, sociale et économique de l'époque, des groupements sociaux structurés, dans lesquels on pourra intégrer, en tant qu'éléments partiels, les œuvres étudiées, en établissant entre elle et l'ensemble des relations intelligibles et, dans les cas les plus favorables, des homologies.' – *Ibid.*, p. 231.

51. '... [l'écrivain] a une liberté totale'. – *Ibid.*, p. 226.

proves to *be the veritable subject of the creation*'.[52]

Another attempt to conceptualize a sociological approach is that of Pierre Bourdieu, who takes up and systematizes certain recent works not directly inspired by Marxism.[53] Here again the sociologists deny any summary sociologism and prove to be less eager than certain philosophers to reject all judgements of value and dismiss the claims of the creator. Bourdieu starts from a remark by Valéry, who contrasted 'works *which are as though created by their public* (whose expectations they fulfil, and are thus almost determined by knowledge of those expectations) and works which, on the contrary, *tend to create their public*'.[54] The second are genuine creations, which impose the idea of a 'creative project' ('*un projet créateur*'), which is 'the place of intermingling, and sometimes of contradiction, of the *intrinsic necessity of the work* which demands to be continued, improved, completed, and the social *constraints* which orient the work from without'.[55] It is with the idea of disentangling this interplay of two opposing necessities that Bourdieu proposes the concept of an intellectual 'field' by means of which society intervenes at the heart of the creative project. It could be understood in the light of that critical procedure which American sociologists call opinion-making; but it is more broadly constituted. Its elements have still to be accurately noted for each specific case, and Bourdieu mentions only, by way of example, 'artists, critics, intermediaries between the artist and the public such as publishers, picture dealers or journalists required to make an immediate appraisal of works of art, etc.' [56] In other ages, such as those studied by Schücking and Williams, the specific authorities selecting and consecrating works may obviously be different. What is important is that this intellectual

52. '... correspond à celle vers laquelle tend l'ensemble du groupe' ... 'c'est le groupe social qui – par l'intermédiaire du créateur – se trouve être, *en dernière instance, le véritable sujet de la création.*' – *Ibid.*, p. 225. See also GOLDMANN, *Structures mentales et création culturelle* (1970).

53. In particular, SCHÜCKING, *Die Soziologie der literarischen Geschmacksbildung* (1931) (English translation, *The Sociology of Literary Taste*, 1966); WILLIAMS, *Culture and Society* (1958) and *The Long Revolution* (1965/66). Of works concerned with particular aspects of contemporary production in the arts mention may be made of the following: WILSON, R. N. (ed.), *The Arts in Society* (1964); BECKER, 'The professional dance musician and his audience' (1951); NASH, 'The socialization of an artist: the American composer' (1957); MUELLER, *The American Symphony Orchestra* (1958); MYERS, *Problems of the Younger American Artist* (1957).

54. '... des œuvres *qui sont comme créées par leur public* (dont elles remplissent l'attente et sont ainsi presque déterminées par la connaissance de celle-ci) et des œuvres qui, au contraire, *tendent à créer leur public*' – VALÉRY, 'L'enseignement de la poétique au Collège de France' (1937), p. 1442 in *Œuvres*, Bibliothèque de la Pléiade, Vol. I (1957).

55. '... le lieu où s'entremêlent et parfois se contrarient *la nécessité intrinsèque de l'œuvre* qui demande à être poursuivie, améliorée, achevée, et *les contraintes sociales* qui orientent l'œuvre du dehors' – BOURDIEU, 'Champ intellectuel et projet créateur', p. 874 in *Les Temps modernes*, No. 246, Nov. 1966.

56. '... artistes, critiques, intermédiaires entre l'artiste et le public tels qui les éditeurs, les marchands de tableaux ou les journalistes chargés d'apprécier immédiatement les œuvres, etc. ...' – *Ibid.*, p. 880.

field was gradually constituted in the history of the West as an independent system governed by its own laws. It does itself occupy a certain position in society, and it is the intermediary by means of which its agents communicate with what Bourdieu calls the cultural field – a system of themes and problems, codes, forms of perception, etc. – which for the individual constitutes a 'cultural unconscious' (*inconscient culturel*) involved in all creation and always implied. In the intellectual field each agent is in turn determined by the position it occupies, which determines both its participation in the overall cultural field and its functional weight in the system. It follows that the creative project is constituted with reference to this intellectual field, to the objective truth of the work which this field offers to its author: it is in this field that 'the progressive objectivation of the creative intention takes place, and the *significance for the public* of the work and of the author is constituted, by which the author is defined and with reference to which he must define himself'.[57] This judgement on the truth of the work of art, which is effected anonymously and collectively by way of an infinity of specific social relationships is also a judgement on the value of the work and, in the first place, on its 'cultural legitimacy' (*légitimité culturelle*); for the various systems of artistic expresion are organized in accordance with a hierarchy which defines their degree of legitimacy, which is not the same, for example, for painting and photography, or for literature and the cinema. 'All creation . . . involves the position of the subject in the intellectual field and the type of legitimacy to which the subject lays claim';[58] to which the consumer, also, lays claim in making a judgement of taste, as his behaviour, too, is qualified and hierarchized.

An analysis of the intellectual field must therefore show how unequally legitimized and legitimizing authorities are opposed to one another and how they are connected with one another – 'legitimate authorities of legitimation, or authorities claiming to be legitimate, academies, learned societies, coteries, clubs or cliques more or less recognized or anathematized, authorities of legitimation and transmission such as the education system, authorities of simple transmission such as science journalists, with all the mixed types and all possible forms of dual membership'.[59] The work of Bourdieu in collaboration with Darbel, Passeron, etc.,[60] has here revealed the decisive part played by schools in Western societies: as cultural conservation authorities, they set institutional authority against the personal authority to which the creator lays

57. '. . . que se réalise l'objectivation progressive de l'intention créatrice, que se constitue le *sens public* de l'œuvre et de l'auteur, par lequel l'auteur est défini et par rapport auquel il doit se définir' – *Ibid.*, p. 880.
58. 'Toute création [. . .] engage la position du sujet dans le champ intellectuel et le type de légitimité dont il se réclame'. – *Ibid.*, p. 888.
59. '. . . instances de légitimation légitimes ou prétendant à la légitimité, académie, société savante, cénacle, cercle ou groupuscule plus ou moins reconnu ou maudit, instances de légitimation et de transmission comme le système d'enseignement, instances de simple transmission comme les journalistes scientifiques, avec tous les types mixtes et toutes les doubles appartenances possibles'. – *Ibid.*, p. 892.
60. Cf. *Les héritiers* (1964), and *L'Amour de l'art* (1966).

claim – a dialogue between the priest and the wizard. This is where Bourdieu is in agreement with the celebrated analyses of Panofsky on the relationship between Gothic art and scholastic thinking.

We see from this how contemporary sociology, by advocating a more subtle analysis of social structures and social relationships, is able to recognize the claims of the creator subject: it in no way abandons the attempt to discern the conditions and constraints weighing upon it, but it discovers that these determinisms are always refracted by the structure of the intellectual field in which the creator is situated and are active only in so far as they encounter the creative project. At the same time – and here again we may turn to Panofsky – it links this sociological study of creation very closely with the formal study of the object created.

II. THE STUDY OF THE OBJECT CREATED

All approaches to creation do, in fact, converge on the study of the object created, that is to say, on creation as a product and not as the act of a creator subject. For two reasons at least: because the object is there, more directly accessible to an objective study than the creator; and because only reference to that object makes it possible to discern cases where the word 'creation' should be understood in the strong sense of the term, if necessary by introducing a judgement of value. All production is creation, but only an actual creative work shows genuine creativity and possibly rules out a rejection of the word creation. This second reason, however, does not always motivate research workers, for research may follow either of two directions: either an analysis of any object, which we might dare to call generic, with the aim of determining a type, for example the structures of folk tales, cowboy films or sonatas, and sometimes of following up their development; or else the analysis of a single work with the intention of investigating the originality of an artist. In one case we define what Barthes calls a 'writing', characteristic of mass production, and in the other what he calls style characteristic of a creator. Note, moreover, that these two subjects of study are not so much opposed as reciprocal: for the works certainly have to be examined if the types are to be defined; and, above all, it is quite essential to have determined the rules of the type to see how far they have been followed and how far they have been transgressed by really personal works, which never produce their style *ex nihilo*. These two kinds of study are becoming increasingly numerous today, since the pioneer work done by the Russian formalists. Louis Marin has attempted to sum them up in his contribution to the preceding chapter.

I should merely like to mention here a new trend which seems to me to be emerging in these interdependent studies, doubtless inspired by contemporary artistic *praxis*. Traditionally, but still in the case of Lipps, Croce and Etienne Souriau, in all aesthetics from which the notion of beauty is not excluded, the aesthetic object is conceived of as independent, complete, subject to a kind of inner compulsion; even if its meaning, at whatever level it is

sought, is equivocal or plurivocal, its form, we might venture to say, is univocal. The Gestaltists have expressed this by saying that the work offers good form, par excellence. Solar perfection:

> Midi là-haut, midi sans mouvement
> En soi se pense et convient à soi-même.

But the poet adds:
> Tête complète et parfait diadème,
> Je suis en toi le secret changement.[61]

Similarly, the study of contemporary aesthetics is concerned with finding the secret blemish in this perfect object, the non-being in this Parmenidean being. A Gestaltist inspired by psycho-analysis, such as Ehrenzweig, detects ugliness in beauty, emphasizing that art rejects the charms of formal beauty in favour of exhibiting the disorders of the unconscious; and if beauty is still spoken of, it is on condition that it should be called horrible, as Baudelaire called it in his time, bitter as Rimbaud did, convulsive as Breton did: all informal art comes to justify these predicates. Approaching the matter from another angle, that of the meaning of the work, an attempt will be made to show, that it is sometimes unpremeditated and ambiguous, as Valéry once said; that, in the words of Eco, the work is 'open', bearing within itself the principles of its indefinite variations; that the work is sometimes in itself 'incomplete', as is said by Macherey, who explicitly contrasts this notion with that of an open work: 'The incompleteness indicated in it by the opposition of different meanings is the true *reason* for the form in which it is presented'.[62] Here again we find, as earlier with regard to a certain use of psycho-analysis, this theme of absence or lack [63] which haunts contemporary thinking from Heidegger to Lacan: a theme curiously inserted by Althusser and Macherey in a would-be Marxist context: 'books are made up of that lack, which gives them their history and *their relationship to history*.[64]

　Structural analysis nevertheless manages to live quite happily with such aesthetics. As we noted, it has been practised, and was in large measure initiated, by historians and sociologists themselves: for instance, by the school of Warburg. The different levels of meaning distinguished by Panofsky in his *Essais d'iconologie*, systematize a structural reading of the object. Structural-

　61.　VALÉRY: 'Le cimetière marin' (1st publ., 1920), in *Charmes* (1922, 1926, etc.).

　62.　'L'incomplétude que signale en elle l'affrontement de sens distincts est la vraie *raison* de son agencement.' – *Pour une théorie de la production littéraire* (1966), p. 97 (see also MACHEREY, 'L'analyse littéraire, tombeau des structures', 1966).

　63.　'Expliquer l'œuvre, c'est montrer que, contrairement aux apparences, elle n'existe pas par elle-même, mais porte au contraire jusque dans sa lettre la marque d'une absence déterminée qui est aussi le principe de son identité.' – MACHEREY, *Pour une théorie ...*, p. 98.

　64.　'Le livre est fait de ce défaut qui lui donne son histoire et *son rapport à l'histoire*.' – *Ibid.*, p. 98 (I have italicized the final words).

ism itself has finally, with Chomsky, introduced the notion of creativity, and not only of 'rule-governed creativity', which manifests itself as the power to transform, but also 'rule-changing creativity'.[65] With all the more reason when, in analysing works, stress is placed on creation, structural analysis must emphasize the deconstruction and transgression of the rules, the polemical character of the relationship between one work and another. Here are two examples: Tynianov wrote in 1921 of the relationship between Dostoevski and Gogol: 'When we speak of affiliation ... there is no prolongation of a straight line, but rather a deflection, propulsion from a given point, struggle ... a literary affiliation is primarily combat, the *destruction* of all that went before and a *fresh construction* of the old elements'.[66] Genette, at the end of a study on the style of Stendhal, reaches the same conclusion: 'Everywhere, at all levels, in all directions, there can be found the essential mark of Stendhalian activity, which is constant and typical transgression of the limits, rules and functions which apparently constitute standard literary practice'.[67]

But analysis cannot be limited to this negative aspect. Non-art is no more than a moment in the dialectic of art. To create is to construct after having deconstructed, to invent a new style which appears as a new system of rules. That is how, to sum up in a word what it has taken a long time to analyse, Francastel describes the mutation introduced by impressionism in painting. At the same time as he destroys local tone and dissociates colour from form Monet rediscovers light – in a different way from the luminists – and produces a new colour which has, as it were, emerged from light, just as, in music, the outburst of tonality occurs really only through the invention of polytonality or atonality which, for certain composers, momentarily constitute new systems. And doubtless it is not always easy to determine what is really new and innovating in a work or group of works. Francastel has clearly shown that certain works call for a mutation without going so far as to effect one, that the elements of a new system may already be present without being consciously perceived and utilized; as happens with the figuration of space in impressionism. But however that may be, it is the novelty of the work that defines creation and measures creativity. The study of creation is therefore reduced to discerning this novelty in the study, both formal and historical, of the work.

Thus by following, through the works, the inventions that mark the stages of a history – relatively independent and non-linear – of literary, plastic or musical forms, we may build up a theory of creation that does away with any need to refer to individual creators; and this, as we have seen, is precisely what the historical approach sets out to do. But reference can also be made

65. *Current Issues in Linguistic Theory* (1964), Section I, 'Goals of linguistic theory', p. 22.

66. Taken from *Archaïstes et novateurs* (1929), quoted in *Change*, II, 1968.

67. 'Partout, à tous les niveaux, dans toutes les directions, se retrouve la marque essentielle de l'activité stendhalienne qui est transgression constante, et exemplaire, des limites, des règles et des fonctions apparemment constitutives du jeu littéraire.' – *Figures II* (1969), p. 191.

234 Mikel Dufrenne et al.

to subjectivity; and, for example, the transgressive – and sometimes aggressive – element of creation may have light thrown upon it by the psychoanalytical approach as we have sketched it out. But can a study of creation make it unnecessary to examine subjectivity? It is on this point that I should first like to reach a conclusion before finally introducing a strictly philosophical approach.

CONCLUSIONS

1. *Creation and creator*

We have seen how most of the approaches to creation converge. Those which are concerned with the act of creation do not make it unnecessary to examine the object created; but is the contrary also true? In contradiction with the prevailing tendency in the most recent works, I should answer yes, and for two reasons. The first is, that we must take fully into account the personal experience of the artists. Even if this experience is illusory, even if they are unaware of what stimulates or conditions them, even if they understand themselves only through a questionable ideology or justify themselves by questionable rationalizations, it is important at least to evaluate the illusion and realize how it comes about. To show how the subject is 'dispossessed' or 'decentred', or for that matter determined, we must at least take him into consideration. The second reason is that the historical and sociological approach to creation is itself bound to entail some subjectivity, which is no doubt anonymous and, as it were generic, but which must be invoked if we are to understand how a work of art can be incorporated in certain socio-cultural conditions and reveal them. It is a single consciousness – even though it be collective – which is sensitive to the atmosphere of the time, to a style of life and of thought, to events and institutions, and which manifests its presence through works of art. How can we speak of a system (of conditions or forces) which has not been experienced in some way, if only unconsciously and at least by the person who speaks of it? If, as Le Bot says, 'the fundamental problem of the history of art is to define a link of causality between modifications in the structure of figurative activity and those which occur in the social system in general',[68] how are we to establish this link without the mediation of a subjectivity which experiences these modifications? A subjectivity which, however impersonal in conception, is not deprived of all liberty, or of all power of invention since, as Le Bot again says, 'art is never purely the result of the

68. '... le problème fondamental de l'histoire de l'art est de définir un lien de causalité entre les modifications de la structure de l'activité figurative et celles qui se produisent dans le système social en général'. – 'Machinisme et peinture', p. 21 in *Annales*, 1, 1967 (see also LE BOT's newest work: *Peinture et machinisme*, 1973).

determinations to which it is subjected'.[69] Furthermore, are we to give up personalizing subjectivity if we do not give up stating what there is of an inimitable and irreplaceable character in a singular work, and what precisely gives it its place in history as historic? Nothing, in any case, rules out the psychological or the psycho-analytical approach to creation, even if we have to enter on paths where science is more uncertain.

But if such an approach is to be attempted, it may itself be the subject of a preliminary question: what makes man a creator? What is it that impels him to create? [70]

2. *Creation and nature*

Taking the word 'creation' in a weak sense, it cannot be denied that man has a vocation to create: from daubing to graffitti, and not leaving out masterpieces, this vocation is everywhere to be seen. What characterizes creation is thus that it seems to be radically different from the production of what is useful: man labours at it for nothing, merely, as we say, for his own pleasure – if, that is, we regard it as nothing to give shape to his gods, and also to give shape to himself as in the dance, to his heroes as in the epic or the novel, to his city as in the theatre, or nowadays in the cinema. And can we ignore the fact also that in many cultures, 'artistic' *praxis* must be combined with 'technical' *praxis* to guarantee the efficiency of tools? This is a form of magic of which we still find lingering traces even in industrial aesthetics: what is beautiful sells better ... *Technē* originally means both art and craft, and this saves us from a misconception: genuine art is not a second and a secondary activity which would turn us away from an already constituted reality in which we would occupy the position of masters, or which would add to that reality the luxury of ornament. What is imaginary is not introduced from outside into what is real, like another subjective sense into the objective sense, to metamorphose it after the event; it forms part of what is real. To create does not mean forsaking the world, but really living in it. We know how admirably Heidegger has turned to account the following line of Hölderlin: *Dichterisch aber wohnt der Mensch.*[71]

This brings us back to what we have learned from psycho-analysis, namely, that what establishes the reign of the imaginary, is, in the psyche, the libido finding an outlet through phantasm. But, I repeat, the absence in which the image takes shape develops against the background of a presence constantly felt by being-in-the-world: the imaginary is rooted in this field of

69. 'L'art n'est jamais un pur effet des déterminations qu'il subit'. – *Ibid.* The notion of a liberty – albeit quite relative – of creation is developed in a recent work by O. REVAULT d'ALLONNES, *La création aritstique et les promesses de la liberté* (1972).

70. A book like KOESTLER's *The Act of Creation* (1964) testifies to the fact that the question is still being asked.

71. HEIDEGGER, '... *Dichterisch wohnt der Mensch* ...' (1954).

presence; the history of the libido must be linked with that of perception; and this is perhaps yet another task for phenomenology. And why the desire to create? Why allow what is imaginary to take shape in creation – if not to deliver the real of the imaginary which it bears within it? And what name are we to give to this reality, pregnant with all the possibles and all the images clamouring within the psyche, if not that of Nature? The creator is thus the man who wishes to be *naturans* in response to Nature *naturans*; he becomes so precisely because for him reality is not to be taken as a matter of course, because he is still capable of wonder, sensitive to what Char calls the prodigious question, the marvel of what is visible. For the creator, the world is not a mastered and humanized spectacle to be viewed from a distance; in what is constituted, he divines a constituent that is not himself, to which he belongs, the power of substance in the mode; a deep in the depth of the horizon; in what is visible, something invisible from which it springs. Not a hidden god, but the inexhaustible reality of what is real on this side of all consciousness. But what is prodigious is that the veil lifts, that what exists becomes apparent, that a natural light – man – in an endlessly repeated blaze, calls forth the visible. The creator is the man who rejects appearance in favour of finding the moment of appearing, of converting the epiphany of what is sentient into what is hierophantic. Thus, painting today takes us back to the origin of looking, to the point where we cannot yet say that we have seen, music to the origin of hearing, poetry to the origin of speech: by deconstructing the prose which consecrates the prose of the world, poetry restores to the name its original kinship with what it names, it restores language to its nature, to Nature.

In other words, the creator is the man who, tearing himself away from the safety of representation, returns to the presence, close to the original where man and the world are not yet separated; both to let himself be inspired by that native familiarity and to express it in his own way: to express creation, the creation of the work, in those reflective works which we know today, which are the poetry of poetry, or construction 'in abyss', but also the creation of the world, that world which emerges in the poem through the poem. For every work is a cosmogony, even when it does not relate a genesis as in the time of the Bible or of Hesiod; it brings to light the emergence of a new world, of a real interpenetrated throughout by the surreal. It follows that the stronger meaning of the word 'create' must not be rejected. It is indeed with man that the *fiat lux* is accomplished, even though he has not the initiative for it, even though he is actuated by Nature. For he is a creator precisely when he confesses to his condition of creature or, let us say – abandoning the religious overtone – of finite mode, of son of the Earth, when he returns to the region of his birth and sets out to express or show, not what originates from him – the world he moulds – but that from which he originates – the inexhaustible deep.

B. RECEPTION OF THE WORK OF ART, *by Jacques Leenhardt**

1. SOCIAL STRUCTURES AND PUBLICS

Sociological research intended to reveal the relationships between created works of art and the various publics to which they have been submitted in the past is faced from the start with fundamental breaks in the actual history of art production. This implies profoundly different types of research. In point of fact, the emergence at the time of the Renaissance of the notion of the 'artist' as a creator to whom there is attached some personal merit, led to a first break in the social function of art, in so far as art will become correspondingly a subject for private enjoyment, whereas previously it had belonged *de jure* and *de facto* to the community as a whole. From that time onwards, the links between it and the community will be subjected to very severe strain which will increase proportionally with the development of individualization until, with the appearance of new methods of mechanical reproduction on the threshold of the twentieth century, a second change will be observed, the essential features of which have been very clearly determined by Walter Benjamin.

We are thus concerned with three distinct epochs:

1. the first, of which it may be said that the public extended as of right to the entire social community;
2. the second, in the course of which artistic production will be appropriated by different classes or social groups in a much more restrictive fashion, with the possibility of various forms of art being contemporaneous, as were the groups and classes to which they were addressed;
3. lastly, the third of these periods, in which the mechanical means of reproducing literature, art and music were developed; implying a transformation not only of the relationship between the works and the public, but of the works and of the public themselves.

These three major types of relationship between cultural productions and their publics imply different types of research. I shall try to list them rapidly, stressing mainly the nature of each kind of research. It is obvious, for example, that, apart from their being impossible in practice, studies on attendances at the places where works of art are housed would be almost meaningless for the Romanesque and Gothic periods, inasmuch as these places were themselves 'public', meeting places for the community, where we can be reasonably certain that a community really existed. It follows that the greater part of the cultural community was gathered together in the very places where the art of the time existed. A statistical analysis of publics is therefore justified only from the time when the various publics appear, when the community as spectator is split into fragments.

In this initial period, when public and works of art constitute two homo-

* Ecole Pratique des Hautes Etudes, Paris.

geneous elements, the natural link between them consists of a common system of deciphering and of creation. It is on the basis of this pre-knowledge of the code and the meaning of the symbols articulated therein that we can interpret the relationship between created works and the public. There is no art for the erudite, there is only an art which speaks to all in the same way, in accordance with a code accepted and adopted by all. Naturally, what is said here with reference to the Middle Ages in Europe is also true for every society (which, for the sake of simplicity, we shall call 'traditional') in which there is no fundamental rupture. That is precisely what is meant by Ferdinand N'sougan Agblemagnon when he writes, 'In traditional Africa, literary and artistic expression depended on the various manifestations of collective life at every level'.[1] Here we have a clear picture of a society in which all manifestations, and in particular literary and artistic expressions are in perfect communion with one another and also with those who apprehend them. It should moreover be noted that the division of social labour is not completely achieved in those circumstances, in which, in many cases, literary and artistic producers are not socially differentiated in relation to the rest of the community. But Agblemagnon finds a break in African society comparable with the one attributed to the period of the Renaissance, when he writes: 'Today, on the contrary, this expression aims at a concise, written form, stabilized and signed by the author'.[2]

And so we find at one and the same time a desire for originality, and emphasis on a particular form, and all the more particularized as it can be signed by an author who thereby, instead of being integrated in the community, detaches himself from it in a certain sense, while retaining it as an echo necessary to his own work of creation.

It goes without saying that a traditional society of this kind, characterized by the integrating power of institutions and practices, finds a particularly adequate form of expression in certain *genres*. Thus, it has been possible to demonstrate that the epic was eminently suited to such forms of integrated society and it is not surprising to find the considerable importance of poetry in the African literary tradition. Agblemagnon's extremely pertinent remark brings up a fundamental problem of the sociology of creation. If in fact Africa today has a preference, as consumer, for poetry and theatre, it is for the same reason that its creators have a preference for producing poetry and theatre. The two acts are here united as manifestations of the same aspect of reality and the same need. It is certainly not hard to understand that these two forms of expression are infinitely closer to the traditional bases of cultural practice. If the Africans still find the novel to be relatively alien to their

1. 'Dans l'Afrique traditionnelle, l'expression littéraire et artistique dépendait des diverses manifestations de la vie collective toute entière à tous les échelons'. – N'sougan AGBLEMAGNON. Contribution to the present study, published under the title, 'Sociologie littéraire et artistique de l'Afrique noire', p. 103 in *Diogène*, No. 74 (1971). English version, 'The literary and artistic sociology of Black Africa', p. 97 in *Diogenes*, same reference.

2. 'Aujourd'hui, par contre, elle se veut concise, écrite, figée dans une certaine forme, signée par un auteur'. – *Id., ibid.*

sensibility, if no wide public has so far emerged to read the contemporary African novel, this is because that public is lacking in the mental categories needed to understand the developing pattern of the novel. We must not forget that Europe took several centuries to grow accustomed to the hero as depicted in novels and, above all, that becoming accustomed was not simply the result of repetition, but of the fact that the actual social setting in which men lived presented an image similar to that which the novelists presented.

There was therefore twofold action, convincing at both levels, whereas today the African novel is still able to exercise only one action at the literary level, for social development advances only at a very slow pace along the road that leads from *being part of the community* to the individualization of existences. Moreover, the European pattern is not necessarily the one that Africa will follow, and this may lead us to wonder whether there will ever be a truly African novel, as there was the French novel of the nineteenth century. In his assessment of the possibilities of the various literary genres at a given moment in the history of the countries of decolonized Africa, Agblemagnon naturally takes account of the feeling of writers seeking to make contact with their public.

This is what had already been demonstrated by Lilyan Kesteloot in her work, *Les écrivains noirs de langue française. Naissance d'une littérature* (1962), when she showed that the main concern of all the writers interviewed was to find some way of making 'contact with the masses'; for all of them are still thinking of the old traditional community which has been shattered first by colonization, and certainly a second time by decolonization: 'They have a conscience about belonging to another culture which makes them feel removed from their illiterate brothers, still living in the villages: for the writer, then, this mass becomes the symbol of traditional society, and it is this reaction which provokes the acute and poignant tone with which the writers describe their contacts with the masses'.[3]

It can certainly be said that the novelists would not be so eager to establish this contact if they did not have the precise feeling that they had lost it. For them the break is twofold: within their society, since they are town-dwellers and the masses are peasants; within their culture, since they have been influenced by Europe while their public belongs to quite another tradition.

And so, in historical contexts that are radically different, the sociologist is obliged to see the same break in the traditional community as a cultural and social break, and as a need for a new approach.

If we now leave this period and this type of relationship between art and the public – the word 'art' being, of course, set between inverted commas inasmuch as this art is not yet the product of an 'artist' properly speaking – and if we come to that second period in which the individual will claim the

3. 'Ils ont mauvaise conscience du fait qu'appartenant à une autre culture, ils se sentent différents de leurs frères analphabètes demeurés au village; cette masse devient donc pour eux le symbole de la société traditionnelle, d'où l'accent poignant avec lequel ils parlent de leur contact avec elle.' – AGBLEMAGNON, *art. cit.*, p. 107 (English translation, p. 102).

product of his work as being the product of his genius and of his inspiration, the problem of the relationships between the work of art and the public will have to be approached in a different way. There will indeed no longer be *one* code valid for the whole of society, but, in proportion as that society is divided into classes and groups, a multiplicity of codes to which each class or group has the key. This fragmentation of publics is obviously the result of a radical transformation of the function of art in society. It may be said that, in Romanesque or Gothic painting, or in the traditional arts of Africa, what predominated was *figuration*, that is to say, the need to give outward form to elements of an eternal quality. The period which begins with the Renaissance in Europe, will, on the contrary, see the preponderance of *representation*, and this is attached to a world anchored in time, a world in which trans-temporal identity is no longer guaranteed and in which painting is to begin to play the rôle of a representification. From then on it exists for man to contemplate his image therein, just as in the novel. Nature becomes *his* nature, and he himself his own masterpiece. From the time of the Renaissance, painting and the arts attest man's mastery over the world. This rôle of representation was, moreover, not invented at that moment, for it may well be thought that the figures of bison on the walls of the caves of Lascaux are indeed already the victory of representation over figuration. They are like a spell that has succeeded, the bison is vanquished beforehand by the mastery of the representation. From the very moment when the latter prevails, the question of the public will arise; for, as Goethe said, the public must not be treated as 'of no importance'. The characteristic of man is his capacity for *representation*.

What can sociological research do for that period, and what procedures must it adopt? In contrast with the earlier period, quantitative investigation is not meaningless inasmuch as the relative importance of the public becomes a preponderant factor in explaining the actual productions. There is no longer *a* code and *the* public, but a multiplicity of codes, and each creator and each genre has his or its public. There will be salons and coteries, the public of Shakespeare and the public of Ben Jonson, the Commedia del Arte and the French Players. Furthermore the size and nature of the publics differ according to the types of expression. It is obvious that, in the sixteenth, seventeenth and eighteenth centuries, the theatre had a much bigger public than printed literature, and consequently the diversity of the publics whose needs had to be satisfied was enlarged in the same proportion. 'The theatre of the seventeenth century had had to concern itself with a more heterogeneous public than that of the printed literature of the time. To gain the interest of people whose tastes were ever more diverse, an appeal had been made to a whole arsenal of means for acting upon the public: 'spectacular' or 'sensational' effects, of which the stage producers in the seventeenth century made great use, and which were not essentially different from those current in the days of Addison or in the Elizabethan age'.[4]

4. LÖWENTHAL, *Literatur und Gesellschaft. Das Buch in der Massenkultur* (1964), p. 164.

But the break in publics or in tastes was no less great in the case of painting. It is related that, towards the end of his reign, Louis XIV gave orders to 'remove these horrors', with reference to Dutch genre paintings which had been hung in his apartments. Obviously a peaceful middle-class domestic scene seemed to the monarch something like a crime of lèse-majesté. There was therefore a very great *distance* between the taste of the sovereign, that of the court, and that of the middle classes. Vocabulary apart (for times have changed), the scene reported by John Berger,[5] in which Nikita Krushchev and the sculptor Neizvestny are brought face to face, is evidence of the same type of *distance*. The absolute and unrelieved failure to understand arises from an excessive distance between the respective codes of the transmitters and receivers involved. Which does not mean that there was not a public elsewhere for genre scenes or a public for Neizvestny.

Not much has been done in the way of sociological research on publics of the past. One of the sectors of which we know most is certainly the reading public of the eighteenth century in England. Indeed, in England, the industrial development that took place at an early date provided the technical achievements and also created the cultural demand for a widespread dissemination of the novel that was unique at that time. But it is only in the nineteenth century that it is really possible to speak of a democratization of reading, as is remarked by R. D. Altick in his excellent monograph on the subject.[6]

However, many works revealed what may properly be called the phenomenon of the creation of a reading public and its reciprocal effect on the actual forms of literature.

Just as the theatre found ways of attracting a new public, so literature sought to adapt itself to its own new public. Leslie Stephen notes in this connexion:

the gradual extension of the reading class affected the development of the literature addressed to them.[7]

The mutual transformation of social structures and publics is a fundamental problem for the sociologist, but it is a professor of literature, Ian Watt who has made the best sociological contribution concerning this period in England.[8]

Using a less historical method, Erich Auerbach nevertheless arrives at equally convincing results in his essay, 'La Cour et la ville'. Taking actual literary texts, he explores the boundaries of this new phenomenon of the age: *the public*. Through the writers of the seventeenth century, he shows how the

5. BERGER, J., *Art and Revolution. Ernst Neizvestny and the Rôle of the Artist in the U.S.S.R.* (1969).

6. ALTICK, *The English Common Reader. A Social History of the Mass Reading Public, 1800-1900* (1957).

7. STEPHEN, *English Literature and Society in the Eighteenth Century* (1904) (quoted by WATT in *The Rise of the Novel*, p. 35).

8. WATT, *The Rise of the Novel* (1957).

court comes to be duplicated by another centre of reference: the *town*.

> Entre nous verras-tu d'un esprit bien tranquille
> Chez ta femme aborder et la cour et la ville?[9]

Of course, the 'town' is neither the people nor the middle classes in general. Auerbach shows clearly the élitist connotations of the term. Once these differences have been noted, there is no doubt that a new, a sociologically new, *public* has emerged. Its characteristics distinguish it sharply from the middle class with its ethics of hard work and from that aristocracy of which it has only the means. Yet, at the time, 'the phenomenon of the mass flight of the middle class public, *the town*, far from the active life of production reveals that middle-class public in a new light, enabling us to understand what it has in common with the *court*'.[10]

Just as the unity of the public was broken up and replaced by diversity, so today we see a movement in reverse to extend the characteristics of one public – the public created by mass culture – to all the groups which make up society in the highly industrialized countries. The phenomenon is multiple. On the one hand, we must note the radical transformation of the technical methods used to disseminate works. These are increasingly handled like any product in a market which is not essentially different in its nature from a market for industrialized products. Such notions as 'high-pressure salesmanship' or 'market support' clearly show the nature of the sales promotion of which, in painting, for example, the private art galleries are the originators. Such a development will be increasingly rapid should the *multiple* offensive become general. For reproduction, which until now had been no more than an inferior form of the unique original, is in its turn becoming a *production* in the fullest and best meaning of the term. It has ceased to be dependent on an external referent; by becoming *multiple* it has abolished the very notion of the *unique*.[11]

At the same time, then, as art and the conditions in which it is disseminated among the public are modified to follow the pattern of other commercial circuits, the functions of that art are changing. That is what Walter Benjamin was the first to express systematically, in his celebrated essay in 1936, 'L'oeuvre d'art à l'époque de sa reproduction mécanisée', published in a French translation in the *Zeitschrift für Sozialforschung*', which at that time had sought refuge in Paris.

Remove its veil from the object, destroy its *aura*, and that immediately announces the presence of a perception so attentive to what 'is repeated identically throughout the world' that, thanks to reproduction, it even succeeds in standardizing what exists only once. Thus in the field of intuition, there occurs a phenomenon similar to what the importance of statistics represents in the realm of theory. The bringing of reality

9. BOILEAU, Tenth *Satire*.
10. AUERBACH, 'La cour et la ville' (1951), p. 45.
11. Cf. René BERGER's contribution to the present study, published under the title 'Une aventure de Pygmalion' in *Diogène*, No. 68 (1969) (English translation, 'A Pygmalion adventure', in *Diogenes*, same ref.).

into line with the masses, and the corresponding bringing of the masses into line with reality constitute a process of limitless range both for thought and for intuition.[12]

Even so, we must avoid assigning independent power to technical development itself. It is, of course, only a structural effect of the general advance of industrialization, itself linked to a new division of labour *and* of social power. These profound modifications have led to the breaking up of the classes and consequently of the publics. Into the cultural gaps left by these changes, fresh contents have been poured by the new *media*. Of course, to distinguish between the various publics, reference should still be made to the notions of code or system of evidence. On the other hand, the difficulties become numerous as soon as we try to attach configurations of this type to organized social groups. If we venture along that path with the necessary courage, or temerity, we run the risk of gaining nothing more than confused generalizations, whether in the field of sociology or in the field of aesthetic analysis.

Everything seems indeed to suggest that in the case of spectators who are partly or totally bereft of genuine pictorial competence, aesthetic judgements are in reality *ethical* judgements; so that the 'aesthetic' of the middle classes (aesthetic in itself and not for itself) is only one dimension of an ascetic *ethos* which leads to a rejection of 'art for art's sake' and to a demand that every representation should fulfil an educative or informative function.[13]

Any attempt to gain a public by means of these concepts raises a large number of problems. On the one hand, we saw that the educative and informative function exists in the definition of numerous examples of taste, that of 'socialist' art in particular. Even more, it is not certain that any system of aesthetic judgement is totally cut off from ethical judgements. For example, the acceptance of art for art's sake could easily be taken as a judgement that is more ethical than aesthetic. What Bourdieu says is therefore not false, but it clashes with an alternative possibility: either all 'aesthetic' judgements have an ethical character and it is no longer possible merely to contrast 'pictorial competence' with the 'ascetic ethos', or else we must conclude that the qualified milieu, the cultivated milieu, enjoys a very high degree of independence; which wipes out any hope of building up a sociology of culture, whilst leaving the possibility of evolving one for *a-culture*.

We find ourselves here in the very centre of the current problems of research in the sociology of culture, for we find an autonomization of producers and production in relation to the social groups forming society, with-

12. BENJAMIN, 'L'œuvre d'art au temps de ses techniques de reproduction' (republ. of the essay of 1936 in a new French version), p. 202 of *Œuvres choisies*, I, translated by Maurice de Gandillac (1971).

13. 'Tout semble indiquer, en effet, que, pour les spectateurs partiellement on totalement dépourvus d'une compétence proprement picturale, les jugements esthétiques sont en réalité des *jugements éthiques*; c'est ainsi que "l'esthétique" des classes moyennes (esthétique en soi et non pour soi) n'est qu'une des dimensions d'un *ethos* ascétique qui porte à refuser "l'art pour l'art" et à exiger de toute représentation qu'elle remplisse une fonction éducative ou informative'. – BOURDIEU *et al.*, *Un art moyen. Essai sur les usages sociaux de la photographie* (1965).

out producers and production being thereby independent of society taken as a whole. The function of art having changed, art having become economic and distinctive, it is in the overall field of social exchanges that it will shortly have to be considered. Let us be quite clear; it is the function of art that has changed; it is no longer either figurative or representative as in the first two periods we mentioned; it is now distinctive and economic. Not that it was entirely lacking in these qualities in the past, but they were always secondary. Now they are almost alone in supporting the function of art.

Three phases have now been described, three types of relationship between social structures and the publics, three functions of art for these publics. We must now discuss the actual notion of 'the public' as it is approached by contemporary sociology and examine the ways in which the cultural message is received by the publics.

2. THE PUBLIC

If we consider the sphere which *grosso modo* includes the cultivated public, we can hope to find some meaning in the notion of 'the public', in its organic oneness.[14] Andrew Carduff Ritchie has suggested a more precise determination by designating as a *public* all the admirers of an artist; in this way each creative artist would have 'his' public.[15] Obviously, this definition is yet another that cannot be accepted by sociologists inasmuch as the 'public' thus fragmented covers no definite sociological reality any more than 'all the people taking coffee at 10 a.m.' represents in itself a sociological reality. Lastly a third definition would limit the 'public' to art lovers, dealers and critics.[16] Here again, although this selection contains a sociological reality inasmuch as it is composed of homogeneous elements of the cultural milieu, the sociologist can find no satisfactory determination of the object 'art public'. Does this mean that no such object exists?

By adopting a definition such as that of Read Bain's which is sufficiently complex and general, it will be possible to assemble the essential elements. A public would be:

... an amorphous social structure whose members share a community-of-interest which has been produced by impersonal communication and contact They are not groups but they are more structured than those who may be placed together in an aggregate. When the members of a public meet each other or communicate in writing or by telephone, they have a "fellow feeling" and "talk each other's language". This is what makes them a social structure, though obviously a very amorphous one, rather than a logical category or term in a classification.[17]

14. Cf. for example, HUNTER, *Modern French Painting* (1956), and SMITH (ed.), *The Artist in Tribal Society* (1961/62).

15. RITCHIE, *Matisse. His Art and His Public* (1951).

16. CLARK, 'Art and society' (1961). (The preceding references are taken from Bruce WATSON's article, 'On the nature of art publics', in *International Social Science Journal*, 1964, No. 4 (special issue: *The Arts in Society*: see, in particular, pp. 667-668).

17 BAIN, article 'Public', p. 558 in GOULD & KOLB (eds.), *A Dictionary of the*

Bain is right in seeking to attribute to the public the characteristics of a social structure, but, in adding immediately that it is amorphous, he becomes more obscure than clear. I should prefer to describe it as 'secondary' or 'dependent'. In point of fact a public never exists in itself, it merely reflects a sociological sector of classes or groups. It *is* not these classes or groups, but it is a dependent variable of them. Thus, whether we lay emphasis on snobbishness or on the desire to rise socially through culture, the many parameters of a public refer us back to the fundamental features of the groups or classes on the basis of which they are defined. What, for example, can be the significance for sociological analysis of the concept proposed by Watson of 'the recreational art public'?[18] Has there not always and everywhere existed a public which seeks distraction? Must we, on the other hand, assimilate the queue outside a cinema for a Chaplin film and the concert hall where the *Barber of Seville* is being performed?

If we acknowledge that the pursuit of entertainment is in general a very human activity – or passivity – what is important for sociological analysis will be to discover what entertains and not who is entertained.

We must therefore investigate the structural features of what is received by a public, in order to understand why such and such an object can be assimilated as a work of art. It is the public that 'makes' the work of art by recognizing that it meets the requirements laid down in the code. Should such a consecration not be forthcoming, the book is pulped, the canvas taken down, the music forgotten. The public is therefore the social authority which, in the ultimate analysis, decides, like Saint Peter, on the right to enter paradise or not. But the paradises are as numerous as the publics! In the realm of art, of course, the public does not judge on the basis of a capacity for a aesthetic judgement which is motivated but on that of a *taste*.

We might return at this point to the example of Louis XIV banishing genre painting from his apartments. Indeed, from the point of view of judgement, his relationship to these works is not that of the middle classes, who regarded it as an artistic achievement, whereas for the King there was *a priori* an insurmountable barrier: the *subject* of the paintings was an affront to his majesty. He therefore could not go beyond a stage from which any really aesthetic judgement was absent. The middle classes, on the contrary, were free – at least in theory – to judge *both* the subject with favour, because of its class connotation, *and* the manner in which it was treated. The middle classes had therefore two criteria to apply, Louis XIV one only, and one which even prevented the application of the second.

The fact is that only a very narrow fringe of the publics can aspire to exercise a really aesthetic judgement. This explains why many research workers have wanted to give autonomy to these enlightened few, either making them

Social Sciences (1964) (reference also taken from WATSON, *art. cit.* (1968), p. 671).

18. WATSON, 'On the nature of art publics' (*sub* 'The typology', paragraph 2), p. 676 in *International Social Science Journal*, 4, 1968 (special issue, *The Arts in Society*).

246 Mikel Dufrenne et al.

the public *par excellence,* or making them a special separate public detached from ideological contingencies. It would seem, in fact, that this aesthetic judgement is not exercised *outside* but inside the framework of tastes; it is added thereto either as justification or as sophistication. At any rate, it then spreads throughout the better informed sectors of the public in the broad meaning of the word, acting on the minds of people with the weapons of terrorism. In this form it is taken over by coteries, it acquires a snob value: such epithets as *ignorant, philistine,* to say nothing of *half-educated,* quickly bring back to the narrow path of orthodox taste anyone who might stray from it. But the reference to purely aesthetic criteria is in this case no more than a rationalization charged *a posteriori* with the task of ratifying a choice.[19]

It follows that the critic is no more uninfluenced than anybody else by the interests and mental patterns of social groups and classes. On the contrary, it is he who gives form to the bond uniting these sociological entities with the publics. He formalizes for others, and publishers have not been misled by it; they employ and allocate their professional 'readers' in accordance with their own theoretical public. The *reader* becomes the quintessence of the public, and it is on the basis of his personal reading tastes that the publisher decides whether or not to publish a book. The reader of novels in a publishing house is by himself a market-research unit in the circuit for the circulation of literary works.

But side by side with the institutional filters through which works pass before they reach the person for whom they are intended, and among the structural determinants of reception, we must include also the actual social groups by which that person is surrounded. A. Losonczi was able to demonstrate this in a specific survey on taste in music:

If a social group likes a tune, a genre, a composer, it is clear that the appreciation of other members or classes of society is not due entirely – and directly – to the real quality of the tune, the genre or the composer. Their relationships with the social class in question, their feelings about that class, also have their effect.[20]

This, of course, applies equally to all forms of art; here the notion of cultural environment or of the structure of the centres of cultural integration comes in. The world of culture must be considered as a field of forces geared to one another, or as a series of smaller fields, closed in on themselves but belonging as a whole to the overall field of culture.

The sociology of the reception of literary and artistic works must, of course, take account also of the intermediary vehicles by which the cultural product reaches the consumer. The critics and publishers' readers have already been mentioned, consideration must also be directed to the selection of

19. Escarpit, *Sociologie de la littérature* (1968), pp. 114-115.
 20. 'Si un groupe social aime un air, un genre, un compositeur, il est clair que les autres membres ou couches de la société ne tirent pas leur appréciation seulement – et directement – de la qualité esthétique de l'air, du genre ou du compositeur; leurs rapports avec la couche sociale en question, leur jugement sur celle-ci interviennent également'. – Losonczi, 'Le changement d'orientation sociale dans la musique de tous les jours', p. 303 in Hegedüs (ed.), *Etudes sociologiques* (1969).

concert programmes and of the subjects of exhibitions which are more and more being organized as mass entertainment (drawing attendances of from half a million to a million). Still more interesting seems to be the problem of *pilot* intermediaries, such as the *pilot galleries* 'invented' by René Berger or the *pilot reviews*. It is indeed an undeniable fact that phenomena so important quantitatively as *op art* cannot be explained without considering the action of such intermediaries.

'Op' art was not born one fine mornng from the will of some solitary genius, nor by some sovereign decree, still less by collective illumination; it was born of the efforts of the first constructivist artists, and the equally sustained effort of certain galleries that took the risk of specializing in it (in France, in the first place, the Denise René Gallery). Equally, the American 'pop' that impregnates our environment so strongly has certain definite places of origin, the galleries of Sidney Janis and Castelli in New York, and the Sonnabend Gallery in Paris. By its work of research, by the discoveries it has made and the faithfulness of its orientation, the 'pilot gallery' arouses the interest of the critics, gets hold of collectors on whom, though one tends to forget this fact, the advent of a form of artistic expression largely depends; in short, it creates a movement in which is constituted the 'art-that-is-being-created'.[21]

This phenomenon has been the subject of a very large number of studies. The work by L. Löwenthal mentioned earlier gives a general idea of the *social determination of success*,[22] while Richard D. Altick [23] studies the profession of author in its relationship to the whole system of consecration and dissemination. But it is the historical research of E. H. Miller which brings such analysis to the highest degree of precision, unfortunately on a past age.[24]

Still on the eighteenth century, but in France this time, the research work collected and published under the title of *Livre et société dans la France du XVIIIe siècle* [25] gives numerous glimpses of specific problems. For instance, the rôle and significance of censorship, or rather of censorships, are very clearly portrayed in their quantitative and qualitative aspects by F. Furet's contribution: 'La "Librairie" du Royaume de France au XVIIIe'. The article

21. *'L'op' art* n'est pas né un beau jour de la volonté de quelque génie solitaire, ni de quelque décret souverain, encore moins d'une illumination collective; il est né de l'effort suivi des premiers artistes constructivistes et de l'effort non moins suivi de certaines galeries qui ont pris le risque de s'y consacrer (en France, en premier lieu la Galerie Denise René). De même, le pop' américain, qui imprègne si fortement notre environnement, a des points de départ précis, entre autres les galeries Sidney Janis et Castelli à New York, la Galerie Sonnabend à Paris. Par son travail de recherche, par les "découvertes" qu'elle fait, par la fidélité de son orientation, la "galerie pilote" suscite l'intérêt de la critique, s'attache les collectionneurs dont dépend en grande partie, on l'oublie, l'avènement d'une expression artistique, bref, crée un mouvement dans lequel se constitue l' "art-en-train-de-se-faire" '. – BERGER, R., 'Une aventure de Pygmalion', p. 47 in *Diogène*, No. 68 (1969), or pp. 32-33 in BERGER, R., *Art et communication* (1972) (English version, p. 44 in *Diogenes*, same reference).

22. LÖWENTHAL, *Literatur und Gesellschaft* (1964), pp. 262 sqq.

23. ALTICK, 'The sociology of authorship' (1962).

24. MILLER, *The Professional Writer in Elizabethan England. A Study of Non-Dramatic Literature* (1959).

25. By BOLLÈME, EHRARD, FURET, ROCHE, ROGER and DUFRONT (1965).

by D. Roche: 'Milieux académiques provinciaux' shows the modulations in the social constitution of these circles. Thus, the cultured public presents distinct, though not contradictory, characteristics in Dijon or in Bordeaux, where the nobility, the clergy and the bourgeoisie constitute variable proportions of the membership of the Academies.

On the current situation, we have only very few synthetic studies available today. On the specific problem of prices and fees, the work of Walter Krieg [26] could be usefully consulted, and also the works of Mason Griff on commercialization.[27]

Other aspects of the phenomenon give rise to fewer problems for sociological research and more works are available; this is the case with research on reading such as the work of the DIVO-Institut in Germany [28] or the *Atlas de la lecture à Bordeaux*.[29]

But as soon as we begin to consider the problems associated with reception, from the angle no longer of the mediators but of the actual effect of reception, as in the case of *Le livre et le conscrit*,[30] the question arises of the transmission of the cultural message and of the conditioning of the receiver by his education.

We saw earlier that cultural transmission, like the transmission of any message, implied that the cypher of the code in which the work is coded is known and assimilated by the person who receives the work. In the case of literature, we are concerned with language, at a very general level, but also with genres, syntaxes, lexicons, etc. For works of art, there will be also what might be called pictorial or plastic 'language'. Where there is no community of code, transmission is impossible. Two examples of this have already been given. For a given public, we must therefore investigate the complexity of the message, this being determined by the gaps between the code which governs this work and a common theoretical code which can be constructed on the basis of the day to day reality of the language or figuration.

The complexity of the cultural message is therefore to be analysed in terms of *distance from the norm*. The desire to shock, in art or in literature, is expressed by a clean break with the code; which does not mean that every break reflects an *intention* to shock. Even so, it cannot fail to produce shock.[31]

The code is so important a reality and so deeply rooted in everybody's mind that no creation can exclude it entirely. The most extreme of extremists invariably stop short of overthrowing the code; but the reference, even if inverted or merely negative, is always there. One instance, however, occurs in our culture of today which goes beyond the limits of the phenomenon as described here. In contemporary music, and to a lesser extent in certain literary

26. KRIEG, *Materialen zu einer Entwicklungsgeschichte der Bücherpreise und des Autorenhonorars von 15. bis zum 20. Jahrhundert* (1953).

27. GRIFF, 'Conflicts of the artist in mass society' (1964).

28. *Buch und Leser in Deutschland* (1965). Similar surveys have been conducted in France by the Syndicat National des Editeurs and in the Netherlands.

29. By ESCARPIT & ROBINE (1963).

30. Also by ESCARPIT & ROBINE (1966).

31. Cf. MOLES, *Sociodynamique de la culture* (1967).

works, the deliberate exploitation of the possibilities of creation by computer has given rise to a break of another kind. A musical work of which the score has been established by a computer on the basis of an extremely haphazard programme has ceased to offer the essential features of what was music as it used to be, in particular the possibility for the mind to retain a musical phrase, a rhythm, an assonance. The machine creates so many different happenings that the human mind becomes confused, and as recognition is the basis of enjoyment and of the arts, it is to be feared that such products do really lie outside the domain of art. In fact, as Abraham Moles very rightly says, this music so fabricated with the help of computers would be music only for brains comparable to a computer as regards the retentive power of memory. For a human brain it ceases to be music because it imposes too many novelties one after the other. This is the extreme case of distance from the norm, when its complexity becomes too much for man to assimilate it.

Research has been carried out on the factors of retention, on the main one in particular: *redundancy*.[32] Such studies, which were concerned at the outset with ordinary non-cultural messages, are becoming increasingly important in the study of the cultural field, in so far as the latter is being basically transformed as a result of its being progressively subjected to the laws of supply and demand. It is true that Cézanne always complained that he sold nothing, but he did not think of studying what would be saleable or, in other words, the forms in which the pictorial message would be receivable. Today, when *avant-garde* artists have hardly time to come into existence before they are consecrated by exhibitions and take their place in collections and museums, the situation is quite changed. The representative function having disappeared, the work of art, especially if it is pictorial, enters a system that is quite extraordinary. Depending on the public he chooses for himself, the artist will be able, as he prefers, to make his product incomprehensible, answerable to no known code, and he will then be hailed as belonging to the *avant-garde;* or else, on the contrary, he will skilfully blend the old and the new, the redundant echo of a culturally familiar pictorial reality and the innovating sign of his emancipation. He will retain something of impressionism, a slight touch of fauvism, or a trace of cubist construction. He will then be despised by some critics, praised to the skies by others, and eagerly bought up by medical men anxious to raise the tone of their consulting rooms. In any event, he will not be understood by those who are not in possession of the code, those for whom Monet, Vlaminck and Delaunay are not well-established points of reference, who have not been given their share of education which is known as culture. In this connexion, an interesting piece of research has been presented by J.-P. Fénelon on what might be called the reception of realism in painting.[33] Six pictures representing flowers, but handled by artists as different from one another as a traditional Chinese

32. KANDEL & MOLES, 'Adaptation de l'indice de Flesch à la langue française' (1958).
33. FÉNELON, 'Analyse mathématique des jugements esthétiques: les données de préférence' (1967).

painter, Paul Klee, Raoul Dufy, Van Gogh, an anonymous illustrator of a painted picture postcard and the Douanier Rousseau, were submitted to a sample group. The object was to determine the rôle, action and interaction of four determinants: the profession of the person questioned, his age, his level of education and that of his parents. The results clearly show, among other things, that the ability to accept abstract treatment – in this case, by Klee – is directly linked to a level of higher education, that a general ability to appreciate modern trends implies, in the case of somebody who has a secondary education, that his father also reached at least that level.

If factoral analysis is developed along these lines, it will become possible to present results of quantitative sociology in the field of culture that are no longer ridiculous and disappointing, but infinitely subtle and precise.

And so, whether we are speaking of codes or aesthetic preferences, all current studies point in the end to the primordial social fact of education. It is the determining factor of cultural life, and of practice too. Writing of attendances at art museums, Pierre Bourdieu comes to the same conclusion:

In fact, the level of education being the same, the sex, the socio-professional category, the place of residence, the age and even the income do not lead to major variations in attendances or the pattern of attendance. . . .
In short, the relationships observed bewteen museum attendances and such variables as profession, age or place of residence comes down almost entirely to the relationship *between the level of education and attendances.*[34]

While such a reduction is possible for the overall phenomenon of attendances, a study that set out to cover the other aspects of contact with art would be faced with a wider range of factors. Robert Escarpit and Nicole Robine, for instance, attempt a closer examination of the exact relationship between readers and their books. The features of that relationship are brought out in sharp relief and, according to the one considered the authors find different social determinants:

The second remark concerns the three factors which have the strongest influence on reading: general level, level of education and socio-professional standing. Although there is a parallelism between them, they obviously act independently of each other, and each within a particular domain.
The literary matter used by the reader depends on the level of his education. The general level decides the degree of participation, of involvement of the personality in the reading, or, better still, the nature of that involvement and of that participation. There are, in fact, 'thresholds' between the lower, middle, higher and top levels beyond each of which the entire behaviour of the reader changes. Finally, the socio-professional status determines the extent to which reading becomes part

34. 'En fait, le niveau d'instruction étant fixé, le sexe, la catégorie socio-professionnelle, la résidence, l'âge et même le revenu ne déterminent pas de variations importantes dans la fréquentation ou le rythme de la fréquentation.
Bref, les relations observées entre la fréquentation du musée et des variables telles que la profession, l'âge ou la résidence se réduisent à peu près totalement à la *relation entre le niveau d'instruction et la fréquentation'. . . .* – BOURDIEU & DARDEL, *L'amour de l'art: les musées et leur public* (1966), p. 10.

of life, whether as regards the material circumstances of the reading or as regards its centres of interest.[35]

We find the same attention paid to the diversity of the factors which explain the behaviour in the study by J. Dumazedier and J. Hassenforder, *Eléments pour une sociologie comparée de la production, de la diffusion et de l'utilisation du livre* (1962).

In any event, it is clear from the various works on the question that there can be no assimilation of the relationships of the public with such different artistic forms as literature, the plastic arts and music. This is due to the difference in treatment enjoyed, or undergone, by these methods of expression. From the time they first go to school, children begin to acquire a certain familiarity with literature, but they know nothing of art and music, at any rate as far as school teaching is concerned. It should be noted also that France offers the extreme case of a bias in favour of literature as compared with the other arts. If therefore the young learners are not to discover art and music through the school, there remains only the family to facilitate the discovery; and it is certainly true that the familiarity needed for any enjoyment of a cultural product is acquired best of all in the family circle.

The influence of the school on the children of the various social classes, which is very unevenly spread (if only from the point of view of duration) and which has only varying degrees of success with those it reaches, tends, in countries like France and Holland at any rate, to intensify and consolidate the initial inequalities, the *family* continuing to be the major vehicle of dispositions and predispositions for cultural practice and aesthetic enjoyment, as can be seen from the fact that the proportion of visitors initiated by their families at an early age increases very rapidly with the level of education. Thus what is apprehended through the level of education is nothing other than the *cumulation* of the effects of the training received in the family circle and the knowledge acquired in school which itself presupposed such training.[36]

35. 'La deuxième remarque concerne les trois facteurs qui influent le plus fortement sur la lecture: niveau général, niveau d'études et statut socio-professionnel. Bien qu'il existe entre eux un certain parallélisme, il est visible qu'ils agissent d'une manière indépendante les uns des autres et chacun sur un domaine particulier. Du niveau d'études dépend le matériel littéraire utilisé par le lecteur. Du niveau général dépend le degré de participation, d'engagement de la personnalité dans la lecture, ou, mieux encore, la nature de cet engagement et de cette participation: il existe en effet des "seuils" entre les niveaux inférieurs, moyens, supérieurs et très supérieurs au-delà desquels tout le comportement du lecteur change. Du statut socio-professionnel enfin dépend l'insertion de la lecture dans la vie, qu'il s'agisse des circonstances matérielles de la lecture ou de ses centres d'intérêt'. – ESCARPIT & ROBINE, *Le livre et le conscrit* (1966), p. 101.

36. 'L'action de l'Ecole qui n'atteint que très inégalement (ne serait-ce que sous le rapport de la durée) les enfants des différentes classes sociales et qui ne réussit que très inégalement auprès de ceux qu'elle atteint, tend, du moins dans des pays comme la France et la Hollande, à redoubler et à consacrer par son action les inégalités initiales, la *famille* restant le grand véhicule des dispositions et des prédispositions à la pratique culturelle et à la délectation esthétique, comme on le voit au fait que la part des visiteurs qui ont reçu de leur famille une initiation précoce croît très fortement avec le niveau d'instruction. Ainsi, ce que l'on saisit à travers

This process of cumulation is, in fact, essential to the social dissemination of cultural products. In our analysis of the cultural message, we have already drawn attention to the importance of *redundancy* for the retention of the message. Culture is made up of an accumulation of such messages received and retained, and the repetition of the incitations is seen to be a necessity for the constitution of this 'culture'.

It is therefore not surprising to find that the level of education is really determined by the *duration* of schooling, much more than by the kind of diploma received in the end. But if teaching, the school, conveys nothing, or next to nothing, in one field – as is the case for music in France – the problem of the reception of that art is profoundly modified. It is then the family alone that is invested with the power to initiate, or possibly secondary bodies, such as clubs for record lovers, book lovers, etc., where, moreover, the 'sectarian' aspect predominates over the 'religious' aspect.

This return to the original conditioning of every individual by his first circle of socialization – the family – extends its implications to all sociology of culture whether in the field of creation or in that of reception. The family does, indeed, in the history of bourgeois civilizations, represent a strong structure which has really had to play the part of intermediary between the individual and society. But today, when the family group has been shattered, sociologists are faced with the same question as the one mentioned earlier: the direct relationship between a social structure and production or reception is seen to be increasingly strained. The disappearance of the family as a necessary vehicle for the introduction to culture is certainly connected with the widespread movement for the autonomization of cultural manifestations, but once again autonomization with reference to the restricted social circles within an all-embracing sociological dependence. In this field of reseacrh, everything still remains to be done.

C. PROBLEMS OF AESTHETIC VALUE, *by Mikel Dufrenne*

Contemporary thinking, in the Western countries at least, is inclined to be suspicious of values, following in that the 'debunking' philosophies of Marx, Nietzsche and Freud. Values are at the centre of the 'ideology' from which Marxism seeks to deliver knowledge; they are regarded as belonging to a 'genealogy' which disqualifies them; and their repressive and alienating character is deprecated. The discussion of values is seen as arbitrary and confused: how can they be discerned? In what order should they be arranged?

le niveau d'instruction n'est autre chose que la *cumulation* des effets de la formation acquise au sein de la famille et des apprentissages scolaires qui supposaient eux-mêmes cette formation'. – BOURDIEU & DARDEL, *op. cit.* (1966), pp. 10-11; see also, BOURDIEU, 'Eléments d'une théorie sociologique de la perception artistique'/'Outline of a sociological study of art perception' (1968).

What status ought they to be given? These questions seem futile and danger-
ous in so far as they are conducive to authoritarianism.

In regard to judgements of aesthetic value, contemporary thinking is borne
out by the practice of artists. They too are wary of dogmatism, especially in
its more official forms, political, religious or moral censorship subordinating
aesthetic value to other values. It is no doubt conceivable in theory that the
State or the Church should impose only prohibitions on art while not dic-
tating the ends to be pursued, or again should dictate the ends while not im-
posing norms, but in practice authority is not readily kept within bounds. In
many countries more often than not art tends to claim independence and ac-
cordingly refuses to be subordinated to politics, but it sometimes happens
that it seeks to become political. Then it is as values from the standpoint of
alerting and contesting that aesthetic value and political value are identified:
whether art strives to challenge or ridicule the social and cultural environ-
ment in which it realizes that it is rooted, or whether by allowing for the ex-
pression of certain desires it flouts not only prohibitions but also the con-
comitant social conventions and rules.[1] In any case, even when art is not
deliberately associated with political protest or revolt, it is usually in actual
practice hostile to norms and axiologies which limit its freedom.

For their part, aesthetics and the sciences of art eschew any dogmatism
today: they set out to be descriptive and not normative. What authority would
venture to tell an artist what he *ought* to do and justify a purely aesthetic
censorship effected in the name of a doctrine of the beautiful?

Nevertheless, at the close of a remarkably well documented study on con-
temporary aesthetics, Morpurgo Tagliabue recommends that aesthetic in-
quiry should be directed to the axiological approach, with the sole proviso
that it should 'free the axiological from the ontological and cosmological
views which distort it' and adopt 'a method based on empirical phenomen-
ology'.[2] Furthermore, critics – whether professional or not – and essayists by
no means refrain from making value judgements on a whole range of current
production, sometimes seriously affecting the fate of the works. What is more,
whether or not we are experts, we are all critics in our own way and we do
not hesitate to appraise what is offered to us. Suspect though it may be, the
word 'beautiful' is still often employed, or replaced by less compromising
equivalent terms such as good, not bad, successful, interesting, etc. Individu-
als and social groups, as we see, are still normative. So are even the philoso-
phers: if they challenge or overthrow values it is in the name of other values
and in order to promote them, not always without dogmatism. Artists are
normative, too, unless they abdicate completely as did Rimbaud or Marcel
Duchamp: for them non-art simply means the death of a certain art and is

1. See, for instance, the collective work *Art et contestation* (1968) or the sym-
posium published in 1969 in the *Revue d'Esthétique* with the title: 'L'art en mai et
en juin 1968'.
2. 'Libérer le fait axologique des vues ontologico-cosmologiques qui le faus-
sent' . . . 'une méthode de phénoménologie empirique' – *L'esthétique contemporaine*
(1960), pp. 612 and 613.

itself another art ... An art which still calls for some normative reaction: publishing, exhibiting, performing or playing a work is not only trying to communicate, it is also a means of soliciting the judgement of the public and therefore its approval. It may happen – and this is important – that the judgement is expressed in a new way, when the work calls for participation rather than contemplation, when it arouses feelings other than the disinterested pleasant feelings described by Kant; but the fact remains that the work awaits judgement and still claims, in a very broad sense, to give enjoyment.

Has reflection on art been drawn into an impasse then? Not at all. Sociologists observed long since that science can be concerned with norms without taking them as its whole purpose. Such is the attitude adopted today in reflection on art: it does not seek – at least at the preliminary stage, and we shall explain this reservation later – to give its views on what is beautiful or what a work should be, but to understand and elucidate what has been said about it elsewhere: to study what the Americans call appreciative or evaluative discourse, the reality of which is patent everywhere, not just over the signatures of critics.[3]

1. THE SOCIOLOGY OF TASTE

This discourse can be the subject of research on several different lines. The first aspects to be investigated are the social and ideological conditions of its appearance. For it is possible that this discourse, so common and so easy to discern in modern Western societies, is not universal and was not always evident. The reception that the public gives a work depends on what that public expects of it and what use it makes of the work, what meaning it thereby attributes to the work (for we might say about works what Wittgenstein said about words, namely that their meaning resides in the uses to which they are put). Scholars, historians, sociologists, ethnologists and also philosophers [4] are well aware of this problem: how is the object, which we call aesthetic because we have placed it in a museum, actually viewed by the culture which produced it? Does the public, confronted with a Negro statue, a Polynesian fetish, a Romanesque stained-glass window, judge of their beauty as aesthetic objects, of their veracity as objects of instruction, of their efficacy as magical objects, of their prestige as objects for ostentatious use or what? According to what criteria are they judged? With what kind of values are they compared? The famous Kantian problem of the universality of the judgement of taste first arises at this level, where it concerns the empirical generality of judgement: is this judgement encountered in all civilizations?

3. This idea, which has met with great success, was probably launched by Ch. MORRIS, who first distinguished three types of discourse: scientific, poetic and technological ('Science, art and technology', 1939), then, in *Signs, Language and Behavior* (1946), four types of statement: designative, appreciative, prescriptive and formative.

4. Cf. DUFRENNE, *Phénoménologie de l'expérience esthétique* (1953, 1967).

The scholars' answer to this question seems cautiously ambiguous. On the one hand, they stress the necessity to understand the object in its cultural context, with reference to the readings made of it and the functions assigned to it in that context, and, for instance, when it is torn away from its native environment for display purposes, the need to reproduce the absent environment as accurately as possible in the exhibition.[5] It is then evident that the work which metamorphosed itself into an aesthetic object for us is, in the first place, mainly a ritual object, a commonplace object or a magical object and as such it is not judged by its aesthetic value. On the other hand, the ethnologists stress also that these objects are the unique handiwork of individuals whom we are really bound to call artists, even if they do not regard themselves as such, and that the identification of *genres* or collective styles must not serve to conceal our ignorance or our incomprehension of their uniqueness. Similarly we must not fail to realize that a person who is a contemporary of these works is capable of appreciating their intrinsically aesthetic value in his own way, often better than we can, even if he does not express it as we do.[6] However, it should no doubt be added that, in so-called archaic societies, aesthetic value, practical value and religious value are not yet clearly distinguished. It may be that aesthetic values became emancipated only at the dawn of our era, when culture ceased to be a totality imbuing and integrating individuals, when a class culture and individualism made their appearance simultaneously, when art expressed desire instead of channelling it. Then the artist is no longer one with the craftsman; art collections, collections of curiosities and museums are set up; what Bourdieu calls an intellectual field consecrating the independence of art and the legitimization and hierarchization of its products is constituted – we shall revert to this concept later on. Aesthetic judgement gains its autonomy when the source conferring on it its legitimacy and authority, through several mediations, acquires its own autonomy. Thus, sociology now proposes to study the advent of evaluative discourse.

At the same time, it elucidates its scope and its validity. In this it gives the same interpretation as Durkheim and Lévy-Bruhl proposed for Kantian formalism in connexion with the categorical imperative. The universality which Kant ascribes to the judgement of taste is explained by the authority of the social institution pronouncing it: the *consensus omnium* is actually a *consensus optimorum*, the agreement of the experts, and the experts are determined not so much by their delicacy of taste, as Hume said, as by their social status. They are, for instance, the professors, so vehemently condemned by Dubuffet, who perpetuate the cult of certain works . . . and the oblivion to which others are consigned, who therefore exercise, often unwittingly, a permanent censorship in the cultural field. Of course the professors are not alone in this; the influence of the leaders of opinion in particular cannot be

5. Cf. 'Arts indiens et esquimaux du Canada', an article by Philip FRY on an exhibition organized in Paris in 1969 (1969).
6. Many reflexions on this subject will be found in the preceding chapter, in A. A. Gerbrands' article on the anthropological approach.

overemphasized – a well-known collector has only to add to his treasures the work of an obscure painter and the painter is launched [7] – nor can that of certain artists themselves.

Moreover, there is no sociology of taste which is not bound up with a sociology of groups or classes.[8] For the intellectual field in which judgements of taste are formed reflects the structures of the society with which it is connected. In modern societies the group it constitutes is closely related to the ruling class; and the aesthetic judgements pronounced by it differ according to the position occupied by that class and the view of the world inspired by that position. As a first approximation, Jacques Leenhardt proposes to distinguish three of these positions: conquering, triumphant, on the defensive, and in accordance with these positions, three types of value system, that is to say, three types of taste: '(a) the constitution of a new taste supported by a rising class; (b) the establishment of a set of fairly rigid canons corresponding to a well established taste and a society that is not only well established but is already more concerned with protecting itself than with conquering; (c) a taste which we might call declining or decadent, corresponding to a social class or group which is losing its power and clinging to certain forms of expression, whilst within the general society to which this class or group belongs a new class or a new group whose taste may be classified as of type (a) is already on the way up'. Jacques Leenhardt illustrates this group typology by reference to the aesthetic problem of realism from pre-Renaissance to classical times.

2. THE SEMANTICS OF EVALUATIVE DISCOURSE

However, the study of axiology – which is not in itself, we repeat, an axiological study – can take a direction other than that of the sociology of evaluative discourse, namely that of the semantics of such discourse. The question is then what Mr. X means when he says: 'This is beautiful', or 'I like this' or, again, 'I prefer this to that'. This question, as we see, is inspired by Wittgenstein's *Philosophical Investigations*; [9] it entails the examination of a certain use of language, of that which is employed in the intellectual field or under its auspices, and which consists of stating judgements of aesthetic value. It will be readily understood that this question is asked chiefly in English-speaking countries. The investigation here parallels those undertaken by *New Criticism* [10] and *New Semanticism*.[11] Just as these schools study the semantics of works (principally literary works, of course) we study the semantics of the

7. Cf. KÖNIG, *Kleider und Leute. Zur Soziologie der Mode* (1967) (English translation, *A la Mode: René König on the Social Psychology of Fashion*, 1973) and also DELLA VOLPE, *Critica del gusto* (1960).
8. Here we follow the suggestions made by Jacques Leenhardt in a summary note. The ensuing quotations are taken from it.
9. Original German: *Philosophische Untersuchungen* (1953). See also *Lectures and Conversations* (1966).
10. Cf. *inter alia*, RANSOM, *The New Criticism* (1941), and WIMSATT & BROOKS,

judgements pronounced on those works. Of course we shall not deal, as Morris and Richards still did, with the values which may be expressed by the works, but with the values which criticism attaches or refuses to attach to the works. This procedure is clearly announced in the title of a book by Bernard C. Heyl: *New Bearings in Aesthetics and Art Criticism. A Study in Semantics and Evaluation* (1943). Heyl refuses any 'real definition' of the valorizing predicates because the same term may have many, and frequently incompatible, definitions (Ogden and Richards distinguished sixteen definitions of the word 'art'), and he shows that the use of these predicates in appreciative discourse is essentially volitional: when I say 'This is beautiful', I am merely expressing a certain emotion. The same is true when I say 'This is good'. Charles Stevenson has extended to aesthetics the method of semantic analysis which he first applied, in a well-known book, to ethics.[12] This method has been frequently adopted by the Oxford school; it runs right through the collection of essays *Aesthetics and Language*.[13] Thus the thesis of the semanticists leads in the first place to a relativism linking up with the empiricism of the eighteenth century and by the same token it appeals to sociological investigation, which has in its favour the undoubted merit of positivity. But this thesis is not confined to the relativization of axiological judgement; it calls for consideration of everything that is said about works of art. It then introduces what Margaret Macdonald terms the 'open texture' idea, very well defined by Morpurgo Tagliabue: 'A work of art does not exist *per se*; it is the series of its past uses and the possibility of its future uses'.[14] This idea was to be taken up by Umberto Eco – who used the term 'open work' – and by the whole of the structuralist school of thinking, which was anxious to dissolve the object in the relationships in which it is involved. Then the history of art is not the history of the works, but the history of their interpretations, of the uses to which they are put. The considerable interest of such a history is evident from a recent book on Baroque by Charpentrat, for example.[15]

But can one stop there? Can one dissolve the object by radically dissociating use and reference? Can one fail to recognize the fact that the interpretation commits us to a certain relationship with the object, to what Pareyson

Literary Criticism (1957).

 11. Cf. STEVENSON, 'Interpretation and evaluation in aesthetics' (1950) and 'On the analysis of a work of art' (1958).

 12. STEVENSON, *Ethics and Language* (1945). See also the analytical studies of aesthetic value in Stuart HAMPSHIRE's *Thought and Action* (1959/1960), a work of an 'analytical' character with a strong ethical interest.

 13. ELTON (ed.), *Essays in Aesthetics and Language* (1954); cf. WEITZ, 'Aesthetics in English-speaking countries' (1958).

 14. 'Il n'y a pas une œuvre d'art en soi, il y a la série de ses emplois passés et la possibilité de ses emplois futurs.' – *L'esthétique contemporaine* (1960), p. 270. Cf. also the article by Lia FORMIGARI, 'L'analisi del linguaggio e l'estetica' (1956), mentioned by Morpurgo Tagliabue.

 15. *Le mirage baroque* (1967).

calls 'recog ition which is both receptive and active',[16] or that, if it is more specifically a question of value, any judgement is supposed to be based on a knowledge of the object? Morpurgo Tagliabue puts it very well: 'Aesthetic criteria are never given. The specialist does not *find* them ready-made in a culture; he discovers them in his experience (of which culture is one element) when he does not frame them himself in a system of his own. And the layman does not just *receive* them from the expert; he also recognizes them in works of art.' [17] And in point of fact the 'analysts' do not seek to eliminate all judgement in favour of description. They, too, believe in evaluative discourse and they wish to establish its validity. Their judgement furnishes certain normative criteria and the dogmatism sometimes attributed to them is just as much a characteristic of the use of these criteria as it is of the affirmation of relativism. Under different names, they still refer to the values in terms of which beauty, harmony, unity, and clarity were traditionally defined. Heyl, for instance, speaks of truth, coherence and, above all, significance, and it is in these terms that he defines the profundity, richness and fruitfulness of great works. This implies at least a judgement of comparison measuring certain qualities as between different works. Others refer to what is new, unique in a work; and we shall see that a theory of creation is bound to have recourse to these concepts which entail an immanent analysis of the work but which are also normative concepts.

3. REVERSION TO VALUE JUDGEMENTS

This brings us to a third trend in axiological research, which finally invite us to reverse our steps, for in it normativity is no longer a subject for study but the actual aim of study. This research is no longer the business of sociologists or semanticists, but of critics, who make judgements and seek to justify them on the basis of certain norms. It is rightly a matter for aestheticians. Many examples could be found in the United States, where there is much reflection on concepts such as that of fulfilment, already developed by Dewey, or that of balance, developed by Ogden and Richards.[18] In France the inaugurating effect of art is much emphasized in aesthetics, and beauty is often defined in terms of the existential plenitude of the object: 'its splendid and autonomous.

16. PAREYSON, *Estetica* (2nd edn., 1960), Chap. II, 8.

17. 'Les critères esthétiques ne sont jamais donnés. Le spécialiste ne les *trouve* pas prêts dans la culture, mais il les *découvre* dans son expérience (dont la culture est un composant), quand il ne les constitue pas lui-même dans un système à lui. Et le profane ne les *reçoit* pas seulement de l'expert, mais il les reconnaît aussi dans les œuvres d'art'. – *L'esthétique contemporaine*, p. 268.

18. Among recent titles in English we might mention: BEARDSLEY, *Aesthetics* (1958); SPARSHOTT, *The Structure of Aesthetics* (1963); STOLNITZ, *Aesthetics and Philosophy of Art Criticism* (1960); WEISS, *The World of Art* (1961); WIND, *Art and Anarchy* (1960, publ. 1963); WOLLHEIM, *Art and Its Objects* (1968); BEARDSLEY & SCHUELLER (eds.), *Aesthetic Enquiry* (1967). A general picture of production since 1958 is to be found in STALLKNECHT, 'Aesthetics in English-speaking countries' (1971). (For earlier years see the article by WEITZ under the same title, 1958.)

existence' as Etienne Souriau said, while Valéry said earlier that the perfect work is the finished work, one which inspired no regrets and no desire to improve it. In Italy, too, Pareyson, making remarkable use of the concept of formativity, defines the virtue of art as the passage from forming form to formed form and as the transparence in the work of the formative activity which created it.[19]

This same idea of form may give rise to yet another axiological trend: form is then design, which is grasped through *gestalt psychology*. It inspires research into the expression of 'functionality' in arts applied to industry, for there is an inclination to say that form is beautiful when it expresses the purpose of the object – the beauty of an architectural hull, of an aerodynamic wing, of a cigarette-lighter which fits into the palm of the hand, of a container which unequivocally proclaims its content. A normative definition of beauty was frequently introduced at the time of the Bauhaus, the Athens Charter, and even later, as a result of all the research inspired by 'industrial design' – with which G. Dorfles will deal later.

Beauty has also been equated with expressivity and it has been suggested that the depth and richness of the latter be taken as a measure of the former.[20] Other analytical studies dealing with aesthetic categories, as for instance R. Bayer's on grace [21] or E. Souriau's on the sublime,[22] imply recognition of other values, for it is hard to define aesthetic categories without thinking that they constitute criteria for the works to which they apply. In short, judgements of value are continually being stated throughout contemporary literature on aesthetics, as also in criticism, whose task it still is. When value judgements are not made, their absence is frequently lamented. We shall give just one example of this: in 1958 R. Wellek, closing an important symposium on style at Indiana University [23] in which linguists, literary critics, psychologists and anthropologists took part, observed: 'No stylistic analysis of a really literary text was presented except for Mr. Higginson's paper on *Finnegan's Wake*. Thus some of the most obvious and central problems of the study of style, at least in literature, have never been raised and could not have been brought nearer to a solution'. He also said 'Literary style is to my mind not exhaustible by linguistic analysis: it needs analysis in terms of the aesthetic effects toward which it is aiming' and he concluded by making 'a plea for literary scholarship as a systematic inquiry into structures, norms and functions which contain and *are* values'.[24]

Mention must moreover be made of the 'aesthetics of ugliness'.[25] For counter-values are still values and, in the art of all ages, on its fringe, some-

19. Cf. *Estetica, teoria della formatività* (2nd edn., 1960), *pass.*
20. Cf. DUFRENNE, *Esthétique et philosophie* (1967), *pass.*
21. BAYER, *L'esthétique de la grâce* (1933).
22. SOURIAU, 'Le sublime' (1966).
23. The proceedings of this symposium were published by T. SEBEOK under the title *Style in Language* (1960).
24. WELLEK, R., 'From the viewpoint of literary criticism – Closing statement', p. 408, p. 417 and p. 419, in SEBEOK, *op. cit.* (1960).
25. Cf. KRESTOVSKY, *Le problème spirituel de la beauté et de la laideur* (1948).

times right in its centre, the formless, the deformed, the monstrous and the terrifying, all the manifestations of anti-art, enjoy considerable prestige. As we have seen, psycho-analysis has much to say about 'this irrational function of ugliness' which removes the veil from the unavowable; and so has sociology, though apparently not attaching much importance to it. For these negative values of derision and destruction may imply a protest against all forms of established order, the overthrowing of all instituted values. It is of course here, in the light of these exemplary counter-examples, that the profound unity of the axiological field is best manifested and, despite all efforts to discern them, it appears impossible to distinguish clearly between aesthetic, religious, ethical and political elements.

This solidarity of values leads us to mention here the Marxist axiology. Indeed axiology is at the heart of the Marxist aesthetic. Certainly, in so far as it promotes a sociology, Marxist thought is very much aware of the historical relativity of the judgement of taste and it cannot remain indifferent to studies establishing that relativity or take no part in them. In any case, they are often inspired by it, even in the case of scholars who are not professed Marxists. Here again axiology is a subject for sociological study. After all, does not sociological *theory* underline a *practice* in cultural policy: the imperative of socialist realism of which Béla Köpeczi spoke? This conception was elaborated as a result of reflection on the relationship of art and society, on the social function of art, on the part it plays in political struggles and on the extent to which a people is ready for art at any particular stage in its history. Mrs. Anna Zador, in a very interesting contribution to the present Study, emphasizes the fact that in the Eastern countries realist axiology has been bound up with a particular cultural policy: it was because the socialist revolution wanted to put art within the reach of the people and in the service of the people that 'the question of content was brought into the foreground and, above all, that works of art had to be intelligible, that their meaning had to be such that it could be explained'. Moreover, 'there are periods in art, and not the least important, which comply with these requirements'. Nowadays, Mrs. Zador goes on, 'a generation is growing up for which the predominance of content and comprehensibility no longer constitute a social question The dangers involved in broadening and changing are a thing of the past There can be no doubt that all over the world a considerable proportion of youth is attracted by the new and the 'never before seen', independently of 'value' and its 'sense'. The essential thing now is to be able to use this experimental unease for the purpose of leading youth to love, appreciate and understand art and to enjoy it more fully. These ideas might be compared with those advanced by Béla Köpeczi in the preceding chapter in his account of the situation of art and literature in the Socialist countries.

But there is perhaps another justification for axiology in the minds of the Marxist thinkers – a truly philosophical justification in which beauty is stressed. Béla Köpeczi informs us: 'In recent times it was V. P. Tugarinov who took up this question and sought to identify aesthetic value with beauty, considering aesthetic enjoyment, with its individual and social character, to

be the essential criterion of beauty. L. N. Stolovich, for his part, maintained that beauty as a value means objective beauty independent of the receptor. This beauty, moreover, is nothing other than the manifestation of Man's freedom. V. Vanslov asserted that in beauty it is the reign of social man, his evolution and his freedom which are expressed. Thus, despite certain points of agreement the Marxist aestheticians offer rather divergent answers to axiological problems.' [26]

However, these answers all converge towards the idea that the predicate *beautiful* retains its meaning and that it describes the object whose presence announces and prefigures the advent of total Man. Lukács was probably the one to express this idea most forcibly: aesthetic experience is 'a process of homogenization' in which the particular is merged in the general, in which Man measures himself with the world and his tasks and reaches up to that universal whose concrete content is provided by society and by the class which incarnates hope for the humanization of Man and the world. In his most recent book on 'the specificity of the aesthetic' [27] Lukács states that the objective of art is defetishization, which raises the question whether this world is human. The impact of this question is catharsis; and beauty is what gives rise to this catharsis. Thus the master concept of aesthetics is also an anthropological concept.

Elsewhere this view was formulated differently – in terms of committed art. We encountered this view when we spoke of the problems peculiar to non-Western countries, but we had already met it when briefly describing changes in forms of expression in literature and the arts in industrial societies. We found that art claims and exercises the utmost freedom with regard to all norms (here including those of realism), but it is not for all that purposeless play, anarchical abreaction, destructive frenzy. The freedom which it takes upon itself is intended as an example and a means of liberation – and for whom if not for mankind? Of course this liberation assumes different forms according to circumstances – social liberation in one case, psychical liberation in another – but basically they are inseparable, for constraints, prohibitions and repression always interfere and it is still the individual who

26. See, in this connexion, Burov, *Èstetičeskaja suščnost' iskusstva* (= The Aesthetic Essence of Art) (1956); Stolovič, *Èstetičeskoe v dejstvitel'nosti i iskusstve* (= The Aesthetic Quality in Reality and in Art) (1959); Tugarinov, *O cennostjah žizni i kul'tury* (= On Values in Life and Culture) (1960); Vanslov, *Problema prekrasnogo* (= The Problem of Beauty) (1957). See also discussions turning on these problems in *Voprosy literatury*, 1960, 1961, 1962, 1966 and 1969 [articles by Zelinskij (1960); Tasalov; Solov'ev; Astahov; Pažitnov & Šragin (1961); Romanenko; the collection on 'K itogam diskussii *Èstetika i žizn'* ' (= For an appraisal of the discussion 'Aesthetics and life'); article by Nujkin (1966); discussion of this article by Kagan, Runin and Kondratenko; and by Nedzvečkij, Astahov, Nujkin himself and Mjasnikov (1966); article by Burov (1969)], and in *Voprosy filosofii*, 1961, 1962 and 1963 [articles by Kornienko (1961); Stolovič; Ivanov, P. L. (1962); and the collection 'K obsuždeniju voprosa o suščnosti èstetičeskogo' (= Contribution to the question of the essence of aesthetic quality) (1963)]. [N.B.: For details see the bibliographical annex under the authors' names or the titles of collections.]

27. *Die Eigenart des Ästhetischen* (1963, 1965).

must be freed from the inhuman both in himself and in the outside world. That is what contemporary art is committed to do – even if unwittingly. And this commitment calls for a certain normativity in aesthetic judgement: it therefore justifies a certain axiology which can give aesthetic counter-values their due, which is itself liberating and not enslaving, that is to say, not dogmatic.

Aesthetic reflection proper can thus accept an axiology without yielding to the temptation of dogmatism, that is to say, without recommending canons and procedures the application of which is supposed to guarantee the beauty of the work. And, in point of fact, although contemporary thinking invokes norms, they are norms according to which objects are judged by themselves rather than from without. To speak of plenitude, compactness or depth, is to say that an object should be what it claims to be. To speak of expressivity is to say that it should express what it is intended to express. A beautiful object is an object which is undeniably itself – unlike unsuccessful, flat or insignificant objects. To this might be added yet another principle of judgement – peculiar to our own time perhaps – according to which an object must be compared with similar objects for its novelty to be appreciated: the newer and the more unique a work is, the more authentic and interesting it is. This, too, is another way of being itself and therefore of being beautiful. It may be said that this definition is too elastic, but why should this be regretted? Let us not forget, moreover, that the being of an object is entirely in is appearance, in the epiphany of the perceptible. This has two consequences. On the one hand, objects such as those produced by contemporary art – which are not masterpieces in the traditional sense – objects which are in their natural state, or which are ephemeral, or as evanescent as a gesture, as fleeting as the passing scene, are still capable of beauty; these improvizations, too, are subject to value judgements. On the other hand, since, according to an old dictum, nothing is perceivable except through the joint act of the perceiver and the perceived, if the object is judged by itself, as we said, it is always on a viewing or a hearing. The receptor is at least associated with that judgement. How is he so? How does he judge without being a judge? Through his enjoyment. The phenomenology of aesthetic experience may, when appealed to by art or contemporary philosophy, modify the Kantian interpretation somewhat, but it cannot ignore the essential feature of it: what informs or justifies aesthetic judgement is our enjoyment – or, when our habits or prejudices are attacked, a certain displeasure perhaps, which is still a refined form of our pleasure.

Since we appreciate this pleasure, we cannot eschew the language of values. Today, however, we are aware that this more modest discourse, different as it is from dogmatic discourse which takes its authority from apodeictic values, may be subjected afresh to the positive studies which we have mentioned and, in particular, to a sociological study, because the enjoyment which gives rise to it, however, spontaneous or ingenuous it appears to be, is a manifestation of a taste which is always more or less educated and which has been formed in a specific cultural field.

So, at the end of this too rapid review, we come full circle back to the positive study of normativity and its social conditions from which we started. There is no reason why philosophy and science should entrench themselves in antagonistic positions.

This we shall confirm when we embark upon the second section of this chapter.

SECTION FIVE: THE STUDY OF THE VARIOUS ARTS

INTRODUCTION

Our study of research on art and literature will now be conducted from a
different angle, that of the various arts taken singly. Such an approach can
certainly be challenged. On the one hand, contemporary thinking has in
fact abandoned taxonomic methods: it no longer devises classifications; it
no longer seeks to establish a 'system of fine arts' (to cite the title of a
well-known work by Alain). Not that it refuses to systematize but, when it
plans a system, it thinks in terms of relationships rather than elements:
as is shown by Thomas Munro's title: *The Arts and their Inter-Relations* (1949,
1967), or Etienne Souriau's: *La correspondance des arts* (1947, 1969).
Furthermore, the practice of artists seems to justify this attitude. New forms
of art struggle to emerge, breaking through the traditional frontiers,
mixing genres, attempting to resist all classification. In what category can
we place the encrustation technique of a Dubuffet, a Pop object, a form of
theatre where the script is abolished, a text which allows itself to be in-
vaded by images? And many artists unceasingly dream of total art, which
would no longer appeal to one privileged sense, but to our entire body, it-
self total and glorious.

We have referred to these changes in practice and theory; they are far
from having produced their full effect. But meanwhile we appear to be still
entitled to speak of a specificity of the arts, the more so because certain
artistic undertakings continue to aim at the unique essence of an art, be
it painting, music or literature. They then seem to operate in their own
particular way the eidetic variations recommended by Husserl, the inten-
tion being less to transgress the essence than to put it to the test. It may
be that for some – may Spinoza forgive them! – this essence is *'l'obscurité
élémentaire'* wherein *'l'exaltante alliance des contraires'*[1] is formed. But
it can test and manifest itself only in the work, and the work, in its turn,
derives its own obscurity from the fact that it is an object. As Blanchot
also says: 'elle *est* éminemment *ce dont* elle *est faite'*. At the origin of the
work there is always an action determined by the matter against which
the action is pitted. That matter, and the *praxis* to which it gives rise,
may still serve as a principle for a specification of the arts.

Furthermore, we know that, at the very time when a transformation is
taking place in the sciences comparable to that in the arts, scientists and
technicians are tending to specialize more and more. The more the speci-
ficity of a domain is challenged, the stronger become the particularization
of the object and the specialization of knowledge. The same applies here:
scientists and critics remain specialists. That is why, finally, there need be
no hesitation in showing how their research is becoming specialized, even

1. BLANCHOT, *L'espace littéraire* (1955), p. 235.

if that means accepting a traditional classification. And it is precisely to specialists that we have entrusted the task of dealing with each of the subjects considered in this last section.

I. VISUAL ARTS, *by Giulio Carlo Argan**

Although often regarded as indefensible from the theoretical standpoint, a distinction does subsist, in practice, in the study of the visual arts, between criticism and history. At first sight it would seem that the diversity of methods should be reflected chronologically: we may write about the history of art in the past, but criticize only contemporary art; which is tantamount to applying to the study of art the distinction commonly observed between history and chronicle. But such a distinction is illusory; for indeed if we understand by chronicle the sum of contemporary phenomena not yet selected with reference to their historical significance, it is clear that the choice we make is itself a stage in the methodological process of constructing history, which consists precisely on choosing a group of phenomena and justifying our choice by determining and describing the relationships by which they are united. Merely distinguishing between what belongs to the past and what belongs to the present cannot lead to a distinction between different chronological levels: every completed work of art, even a very recent one, belongs to the past. Can we therefore argue that history is the criticism of completed art, while criticism is the criticism of art in progress? We cannot pass judgement on what is unfinished, is in process of being created, because judgement consists precisely of verifying that the artist has done what he set out to do, and because it is impossible to pass a judgement of being or non-being on something that may succeed or may not succeed and so is equally liable to end up as being or as non-being. Since everything that is has *come into being*, we cannot confer the attribute of being on something that is in the process of becoming. The answer to this objection is that no study of art need necessarily begin or end with a judgement of being or non-being. But a criticism which does not judge, that is to say, which does not consider the work of art as completed or as belonging to the past, can be only a criticism which *participates* in the becoming, in the realization of art, and it would be superfluous to add that this conception of criticism is typically romantic (Baudelaire). Criticism of this nature necessarily plays the part of *adjuvant*, that is to say, it does not set out to write the history of art within the framework of a general history of civilization; it chooses for itself the same objective as artistic creation, which is to produce art. In this case, of course, the critic does not do the work of an historian; his action is part of the

* Institute of the History of Art, University of Rome.

actual process of artistic creation. The alternative is then simple: either the part played by criticism in the production of the work of art is superfluous, arbitrary and, finally, negative, or else it makes up for an inadequacy of traditional means, that is to say, of the techniques of art. The experience of history confirms this second hypothesis. The intervention of criticism in the process of creation became necessary from the moment when the development of modern technical methods placed traditional artistic techniques in a position of inferiority, of backwardness, of crisis. But if criticism participates without judging and history judges without participating, it would seem that they no longer have anything in common. Yet, once we have ruled out the possibility of criticism being able to judge, because it is concerned with something in the *process of becoming* and not with something that *already exists*, we still have to determine whether the history of art really judges correctly, how it judges and for what purpose.

The aim of the historian is naturally to construct history, and it is obvious that all 'specialized' history is valid only in so far as it falls within the framework of the general history of mankind or of civilization. But, as Marc Bloch has shown, general history can only be a system resulting from the association of the constituent elements of the specialized histories (political history, economic history, the history of religion, the history of art, etc.), and the first and essential work of the historian is to set out in categories phenomena which in reality occur simultaneously and in confusion. Nevertheless, although it must be clearly admitted that certain categories of phenomena play a preponderant or central rôle at various periods and in different cultures, we cannot regard any one of them as possessing absolute primacy as happens, for example, when political history is said to be 'real history', and economic history, the history of religions, the history of art, etc. are merely secondary, marginal, supplementary or explicative. We see therefore that the work of the art historian is by no means to demonstrate how art may provide useful elements for the explanation of political or social phenomena, but quite simply to write the history of art. It is only after writing that history, regarded as a separate branch of the history of culture, that it will be possible to study its relationships with other branches, in order to paint, as far as is possible, a general picture of the history of civilization. But, to come back to the ideas expressed by Marc Bloch in his *Apologie pour l'Histoire* (1949), if the work of the historian consists of forming series of phenomena between which a relationship is seen to exist, and if the series in question may be constituted only of phenomena 'which continue', the history of art has no *raison d'être* unless art is one of those phenomena. For who indeed would undertake to write the history of mankind, if he knew that mankind would shortly – perhaps even this very day – cease to exist? When we say that only the history of phenomena which continue can be written, we must add immediately: *in order that* they may continue. But if the history of art necessarily has the survival of art as its ultimate aim, it is not easy to see in

what way it differs essentially from the critical method, which participates in artistic creation and serves it as adjuvant. It must, however, be emphasized that in bringing order into the chaos of phenomena, the historian postulates that there is really an order in those phenomena. Were it otherwise, if the historian invented an order where none exists, history would be nothing more than a gigantic hoax. Even if we ignore the tremendous influence of spoken or written history on the march of events, precisely because it is the record of human decisions and actions, it may be asserted that history would be meaningless if there were no possibility of finding a certain coherence in human activities or, more exactly, a certain structure: just what is commonly called history. It follows that the history of art can be written only in so far as it is, intrinsically, history; and when we attempt – as criticism would wish to do – to define the specificity of art, we are, in reality, defining only its historicity. In other words, any study of artistic facts tends to define not their absolute nature, but their relative character.

Acknowledging, then, that the only way to approach and explain artistic facts is to do so in the manner of an historian, our research will necessarily have to be conducted according to one of the numerous historical methods. Which one is to be considered the most efficient?

The art historian's first care will naturally be to distinguish between art and the rest. It is also clear that categories cannot be created without grouping phenomena between which there is a certain interrelationship. So there would seem to be only two possibilities: the relationship either springs from a constant quality inherent in all artistic facts – a structural analogy – or from a process, in other words, from the dynamic development of certain relations. The opposition between structuralism and 'historicism' is, in the end, found again in art studies as elsewhere. However, as has been shown on several occasions, such opposition is neither radical nor irreducible. The structure is not necessarily static, and there is no reason why history should not be regarded as a structure of development. We know that certain currents of contemporary philosophical thinking challenge the legitimacy of a philosophy of art or aesthetics. That is to say, they deny the possibility of giving a theoretical definition of a concept of art which can serve as a point of reference for determining artistic value. The concept of art is thus replaced by the entire phenomenology of art. The only criterion for appreciating isolated facts is to verify whether and how each one is integrated in this phenomenological current and can help to turn it into a system. The only criterion which will enable the visual arts to be constituted in categories is, of course, that of perception: art exists to be perceived. As we perceive many things which are not art, perception directed towards art attempts to communicate to us something other than what is given us by normal perception. This intention can be seen in the way in which the things offered to our perception are constructed, that is to say, in the techniques of art. These techniques vary according to time and place; it is therefore impossible to devise an unvarying plan

for the creation of art. What it is sought to determine is a way to transform these techniques into a basic structure, so as to be able to distinguish them from other technical structures – agriculture, navigation or military science, for instance. The technical element is not decisive, as the same basic technique may produce, according to circumstances, a work of art or something different; at any rate in the general opinion. If, for example, we assume that the basic technique of painting consists of spreading coloured pigments on a surface, it is obvious that this technical defini-tion rules out any distinction between the work of a house-painter and that of a great master. It will be noted, moreover, that not only the technique, but also the purpose, is the same since, in both cases, it is a question of modifying the perception of a given surface by introducing an 'aesthetic' value. The difference is quantitative in nature. For the history of painting, the importance of the painting by the great master is capital, that of walls brushed over by a house-painter is trifling. To use the language of 'communication', the house-painter's 'message' is of little interest; that of the great master is of considerable interest. Once the relationship is established, it then remains to determine whether the work of the master is to be considered the finishing-point of a process which starts with the daubing of walls, or whether, on the contrary, the latter is merely a deriva-tion, a vulgarization, in purely quantitative terms, of the painting of the master. In other words, the problem to be resolved is the same as that faced by specialists in linguistic structuralism; namely, whether, in a system of signs, aesthetic communication is to be considered *selective* (at the end of the process) or *institutive* (at the beginning), and consequently whether art is to be considered as the manifestation of the elite or of the basis. The problem assumes particular importance in the cultural situation of today, that is to say, in the conditions of a mass culture which can be transmitted through the intermediary of the mass media; but it had already been raised by Riegl at the end of the last century when he distinguished between decorative art (which is the product of the community) and the art of representation (which is the product of the individual).

Let us now examine the historian's choice of significant phenomena. As was said earlier, he does not seek to determine what is absolute in each work he studies (being or non-being), but what is relative. To him, the most important work is one which is included – as resultant or deter-minant – in the largest mass of relationships. It is hardly necessary to add that only the perception of relationships determines the judgement of value; a typical example is that of 'negro' sculpture, which for long was exclusively of ethnological interest, and the aesthetic value of which appeared only after the Fauves had adopted it as a point of reference, and consequently of relationship, with their own painting.

Can it be said that the historian's choice is of a discriminatory character? I should prefer to call it recapitulatory. Among the works of little value of which the historian takes little account, the lowest rank is, as every-body knows, that of copies and fakes. It cannot be denied that such works

belong technically to the realm of art, or that, objectively speaking, they are artistic facts. So true is this that in historical construction, a copy very often replaces the missing original. All that can be said is that such works of art are of only very little aesthetic value, the more so as their dependence in relation to other works would lead to their being classed in the category of consumer phenomena rather than in that of artistic production. However, the historian does not eliminate them, for he knows very well that the highest summits of art are always reached when and where artistic production is abundant. The works which he makes the pillars of his historical construction are invariably the most 'representative', that is to say, the first to offer certain values, or to offer them with a fresh lucidity and force thereby making it almost superfluous to mention other works in which such values show through in a more confused and fragmentary manner or are even only passively repeated. The picture traced by the historian of art is always the general picture of the artistic culture of an epoch or of a place, just as the historian of political life reveals in the saying and actions of great men and women the sentiments and motivations of a class, a social level, an entire people.

If we agree that historical research is research concerned with a mass of relationships, it is certain that it can be pursued at various levels and on a more or less broad basis. The most superficial, and the most restricted, research is certainly the kind that assimilates the work of art with no matter what other fact or event, concerning which it is always possible to find outside information or documents: date and place of production, various circumstances and details. But as soon as we leave this superficial level of objective information, we approach the genesis of the work of art and the process which has given birth to it; in other words, its structuration. The method which is claimed to be 'historical', but which is really the result of an idealistic conception of history, aims ultimately at determining the author and the date of the work, that is to say, at placing it in the still very restricted framework of the activity of an artist or of a school. A typical aspect of this method is therefore the search for a sum of affinities justitied by contacts which are direct or indirect, but still insufficient to explain the profound meaning of the work, except in so far as these affinities are sublimated in a personal expression. It follows that for anyone who describes the origin of the work in this light there are always two levels: on the one hand, that of the culture with which the artist is permeated, and, on the other hand, that of his personal contribution – his art. This method, when applied with finesse and penetration (Longhi), makes it possible to reduce to the minimum the margin of imponderables and to explain the fact that the work transcends the cultural data by the way in which the relationships are established and made operative. From this it may be concluded that, while the work of art is certainly to be found invariably in a cultural context, its dialectical dynamism is of a very particular type, quite different from that of the other cultural sectors.

The most vital trends in the study of the visual arts are undoubtedly

those which are based on what is known as the theory of pure visuality, that is to say, those which focus analysis exclusively on formal data. A typical example is that of Wölfflin. This point of view is extremely important also because, by taking as a subject for research everything that is offered to perception – and only that – it eliminates the traditional hierarchy between 'pure' and 'applied' art, between art 'for the élite' and popular art. It is indeed this methodological practice, which finds its starting point and its theoretical justification in Fiedler, that gave rise to research into a vast category of artistic phenomena until then regarded as marginal: decoration, everyday architecture, urban and rural handicrafts. The limits of this methodological approach are those defined by identifying the concept of art with the concept of form as a positive representation of the world. It is true that in this way we arrive, as did Wölfflin, at a very precise delimitation of systems of signs, but each of these systems corresponds to what is generally regarded as being a *Weltanschauung*, or fundamental intuition of time and space at a given epoch. The function of the artist would then be to 'visualize' a pre-existing culture or, in the most favourable cases, to co-operate in producing it within the limits in which the culture of an age is based on the sensorial experience that is perception. The positive contribution of research is not only to provide a total justification of the artistic phenomenon considered as a cultural phenomenon, but to identify an epistemological 'content' implicitly present in the quality of signs: it is therefore, in short, a first and still confused attempt at semantic analysis.

While, in Wölfflin's methodology, the fields of artistic representation and intellectual knowledge continue to be coextensive, even though the system of signs of communication are different, the domain of art was extended later by Panofsky, who, on the one hand, draws his inspiration partly from Cassirer's 'philosophy of symbolic forms' and, on the other hand, adopts for his own purposes Jung's analyses on the methods of transmission and transmutation of images. Panofsky's iconological research carries further the study of relationships in time and extends them in space, but above all it endows the study of the genesis of art with the unlimited dimension of unconscious motivations. It is perfectly possible, thanks to Panofsky's method, to reveal the filiation which exists between a work of the Renaissance and mediaeval works of art which were certainly unknown to the Renaissance artists, but which were able to influence them through the intermediary of an underground tradition determining the direction of their creative work. It is similarly possible through subconscious motivations to detect profound affinities between the iconologies of various civilizations distant from one another, between which there had certainly been no direct contact. Naturally, Panofsky's assumption can be the subject of vast developments, which Panofsky himself had in a way foreseen from the moment when he had decided to consider as 'symbolic form', and therefore as a particular iconology, the view, that is to say, the 'rational' concept of space, introduced by the Renaissance. Artistic tradition and the evolution of

images also cover a mass of cultural factors – architectural types, propor-
tions, 'representative conventions' (see the recent writings of Gombrich)
and, in general, all semantic forms belonging to general culture and to the
particular culture of artists, and in relation to which invention – generally
taken to be the mainspring of artistic 'creation' – is seen as an instance
of 'informative innovation' transcending the common heritage. The subject
of the relationship between art and culture – or rather of art considered
as a particular aspect of cultural structuration – has been taken up also
by the supporters of the idealist school, such as Focillon and Lionello Ven-
turi. While Focillon studied mainly the future of artistic forms in relation
to the future of culture and society, Venturi – without, as it happens, going
beyond the premises of the idealists – attacked the problem of a specific
culture of the artist, that is to say, a culture structured and orientated
to meet the requirements of artistic creation. The notion of 'taste' advanced
by Venturi, thus borrowing a term from English criticism of the eighteenth
century, is already very close to the notion of 'poetic' in the sense of cul-
ture directed towards artistic creation, which will be discussed later.

This notion of 'poetic' is another fundamental instrument for the inter-
pretation of artistic facts. The historians of art readily agree that they are
concerned with poetic values, and their work is directed towards elimin-
ating any qualitative rupture between the poetic and art. If we understand
by 'poetic' cultures, cultures of which the object is aesthetic creation, and
if the latter, within the framework of contemporary culture which can
easily be assimilated to a system of mass communication, requires a mini-
mum of imitation and a maximum of innovation, it may be deduced that
the 'poetic' cultures have an eminently critical and historical structure in so
far as they necessarily presuppose criticism of the institutionalized or
'patrimonial' systems of semantic communication. Even if we were to re-
strict the function of the historian to an acceleration of the processes of
the aging and renewal of the systems of visual communication and to their
more or less definitive recording, it would have to be admitted that the
historian thus contributes to the development and the establishment of poetic
cultures, and consequently of art. Moreover, the very notion of 'poetic' was
defined, and gained acceptance, from the moment when it was admitted
that the special approach of the artist and the dynamism of his specific
culture derive from their actual objective – which is to produce an histo-
rical phenomenon – an intrinsically critical dimension and historicity. It is
therefore absurd to try to trace a boundary between the history of art and
what we have termed the criticism of participation; for indeed if we can
write only the history of phenomena which 'continue', it is clear that the
art historian must start from the principle that the artistic phenomenon
continues and that he must therefore act in such a way that it will continue.
If there is theoretically a relationship between every artistic fact and all
the other facts which belong, within the framework of contemporary cul-
ture, to the category of art, it is obvious that no distinction can be made
between the historian interested in Antiquity or in the Middle Ages and

the critic concerned with contemporary art, or even with art in the process of development. By 'art in the process of development', we mean naturally not works of art now being created or on the stocks, but a situation of artistic culture in course of evolution, a situation which the critic may influence in various ways, direct or indirect. But all artistic phenomena, from the start of civilization up to our own time, may be considered as a unique situation in course of evolution, and even, at the present time, in a state of crisis. It is therefore quite certain that if ever the aesthetic component should disappear from the cultural system of the future, everything we call the cultural heritage of mankind would lose its value and, sooner or later, finish up by returning to nothingness. The problem which today is a source of preoccupation for all·those who are interested in the visual arts is precisely whether the phenomena will or will not continue. Because of this uncertainty, and also of the crisis into which the technico-scientific culture of our time has plunged the history disciplines, many people are of the opinion that the historical method can no longer be regarded as the 'scientific' one for the study of the visual arts.

This is a highly complex problem, lying outside our subject; there is however one point which cannot be allowed to pass without comment, because it directly concerns the very possibility of a study of artistic phenomena. We have said that, in our opinion, art is, and cannot be anything other than, a sum total of modes of action having a certain purpose in view, and we say that that purpose is to determine aesthetic value. Without examining in detail what should be understood by that term, I shall merely recall that aesthetic judgement has always been regarded as inherent in our experience of the world, through perception, but that perception, in its turn, cannot be kept separate from the conditions in which it is produced, and more precisely from the active life of men, from their actions. It is for this reason that art, as a structuring activity of aesthetic experience, has always been linked with human activity and its techniques.

It is not difficult to see that, from the moment when what is known as the industrial age changed the structures of activity and of production, the traditional artistic techniques likewise entered upon a state of crisis. Today it is no longer possible to talk of architecture, painting, sculpture, nor is it possible any longer to consider works of art as artistic objects, since, like the techniques of the handicrafts, they are seen as a value belonging to the past. Experiments with new materials and processes, borrowed for the most part from industrial technology and the techniques of mass communication, are still at too rudimentary a stage (being attempts rather than experiments) to give an accurate idea of future possibilities. All that can be said is that not only are the traditional techniques apparently exhausted, but even all possibility of coherent developments of these techniques would now seem to be ruled out. A radical technological mutation is inevitable in the sphere of aesthetic activity as in everything else, and a technical approach to the study of such activity is all the more necessary in that technology is undeniably the axis on which contemporary culture turns.

The problem is therefore not so much that of the possibility of art surviving in a technological and consumer society, as of the survival of aesthetic experience within the framework of mass culture, with its systems of information and communication. It is already possible to say with certainty that, in the 'affluent society', information by image will be of increasing importance. The phenomenon of urbanism itself, wherein the way in which society basically conceives space and time necessarily takes its shape and outward semblance, must no longer be judged, as in the past, from the standpoint of the institutionalization and consecration of values, but from that of their renewal, that is to say, as a veritable system of information. If aesthetic experience is to continue to play any part in establishing an awareness of reality, it will inevitably have the support of the mass media. What we must ascertain, then, is whether the mass media will simply be the means for disseminating a pre-existing culture or be instruments capable of structuring culture in a new way; whether they will be means of reproduction or of cultural production. It is absolutely certain that the mass media, if applied to a historic culture, are the cause of a gradual deterioration which leads, at the worst, to a disintegration of values. It is clear that the structure of the 'message' can never be reduced to that of the 'support' (the medium). The latter should therefore be considered an instrument of cultural production and not of cultural reproduction. The support, if it is to have a constructive and not a destructive function, must not devalue a highly significant cultural material (the historical fact), but must confer value on a material in itself non-significant (the new fact). Once it is admitted that the mass media must have a structuring and valorizing function, it remains to determine: 1) whether the value produced by that function will still be an aesthetic value; 2) whether the operation which will make possible the structuring and valorizing of the new fact will be similar, in its intention and final purpose, to what the artistic operation formerly was. It is impossible at the present time to answer these questions. In any case, there can be no possibility of two different levels of communication – one for the masses and one for the élite – existing together within the framework of a mass culture, or of aesthetic culture being able to remain, as in the past, an inter-personal communication. Either all communication will, by its structure, be aesthetic in nature, or the aesthetic component will be irremediably banished from the system of culture of tomorrow.

McLuhan has shown that the message is not to be distinguished from the support. Through the message the support unceasingly communicates itself exclusively – communicates its own value of information, its own structuring function, its cultural and social dynamism. The society now taking shape is no longer a society founded on possession, that is to say, on stability of values; it is a society of the circulation, the rapid and continual renewal, of values. While the art of the past sanctioned the significance of the object as a symbol of possession by giving it an aesthetic value, modern aesthetic research can only try to confer an aesthetic value on information. It follows that while deliberately aesthetic manifestations are

bound to be studied from the point of view of technique, inasmuch as the latter lies at the centre of an active cultural system, it is clear that the subject of research will no longer be technology aimed at the production of objects, but the technology of circuits of information. We can understand therefore how all attempts to liken new facts to facts which have a historical value and are implicitly aesthetic, are nowadays included within the framework of the theory of information and linguistic structuralism. Starting from a strictly phenomenological point of view, modern history of art has succeeded in giving the abstract notion of space – fundamental for all the visual arts – an outward expression in the form of urban space. And as urban space – the city – is today conceived of as a veritable system of information,[1] all strict research into the phenomenology of aesthetic experience, both past and present, tends to be research into the phenomenology of urban space conceived of as space for life in society, and consequently for communication. In fact, it is precisely in the study of town-planning and of its history that the sociological and urbanist approaches come together and are merged into one. As a continuing phenomenon, the urban phenomenon cannot be scientifically explained outside the methods of history, which is seen to be the only discipline capable of uniting the arbitrarily separated functions of criticism and the history of art.

(Original: Italian)

II. LITERATURE, *by Jean Starobinski**
(Considerations on the present state of literary criticism)

If the methodology of criticism is under scrutiny today, it is largely because literary criticism has come to be regarded as one of the branches of learning. To begin with, therefore, attention must be drawn to the semantic change in the word *critique* (criticism). It formerly designated mainly an activity of judgement and discrimination, based on a normative aesthetic or on preferences in matters of taste. Armed with criteria, whether implicit or explicit, criticism – whether of beauties or of defects – was mainly concerned with selecting, disapproving or praising. On consulting French dictionaries from the seventeenth century onwards, we find that the first and basic meaning of the noun *la critique* was:

Art of judging a work of the mind (*Art de juger d'un ouvrage d'esprit* (Académie, 1964)).

1. Cf., in the present work, sub-section VI: 'Architecture and town-planning', by Françoise Choay.
 * University of Geneva – An amplified version of this essay has been published in Diogène, No. 74 (Apr.-June 1971) (English translation, Diogenes, No. 74, Summer 1971).

To this first sense was added, from 1740 onwards, the idea of *clarification* and *explanation*. This second sense, though confirmed as it was by usage, did not seem sufficiently certain to the editors of the eighth edition of the *Dictionnaire de l'Académie* (1932). The definition put forward at that time scarcely differed from the 1694 one:

Critique (noun): Art of judging works of the mind, literary productions or works of art (*Art de juger les ouvrages d'esprit, les productions littéraires, ou les œuvres d'art*). *Critique* (adj.): the purpose of which is to distinguish in a work of the mind, a literary production, a work of art, etc., what is not consistent with ideas held on the beautiful or with what is considered to be the truth. (*Qui a pour objet de distinguer dans un ouvrage d'esprit, une production littéraire, une œuvre d'art, etc. ce qui ne répond pas aux idées que l'on se fait du beau, à ce que l'on juge la vérité.*)

This limitation of the term, in such recent times, may be thought surprising. It has at least the great merit of reminding us of a function that seemed likely to be forgotten or relegated to the list of implied meanings in the work of analysis or interpretation: unless the value, importance and significance of a work have already been discerned, it hardly seems worth studying. Knowledge-criticism presupposes a prior verdict of judgement-criticism – if only of a provisional nature and subject to review. The quite considerable development of specialized methodologies does not seem to have made any impact so far on the selective procedures applied to newly issued works or to manuscripts submitted to publishers' reading committees. Criticism leading to acceptance or rejection can still be regarded as spontaneous criticism, as Albert Thibaudet called it in 1930. The new trends in research are all of the kind which this author defined as *professional criticism*: criticism aimed at demonstrating the existence of an intelligible order in the works themselves and also in the succession of works generations. Professional criticism, that is to say, criticism practised by professors. It would be vain to try to deny the sociological links between the new directions followed in critical research and the changing structures of our universities.

Educational problems: the recourse to immanent study (close reading, explanatory comments on texts, analyses of style) is largely due to pedagogical considerations. Problems of selection and advancement of teachers: in most countries academic standing depends on the number, quality and originality of publications. Whence the rapid increase in the number of publications, periodicals, meetings, etc. This increase in the volume of 'professional criticism' does not always correspond to an improvement in its standard. It is however not impossible that emulation may contribute to the encouragement of new ideas and useful or merely ingenious experiments. It is also not impossible that growing attendances at courses or the cultural immaturity of participants in seminars may impel teachers to presume on established scientific knowledge. The impersonal and constraining character of positive methods satisfies both the teacher's desire for authority and the student's desire to acquire rapidly a technical mastery which he can turn to use immediately. The factors which

are mentioned here are probably only external adjuvants, incidental causes: the development of literary methods and knowledge also has a logic of its own and it is not necessary to invoke the vicissitudes of university life to justify the junction effected (or merely attempted) between literary criticism and the various disciplines included in the sphere of the human sciences.

1. TRADITIONS CONTINUED

Nothing could justify the abandonment or neglect of the strict rules governing literary history. The authentification of texts, their dates and authorship, the philological criticism of variant readings, the comparison of the printed text and manuscripts, etc. do indeed remain indispensable. New methods and techniques – team work and the use of machines – which are beginning to be employed accelerate or simplify the work of cataloguing and classifying. Fairly reliable lexicological *concordances* can now be obtained to serve as an objective basis for studies of themes, ideas and style. Statistics on the use of terms or forms provide the interpreter with new material for reflection. Scanning is no longer limited to the work of a single author, but may cover a whole range of contemporary works or a whole series of issues of a periodical.

It soon becomes evident that descriptive procedures are no longer neutral once they are 'exploited' – as in research with a bias which varies according to the investigator's interests or pet theories. We seek to establish only that type of facts to which we attach importance... Behind all positive procedures we must therefore recognize a non-positive choice, a free determination in favour of an objective regarded as important. In fact, in any enumeration a possible interpretation of the facts enumerated is implied. The field and scope of the research will vary according as the investigator intends to give priority to close reading of the text or to biographical and psychological research or, again, to the relationship between the work and its historical and social setting.

2. INDICATIONS AND CAUSALITY

Both psychological study of works and their sociological analysis follow the lines laid down last century. It was inevitable that, in this direction, the initiative should fall to the sociological or psychological disciplines and that literary criticism should become dependent on their evolution: they provide the models, the key terms, the operational concepts. Literary works then become cases for the application of psychological research or for an historical-social survey. The variety of the trends which can then be followed in the work of criticism must be stressed: literary works can be treated as indications, as symptomatic revelations. It will then be possible to go right

back through the author's work to his individual psyche or the conflicts of the society in which he lives. But extrinsic information concerning the author's emotional life or social background will, in its turn, furnish indications throwing light on his work, which will then be seen from the standpoint of what gave rise to it: a causal and genetic vision. Although literary psychology and sociology do not seek to impose their findings as a sufficient explanation of the existence of the work, and although they are modest enough to claim to demonstrate only some of the requisite conditions for it, there is no reason to challenge their suggestions.

It is apparent that the model used in most psychological and sociological explanations is one making the object to be explained the product of a causal system external to it. Indeed no one can claim that a literary work is created *ex nihilo*; it is always *preceded by something;* it is, if not preformed, at least prefigured in the mind of its author and in the historical moment. An 'existential' decision determined the transformation into literature, into a work. For the critic, the whole question is whether he is interested chiefly in what made the work possible, or in the resulting work or, again, in the relationship between the finished work and the conditions of which it is a result. The mistake to be avoided – and it is not always avoided – is to make the work identical, coextensive, homologous with the conditions revealed: it would then be a mere superfluity, a pure reflection, the manifest formulation, with a greater degree of obviousness or symbolization, of an entirely pre-existing reality. Although the work is not born *ex nihilo*, it does however establish its own order *beyond* all that gave it its impulsion: it still bears that impulsion, within itself but in a modified form, exploited to serve an original achievement. The most specific study will be seen to consist not of identifying residues of the antecedent impulsion in the work but of perceiving the original character of the final intention as embodied in the closed form of a text. Critical examination will at least have to make a distinction – it will have to take note of the divergence, the contrast, the distance that may separate the work from its original conditions: it proceeds from them in order to differ from them; it expresses them by being untrue to them. It moves history forward, if only in an infinitesimal way, and can no longer be reduced to the balance of forces of the preceding moment.

3. PROBLEMS OF LITERARY SOCIOLOGY

Literary sociology will have as its particular problem the question of how to pay sufficiently keen attention to the individual aspects of works while giving due consideration to the effects of social conditions. It will be asked whether sociology has the means to go beyond the presentation side by side of statistical averages: the overall structures of society, on the one hand, literary climates and trends, on the other. It is obvious to most research-workers that it is not enough to fix on a causal pattern in which

the work is regarded as a mere product of the environment and of the moment. In a sense, in relation to the work, society is much more all-embracing than might be supposed solely from the single standpoint of causal sequence; society is present not only at the level of the origins of the work, it is present also at the level of those for whom it is intended (readers, publics, audiences) and it may be said without exaggeration to run through the work and to permeate it. But, can its manifestation be characterized more specifically than in a whole series of general features all belonging to the same period style? Otherwise we could do no more than point to some common denominator. If the period seems to be too vast a frame of reference, it can be broken down according to different lines of cleavage or conflict, that of the various social strata in particular. But to carry this pattern over into literary works is a hazardous under-taking: it means extending an interpretation of a society of the past to an interpretation of its literature, its art works and the whole of its culture. This is a very roundabout method, abounding in 'non-falsifiable' assertions which can be neither refuted nor strictly proved. In many respects this method is not unlike the one current at the beginning of the century which sought to establish a special relationship between literary works and the genius of a 'race' (nation or province): very often it means hypostatising a minor or accessory component and raising it to the level of a dominant characteristic. Sociology (Marxist in many instances) is not, of course, concerned solely with assigning to a work a place of origin, an indication of its social background or of the ideology with which it is connected. The aim is to assign a place to the work in relation to the complex interactions which make up the social fabric. Sociology is then faced with the question of the validity of the relationships which it establishes. For some sociologists (in particular, Lucien Goldmann, following Georg Lukács), a work of genius, far from being an exceptional case, has the utmost representative value because it develops to the full the 'potential consciousness' of a social group: although the critic cannot describe the intermediate moments and links, he sees in the homology of literary facts and social facts a process of reciprocal expression taking place. It may nevertheless be thought that the yawning gap between the economic and social plane and the specifically literary plane should be closed and that it is the task of the human sciences, guided by philosophy, to discover means to bridge it. Such is the view taken by Jean-Paul Sartre in the important essay which he devoted to *Questions de Méthode* (1957, 1960, 1967).[1] Thus the essential purpose of micro-sociological studies (dealing with limited groups or small communities) and, in particular, of psycho-analytical studies (with their emphasis on family environment and the fundamental choices made in childhood) is to establish a connexion between a specific and balanced analysis of the works and their historical and social setting, without detracting from their individuality and the unique nature of the freedom which

1. English translation, *Search for a Method* (1968).

stirred them into being. In the view of Sartre, psychology (in the form of existential psycho-analysis) must of necessity enter the picture, both in order to ensure that the social foundation of the work is understood and in order to preserve the irreducible character of the *'choix en situation'* which stamps the work with its individuality. Psychology therefore has a twofold function, since it is necessary, on the one hand, to go back to the universal, to general conditions and, on the other hand, to ensure that *this* poem or *that* book is understood as a free and original act, the outcome of a single will. Psychology thus becomes the discipline which observes the genesis of the individual from collective conditioning. It will therefore have to mark, on a background of a limited determinism, the moments at which the individual creator frees himself from strict dependency and becomes the one who produces his own style.

4. PROBLEMS OF PSYCHOLOGICAL ANALYSIS

In psychological analysis the problems will be centred on the idea of expression. If it is a question of retracing the author's 'psycho-biography', literary texts will assume the status of documents – of material – on the same footing as extra-literary indications (letters, notes, actions, attitudes): they will be interpreted as revealing tendencies, conflicts, complexes, of which they indicate the probable existence. They lend themselves to conjectural induction, which of course, will have to be checked against as many external sources of evidence as possible. In principle, the *person* reconstructed in this way can have but slight credibility. By conferring on each of his acts and each of his writings the status of a piece of expressive evidence, we project his probable motivations on to an imaginary background: we construct a picture of a psychic structure corresponding to the possibility of the life and of the work as we know them.

The critic, having at his disposal the tools of psychology, thus becomes the creator of a figure, as a rule incomplete. Nevertheless he will strive to produce it in an historical pseudo-objectivity. This is certainly legitimate – biography is a branch of study which has its dignity – but it is no longer legitimate when the critic goes back to the work with the intention of explaining it entirely on the basis of the psychic structures thus arrived at inductively without any experimental control: there is an obvious paralogism in trying to find in an uncertain (though apparently global) construction the explanation of a certain (though partial) fact. The text is not a possibility; it is a reality. The act of reading gives it an objective presence the evidence of which is stronger than anything that I can strain my wits to conjecture behind it. While the text *may* be preceded by its conditions, I cannot *actually* point to anything in this connexion which is more than one probable factor among others, mingled with others which can never be accurately identified and analysed. It would be presumptuous to claim to be able to identify an exhaustive unchallengeable causal

system. To postulate that the work should be understood as an expression
of its author is to give it status of a representation, a reflection of em-
pirical subjectivity: but as this empirical person was built up by derivation
and projection – largely from the work itself – the work is thus seen
to issue from its own shadow. The *empirical* ego would seem to be mis-
named here, for if it is assumed to have been the subject of some ex-
perience prior to the work, it is not for us the object of any direct ex-
perience: it is conjectured by mediate means. To consider the work from
the angle of the psychological reality which it expresses is to approach
it in a doubly mediate fashion: it is to make it the emanation of a psychic
universe which the critic has built up from it. In this way a circular
exegesis is developed: after leaving the text, the critic returns to it to make
it depend on a phantom underlying text Ought we to conclude from this
that we can expect nothing from psychological criticism? There remain at
least two ways of escaping the dangers to which we have just alluded. The
first is to abandon the idea of establishing too close a connexion between
the man and the work, to recognize the hypothetical nature of the supposed
mental structures and emotional history, to mention them only as the
probable basis from which the work took shape: the causal relationship
becomes looser; it takes on an optional value; the fact that it is an in-
ference is no longer concealed. The second way – and by far the most
rewarding – which makes it possible to preserve the psychological inter-
pretation, is to base it on the text and palpable facts, that is, to give up
trying to construct an ego distinct from the text. The analysis then no
longer explores a subjectivity that preceded the work, but a subjectivity
immanent in the work; the text, the intentions inherent in it, thus become
the equivalent of a complete psychic universe. In this connexion, let us
recall Charles Mauron's procedure: determined to work along Freudian
lines, he finds himself obliged to seek a substitute source to replace the
material which the therapeutist obtains from the free associations of the
living patient. He will go through all manner of texts by the same author in
order to reveal and trace faithfully any series of images which seem to ob-
sess the writer. This involves both a figurative universe (for it rests solely
on words) and an objective presence which offers itself to the reader for
him to perceive and comprehend. The act of reading thus becomes an
essential stage in the psychological decoding: the meanings revealed by the
text itself will have to be discerned, the manifest organization, latent
conflicts, dominant themes and implications of all sorts will be recognized.
The text, as it allows the reader to dwell on it, induces a demonstration of
desire, a freeing of images, a compulsory effort of the mind and the imag-
ination. In this case, psychological reflection operates not on a hypothetical
author, but on the whole set of phenomena, for which the reader himself
will have become the theatre on receiving the text. It can doubtless never
be known with certainty whether the reception was perfectly sure and
unmixed with elements projected by the subjectivity of the reader himself,
who cannot perceive the values in the text except by giving them all his

attention and his own emotional energies.

Cannot the same be said of a performer of a musical work? Any reading – even 'sight-reading' – may be regarded as an interpretation. Now in music we know of faithful renderings which appear to respect what the composer wrote, and in which the performer's personality does not intrude unduly. It is therefore not chimerical to believe that in the case of literary works, too, there is a reading very close to the ideal of integral conversion to reality such as may serve as a reliable basis for subsequent interpretation. In this way a distinct being comes to life, developed by its own 'relational' substance: it is not a person and still less an impersonal thing. The psychic values manifested in the work must not be regarded as representations; they are detached figures, which have become independent of the author, supported by the system of connotations of the language and capable of arousing in the reader an impression of complexity, depth and truth. The method worked out by Georges Poulet, who goes on from identification to the writer's subjectivity, is based on a study of the work and of nothing else. The mind explored by this critic is not that of the empirical man (prior to the work and caught up in the conflicts of everyday life), but the mind which organizes the time-space categories of the work: for each writer then the critic describes a unique way of existing in space and time. This is doubtless a case of an existential register to which the critic gives his preference for reasons of individual taste and interest. But this attitude cannot be regarded as unwarranted unless there is some alternative approach which can not only be identified as being different but can prove to be better and more soundly based. This can be said of all thematic studies (whether or not they have a psychological aim); by choosing a motive or a theme the critic imposes limits on himself. These limits will not necessarily be narrow: they may cover a whole tradition, a whole period, and so draw on the resources of *comparative literature*. In this connexion it should be observed that concern with a theme does not preclude more extensive exploration: on the contrary, it may happen that a well selected theme will make it possible to situate all the other elements in a work in relation to it. It provides a frame of reference for the appreciation of many associated variables.

In more than one case, a reading of a mythical or symbolic nature seems imperative inasmuch as the story, the characters and the images take on an aspect of universality under our eyes, developing a resemblance with older legendary themes of which they appear to be presenting a new incarnation. A field of application might be sought here by Jung's school of psychoanalysis (with its notion of collective unconscious and archetypes). Northrop Frye,[2] using a most original method, does not hesitate to treat the universals of the imagination as objects, to classify them, group them,

2. It should be mentioned that Northrop Frye, although he uses the 'archetype' idea, gives it the meaning of a *literary* scheme or model. In this notion there is no reference to a 'collective unconscious'. One must therefore be careful not to talk about Jung's influence in regard to this critic. Cf. *The Anatomy of Criticism* (1957).

etc., so that the whole of literature, like a second nature, is arranged as a vast order of speech, governed by its own laws and divided into separate rules. At this stage the psychic elements, freed from all connexion with the empirical person of the author, appear as entities *sui generis*. They are no longer subjective properly speaking (except by reason of their anonymous aptitude to show themselves as stable elements of a universal timeless language which is spoken in the human mind). Rising from the inmost recesses, they surface as entities and their relationships, with their complex interplay become manifest as a spectacle that is fully evident and visible in the light of day.

Here the reader may hesitate somewhat between an allegorical interpretation and the decisiveness of a strictly literal reading. At least we see any reference to what is presumed to be the author's intention becoming indistinct. The act of criticism will not seek to capture in the work or behind the work an initial desire or purpose, of which the values inherent in the work will be a sign and a realization: the criticism will not be directed towards discovering the author's exact aims in the text analysed. The reconstitution of intentions is a delusion (intentional fallacy) according to a considerable current of American criticism, not only because it is not possible to arrive at them, but rather because there is probably no work which adheres entirely to the project which gave birth to it. It thus seems justifiable to treat the text as a verbal figure (*verbal icon*),[3] of which the form has to be analysed as carefully as possible if the text is to be understood.

5. STUDY OF FORM

This section will cover most of the studies of form, style and composition and the trend usually known in France by the name of structuralism. Style has, of course, been frequently studied with psychological objectives: to get to the heart of an author, a period, a nation, etc. In Auerbach it is also connected with sociological research. Long dominated by a certain conception of expression (in which Croce, Vossler, and Spitzer in his early studies, sought to grasp the poet's lyrical intuition), stylistics is more and more claiming its place as an independent discipline with the aim of covering in its descriptions every aspect of the texts studied. The great variety of methods employed demonstrates that, despite the frequently expressed desire to raise the subject to the level of scientific precision, a consensus of opinion is far from having been reached as yet. Descriptive stylistics tends to borrow its language and tools from linguistics, but the latter, despite considerable advances, is still, on essential points, open to conflicts between rival doctrines. For instance, the codes of the descriptive language (or meta-language) vary from one school to another – while

3. *The Verbal Icon* is the title of a work by W. K. WIMSATT Jr., published in 1954.

each claims to have the same 'scientificity'.

In their applications to literary criticism, poetics and the analysis of narrative, current trends in structuralism derive not only from Saussure's linguistics but also from the joint contribution of gestaltism, phenomenology, logical positivism and information theory. Inspiration is drawn also from the methodology applied in ethnography and cultural anthropology. As may be expected, all this inevitably results in confusion and misunderstandings.

A functional whole is not merely the passive sum of its parts; its meaning is immanent in each of its components – such is the basic assumption of structuralism. 'It is from the interdependent whole that a start must be made if one wants to discover by analysis the elements of which it is made up.' (Ferdinand de Saussure). The object of the structural method is to reach an adequate understanding of complex organisms without dismantling them and in terms of the internal relations (mainly relations of contrast and opposition) which govern their interdependence. As the term 'organism' is considered too suggestive of living things, it is more often than not replaced by the more neutral term 'system'; mechanical or mathematical models tend to prevail, even when it is a matter of analysing the meaning of the message communicated (semiology, semantics).

But structuralism is not, like Marxism, 'a way of looking at the world' or, like psychoanalysis, a technique of interpretation based on an almost unvarying representation of the affective processes. Generally speaking, structuralism is just a tendency towards formalization, with due regard for the complex interplay of the component parts within a whole. This explains its universal validity, making it applicable to very different disciplines, and also the need to specify the procedure adopted in structural analysis by defining for each domain – perhaps for each case – a specific descriptive vocabulary, a relevant transcription code, of which the results may subsequently lend themselves to interpretation with good effect.

Furthermore, the structures to be decoded must not be regarded as inert things, stable objects – contrary to the affirmations of those who would like to confer an entirely material objectivity on literary works. They arise from a relationship established between the observer and the object; they take shape in response to a preliminary question; and it is only in terms of that question that the order of priority of the decoded elements of the work will be established. It is only on investigation that the structures appear, become active and tangible, in a text which has long been fixed on the page of the book. In the various types of reading, the structures which are preferred are selected and seized upon. Much as we may wish to confine ourselves to the verbal characteristics of the text, we cannot avoid the interminable (and truly senseless) task of making a complete inventory except by giving our question a particular 'slant', directing it in a particular sense, whether it is a matter of aesthetic effect, of social and historical significance, or of emotional relationships, etc., which are all embodied in the text. Each of these approaches implies a certain standpoint;

it will have the effect of changing our general view of the whole, calling for a new context, marking out new frontiers within which will reign a different law of coherence. It is very soon realized that, according to the question asked, the same text will reveal several structures which are equally acceptable or again that the work may be seen as forming part of broader systems which go beyond it and encompass it. Here it is not the structural thought that has the means to decide; on the contrary, structural analysis can only follow a prior decision fixing the scope and the purpose of the research. A desire for comprehensive knowledge would doubtless prompt us to co-ordinate the findings of these various readings, to treat them as component parts of a large structure, which would be the total significance, the exhaustive meaning. There is every reason to believe that this large structure is the end-result, which is only visible in an asymptotic way – unless a premature synthesis is forcibly introduced.

The network of structural correlations is deployed simultaneously. Everything is contemporaneous, synchronous, in a constituted structure. I would not conclude that structuralism ignores the historical aspect and is reduced to interpreting the past as a sequence of stable states separated by inexplicable breaks. How could the critic hazard conferring a false timelessness on structures which he knows very well he picked out in the course of a story, at a pinpoint of time x in a diachronic evolution? In my view, the danger of taking refuge in *ahistorical* formalism is averted once the objective structures (the text in its formal complexity) are examined as the product of a structuring mind. Here it is necessary to return to the idea of *intention*, with the reservation that it can be only an intention immanent in the unfolding of the language and the pages of text and not a prior intention. The critic's memories of 'uncritical' reading may remind him that texts were not written to become, in their turn, the subject of a description. They convey emotions, striking experiences, tangible signs, in short, *meaning*. At this stage it may properly be asked: Who is speaking? Who is being spoken to? To what end? By what means? These questions, which were not unknown in classical rhetoric, situate the work in the field of actual experience and that experience itself in the field of history. The objective structure of the work fixes the final form of the story. However, the tension which maintains this form in place, which unfolds it in the time allotted to it, is an historical vector whose presence the critic ought never to ignore. It has therefore been said that all true criticism is circular – starting from a primary meaning and finding it again better understood when the interpretation has reached a later phase.

The following are two domains in which structuralism may with advantage be applied:

Story analysis

Story analysis is the counterpart in literature of structural analysis of myths in ethnology. The method was applied successfully by Vladimir J. Propp

as long ago as in 1928 in the study of popular tales. It is indeed possible to list and classify the typical functions of the characters, to describe events schematically and also their sequence and the various endings, reducing them to a relatively small number of constant models. This brings out the contribution of narrative codes, of which the constraints and degrees of freedom can be measured with some accuracy. The method will be applicable to literature whenever literature is subordinated to the requirements of pre-established *genres*. It will not be so easy to proceed in this way with modern literary works (at all events in the West and from the eighteenth century onwards), each of them appearing to be a 'special case': earlier models no longer call for conformity but stimulate authors to go further and to innovate. There are thus no longer any genesis rules, but there is a common tendency to alter – unexpectedly if possible – the picture of the characters, their mutual relationships, the rôle of events, setting, dialogue, etc. In short, whereas the analysis of popular tales may be based on a single definition of the narrative style, regarded as invariable, the structural study of a modern story is primarily concerned with the changes affecting the way of telling it. As a result, contemporary research, frequently influenced by the linguistic approach, is directed towards describing *the point of view* (sometimes single, sometimes varying or multiple) from which each story is told. Is this point of view limited, restricted, biased? Or, on the contrary, are we dealing with an omniscient narrator? This amounts to inquiring into the nature of the sender of the narrative message and, as a corollary, of its receptor. The complexity of the question is soon realized: the story may be told by the 'author' himself, sometimes by a fictional character, acting as a substitute for the author who is supposed to have witnessed the action, or again by one of the characters involved in the action, the writer then taking on the rôle of a receptor, etc. Such research may lead to a general theory of the story. It may also be restricted to the investigation of a relatively small number of works or groups of works. Classical and mediaeval literature, traditionally studied exclusively from the historical and philological standpoints, will gain by being examined as a whole by the method applied to tales and myths and the method which we are obliged to apply in our consideration of modern works. A start has been made in this direction.

Poetics

The poetic use of the resources of language calls for specific study, with due regard to all the factors involved: selection of vocables, images, conformity or non-conformity in regard to syntax, concordances and contrasts in sound, rhyme play, stress, pauses and rhythms, metrical requirements. Roman Jakobson, as early as in the 'Travaux du Cercle linguistique de Prague' (1929), discussed the difference between the 'poetic function' of language and its emotive, referential and conative functions. He con-

cluded that in poetry 'The set (*Einstellung*) toward the MESSAGE as such, focus on the message for its own sake, is the POETIC function of language'.[4] Having distinguished in all statements the choice of paradigms (principle of selection) and the syntagmatic arrangement (principle of combination), Jakobson advances the view that 'The poetic function projects the principle of equivalence from the axis of selection into the axis of combination'.[5] Starting from this idea, it has been possible to take up again the study of various systems of homology, contrast, repetition, thwarted anticipation, which contribute to the making of a poetic text. In this way a detailed analysis of the 'functioning' of the various texts studied can be made and certain generalizations from repeated observation are possible in each branch of linguistics. It might be added that structural analysis of poems, far from precluding an historical reading or a philosophical interpretation, can provide a firm basis for them.

It should also be borne in mind that timbre, pitch, stress, rhythm, etc. can be the subject of recordings and graphic transcriptions which will give a quantified image of the physical phenomena of reading aloud. The laboratory techniques used in experimental phonetics, when applied in this way, make it possible to compare the text of a poem with the material record of its reading.

At the beginning of this essay we saw that any exercise of criticism must be based on a prior judgement – usually implicit – which brings to our attention a work, a problem, a theme. It is understood, or it should be understood, that we study only what interests us, what has meaning and value, of which we are made aware by the arousing of our interested attention. Explanatory techniques to which we have just referred vary considerably. All in all, they complement rather than contradict one another: situating, describing, analysing, interpreting, are activities which ought mutually to reinforce one another. Such convergence and co-operation of different methods is possible only if, without in the slightest degree lessening strictness, each of these activities refrains priding itself on its own functional perfection and is prepared to be regarded as merely a step towards the ultimate comprehensive judgement – a judgement which will not necessarily bring us full confirmation of the initial judgement from which the critical undertaking drew its initial brief.

The characteristic features of contemporary criticism would still be ill described if no reference were made to all the marginal reflection and discussion, which cannot be reduced to methodological description. Many

4. JAKOBSON, 'Lingustics and poetics', p. 256, in SEBEOK (ed.), *Style in Language* (1960). The question which might be asked is whether the 'set toward the message as such' is not secured by adding together the referential, emotive and conative functions.

5. JAKOBSON, *op. cit.*, p. 358. See also, in the preceding chapter of the present work, Louis Marin's contribution, 'The semiotic approach'.

philosophers, writers and essayists ask themselves: Why literature? What can literature do? What contribution is made by commentary? It is no doubt necessary that these questions should be asked – sometimes in a truculent manner – so that critics shall not shut themselves up in the hall of mirrors of pure methodology. For criticism offers us the case, assuredly a singular one, of reflection which, while calling for support from auxiliary techniques can take place only in a sphere external to all technicity.[6]

6. Fuller information on the various trends in the study of literature may be gained from the following works, which for greater clarity we have arranged in broad categories.

1. *Theory of the creation of literary works. History of literary criticism. Discussions and comparisons:*
'Littérature et stylistique' and 'Les visages de la critique depuis 1920' (1964); 'Quatre conférences sur la nouvelle critique' (1968); BARTHES, *Critique et vérité* (1966); BECKSON (ed.), *Great Theories in Literary Criticism* (1963); BINNI, *Poetica, critica e storia letteraria* (1963); BLANCHOT, *L'espace littéraire* (1955) and *Le livre à venir* (1959); BLIN, *La cribleuse de blé* (1968); BROWER & POIRIER (eds.), *In Defense of Reading. A Reader's Approach to Literary Criticism* (1963); CASEY, *The Language of Criticism* (1966); COOMBES, *Literature and Criticism* (1963); CORTI & SEGRE (eds.), *I metodi attuali della critica in Italia* (1970); DAICHES, *Critical Approaches to Literature* (1963); DE MAN, '*New Criticism* et nouvelle critique' (1966); DOUBROVSKY, *Pourquoi la nouvelle critique?* (1966); DUFRENNE, *Phénoménologie de l'expérience esthétique* (1953, 1967) and *Le poétique* (1963); FAYOLLE, *La critique littéraire* (1964); FRYE, *The Well-Tempered Critic* (1963); GADAMER, *Wahrheit und Methode* (1960); GARDNER, *The Business of Criticism* (1963); GARELLI, *La gravitation poétique* (1966); GETTO, *Letteratura e critica nel tempo* (1968) and *Storia delle storie letterarie* (1969); HARDISON, *Modern Continental Literary Criticism* (1962/64); HYMAN, *The Armed Vision. A Study in the Methods of Modern Literary Criticism* (1955); INGARDEN, *Das literarische Kunstwerk* (1931); INGLIS, *An Essential Discipline. An Introduction to Literary Criticism* (1968); JAUSS, *Literaturgeschichte als Provokation* (1970); KIBÉDI VARGA, *Les constantes du poème* (1963); LAWALL, *Critics of Consciousness* (1968); LEVIN, *Contexts of Criticism* (1963) and *Why Literary Criticism Is Not an Exact Science* (1967); MARINO, *Introducere in critica literara* (1968); PAREYSON, *Estetica. Teoria della formatività* (2nd edn., 1960); PICARD, *Nouvelle critique ou nouvelle imposture?* (1965); POULET, *Etudes sur le temps humain* (1951-68); POULET et al., *Les chemins actuels de la critique* (1967); RAIMONDI, *Techniche della critica letteraria* (1967); RAYMOND, *Etre et dire* (1970); RICHARD, *L'univers imaginaire de Mallarmé* (1962); RIGHTER, *Logic and Criticism* (1963); SCOTT-JAMES, *The Making of Literature. Some Principles of Criticism Examined in the Light of Ancient and Modern Theory* (1963); SHUMAKER, *Elements of Critical Theory* (1952-64); SPINGARN, *Creative Criticism and Other Essays* (1964); STAROBINSKI, *La relation critique* (1970); SUTTON, *Modern American Criticism* (1963); SUTTON & FOSTER (eds.), *Modern Criticism. Theory and Practice* (1963); SZONDI, *Theorie des modernen Dramas* (1959); THIBAUDET, *Physiologie de la critique* (1930); TRILLING, *The Liberal Imagination* (1951, 1964); WATSON, *The Literary Critics. A Study of English Descriptive Criticism* (1964); WELLEK, R., *The Rise of English Literary History* (1941), *A History of Modern Criticism* (1955-) *Concepts of Criticism* (1963) and *Discriminations* (1970); WELLEK, R. & WARREN, *Theory of Literature* (1949); WILSON, E., *The Intent of the Critic* (1963); WIMSATT & BROOKS, *Literary Criticism. A Short History* (1957).

2. *Aspects and problems of comparative literature:*
BRANDT CORSTIUS, *Introduction to the Comparative Study of Literature* (1968);
ETIEMBLE, *Comparaison n'est pas raison* (1963); LEVIN, H., *Refractions* (1966);
PICHOIS & ROUSSEAU, *La littérature comparée* (1967); WEISSTEIN, *Einführung in die vergleichende Literaturwissenschaft* (1968) (English translation, *Comparative Literature and Literary Theory*, 1974).

3. *Criticism with a sociological bias:*
ADORNO, *Prismen. Kulturkritik und Gesellschaft* (1963) (English translation, *Prisms*, 1967) and *Noten zur Literatur* (1958-65); BENJAMIN, *Illuminationen* (posth. publ., 1961) (English translation, *Illuminations*, 1968); DUNCAN, *Language and Literature in Society* (1953); ESCARPIT, *Sociologie de la littérature* (1968); GOLDMANN, *Le dieu caché* (1956) and *Pour une sociologie du roman* (1964); HAUSER, *Sozialgeschichte der Kunst und Literatur* (1953) (English translation, *The Social History of Art*) and *Philosophie der Kunstgeschichte* (1958) (English translation, *The Philosophy of Art History*, 1959); LEENHARDT, J., 'La sociologie de la littérature: quelques étapes de son histoire' (1967) (parallel English version, 'The sociology of literature: some stages in its history'); LÖWENTHAL, *Literature and the Image of Man. Sociological Studies of the European Drama and Novel, 1600-1900* (1957) and *Literatur und Gesellschaft* (1964); LUKÁCS, *Die Theorie des Romans* (1920) (French translation, *La théorie du roman*, 1963) and *Die Gegenwartsbedeutung des kritischen Realismus/Wider den missverstandenen Realismus* (1958) (French translation *La signification présente du réalisme critique*, 1960); MACHEREY, *Pour une théorie de la production littéraire* (1966); MINDER, *Dichter in der Gesellschaft* (1966); SARTRE, *Questions de méthode* (1957, 1960, 1967) (English translation, *Search for a method*, 1968).

4. *Criticism inspired by psychology:*
 (a) Bibliographies: HOLLAND, *Psychoanalysis and Shakespeare* (1966); KIELL, *Psychoanalysis, Psychology and Literature* (1965); MORRISON, *Freud and the Critic. The Early Use of Depth Psychology in Literary Criticism* (1968).
 (b) Exposés, discussions: BACHELARD, *La poétique de l'espace* (1958) and *La poétique de la rêverie* (1960) (English translation, *Poetics of Space*, 1964, and *Poetics of Reverie*, 1967); DAVID, *La psicoanalisti nella cultura italiana* (1966) and *Letteratura e psicoanalisi* (1967); DURAND, *Les structures anthropologiques de l'imaginaire* (1960); GREEN, *Un œil en trop. Le complexe d'Œdipe dans la tragédie* (1969); HOFFMAN, *Freudianism and the Literary Mind* (1959); JONES, *Hamlet and Oedipus* (1949); KRIS, *Psychoanalytic Explorations in Art* (1952); LACAN, *Ecrits* (1966); MAURON, *Des métaphores obsédantes au mythe personnel. Introduction à la psychocritique* (1963); MEHLMANN, 'Entre psychanalyse et psychocritique' (1970); PONTALIS, *Après Freud* (1965, 1968); RICOEUR, *De l'interprétation. Essai sur Freud* (1965) (English translation, *Freud and Philosophy. An Essay on Interpretation*, 1969) and *Le conflit des interprétations* (1969); ROBERT, *L'ancien et le nouveau* (1963) and *Roman des origines et origines du roman* (1972); SCHNEIDER, *The Psychoanalyst and the Artist* (2nd edn., 1954).

5. *Analysis of form and style. Structural criticism:*
 (a) Bibliographies: HATZFELD, *A Critical Bibliography of the New Stylistics Applied to Romance Literatures, 1900–1952* (1953, 1971) and *Id., 1953-1965* (1966); MILIC, *Style and Stylistics. An Analytic Bibliography* (1967).
 (b) Periodicals (special issues) and symposia: *Recherches sémiologiques* (1964); *Recherches sémiologiques: l'analyse structurale du récit* (1966); *La notion de structure* (1965); *Théorie d'ensemble* (1968); *Structuralism* (1966, 1970) (includes bibliography; mentions the work of Soviet research workers); *Linguistique et littérature* (1968); BASTIDE (ed.), *Sens et usages du mot 'structure'* (1962); MACKSEY & DONATO (eds.), *The Languages of Criticism and the Sciences of Man* (1970).

c) Theoretical exposés and outstanding research: AUERBACH, *Mimesis* (1946) (English translation, *Mimesis*, 1953); BAHTIN, *Problemy poetiki Dostoevskogo* (1963) (English translation, BAKHTIN, *Problems of Dostoevsky's Poetics*, 1973) and *Tvorčestvo Fransua Rable i narodnaja kul'tura Srednevekov'ja i Renessansa* (1965) (English translation, BAKHTIN, *Rabelais and His World*, 1968); BARTHES, *Essais critiques* (1964) (English translation, *Critical Essays*, 1972) and *Critique et vérité* (1966); BURKE, *The Philosophy of Literary Form* (1941); CORTI, *Metodi e fantasmi* (1969); CROLL, *Style, Rhetoric and Rhythm* (1966); D'ARCO, *L'analisi letteraria in Italia. Formalismo – Strutturalismo – Semiologia* (1970); DEVOTO, *Nuovi studi di stilistica* (1962); DUBOIS *et al.*, *Rhétorique générale* (1970); ECO, *Opera aperta. Forma e indeterminazione nelle poetiche contemporanee* (1962) (French translation, *L'œuvre ouverte*, 1965), *La struttura assente* (1968) (French translation, augm., *La structure absente*, 1972) and *Le forme del contenuto* (1971); ERLICH, *Russian Formalism. History. Doctrine* (1955); GARVIN (ed.), *A Prague School Reader on Aesthetics, Literary Structure and Style* (1964); GENETTE, *Figures I, II and III* (1966-69-72); GREIMAS, *Sémantique structurale* (1966) and *Du sens* (1970); GREIMAS *et al.*, *Essais de sémiotique poétique* (1972); JAKOBSON & LÉVI-STRAUSS, '"Les Chats" de Charles Baudelaire' (1962); KRISTEVA, *Σημειωτική – Recherches pour une sémanalyse* (1969); LEVIN, S. R., *Linguistic Structures in Poetry* (1962); LOTMAN, *Lekcii po struktural'noj poetike* (1964); MOLES, *Théorie de l'information et perception esthétique* (1958) (English translation, *Information Theory and Esthetic Perception*, 1966); PROPP, *Morfologija skazki* (1928, rev. 1969) (English translation, *Morphology of the Folktale* (1958, 1968) from the 1st edn.; French translation, *Morphologie du conte* (1970) from the 2nd edn.); RIFFATERRE, *Essais de stylistique structurale* (a selection of essays in French version, 1970); ROUSSET, *Forme et signification* (1962); SAPORTA & DE CHASCA, *Stylistics, Linguistics and Literary Criticism* (1961); SAYCE, *Style in French Prose* (1953); SEBAG, *Marxisme et structuralisme* (1964); SEBEOK (ed.), *Style in Language* (symposium, 1958; publ. 1960); SEGRE, *I segni e la critica* (1969); SOLLERS, *Logiques* (1968); SPITZER, *Linguistics and Literary History* (1948), 'Les études de style et les différents pays (1961) and *Etudes de style* (a selection of essays in French translation, 1970); TERRACINI, *Analisi e stilistica* (1966); TODOROV, *Introduction à la littérature fantastique* (1970) and *Poétique de la prose* (1971); TODOROV (ed.), *Théorie de la littérature. Textes des formalistes russes* (1965); UITTI, *Linguistics and Literary Theory* (1969); ULLMANN, *Semantics* (1962); WEINRICH, *Tempus. Besprochene und erzählte Welt* (1964); ZUMTHOR, *Essai de poétique médiévale* (1972).

See also the works pertaining to the study of literature which are mentioned in the preceding chapter, in various essays in Section III, *The Scientific Approaches* and in this chapter, in Section I, *The Study of General Problems*.

III. MUSIC, *by Claude V. Palisca**

The study of music, of all the arts, is the most difficult to circumscribe as a discipline. As soon as scholars probe its problems with any depth, it spills into neighboring fields – social and physical sciences, philosophy, literature, and history. It is easier to identify musicologists than to define musicology.

* Department of Music, Yale University, U.S.A.

The founders of musicology saw it as a universal science, and called it *Musikwissenschaft*. Karl Friedrich Chrysander (1826-1901) wished to see it modeled on the exact sciences. Reflecting this ideal, Hugo Riemann (1849-1919), a professor at Leipzig, conceived the field as containing five divisions[1]: (1) acoustics, (2) tone-physiology and -psychology, (3) musical aesthetics, including speculative music theory, (4) theory of composition or performance, and (5) music history.

In a number of German universities today, for example in Hamburg, Cologne and at Humboldt-University in Berlin, all of these branches of musical study are still included in institutes of musicology. A number of such institutes exist also elsewhere, for example in Warsaw, Ljubljana, Moscow, and Tokyo. In England, France, and Italy, which, with the United States and Germany, are the leading countries in musical scholarship, university musical studies consist chiefly of theory, criticism, and the history of Western music.

From the standpoint of what musicologists actually do, then, the field appears more restrictive than traditional theoretical definitions. Such a restrictive view is particularly strong in the United States, where musical competence is in greater demand than universal culture for university teaching positions, whose incumbents must spend much of their time teaching laymen, musicians, and teachers. A survey of musical scholarship in the United States up to 1961 showed a decided preference for problems that were amenable to humanistic methods as against those subject to scientific examination. In this context the following was found a workable definition: 'The musicologist is concerned with music that exists, whether as an oral or a written tradition, and with everything that can shed light on its human context.'[2] This places the art of music, the works created, performed, and contemplated by men in the center. The musical work is the principal datum, on which structural analysis, historical explanation, and critical evaluation converge.

A number of European scholars have voiced dissatisfaction with this parochialism. Jacques Handschin has urged that musicology should focus its concern not so much on music as on musical man:

What, then, is the true object of musicology? It is nothing but man, who, standing in a certain location in space and time, impresses his artistic striving in an appropriate music; thus man in his musical activity, man artistically forming something that he leaves behind to posterity.[3]

François Lesure, taking up this line of thought, would have musicology ally

1. RIEMANN, *Grundriss der Musikwissenschaft* (1908).
2. PALISCA, 'American scholarship in Western music', p. 116 in HARRISON *et al., Musicology* (1963).
3. 'Was ist dann aber das wirkliche Objekt der Musikwissenschaft? Es is nichts anderes als der Mensch, der, an einer bestimmten Stelle des Raumes und der Zeit stehend, sein künstlerisches Streben in einer ihm gemässen Musik ausprägt, also der Mensch in seiner musikalischen Betätigung, der künstlerisch gestaltende Mensch, der der Nachwelt die Erzeugnisse seiner Gestaltung hinterlässt.' – HANDSCHIN, 'Der Arbeitsbereich der Musikwissenschaft', p. 24 in *Gedenkschrift J. Handschin* (1957).

itself more with the 'human sciences,' which in their methodological inno-
vations have left it far behind. He warns us to beware of isolating works
of art from their context and the conditions which brought them into being,
and particularly from the social, political, and economic functions in
which musical life is embedded.[4]

The opinions just cited are those of historical musicologists who specialize
in western music. A similar cleavage between those who would place the
emphasis on music and those who would center studies in man and society
has developed among those musicologists who specialize in non-western
art music and the folk and popular musics of the world.[5] Mieczyslaw
Kolinsky[6] has suggested that ethnomusicology contains two distinct types
of investigation: comparative musicology and musical anthropology. Here
the German musicological tradition clashes with the American anthropolo-
gical orientation. Kolinsky, who specializes in structural, melodic, rhythmic
and scale analysis, is a product of the school of the psychologist Eric M.
von Hornbostel in Berlin, which relied greatly on laboratory analysis of
music recorded by others in the field. American ethnomusicologists have
been typically field workers trained by anthropologists to study music
within the context of a whole culture. But even within the company of
field workers there is a significant divergence of approach.[7] Some, like
Alan P. Merriam, a specialist in African music, study music and behaviour
in relation to music as detached observers, whereas others, like Mantle
Hood, a specialist in Indonesian music, or William P. Malm, in Japanese
music, have undergone rigorous apprenticeships as performers with native
master musicians and study the music from within the musical culture.
Although all of these men profess an interest in both music and behaviour
as organically wedded, the anthropologist-musicologist tends to concen-
trate on the behaviour of musicians and the function of their music, whereas
the musician-ethnologist tends to study the character of musical art as a
living component of a culture, developing a sensitivity to its values by
immersing himself in its musical idiom.

There is no sign that these streams are merging into a common metho-
dology. Rather the eclecticism and diversity of ethnomusicological method
today is one of the surest signs of the vitality of the field.

If the division of musicology into western historical musicology on the

4. LESURE, article 'Musicologie' in MICHEL (ed.), *Encyclopédie de la Musique*
(1961), Vol. III, and 'The employment of sociological methods in musical history
(Pour une sociologie historique des faits musicaux)' (1961).

5. The 'special contribution' by TRÂN VAN KHÊ, 'Les tendances actuelles de
l'ethnomusicologie', provided both general enlightenment and particular facts for my
survey. No summary could do justice to the richness of thought and information in this
paper, so I have not attempted one. It is good that it can be read in its integral form (in
French) in the *Journal of World History* (1970).

6. KOLINSKY, 'Recent trends in ethnomusicology' (1967).

7. For the point of view of anthropologists, see sub-section 7, 'Music', in Section C
('The Main Fields of Study') of *Social and Cultural Anthropology* by Maurice
Freedman, pp. 59–62.

one hand and ethnic, non-western, and folk music study on the other must be acknowledged a *fait accompli*, theorists of both disciplines have insistently expressed dissatisfaction with this condition. Historical musicologists have been particularly reproached for failing to take advantage of ethnomusicological methods and insights. Handschin complained that it is 'strange that after the appearance of musical psychology and ethnology the historical branch of musicology has continued on its merry way as if nothing had happened'.[8]

Charles Seeger has been the most eloquent pleader for a unified musicology and for the application of systematic methods developed in the study of non-western music to contemporary music of the West, not only art music but the total musical scene in all levels of the culture. 'The sooner Western music-historians take off their blindness of Europophilism – as practically all other Western historians have done – and go to work upon the history of non-western musics (and their own popular and folk musics, which are now ethnomusicological data) and ethnomusicologists (hopefully, anthropological as well as musicological, and some of them non-Westerners) summon the courage to go to work upon the ethnomusicology of the music of the West, dealing with it as a whole – its professional as well as its popular and folk idioms – the better it will be for all concerned.'[9]

The shrinking interest among today's ethnomusicologists in 'universals' about music, such as were sought earlier by comparative musicologists, is paralleled by a decline in generalization among historical musicologists. Werner Korte[10] has attributed this to the disillusionment with the products of the generation of musical *Geisteswissenschaftler* who tried to carry out Willibald Gurlitt's aim of a synthetic *Stilgeschichtsschreibung*. As expounded in 1918, this synthesis united two directions: 1) *Ausdrucksgeschichte*, the intellectual history behind music, the interpretation of its content, and the clarification of cultural concepts; and 2) *Problemgeschichte*, the study of formal, artistic and stylistic concepts. It led not to the synthesis Gurlitt envisioned but to unrestrained subjective reactions, the construction of broad artistic style-types like *Gesamtgotik*, a *Formenlehre* of stereotyped categories, and a general dilution of methodological rigor. Korte believes that this method reached a crisis in the 1930-1950 period, and the reaction to it produced a resurgence of the fact-oriented research that Gurlitt tried to replace. There resulted the present trend towards formal technical analysis on the one hand and philological, document-oriented research on the other. Friedrich Blume[11] has called the movement towards documentary and ar-

8. '. . . curieux que, après l'avènement de la psychologie et de l'ethnologie musicales, la branche historique de la musicologie ait d'abord continué sa marche, comme si rien ne s'était passé – HANDSCHIN, 'Musicologie et musique', p. 14 in *Kongress Bericht, Internationale Gesellschaft für Musikwissenschaft, Basel, 1949* (1949).

9. SEEGER, Foreword, p. xii in PRUETT (ed.), *Studies in Musicology* (1969).

10. KORTE, 'Struktur und Modell als Information in der Musikwissenschaft' (1964).

11. BLUME, 'Historische Musikforschung in der Gegenwart' (1968).

chival study Neo-positivism and has blamed it for the present isolation of scholars by specialization and location, the decline of international cooperation, and the alienation of lay music-lovers and general historians.

The way out of this impasse is seen by many today in a return to the individual work of art as the starting point of research and explanation. 'The beginning and end of musicological studies lie in sympathetic and critical examination and evaluation of the individual work of art,' Lowinsky has said.[12]

What the nature of explanation should be has been the subject of some discussion recently. Joseph Kerman has suggested that the ultimate function of musicology is criticism. He sees criticism as the top rung of a ladder to which the component disciplines of musicology lead. 'Each of the things we [musicologists] do – paleography, transcription, repertory studies, archival work, biography, bibliography, sociology, *Aufführungspraxis*, schools and influences, theory, style analysis, individual analysis – each of these things, which some scholar treats as an end in itself, is treated as a step on a ladder.' [13] A work is not understood in isolation but in context. Lowinsky has challenged Kerman's hierarchical view as debasing certain legitimate musicological tasks, such as archival studies or transcription, which may, for some scholar, be ends in themselves. While concurring with Kerman that scholars should be critics, he would not have criticism ever part ways from style analysis. 'For if stylistic analysis is understood as the attempt to define a composition by describing the modes of behavior of its musical components, if criticism is understood to be the discernment and evaluation of the distinctive, individual traits of that composition, then the more the two are separated, the worse it will be for either.'[14]

Along with the tendencies deplored by Blume and Korte must be counted the blind pursuit of the banner of style criticism. Manfred Bukofzer had said: 'Style criticism must be recognized as the core of modern musicology.... The description of the origin and development of styles, their interrelation, their transfer from one medium to another, is the central task of musicology.'[15] Whereas Bukofzer conceived of style contextually as related to the world of ideas and he subordinated description to understanding, those who followed the slogan of style criticism sacrificed both context and ideas for descriptive, often statistical statements of what occurs in the music of certain composers, genres or periods. Excessive application of statistical analysis has been criticized as misplaced scientism by Paul Henry Lang: 'To impose abstraction upon experience is to fail as a creative scholar while doing bad-

12. LOWINSKY, *Tonality and Atonality in Sixteenth-Century Music* (1961), p. 72.

13. KERMAN, 'A profile for American musicology', pp. 62-63 in *Journal of the American Musicological Society*, XVIII, 1965.

14. LOWINSKY, 'Character and purposes of American musicology. A reply to Joseph Kerman', p. 224 in *Journal of the American Musicological Society*, XVIII, 1965.

15. BUKOFZER, *The Place of Musicology in American Institutions of Higher Learning* (1957), pp. 21 and 31.

294 *Mikel Dufrenne et al.*

ly the work of science'[16]

Objective description has often been strangely mated with subjective interpretation. Historians who would disclaim allegiance to evolutionary theories of musical development allow evolutionary habits of thought to invade their writing, as Leo Treitler has shown. He finds the growth image constantly evoked by such phrases as 'points to the future,' 'he was a pioneer with respect to. . .', 'shows greater mastery of'; or styles are described as 'nascent' and 'ripe' or 'a mixture that rarely resulted in a satisfying synthesis'.[17] Musicologists, Treitler observes, treat works as examples of 'a collective, impersonal enterprise. . . as manifestations of an Idea, like the shadows in Plato's cave, whose value is measured by the closeness with which they approximate their models, and whose necessities are imposed from without'.[18]

An effective palliative to the tendency to create universals and evolutionary schemes is a concentration upon the individual work. Multidimensional examination of individual artworks could lead not only to better understanding of them but also to more solid grounds for generalization. Treitler [19] has called for 'musical analysis in historical context'. He views the process as containing a number of overlapping approaches: 1) a search for the significant form of a work, 2) a search for values and schemata that condition apprehension of the work, 3) explanation, particularly causal, of the work in terms of past and contemporary practices and events outside the work, 4) investigation of the music's functions and environmental relations.

The insistence upon historical context in analysis reflects a split that has developed between historians and theorists. Music theory and analysis are taught in conservatories throughout the world mainly by composers. In some countries, particularly England and the United States, this near monopoly extends to universities. Germany, however, is rather exceptional in confiding theory teaching in the universities mainly to musicologists. Nevertheless it is safe to say that the major contributions to music theory in the twentieth century have been made by persons not trained as musicologists and who did or do not consider themselves such. Among these are Heinrich Schenker, Georg Capellen, Bernhard Ziehn, Arnold Schönberg, Paul Hindemith, Milton Babbitt, and Allen Forte. On the other hand, several prominent music theorists, particularly among those educated in Germany, were musicologically trained, for example Ernst Kurth, Alfred Lorenz, and Felix Salzer. As long as a theorist limits himself to explaining the music he knows exhaustively, as Schenker and Lorenz did, or contemporary music, as with Babbitt, the problem of historical context is not raised. But when theorists apply categories tested and found valid in one repertory to music distant in time from

16. LANG, Editorial, p. 219 in *Musical Quarterly*, L, 1964.
17. TREITLER, 'On historical criticism', pp. 203-205 in *Musical Quarterly*, LIII, 1967.
18. *Id.*, p. 205.
19. TREITLER, 'Music analysis in an historical context' (1966).

it, they often introduce concepts and explanations quite alien to the mode of thinking of the composers being analyzed.

Less affected by the problem of historical context are analysis, theory, and criticism of contemporary music. Whereas in literary criticism many of the same writers who comment upon older literature also review and interpret the modern, in music the commentators on older and recent compositions tend to be different sets of persons. Critics of contemporary music are most often composers, performers, or professional critics. Much of their writing has either an ideological or polemic purpose. There abound statements that are mystic, pseudo-philosophical, pseudo-mathematical, and pseudo-scientific.

However a school of theorists has grown up which aspires to the rigor of mathematics and science.[20] Milton Babbitt, who is the acknowledged leader of the school, has brushed aside distinctions between sciences and humanities and insists 'there is but one kind of language, one kind of method for the verbal formulation of 'concepts' and the verbal analysis of such formulations: 'scientific' language and 'scientific' method. . .,' and adds that 'statements about music must conform to those verbal and methodological requirements which attend the possibility of meaningful discourse in any domain'.[21] A theory, if it is truly one, should be 'statable as a connected set of axioms, definitions, and theorems, the proofs of which are derived by means of an appropriate logic.' None of the theories of the past satisfies these conditions. They have failed by not stating their 'empirical domain', and not choosing their 'primitives'. Another fault has been the futile concern with justifying a theory by ultimate causes, like numerology or nature, outside the formal system of the theory. Babbitt himself has developed a formal theory for the well defined sphere of twelve-tone music.[22] The basic assumptions of the theory are the human ear's consistency in perceiving pitches an octave apart as belonging to the same class, therefore the term pitch-class, and in perceiving intervals of the same size as identical regardless of pitch, hence the term interval class. From these characteristics he draws a number of consequences by means of theorems of finite group theory. These theorems deal particularly with variance and invariance, which are applied to forms of the twelve-tone set. Babbitt's theory has been extended by a number of other investigators, including David Lewin, Donald Martino, John Rothgeb, Stefan Bauer-Mengelberg, and

20. I acknowledge with thanks the generosity of Allen FORTE, who allowed me to study the article, 'Musical theory in the 20th Century. A survey', prepared for the *Dictionary of 20th-Century Music*, edited by John VINTON, in preparation. It illuminated my way through the extensive recent literature on music theory and pointed out for me the significance of many recent developments.

21. BABBITT, 'Past and present concepts of the limits of music', pp. 398-399 in *Report of the Eighth Congress, International Musicological Society, New York, 1961*, Vol. I (1961).

22. BABBITT, 'Some aspects of twelve-tone composition' (1955); 'Twelve-tone invariants as compositional determinants' (1960); 'Set structure as a compositional determinant' (1961).

Melvin Ferentz. Influenced by Babbitt's method is Forte's theory of set-complexes[23] which is a systematic way to analyze the basic material of pre-twelve-tone music written outside the system of the major and minor scales. Forte's set-complexes are unordered collections of pitches (disregarding octave duplications) having certain arrangements of intervals. His theory permits the analysis of music based on other configurations of notes than the major and minor scales and on other chords than those based on superposition of thirds.

Another mathematical model tending toward a demonstrable music theory is that of information or communication theory. This provides a method of calculating the variety (information) and sameness (redundancy) residing in a composition with respect to a certain characteristic. Investigations have been made, for example, of the comparative rate of information in stable and unstable sections of various composers[24] measured in terms of the occurrence of twelve pitch classes, and the probability of consecutive intervals.[25] These studies have been on an elementary level not involving dependent probabilities. Despite the huge amount of calculation needed, comparing certain probabilities of a more sophisticated order in different styles may reveal aspects of classical music that otherwise would remain undetected. Information theory has even greater relevance for some forms of contemporary music. Electronic music, for example, has so extended the range of sounds in terms of pitch, dynamics, divisibility in time, and so on, that both the limits of the channels of communication, such as phonograph records, and of the human receptor need to be studied. Iannis Xenakis[26] has shown that what he calls 'stochastic' music can be composed at various levels of determinacy in which general and transition probabilities are regulated according to the desired outcome, aesthetic aim or other function. Aleatoric or chance music and that which relies partly on improvisation is probably more susceptible to study in terms of information theory than to more conventional theories. Abraham Moles[27] has also suggested the relevance of information theory to the understanding of the dynamics and effects of mixed media, such as dance or operatic recitative.

The limits of perception and apprehension – therefore of communication – so far as certain kinds of contemporary music are concerned have been studied by Robert Francès and Albert Wellek. Francès[28] asked a group of composers, conductors, and analysts to distinguish between fragments based

23. FORTE, 'A theory of set-complexes for music' (1964); 'The domain and relation of set-complex theory' (1965).

24. HILLER & BEAN, 'Information theory analyses of four sonata expositions' (1966).

25. See WINCKEL, 'Musik – VI. Informationstheorie' (1963).

26. XENAKIS, *Musiques formelles* (1963).

27. MOLES, *Théorie de l'information et perception esthétique* (1958) (English version, *Information Theory and Aesthetic Perception*, 1966); see also, by Abraham A. Moles, the sub-section 'The informational approach' in the preceding chapter.

28. FRANCÈS, *La perception de la musique* (1958); see also, by Robert Francès, the sub-section 'The experimental approach', in the preceding chapter.

on two different twelve-tone sets and found their identifications erred in more than 50% of the cases. This casts some doubt, Francès remarks, on the unifying efficacy of a twelve-tone series. Wellek[29] introduced errors of performance or intonation in a piece of Schönberg and found that music students could spot only a third or a fourth of the alterations in this music, whereas they almost never failed to pick out such errors in pieces of Dussek or C. P. E. Bach.

A number of recent analytical studies of music have required a vast amount of data that could not have been handled without a computer. However, artificial languages for encoding music and programs for analyzing it had first to be devised by the authors of these studies. Bauer-Mengelberg has invented a comprehensive music encoding language called the Ford-Columbia language after his sponsors. Forte[30] worked out a program for the analytic reading of music scores in a language, SNOBOL 3, for which he wrote a manual.[31]

Although historians of music have been slow in exploiting the computer, a few recent projects are paving the way for others by coming to terms with some of the problems of encoding older notations. Raymond Erickson[32] has modified the Ford-Columbia language to accommodate the notation of 12th-century Notre Dame polyphony for a study of rhythmic problems and melodic structure in *organum purum*. Murray Gould[33] has published a scheme for translating the plain chant notation of the *Liber usualis* into symbols available on a key-punch machine. Nanna Schiødt and Bjarner Svejgaard[34] have developed a scheme for analyzing the operation of melodic formulae in the Byzantine Sticherarion. As programming and encoding languages become standardized, as 'software' is developed for program conversion to many forms of computer input, many scholars now intimidated by the technical problems will be attracted to high-speed data processing for analysis.

A much more common use of computers in musicology has been for indexing and bibliographical purposes. Indexing of purely verbal material, such as titles, has profited by the advancement of information retrieval generally. The most notable project is the *Répertoire International de la Littérature Musicale (RILM)*, headed by Barry S. Brook and established in 1966 by the International Musicological Society and the International Association of Music Libraries under the sponsorship of the American Council of Learned Societies. RILM has indexed in some depth

29. WELLEK, A., 'Expériences comparées sur la perception de la musique dodécaphonique' (1966); see also, in the preceding chapter, in the sub-section 'The psychological approach', paragraph I, 'The psychology of music hearing', by Albert Wellek.

30. FORTE, 'A program for the analytic reading of scores' (1966).

31. FORTE, *SNOBOL Primer* (1967).

32. ERICKSON, 'Music analysis and the computer' (1968).

33. GOULD, 'A keypunchable notation for the *Liber usualis*' (1967).

34. SCHIØDT & SVEJGAARD, 'Application of computer techniques to the analysis of Byzantine Sticherarion-melodies' (1967).

all the significant literature on music that has appeared since January 1, 1967 and is intended to provide a model for indexing in other fields.

As opposed to bibliography, indexing of music is more problematic because of the encoding problem. Some of the indexing projects now in progress are those of Jan LaRue on themes of 18th century symphonies[35] and Harry Lincoln[36] of 16th century frottola melodies. Similar thematic indices in such fields as troubadour melodies, tropes and sequences, motets, masses, chansons, and madrigals, not to mention sonatas and concertos have either been contemplated or begun, and when completed could be a boon to the many musicologists constantly seeking to identify composers, authenticate works, describe variants, and search for sources.

Ethnomusicologists have made comparatively little use of the computer. This is understandable, since much of the data concerning a culture and its music must be expressed in narrative statements. On the other hand in comparing melodies of one culture to another or of neighbouring peoples, such as related tribes, or in generalizing upon the style of one culture, computational methods would be as useful as they are in the study of historical repertories. The actual tendency has been, rather, the development of various melody-writing instruments, such as Seeger's melograph[37] and Uppsala University's 'Mona',[38] which permit monophonic performances to be represented and visually analyzed in every detail.

The 'information explosion' is both a blessing and a cause for concern. When information is so easily gathered, stored and analyzed, we can be deluged with data. The scholar will need to know when to stop, to recognize the point of diminishing relevance.

Arthur Mendel in the first public address to the New York Congress of the International Musicological Society in 1961 asked why we inquire into the history of music. It is suggested, he said, that we do so to learn from the past how to act in the future. He rejected this utilitarian explanation as not consistent with practice, since very few readers of history deal with the future; for example, composers make little use of our knowledge of the music of the remote past. Mendel concluded that we study history of music primarily 'because we have a passion for understanding things, for being puzzled and solving our puzzles; because we are curious and will not be satisfied until our curiosity rests.'[39]

This answer will not satisfy everyone, since it could be objected that there are too many things to understand, too many puzzles to solve. There

35. LaRue & Cobin, 'The Ruge-Seignolay catalogue: an exercise in automated entries' (1967).

36. Lincoln, 'Some criteria and techniques for developing computerized thematic indices' (1967).

37. Seeger, 'Versions and variants of the tunes of "Barbara Allen"' (1966).

38. Bengtsson, 'On melody registration and "Mona"' (1967).

39. Mendel, 'Evidence and explanation', p. 4 in *Report of the Eighth Congress, International Musicological Society, New York, 1961*, Vol. II (1962).

are obviously priorities. Solution of problems in which others besides musicologists have a stake have such priority.

Musicology must continue to benefit performers and conductors and through them their public. The rediscovery of Bach in the early 19th century and since then of hundreds of other composers both earlier and later has revolutionized the repertory of concert and recorded music. It has also created problems for performers who must relive a practice buried in the past. At first it seemed that having critical editions that present the music in the state in which it left the composer's pen would provide the basis for the restoration of the authentic sound of the music. By now such editions are common, but it has become evident in the meantime that composers before the 19th century, at least, left much to the taste and elaboration of the player.[40] Concerning the interpretation of the composer's text, simple answers once accepted have given way to multiple answers, as instruction books and other literary and musical documents have been read more carefully and exhaustively. It is obvious that most of the issues cannot be settled definitively and that several alternate solutions may be equally authentic. To pass on to the performer these options in such a way that he can understand them and use them artfully remains a challenge to musicology.[41]

Another obvious priority is to make available to the musical public the means for understanding significant music of all traditions and cultures.

Being a relatively young field of university study, music has had to guard its identity as a scholarly discipline jealously; so in most countries it has failed to establish close ties with the public or lower levels of education. The music scholar tends to operate in the hermetic atmosphere of libraries, institutes, and seminars and to communicate through specialized reviews. Few of his discoveries and interpretations leak out to the general public. In earlier days, when the scholarly readership was small, musicologists were compelled to appeal to the amateur if they were to see their work in print. But today only a small proportion of active scholars write books of general interest. On the other hand, other channels have opened up, such as radio-television networks, most notably those in Germany, England, Italy, and France, which have confided the direction of important series of programs to scholars. Also a number of periodicals such as *The Musical Times* (London), the *Saturday Review* (New York), *Österreichische Musikzeitschrift* (Vienna) carry articles of scholarly depth for the amateur and musician.

There are also encouraging signs that university scholars are establishing contacts with elementary and secondary schools. In England and Germany, where the prospective secondary school teacher is not isolated from the normal music program of the university, he is frequently exposed to the point of view of the scholar in his training. In the United States, on the other hand, elementary and secondary school teachers are trained mainly

40. See MENDEL, 'The services of musicology to the practical musician' (1957).
41. See TAGLIAVINI, 'Prassi esecutiva e metodo musicologico' (1964).

in university schools of education and have relatively little contact with musical scholarship. Recently however, several projects sponsored by the federal government and private foundations in the United States have brought scholars, composers, theorists, teachers, and professors of education together.[42] In Italy a recent legislative proposal (Chamber of Deputies, No. 4327, 27 July 1967)[43] projects a reorganization of musical studies in which holders of degrees in musicology would teach history of music in the *scuole secondarie superiori* and in the conservatories, as well as in the universities.

Through rapports such as these with the general education of young persons and with the public, musicologists will discover yardsticks of relevance that can restore a balance between fact-finding for its own sake and the needs of the world of music and society at large. Friedrich Blume, editor of the great fourteen-volume encyclopedia *Die Musik in Geschichte und Gegenwart*, addressed principally to professional scholars and musicians, has clearly expressed the music historian's concern with this larger responsibility, and what he says applies equally well to theory and ethnomusicology:

> The hunger for musical understanding cannot be satisfied with recipes for alchemists' clandestine cookery. ... Music is a cultural resource of mankind and not a handtool for the musician. Interest in the history of music does not restrict itself to the narrow circle of historians. We should remain concerned that music history not lose its place in the general education of the *homines bonae voluntatis*, that is not trickle away into the dry streams of narrow professionalism.[44, 45]

42. See *Current Musicology*, 1966, Special Section: 'Musicology and music education', II (2); *College Music Symposium*, IX, 1969, pp. 36-47 and 65-111.

43. See MASCAGNI, 'L'insegnamento della musica in Italia' (1969).

44. 'Der Hunger nach dem Verstehen von Musik kann nicht mit den Rezepten alchimistischer Geheimküchen gestillt werden. ... Musik ist ein Kulturgut der Menschheit und nicht ein Handwerkszeug für den Musiker. Das Interesse für die Geschichte der Musik beschränkt sich nicht auf den engen Kreis von Historikern. Wir sollten bemüht bleiben, dass Musikgeschichte im universalen Bildungsbedürfnis der *homines bonae voluntatis* ihren Platz nicht verliert, dass sie nicht auf den Durststrecken engen Fachdenkens dahinwelkt.' – BLUME, 'Historische Musikforschung in der Gegenwart', pp. 15 and 21 in *Acta musicologica*, XL, 1968.

45. In addition to the literature mentioned in the preceding footnotes, the reader may also refer to the following works of general interest: ADORNO, *Philosophie der neuen Musik* (1949) (English translation, *Philosophy of Modern Music*, 1973) and *Klangfiguren. Musikalische Schriften* (1959-63); ANSERMET, *Ecrits sur la musique* (1971); BRELET, *Esthétique et création musicale* (1947) and 'Musique et structure' (1965); DANIÉLOU, *Traité de musicologie comparée* (1959); McLAUGHLIN, *Music and Communication* (1971); MEYER, *Emotion and Meaning in Music* (1956); MOLES, *Les musiques expérimentales* (1960); POUSSEUR, *Fragments théoriques sur la musique expérimentale* (1970) and *Musique, sémantique, société* (1972); SCHAEFFER, *Traité des objets musicaux* (1966) and *La musique concrète* (1967); SCHLOEZER, *Introduction à J.-S. Bach. Essai d'esthétique musicale* (1947).

Works pertaining to the historical, sociological, experimental, psychological, semiotic, and informational study of music are also cited in the relevant essays in the preceding chapter.

IV. THE DRAMATIC ARTS, *by André Veinstein**

1. THE FRAMEWORK OF RESEARCH

International study and documentation centres

Of the various dramatic arts considered in the present study – the theatre, the dance, miming, marionettes, the circus, the art of festivals – the theatre is by far the subject that has been most fully investigated.

Indeed, so far as pure theory is concerned, only the theatre has its own international organization: the International Federation for Theatre Research, founded in London in 1955.[1] The same is true of the field of 'mixed' studies, that is to say, both theory and practice, with the International Theatre Institute, founded under the auspices of Unesco in 1948, the International Section of Theatre Libraries and Museums of the International Federation of Library Associations, founded in 1954; together with the International Federation of Actors, the International Federation of University Theatres, the International Amateur Theatre Association, and the International Association of Theatre Technicians. UNIMA (the International Marionette Union), it is true, is also organized on a mixed international basis.

These international theatre organizations frequently sponsor interesting work concerned with some of the other dramatic arts. A few years ago, the I.T.I. took the initiative in setting up a liaison committee linking these various organizations, including UNIMA.

What has been briefly said above finds its counterpart in the various countries where possibilities of studying theory, or theory and practice together, have been considerably more developed in the theatre than in the other branches of the dramatic arts: university chairs,[2] university institutes, study associations; congresses, symposia, seminars, conferences; the publication of periodicals and works; schools of dramatic art, centres for experiment and research.[3] Nevertheless, in various countries there are for the dance, puppet shows and the circus study associations, numerous schools and even university courses.

Within the field of the dramatic arts with which the present study is concerned, libraries, museums, collections and documentation centres have developed considerably in recent years. Over 300 public and private collections have been found to exist, most of them (about 85%) devoted to the

* University of Paris-VIII; President of the International Section of Theatre Libraries and Museums (International Federation of Library Associations).
 1. Cf. *The Transactions of the International Conference of Theatre History* (1957).
 2. Europe has thirty professional chairs or lectureships. See reports on the subject published in *Theatre Research*, the organ of the International Federation for Theatre Research.
 3. For example, the Prague Institute of Scenography and the East Berlin Institute of Technology of Cultural Establishments.

theatre. Some of them are closely associated with the activities of research and teaching centres, others with professional associations or undertakings, while others – independent ones – try both to satisfy the interests of the theorists and also to meet the requirements of practitioners. In addition to the above-mentioned International Association, important theoretical work on the methods and techniques of conservation, cataloguing and communication has been undertaken over the last 15 to 20 years by national associations in the United States,[4] the U.S.S.R.[5] and France.[6]

Practice and the study of theory

Among the different arts, the dramatic arts thus offer a whole series of outstanding examples which demonstrate the close connexion between practice and theory. This connexion is further strengthened by the considerable development of research and experimentation in the dramatic arts,[7] the direct participation of artists, technicians and theorists in joint work,[8] the exceptionally important part played by the writings of dramatic artists (dramatists, producers, actors, musicians and choreographers).[9]

Recent artistic trends

By their nature, the most striking recent innovations affecting the practice of the arts may shed some light on certain typical aspects of the studies of which they are the subject:

1) Being anxious to introduce changes and wishing to take advantage of the most advanced technological and scientific research, certain artists and technicians of the theatre and dance are experimenting with recent materials, techniques and methods: for example, polyester in architecture, plastic materials for stage settings and accessories, the use of remote control and of punch cards and perforated strips for lighting. Czechoslovakia, France, Germany, Romania and Poland are the main centres for such research.[10]

4. Theatre Libraries Association (U.S.A.).
5. Association of Theatre and Music Libraries (U.S.S.R.).
6. Section of Theatre Libraries and Museums (France). Cf. *Bibliothèques et Musées des arts du spectacle dans le monde.*
7. See my publication, *Le théâtre expérimental* (1968).
8. Cf. the two works by groups of authors, *Architecture et dramaturgie* (1949-50) and *Théâtre et collectivité* (1953); COLE & CHINOY's compilation, *Directors on Directing* (1963); the symposia of the Theatre Study Group of the National Centre for Scientific Research (France); the seminars on theatre or miming held by the European Forum at Alpbach (Austria); etc.
9. See my article: 'Ex libris de notre théâtre', in *Encyclopédie du théâtre contemporain*, Vol. II (1959).
10. Cf. *Le décor de théâtre dans le monde* (1964), and the stage-craft reviews:

2) Because of the antiquity and the enduring character of the dramatic arts, their highly complex structural composition, their intense international life, and the fact that they are always open to practitioners, to the means of expression and to the methods and styles associated with other arts, they are able to renew their own powers of expression, to absorb or assimilate means (for example, projection techniques – scenery, films, slides)[11], materials (see 1 above) and forms[12] from outside sources so as to achieve total theatre, or create a new art: integral spectacle.[13]

3) During the last twenty years, the desire to win the favour of the general public for the dramatic arts has in many countries been one of the most powerful factors of change. In the people's democracies, in many Western countries and in Latin America, the practical measures most commonly adopted have been: decentralization, travelling theatres, the opening of theatres in the heart of working-class residential districts or on the outskirts of large cities, the choice of readily understood repertoires and styles of production, the creation of cultural centres with the theatre as the main feature, publications, information and lectures at the place of work, the formation of playgoers' associations, the reduction of the price of seats; the adaptation of the hours of performances to those of workers, etc.

4) Initially (about 1950), the promoters of a theatre for the people – foremost among them, in France, Jean Vilar – considered a theatrical performance as both an entertainment and a means for social and cultural communion. Later, under the influence of the works and doctrines of Piscator, and especially of Bertolt Brecht, the theatre, regarded as both a meeting-place and a tribune, was seen as a licensed instrument of revolution or evolution. In Eastern Europe, and later in the West (France, Britain and Italy in particular), committed writers and militant producers or troupes banded together in working class districts or residential areas to create 'montages', documentary plays (documentary theatre) or traditional shows, of which the subjects, drawn from the past or present, the realistic style considered to be acceptable by the greatest number, the didactic approach to the acting, and the auditorium, entirely stripped of the illusionism characteristic of the bourgeois theatre, combined to create a critical awareness and foster the political commitment of the audience itself.

The fact that, despite an appreciably bigger public, there was no participation by really working-class elements led to a third stage in which the intention was to bring the theatre actually into the street in order to reach the 'non-public'. Attempts of this nature were made in the United States, in France during the events of May and June 1968 and, more recently, in Great Britain.

Interscena (international); *Acta Scaenographica* (Czechoslovakia); *Bühnentechnische Rundschau* (Federal Republic of Germany); *Scena* (German Democratic Republic); *Tabs* (Great Britain); *Theater Design and Technology* (U.S.A.).

11. Cf. VIEFHAUS-MILDENBERGER, *Film und Projektionen auf der Bühne* (1961).
12. See my publication (1968) mentioned above.
13. Cf. *Scénographie nouvelle* (1963).

5) During the last ten years, projects have emerged within the framework of the traditional dramatic arts the purpose of which was to introduce new arts or to assert the artistic independence of certain means of expression: stage-craft (J. Polieri, France): the spatio-dynamic theatre (N. Schöffer, France); the art of mime (E. Decroux, France).

2. CURRENT TRENDS AND RESEARCH PROBLEMS

First of all, some preliminary remarks:

1) The titles adopted by certain university institutes or associations for the study of the theatre – a branch which, as we saw earlier, has grown proportionally faster than any other: 'Theatre Research' (Great Britain, Italy), 'Theatre Studies' (France), 'The Sciences of Theatre' (Berlin, Vienna), 'The Sciences of the Theatre (Budapest).

2) Not one of the big theatre encyclopaedias, whether the monumental *Enciclopedia dello spettacolo* or the *Oxford Companion to the Theatre,* contains any article on the trend of studies on the dramatic arts, on the science or sciences of the theatre, or on questions of methodology.

3) The only compilations of major works published on these subjects are to be found in *The Transactions of the International Conference on the Theatre, London 1955* (1957); the *Atti dello IIo Congresso Internazionale di Storia del Teatro, Venezia 1957* (1960); the articles assembled in the third number (1957) of the Austrian review *Mask und Kothurn* and the proceedings of the various international congresses of the International Section of Theatre Libraries and Museums published successively from 1961 onwards.[14]

In general, the university institutes and professorial courses have paid little attention to questions of methodology. Mention should however be made of some courses in theatre methodology given in certain American universities and in the University of Louvain (1968-1969), and series of courses in theatre documentology given in the United States, at Columbia University and the Graduate School of Library Science at the Drexel Institute of Technology (Philadelphia).

It should be noted, however, that some theorists had attempted at an earlier date to define a few principles of theatre methodology: the Russian Alexei Gvordev about 1924,[15] the Swiss Oskar Oberlé about 1928, and the German Arthur Kutscher about 1936.[16]

4) In the major countries, bodies for study and research on the dramatic arts and individual research workers are given relatively considerable aid from some international organizations, universities, national scientific research bodies and private foundations; all of which is proof that the posi-

14. Paris (1961), Munich (1963), Amsterdam (1965), Budapest (1967), Genoa (1970).
15. Cf. GOURFINKEL, 'La théâtrologie soviétique' (1968-69).
16. KUTSCHER, *Grundriss der Theaterwissenschaft* (1949).

tive value of research in this field is publicly recognized. In most countries, a relatively considerable importance is attached in the universities to diplomas and theses relating to the dramatic arts, more particularly to the theatre.

Orientation and spirit of the work

Under the names of theatre science or sciences, theatrology or theatre research or study, the work undertaken, whether by individuals or by groups, is marked by the following characteristics, the constancy of which is striking, as for example, in the papers presented at the Second Congress of the International Federation for Theatre Research (Venice 1957) by participants from eighteen countries.

1) Recognition of the artistic specificity of the theatre and of the various other dramatic arts; their 'liberation' with reference to the other arts, literature in particular, thereby implying the need for original research unrelated to literary studies and literary criticism.

2) Recognition of the 'spectacular' aspect of theatre: whence the need to extend the field of study to the means of scenic expression: architecture, production, scenography, stage settings, machinery, costumes, lighting, music, etc.

3) Recognition of the need to be no longer limited to a purely bookish approach but to have recourse to original objects: models of scenery and architecture, masks, costumes; documents (photos, slides, films, records, etc.) showing as faithfully as possible what the actual performances will look like.

The developments which have for a long time past marked the advent of a modern science of theatre, the papers presented at the Second Congress of the Federation for Theatre Research and the most recent studies[17] accord to the problems raised by the intrinsic value of documents (authenticity, fidelity, interpretation) so predominant an attention that, in many respects 'the science of theatre' would seem to be identical with a 'documentology' of the theatre.

But the dramatic arts, being not only arts of time and space but also arts of synthesis, are favourite subjects chosen in different countries by the representatives of the various human sciences, in particular, history, aesthetics, psychology, sociology, philosophy, philology and stylistics.

History and the dramatic arts

Up to ten or fifteen years ago, history occupied an overwhelmingly predominant position among these disciplines, as can be seen in most countries

17. Cf., for example, LAWRENSON & PURKIS, 'Edition illustrées de Térence dans l'histoire du théâtre' (1964); CHRISTOUT, 'Documentation iconographique et authenticité théâtrale' (1965); etc.

from the titles and activities of study associations and educational courses, overshadowing the important contribution of philosophy, psychology, aesthetics and sociology in many treatises and studies and in the prefaces of publications regarded as key works. Fortunately, over the last forty years or so, texts that were too often anecdotal and of no real scientific value have been replaced in such studies by others with a genuinely historical approach or by exclusively historical works.

Psychology and the dramatic arts

For the study of the dramatic arts, psychology offers an approach that is much favoured in the most varied fields.

(a) Such an approach may indeed, more particularly in respect of the theatre, be associated with the exceptionally abundant wealth of artists' reflections: those of dramatists, actors and, above all, producers; for few of the greatest amongst them, in France, Germany, Great Britain, Italy, the U.S.S.R., Poland and Czechoslovakia, have failed to recount their experiences either in unpublished form or in the form of studies from which active research daily draws observations, analyses and interpretations of fundamental importance.

(b) In recent years, new horizons have opened out or old ones have been rediscovered with the practice of the psychodrama – particularly in the United States – or with group improvisations, such as 'happenings', and with research on the psychotherapeutic value of theatre and dance.

Philosophy and theatre

The philosophy of the theatre has given rise, particularly in France, to the publication of important essays or works, the writings of philosopher-dramatists, such as Albert Camus or Jean-Paul Sartre, or philosopher-dramatic critics such as Henri Gouhier.[18]

Sociology and the theatre

While psychologists and philosophers who use the dramatic arts when the opportunity offers as the subject of their work or as field for it, accept the intervention of other disciplines and frequently themselves invite it, many sociologists tend, on the other hand, to regard the dramatic arts – specifically, theatre, which is both a group art and a 'social' art – as their own preserve as a field of study.

18. See in particular, *Le théâtre tragique* (the work done on tragedy by the Theatre Study Group of the National Council for Scientific Research) (1962); GOU-HIER, *L'essence du théâtre* (1943, 1968) and *L'œuvre théâtrale* (1958); etc.

In recent years, the sociology of the theatre has taken the following forms in particular:

(a) the study of the reactions of the audience and the critics to a given work[19];
(b) research on the relationship between a certain repertory, certain buildings, certain interpretations and a given society[20];
(c) surveys concerning the composition of audiences, their tastes, their needs;
(d) surveys and symposia concerned with the theatre's social and cultural rôle in the context of a policy for leisure;
(e) surveys on the question of introducing new theatrical activities in certain places;
(f) studies on the economic aspects of a policy of cultural expansion.

Aesthetics and the dramatic arts

In the different countries, the 'sciences of the theatre' certainly appear to identify themselves with the various human sciences applied to the theatre proper (and to the other dramatic arts). They use, or revive, the same techniques and methods of research (interviews, surveys, conversations), and methods of analysis and reflexion (phenomenology, structuralism, historical materialism, semiology, etc.), for the most part, incidentally, as and when the research worker decides, without any systematic application in accordance with a generally accepted methodology.

In countries where the study of aesthetics has reached the most advanced stage, no special importance is attached to the dramatic arts in current research, despite the exceptional value they present in many respects for aesthetics[21]. The most important work done, for example, in the field of experimental aesthetics and comparative aesthetics applied to the dramatic arts is much more clearly evident through the research and writings of artists and technicians than through those of aestheticians.[22]

Nevertheless, over the last twelve years or so in the aesthetics of the theatre in France an effort has been made to demonstrate the danger for the scien-

19. MIERINDORFF, *Lebt das Theater? Der Wiclair-Test* (1960); RAVAR & ANRIEU, *Le spectateur au théâtre* (1964).

20. Cf. DUMUR (ed.), *Histoire des spectacles* (Encyclopédie de la Pléiade, 1965); and the collection *Dramaturgie et société aux XVIe et XVIIe siècles* (1968).

21. See my report to the Sixth International Congress on Aesthetics (Uppsala, 1968), entitled 'Dix-neuf des raisons qui font du théâtre un sujet privilégié pour l'esthétique' (to be published).

22. It will suffice to mention here the work of the Bauhaus in Germany, the Prague Institute of Scenography, and the East Berlin Institute of Technology of Cultural Establishments.

tific study of the dramatic arts arising from the hegemony exercised by such disciplines as history and sociology.[23]

According to this way of thinking, while these complex arts, which are themselves the fruit of the co-operation of various activities, must necessarily be studied from several angles it is none the less true that their nature, specificity and unity call for co-ordination between those disciplines and for an assessment of the results. And it so happens that the main objective of aesthetics is precisely to group, assess and exploit, by methods which aesthetics must determine, the results of the various scientific approaches applied to artistic activities.

Without the intervention of aesthetics, the 'sciences of the theatre' will be left without a soul.

V. THE ART OF CINEMA, *by Gianfranco Bettetini**

The cinema is a phenomenon too complex in itself and studied over too short a period for one or more trends in research to have emerged definitely and for specialists to have been able to determine general guidelines or governing principles.

Criticism has taken various directions, either successively or simultaneously, so that the study of the cinema has always consisted of a series of complementary works – often unrelated to one another, yet concerned with the objective analysis of the same phenomenon.

In recent years, however, a gradually increasing interest has been taken in audio-visual language which, though stemming from research ond studies dealing with other aspects of human communication[1], has acquired a definitely independent character and assumed the form of an applied discipline based on specific programmes of empirical research. This opening for study has attracted the attention of almost all the most experienced specialists in filmology.

Now that a universal '*dignus est intrare*' has put an end to the old quarrel as to whether or not the cinema is an art form, now that historical studies must keep within the narrow chronological limits – and therefore the restricted prospects – of this still recent phenomenon and now that comparative research on the cinema and other forms of artistic experience (literature and the plastic arts) has nothing further to teach us, filmology has for some years past been trying, by pursuing analysis as deeply as possible, to recover

23. See in this connexion my report to the Second International Conference on the History of the Theatre (Venice, 1957) on the methodology of research on the theatre (1960).

* Catholic University of Milan and University of Genoa.

1. Cf. in particular, MARTINET, *Eléments de linguistique générale* (1961) and *A Functional View of Language* (1962); PRIETO, *Messages et signaux* (1966) and *Principes de noologie* (1964).

what gave it its original unity of purpose.

There has been no attempt – nor would any such attempt be easily conceivable – to run the risk of bringing to a violent halt a flow of studies of the traditional type, which have made a far from negligible contribution in spite of their confused and often heterogeneous nature.

On the contrary the aim has been to interpret that contribution from a different point of view, so as to open up new avenues for research and propose new objectives for an activity that already has a lengthy history.

The remarkable development of structuralism in contemporary thinking as an intellectual instrument for the synthesis and harmonization of different ideological universes[2] – the contradictions between which could have been overcome by abandoning once and for all the traditional notion of 'ideology' – has been reflected even in filmology and film criticism, where it has aroused a general interest which is still somewhat vague and of which the long-term effect is difficult to foresee.

The experience of the Soviet formalist school[3] and of the French groups which draw their inspiration from the work of Roland Barthes[4] and Claude Bremond[5], has made it possible to undertake a very thorough restructuralization of literary criticism, in the direction of an ever-increasingly 'scientific' use of its instruments and of a total rejection of impressionism and traditional ideologies – that is to say, in that of a methodological and linguistic application of structuralism.

The material which served Roland Barthes and his colleagues as a starting point for thinking on semiology and aesthetics is not original, but the outcome of linguistic research and studies based more particularly on the principles and methods of Ferdinand de Saussure[6] and L. Hjelmslev.[7]

Research was first concerned with verbal language and then extended to the instruments of communication which seemed the least codifiable, in particular the language of moving images. Christian Metz[8] was the first to pay serious attention to filmic language from the standpoint of a scientific structuralism, and his studies have given rise to others – in particular by Italians: Pier Paolo Pasolini, Umberto Eco, Emilio Garroni, Gianfranco Bettetini, etc.[9]

2. Cf. for example, FOUCAULT, *Les mots et les choses* (1966) (English translation, *The Order of Things*, 1970).

3. Concerning this school, see, in the preceding chapter, the sub-sections 'In the Socialist countries', by Bela Köpeczi (cf. p. 528, note (8), and 'The semiotic approach', by Louis Marin, pp. 658-676.

4. BARTHES, *Le degré zéro de l'écriture* (1953) (English translation, *Writing Degree Zero*, 1967), 'Eléments de sémiologie' (1964) (English translation, *Elements of Semiology*, 1967) and *Critique et vérité* (1966).

5. BREMOND, 'Le message narratif' (1964) and 'La logique des possibles narratifs' (1966).

6. SAUSSURE, *Cours de linguistique générale* (1915).

7. HJELMSLEV, *Omkring Sprogteoriens Grundlæggelse* (1943) (English translation, *Prolegomena to a Theory of Language* (1963)).

8. METZ, 'Problèmes actuels de théorie du cinéma' (1967); *Essais sur la signification au cinéma* (1968); *Langage et cinéma* (1971).

9. PASOLINI, 'Il cinema di poesia' (1965); 'Per una definizione dello stile nelle

Without underestimating the contribution of other research workers (Antonin Sychra[10], Luigi Faccini, etc.), it may be said that the same approach to the problem and the same intellectual training have given rise to two theories whose provisional conclusions and methodology differ appreciably. Some speak of a universal system of semiotics which can account for all the 'signifier' aspects of a film by keeping strictly to their photographic and reproducible nature, while others, on the contrary, postulate the existence of an independent science of filmic signs.

But in both cases, research is still too closely linked to the precedents of verbal linguistics and, despite a judicious adaptation of operational methods and concepts, they have not so far succeeded in delimiting a distinct experimental field, a framework of reference, that is essentially filmological.

The scientific elucidation of the problem calls for a fine distinction between the two systems of semiotics: the old semiotics which is already codified linguistically, and the new semiotics, which can only be glimpsed through the models and transpositions of earlier studies on other aspects of human communication.[11]

The difficulties encountered in a semiological study of the phenomena of films, and the specific directions taken by research as soon as it makes a definite start, must be attributed to the actual nature of the object analysed, to the signifier function of the cinematographic image, which is pre-eminently iconic.

To the linguist, the filmic sign offers an obvious scientific contradiction in so far as it faithfully reproduces the object, adding to the iconic resemblance the fascination of movement, while at the same time managing to transcend it to the point of meaning something that is no longer the object, but may be linked to it by an explicit conventional relationship.

The relationship between the iconic sign and the reality represented has always been dependent on two opposite and apparently incommensurable parameters: the analogical reproduction and the intellectual pattern superimposed on the sign – the abstraction which may constitute a reference to instruments of outside codification.

The structuralist theory replaces the term 'object', in the relationship of meaning, by 'the signified' as a mental image, a psychic entity. The semiological analyses of the structuralists thus make it possible to formulate in the domain of verbal signs a complete and scientifically intelligible message spontaneously reducible to the limits of a process of abstraction and delib-

opere cinematografiche: la lingua scritta dell'azione' (1966) and 'In calce al cinema di poesia' (1960); Eco, *Apocalittici e integrati* (1964) and *La struttura assente* (1968); GARRONI, *La crisi semantica delle arti* (1964), and *Semiotica ed estetica. L'eterogeneità del linguaggio e il linguaggio cinematografico* (1968); BETTETINI, *Il segno, dalla magia fino al cinema* (1964), *Cinema: lingua e scrittura* (1968), and *L'indice del realismo* (1971).

10. SYCHRA, 'Intervento alla Tavola Rotonda della Mostra Internazionale del Nuovo Cinema a Pesaro' (1967, mimeographed).

11. See, in the preceding chapter, 'The semiotic approach', by Louis Marin.

erately conceived to escape from the constraint of the relationship with the object.[12]

Contrary to the arbitrariness which, in the case of the verbal sign, favours the junction of the 'signified' and the 'signifier', the filmic sign presents, at least at the level of the *denotatum,* an almost total motivation which appreciably reduces the margin that can be used for a schematization transcending the contingency of the various cases. The methodological uncertainties of such research at the level of the elementary units has fostered a critical attitude towards the big complex units, the levels which correspond to the higher structures; with the result that it has been possible to talk of syntagmatic analyses, iconemes, relationships with the 'sentence' unit of verbal language and, above all, that an attempt has been made to restore an analogical dimension to research (with reference to literary expression) by bringing it to bear on the structure of the narrative propositions succeeding one another on the screen.

The 'signified' transmitted by the signs of the film message are then transformed into 'signifiers' at the level of semiological research. Roland Barthes[13] proposes, in fact, the study of a language of the 'story' by borrowing from linguistics the notion of *levels of description* and applying it, successfully it seems, to the formulation of his own hypotheses. His work is supported by the research of the Russian formalists (in particular, Vladimir Propp[14], and confirmed by that of Claude Bremond, A. J. Greimas[15], Tzvetan Todorov and others, who have analysed the narrative communication at structural level. The vehicle of the message – the filmic sign – thus loses its value derived from presence, and the research worker moves in a world of cultural solicitations and of mental structures considered in the abstract, unsupported by any possible phenomenon. The necessity for full analytical references at the level of the major units implies, in fact, the passage to a veritable structural analysis of cinematographic works, considered in the light of their entire narrative content.

If we postulate the research for a language of the story, a code of narration deliberately disregarding the instruments in which the communication takes form, we may also conceive of a film rhetoric and, consequently, the integration of the signifier processes of cinema in another and, this time, universal linguistics.

We could consequently anticipate the birth of a semiotics capable of transcending the nature of the signs in which the message is expressed, and finally arrive at a systematization (hence, a codification), where the axes of meaning would be independent of the signifiers used.

12. Cf. Ullmann, *Semantics. An Introduction to the Science of Meaning* (1962). See also, in Part I of the present Study, Jakobson, 'Linguistics', and, in the present work, Section IV of 'Philosophy', by Paul Ricoeur.
13. Cf. Barthes, 'Introduction à l'analyse structurale des récits' (1966).
14. Propp, *Morfologija skazki* (1928; 2nd edn., rev., 1969) (English translation from the 1st edn., *Morphology of the Folktale*, 1958 and 1968; French translation from the 2nd edn., *Morphologie du conte*, 1970).
15. Greimas, *Sémantique structurale* (1966) and *Du sens* (1970).

But narrative structuralization at the literary level always imposes on the linguistic material a direction and a constraint: a reduction of the signs motivated by the author's intentions; the signs used by the film-maker do not lend themselves to such a restrictive and determinative operation and are more successful than those of verbal language in resisting the attempts at formal structuralization required for the composition of a discourse.

It is therefore not certain that all the experiments of literary invention can serve as a model for similar operations in cinematography; nor can it be affirmed for the moment that a possible language of literary 'narration' could be transposed in its entirety to the domain of the cinema.

Borrowings from other sectors of communication and from the research devoted to them may be useful or may favour dispersion both at the elementary level, and on the syntagmatic level, and even on that of narrative structures. Only a close and careful analysis of the film phenomenon as a whole can provide confirmation of the possibility of that systematization of the iconic-cinematic signs to which all attempts at semiological codification are directed.

Structuralism has thus left research on cinema at a blind end, from which some research workers are trying to emerge by going back to the sources of the studies on semantic iconicity (Ch. S. Peirce[16] and Ch. Morris[17] or by following the brilliant theories of R. Jakobson.[18]

Despite the marked differences between these two currents of research, there can be seen in each of them a special interest in the relationships between the filmic sign and reality, and an effort to replace these relations within the framework of schemas broader than a cold structuralist abstraction.

R. Jacobson tries to give an overall view of the phenomenon by proposing the model of a syntagmatics in which associations are made by analogy and that of a syntagmatics in which expression uses the process of substitution: that is to say, the model of metaphor and that of metonymy.

From this standpoint, the filmic sign is seen to be strongly conditioned by the object and its meaning must be defined by reference to the social use of the reality represented.

From this point of view, Jacobson has attempted an interesting rehabilitation of Aurelio Agostino's theory of signs, and we may also note the present-day relevance – despite appearances – of certain references to American culture in connexion with a recent study by Lee Russell.[19]

Borrowing from Ch. S. Pierce's theory his classification of signs in three categories, the American specialist notes the existence of the 'indication' function of the sign in all the examples of realistic films – a cinematographic category – considered by André Bazin to be of fundamental importance for the historian of the seventh art.

16. PEIRCE, *Collected Papers* (1931-35).
17. MORRIS, *Signs, Language and Behavior* (1946).
18. Cf. below, *List of Works Cited, sub* JAKOBSON.
19. RUSSELL, L., 'Cinema: code and image' (1968).

After demonstrating the existence of two other types of sign – symbols and icons – Russell shows that the latter are not easy to place in categories, and that the subjectivity and individuality which always characterizes them rules out the possibility of a simple and spontaneous codification.

The three functions of the sign are always present at the same time in a film, whatever the nature and destination of the messages transmitted, but their relative importance and value differ.

Giving a meaning to a work of cinema, as can be seen from this attempt to go beyond (or rather, to 'integrate') the structuralist method, is therefore a complex operation, with phases that are often heterogeneous. Moreover, its final form, internal method and structure are always defined in contact with the communicating object. Each film is for the spectator a unique and separate experience, calling for a specific and no less unique analysis.

It might be argued that it is always possible to find, in the semantic space of a film image, an unmotivated arbitrary component – and consequently a mode of meaning which can be referred to symbolic paradigms; but the history of cinema abounds in examples which contradict any such contention.

This conception of interpretation can apply only to films in which the structure of signs definitely fulfils a symbolic function; in which case, paradoxically, the functions of icon and of indications of images would have to be regarded almost as an effect of the personal and subjective intervention of the author (as 'words' in fact) in the build-up of his language, by reference to a 'language' of ideological symbols which can be transposed metalinguistically into the forms of spoken language.[20]

Critical interpretation should therefore go beyond the function of icon and the function of indication, arriving finally at the abstract concept of a codified universe – a universe of symbols, values, emblems produced, through association, by the ideology of the work. The meaning of the film would then be nothing other than a sum of conceptual significations.

In the case of films to which this type of semiological analysis is unsuited (they constitute the majority), the possible patterns of reading are more fluid and fragmentary. Generally speaking, it might be possible to contemplate an attempt at synthesis of the symbolic codification and the iconographic codification, which interfering dialectically with the spontaneous manifestation of reality (function of 'indication') might facilitate the definition of a meaning, conceived of as a formative idea, as a cultural choice permeating the whole substance of the filmic object.

If the present notes are concerned mainly with the phenomenon of the cinema from the linguistic standpoint, it is because that aspect is the one in which theorists have shown the keenest interest during recent years and which has given rise to the most interesting arguments and hypotheses. Quite recently, the primacy accorded to the linguistic aspect has been manifested even in the spheres of production and 'writing', especially by the

20. Cf. Ernst CASSIRER, *Philosophie der symbolischen Formen, I: Die Sprache* (1928) (English translation, *Philosophy of Symbolic Forms*, I: *Language*, 1953).

group connected with the review *Cinétique,* and later by the *Cahiers du cinéma* group (the theoretical bases were laid by the work of the 'Tel Quel' group, and especially by the essays of Julia Kristeva.[21]

But mention should certainly be made of the work done by Jean Mitry on the aesthetic and psychological analysis of the cinema[22], and of that of the various French and German schools of psychology.

Mitry does not even contemplate the possibility of a finality of the image as sign. Speaking, with reference to cinema, of a language without signs, he sees the film image as resulting from a process of 'auto-connotation' of the world represented. The mark made by the film-maker would then be reduced to a kind of analogon, essentially fleeting in signification, and of a 'typical immanence'. Mitry in this way denies the existence of a cinematographic syntax and postulates absolute freedom of creation for film-makers, who are to be liberated from any constraint codifying their linguistic system. In films, it is reality that organizes itself into logos: cinematographic creation is in itself the act of signifying and must not be made subservient to significations.

Because of this 'realistic' basis these views recall those of André Bazin[23], who began to study the cinema when at the height of his critical powers, without passing through the various stages (decoding, analysis and judgement) of the progressive approach described, and immediately criticized, by the author of 'Esthétique et psychologie du cinéma'.

The transition from linguistics to aesthetics is more than a simple methodological or qualitative change. It is a veritable transcendence, leading finally to basically different intellectual interests. In this respect, M. Dufrenne recently demonstrated very clearly the non-iterative character of familiarity with a work of art and the alinguistic structure of the relationship of communication which is established between it and the spectator.[24]

Thus we see a cultural interest in the film phenomenon developing side by side with the semiological studies referred to above. Neglecting the possibility of a linguistic interpretation of this phenomenon, there is a tendency to confer upon it as far as possible an aesthetic dimension which has not so far occupied the serious attention of scholars. This personal reaction to the sole filmed work is also contrary to the iconographic theories of Erwin Panofsky[25] and the conceptualist theories of Ernst H. Gombrich.[26] In the first case, an attempt is made to work out a code of images and, in the

21. KRISTEVA, $\Sigma\eta\mu\epsilon\iota\omega\tau\iota\varkappa\eta$ – *Recherches pour une sémanalyse* (1969).

22. MITRY, *Esthétique et psychologie du cinéma* (1963-65) and 'D'un langage sans signes' (1967).

23. BAZIN, *Qu'est-ce que le cinéma?* Vol. I: *Ontologie et langage*; Vol. II: *Le cinéma et les autres arts* (1958-59) (English translation, *What Is Cinema?*, 1967-72).

24. DUFRENNE, 'L'art est-il langage?' (1968). See also his collection of essays, *Esthétique et philosophie* (1967).

25. PANOFSKY, *Studies in Iconology* (1939) and *Meaning in the Visual Arts. Papers in and on Art History* (1955).

26. GOMBRICH, *Art and Illusion. A Study in the Psychology of Pictorial Representation* (1959).

second, to highlight in every work of art a conceptual element that is more or less manifest, a reaction of the artist to the world suggested and conditioned by interior schemas (see also the extremely interesting work of Galvano Della Volpe[27]). The late A. Ayfre and H. Agel[28] have, on the contrary, outlined a 'symbolic' interpretation of film narrative, with particular stress on the possibilities of the spiritual transcendence of the cinematographic image and of the language which organizes it in articulated signs. The image would then be evidence of a presence which is incarnate in what is real and which the film-maker would reveal through his work of selecting and reducing to order. Similar research work is being pursued in Italy by Luigi Bini.

It cannot be said that the application of aesthetics to cinema has produced any striking results in recent years; and while the level of studies remains high, no leading figure has emerged and no original theory has been formulated that is capable of arousing any real interest among research workers.

The time for theorizing on the art of cinema is perhaps at an end, just as any discussion of its specific nature and the formal consequences resulting therefrom is now empty of substance.

On the other hand, fresh prospects for study have become apparent in the field of psychology and particularly in that of the sociology of the cinema as a result of recent progress in these scientific disciplines and of the fact that their methods (survey, interview, content analysis, etc.) apply naturally to audio-visual communications. The earlier and slightly out-of-date works of Arnheim and Kracauer have now been supplemented, in specialized libraries, by the recent studies of C. Bremond and J. Gritti, the surveys of the United States universities and, in Italy, the research of F. Alberoni, G. Galli and F. Rositi.[29]

Nor should we overlook the fact that a discipline of filmology cannot be limited to psycholinguistic references for its analyses, but must also embrace the various fields of study – sociology, economics, politics and, of course, history – which are covered by the art of cinema.[30]

If we have not dwelt on any one of these aspects of the question, that is because it seems to us that no new theories have emerged to disturb these calm waters, nor has any work of importance been published of late.

The typical solitary research worker (almost always borrowed from the world of libraries or literary criticism) has little to do with a science of cinema reflecting the reality of the phenomenon which it studies and the society in which it is born and develops.

27. DELLA VOLPE, *Critica del gusto* (1960) and 'Il verosimile filmico' (1962).
28. AYFRE, *Conversion aux images?* (1964) and *Cinéma et mystère* (1969); AGEL & AYFRE, *Le cinéma et le sacré* (1953).
29. ALBERONI, *L'élite senza potere* (1963); GALLI & ROSITI, *Cultura di massa e comportamento collettivo* (1967).
30. See, *inter alia*, MORIN, E., *Le cinéma ou l'homme imaginaire* (1958); ROMANO, *L'esperienza cinematografica* (1965).

The problem of research in the field of the cinema can be solved only within the framework of specialized institutes, which are rare at the present time and, for the most part, endowed with inadequate means.

One exception may be mentioned, namely the Centre d'études des communications de masse of l'Ecole pratique des Hautes études, in Paris. The Centre publishes the basic review '*Communications*', with the collaboration of linguists, sociologists, historians, psychologists and other specialists in the human sciences. The 'Agostino Gemelli' Institute for the experimental study of the social problems of visual training, in Milan, which publishes the review '*Ikon*', occupies a closely similar position, stress being at present laid on the psychological aspects of the problem.

All serious scientific study will in future have to be based on well-organized experimental research, necessitating an abundant and complete supply of film material. The comprehension and definition of the unity of a film presupposes a close analysis of its morphological elements.

Only by the detailed study of a large number of films can errors and misconceptions be avoided.

Film libraries, specialized schools and institutes must understand the cultural importance of the current situation and find how best to adapt themselves to it.

(Original: Italian)

VI. ARCHITECTURE AND TOWN-PLANNING, *by Françoise Choay*[*]

1. A DISCIPLINE FINDING ITS FEET

Origins

Three groups of works in particular can be regarded as having contributed since the 1940's to undermining the traditionally aesthetic approach to architecture and town-planning. L. Mumford[1] centred his work on the correlation between the organization of space and social value systems. In particular, he saw contemporary town-planning in terms of a crisis in civilization and violently contested the proposals put forward by the CIAM[2]. S.

[*] University of Paris-VIII and Ecole Nationale Supérieure d'Architecture et d'Arts visuels, Brussels.

1. His major book on the subject, *The Culture of Cities*, was published in 1938. Many others preceded (e.g., *Sticks and Stones*, 1924) and followed it (e.g., *The Highway and the City*, 1953).

2. Congrès internationaux d'Architecture moderne, founded in 1928 at La Sarraz, Switzerland. *The Athens Charter*, which resulted from the 1933 Congress, clearly sets forth the ideology of the 'rationalist' architects among the CIAM's members.

Giedion[3] developed the functionalist approach (in accord with the CIAM ideology) and showed very clearly the part played by technological invention in the morphogenesis of built-up space. E. Panofsky[4] and R. Wittkower[5] – both products of the Warburg Institute – explored the symbolic aspect of built-up and revealed the links which, under the influence of historical circumstances, unite it with contemporary ideologies and knowledge.

A new set of space problems

However, over the past fifteen years or so studies relating to town-planning and architecture have undergone a more profound and more general transformation. This took place under the pressure of a whole series of factors which confronted architecture and town-planning with a new set of problems arising for the first time, on a world scale and in a world-wide setting.

Among these factors, of which we shall name only the most important, we must first mention the world process of urbanization, a source of problems of a quantitative nature (the rate of production of housing, for example), but above all of dangers of a qualitative character: pathogenic population densities, pollution of both the natural and the cultural environment, acculturation (in the urbanization of certain developing countries).

Mention must then be made of the crisis through which the profession of architect-town-planner is passing. The archaic nature of its organization has been suddenly discovered and analysed both in economic terms[6] and also in epistemological terms: its corporative character is denounced, while the spectre of the system analyst, the new *homo universalis*, who would replace him in his task of designing and arranging, is paraded before the aesthetic-practioner[7]. At the same time, the teaching of architecture and town-planning is also going through a crisis[8] of which the death throes of the Ecole des Beaux-Arts in Paris were just one spectacular phase, and which might be symbolized by the disaffection witnessed in all Schools towards the traditional 'projects' and drawing and the popularity of pluridisciplinary approaches.

K. Frampton observes that 'technique appears today as the most contro-

3. See, in particular, *Space, Time and Architecture* (1941) and *Mechanization Takes Command* (1950).

4. Cf. in particular 'Abbot Suger of Saint-Denis' (1946) and *Gothic Architecture and Scholasticism* (1951).

5. Cf. *Architectural Principles in the Age of Humanism* (1961).

6. L. SCHEIN writes: 'For two centuries and more nothing, absolutely nothing, has changed in the practice of a profession which produces all the places where men, ideas and things are born, live and disappear ('Ledoux et notre temps', 1971).

7. ABEL, 'A come-back for universal man' (1969).

8. Cf. in particular, MALDONADO, '*Training for the Future*' (1965); *Proceedings of AIA/ACSA Teachers' Seminar, Montreal* (1969); the journal *Architecture. Mouvement, Continuité*, Nos. 14 and 16, Paris, 1969 and 1970; FRAMPTON, 'Polemical notes on architectural education' (1970).

versial aspect of the architectural object'.[9]

Furthermore, studies relating to architecture and town-planning have been influenced by the opening up of a political horizon. G. C. Argan was one of the first to analyse and stress the ideological and political aspect of arranged space, more particularly in his article-manifesto, 'Architettura e ideologia' (1957). But he confined himself to a speculative and historical approach, 'demystifying' the Bauhaus 'rationalism', for instance. Since then, social conflicts, and more especially the events of May 1968, have contributed to the full recognition of this aspect[10], which implies the inclusion of architecture and town-planning amongst the instruments of the class struggle and furnishes support for action. H. Lefebvre[11], one of those who have contributed most to demonstrating the political significance of built-up space, notes: 'The postulate of an objective and neutral space was preserved. But now it appears that space is political. Space is not a *scientific object* misappropriated by ideology or politics, . . . [it] is political and ideological'.

2. GENERAL CHARACTERISTICS OF CURRENT RESEARCH

The result of this situation was that architecture and town-planning were given wide significance and integrated in the total field of human action. Architecture and town-planning are tending to become an integral part of anthropology and, as such, from the standpoint of current research, come within the scope of what are called the human sciences and also within that of the natural sciences.

The eclipse of aesthetics

This new appropriation has taken place at the expense of the aesthetic approach to built-up space, which is tending more often than not be abandoned, as is the case, for example, with J. Jacobs or Ch. Alexander. At best, having fallen from the status of master to that of servant, it is subordinated to some other form of approach – psychological (K. Lynch), political (H.Lefebvre), semiological (G. Dorfles) – or else it assumes a disguised form as with J. Johansen[12] and R. Banham[13]. Actually when these champions of 'anti-architecture' and 'anti-art' define building activity as 'anti-perfection,

9. 'Polemical notes. . . .' (1970).
10. Cf. the two French journals, *Utopie. Sociologie de l'urbain* (1968) and later *Espaces et sociétés* (1970) published by Anthropos, Paris,
11. 'Réflexions sur la politique de l'espace' (1970).
12. The architect J. JOHANSEN launched in succession the concepts of 'action architecture' (based on that of 'action painting') and 'anti-architecture'. He states suggestively: 'In fact there will be no need to compose once we shift to the idea of free life-generating assemblage rigged on an ordering device which may be structural, transportational, distributional'. Cf., as also for the next quotation given here, his articles, 'Johansen declares himself' (1966) and 'The Mummers Theatre' (1968).
13. BANHAM militates for 'a genuinely functional approach without cultural pre-

anti-masterwork, without pretensions to architecture', their anti-aestheticism is a dialectized form of aestheticism.[14]

Work situated unequivocally on the plane of an aesthetic remains the exception.[15] It is then influenced by the semantic or semiotic research of contemporary literary criticism, as for instance the analytical studies in which R. Venturi[16] makes ambiguity the key value in architecture and shows how the architect can take over the Pop vocabulary and incorporate it in a different syntax and a different semantic.

This disaffection toward aesthetics is, of course, a reactionary attitude; but it must also be connected with the present crisis of the 'avant-garde' in the plastic arts.

Multiformity

The epistemological transformation aimed at restoring to built-up space its

conceptions' which views architecture solely from the standpoint of its practical efficacity in the context of an industrial society which has now entered the electronic age. His condemnation of design and of any kind of formalism – his lack of interest in the 'envelope' – leads him to define architecture in terms of equipment and mechanical servicing. For him the real technological revolution of the nineteenth century was the discovery of 'regenerative' installations, 'environment management by the consumption of power in regulative installations, rather than by simple reliance on conservative and selective structures'. The devices which make it possible to maintain optimal constants in the human environment, such as central heating, electric lighting, sound-proofing, air-conditioning, are the real tools and should be the sole determinants of the new architecture. (Cf. *The Architecture of the Well-Tempered Environment* (1969). See also the 1965 and 1968 articles republished under the title, 'The architecture of Wampanoag', in JENCKS & BAIRD (eds.), *Meaning in Architecture*, 1969). But his lack of trust in regard to historic buildings and formal architecture finally leads him to a 'pop' aesthetic: with economic activities and the technology of transport, it is popular culture and not design which shapes the landscape. He gives a brilliant demonstration of this in respect of Los Angeles in *The Architecture of Four Ecologies* (1971).

14. Cf. BOYD, 'Anti-architecture' (1968) and *The Puzzle of Architecture* (1965), which is a history of modern architecture from the 1920's to the present time and constitutes an apologia for the 'third phase' – expressionist, brutalist, etc. – of modern architecture represented by L. Kahn, K. Tange and even J. Johansen.

15. One such is V. SCULLY: cf., for example, 'L'ironie en architecture' (1962), treating irony as the key value in an architecture which, after having traditionally served as a means of expression of divine transcendence, is doomed, 'now God is dead', to portray in aesthetic terms the existentialist vision of man's estate.

16. Not only in present-day architecture: in his view the semantic richness of Italian baroque is also based on ambiguity: cf. his essay *Complexity and Contradiction in Architecture* (1966). On the relationship with Pop, see the articles by SCOTT BROWN, 'Il "pop" insegna'/'Learning from Pop', and by FRAMPTON, 'America 1960-1970. Appunti su alcune immagini e teorie della città'/'Notes on urban images and theory' (followed by SCOTT BROWN's reply) and their bibliographies, in the double bilingual issue of *Casabella* (1971) entitled *The City as an Artifact*. Cf. also GREGOTTI, 'Kitsch e architettura' (1968) (English translation, 'Kitsch and architecture', 1969).

multiformity has had as its immediate effect a decompartmentalization and a splitting up of research, which combines its entry into new fields with new methods of investigation. On the one hand, a group of research workers not connected with town-planning and architecture have opened up their disciplines to the problems of built-up space and introduced in them new concepts. A few typical contributions may be recalled in this connexion. For instance, among the specialists in animal and human behaviour[17], the ethologists (I. B. Calhoun, J. Christian, H. Hediger, P. Leyhausen, K. Lorenz, V. C. Wynne-Edwards, etc.) drew attention to the idea of living space and territoriality and emphasized the correlations that exist between aggressiveness and population density. Next must be mentioned the contribution of psychiatrists and psycho-analysts[18] such as A Mitscherlich[19], who considered the shortage of built-up space to be a contributing factor in the genesis of neurosis and, confirming K. Lorenz's findings[20], put forward the idea of 'thresholds of denaturalization' in order to apply it to the environment. We must also mention the part played by the biologists[21] who proposed applying to the analysis of cities the theory of systems by means of which they are trying to elucidate the functioning of organisms.

On the other hand, art historians and architects have, for their part, engaged in a vast 'recycling' operation in order to bring their practice into line with a whole range of new methods, new knowledge and new know-how, which can be regarded as amounting to what M. Foucault would call a new *epistēmē*. In this connexion mention should be made, in particular, of the information theory and its applications (data processing and cybernetics), linguistics, in so far as it seems to make possible the unification of the fields of biology and anthropology and, lastly, epistemology, which, through the work of G. Bachelard and J. Piaget, affords a new insight into the processes of production of living space. In this general heightening of sensitivity to the electronic age, M. McLuhan's work has exerted a decisive influence in

17. Some idea of the importance of their contribution can be gained from the excellent anthology, *Environmental Psychology*, compiled by PROSHANSKY, ITTELSON & RIVLIN (1970).

18. Cf. the works of J. C. Lilly, D. F. Duffet, L. Stratton, or again the research mentioned in the bibliography in DUHL (ed.), *The Urban Condition* (1963) (in the contributions by E. Lindemann, L. J. Duhl and B. P. Dohrenwend in particular).

19. *Die Unwirtlichkeit unsere Städte* (1965).

20. Cf., in particular, LORENZ, *Über tierisches und menschliches Verhalten* (1965).

21. Cf., for example, the three articles published under the general title 'Living systems' (1965) by J. G. MILLER, in which the latter indicates the precautions to be taken when dealing not with living systems but with their 'artifacts', which 'have important systems characteristics which can be studied for themselves alone so as to understand the living systems that produced them ...', but ... are not living systems' (p. 223). Arranged space is, in his view, just such an 'artifact' and he refers to it on several occasions. He also gives a bibliography of similar approaches, such as GIFFORD, *The Nature of the Cities as a System* (1962) and SIMON, 'The architecture of complexity' (1962).

architectural circles in the English-speaking countries.[22]

Another notable feature is the impact of the structuralist method on a series of European works, whereas the behaviourist approach continues to predominate in the United States.

Some hesitancy is therefore to be noted in research and it is heightened by the very nature of built-up space, which serves both utilitarian and symbolic purposes, being at the same time a technical instrument, a material environment and a field open to symbolic creation. Actually, this aspect of built-up space is only rarely recognized. Yet in research work generally it gives rise to an overlapping of angles of approach which, whether involuntary or deliberate, is never explicitly admitted by authors. In our view, however, we must distinguish between four levels of approach to built-up space which are always confused. They involve respectively: the collection and accumulation of information, often quantifiable, relating to organized space (*eco-graphy*); the consequent theorization (*eco-logy*); the application of that information in practice (*eco-praxis* or *eco-therapy*); and its integration in a system of values (*eco-ideology*).[23]

Further, the fact that the deliberate organization of built-up space rests on value options gives a polemical bias to studies, most of which are motivated by a wish to escape alienation. This polemical aim, and consequently the rôle of the fourth approach (*eco-ideology*) in relation to the others, varies in importance according to the author. In some cases its predominance is such that it is questionable whether the term 'research' is appropriate for the work in question. *Ecography* is of little significance for authors such as J. Jacobs[24] or H. Lefebvre[25], for instance, when they rail against present-day town-planning and accuse it of being incapable of promoting real social relations. When the one takes up the defence of the street, economic wastage and inefficiency[26] and the other that of centrality, festivity and *consumation,* their assertions are based on nothing but emotion. They rest on the postulate of the perdurability of the urban phenomenon,

22. McLUHAN's impact on the architects of English-speaking countries has been considerable since the publication of *The Gutenberg Galaxy* (1962). Some idea of it can be gained from the following observation by BOYD in 'Anti-architecture' (1968) concerning the attitude of the English group *Archigram*: 'It is fascinated by the population explosion and plugging-in and pop, by McLuhan of course and by systems and electronics . . .'.

23. These neologisms, which are not as happy as we would have liked, are here intended merely to mark more clearly a distinction too often overlooked. We fell back on the root *eco* (already in current use in the term 'ecology' with a wider sense than ours) because *architecture* or *tecto* seemed to us to be too restrictive and *poli* too wide and ambiguous.

24. *The Death and Life of Great American Cities* (1961); *The Economy of Cities* (1969).

25. *Le droit à la ville* (1968); *La révolution urbaine* (1970).

26. 'Cities are indeed inefficient and impractical, but I propose to show that these grave and real deficiencies are necessary to economic development and are thus exactly what makes cities uniquely valuable to economic life.' – JACOBS, J., *The Economy of Cities* (1969).

unconditional faith in its value[27] and an urban model borrowed from the pre-industrial era[28]. However, these works, committed as they may be to liberal humanism or neo-Marxist humanism, are rich in ideas, both because they introduce new sets of problems[29] and because they call for new research and new analytical studies concerning the real purpose of the street, the concept of centrality, the part played by economic decision-makers in the production of living space, etc.

Political ideology preponderates similarly in a series of authors who, like A. Medam or M. Castells[30], nevertheless grapple with *ecographical* data, systematically assembled and compared, and try to construct tools for theorizing.

Elsewhere *ecography* and *ecology* play more important parts and the rôle of *eco-ideology* is perhaps all the more disturbing on that account. Such is the case with H. Laborit, who, in his most recent work[31] furnishes valuable information on the function of phylogenetic mechanisms in the structuration of the spatial field, advances a theory concerning the individual/environment relationship founded on cybernetics and the systems theory and, finally, bases the dialectic of built-up space on a conception of the class struggle. R. de Fusco, whom we shall meet again later, similarly makes his semiological approach to space dependent on a theory of political and cultural history and a strategy designed to promote the mass culture of the modern proletariat through the compilation of a specific urban code.

Elsewhere the incidence of theories and value systems is less evident although just as determining: the observations and experiments of K. Lynch[32] on the legibility of the city are conditioned both by a Gestaltist conception of space and by an optimistic ideology of needs, which is also to be found at the root of Ch. Alexander's proposals.[33]

It is not possible in the space available here to review the progress made in *ecography*. We shall confine ourselves to emphasizing the importance of the work in geography[34] and mentioning the considerable development of a qualitative and quantitative sociography.

27. 'the development of society is conceivable only in urban life, through the realization of the urban society'. – LEFEBVRE, *Le droit à la ville* (1968).

28. This model shows through, in spite of everything, in some of H. Lefebvre's assertions, as for instance, 'the loftiest urban creations, the most beautiful works of urban life (beautiful, as one says, because they are works rather than products), date from periods prior to industrialization' (*ibid.*).

29. Cf. their 'demystification' of design as proceeding from micro-groups of decision-makers (the representatives of a class according to H. Lefebvre, the inheritors of a caste according to Jacobs), of whose ideology it is the alienating expression. Cf. also Lefebvre's application of Marxist categories of 'use value' and 'exchange value' to urban space.

30. MEDAM, *La ville censurée* (1971); CASTELLS, *La question urbaine* (1972).

31. *L'homme et la ville* (1971).

32. *The Image of the City* (1960).

33. *Notes on the Synthesis of Form* (1964).

34. Cf. for example, GOTTMANN, *La politique des Etats et leur géographie* (1952); GOTTMANN, SESTINI, TULIPPE, WILLATTS & VILA, *L'aménagement de l'espace: planification régionale et géographie* (1952); LABASSE, *L'organisation de l'espace* (1966).

In this latter field the qualitative studies, of which there are a vast number, are of unequal standard. However, the importance of the work centred on the user of space must be stressed. Three examples will give some idea of its interest.

In *Two Chicago Architects and Their Clients (1969)*, L. K. Eaton revealed the surprising part played in the genesis of Frank Lloyd Wright's style by his first clients – self-made and new-rich – untrammelled by tradition.

In a work which made a big impact in architectural circles, Ph. Boudon[35] studied the transformations effected by the inhabitants of the famous Pessac site in the houses imposed on them by Le Corbusier. Lastly, on the occasion of an operation undertaken in the thirteenth arrondissement of Paris, H. Coing produced an excellent study of urban renovation from the point of view of the people affected by it: his work *Rénovation urbaine et changement social* demonstrated the relationship existing between the praxis of space and the whole range of social behaviour and showed how the inhabitants' tolerance or acceptance of renovation, that is, of a new structuration of space, is conditioned by the possibility of an overall restructuration of their social behaviour and value systems.

In conclusion, research on architecture and town-planning, although it has set about building up a stock of information on many aspects, is still caught up in a web of confusion and contradiction which has so far prevented it from making final the 'epistemological break' about to mark the birth of a new discipline. It is this ambiguous transitional situation, this state which heralds a mutation yet to take place, which it seemed to us essential to touch on here.

Some particularly fruitful lines of research will be dealt with in greater detail in the following section of this study, which is centred chiefly on *ecology* and *eco-praxis*.

3. PRIORITIES IN ECO-PRAXIS: APPRAISAL AND CHANGING OF METHODS

The new trends in the discipline which arranges space reflexively *(eco-praxis)*, if they had to be summed up in all their diversity under one common denominator, might be chararcterized by the fact that they all call in question the methods and processes of town-planning and architecture advocated by the CIAM. This opposition to the CIAM takes two forms, one critical and negative, the other constructive, with the suggestion of novel procedures.

An epistemological criticism

The main feature of this criticism, which started to develop in the 1960's, is that it is essentially aimed at the scientific pretensions of earlier building

35. *Pessac de Le Corbusier* (1969).

procedures, that, for the first time, effecting a veritably Copernican reversal, instead of tackling the *achievements* of architecture and town planning (as did L. Mumford, for instance), it is directed at the *guiding principles and methods* on which those achievements rest.

The first level of analytical study, which originated with the work of G. C. Argan, consisted of demonstrating the impact of ideology and ideologies on the alleged 'objectivity' of arrangement and design. Thus, in *L'urbanisme, utopies et réalités* (1965), we showed how all the proposals for the arrangement of space formulated since town planning emerged at the beginning of the nineteenth century are modelled on two ideological patterns, which we called progressist and culturalist. H. Lefebvre took up these ideas for the purpose of exploding the myth of town-planning and showing that this discipline does not exist in its own right and that concerted space is only a product of the leading classes – a theme whose development would gain if the concept of class were replaced by that of directing group (as H. Lefebvre himself would probably agree), but a theme which, in its initial form, has become the somewhat sterilizing *leitmotiv* of most the Marxist interpretations of space.

A second level of analytical study is concerned with the logical process of the town-planner's and designer's conceptual approach. In this connexion we would emphasize the seminal value of Ch. Alexander's *Notes on the Synthesis of Form* (1964). While his concrete proposals were very soon criticized by the author himself, this work is nevertheless the first to deprecate the actions of those who are content to criticize the built-up environment and propose new models without going into the question of how they should be constructed. (It is precisely in this way that the Athens Charter proceeds). In Alexander's view, this is the only problem for criticism and it is in the name of logic and modern mathematics that he tears to pieces the former divisions of space.

The critical work of the English group, *Archigram*[36], founded in 1961 by P. Cook and C. Price, was just as decisive. However, this is in lighter vein and it is in a joking humorous fashion, mainly through pictures and comic strips, that the group wages a war with no quarter on the concepts passed on by tradition (including those relating to architecture and cities), hunts for signs of anachronism and denounces the compartmentalization of knowledge in which the building profession is bogged down. The object is to remove the epistemological and epistemic obstacles which stand in the way of revolutionary liberation of architecture and town planning.

36. Cf. the publication under the same name (Nos. 1 to 9 collected in one volume in 1969); the numerous articles and drawings published by members of the group in the journal *Architectural Design*; and Cook, *Architecture, Action and Plan* (1967) and *Experimental Architecture* (1970).

Praxis

According to *Archigram* the way to achieve liberation is to give power to imagination. This explains the importance attached to the production of pictures. Rather than actually building, the members of *Archigram* first set about building in pictures systems of forms never seen before, organizations springing out of nowhere, which were to condition the new generation of architects all over the world.

If we try to determine the principles underlying this research, deliberately open and without principles, we might say that it gives preference to the qualities of mobility, lightness, transformability, precariousness and indetermination and that it is an attempt to appropriate and integrate all the elements which jointly and spontaneously go to make up the new denaturalized environment of industrial society, such as the technology of communications and telecommunications in particular.

Examples are the 'walking city' on telescopic feet by R. Herron (1963), the 'plug-in city' by P. Cook (1964, inspired by the metaphors of mechanical or electrical plugging in), the 'Potteries Thinkbelt'[37] of C. Price, constituted of motor cars, the 'Instant City' (*Archigram,* 1969), conceived of as a parachutable circus composed chiefly of light and sound: these cities emerging fully fledged from drawings are at the root of two new basic concepts, that of the instantaneous organization of space and that of plugging in.[38]

This determination to refuse the traditional constraints has been taken so far that R. Banham, P. Barker, P. Hall and C. Price proposed a 'non-plan' for the development of a region in England.[39] Apart from the picturesque aspect of its proposals, *Archigram* derives its importance in the main from the fact that although animated by an empirical spirit curiously hostile to theory, this group is aiming at a decisive step in the planning of space which would rescue it from the omnipotence of 'models' which, after the analytical studies of J. Derrida, we personally regard as a legacy from Platonic thinking and one of the brakes on creativity in the field of architecture and town-planning. By giving a free rein to the spontaneity of imagination and short-circuiting the *a priori* character of concepts by pictures, *Archigram* is trying to make drawing productive again.

This attitude must not be confused with that of the 'visionary' architects enwrapped in a technological formalism or with that of pure science fiction. On the other hand, the French group *Utopie* formed in 1967 was imbued with the *Archigram* spirit. For this group the significance of the architec-

37. Project for a university centre in which the basic unit is a mobile house and the teaching cells are accommodated either in collective vehicles or in light temporary structures, published with a Manifesto article under this tilte (1966).
38. 'The plug-in idea, or the idea that various systems are semi-autonomous, change at different rates,' leads up to the conception of 'a basic structure with a forty year span system' into which a series of other systems with spans never exceeding twenty years are plugged.
39. BANHAM, BARKER, HALL & PRICE, 'Non-plan: an experiment in freedom' (1969).

tural revolution is primarily political, however. Looking to the future, the 'Utopians' have, in particular, explored the resources of 'dilatable cities' for a new mobile and variable environment.[40]

Ch. Alexander's critical work results in an opposite methodology. The concept of design is no longer abandoned, but preserved in a suitable logical and mathematical framework. Alexander regards any constructive solution as the answer (which can be formalized and optimized) to a problem, a given situation, whose physical (climatic, topographical, etc.), psychosocial, economic and other elements must be analysed objectively and correctly. These factors of the object constructed therefore correspond to an analytical statement of the *needs* and we see that, unlike *Archigram,* Alexander does not concern himself with *desires.* It is nevertheless evident that, once this limitation has been recognized, the methods of logical breakdown advocated by Ch. Alxander prove highly effective and can constitute the basis of a neofunctionalism. He himself, in an article of 1966 entitled 'A city is not a tree',[41] showed the inadequacy of a dichotomous breakdown 'as a tree', the over-simple logic of which is a characteristic of all the creative work of town-planning. As against this he set the semi-trellis-work structure which according to him is revealed by an analytical study of the old spontaneously grown cities. Subsequently the complexity of urban patterns led Alexander to turn to the model of self-regulating biological systems. Here, however, he encounters obvious contradictions and difficulties when he develops his concept of a generating system, which he defines as 'a kit of parts with rules about the way these parts may be combined', asserting that 'in a properly functioning building, the building and the people in it together form a whole, a social, human whole. The building systems which have so far been created do not in this sense generate wholes at all'.[42] Alexander foresees a future in which 'the designer becomes a designer of generating systems.[43] But this assumes that the theory of living systems is applicable to the artefacts of Man.

Mention must be made of an important body of work done by followers of Alexander ranging from the research carried out by G. Broadbent[44] on the use of data processing, to that of L. March[45] and his team on systems and the application of mathematics to the search for models of 'densification' of inhabited space and the distribution of new centres of population, and passing by way of the research work of N. Negroponte[46] – ambitious but as

40. Cf. the dilatable city, *Dyoden,* drawn by J. P. Jungmann as a member of the group *Utopie.*

41. Cf. also his more recent self-criticism in an interview which he gave Max Jacobson in 1971.

42. ALEXANDER, 'Systems generating systems' (1968).

43. *Id., ibid.*

44. Cf., in particular, BROADBENT, 'Design method in architecture' (1967) and 'Portsmouth symposium on design methods in architecture' (1968), and BROADBENT & WARD (eds.), *Design Methods in Architecture* (1969).

45. 'Homes beyond the fringe' (1967).

46. *The Architecture Machine* (1970) (this work contains a very full bibliography).

yet not very conclusive – on the participation of the computer in the processes of design.

Some architects, attempting to use logic synthetically rather than analytically and attracted by the work of both Chomsky and semioticians such as Ch. Peirce, have attempted to work out a semiological method for architectural composition. As early as in 1964 L. Moretti[47] took the binary structure of data processing systems and the group theory as a starting-point for studying the formation and the transformations of the series of relations (structures) which link and organize the component parts of architectural forms. The criteria for critical appraisal as also for creative work were provided both by the number of integrated structures and by their isomorphism.

In recent years P. Eisenman has endeavoured to work out an architectural syntax which would enable him to produce forms and meanings without reference to any context. Behind the function and aspect of buildings (their superficial structure) he tries to discover the 'deeper structure' which makes possible their creation and consists only of 'relationships between relationships, defined by the three primary physical systems of line, plane and volume'.[48]

A very original synthesis of the three approaches described above was developed in Spain by R. Bofill's studio.[49] Every project starts with an image on which the whole team works and more especially the poet and writer who are members of the team. Then comes the mathematical generation of a formal structure and its comparison with the requirements (social, economic and legal) revealed by factorial analysis. Since 1964 all the *Taller de Arquitectura*'s projects have been worked out on the basis of this dialectic between 'the *a priori* ideas on the organization of space' and 'the findings of analytical studies concerning the actual needs...., possibilities.... and constraints', which leads to the creation of 'urban models' whose implementation is under constant control as the result of a complex system of representative codes.

Lastly, among new practices, limited, however, to the level of strategy, mention must be made of the whole series of methods of simulation. A wide variety of town-planning games,[50] ranging from the psychodrama *in situ* to devices involving the handling of computers, and including some kinds of 'Monopoly', were first developed in the United States. Although difficult

47. Cf. an article by him published in English in 1966, 'Form as structure', repeating some of his earlier analyses.

48. GANDELSONAS, 'On reading architecture' (1972).

49. Cf. the most recent summing up by Anna Bofill, *Rapport sur la rationalisation du processus de travail du Taller de Arquitectura* (mimeographed document submitted at the second E. Galion international seminar, 'La concrétisation en mathématique', held at Fryksas in July 1971).

50. Cf. CALDER, *The Environment Game* (1967); DUKE, *Gaming Simulation in Urban Research* (1964); RASER, *Simulations and Society. An Exploration of Scientific Gaming* (1963); TAYLOR, J. L., *Instructional Planning Systems. A Gaming Simulation Approach to Urban Problems* (1971).

to apply when it comes to real decision-making, they do sensitize players, at the symbolic level, to the complexity of problems of space arrangement and they have considerable educational value both for students and for the general population and also for specialist authorities (local communities, for example).

On the whole, work looking to the future is techno-sociological in nature (see, in particular, the studies on space in a famous issue of *Daedalus*[51] or the large body of research on individual aspects such as transport carried on within bodies such as the Rand Corporation).[52] Meanwhile, Ch. Jencks has just written a book on styles and trends in architecture around the year 2000,[53] which brings out very clearly the therapeutic and prophylactic value of 'prediction'. As for the scenario method once in favour with the decision-makers concerned with town- and coutry-planning (Datar in France), it now seems to have been abandoned.

4. GENERALIZED RELATIVIZATION

The contribution of history and ethnography

Going beyond the accumulation of information to advance explanatory hypotheses and theories presupposes that the latter can be corroborated by the introduction of variables and the comparison of findings. However, despite the arguments advanced by an author such as R. Sommer[54] in respect of certain limited and specific cases, experimentation with built-up space is rarely possible. It has to be replaced by the more abstract method of comparing the structures and functioning of built-up space in time and/ or geographical space by means of documents supplied by history and/or ethnography and cultural anthropology.

History

Opportunities for historical comparison have been singularly increased in the last few years owing to the interest which general historians have themselves shown in the material history of towns – an aspect which they had long neglected. Evidence of this is to be found in the activities of the Commission Internationale des Villes, which has sponsored the publication first

51. BELL (ed.), *Toward the Year 2000. Work in Progress* (1967). See, in particular, the contributions by BELL, 'The year 2000 – The trajectory of an idea', PERLOFF, 'Modernizing urban development', and PIERCE, 'Communication'.

52. Cf. LOWRY, *Seven Models of Urban Development* (1967).

53. *Architecture 2000: Methods and Predictions* (1970).

54. In *Personal Space* (1969), where he proposes, in particular, experiments on psychiatric space and prison space with a view to meeting the real needs and desires of the inmates.

of national bibliographies of the history of towns[55] and then of anthologies of sources of the history of towns,[56] as also in the Congress of Urban History held at Princeton in 1969 and in the recent publication by the review *Annales* of a special issue devoted to *Histoire et urbanisation,* echoed in the United States by S. Thernstrom's article on the necessary changes in urban history,[57] which appeared in the issue of *Daedalus* on *The Historian and the World of the Twentieth Century.* Historians are starting to go through the archives of towns methodically. Data processing of certain Community archives by computer has already yielded interesting results for those concerned with quantitative history, such as E. Le Roy Ladurie, who studied leases and rentals in Paris over a period of nearly four centuries.[58] Diachronic comparison of cadastral documents, demographic statistics and legal or economic texts will give an account of structural changes in the urban environment and consequently throw light on their significance.

Today, however, all theoreticians dealing with built-up space tend to become historians. The diachronic approach is becoming more general, serving as a test for other approaches or theories — Marxist with L. Benevolo,[59] psycho-analytical with J. Rykwert,[60] semiological with E. Kaufmann[61] or M. Tafuri,[62] prospectivist with Ch. Jencks.[63]

The structuralist method — whether or not assumed as such, according to the circumstances — underlies a considerable part of this historically based research, which, carrying further the work started by E. Panofsky and P. Francastel, has emphasized the discontinuity of spatial creation and systematically related it to discontinuous bodies of knowledge and know-how.

The big break in continuity brought about in the nineteenth century by the industrial revolution has been studied by K. Frampton and myself from a semiological standpoint, as will be seen later.

So far as the twentieth century is concerned, M. Webber[64] is perhaps the first to have denounced, as early as 1963, the lack of synchrony in the planning and arrangement of space by present-day town-planners and the irrelevance of the concepts of towns and of urban centres in an age characterized

55. For Scandinavia, Switzerland, Germany, Great Britain; the latest one is the *Bibliographie d'Histoire des villes de France,* prepared by Dollinger & Wolff (1967).

56. Cf. *Elenchus Fontium Historiae Urbanae* (eds. van de Kieft & Niermeyer) (1967).

57. 'Reflections on the new urban history' (1971).

58. Le Roy Ladurie & Couperie, 'Le mouvement des loyers parisiens de la fin du Moyen Age au XVIIIe siècle', in the special issue of *Annales* on *Histoire et urbanisation* mentioned above (1970).

59. *Storia dell'architettura moderna* (1965) (English translation, *History of Modern Architecture,* 1971/72); cf. also *Roma da ieri a domani* (1971).

60. *On Adam's House in Paradise* (1973).

61. *Architecture in the Age of Reason: Baroque and Post-Baroque in England, Italy and France* (1961).

62. *Teorie e storia dell'architettura* (1968).

63. *Architecture 2000: Methods and Predictions* (1970).

64. 'The urban place and the non-place urban realm' (1964).

by the development of communications and telecommunications, when the ideas of openness and decentralization are an integral part of the *epistēmē*. Webber does not, however, explain the reasons for what he considers a scandalous discrepancy: we put it down to the interference in the West of two tempos in history and the resistance which the slow cycles of the heavy history offer to the accelerated speed of rapid history.

Ch. Jencks, for his part, bases his history of architecture from 1920 to the year 2000[65] on constellations in the making, which can be treated by means of prospective studies and organized around six permanent structures of mentality which he designates by the following terms: logical, idealist, self-conscious, intuitive, activist, un-self-conscious.

Ethnography

Ethnographycal material allows of more radical comparisons and, through its exoticism, can bring out even more strikingly the cultural programming of the built-up environment.

Unlike general historians, the ethnographers and anthropologists do not seem anxious to contribute documents of a nature to promote the study of space.

Wide use has been made by space theoreticans of Cl. Lévi-Strauss's well-known work on the arrangement of Amazonian villages, but it does not seem to have left any significant traces in ethnography, apart from a few exceptions, amongst them the research directed by P. Bourdieu.[66] The study of space in non-industrial societies can, however, be expected to take on a new impetus following the Frobenius Congress on African Space held in the summer of 1972, in particular.

Up to present time, indeed, we can mention only two books written by an anthropologist attempting systematically to reveal the existence of the hidden cultural structures of the environment. In *The Silent Language* (1959) and *The Hidden Dimension* (1966), E. T. Hall studies in particular, under the name of 'proxaemia', the variety of the methods of organizing space according to cultures and brings out the considerable differences to be found even within Western culture and in peoples apparently so alike as the English, the French and the Germans. These works, the material for which the author drew from a variety of scientific and literary sources, call for more far-going research. They made a great impression on the architects and town-planners for whom they were specially intended, however, and they contributed to the weakening of the universalist positions of the CIAM, which was seeking to impose throughout the world the 'rational' Western models of architecture and town-planning.

As a matter of fact, these positions were also opposed by architects and

65. *Architecture 2000: Methods and Predictions* (1971).
66. Cf. Bourdieu & Sayad, *Le déracinement* (1964); and Bourdieu, 'La maison kabyle' (1970).

town-planners from the beginning of the 1960's. Some, taking a more aesthetic viewpoint, set against the functionalism of industrial societies the vernacular functionalism which they discovered in 'architecture without architects".[67]

This experience, which was the same as that of A. van Eyck[68] among the Dogon, is well described by J. Stirling with reference to the anonymous architectures of Europe of which he states that 'though dating back to mediaeval time they are particularly modern, suggestive of the early ideas of Functionalism, but less of the machine aesthetic, which was primarily a style concern'.[69]

Others, who have made a decisive theoretical contribution to the relativization of built-up space were nevertheless motivated in their research by practical demands[70] and the need to solve the problems created by urbanization in developing societies and, at the level of ethnic minorities, in developed societies. It was Ch. Abrams[71] who was the first, in the United States, to show that the 'CIAM' system of values was inoperative in the rehabilitation of ghetto districts and to demonstrate the part played by a feeling of security and the importance of the participation of the inhabitants in the development of a district. This pioneer work was taken further and given a more general application by Ll. Rodwin's team at the M.I.T. and, in particular by J. Turner,[72] who had become the principal expert for the developing countries. In his view, the challenging of Western criteria for development, which are claimed to be universal,[73] and the importance attached to participation[74] lend up to the rehabilitation of the 'spontaneous urban colony', squatting and shanty towns and the framing of a policy for the development of space at State level, the task of the State in a world in the process of urbanization being no longer defined in terms of construction but in terms of land control. 'The task of transforming incipiently industrial cities with huge low-income populations into fully equipped modern cities, far in advance of the necessary resource development, is clearly hopeless. If

67. Cf. RUDOFSKY, *Architecture without Architects* (1965). The objective chosen by Rudofsky is to 'break down our narrow concepts of the art of building by introducing the unfamiliar world of non-pedigreed architecture'.

68. Cf. 'The interior of time' (1969) and 'A miracle of moderation' (1969).

69. STIRLING, 'Functional tradition and expression' (1960).

70. In the present study we are confining ourselves to work connected with the 'spontaneous urban colony'. Mention should, however, be made of the research undertaken by certain builders on the space of foreign cultures for which they have to build: cf. RAPOPORT, *House Form and Culture* (1969).

71. ABRAMS, *Forbidden Neighbors* (1955) and *Housing in the Modern World* (1964).

72. See especially, *Uncontrolled Urban Settlement. Problems and Policies* (1966) (report prepared for the United Nations Centre for Housing, Building and Planning).

73. 'The mass-designed, mass-produced environments for an increasingly homogenized market of mass-consumers are no more than assemblies of material goods devoid of existential meaning.' – TURNER, 'Architecture of democracy' (1968).

74. '... freedom to manipulate one's own living space ... extended to the community as a whole.' – *Id., ibid.*

governments can be persuaded to abandon this thankless task and to concentrate on the provision of land and the control of its values and uses, instead of on the construction of buildings few can afford, the present situation can be greatly improved.'[75]

These ideas have already been applied on a wide scale, in Peru for example, where the Government finally accepted the 'barriadas' and called in architects like A. Van Eyck and J. Stirling to help in their development, or again for a time, in Morocco where under the impulsion of A. Masson, the C.E.R.F.[76] worked out a strategy opposed to the one introduced by M. Ecochard. Furthermore, in the United States, recognition of the right of ethnic or other minorities to specific living space led to the 'advocacy planning' championed by P. Davidoff,[77] according to which the planner has to become literally the advocate of the interests of the communities or minorities for which he works.

5. SEMANTICS OF LIVING SPACE

General remarks

The problems raised by urbanization and, in particular, the current accusation of insignificance or non-significance brought against the new environment have given rise, at the *eco-logical* level, to the questioning on an unprecendented scale of the significance and the way of signifying peculiar to the built-up environment. This questioning has been further intensified by the development and simultaneous popularization of the sciences of language and communication.

At the same time fresh interest has been shown in the theoretical writings of the past on living space. Over the past decade manuscripts have been published – Filarete,[78] Francesco di Giorgio Martini[79] – classical works have been reissued – Alberti[80] – as also have recent works no longer to be found – *Bauhausbücher*[81] – and critical editions of works out of print or abridged have been brought out – I. Cerda,[82] C. Sitte.[83]

A great deal of theorization based on the corpus of theoretical writings on living space is under way. In a more detailed analytical study it would

75. TURNER, 'Uncontrolled urban settlement' (condensed version), p. 122 in *Ekistics*, No. 135 (1967).

76. Centre expérimental de Recherche et de Formation, founded in 1967 by A. Masson. Cf. its publications under the aegis of the French Ministry of the Interior.

77. Cf. 'Advocacy and pluralism in planning' (1965).

78. *Filarete's Treatise on Architecture* (1965).

79. *Trattati di Architettura in ingegneria e arte militare* (1967).

80. *Ten Books on Architecture* (1965).

81. *Neue Bauhaus Bücher* (1965).

82. *Teoría general de la urbanización* (1971).

83. *City Planning according to Artistic Principles* (1965).

have been essential to deal separately with works using the human sciences in order to elaborate directly a theory of the built-up environment and the research work applying them to the study of this literature. Such a distinction cannot be made here. We shall confine ourselves to distinguishing two broad semantic approaches (of the literature and the environment itself), one of which we shall call hermeneutic (because it involves the decoding, through Marx and Freud, of a hidden meaning) and the other semiological.

The hermeneutic approach

We shall not dwell further on Marxist research – concerning which we have already pointed out that in France it was tending to become repetitive and one-dimensional. We must mention, however, the more open approach formulated, and then developed, by M. Cornu[84] on the basis of L. Althusser's ideas and P. Macherey's work, *Pour une théorie de la production littéraire* (1966).

On the psycho-analytical front, apart from the work of A. Mitscherlich,[85] mainly polemical, we must mention a first attempt to apply to built-up space Lacan's concepts of need, demand and desire. It is in this sense that C. Burlen analyses habitation in accordance with some of its signifiers, such as the garden of the suburban individual house owner – 'The main show-space' (*'espace-montre maître'*), 'a kind of relationship to others since they recognize the one who expresses himself through it.' Similarly, the author demolishes the functional approach: it lifts out of their symbolic setting all the fragments of everyday life [which then] split up into needs . . . stored away, arranged, catalogued (*'désinsère de leur contexte symbolique tous les fragments de la vie quotidienne [qui] se découpent [alors] en besoins . . . rangés, agencés, catalogués'*).[86]

However, the most successful research relates not to the environment itself, but to the literature concerning it. J. Rykwert derived from Jung's theory of memory a conception[87] of the history of ideas and theories of architecture, equated with a collective unconscious, knowledge of which he regards as the only way to a full understanding of the essentially symbolic meaning of human constructions (buildings or plans), those of the present day in particular: 'There is no humanity without memory and there is no architecture without historical reference'.[88] However, historical evidence is

84. 'Autocritique du critique' (1968) is the first of a series of articles contributed by CORNU over a period of four years to the journal *Architecture. Mouvement, Continuité.*

85. Cf. *Die Unwirtlichkeit unserer Städte* (1970) and *Thesen zur Stadt der Zukunft* (1972).

86. *La réalisation spatiale du désir et l'image spatialisée du besoin* (unpublished work); cf. the review by DREYFUS (1971).

87. RYKWERT, 'The sitting position – a question of method' (1965, 1967, 1969); the quotations which follow are borrowed from this essay.

88. RYKWERT, *art. cit.*, p. 242 in JENCKS & BAIRD (eds.), *Meaning in Architecture* (1969).

masked and distorted in precisely the same way as individual memories are by the censorship of the Unconscious. Shedding light on the present through history demands a reinterpretation of the latter and entails a new conception of historiography and the part played by the historian. 'As the psychiatrists have extended the area of responsible moral decision through exposing the pseudo-motives with which we rationalise our approval and disapproval, so they have also expanded the area in which rational discourse about design problems becomes necessary through making us aware of the strong emotional charge which symbolic forms carry. . . . The whole of environment, from the moment we name it and think of it as such, is a tissue of symbolic forms. . . . To understand how the situation can be managed we are forced to look to the past; no contemporary guide can offer real help here. This burdens the historian with a task to which he is not altogether used: that of acting as a psychoanalyst to society.'[89] Rykwert has just assumed this task in a work on the representation and theory, in the course of history, of the house of the first man.[90] In that work he questions the traditional aspects of the history of art, which he reduces to the rank of insignificant super-structures.

The semiological approach

Those who represent this trend consider that the sciences of language and communication should be used to deal with space (both architectural and urban) as a system more or less comparable with natural languages. The decoding and reading referred to here must not be confused with the concept of legibility developed by K. Lynch, for whom legibility[91] is a 'particular visual quality' making it possible to give the urban field a structure as a result of catalytic elements, the form and content of which vary from one culture to another and the respective importance of which varies from one individual to another in the same society, but which can nevertheless be classified in general categories: barriers, knots, landmarks, sectors, etc. Although the word *Gestalt* is not usually employed, the meaning is clear: (by) legibility of the cityscape . . . we mean the ease with which its parts can be recognized and can be organized in coherent pattern'.

Semiological research can be regarded as having had two originators. One of them, the historian and art critic, G. Dorfles, was impelled in this direction by his general knowledge of the problems of contemporary art and the methods of structural analysis used in literary criticism. The other one, a practitioner, Ch. Norberg-Schulz, was attracted by semantics and semiotics as a result of the crisis in functional architecture and the need to find new bases for practice.

 89. RYKWERT, *loc. cit.*
 90. *On Adam's House in Paradise* (1973).
 91. LYNCH, *The Image of the City* (1960); and *A Classification System for the Analysis of the Urban Patterns* (1964).

Dorfles [92] is probably the first to have stated that 'architecture, like any other art, can, or rather must be considered as an organic or, up to a certain point, institutionalized set of signs . . ., and as such can be identified, at least partially, with other linguistic structures', and to have deduced the consequences: 'this is tantamount to saying that it is important, indeed absolutely decisive, for the healthy development of modern architecture that it should "semanticize" itself or, in other words, that it should justify any new architectural creation by the adoption of forms which are semantically evident and conducive to clear communicability'.[93]

However, he emphasized from the outset the danger of extrapolating from linguistics to architecture and the specificity of the architectural message (the symbolic transcription of architecture in drawing being governed by rules closer to those of the verbal languages than architecture itself). For G. Dorfles the contrast between language and speech has no more relevance to the organization of space than duality of patterning or the concept of a minimal, meaningful unit. On the other hand, he has taken over one of the great dichotomies of linguistics in order to contrast the connotation (iconological-symbolic) of buildings with their denotation (iconological-typological). But he made use of this distinction to construct a theory of the perenniality of the architectural message, the code of symbolic messages transcending the temporary.

Ch. Norberg-Schulz, [94] for his part, drew up a kind of analytical balance sheet of the elements which communication and information theory might contribute to architects for a new understanding of their practice. He reached conclusions relatively close to those of Dorfles as to the specificity of architectural symbolism. However, his contrasting of the 'physical milieu' with the 'symbol milieu' (the latter being itself made up of 'perceptual schemata' and 'artificial symbol systems') gives expression to a dichotomy which is also found in the relationship between structure and meaning. 'Although the symbol systems as such are "empty", there is evidence to support the belief that they imply certain basic isomorphisms.'[95]

These authors directly inspired, or merely preceded, a series of research efforts which literally pillaged linguistic and semiological concepts in order

92. DORFLES, 'Valori semantici degli "elementi di architettura" e dei "caratteri distributivi"' (1959); *Simbolo, communicazione, consumo* (1962); 'Structuralism and semiology in architecture' (1969).

93. '. . . l'architettura, come ogni altra arte, può anzi deve essere considerata come un insième organico o, sino a un certo punto, istituzionalizzato di segni . . . e come tale può essere identificata almeno parzialmente con altre strutture linguistiche' . . . 'questo equivale ad affermare che è importante, addirittura decisivo, per una sana evoluzione dell'architettura moderna, che essa "si semantizzi" ossia che giustifichi ogni sua nuova creazione attraverso l'adozione di forme che siano semanticamente palesi, e capaci di portare a una chiara comunicabilità.' – DORFLES, *Simbolo, comunicazione, consumo* (1962).

94. Cf. *Intentions in Architecture* (1963) and 'Meaning in architecture' (1969); see also *Existence, Space and Architecture* (1971).

95. NORBERG-SCHULZ, 'Meaning in architecture', Post-Scriptum, p. 228 in JENCKS & BAIRD (eds.), *Meaning in Architecture* (1969).

to transfer them to the system of living space, heedless only too often of the warnings of G. Dorfles. Saussure, Martinet, Prieto, Jakobson, Hjelmslev, Trubetzkoy together with Greimas, Barthes, Peirce and Chomsky are the names that are attached today to research of which the Congress of Architectural Semiology held in Barcelona in March 1972[96] revealed not only the diversity but also the incoherences and the present meagreness of the results. Two trends can be discerned, the one more epistemological, the other more formal.

The epistemological trend is followed by research in which the theory of meaning is subordinated to a general theory of knowledge, itself bound up with a certain conception of history. We give three examples.

G. Baird,[97] in analytical studies akin to those of Gombrich for painting, starts from the language-speech opposition, language corresponding to the whole set of rules applicable to the organization of built-up space and speech corresponding to the combinations actually selected and produced. As information is a function of probability in a matrix of improbability, the problem of architecture and of the arrangement of space is, in his view, how to use words meaningful enough not to be beyond the threshold of improbability or to fall short of the threshold of probability where they can be consciously perceived ('thresholds of awareness'). In Baird's view the user's 'awareness' is at the root of the structural analysis of the built-up system, owing to the unconscious fringe of language, and also the dialectic of the arbitrary and the necessary (borrowed from Lévi-Strauss) in the signifier-signified relationship. From this standpoint the built-up system is seen to be constantly evolving, the legacy of the past being at all times a part of the meaning of the present, the novelty of which in turn modifies our view of the past. The result is a theory of tradition (which rehabilitates Perrault), an interpretation of our relationship with ancient or exotic architectures, criteria for judging (which allow of criticizing recent works), and finally a theory concerning the permanent incompleteness of meaning and an epistemological criticism of the theories and criticisms of architecture.

The other two examples are characterized by a discontinuous rather than a continuous conception of history. For the author of the present contribution,[98] the organization of living space as a semiological system is an hypothesis which is valid essentially for societies without a history and, to a lesser extent, for pre-industrial societies. Seen from a standpoint adopted by Bachelard and Foucault, the advent of industrial society is regarded as a break and a mutation, after which the buildings system ceases to inform in the wide sense of the term, information being relayed by other systems,

96. Organized by the Colegio Oficial de Arquitectos de Cataluña y Baleares, which will publish the proceedings.

97. ' "La dimension amoureuse" in architecture' (1967) (the title of this article is borrowed from Roland Barthes. However, the three main influences which Baird recognizes are those of Lévi-Strauss, Wiener and Jakobson).

98. CHOAY, *The Modern City: Planning in the XIXth Century* (1969) and 'Sémiologie et urbanisme' (1967, 1969).

in particular by telecommunication. On the one hand, the meaning of the buildings system must be clarified by comparison with the synchronous structures of the successive historical constellations in which it takes its place, with the system of knowledge in particular. This leads to the disclosure of the broad historical structures of the organization of space, and explains the value for criticism of the criterion of synchronism, which makes it possible to reveal the anachronism of some of the present-day proposals for town-planning and, in the light of contemporary epistemology, to develop the concept of connexion[99] as a meaning of the built-up space of today. On the other hand, if the semiological reduction which affected the urban system as from the fifteenth century has as its counterpart the emergence of a (written) discourse engendering new spaces, this text also lends itself to semiotic analysis.[100]

Kenneth Frampton[101] attributes the same semantic break to the industrial revolution. A set of concepts borrowed from Hannah Arendt underlie his interpretation. In point of fact, Hannah Arendt divides human actions into two categories according to whether they correspond to the activities of work ('the activity which corresponds to the unnaturalness of human existence') or labour, ('the activity which corresponds to the biological process of the human body').[102] Frampton applies this distinction to the details of methods of human settlement in space. Human settlement has always involved a proportion of *labour,* building, and a proportion of *work,* architecture. So defined, architecture, a language with a strict syntax, gave the old cities their informative and integrative value. It was essentially concerned with public buildings (for religious or communal purposes), although it could reach into the cellular tissue of private homes. With the industrial revolution and the threefold impulsion given by atheism, the development of scientific thought and population pressure, the former equilibrium between building and architecture was disturbed (as also was that between the various other forms of *labour* and *work* in society). The old syntax fell apart, while housing, subsumed under fallacious concepts, proliferated. The architect's relationship with society then became a problem. He was obliged 'to reformulate his operating image as a functionary within the society. Such a reformulation involves an attempt at a complete re-assessment of the cultural significance of the full range of building'.[103] Frampton is thus led to 'totally secular megastructures or infrastructures',[104] in accordance with an image absolutely the opposite of that of pre-industrial times.

The formalistic trend covers research centred more on the homology of architecture and language and is essentially concerned with establishing an

99. Cf. our two works, *Espacements* (1969) and *Connexions* (1971).

100. See our contribution to the Barcelona 1972 Congress, 'Pour une sémiotique du discours sur la ville' (to be published).

101. FRAMPTON, 'Labor, work and architecture (1969).

102. ARENDT, *The Human Condition* (1958).

103. FRAMPTON, *op. cit.,* p. 154 in JENCKS & BAIRD (eds.), *Meaning in Architecture* (1969).

104. *Id., ibid.,* p. 164.

architectural semiology: the two special issues which the review *Werk*[105] devoted to semiology in April and June 1971 give a panoramic view of the subject . We shall confine ourselves to a few glimpses.[106]

Between this trend and the preceding one Ch. Jencks occupies a pivotal position. Although he studies the theoretical writings and the history of architecture from an epistemological and structuralist standpoint, he nevertheless seeks to discover the ultimate units of the architectural language from what he considers its three articulations: 'It would be highly appropriate if the architectural explorer found formemes, funcemes and technemes, those fundamental units of architectural meaning' (connected with form, function and technology, which are the three semantic axes of the domain of building).[107] In this recent studies of the succession of architectural systems from the end of the classical period onwards, he brought out the parts played respectively by icons, indexes and symbols (ideas borrowed from Ch. S. Peirce) and emphasized the importance of systems of relationships in the meaning process, showing how eclecticism, for example, can make historical styles fulfil the symbolic purpose of the classical orders.[108]

The strictly semiological position has developed mainly in Italy, where it has aroused considerable critical interest[109] and has even led to an attempt at synthesis on the part of M. L. Scalvini, who has restated the problem in the light of contemporary architectural theory.[110]

Two influences can be discerned in Italy. On the one hand, Ch. Morris's semiotics has marked the Florence school (Gamberini, Koenig, Spadolini).[111] I. Gamberini[112] has attempted a classification of the elements of architecture considered as words in the architectural language, which leads him to assimilate the constructed form to the sign and the user to the *designata*.

G. K. Koenig took over Morris's idea of 'iconicity' and began by formulating a theory of 'consumation'[113] *('consumo o entropia della comunicazione')* of the architectural language, which is thus doomed to reconstruct

105. Entitled *Was bedeutet Architektur?* and presenting *inter alia* two sets of contributions received in response to the survey, 'Die Aussage der Architektur'/'Le langage de l'architecture'/'Meaning in Architecture'.
106. We have regretfully to omit interesting studies, such as those by P. Bonta and M. Gandelsonas (in the case of the latter, however, cf. note 48 above).
107. JENCKS, 'Semiology and architecture', p. 17 in JENCKS & BAIRD (eds.), *Meaning in Architecture* (1969).
108. 'Thus in *one* transformation, the Hindu style was substituted for the Corinthian order, Gothic for Ionic and even Corinthian for Doric' – JENCKS, contribution to the 1972 Barcelona Congress mentioned above.
109. See, for example, ZEVI, 'Alla ricerca di un "codice" per l'architettura' (1967).
110. SCALVINI, *Spazio come campo semantico* (1968). Among her more recent publications see, in particular, 'Über das Signifikat in der Architektur' (1971) and, in collaboration with DE FUSCO, 'Significanti e significati della Rotonda palladiana' (1969) and 'Segni e simboli del Tempietto di Bramante' (1970).
111. SPADOLINI, *Dispense del corso di progettazione artistica per industrie* (1960).
112. GAMBERINI, *Introduzione al primo corso di elementi di architettura* (1959).
113. KOENIG, 'Il linguaggio dell'architettura: notazione di "linguaggio comune"' (1960); *Lezioni del corso di plastica* (1961); *L'invecchiamento dell'architettura moderna* (1963) (from which the phrase quoted in parenthesis is taken).

itself indefinitely through the emergence of new elements. In passing from the cultured language to the common language, the image or symbol 'slowly *consumes* its lyrical content until it becomes a platitude, in other words, an image endowed with immediate communicative force but with little aesthetic value. It is from that point that the image begins to degenerate because the semantic component too is subject to rapid consumation'.[114] The small-paned windows of the 1920's are one example among many of this aesthetic-semantic degeneration. These studies led Koenig to a behaviourist theory of the relationships between signs and behaviour[115] and a formulation of types of behaviour and criteria for judgement in architecture directly based on that of Morris.

On the other hand, it is the work of the Saussure school, the research of R. Barthes and his opposition to U. Eco,[116] that influenced the work of R. de Fusco,[117] who transposes Saussure's famous metaphor of the sheet of paper by expressing the signifier-signified relationship in that of an envelope and the space inside. But in the field of space arrangement he rejects the dialectic of information and communication and opts for communication alone. This position is based on a theory of political and cultural history: in his view, indeed, the West has reached a crucial stage, that of the 'third culture', or mass culture, or *nuova cultura cittadina*, which has succeeded the religious and then the humanist and the nationalist periods. Now, among the mass media, town-planning (*'urbanistica'*) is seen by him as a predominant medium, on account both of the priority of its emergence and of its power of social integration. 'Architecture can be said to take precedence over many other mass media, not only because of its technological advance, due to the fact that modern building structures and schemes seem to us to have preceded the invention of radio, television and rotogravure, but also and above all because architecture, allied with town-planning, is one of the activities most directly connected with the origins of the industrial revolution and the formation of the modern proletariat'.[118] The value attached to

114. '... consuma lentamente la sua carica lirica fino a diventare un luogo comune, un immagine cioè dotata di un immediato potere comunicativo ma di scarso valore estetico. A questo punto inizia il decadimento dell'immagine poichè la componente semantica è anch'essa soggetta ad un rapido cònsumo.' – KOENIG, 'Il linguaggio dell'architettura', quoted by DORFLES, p. 192, note (1) in *Simbolo, Comunicazione, Consumo* (1962).

115. *Analisi del linguaggio architettonico* (1964).

116. By Umberto ECO, see in particular *Opera aperta* (1962) (French translation, *L'œuvre ouverte*, 1965) and *La struttura assente* (1968) (French translation, *La structure absente*, 1972). R. de Fusco reproaches U. Eco with, among other things, breaking the architectural language down into extra-temporal elements such as the column and refusing to distinguish between different semiotic levels.

117. DE FUSCO, *Architettura come mass medium. Note per una semiologica architettonica* (1968) (from which our quotations are taken); *Il codice dell'architettura* (1968); see also the works in collaboration mentioned above in note 110.

118. 'Si può dire che l'architettura preceda molti altri mass media, e cio non solo in quanto al progresso technologico perchè, poniamo, le moderne strutture e schemi edilizi precedano l'invenzione della radio, della televisione o dello rotocalco, ma

contemporary *urbanistica* as a means of communication is bound up with an ethic and implies a strategy for action. On the one hand, it provides a criterion for judging contemporary architectural works: 'Architecture understood as a mass medium is equivalent to a sociological-cultural model by reference to which the architectural realities of today can be interpreted in the form of analogies and deviations.'[119] On the other hand, and above all, it calls for a reinforcing of the power of the semiological system in the process of being constituted by investigation of the collective imaginary ('meeting ground of the decision-making groups and the mass of users'[120]) and by the drawing up of a specific code.

In this work we have abandoned the security and clarity of a systematic classification of trends for fear of artificially separating similar studies. This decision forced some repetition upon us without, however, enabling us to escape the arbitrary. Comparisons which we have not made will certainly occur to the reader. For instance, in many respects M. Webber or R. De Fusco are close to Archigram, while R. Venturi, considered only in his relations with aesthetics, might quite rightly have been included with those who seek to base their practice on a semiotic method. Similarly, M. Castells, whose political preoccupations were emphasized, also belongs to the epistemological trend.

It would also have been possible to show the connotations linking the concepts of *oeuvre, work, polysemy* or, even, to have adopted other categories for our analytical study such as the importance attached to tradition or to innovation, the contribution made by a theory of knowledge, etc. We hope that the foregoing pages will at least have given some idea of the wealth and complexity of the various research projects which are being actively pursued and which, though inspired by a common set of problems, sometimes converge and sometimes diverge.

VII. THE ARTS OF INFORMATION AND THE MASS MEDIA, *by Gillo Dorfles**

The vast sector of means of communication generally known as the 'mass media' includes many forms of expression which, whether we like it or not,

sopra tutto perchè l'architettura urbanistica è una delle attivite piu direttamente connesse alle origini della rivoluzione industriale e alla formazione del moderno proletario.' – DE FUSCO, *Architettura come mass medium* (1968).

119. 'L'architettura intesa come mass medium equivale ad un modello sociologico-culturale rispetto al quale è possibile interpretare la realtà architetturale d'oggi sotto forma di analogie o di deviazioni.' – *Id. ibid.*

120. '... piano d'incontro fra i gruppi decisionali e la massa degli utenti.' – *Id., ibid.*

* University of Cagliari (Italy).

come within the sphere of artistic creation and are consequently as worthy of analysis as other new forms of art and communication such as the cinema.

The special characteristic of these forms, which tend increasingly to become the fundamental 'aesthetic pabulum' of mankind today, is that they are widely disseminated and reach the largest groups of the population (which is rarely the case with painting, music and poetry!), but are, in almost every instance, *unidirectional;* that is to say, they convey a *one-way message*. The member of the public (the listener, viewer, passer-by, etc.) is the recipient of these messages, but finds it difficult to reply to them. This is the prime reason why these means of information are effective, and also why they are dangerous. Being placed in most cases in the hands of governments, of statesmen or of those who direct big industrial monopolies, and consequently being 'manipulated from above', they are likely, however well-intentioned those who employ them, to gain control over the opinions and the tastes of a public that is powerless to rebel against them and apt to yield passively to their influence.

The phenomenon is well known. Many research workers – anthropologists, sociologists, politicians – have been giving it thought for some time past[1] and it should never be overlooked in any discussion of these great means of information. It is, moreover, an undoubted fact that the 'arts of information' (even though in the service of industry, commerce or politics) are capable – precisely because of the special nature of their message, their wide dissemination and their adoption of a vocabulary easily understood by all – of exercising an immediate and powerful influence over the public and therefore, at the same time, of conveying (we might say 'of smuggling in') artistic material which is often remarkable and which, in other circumstances, would never reach the masses.

It is for this reason that I noted as early as 1964[2] that the visual universe in which contemporary man is evolving consists to a large extent of what I then called the 'new icons': roadside advertising posters, traffic signals and signposts, television broadcasts, and all the other forms of graphic art (shop signs, prospectuses, neon advertising at night, etc.) and lettering. I remain convinced that we have much to learn – provided that we never overlook the dangers of the phenomenon – from the presence in our midst of these 'new icons', which will perhaps one day make it possible to give our society a more balanced structure.

I have no intention of drawing up a detailed list here of the images of which we are the assiduous consumers (and frequently the victims); I should like merely to describe some of those which seem to me to be the most important and determinative at the present time. Take, for example, road

1. MORIN, E., *L'esprit du temps* (1962). Cf. ROSENBERG & WHITE, *Mass Culture* (1960); ANDERS, *Die Antiquiertheit des Menschen* (1956); ARANGUREN, *Sociología de la comunicación* (1967).

2. See my study *Nuovi riti, nuovi miti* (1965), in particular Chapter VII, 'Le Nuove Iconi e la civiltà del consumo'.

signs – a new and too much neglected feature of our urban environment. In a modern country, the entire population is exposed from earliest infancy to the effects of a series of signs and signals which it is impossible to avoid. Even before they learn to read and write, town dwellers are impelled to store up various peremptory and stimulating 'ideograms' which cannot be eliminated.

To road signs pure and simple must be added all the other figurative elements spread over house-fronts, roadside walls and public transport. We are living today in a new 'anti-iconoclastic' age, and the new icons peopling it are reproduced mechanically in thousands of identical copies. This serial nature of the images is another phenomenon that must be considered from an aesthetic standpoint, for it has finally influenced a larger number of 'works of pure art' also (as is proved by the many recent editions of *'multiples'* in painting and sculpture).

The widespread use of lettering (the graphic application of the ordinary letters of the alphabet on signboards, in advertising) is another contemporary phenomenon that must be classified among the arts of information. The means employed to load with 'information' the message reproduced in a specific text (such and such a class of 'lettering') are numerous: the typography may be grossly enlarged or, on the contrary, 'miniaturized'; use may be made of unusual typographic elements and advantage may be drawn from difficulties of reading which prevent immediate understanding of the text in order to fix the attention more strongly, sometimes thanks to a certain *coefficient of ambiguity.*

After this brief survey of the most important sectors of the arts of information, I should like to examine in greater detail some of the special linguistic characteristics of the mass media considered more particularly from the point of view of semiology and with reference to the language of *advertising,* both graphic and pictorial, and televised and verbal, the more so as these various genres are as often as not blended and amalgamated.

It would be as well to begin by seeking to determine the extent to which the semiotic schemas generally used in studying other visual arts can be applied to advertising images, and this can perhaps best be done by referring to the now generally accepted distinction made by Charles Morris (and before him by Charles S. Peirce) between the three different functions of signs: the *pragmatic* function, the *syntactic* function and the *semantic* function.[3]

The message transmitted by advertising must clearly have these three functions, since it is intended for the public (and so is *pragmatic*), is due to a complex combination of signs (hence it *syntactic* quality), and finally – and this is its essential feature – it conveys a 'meaning', and so fulfils a typically *semantic* function.

The semantic nature of the advertising message must be made clear at once. This semantic function cannot, as it can in any work of visual art, be

3. Morris, *Signs, Language and Behavior* (1946).

more or less accurately defined; it must serve to convey a 'message' that can really be 'conceptualized'. In the case of advertising, it is quite obvious that the person to whom it is addressed must understand correctly the conceptual content of the message, otherwise the latter would fail to have its intended effectiveness.

What therefore will be the particular form assumed by this semantic function of advertising? The most obvious answer is doubtless that which relies on the possibilities of a multiple valorization of the signifier (in the sense given to the term by Saussure), which amounts to fulfilling a function not entirely exhausted by *the signified* (contrary to what generally happens in linguistic morphology)[4] and acquiring a certain independence, changing into a new signifier without there being any constant relation between the constituent terms of the signified and the signifier. (We are concerned, in fact, with a phenomenon somewhat similar to the one which is mentioned by Lacan with reference to the *'sliding of the signified under the signifier'* and which we find in certain cases of pathological (schizophrenic) language where the relation between the two terms is no longer clearly fixed.[5]

To give one example, the ESSO Company's 'tiger', after having, as 'the signified', the notion of 'strength' or 'power' applied to this brand of petrol (a typical example of an advertisement image of the metaphorical type[6], ends up by signifying merely 'ESSO petrol', thus losing its metaphorical meaning and acquiring a secondary 'denotatum' which is no longer that of the 'tiger', but of the brand of petrol itself. The fact that a secondary 'reference' (a denotatum) replaces a primary denotatum is one of the linguistic phenomena most characteristic of a large part of visual advertising. In the case of brandmarks, it generally happens that a specific mark (a monogram) becomes identified with a product to be launched on the market, or with the company which launches it, to the point of completely losing its original meaning. Once the brandmark has replaced the product, the company can carry out any operation for launching a specific product under the aegis of the new sign, which has now become 'emblematic'.

That being so, the essential difference between the semiotic function of advertising and that of the visual arts may be summed up as follows: the aesthetic element *is not indispensable* in the advertising message (which may, in fact, prove very effective even if it is made up of 'inartistic' elements or savours of the art of the shoddy, since the real aim of advertising is achieved through its power to persuade). But it should not be forgotten that for the graphic and advertising message use is often made of elements of outstanding artistic quality, and it may thus undoubtedly be an excellent school for the aesthetic education of the man in the street.

4. See the article by GIUDICI, 'In principio era il communicato' (1967).
5. LACAN, *Ecrits* (1966), p. 502. Lacan denies the existence of a fixed relation between the signifier and the signified, and admits a certain arbitrary quality of the linguistic sign.
6. For everything concerning the rhetoric of advertising images, see BONSIEPE, 'Visuell-verbale Rhetorik' (1965).

A further difference between the art of advertising information and 'pure' visual art lies in the use of *redundancy* and *suggestion*. Whereas in poetry semantic redundancy may increase its aesthetic value, in advertising an excess of redundancy (or, on the contrary, an excess of suggested information) is to be avoided if it is an obstacle to the understanding of the message, to the possibility of decoding it. For this reason, 'novelty in information', which is always desirable in a work of pure art, may have a negative effect in advertising if it is excessive. Conversely, an excessive redundancy in the images may lead to their obsolescence and diminish their effectiveness.

Another element to be borne in mind when studying the semiological aspect of advertising is the existence of a graphic-verbal coefficient in addition to the figurative (iconic) coefficient. The 'inscription', for example – or rather, the sequence of letters forming a 'stimulus word', and generally known as a 'logotype' – plays an essential part in the structure of every advertising message. Such inscriptions as 'Coca Cola', 'Fiat', 'Colgate', etc., even before being 'decoded' as verbal elements (that is to say, 'read' as words), are 'seen' as a whole, a *'Gestalt'*, an ideogram. All that need be said here is that, in the semiotics of advertising, account must always be taken, side by side with the customary code of verbal language, of a *mixed visual and verbal code* rich in shades of meaning and not easy to define.

Many studies have been devoted to the readability of purely iconic images, 'inscriptions' and mixed forms, and to the comparative effectiveness of the *logotype* and simple figurative images for purposes of 'motivation'.[7]

Considerable research has also been done on the level of the 'symbolism' of advertising images,[8] and an attempt has been made to classify the various categories of image, ranging from the most realistic to the most symbolical.

Amongst the many subdivisions and classifications of symbolic material, mention may be made of those proposed by Erich Fromm: conventional, accidental and universal symbols; or by Ernest Dichter[9]: allegorical, interpretative and intentional symbols. It seems preferable, however, to keep to the schemata based on the research work of Peirce and Morris (leaving aside the more recent, but too complex, classifications of Luis J. Prieto[10]). That terminology, now generally accepted, enables us to define the essential differences between indexical signs ('indexes', that is to say, signs to be interpreted in their context) and *non-indexical signs* (signs which, unlike the former, do not need a specific context), *iconic signs* (offering a certain analogy to what they represent), *'signals'* (signs which can carry a meaning artificially conferred), *'marks'* (signs of an emblematic character presenting a relationship with a specific object already fully institutionalized, such as a

7. ADAMS, N., 'Corporate identity as a system' (1967).
8. DOBLIN, 'Trademark design' (1967); also GERSTNER, *Programme Entwerfen* (1963).
9. DICHTER, *Gli oggetti ci comprano* (1967); see also, by the same writer, *The Strategy of Desire* (1960).
10. PRIETO, *Messages et signaux* (1966).

'brandmark') and, lastly, 'symbols' (signs which are always conventionally determined).

Having described some of the more important features of graphic and visual advertising, I should now like to devote a few lines to another important medium of mass communication, *television,* which – together with the cinema – is undoubtely one of the most vigorous branches of the arts of communication. Clearly, we find in television not only all the characteristics of non-televised radio broadcasts, but also some characteristics appertaining to cinema as such. It very often happens, as we know, that television is used to broadcast either cinema films or programmes which borrow their elements from advertising graphism, from the system of signs, and from the arts of design in general. It may therefore be regarded as a highly composite *means of expression* ('medium') sharing with other mass media of communication the characteristic of transmitting a one-way message.

I do not think I need dwell here on the aesthetic features of radio broadcasts. We all know that mankind nowadays is subjected by radio to unceasing sound and musical stimuli which should, in principle, contribute to its 'musical education'. Unfortunately, this is only partially the case, for most radio broadcasts of music are of little or no artistic value; and moreover, the listener gives them no more than the divided attention mentioned by Adorno. Such conditions are unlikely to awaken the artistic sense.

Let us therefore examine the case of television in greater detail. Considering the vast public reached by it every day, its importance must not be underestimated.

First of all, it should be said once again – and this applies to the cinema also – that television must be regarded as an independent language, comprising elements that are visual and acoustic, verbal and graphic. In other words, it is impossible to isolate any one of these aspects once the specificity and the unitary character of the language are really recognized.

We may apply to television the classification we owe to Roman Jakobson[11] of the *six main functions* of any form of linguistic communication, namely: the *emotive* function, the *phatic* function, the *conative* function, the *metalinguistic* function, the *poetic* function and the *referential* function. Although it is impossible for me to dwell further on the special features of each of these various functions, I should like to emphasize the importance in the case of television, of the *conative* (imperative) function and of the *phatic* function (concerned with contact). Contrary to what happens in the case of the cinema, the presence of the announcer in television guarantees the establishment of the direct 'affective' relationship with the viewer which is one of the characteristics of the medium. Similarly, it may be said of the *conative* function that it assumes an exceptional rôle in the case of advertising broadcasts through the channel of television.

The need to be 'initiated' into reading the televisual image (as, also, for that matter, the photographic image – a question already dealt with by

11. JAKOBSON, 'Linguistics and poetics' (1960).

Pierre Francastel[12] – has been discussed by several writers, and I should like to recall here the comments of Christian Metz concerning the need to learn the code (or pseudo-code) of films,[13] which apply equally well to the television code.

In the case of television, of course, this code coincides to a large extent with that of so many other conventions of daily life: thus, it is all the gestures, actions, facial expressions, which already in a sense constitute for everyone the 'ethnic code' of his epoch, that we find again in the contemporary television code.

But, it must not be forgotten that the images transmitted by the little screen are, at all events in some measure, an exact reflection of the images of the outside world, and that televisual language is in most cases built up on the foundation contributed by graphic, iconic, acoustic and cinematographic material which distorts its realism, and which cannot be ignored.

It therefore seems to me to be hazardous to try to give a precise definition of the 'televisual code'; for rather than speak of televisual 'phonemes', 'morphemes' and 'monemes' (and so fall into the error so often committed in regard to film linguistics), I think it would be preferable to admit only the existence of televisual 'syntagms'; that is to say, of more complex particles of the discourse, according to the hypothesis of Christian Metz – thereby making it possible to avoid the complications that arise in any attempt to reduce televisual images to separate particles which can be superimposed on those of the verbal language.

I shall therefore avoid speaking of 'double articulation' (in Martinet's meaning of the term), even for the purpose of showing that television advertising often introduces elements which may be regarded as 'doubly significant', the reason being – as we already pointed out at the beginning of this article – that it tends to use signs which, while referring back to the '*denotatum*', also end up by becoming identified with the actual product they are supposed to 'designate'.[14]

There is no need, I think, to embark here on a more detailed analysis of the problems related to television linguistics, for that would necessarily compel me to repeat what has already been said concerning film language. On the other hand, it seems to me advisable to emphasize the aesthetic value of this message, to point out the considerable impact of television both from the point of view of education and from a more strictly aesthetic point of view.

12. FRANCASTEL, *Estève* (1956).
13. METZ, 'Le cinéma: langue ou langage?' (1964, 1968); see also, by the same writer, 'Problèmes de dénotation dans le film de fiction' (1968).
14. In regard to the difference between the 'diegetic word' and the 'non-diegetic word' in both cinema and television, reference can be made to the article by Christian METZ, 'Les sémiotiques ou sémies' (1966), which also discusses the value of the announcer's 'non-diegetic word': 'comments of announcers and narrators, together with various forms of voices off'. This occurs where the discourse is attributed to the author and not to the character, a device which clearly proves the existence of a kind of 'metalinguistic function' of televisual language.

It will be important therefore not to overlook this power of television whenever there is any question of handing over the control of the mass media to governmental or industrial bodies whose leaders may lack the indispensable notions of culture.

For good or ill, the influence of the mass media just discussed is tremendous, and to neglect it would mean losing the possibility of exercising an influence for good on both the opinions and the taste of millions of people. Conversely, abuse of the media (made all the worse by their undirectional character) may do irreparable and even fatal damage, from which mankind would long have to suffer.[15]

(Original: Italian)

15. In addition to the references given in the preceding notes, the following works may be consulted as examples taken from an extremely rich literature: ADAMS, J. W. R., *Posters Look to the Future* (1966); ADORNO, *Eingriffe* (1963) and 'Television and the patterns of mass culture' (1957); ALSLEBEN, *Ästhetische Redundanz* (1962); ANDERS, 'Die Welt als Phantom und Matrize' (1955); ARENDT, 'Society and culture' (1960, 1961); ARON, 'Signification politique de la radio-télévision' (1957); BARTHES, 'Le message publicitaire' (1963), 'Rhétorique de l'image' (1964), *Système de la mode* (1967) and 'Società, immaginazione, pubblicità' (1968); BAUDRILLARD, *Le système des objets. La consommation des signes* (1968, 1972); BERGER, R., 'Une aventure de Pygmalion' (English version, 'A Pygmalion adventure', 1969); BOHRINGER, *Rhetorische Kommunikation* (1967); BOORSTIN, *The Image* (1961); BRANDI, 'Structure de la télévison' (1967); CAZENEUVE, *Sociologie de la radio-télévision* (1965), *Les pouvoirs de la télévision* (1970) and *La société de l'ubiquité* (1972); CLAUSSE, 'Le grand public aux prises avec la communication de masse' (English version, 'The mass public at grips with mass communications', 1968); COHEN-SÉAT & FOUGEYROLLAS, *L'action sur l'homme: cinéma et télévision* (1961); CROCE, M. A., 'Conditionnements sociaux à travers les techniques cinématographiques' (1964); DE BENEDETTI, *Il linguaggio della publicità contemporanea. Guida bibliografica agli studi di psicopedagogia dei 'mass media'* (1966); DIEUZEIDE, 'Problèmes de l'image télévisée non spectaculaire' (1961); DORFLES, 'Pubblicità e communicazione' (1959), 'Pour ou contre une esthétique structuraliste' (1965), 'Morfologia e semantica della pubblicità televisiva' (1968-69), *Artificio e natura*: Chap. VI, 'Semanticità del linguaggio televisivo' (1968), and 'Sui mass-media' (1969); ECO, 'Valori estetici e cultura di massa' (1966) and 'Ciò che non sappiamo della pubblicità televisiva' (1968-69); FELDMANN, *Theorie der Massenmedien: Presse, Film, Funk, Fernsehen* (1962); FRIEDMANN, 'Sociologie des communications: introduction aux aspects sociologiques de la radio-télévision' (1961); FRYE, *The Modern Century* (1967); FULCHIGNONI, *La moderna civiltà dell'immagine* (1964) (French translation, *La civilisation de l'image*, 1969); GARNICH, *Konstruktion, Design, Ästhetik* (1968); GILSON, *La société de masse et sa culture* (1967); GRIFF, 'Advertising – The central institution of mass society' (1969); HAUG, *Kritik der Warenästhetik* (1971); HOGGART, *The Uses of Literacy* (1957) and 'Humanistic studies and mass culture' (1970); JOANNIS, *De l'étude de motivation à la création publicitaire* (1965); LAZARSFELD, *Communications in Modern Society* (1948) and 'Tendances actuelles de la sociologie des communications' (1959); LIPPARD, *Pop Art* (1966); LUTHE, 'Recorded music and the record industry' (1968); MACDONALD, 'A theory of mass culture' (1953); MCLUHAN, *The Gutenberg Galaxy* (1962) and *Understanding Media* (1964); MCLUHAN & FIORE, *The Medium is the Message* (1967); MCNEAL, *Dimension of Consumer Behavior* (1965); MALDONADO, 'Beitrag zur Terminologie der Semiotik' (1961); MARTINEAU, *Motivation et publicité* (1969); METZ, *Essais sur la signification au cinéma* (1968); MOLES, *L'affiche dans la société urbaine* (1969); MORIN, E., ' "Matérialité" et

348 *Mikel Dufrenne et al.*

CONCLUSION *by Mikel Dufrenne*

At the beginning of this essay, we drew special attention to the presence
and dynamism of forms of expression in literature and in the arts in con-
temporary societies. We tried to show what developments that presence was
bringing about in scientific thinking. We should like now to consider very
briefly the significance of that presence – more particularly with reference
to what is called 'the crisis of humanism'. For it seems to us – this is the
view we are putting forward – that art and literature (which is to be under-
stood as included from now on) both testify on behalf of man, and are of
importance to man. They consequently require the maintenance of a certain
concept of man and they serve the cause of specific individual men.

What today's anti-humanism questions is, clearly, the fate of the concept
and not of the individual. Of course, it is absolutely right in denouncing
traditional humanism in so far as the latter, being dogmatic and author-
itarian, imposes on man a certain image of himself and assigns to him a
specific destiny in relation to God. But even if we think – to adopt the
famous formula of Nietzsche – that 'God is dead', a new man may come
into being; what dies is the man to whom an essence and a destiny have
been assigned, a man who was not rooted in nature but inserted in creation.
The void left by theistic thinking is not a desert in which man loses his way,
a corrosive nothingness in which he is dissolved; it is the fullness of being,
the strength of his development, and the place in which he strays about is
also that of history. The age now dawning is perhaps that of a second
Renaissance, where thought will no longer mobilize the gods of Antiquity

"magie" de la musique à la radio' (1955); MORIN, V., 'Erotisme et publicité (1969);
POWELL, *Channels of Learning. The Story of Educational Television* (1962); RAI-
MONDI, 'L'industrializzazione della critica letteraria' (1966); SHILS, 'Mass society
and its culture' (1960-61); SILBERMANN, *La musique, la radio et l'auditeur* (1954)
(German version, *Musik, Rundfunk und Hörer*, 1959); THOMPSON, *Discrimination
and Popular Culture* (1964); TOFFLER, *The Culture Consumers* (1965); VOLPICELLI,
'Alfabetizzazione e mezzi audiovisivi' (1965); WILLIAMS, *Communications* (1962,
1966/67); etc. and the articles and contributions assembled in a very large number
of collections and special numbers of reviews such as, to mention a few examples
only: *L'analyse des images* (*Communications*, 1970); *Mass Communication and
Culture* (*Diogenes*, 1969); EHMER (ed.), *Visuelle Kommunikation. Beiträge zur
Kritik der Bewusstseinsindustrie* (1971); JACOBS, N. (ed.), *Mass Culture and Mass
Media* (*Daedalus*, 1960), republished in book form under the title: *Culture for the
Millions?* (1961); NARDI (ed.), *Arte e cultura nella civiltà contemporanea* (1966);
Radio, musique et société (*Cahiers d'Etude de Radio-télévision*, 1955); SCHRAMM
(ed.), *Mass Communications* (1960); STEARN (ed.), *McLuhan Hot and Cool* (1967);
etc.
See also works concerned with the study of the *mass media* and of 'mass culture'
mentioned in the preceding chapter by J. Leenhardt in 'The sociological approach'
and by A. A. Moles in 'The information approach'; and, in the present chapter,
those mentioned by M. Dufrenne in 'Artistic creation' (*sub* 'The sociological ap-
proach'), J. Leenhardt in 'Reception of the work of art', G. Bettetini in 'The art of
cinema', F. Choay in 'Architecture and town-planning', etc.

against the God of Scripture, but where – and the gap today is a wider one – it sets against the catholicity of a world unified by industry the effervescent incoherence of a nascent world, of the world of nascence. Consequentely, man will no longer be defined according to what he is, but according to what he wants to be; and here and there signs – ambiguous signs – can be discerned of that new man, who refuses to plead guilty, that is to say, to submit to a Judgement, who does not think of himself as one, or even as bound to make himself one (to be classified and judged), who no longer counts on history to make certain of a future, who seeks a more direct communion with things and men, short of the mediation of techniques and institutions. But if it is actually impossible to define this man who represents the future of man – to quote Sartre, borrowing in turn from Ponge – why is it still necessary to name him, why is he still the subject of a concept? It is because he is always and everywhere recognizable and recognized : like the other, but who is also the counterpart. The new man is another man, who will possibly merit the title of superman, who in any event calls for a new humanism; but he is still a man: elusive, but also indomitable. Always, whatever his age and whatever the world in which he lives, and even in the adventures wherein he becomes estranged, in the position of a *subject* and in the character of an *individual*.

Now, it seems to us that aesthetic experience justifies our attributing to him that permanence both as producer and receptor – these two functions of the subject not being necessarily contradictory, as we have seen. While it is true that, according to a certain philosophy, it is science, or *epistēmē*, that nullifies the concept of man (and it may even be that certain philosophies of being and non-being are inspired by that epistemology), it does not seem to us that the science of art, the main trends of which we have examined, inevitably recommends any anti-humanism.

Consider the function of the creative subject. Of course, contemporary criticism deliberately sets aside the author, either in favour of the work which he creates, or else in favour of the cultural field and the ideology by which he is conditioned. In the same way, Saussurian linguistics has chosen to study language without reference to the spoken word or the speaking subject. A methodological preference, the rightness of which is eloquently established by current research. But how far does this preference go? When the sociologist Bourdieu works out the theory of the intellectual field, it is in its relationship to a creative project. When the new poetics treats a work as a text that can be the subject of structural analysis and is incorporated in a context wherein it represents a term in a whole or an instant in the history of a style, the author may be excluded but he is not thereby rejected, and it reverts to him when it considers the work in its uniqueness. Thus the expert, on detecting the traces of a gesture or of a unique voice, pronounces that judgement of attribution of which Morelli has given the theory. Of course, the creator is not in that case the individual of whom we may, or may not, relate the life and study the psychology. He is defined only in relation to the work, he is the man of the work, the master of the work, but

that is enough to define him as subject. And conversely, the work is defined only in relation to him: it bears his mark in so far as it is a genuine work: an *apax* in the *corpus,* the evidence of an original project and *praxis,* a unique power of invention. What a critic says of the writings of Stendhal should be said of all major works: 'Everywhere, at all levels, in all directions, we find again the essential mark of Stendhalian activity, which is constant and exemplary transgression of the limits, rules and the apparently constituent functions of standard literary practice'.[1] This activity, of which the work is the product, may still impose the idea of a specific subject: hence the psychology, and mainly the psycho-analysis, of creation. Psychoanalysis also doubtless plays its part in the concert of anti-humanism. In comparing the work of creation with the work of the dream, in detecting traces of phantasm in a work of art, a 'decentred' subject is evoked, a subject with no assignable place in his own dream, who is not yet an Ego, who might be called a pre-subject. But it is none the less true, as Freud says, that 'where id was, there ego shall be',[2] and that the pre-subject establishes and illuminates the subject. It is Leonardo's own style on which Freud throws light by analysing a phantasm, it is the 'personal myth' of such and such a poet that Mauron elucidates.

At the opposite pole of exegesis, a meditation such as that of Blanchot, who wishes to owe to psychology or science (even if one is tempted to understand it in the light of certain scientific themes) describes the creator wandering in the place of absence, haunted by the impossibility of the work, fascinated by his own death and dying to himself: the victim of an inspiration which condemns him to die in the silence of that living death that is madness. But is not this subject, who is already posthumous, this post-subject (of whom it might be said moreover that he becomes so from having wished to look in the face the desire inhabiting the pre-subject), as if in return, the true subject? In losing his soul he saves it, at any rate as far as the edge of the abyss into which he may be precipitated; and the incomparable adventure to which he exposes himself is indeed his, and throughout his activity it confers a unique accent on all he offers us.

However, anti-humanism may seek its material elsewhere than in the meditations of Hölderlin or Mallarmé: in the practice of artists who today, particularly in the West (for we have dealt separately with the Socialist countries and developing societies), reject the traditional idea of the work of art: who snatch the work away from the setting that excluded it from day-to-day existence, who replace the work by the happening and, if need be, by chance. At the start of our survey mention was made of these forms of contemporary art – or non-art. How can we believe that they signify the

1. 'Partout, à tous les niveaux, dans toutes les directions, se retrouve la marque essentielle de l'activité stendhalienne, qui est transgression constante, et exemplaire, des limites, des règles et des fonctions apparemment constitutives du jeu littéraire.' – GENETTE, *Figures* (1966), p. 191.
2. 'Wo Es war, soll Ich werden.' – *Neue Folge der Vorlesungen zur Einführung in die Psychoanalyse* (1932).

death of man? The death of the author, yes; but so that individual man may live. When practice is reduced to the gesture, the cry, the excitement of the game, individual man destroys language – the codes – which stands for law, but does so in order finally to speak for himself. He rejects all those institutions which forced on him the mask of an anonymous and neutral humanity, but so that his visage may be naked as on the day he was born. And this subject in his native state does not go into solitary exile, he still wishes to communicate, and in the most immediate and direct way possible: not between text and text (which is a matter for the learned), but between man and man. If he abandons the work it is in order that it should be the work of all: not mediation but immediate. If he abandons the object, it is in order that the happening should be the feast to which all are invited: ceremony or orgy? And why not both together?

And so the creative subject abolishes himself only in order to proliferate in the receptor subjects whom he inoculates with his passion. To all those who examine the reception given to art, the concept of man as a subject thus continues to be proposed. If art remains so alive, even in the forms in which it contests itself, that is because it is of importance to man. Can we evoke an 'aesthetic need' in him? The expression is ambiguous, for such a need might well be regarded as of secondary importance and consequently as artificial and open to manipulation (which is certainly the case in societies like ours in which art is commercialized). What should be named here is the desire rather than the need, in so far as it is irreducible to the need, as defined by Freud, because it is not connected in principle with a real object like the one through which need is satisfied. That desire, which is not desire to, which is unaware of itself, is manifested in *doing*: why mark the world with one's seal, if not to reshape it in the image . . . of the images which haunt the psyche? And does not the pleasure which animates the aesthetic experience proceed from what is roused in us? From the free agreement of the understanding and the sensibility, no doubt, but also from the free play of the impulses which are normally repressed. Pacification, *catharsis*? This theme has often been exploited. Alain has powerfully demonstrated how art – and in the first place, ceremony – civilizes by teaching civility and by repressing the imagination. And this function is perhaps given a foremost place in the arts which sought to integrate the individual in culture and to strengthen the institutions; a caricature of which is still to be found in our societies which have liquidated or perverted the sacred, but wherein the theologians have been replaced by the police. But living art today, at any rate in our Western societies, in so far as it is not taken over by fashion and commerce, aims rather at demystifying culture and promoting anti-culture; it gives play to the forces in rebellion which prey on subjectivity. That does not mean that it restores man to the unconscious, but that it restores the unconscious to man, by giving him access, in the imaginary, to the lost object that the law denies him; it delivers him from himself, from that super-ego in him that has interiorized what is forbidden, instead of accepting it freely, with no sense of guilt.

That might be expressed in language other than that of psycho-analysis. In the Dionysian play of art – untamed perception and enjoyment – the denatured individual reassumes his nature. He returns to the innocent world of pre-history, to Nature in which he takes root. Because the origin constantly eludes, because Nature is always previously thought or dreamed by a subjectivity, it may be that to some people it offers the appearance of nothingness, night, the desert, because they are more susceptible to Thanatos than to Eros; but why should Nature not also be plenty and profusion, the strength of day and the power of becoming? Nevertheless, this return to the sources to which we are invited by art is not a reassuring experience: the subject can there assert himself only be retracing the path of individuation where he will have to 'earn his living' by embracing 'harsh reality', as Rimbaud said. But for a moment art offers him an abode at that ambiguous point where the real and the imaginary are not as yet disassociated, where appearance has not been reduced and then mastered, where language still has a grasp on things, where it is Nature that beckons. And art perhaps invites us not to forget that abode, not to drop entirely the substance for the shadow: the surreal for the real, Nature *naturans* for Nature *naturata*. How can it be said, in any case, that art signifies the death of man? It brings us back to his birth; it is with art that man is reborn into the world and finds himself again. In that sense, art is humanistic, and the humanism of today could be a meditation on birth and individuation, on the invention of man by man.

BIBLIOGRAPHICAL ANNEX

I. LIST OF WORKS CITED

ABEL, Chris, 'A come back for universal man', *Architectural Design*, Mar. 1969.
ABRAMS, Charles, *Forbidden Neighbors*, New York, Harper, 1955.
——, *Housing in the Modern World*, Cambridge (Mass.), The M.I.T. Press, 1964.
ACKERMAN, James S., 'Western art history', in ACKERMAN, J. S. and CARPENTER, Rhys,
 Art and Archaeology, Englewood Cliffs (N.J.), Prentice-Hall, 1963, 'Human-
 istic Scholarship in America. The Princeton Studies' ser.
*Actes du Vème Congrès de l'Association internationale de Littérature comparée,
 Belgrade, 1967*, Amsterdam, 1969.
ADAMS, J. W. R., *Posters Look to the Future*, London, Fanfare Press, 1966.
ADAMS, Nan, 'Corporate identity as a system', *Dot Zero*, No. 2, 1967.
ADLER, Guido, *Methode der Musikgeschichte*, Leipzig, 1919.
ADLER, Guido (ed.), *Handbuch der Musikgeschichte*, 1924; 2nd edn., Berlin, 1930,
 2 vols.; reprinting, Tutzing, Schneider, 1961.
ADORNO, Theodor W,, *Philosophie der neuen Musik*, Tübingen, J. C. B. Mohr, 1949
 (English translation, *Philosophy of Modern Music*, New York, Seabury Press,
 1973).
——, 'Television and the patterns of mass culture', in *Mass Culture. The Popular
 Arts in America*, Glencoe (Ill.), The Free Press, 1957 (1st publication, *Quar-
 terly of Film, Radio and Television*, Vol. VIII, 1954, pp. 213-235).
——, *Noten zur Literatur*, Frankfurt am Main, Suhrkamp, 1958-65, 3 vols.
——, *Klangfiguren. Musikalische Schriften*, Frankfurt am Main, Suhrkamp, 1959-63,
 2 vols.
——, *Einleitung in die Musiksoziologie. 12 theoretische Vorlesungen*, Frankfurt am
 Main, Suhrkamp, 1962.
——, *Eingriffe*, Frankfurt am Main, Suhrkamp, 1963.
——, *Prismen. Kulturkritik und Gesellschaft*, Munich, Deutscher Taschenbuch Ver-
 lag, 1963 (English translation by Samuel & Shierry Weber, *Prisms*, London,
 Spearman, 1967).
AGBLEMAGNON, Ferdinand N'sougan, 'Sociologie littéraire et artistique de l'Afrique',
 Diogène, No. 74, Apr.-June 1971, pp. 96-115 (parallel publication of English
 version, 'The literary and artistic sociology of Black Africa', translation by
 Simon Pleasance, *Diogenes*, No. 74, Summer 1971, pp. 89-110).
AGEL, Henri & AYFRE, Amédée, *Le cinéma et le sacré*, Paris, Editions du Cerf, 1953.
ALAIN, *Système des beaux-arts*, Paris, Gallimard, 1926.
ALBERONI, Francesco, *L'elite senza potere. Ricerca sociologica sul divismo*, Milan,
 Edizione Vita e Pensiero, 1963.
ALBERTI, Leon Battista, *Ten Books on Architecture*, translation by James Leoni,
 edited by J. RYKWERT, London, Tiranti, 1965.
ALBRECHT, Milton C., 'The relationship of literature and society', *American Journal
 of Sociology* LIX (5), 1954, pp. 425-436.
——, 'Does literature reflect common values?', *American Sociological Review* XXI
 (6), Dec. 1956, pp. 722-729.
ALBRECHT, Milton C., BARNETT, James H. & GRIFF, Mason (eds.), *The Sociology of
 Art and Literature. A Reader*, New York, Praeger, 1970.
ALEKSEEV, M. P., *Iz istorii anglijskoi literatury* (= Outline of the History of Eng-
 lish Literature), Moscow-Leningrad, Goslitizdat, 1960.
——, *Šekspir i russkaja kul'tura* (= Shakespeare and Russian Culture), Moscow-
 Leningrad, Goslitizdat, 1965.
ALEXANDER, Christopher W., *Notes on the Synthesis of Form*, Cambridge (Mass.),
 Harvard University Press, 1964 (French translation, *De la synthèse de la*

354 *Mikel Dufrenne et al.*

forme, Paris, Dunod, 1971).

——, 'A city is not a tree', *Architectural Design*, Feb. 1966 (French translation, 'La cité est semi-treillis, mais non un arbre', *Architecture. Mouvement. Continuité*, 1967).

——, 'Systems generating systems', *Architectural Design*, Dec. 1968.

——, Interview (by Max Jacobson), *Design Methods Newsletter* V (3), Mar. 1971; reproduced in *Architectural Design*, XLII, Dec. 1971, pp. 768-770 (French translation, 'A propos de la méthodologie du *design*', *Architecture. Mouvement. Continuité*, No. 25, 1972, pp. 11-13).

AL'PATOV, Mihail V., *Russian Impact on Art*, edited by M. L. Wolf, translation by I. Litvinov, Westport (Conn.), Greenwood Press, 1950.

——, *Geschichte der Kunst*, Dresden, Verlag der Kunst, 1961-63, 2 vols.

——, *Etjudy po istorii zapadnoevropejskogo iskusstva* (= Studies in the History of Western European Art), Moscow, Izdatel'stvo Akademiai Hudožestvennaja S.S.S.R., 1963.

——, 'Interprétation des anciennes icônes russes', *L'information sur l'histoire de l'art* (Paris), 1969.

——, 'Patrimoine artistique de l'homme moderne et problèmes d'histoire de l'art' (translated from Russian), *Cahiers d'Histoire mondiale / Journal of World History* (Unesco), XII (4), 1970, pp. 643-654.

ALSLEBEN, Kurt, *Ästhetische Redundanz*, Quickborn-Hamburg, Schnelle Verlag, 1962.

——, MOLES, A. A. & MOLNAR, F., *Probleme der Informations-Ästhetik*, Munich, Dieter Hacker & Klaus Staudt, 1965.

ALTHUSSER, Louis, 'Marxisme et humanisme', in L. ALTHUSSER, *Pour Marx*, Paris, Maspero, 1965 (English translation by Ben Brewster, *For Marx*, New York, Pantheon Books / London, Allen Lane, 1970).

ALTICK, Richard Daniel, *The English Common Reader. A Social History of the Mass Reading Public, 1800-1900*, Chicago, University of Chicago Press, 1957.

——, 'The sociology of authorship', *Bulletin of the New York Public Library*, LXVI, June 1962, pp. 389-404.

ALVAREZ, Alfred, *Under Pressure. The Writer in Society – Eastern Europe and the U.S.A.*, Harmondsworth (Middx.) and Baltimore (Md.), Penguin Books, 1966.

AMOROS, Andrés, *Sociología de una novela rosa*, Madrid, Taurus, 1967.

L'Analyse des images = *Communications* (Paris), No. 15, 1970.

L'Analyse structurale du récit: see *Recherches sémiologiques. L'analyse structurale du récit*.

ANAND, Mulk Raj, 'The birth of Lalit Kala. An essay on the aesthetic of the age of the Gods, in relation to Western perspectives on aesthetic of humanism', to be published in *Cultures* (quarterly, Unesco, Paris).

ANDERS, Günther, *Die Antiquiertheit des Menschen*, Munich, Beck, 1956.

——, 'Die Welt als Phantom und Matrize. Philosophische Gedanken zu Rundfunk und Fernsehen', *Merkur* (Stuttgart), Vol. IX, 1955, Nos. 87 (Fasc. 5, May), pp. 401-416; 88 (Fasc. 6, June), pp. 533-549; and 89 (Fasc. 7, July), pp. 636-652.

ANDERSON, J. M., 'Art history?', *Journal of Aesthetics and Art Criticism*, Vol. XXV, 1967.

ANSCHÜTZ, G., *Kurze Einführung in die Farbe-Ton-Forschung*, Leipzig, 1927.

——, *Farbe-Ton-Forschungen*, Leipzig-Hamburg, 1927-36, 3 vols.

——, *Das Farbe-Ton Problem im psychischen Gesamtbereich*, Halle, 1929.

——, 'Zur Frage der "echten" und "unechten" *audition colorée*', *Zeitschrift für Psychologie*, 116, 1930.

ANSERMET, Ernest, *Les fondements de la musique dans la conscience humaine*, Neuchâtel, La Baconnière, 1961.

——, *Ecrits sur la musique*, edited by Jean-Claude Piguet, Neuchâtel, La Baconnière, 1971, 'Langages' ser.

ANTAL, Frederick, *Florentine Painting and Its Social Background*, London, Routl-

edge, 1948.

ANZIEU, Didier, 'Le discours de l'obsessionnel dans les romans de Robbe-Grillet', *Les Temps modernes,* 21st Year, No. 233, Oct. 1965, pp. 608-637.

APPLETON, A. William W., *A Cycle of Cathay. The Chinese Vogue in England during the Seventeenth and Eighteenth Centuries,* New York, Columbia University Press, 1961.

ARANGUREN, José Luis, *Sociología de la communicación,* Madrid, Guadarrama, 1967.

Archigram, Nos. 1 to 9, collected in one volume, with the title *Archigram,* London, private edition by the group Archigram, 1969; to be issued in a commercial edition.

L'Architecture actuelle dans le monde = *Revue d'Esthétique* (Paris), XV (3-4) (double issue), July-Dec. 1962.

Architecture et dramaturgie (texts by André BARSACQ, Raymond BAYER, André BOLL, Louis JOUVET, LE CORBUSIER, Pierre SONREL, Etienne SOURIAU, André VILLIERS), Paris, Flammarion, 1949-50.

Architecture. Mouvement. Continuité (Paris), Nos. 14 to 16 (*Bulletin de la Société des Architectes diplomés par le Gouvernement,* S.A.D.G., Nos. 174 and 176), 1969 and 1970: articles, round table and informations on the teaching of architecture in various countries and its reorganization in France.

ARENDT, Hannah, *The Human Condition. A Study of the Central Dilemmas Facing Modern Man,* Chicago, University of Chicago Press, 1958 (French translation by Georges Fradier, *Condition de l'homme moderne,* Paris, Calmann-Lévy, 1961).

——, 'Society and culture', in JACOBS, N. (ed.), *Culture for the Millions?, op. cit.* (1961) (1st publ. in *Mass Culture and Mass Media* = *Daedalus,* Spring 1960, pp. 278-287).

ARGAN, Giulio Carlo, 'Architettura e ideologia', *Zodiac* (Milan), No. 1, 1957. [See also sub KLEE, *Das bildnerische Denken,* English translation.]

ARNHEIM, Rudolf, 'Perceptual abstraction and art', *Psychological Review,* Vol. LIV, 1947, pp. 66-82.

——, 'The holes of Henry Moore', *Journal of Aesthetics and Art Criticism,* Vol. VII, 1948, pp. 29-38.

——, 'The *Gestalt* theory of expression', *Psychological Review,* Vol. LVI, 1949, pp. 156-171.

——, 'The priority of expression', *Journal of Aesthetics and Art Criticism,* Vol. VIII, 1949, pp. 106-109.

——, '*Gestalt* psychology and artistic form', in WHYTE (ed.), *Aspects of Form, op. cit.* (1951).

——, 'Perceptual and aesthetic aspects of the movement response', *Journal of Personality,* Vol. XIX, 1951, pp. 265-281.

——, *Art and Visual Perception. A Psychology of the Creative Eye,* Berkeley-Los Angeles, University of California Press, 1954 and London, Faber & Faber, 1956; republ., Berkeley-Los Angeles, University of California Press, 1965.

——, 'Information theory. An introductory note', *Journal of Aesthetics and Art Criticism,* Vol. XVII, 1959.

——, *Toward a Psychology of Art* (collected essays), Berkeley-Los Angeles, University of California Press, 1966.

——, *Visual Thinking,* Berkeley-Los Angeles, University of California Press, 1970.

——, *Entropy and Art. A Study of Disorder and Order,* Berkeley-Los Angeles, University of California Press, 1971.

ARON, Raymond, 'Signification politique de la radio-télévision dans le monde présent', *Cahiers d'Etudes de Radio-Télévision,* No. 15, 4th quarter 1957, pp. 229-244 (English summary, pp. 227-228).

'L'Art en mai et en juin 1968', chronicle (round table). *Revue d'Esthétique,* XXII (1) 1969, pp. 75-96.

Art and Play = *Diogenes,* No. 50, Summer 1965 (parallel publication in French.

L'Art et le jeu = *Diogène*, No. 50, Apr.-June 1965).
Art et contestation (collective work), Brussels, Editions La Connaissance, 1968.
Art et philosophie (articles by Etienne GILSON, Stephen C. PEPPER, Mikel DU-
 FRENNE, Guido MORPURGO TAGLIABUE, P. A. MICHELIS, Ugo SPIRITO, Richard
 WOLLHEIM and Max LOREAU) = *Revue internationale de Philosophie* (Brussels),
 No. 68-69, 1964, Fasc. 2-3 (double issue).
Art et société = *Revue d'esthétique*, XXIII (3-4) (double issue), 1970.
The Arts in Society = *International Social Science Journal* (Unesco), Vol. XX
 (1968), No. 4: Introduction by SILBERMANN and articles by BOURDIEU, BROWN,
 CLAUSSE, KARBUSICKY, LUTHE and WATSON (*op. cit.*), pp. 565-680; 'Select bibli-
 ography', pp. 681-687 (parallel publication in French, *Les arts dans la société*
 = *Revue internationale des Sciences sociales*, same reference: texts, pp. 615-
 740; 'Bibliographie sélective', pp. 741-747).
ARVON, Henri, *Georges Lukacs, ou le Front populaire en littérature*, Paris, Seghers,
 1968, 'Philosophes de tous les temps' ser., No. 41.
ASHBY, William ROSS, *An Introduction to Cybernetics*, London, Chapman & Hall,
 1956.
ASTAHOV, I., 'Diskussionnoe v estetike' (= What is under discussion in aesthetics),
 Voprosy literatury, 1961, No. 11.
Atti della Ia Conferenza Internazionale di Informazione Visiva, Milan, Istituto per
 lo studio sperimentale di problemi sociali con tecniche filmologiche, 1961.
Atti del IIo Congresso Internazionale di Storia del Teatro, Venezia, 1957, Rome,
 De Luca, 1960.
ATTNEAVE, Fred (ed.), *Application of Information Theory to Psychology*, New
 York, Holt, Rinehart & Winston, 1959.
AUERBACH, Erich, *Das französische Publikum des XVII. Jahrhunderts*, Munich,
 Hueber Verlag, 1933.
——, *Mimesis. Dargestellte Wirklichkeit in der abendländischen Literatur*, Bern,
 Francke, 1946; 2nd edn., *ibid.*, 1959 (English translation by W. R. Tresk,
 Mimesis. The Representation of Reality in Western Literature, Princeton (N.J.),
 Princeton University Press, 1953).
——, 'La Cour et la Ville', in AUERBACH, *Vier Untersuchungen zur Geschichte der
 französischen Bildung*, Bern, Francke, 1951.
AUROBINDO, Sri, *The Significance of Indian Art*, Bombay, 1947.
'Die Aussage der Architektur' / 'Le langage de l'architecture' / 'Meaning in Archi-
 tecture' (contributions collected in response to an inquiry on 'Architecture and
 semiotics'), *Werk* (Winterthur, Switzerland), 1971, No. 4 (April), pp. 242-255
 and 269-272 and No. 6 (June), pp. 384-399 (issues entitled *Was bedeutet Ar-
 chitektur?).
AYFRE, Amédée, *Conversion aux images?*, Paris, Editions du Cerf, 1964, 'Seventh
 Art' ser.
——, *Cinéma et mystère*, Paris, Editions du Cerf, 1969.
 [See also AGEL & AYFRE.]
AZEVEDO, W. L. d', *The Artist Archetype in Gola Culture*, Reno, University of
 Nevada, 1966, Desert Research Institute, Preprint No. 14.

BABBITT, Milton, 'Some aspects of twelve-tone composition', *The Score*, Vol. XII,
 1955, pp. 53-61.
——, 'Twelve-tone invariants as compositional determinants', *Musical Quarterly*,
 Vol. XLVI, 1960, pp. 246-259.
——, 'Past and present concepts of the limits of music', in *Report of the Eighth
 Congress, International Musicological Society, New York, 1961*, Vol. I, *op.
 cit.* (1961), pp. 398-403.
——, 'Set structure as a compositional determinant', *Journal of Music Theory*, Vol.
 V, 1961, pp. 72-94.

BACHELARD, Gaston, *La psychanalyse du feu*, Paris, Gallimard, 1938 (English translation by A. Ross, *The Psychoanalysis of Fire*, London, Routledge, 1964).

——, *La poétique de l'espace*, Paris, Presses Universitaires de France, 1958 (English translation by Maria Jolas, *Poetics of Space*, New York, Grossman, 1964; paperback edn., Boston, Beacon Press, 1969).

——, *La poétique de la rêverie*, Paris, Presses Universitaires de France, 1960 (English translation by Daniel Russell, *Poetics of Reverie. Childhood, Language and the Cosmos*, New York, Grossman, 1969; paperback edn., Boston, Beacon Press, 1971).

Bachelard (special issue of *L'Arc*): see BACKÈS, PINGAUD *et al.*

BACHEM, A., 'The genesis of absolute pitch', *Psychological Bulletin*, 11, 1940.

——, 'Note on Neu's review of the literature on absolute pitch', *Psychological Bulletin*, 45, 1948.

BACKÈS, Catherine, PINGAUD, Bernard *et al.*, *Bachelard = L'Arc*, No. 42, 3rd quarter 1970.

BAHTIN, Mihail, *Problemy poetiki Dostoevskogo*, Moscow, Sovetskij Pisatel', 1963 (English translation by R. W. Rotsel, BAKHTIN, *Problems of Dostoevsky's Poetics*, Ann Arbor (Mich.), Ardis Pub., 1973 – also in paperback edn.).

——, *Tvorčestvo Fransua Rable i narodnaja kul'tura Srednevekov'ja i Renessansa.* Moscow, Izd. Hvd. Lit., 1965 (English translation by Helene Iswolsky, BAKHTIN, *Rabelais and His World*, Cambridge (Mass.), The M.I.T. Press, 1968). [See also *Linguistique et littérature*.]

BAIN, Read, Article 'Public', in Julius GOULD & William L. KOLB (eds.), *A Dictionary of the Social Sciences*, London, Tavistock Publications / New York, Free Press, 1964, pp. 557-558.

BAIRD, George, ' "La dimension amoureuse" in architecture', 1st publication in *Arena*, June 1967; reproduced in JENCKS & BAIRD (eds.), *Meaning in Architecture, op. cit.* (1969), pp. 78-99.

BAKHTIN, Mikhail: see BAHTIN, Mihail.

BALLESTER, Torrente, *Panorama de la literatura española contemporánea*, 3rd edn., Madrid, Guadarrama, 1965.

BALTRUŠAITIS, Jurgis, *Le Moyen Age fantastique. Antiquités et exotisme dans l'art gothique*, Paris, A. Colin, 1955, 'Henri Focillon' ser.

BANHAM, Reyner, *The Architecture of the Well-Tempered Environment*, London, Architectural Press, 1969.

——, 'The architecture of Wampanoag', in JENCKS & BAIRD (eds.), *Meaning in Architecture, op. cit.* (1969), pp. 100-118.

——, *Los Angeles: The Architecture of Four Ecologies*, New York, Harper & Row, 1971, Icon Editions.

——, BARKER, B., HALL, P. & PRICE, C., 'Non-plan: an experiment in freedom', *New Society*, 20 Mar. 1969.

BARBAUD, Pierre, *Initiation à la composition musicale automatique*, Paris, Dunod, 1965.

——, *La musique, discipline scientifique*, Paris, Dunod, 1968.

BARBI, Michele, *Dante. Vita, opere e fortune*, Florence, Sansoni, 1940 (English translation edited by Paul G. Ruggiers, *Life of Dante*, Berkeley-Los Angeles, University of California Press, 1954).

BARNETT, James H., 'The sociology of art', in R. K. MERTON, L. BROOM & L. S. COTTRELL, Jr. (eds.), *Sociology Today. Problems and Prospects* (under the auspices of the American Sociological Society), New York, Basic Books, 1959, pp. 197-214.

BARTHES, Roland, *Le degré zéro de l'écriture*, Paris, Seuil, 1953, 'Pierres vives' ser.; republ., followed by 'Eléments de sémiologie', Paris, Gonthier, 1965, Bibliothèque 'Médiations', and followed by 'Nouveaux essais critiques', Paris, Seuil, 1972, 'Points' ser. (English translation by Annette Lavers & Colin Smith,

Writing Degree Zero, London, Jonathan Cape, 1967; New York, Hill & Wang, 1968).

——, *Mythologies*, Paris, Seuil, 1957, 'Pierres vives' ser.; republ., *ibid.*, 1970, 'Points' ser. (English translation by Annette Lavers, *Mythologies*, London, Jonathan Cape, 1972).

——, 'Le message publicitaire', *Cahiers de la publicité*, 7, 1963.

——, *Sur Racine*, Paris, Seuil, 1963, 'Pierres vives' ser.

——, 'Eléments de sémiologie', in *Recherches sémiologiques* (= *Communications*, No. 4), *op. cit.* (1964), pp. 91-135; republ. in volume form with BARTHES, *Le degré zéro de l'écriture, op. cit.* (republ., 1965) (English translation by Annette Lavers & Colin Smith, *Elements of Semiology*, London, Jonathan Cape, 1967).

——, *Essais critiques*, Paris, Seuil, 1964, 'Tel Quel' ser. (English translation by Richard Howard, *Critical Essays*, Evanston (Ill.), Northwestern University Press, 1972).

——, 'Rhétorique de l'image', in *Recherches sémiologiques, op. cit.* (*Communications*, 1964), pp. 40-51.

——, *Critique et vérité*, Paris, Seuil, 1966, 'Tel Quel' ser., 1966.

——, 'Introduction à l'analyse structurale des récits', in *Recherches sémiologiques. L'analyse du récit, op. cit.* (*Communications*, 1966), pp. 1-27.

——, *Système de la mode*, Paris, Seuil, 1967.

——, 'Drame, poème, roman', in FOUCAULT, BARTHES, DERRIDA *et al.*, *Théorie d'ensemble, op. cit.* (1968), pp. 25-40 (1st partial publ. as a review of Philippe Soller's *Drame, Critique*, July 1965).

——, 'Società, immaginazione, pubblicità', in *Pubblicità e televisione, op. cit.* (1968-1969), pp. 164-174.

——, *S/Z*, Paris, Seuil, 1970, 'Tel Quel' ser.
 [See also *sub Linguistique et littérature.*]

BASTIDE, Roger (ed.), *Sens et usage du mot structure*, Paris-The Hague, Mouton, 1962.
 [See also *Critique sociologique et critique psychanalytique.*]

BASTIN, M. L., *Art décoratif Tshokwe*, Lisbon, 1961, 2 vols.

BATESON, F. W., 'Linguistics and literacy criticism', in DEMETZ *et al., The Disciplines of Criticism, op. cit.* (1968).

BAUDOT, J. A., *La machine à écrire*, Montreal, Editions du Jour, 1964.

BAUDRILLARD, Jean, *Le système des objets. La consommation des signes*, Paris, Gallimard, 1968; republ., Paris, Denoël/Gonthier, 1972, Bibliothèque 'Médiations'.

BAYER, Raymond, *L'esthétique de la grâce*, Paris, Alcan, 1933.
 [See also *sub Architecture et dramaturgie.*]

BAZIN, André, *Qu'est-ce que le cinéma?*, Paris, Editions du Cerf, 1958, 2 vols.: Vol. I. *Ontologie et langage*; Vol. II. *Le cinéma et les autres arts* (English translation by H. Gray, *What Is Cinema?*, Berkeley-Los Angeles, University of California Press, 1967-72, 2 vols.: paperback edns., 1967-73).

BEARDSLEY, Monroe, *Aesthetics. Problems in the Philosophy of Criticism*, New York, Harcourt-Brace, 1958.

BEARDSLEY, Monroe & SCHUELLER, Herbert M. (eds.), *Aesthetic Enquiry. Essays on Art Criticism and the Philosophy of Art*, Belmont (Calif.), Dickenson, 1967.

BECKER, H. S., 'The professional dance musician and his audience', *American Journal of Sociology* LVII (2), 1951, pp. 136-144.

BECKING, G., *Der musikalische Rhythmus als Erkenntnisquelle*, Augsburg, 1928.

BECKSON, Karl E. (ed.), *Great Theories in Literary Criticism*, New York, Farrar, Straus, 1963.

BEITTEL, Kenneth R., 'Creativity in the visual arts in higher education: criteria, predictors, experimentation, and their interactions', in TAYLOR, C. W. (ed.), *Widening Horizons in Creativity, op. cit.* (1964), pp. 379-395.

BÉKÉSY, G. von, 'Zur Theorie des Hörens', *Physikalische Zeitschrift*, XXX, 1929 and XXXI, 1930.
—, *Experiments in Hearing*, translated by E. G. Weaver, New York, McGraw-Hill, 1960.
BELL, Daniel, 'The year 2000 – The trajectory of an idea', in BELL (ed.), *Toward the Year 2000, op. cit. (Daedalus,* 1967), pp. 639-651.
BELL, Daniel (ed.), *Toward the Year 2000. Work in Progress* = *Daedalus, Journal of the American Academy of Arts and Sciences* (Cambridge(Mass.), 96 (3), Summer 1967, pp. i-vi and 639-994.
BELLAK, Leopold, 'Free association. Conceptual and clinical aspects', *International Journal of Psychoanalysis*, Vol. XLII, 1961.
BELVIANES, Marcel, *Sociologie de la musique*, Paris, Payot, 1949, 1950.
BENEVOLO, Leonardo, *Storia dell'architettura moderna*, Bari, G. Laterza, 1965 (English translation by J. Landry, *History of Modern Architecture*, London, Routledge, 1971 / Cambridge (Mass.), The M.I.T. Press, 1972, 2 vols.).
—, *Roma da ieri a domani*, Bari, G. Laterza, 1971.
BENGTSSON, Ingmar, 'On melody registration and "Mona"', in HECKMANN (ed.), *Elektronische Datenverarbeitung in der Musikwissenschaft, op. cit.* (1967), pp. 136-174.
BENJAMIN, Walter, 'Das Kunstwerk im Zeitalter seiner technischen Reproduzierbarkeit', first published in French in a translation by Pierre Klossowski, 'L'œuvre d'art à l'époque de sa reproduction mécanisée', *Zeitschrift für Sozialforschung* (having then sought refuge in Paris, Librairie Félix Alcan), Vol. V, 1936, pp. 40-66; publ. in German in BENJAMIN, *Schriften*, eds. Th. W. & G. ADORNO, Frankfurt am Main, Suhrkamp, 1955, pp. 366-405; new French translation (integral) by Maurice de Gandillac, 'L'œuvre d'art à l'ère de sa reproductibilité mécanisée', in BENJAMIN, *Œuvres*, Vol. II, *Poésie et révolution*, Paris, Denoël, 1971, pp. 171-210.
—, *Illuminationen*, Frankfurt am Main, Suhrkamp, 1961 (posth.) (English translation by Harry Zohn, edited by Hannah Arendt, *Illuminations. Essays and Reflections*, New York, Harcourt-Brace, 1968; paperback edn., New York, Schocken, 1969; another edn., London, Jonathan Cape, 1970).
BENSE, Max, *Aesthetica*, 4 vols.: Vol. I. *Metaphysische Beobachtungen am Schönen*, Stuttgart, Deutsche Verlags-Anstalt, 1954; Vol. II. *Ästhetische Information*, Krefeld-Baden-Baden, Agis Verlag, 1956; Vol. III. *Ästhetik und Zivilisation. Theorie der ästhetischen Kommunikation, ibid.,* 1958; Vol. IV. *Programmierung des Schönen. Allgemeine Texttheorie und Textästhetik, ibid.,* 1960.
—, *Einführung in die Informations theoretische Ästhetik*, Reinbek bei Hamburg, Rowohlt Deutsche Enzyklopädie, Oct. 1960.
—, *Theorie der Texte. Eine Einführung in neuere Auffassungen und Methoden*, Cologne, Kiepenheuer & Witsch, 1962.
—, *Bestandteile des Vorüber*, Cologne, Kiepenheuer & Witsch, 1964.
BENVENISTE, Emile, 'Les niveaux de l'analyse linguistique', in *Proceedings of the 9th International Congress of Linguistics, Cambridge (Mass.), 1962,* The Hague, Mouton, 1964; reproduced in BENVENISTE, *Problèmes de linguistique générale, op. cit.* (1966).
—, *Problèmes de linguistique générale*, Paris, Gallimard, 1966, Bibliothèque des Sciences humaines (English translation by Mary E. Meek, *Problems in General Linguistics*, Miami, University of Miami Press, 1971).
—, 'Sémiologie de la langue', *Semiotica* (The Hague), I (1 and 2), 1969, pp. 1-12 and 127-135.
BERELSON, Bernard R., *Who Reads What Books and Why?*, Glencoe (Ill.), Free Press, 1957.
BERESTNEV, V. F. & NEDOŠIVIN, G. A., (eds.), *Osnovy marksistsko-leninskoj èstetiki,* (= The Foundations of Marxist-Leninist Aesthetics), Moscow, Izd. političeskoj literatury, 1960.

BERGE, André, CLANCIER, Anne, RICOEUR, Paul, RUBINSTEIN, Lothar-Henry *et al.*, *Entretiens sur l'art et la psychanalyse* ('Décade' of the Centre culturel international de Cerisy-la-Salle, France, 6-11 Sept. 1962), Paris-The Hague, Mouton, 1968.

BERGER, Bruno, *Der Essay*, Bern-Munich, Francke, 1964.

BERGER, John P., *Art and Revolution: Ernst Neizvestny and the Role of the Artist in the U.S.S.R.*, New York, Pantheon Books / London, Weidenfeld, 1969 (French translation, *Art et révolution: Ernst Neizvestny et le rôle de l'artiste en U.R.S.S.*, Paris, Denoël, 1970, 'Lettres nouvelles' ser.).

BERGER, René, 'Une aventure de Pygmalion. La mutation des moyens de présentation, de diffusion, de reproduction et ses conséquences pour l'étude des expressions artistiques', in *Communication et culture de masse, op. cit. (Diogène, 1969)*, pp. 32-56 (parallel publication of English version, 'A Pygmalion adventure. The mutation of the means of presentation, of diffusion or reproduction and its consequences for the study of artistic expressions', in *Mass Communication and Culture, op. cit. (Diogenes, 1969)*, pp. 29-52); original French text reproduced in BERGER, R., *Art et communication, op. cit.* (1972), pp. 13-43.

——, *Art et communication*, Paris, Casterman, 1972, 'Mutations. Orientations' ser.

BERGLER, Edmund, *Laughter and the Sense of Humor*, New York, Grune & Stratton, Intercontinental Medical Book Corporation, 1956.

BERLINER, Anna, *Lectures on Visual Psychology*, Chicago, Professional Press, 1948.

BERLYNE, D., 'The influence of complexity in visual figures on orienting responses', *S. Exp. Psychol.*, 55, 1958, pp. 289-296.

BERNE-JOFFROY, André, *Le dossier Caravage. Psychologie des attributions et psychologie de l'art*, Paris, Minuit, 1959, 'Forces vives' ser.

BERTHOLD, Margot, *Weltgeschichte des Theaters*, Stuttgart, Kröner, 1968 (English translation by Edith Simmons, *A History of World Theatre*, New York, Ungar, 1972).

BETTETINI, Gianfranco, *Il segno. Dalla magia fino al cinema*, Milan, Edizioni i 7 (O.D.C.), 1963.

——, *Cinema: lingua e scrittura*, Milan, Bompiani, 1968.

——, *L'indice del realismo*, Milan, Bompiani, 1971.

BEYER, J., *Die Künstler und der Sozialismus*, Berlin, Dietz, 1963.

Bibliothèque et musées des arts du spectacle dans le monde, 2nd edn., Paris, Editions du Centre national de la Recherche scientifique (CNRS), 1967.

BILLARD, P., 'La musique baroque', in *Encyclopaedia Universalis* (Paris), Vol. II, 1968, p. 1097 A-C.

BINNI, Walter, *Poetica, critica e storia letteraria*, Bari, Laterza, 1963.

BIRKHOFF, George David, *Aesthetic Measure*, Cambridge (Mass.), Harvard University Press / Oxford, Oxford University Press, 1933.

——, 'Structure and communication', in KEPES (ed.), *Structure in Art and Science, op. cit.* (1965).

BLACK, Max, *Models and Metaphors. Studies in Language and Philosophy*, Ithaca (N.Y.), Cornell University Press, 1961.
[See also *sub* STEVENSON, 'Interpretation and evaluation . . .'.]

BLAKE, Robert R. & RAMSEY, Glenn V. (eds.), *Perception. An Approach to Personality*, New York, Ronald Press, 1951.

BLANCHOT, Maurice, 'La folie par excellence', Preface to JASPERS, *Strindberg et Van Gogh*, French translation, *op. cit.* (1953).

——, *L'espace littéraire*, Paris, Gallimard, 1955; republ., *ibid.*, 1968, 'Idées' ser.

——, *Le livre à venir*, Paris, Gallimard, 1959.

BLIN, Georges, *La cribleuse de blé*, Paris, José Corti, 1968.

BLOCH, Marc, *Apologie pour l'histoire, ou Métier d'historien* (posthumous work), Paris, Armand Colin, 1949 (English translation by Peter Putnam, with an

Introduction by Joseph Strayer, *Historian's Craft*, New York, Knopf / Manchester, Manchester University Press, 1954).

BLUME, Friedrich, 'Das musikalische Kunstwerk in der Geschichte', in M. RUHNKE (ed.), *Festschrift für B. Stäblein*, Kassel-Basel, 1967.

——, 'Historische Musikforschung in der Gegenwart', *Acta Musicologica*, Vol. XL, 1968, pp. 8-21.

BLUME, Friedrich (ed.), *Die Musik in Geschichte und Gegenwart*, Kassel-Basel-Paris, Bärenreiter Verlag, 1949-68, 14 vols.

BOAS, Franz, *Primitive Art*, 1st publ., 1927; new edn., New York, Dover, 1955.

BODROGI, T., *Oceanian Art*, Budapest, 1959.

——, *Art in North-East New Guinea*, Budapest, 1961.

BOFILL, Anna, *Rapport sur la rationalisation du processus de travail du Taller de Arquitectura* (mimeographed), document submitted at the 2nd E. Galion international seminar held at Fryskas in July 1971 on the theme '*La concrétisation en mathématique*'.

BOGATYREV, P. G. & JAKOBSON, Roman, 'Die Folklore als besondere Form des Schaffens' (= Folklore as a particular form of creation), in *Verzameling van opstellen door oud leerlingen en bevriende vakgenoten opgedragen aan Mgr. Prof. Dr. Jos. Schrijnen* (= Collection of Essays by Former Pupils and Friendly Colleagues Offered to His Lordship Professor Dr. J. S.), Utrecht, 1929, pp. 900-913.

BOHRINGER, B. Frank, *Rhetorische Kommunikation*, Hamburg, Schnelle Verlag, 1967.

BOLLÈME, G., EHRARD, J., FURET, F., ROCHE, D., ROGER, J. and DUPRONT, A., *Livre et société dans la France du XVIIIe siècle*, Paris-The Hague, Mouton, 1965.

BOLLNOW, Otto Friedrich, *Die Methode der Geisteswissenschaften*, Mainz, Johannes Gutenberg-Buchhandlung, 1950.

BONAPARTE, Marie, *Edgar Poe. Etude psychanalytique*, Foreword by Sigmund FREUD, Paris, Denoël & Steele, 1933 (English translation by John Rodker, with a Preface by Sigmund FREUD, *The Life and Works of Edgar Allan Poe. A Psychoanalytic Interpretation*, London, Imago, 1949 and New York, Anglobooks, 1951; reprint, London, Hogarth Press / New York,, Humanities Press, 1971).

——, 'Poe and the function of literature', in PHILIPS (ed.), *Art and Psychoanalysis, op. cit.* (1957).

BONNAFÉ, E., *Le commerce de la curiosité*, Paris, Champion, 1895.

BONSIEPE, Gui, 'Visuell-verbale Rhetorik', *Ulm* (Hochschule für Gestaltung, Ulm), No. 14-15-16 (triple issue), Dec. 1965, pp. 23-40.

BOORSTIN, D. J., *The Image*, Harmondsworth (Middx.), Penguin Books, 1961 (French translation by Marie-Jo Milcent, *L'image*, Paris, Union générale d'éditions, 1971, '10/18' ser.).

BORNSTEIN, Eli, 'Transition toward the new art', *Structure* (University of Saskatchewan), I (1), 1958.

——, 'Structurist art – its origin', *The Structurist* (University of Saskatchewan), II (1), 1960-61.

——, 'Conflicting concepts in art', *The Structurist*, Vol. III, 1963.

——, 'Sight and sound – Analogies in art and music', *The Structurist*, Vol. IV, 1964.

BOUDON, Philippe, *Pessac de Le Corbusier*, Paris, Dunod, 1969.

BOULEZ, Pierre, 'Musique traditionnelle – Un paradis perdu?', *Informations Unesco*, No. 511, Sept. (II) 1967 (parallel publication of English translation, 'Traditional music – A lost paradise?', *Unesco Features*, same ref.); reproduced, *The World of Music* (Kassel-Basel), 9, 1967.

BOURDIEU, Pierre, 'Champ intellectuel et projet créateur', in *Problèmes du structuralisme, op. cit.* (*Les Temps modernes*, 1966), pp. 865-906.

——, 'Postface' (pp. 133-167) to the French translation, *Architecture gothique et*

pensée scolastique (1967), of PANOFSKY, *Gothic Architecture and Scholasticism, op. cit.* (1951).

——, *Sur les conditions sociologiques de la perception esthétique*, Paris, Publications du Centre de Sociologie européenne, June 1968.

——, 'Eléments d'une théorie sociologique de la perception artistique', in *Les Arts et la société, op. cit. (Revue internationale des Sciences sociales,* 1968), pp. 640-664 (parallel publication of English version, 'Outline of a sociologica. study of art perception', in *The Arts and Society, op. cit. (International Social Science Journal,* 1968), pp. 589-612).

——, 'La maison kabyle', in Jean POUILLON & Pierre MARANDA (eds.), *Echanges e. communications. Mélanges offerts à Claude Lévi-Strauss,* The Hague-Paris, Mouton, 1970 (English translation, 'The Berber house, or the world reserved', *Social Science Information/Information sur les sciences sociales* (Paris), IX (2), Apr. 1970, pp. 151-170).

——, BOLTANSKI, L., CASTEL, R., CHAMBOREDON, J.-C., LAGNEAU, G. & SCHNAPPER, D., *Un art moyen. Essai sur les usages sociaux de la photographie,* Parıs, Minuit, 1965, 'Le sens commun' ser.

—— & DARBEL, Alain, with SCHNAPPER, D., *L'amour de l'art. Les musées et leur public,* Paris, Minuit, 1966.

—— & PASSERON, Jean-Claude, *Les héritiers. Les étudiants et la culture,* Paris, Minuit, 1964.

—— & SAYAD, Abdelmalek, *Le déracinement. La crise de l'agriculture traditionnelle en Algérie,* Paris, Minuit, 1964.

BOYD, Robin, *The Puzzle of Architecture,* Melbourne, Melbourne University Press / Cambridge, Cambridge University Press, 1965; Portland (Oreg.), International Scholarly Book Service, 1966.

——, 'Anti-architecture', *Architectural Forum,* Nov. 1968.

BRANDI, Cesare, 'Structure de la télévision', *Revue internationale de philosophie,* No. 81, 1967/3 (special issue: *Forme et pensée*).

BRANDT CORSTIUS, Johannes Christiaan, *Introduction to the Comparative Study of Literature,* New York, Random House, 1968.

BRECHT, Bertolt, *Schriften zur Literatur und Kunst,* Berlin, Aufbau-Verlag, 1966, 2 vols.

BRELET, Gisèle, *Esthétique et création musicale,* Paris, Presses Universitaires de France, 1947, 'Nouvelle Encyclopédie philosophique' ser.

——, 'Musique et structure', in *La notion de structure, op. cit. (Rev. int. de phil.,* 1965), pp. 387-408.

BREMOND, Claude, 'Le message narratif', in *Recherches sémiologiques, op. cit.* (*Communications,* 1964), pp. 4-32.

——, 'La logique des possibles narratifs', in *Recherches sémiologiques. L'analyse structurale du récit, op. cit. (Communications,* 1966), pp. 60-76.

BROADBENT, Geoffrey, 'Design method in architcture', *The Architects Journal,* 14 Sept. 1967.

——, 'Portsmouth Symposium on design methods in architecture', *Arena Interbuild,* Feb. 1968.

BROADBENT, Geoffrey, 'Design method in architecture', *The Architects Journal,* 14 London, Lund Humphries, 1969, Architectural Association Papers No. 4.

BROWER, Reuben A. (ed.), *On Translation,* Cambridge (Mass.), Harvard University Press, 1959.

—— & POIRIER, R. (eds.), *In Defense of Reading. A Reader's Approach to Literary Criticism,* New York, Dutton, 1963.

BROWN, Calvin S., *Music and Literature,* Athens (Ga.), University of Georgia Press, 1948.

BROWN, Roger L., 'The creative process in the popular arts', in *The Arts in Society, op. cit. (International Social Science Journal,* 1968), pp. 613-624 (parallel publication in French, 'Le processus de création dans la culture de masse', in *Les*

Arts dans la société, op. cit. (Revue internationale des Sciences sociales, 1968), pp. 665-678).

BRUNER, Jerome S. & KRECH, David (eds.), *Perception and Personality. A Symposium* (on personal and social factors in perception, Denver, 1949), Durham (N.C.), Duke University Press, 1950.

BUCHLER, Justus (ed.), *The philosophy of Peirce. Selected Writings,* New York, Harcourt-Brace / London, Routledge, 1940; republ., 1950.

Buch und Leser in Deutschland (a study by the DIVO-Institut), Gütersloh, 1965, Schriften zur Buchmarkt-Forschung, No. 4.

BUKOFZER, Manfred, *The Place of Musicology in American Institutions of Higher Learning,* New York, The Liberal Arts Press, 1957.

BURCHARTZ, Max, *Gleichnis der Harmonie. Ein Schlüssel zum Verständnis von Werken d. Vergangenheit u. Gegenwart,* Munich, Prestel, 1949.

BURKE, Kenneth, *The Philosophy of Literary Form. Studies in Symbolic Action,* Baton Rouge (La.), Louisiana State University Press, 1941.

BURLEN, Catherine, *La réalisation spatiale du désir et l'image spatialisée du besoin* (work performed in the framework of the 'Urbanization' concerted action initiated in 1967 by the Direction générale à la Recherche scientifique et technique – DGRST –, France), unpublished: see review by J. DREYFUS, *op. cit.* (1971).

BUROV, A. I., *Èstetičeskaja suščnost' iskusstva* (= The Aesthetic Essence of Art), Moscow, 1956.

——, 'O prirode ob"ektivnosti krasoty' (= On the nature of the objectivity of beauty), *Voprosy literatury,* 1969, No. 3.

BURSSENS, H., *Yanda-beelden en Mani-sekte bij de Azande* (= Images of Yanda and Sect of Mani among the Azande), Tervuren (Belgium), Musée royal de l'Afrique centrale, 1962, *Annales,* new series, 'Sciences humaines', No. 4.

BURT, Sir Cyril, 'The psychology of art', in Sir Cyril BURT (ed.), *How the Mind Works,* London, 1933.

BUTOR, Michel, 'Le livre comme objet', in M. BUTOR, *Répertoire. Etudes et conférences, 1948-1959 [Repertoire I],* Paris, Minuit, 1960.

——, *Les mots dans la peinture,* Geneva, Skira, 1969, 'Les sentiers de la création' ser.

BUYSSENS, E., *Les langages et le discours. Essai de linguistique fonctionnelle dans le cadre de la sémiologie,* Brussels, Office de Publicité, 1943.

——, *La communication et l'articulation linguistique,* Brussels-Paris, Presses Universitaires de France, 1967, Travaux de la Faculté de Philosophie et Lettres de l'Université libre de Bruxelles.

BYSTRON, Jan St., *Socjologia literatury,* Lwow-Warsaw, *Publiczosc literacka,* 1938.

CALDER, Nigel, *The Environment Game,* London, Secker & Warburg / Ontario, Collins, 1967 (also published under the title: *Eden Was No Garden. An Inquiry into the Environment of Man,* New York, Holt, Rinehart & Winston, 1967.)

CAMPION, D., *Computers in Architectural Design,* Amsterdam, Elsevier Publ. Co., 1968.

CARRÉ, Jean-Marie, 'Préface' to GUYARD, *La littérature comparée, op. cit.* (1951).

CASEY, John, *The Language of Criticism,* London, Methuen, 1966.

CASSIRER, Ernst, *Der Begriff der symbolischen Formen im Aufbau der Geisteswissenschaften,* Berlin, Teubner, 1921-22.

——, *Philosophie der symbolischen Formen,* Berlin, D. Cassirer, 1923-29, 3 vols. (English translation by K. Manheim, with a Preface by Ch. W. HENDEL, *The Philosophy of Symbolic Forms,* New Haven (Conn.)-London, Yale University Press, 1953-57).

CASTELLS, Manuel, *La question urbaine,* Paris, François Maspero, 1972

CATTEL, J., GLASCOCK, J. & WASHBURN, M. F., 'Experimenst on a possible test of aesthetic judgment', *Amer. J. Physiol.,* No. 29, 1918, pp. 333-336.

CATTELL, Raymond B. & SAUNDERS, D. R., 'Musical preferences and personality diagnosis', *Journal of Social Psychology*, 39, 1954.

CAUDWELL, Christopher, *Illusion and Reality*, new edn., London, Lawrence & Wishart, 1950.

CAZENEUVE, Jean, *Sociologie de la radio-télévision*, Paris, Presses Universitaires de France, 1965.

——, *Les pouvoirs de la télévision*, Paris, Gallimard, 1970.

——, *La société de l'ubiquité*, Paris, Denoël, 1972, 'Médiations' ser.

CERDA, Ildefonso, *Teoría general de la urbanización*, facsimile with critical studies by A. BARRERA DE IRIMO and F. ESTAPÉ, Barcelona, Instituto de Estudios Fiscales, 1971.

CHADWICK, Nora K. & ZHIRMUNSKY (= ŽIRMUNSKIJ), Victor M., *Oral Epics of Central Asia*, Cambridge, Cambridge University Press, 1969.

CHAILLEY, Jacques, *40.000 ans de musique*, Paris, Plon, 1961, 'D'un monde à l'autre' ser.

CHARPENTRAT, Pierre, *Le mirage baroque*, Paris, Minuit, 1967, 'Critique' ser.

——, 'Le baroque littéraire', in *Encyclopaedia Universalis* (Paris), Vol. II, 1968, pp. 1096 A-1097 A.

CHASTEL, André, 'Problèmes actuels de l'histoire de l'art', *Diogène*, No. 4, Oct. 1953, pp. 94-121 (parallel publication in English version, 'Current problems in the history of art', *Diogenes*, No. 4, Fall 1953, pp. 74-101).

CHENEY, Sheldon Warren, *A World History of Art*, New York, Viking Press, 1937.

CHERRY, Colin, *On Human Communication*, New York, Wiley, 1957.

CHILD, I. L. & SIROTO, L., 'Bakwele and American aesthetic evaluations compared', *Ethnol.*, 1965, No. 4, pp. 349-350.

CHKLOVSKI, V. (French transliteration): see ŠKLOVSKIJ, V.

CHOAY, Françoise, 'Sémiologie et urbanisme', *L'architecture d'aujourd'hui*, June-July 1967; republished in a revised and developed English version, 'Urbanism and semiology', in JENCKS & BAIRD (eds.), *Meaning in Architecture, op. cit.* (1969), pp. 26-37.

——, *The Modern City: Planning in the XIXth Century* (English translation by Marguerite Hugo & George R. Collins), London, Studio Vista, 1969, New York, Braziller, 1970.

——, *Espacements*, Paris, private publication by L'Immobilière-Constructions de Paris, 1969.

——, *Connexions*, Paris, private publication by L'Immobilière-Constructions de Paris, 1971.

——, 'Pour une sémiotique du discours sur la ville', in *Proceedings of the International Congress of Architectural Semiotics (Barcelona, March 1972), op. cit.* (publ. forthcoming).

CHOAY, Françoise (ed.), *L'urbanisme, utopies et réalités. Une anthologie*, Paris, Seuil, 1965.

CHOCHOLLE, René, 'Das Qualitätssystem der Gehörs', in W. METZGER (ed.), *Handbuch der Psychologie*, I, 1, Göttingen, Verlag für Psychologie, Dr. J. C. Hogrefe, 1966.

CHOMSKY, Noam, *Syntactic Structures*, The Hague-Paris, Mouton, 1957 (French translation by Michel Braudeau, *Structures syntaxiques*, Paris, Seuil, 1969).

——, 'Explanation models in linguistics', in E. NAGEL *et al.* (eds.), *Logic, Methodology and Philosophy of Science – Proceedings of the 1960 International Congress*, Stanford (Calif.), Stanford University Press, 1962.

——, *Current Issues in Linguistic Theory*, The Hague, Mouton, 1964.

——, *Cartesian Linguistics. A Chapter in the History of Rationalist Thought*, New York-London, Harper & Row, 1966 (French translation by Nelcya Delanoë & Dan Sperber, *La linguistique cartésienne. Un chapitre de l'histoire de la pensée rationaliste*, followed by 'La nature formelle du langage', Paris, Seuil, 1969).

—— & MILLER, George A., 'Introduction to formal analysis of natural languages',

in R. D. LUCE, BUSH & GALANTER (eds.), *Handbook of Mathematical Psychology*, Vol. 2, New York-London, Wiley, 1963 (French translation by Ph. Richard & N. Ruwet, 'Introduction à l'analyse formelle des langues naturelles', in CHOMSKY & MILLER, *L'analyse formelle des langues naturelles*, Paris, Gauthier-Villars/Mouton, 1968).
[See also *sub Logique et linguistique*.]

CHRISTOUT, Marie-Françoise, 'Documentation iconographique et authenticité théâtrale', in *Proceedings of the VIIth International Congress of Libraries and Museums of the Performing Arts, Amsterdam, 1965, op. cit.* (see *sub* International Congresses of Libraries and Museums . . .).

CLARK, Sir Kenneth, 'Art and society', *Harper's*, 223, Aug. 1961, pp. 74-82.

CLAUSSE, Roger, 'Le grand public aux prises avec la communication de masse', in *Les Arts dans la société, op. cit. (Rev. int. des Sc. soc.,* 1968), pp. 679-697 (parallel publication of English version, 'The mass public at grips with mass communications', in *The Arts in Society, op. cit. (Int. Soc. Sc. J.,* 1968), pp. 625-643).

COHEN, Jean, *Structure du langage poétique*, Paris, Flammarion, 1966, Nouvelle Bibliothèque scientifique.
[See also *sub Linguistique et littérature*.]

COHEN-SÉAT, Gilbert & FOUGEYROLLAS, Pierre, *L'action sur l'homme: cinéma et télévision*, Paris, Denoël, 1961.

COING, Henri, *Rénovation urbaine et changement social: l'îlot no 4 (Paris, XIIIe)*, Paris, Editions ouvrières, 1967.

COLE, Toby & CHINOY, Helen Krich (eds.), *Directors on Directing. A Source Book of the Modern Theater, with an Illustrated History of Directing by Helen Krich* CHINOY, revised and updated edition, New York-Indianapolis, Bobbs-Merrill, 1963 (1st edn. published under the title *Directing the Play*).

College Music Symposium, Vol. IX, 1969, pp. 36-47 and 65-111.

COMBARIEU, Jules & DUMESNIL, René (eds.), *Histoire de la musique des origines à nos jours*, Paris, A. Colin, 1955-60, 5 vols.

Communication et culture de masse (= *Diogène*, No. 68, Oct.-Dec. 1969): see *Mass Communication and Culture*.

Congresses (publication of proceedings): see *Actes* . . .; *Atti* . . .; International congresses; *Proceedings* . . .; *Transactions*

CONRAD, W., 'Das ästhetische Objekt', *Zeitschrift für Ästhetik*, Vols. III and IV, 1904, 1905.

COOK, Peter, *Architecture, Action and Plan*, London, Studio Vista / New York, Reinhold, 1967.

——, *Experimental Architecture*, London, Studio Vista, 1970.

COOMBES, H. Edward Thomas, *Literature and Criticism*, Harmondsworth (Middx.), Penguin Books, 1963.

CORNU, Marcel, 'Autocritique du critique', *Architecture. Mouvement. Continuité*, No. 9, Nov. 1968.

CORTI, Maria, *Metodi e fantasmi*, Milan, Feltrinelli, 1969.

CORTI, Maria & SEGRE, Cesare (eds.), *I metodi attuali della critica in Italia*, Turin, ERI, Edizioni RAI Radiotelevisione italiana, 1970 (with an international bibliography).

Critique sociologique et critique psychanalytique (a symposium organized jointly by the Institut de Sociologie de l'Université libre de Bruxelles and the Ecole pratique des Hautes Etudes (6e Section) of Paris, with the assistance of Unesco, from 10 to 12 Dec. 1965 under the chairmanship of Lucien Goldmann: contributions by Umberto ECO, André GREEN, Robert WANGERMEE, Guy ROSOLATO, Charles MAURON, Jacob TAUBES, René GIRARD, Paul RICOEUR, Lucien GOLDMANN, and Serge DOUBROVSKY), Brussels, Editions de l'Institut de Sociologie, Université Libre de Bruxelles, 1970, 'Etudes de sociologie de la littérature'

ser. [For Volume II, see *Psychanalyse et sociologie comme méthodes d'étu-de* ...]

CROCE, Benedetto, *Estetica* (1902), 10th edn., Rome, 1958 (English translation by Douglas Ainslie, *Aesthetic*, new edn., London, Peter Owen & Vision Press, 1967, Unesco series of representative works, Italian series.

CROCE, M. A., 'Conditionnements sociaux à travers les techniques cinématographiques', *Revue internationale de Filmologie*, 14, 1964.

CROLL, Morris W., *Style, Rhetoric and Rhythm*, edited by J. M. Patrick *et al.*, Princeton (N.J.), Princeton University Press, 1966.

CROZET, René, *La vie artistique au XVIIe siècle (1598-1661). Les artistes et la société*, Paris, Presses Universitaires de France, 1954.

CRUTCHFIELD, Richard S., 'Conformity and creative thinking', in GRUBER, H., TERRELL & WERTHEIMER (eds.), *Contemporary Approaches to Creative Thinking, op. cit.* (1962), pp. 120-140.

CURTIUS, Ernst-Robert, *Europäische Literatur und lateinisches Mittelalter*, Bern, Francke, 1948 (English translation by Willard R. Trask, *European Literature and the Latin Middle Ages*, London, Routledge / Princeton (N.J.), Princeton University Press, 1953).

DABEZIES, André, *Visages de Faust au XXe siècle. Littérature, idéologie et mythes*, Paris, Presses Universitaires de France, 1967.

DAHLHAUS, Carl, *Musikästhetik*, Cologne, 1967.

DAICHES, David, *Literature and Society*, London, Gollancz, 1938.

——, *Critical Approaches to Literature*, London, Longmans, 1963.

DANIÉLOU, Alain, *Traité de musicologie comparée*, Paris, Hermann, 1959.

D'ARCO, Silvio Avallo, *L'analisi letteraria in Italia. Formalismo – strutturalismo – semiologia*, Milan-Naples, Ricciardi, 1970.

DAVID, Michel, *La psicoanalisi nella cultura italiana*, Turin, Boringhieri, 1966.

——, *Letteratura e psicoanalisi*, Milan, Mursia, 1967.

DAVIDOFF, Paul, 'Advocacy and pluralism in planning', J.A.I.P., Nov. 1965; reproduced in Stanford ANDERSON (ed.), *Planning for Diversity and Choice*, Cambridge (Mass.), The M.I.T. Press, 1968.

DAVIES, Hugh (ed.), *International Electronic Music Catalog*, Cambridge (Mass.), The M.I.T. Press, 1968.

'Débats sur les problèmes idéologiques et culturels' (statements by Louis ARAGON, Guy BESSE, Roger GARAUDY, André STIL *et al.*), *Cahiers du Communisme* (Paris), No. 5-6 (double issue), May–June, 1966, pp. 1-322.

DE BENEDETTI, Andrea, *Il linguaggio della pubblicità contemporanea. Guida bibliografica agli studi di psicopedagogia dei 'mass media' (Dal corso libero 1956-1967)*, Turin, Università di Torino, Facoltà di Magisterio, Ca-Ma, 1966.

Le Décor de théâtre dans le monde, Brussels, Meddens, 1964, 2 vols.

DE FUSCO, Renato, *Architettura come mass medium. Note per una semiologia architettonica*, Bari, G. Laterza, 1968.

——, *Il codice dell' architettura*, Naples, Edizioni scientifiche italiane, 1968.

—— & SCALVINI, Maria Luisa, 'Significanti e significati della Rotonda palladiana', *op. cit.* (periodical, University of Naples), No. 16, Sept. 1969.

——, 'Segni e simboli del Tempietto di Bramante', *op. cit.* (Naples), No. 19, Sept. 1970.

DELLA VOLPE, Galvano, *Critica del gusto*, Milan, Feltrinelli, 1960; 3rd edn., 1966.

——, 'Il verosimile filmico', *Filmcritica* (Rome), No. 121, 1962.

DE MAN, Paul, *'New Criticism* et nouvelle critique', *Preuves* (Paris), No. 188, Oct. 1966.

DEMETZ, Peter, GREENE, T. & LOWRY, N. Jr. (eds.), *The Disciplines of Criticism. Essays in Literary Theory, Interpretation and History Honoring René Wellek on the Occasion of His Sixty-fifth Birthday*, New Haven (Conn.)-London, Yale University Press, 1968.

DERRIDA, Jacques, *L'écriture et la différence*, Paris, Seuil, 1967.
——, *De la grammatologie*, Paris, Minuit, 1967, 'Critique' ser.
——, 'La parole soufflée', in DERRIDA, *L'écriture et la différence, op. cit.* (1967), pp. 253-292 (1st publ., *Tel Quel*, No. 20, Winter 1965).
——, 'Sémiologie et grammatologie', *Information sur les sciences sociales / Social Science Information* VII (3), June 1968, pp. 135-148.
——, *La dissémination*, Paris, Seuil, 1972, 'Tel Quel' ser.
 [See also FOUCAULT, BARTHES, DERRIDA *et al.*, *Théorie d'ensemble.*]
DEUGD, Cornelius de, *De eenheid van het comparatisme* (= The Unity of Comparatism), with summary in English, Utrecht, Instituut voor vergelijkend literatuuronderzoek aan de Rijksuniversiteit te Utrecht, 1962.
IIe (Deuxième) Congrès international d'histoire littéraire, Amsterdam 1935: 'Les périodes dans l'histoire de la littérature depuis la Renaissance', *Bulletin of International Commission of Historical Sciences*, IX, 1937.
DEVAMBEZ, Pierre, BABELON, Jean and DORIVAL, Bernard (eds.), *Histoire de l'art*, Paris, Gallimard, Encyclopédie de la Pléiade, 4 vols.: 1961 (Vol. 1, ed. DEVAMBEZ), 1965 (Vol. 3, ed. BABELON), 1966 (Vol. 2, ed. BABELON), 1969 (Vol. 4, ed. DORIVAL).
DEVOTO, Giacomo, *Nuovi studi di stilistica*, Florence, F. Le Monnier, 1962.
DICHTER, Ernst, *The Strategy of Desire*, New York, Doubleday, 1960.
——, *Gli oggetti ci comprano*, Milan, Ferro, 1967.
Dictionaire Laffont-Bompiani des Œuvres de tous les temps et de tous les pays, Paris, Robert Laffont, 1955, 4 vols.
DIEUZEIDE, Henri, 'Problèmes de l'image télévisée non spectaculaire', in *Atti della Ia conferenza internazionale di informazione visiva, op. cit.* (1961).
DILTHEY, Wilhelm, *Gesammelte Schriften*, Vol. II. *Weltanschauung und Analyse des Menschen seit Renaissance und Reformation*, Abhandlungen zur Geschichte der Philosophie und Religion, edited by G. Misch, Leipzig, Teubner, 1914; repr., Stuttgart, Teubner, 1944.
DIMA, Alexandru, *Principii de literatură comparată*, with summary in French, Bucharest, Editura pentru literatură, 1969.
DITTMANN, Lorenz, *Stil, Symbol, Struktur. Studien zu den Kategorien der Kunstgeschichte*, Munich, Fink, 1967.
DOBLIN, Jay, 'Trademark design', *Dot Zero*, No. 2, 1967.
DOLLINGER, Philippe & WOLFF, Philippe, *Bibliographie d'histoire des villes de France*, Paris, Klincksieck, 1967.
DOMENACH, Jean-Marie, *Le retour du tragique*, Paris, Seuil, 1967.
DORFLES, Gillo, 'Pubblicità e comunicazione', *Criteri*, 1959, No. 9.
——, 'Valori semantici degli "elementi di architettura" e dei "caratteri distributivi"', *Domus* (Milan), No. 360, Nov. 1959, pp. 33-35.
——, *Simbolo, comunicazione, consumo*, Turin, Einaudi, 1962.
——, *Nuovi riti, nuovi miti*, Turin, Einaudi, 1965.
——, 'Pour ou contre une esthétique structuraliste', in *La notion de structure* (= *Revue internationale de Philosophie*, No. 73-74), *op. cit.* (1965), pp. 387-408.
——, *Artificio e natura*, Turin, Einaudi, 1968.
——, 'Morfologia e semantica della pubblicità televisiva', in *Pubblicità e televisione, op. cit.* (1968-69), pp. 175-185.
——, 'Sui mass-media', *Problemi*, 14, 1969.
——, 'Structuralism and semiology in architecture', in JENCKS & BAIRD (eds.), *Meaning in Architecture, op. cit.* (1969), pp. 38-49.
——, 'Sociological aspects of industrial aesthetics. Industrial design as a popular art-form in a technological civilisation' (translated from Italian), *Diogenes*, No. 74, Summer 1971, pp. 111-122 (parallel publication in French, *Diogène*, same ref.).
DORFLES, Gillo (ed.), *Il Kitsch. Antologia del cattivo gusto*, Milan, Marzotta, 1968

(English version, *Kitsch. The World of Bad Taste*, New York, Universe Books, 1969).

DOUBROVSKY, Serge, *Pourquoi la nouvelle critique? I. Critique et objectivité*, Paris, Mercure de France, 1966.
[See also *sub Critique sociologique et critique psychanalytique*.]

Dramaturgie et société aux XVIe et XVIIe siècles, Paris, Editions du C.N.R.S., 1968, 2 vols.

DREPS, H. F., 'The psychological capacities and abilities of college art students of high and low standing', *Psychol. Monogr.*, No. 45, 1933, pp. 134-146.

DREYFUS, Jacques, Review of the unpublished work by C. BURLEN, *La réalisation spatiale du désir et l'image spatialisée du besoin (op. cit.), Le progrès scientifique*, No. 143, June 1971.

DRÜE, Hermann, *Husserls System der phänomenologischen Psychologie*, Berlin, De Gruyter, 1963.

DUBOIS, J., EDELINE, F., KLINKENBERG, J. M., MINGUET, P., PIRE, F. & TRINON, H., *Rhétorique générale*, Paris, Larousse, 1970, 'Langue et langage' ser.

DUBUFFET, Jean, *Prospectus et tous écrits suivants*, presentation by H. DAMISCH, with a 'mise en garde' by the author, Paris, Gallimard, 1967, 2 vols. (reproduces, *inter alia*, the text of *Prospectus aux amateurs en tous genres*, Paris, Gallimard, 1946, 'Métamorphoses' ser.).

——, *Asphyxiante cuture*, Paris, J. J. Pauvert, 1968, 'Libertés nouvelles' ser., No. 14.

DUBY, Georges, 'La méthode de l'histoire des mentalités', in Charles SAMARAN (ed.), *L'histoire et ses méthodes*, Paris, Gallimard, 1961, Encyclopédie de la Pléiade.

——, *Des sociétés médiévales* (Inaugural Lecture at the Collège de France), Paris, Gallimard, 1971.

DUCHET, C. & LAUNAY, M., 'La lexicologie au service de l'histoire et de la critique littéraires', in *Méthodologies, op. cit. (Revue d'Hist. litt. de la France*, 1970), pp. 810-818.

DUCHET, Michèle, 'L'informatique au service de l'analyse des textes', in *Méthodologies, op. cit. (Revue d'Hist. litt. de la France*, 1970), pp. 798-809.

DUFRENNE, Mikel, *Phénoménologie de l'expérience esthétique*, Paris, Presses Universitaires de France 1953, 2 vols.; 2nd edn., *ibid.*, 1967.

——, *Le poétique*, Paris, Presses Universitaires de France, 1963.

——, 'Art et sémiologie', in DUFRENNE, *Esthétique et philosophie, op. cit.* (1967), pp. 73-143.

——, *Esthétique et philosophie* (collected essays), Paris, Klincksieck, 1967.

——, 'L'art est-il langage?', *Rivista di Estetica* XIII (2), 1968, pp. 161-177.

——, 'L'art et le sauvage', *Revue d'Esthétique* XXIII (4), Oct.-Dec. 1970.
[See also *sub Art et philosophie*.]

DUHL, Leonard J. (ed.), *The Urban Condition*, London-New York, Basic Books, 1963.

DUKE, Richard D., *Gaming-simulation in Urban Research*, Ann Arbor, University of Michigan Press, 1964.

DUMAZEDIER, Joffre & HASSENFORDER, Jean, *Eléments pour une sociologie comparée de la production, de la diffusion et de l'utilisation du livre*, Paris, Bibliographie de la France, 1962.

DUMUR, Guy (ed.), *Histoire des spectacles*, Paris, Gallimard, 1965, Encyclopédie de la Pléiade.

DUNCAN, Hugh Dalziel, *Language and Literature in Society. A Sociological Essay on Theory and Method in the Interpretation of Linguistic Symbols, with a Bibliographical Guide to the Sociology of Literature*, Chicago, University of Chicago Press / Cambridge, Cambridge University Press, 1953; new edn., Totowa (N.J.), Bedminster Press, 1961.

——, 'Sociology of art, literature and music. Social contexts of symbolic experience', in Howard BECKER & Alvin BOSKOFF (eds.), *Modern Sociological Theory in Continuity and Change*, New York, The Dryden Press, 1957, pp. 482-500.

DURAND, Gilbert, *Les structures anthropologiques de l'imaginaire. Introduction à l'archétypologie générale*, Paris, Presses Universitaires de France, 1960, 'Publications de la Faculté des Lettres et des Sciences humaines de Grenoble'.

DUVIGNAUD, Jean, *Sociologie de l'art*, Paris, Presses Universitaires de France, 1967.

DVOŘAK, M., *Kunstgeschichte als Geistesgeschichte. Studien zur abendländischen Kunstentwicklung*, Munich, Piper, 1924.

EATON, Leonard Kimball, *Two Chicago Architects and Their Clients: Frank Lloyd Wright and Howard Van Doren Shaw*, Cambridge (Mass.), The M.I.T. Press, 1969.

ECO, Umberto, *Opera aperta. Forma e indeterminazione nelle poetiche contemporanee*, Milan, Bompiani, 1962 (French translation by Chantal Roux de Bézieux & André Boucourechliev, *L'œuvre ouverte*, Paris, Seuil, 1965).

——, *Apocalittici e integrati*, Milan, Bompiani, 1964.

——, 'Valori estetici e cultura di massa', in NARDI (ed.), *Arte e cultura nella civiltà contemporanea, op. cit.* (1966), pp. 195-212.

——, 'Appunti per una semiologia delle comunicazioni visive', non-commercial distribution, Florence, 1967; reproduced in ECO, *La struttura assente, op. cit.* (1968).

——, *La struttura assente. Introduzione alla ricerca semiologica*, Milan, Bompiani, 1968 (French translation, augm., by Uccio Esposito-Torrigiani, *La structure absente*, Paris, Mercure de France, 1972).

——, 'Ciò che non sappiamo della pubblicità televisiva', in *Pubblicità e televisione, op. cit.* (1968-69).

——, *Le forme del contenuto*, Milan, Bompiani, 1971.

[See also *sub Critique sociologique et critique psychoanalytique; Sociology of Literary Creativity*.]

EHMER, Herman K. (ed.), *Visuelle Kommunikation. Beiträge zur Kritik der Bewusstseinsindustrie*, Cologne, DuMont, 1971.

EHRENZWEIG, Anton, *The Psychoanalysis of Artistic Vision and Hearing. An Introduction to a theory of Unconscious Perception*, London, Routledge, 1953; 2nd edn., New York, Braziller, 1965.

——, 'Une nouvelle approche psychanalytique de l'esthétique', in BERGE, CLANCIER, RICOEUR, RUBINSTEIN *et al.*, *Entretiens sur l'art et la psychanalyse, op. cit.* (1968), pp. 76-86 (followed by a discussion, pp. 87-94).

EHRMANN, Jacques: see *sub Problèmes du structuralisme; Structuralism*.

EIKHENBAUM, Boris: see EJHENBAUM, Boris.

EIMERT, H., *Grundlagen der musikalischen Reihentechnik*, Vienna, Universal Edition, 1964.

EINSTEIN, Alfred, *The Italian Madrigal*, Princeton (N.J.), Princeton University Press, 1949, 3 vols.

EJHENBAUM [EIKHENBAUM], Boris, 'La théorie de la méthode formelle' (1925), in a French translation in *Théorie de la littérature, op. cit.* (1965), pp. 31-75.

Elenchus Fontium Historiae Urbanae, ed. by C. van de KIEFT & J. F. NIERMEYER, Leiden, Brill, 1967.

ELIOT, T. S., 'Tradition and the individual talent', in T. S. ELIOT, *The Sacred Wood*, London, Methuen, 1920.

ELISOFON, Eliot & FAGG, William, *The Sculpture of Africa*, 405 photographs by ELISOFON, text by FAGG, preface by Ralph LINTON, London, Thames & Hudson / New York, Praeger, 1958.

ELSBERG, J., 'La sociologie dans l'étude bourgeoise contemporaine de la littérature' (extract from *Voprosy literatury*, No. 41, 1967), in *Sociologie de la littérature. Recherches récentes et discussions, op. cit.* (1969, 1970), pp. 197-209; reply by Lucien GOLDMANN, pp. 211-213.

ELTON, William (ed.), *Essays in Aesthetics and Language*, Oxford, Blackwell, 1954.

Enciclopedia dello spettacolo, Rome, La Maschere, 1954, 10 vols.

ENGELHARDT, Ursula, *Beiträge zur Entwicklungspsychologie des absoluten Gehörs und seiner Typen*, Mainz, Philosophische Dissertation (Thesis), 1968.

ENGELS, Friedrich, *Letters to A. Bebel, W. Liebknecht, L. Kautsky and others*, with a Comment by G. LUKÁCS, Moscow, 1933. [See also MARX & ENGELS.]

ENGELSING, Rolf, 'Der Bürger als Leser. Die Bildung der protestantischen Bevölkerung Deutschlands im 17. und 18. Jahrhundert am Beispiel Bremens', *Archiv für Geschichte des Buchwesens* (Frankfurt am Main), III, 1960.

Entretiens sur l'art et la psychanalyse: see BERGE, CLANSIER, RICOEUR, RUBINSTEIN *et al.*, *Entretiens sur l'art et la psychanalyse*.

ERICKSON, Raymond, 'Music analysis and the computer', *Journal of Music Theory*, XII, 1968, pp. 240-263.

ERLICH, Victor, *Russian Formalism. History, Doctrine*, Preface by René WELLEK, The Hague, Mouton, 1955.

ERMOLAYEV, Hermann, *Soviet Literary Theories, 1917-1934. The Genesis of Socialist Realisms*, Berkeley-Los Angeles, University of California Press, 1963.

ERTEL, Suitbert, *Eine psychologische Theorie des Komischen*, Münster, 1968.

ESCARPIT, Robert, 'Histoire de l'histoire de la littérature', in QUENEAU (ed.), *Histoire des littératures*, Vol. III, *op. cit.* (1958).

——, *La révolution du livre*, Paris, Unesco, 1965 (English version, *The Book Revolution*, London, Harrap / Paris, Unesco, 1966).

——, *Sociologie de la littérature*, Paris, Presses Universitaires de France, 1968, 'Que sais-je?', ser., No. 777.

—— & ROBINE, Nicole, *L'atlas de la lecture à Bordeaux*, Bordeaux, 1963.

——, *Le livre et le conscrit* (an inquiry of the Centre de Sociologie des faits littéraires de Bordeaux) Bordeaux, Sobodi / Paris, Cercle de la Librairie, 1966.

ESCARPIT, Robert (ed.), *Le littéraire et le social. Eléments pour une sociologie de la littérature*, Paris, Flammarion, 1970.

Esthétique expérimentale, Ier Colloque international, Paris 7-8 juin 1965 = Sciences de l'Art, special issue, Vol. III, 1966.

ÉTIEMBLE, *Comparaison n'est pas raison. La crise de la littérature comparée*, Paris, Gallimard, 1963, 'Les essais' ser.

EYCK, Aldo van, 'The interior of time' and 'A miracle of moderation' (with essays by Paul PARIN and Fritz MORGENTHALER), in JENCKS & BAIRD (eds.), *Meaning in Architecture, op. cit.* (1969), pp. 170-171 and 172-213.

FAGG, William, *Nigerian Images*, London, Lund Humphries, 1963. [see also ELISOFON & FAGG.]

FAIRBAIRN, W. R. D., 'Critical notice on Joana FIELD's *On Not Being Able to Paint*', *British Journal of Medical Psychology* XXXIII (2), 1950.

FARNSWORTH, Paul Randolph, *The Social Psychology of Music*, New York, The Dryden Press / London, Macmillan, 1958.

FAURE, Elie, *Histoire de l'art*, Paris, 1927, 4 vols.; republ., Paris, Plon, 1939.

FAYOLLE, Roger, *La critique littéraire*, Paris, A. Colin, 1964, 'U' ser.

FEBVRE, Lucien, *Le problème de l'incroyance au XVIe siècle. La religion de Rabelais*, Paris, A. Michel, 1942; republ., 1962.

——, *Pour une histoire à part entière* (selected writings), Paris, S.E.V.P.E.N., 1962 (see in English, FEBVRE, *A New Kind of History*, a selection of writings, edited by Peter Burke, translated by K. Folca, New York, Harper & Row, 1973).

FEDERHOFER, H., 'Hörprobleme neuer Musik', *Studium generale*, XX, 1967.

FEIST, Peter H., *Prinzipien und Methoden marxistischer Kunstwissenschaft*, Leipzig, Seemann, 1966.

FELDMANN, Erich, *Theorie der Massenmedien: Presse, Film, Funk, Fernsehen*, Munich-Basel, E. Reinhardt, 1962.

FÉNELON, J. P., 'Analyse mathématique des jugements esthétiques: les données de préférence', *Sciences* (Paris), Nos. 49-50, May-Aug. 1967, pp. 14-23.

FENG, Shu-lan, *La technique et l'histoire du t'seu*, Paris, Librairie Rodstein, 1934.

FERENTZY, E. R., 'Computer simulation of human behaviour in music composition', *Computational Linguistics. Yearbook IV, 1965*, Budapest, Hungarian Academy of Sciences, 1965.

FIELD, Joana, *On Not Being Able to Paint*, London, W. Heinemann, 1950.

FILARETE's *Treatise on Architecture*: Vol. I. Translation, Introduction and Notes by R. SPENCER; Vol. II. Facsimile, New Haven (Conn.)-London, Yale University Press, 1965.

FILIP'EV, I., *Tvorčestvo i kibernetica* (= Creation and Cybernetics), Moscow, Nauka, 1964.

FISCHER, E., 'Künstler der Dan, die Bildhauer Tame, Si, Tompieme und Sŏn - ihr Wesen und ihr Werk', *Baessler-Archiv*, N.S., Vol. X, 1962, pp. 161-263.

FISCHER, Ernst, *Von der Notwendigkeit der Kunst*, Dresden, Verlag der Kunst, 1959 (English translation by Anna Bostock, *The Necessity of Art. The Marxist Approach*, Harmondsworth (Middx.), Penguin Books, 1964, Pelican ser.).

——, *Zeitgeist und Literatur*, Vienna, Europa Verlag, 1964.

FISCHER, Hardi & BUTSCH, Ch., 'Musikalische Begabung und Intelligenz', *Zeitschrift f. exp. u. angew. Psychol.*, No. 8, 1961.

FLEMMING, Willi, 'Das Problem von Dichtungsgattung und Dichtungsart', *Studium generale*, No. XII, 1959.

FOCILLON, Henri, *Vie des formes*, Paris, E. Leroux, 1943; 3rd edn., followed by 'Eloge de la main', Paris, Presses Universitaires de France, 1947 (English translation, *The Life of Form in Art*, New York, Wittenborn, Shultz, Inc., 2nd edn., 1948).

FOHT, U., 'Zakoni istoričeskogo razvitija literatury' (= Laws of the historical evolution of literature), in *Puti russkogo realizma* (= Ways of Russian Realism), Moscow, Sovetskij Pisatel', 1963.

FÓNAGY, Iván, 'Der Ausdruck als Inhalt', in *Dichtung und Mathematik*, Stuttgart, 1965.

——, 'Form and function of poetic language', in *Problems of Language, op. cit.* (*Diogenes*, 1965), pp. 72-110 (parallel publication of French version, translation by Marc-André Béra, 'Le langage poétique: forme et fonction', in *Problèmes du langage, op. cit.* (*Diogène*, 1965; republ., 1966), pp. 72-116).

FORMIGARI, Lia, 'L'analisi del linguaggio e l'estetica', *Rassegna di Filosofia* (Rome), Vol. V, Fasc. 3, July-Sept. 1956, pp. 209-226.

FORTE, Allen, 'A theory of set-complexes for music', *Journal of Music Theory*, VIII, 1964, pp. 136-183.

——, 'The domain and relation of set-complex theory', *Journal of Music Theory*, IX, 1965, pp. 173-180.

——, 'A program for the analytic reading of scores', *Journal of Music Theory*, X, 1966, pp. 330-364.

——, SNOBOL, *Primer*, Cambridge (Mass.), The M.I.T. Press; 1967.

——, 'Musical theory in the 20th century. A survey', in VINTON (ed.), *Dictionary of 20th-Century Music, op. cit.* (publ. forthcoming).

FOUCAULT, Michel, *Les mots et les choses*, Paris, Gallimard, 1966, Bibliothèque des Sciences humaines (English translation, *The Order of Things. An Archaeology of the Human Sciences*, New York, Pantheon Books, 1970).

——, *L'archéologie du savoir*, Paris, Gallimard, 1969, Bibliothèque des Sciences humaines (English translation by A. M. Sheridan Smith, *The Archaeology of Knowledge*, London, Tavistock Publ., 1972).

——, BARTHES, Roland, DERRIDA, Jacques *et al.*, *Théorie d'ensemble*, Paris, Seuil, 1968, 'Tel Quel' ser.

FRAMPTON, Kenneth, 'Labor, work and architecture', in JENCKS & BAIRD (eds.), *Meaning in Architecture, op. cit.* (1969), pp. 150-168.

——, 'Polemical notes on architectural education', mimeographed for the conference on 'Architectural Education U.S.A.: Issues, Ideas and People', held at the

Institute for Architecture and Urban Studies of New York in November 1970; to be published in printed form.

——, 'America 1960-1970. Appunti su alcune immagini e teorie della città' / 'America 1960-1970. Notes on urban images and theory' (Italian and English texts on opposite pages), *Casabella* (Milan), No. 359-360 (double issue), Dec. 1971 (special issue: *The City as an Artefact*), pp. 24-38.

FRANCASTEL, Pierre, *Estève*, Paris, Galanis, 1956.

——, 'Problèmes de la sociologie de l'art', in Georges GURVITCH (ed.), *Traité de sociologie*, Paris, Presses Universitaires de France, 1960, Vol. II, pp. 278-296.

——, 'Note sur l'emploi du mot "structure" en histoire de l'art', in BASTIDE (ed.), *Sens et usages du terme 'structure'*, *op. cit.* (1962), pp. 46-51.

——, *Peinture et société. Naissance et destruction d'un espace plastique. De la Renaissance au Cubisme*, Paris-Lyon, 1964; new edn., Paris, Gallimard, 1965, 'Idées/Arts' ser.

——, 'Art, forme, structure', in *La notion de structure, op. cit.* (*Revue internationale de Philosophie*, 1965), pp. 361-386.

——, *La figure et le lieu. L'ordre visuel du Quattrocento*, Paris, Gallimard, 1967.

——, *Etudes de sociologie de l'art. Création picturale et société*, Paris, Denoël/Gonthier, 1970.

FRANCÈS, Robert, *La perception de la musique*, Paris, Vrin, 1958.

——, 'Limites et nature de l'effet de prestige II: Notoriété de l'auteur et jugement de l'œuvre', *J. de Psychol.*, 1963, No. 4, pp. 437-455.

——, *Psychologie de l'esthétique*, Paris, Presses Universitaires de France, 1968.

—— & TAMBA, A., *Les préférences musicales. Recherche interculturelle* (to be published later).

—— & VOILLAUME, H., 'Une composante du jugement pictural: la fidélité de la représentation', *Psychol. fr.*, 1964, No. 9, pp. 241-256.

FRANK, H., *Grundlagenprobleme der Informationsästhetik und erste Anwendung auf die Mime pure*, Waiblingen, Hess Verlag, 1959.

FREUD, Sigmund, *Gesammelte Werke* (= Complete Works), published with the co-operation of Marie Bonaparte, Anna Freud *et al.*: Vols. I to XVII, London, Imago Publ. Co., 1940-52; Vol. XVIII, Frankfurt am Main, S. Fischer Verlag, 1958 (complete works in English translation, *The Standard Edition of the Complete Psychological Works of Sigmund Freud*, edited by James Strachey, London, Hogarth Press, 1953-66, 24 vols.).

——, 'Entwurf einer Psychologie' (1895), published as an Appendix to *Aus den Anfängen der Psychoanalysis, op. cit.* (1950) (English translation, 'A project for a scientific psychology', in *The Origins of Psychoanalysis, op. cit.*, 1954).

——, *Die Traumdeutung* (1900), 7th edn., Vienna, F. Deuticke, 1945; cf. *G.W.* (*Gesammelte Werke, op. cit.*), Vols. II and III (English translation, *The Interpretation of Dreams, St. Edn. (Standard Edition, op. cit.*), Vols. IV (Chaps. I-VI) and V (Chap. VII), and New York, Modern Library).

——, *Drei Abhandlungen zur Sexualtheorie*, Vienna, 1905; cf. *G.W.*, Vol. V, pp. 29-145 (English translation by James Strachey, *Three Essays on the Theory of Sexuality, St. Edn.*, Vol. VII, pp. 123-243 and New York, Basic Books, 1962).

——, *Der Witz und seine Beziehung zum Unbewussten* (1905), 2nd edn., Leipzig-Vienna, F. Deuticke, 1912; cf. *G.W.*, Vol. VI (English translation, *Jokes and their Relations to the Unconscious, St. Edn.*, Vol. VIII).

——, *Der Wahn und die Träume in W. Jensens 'Gradiva'* (1907); cf. *G.W.*, Vol. VII, pp. 31-125 (English translation, *Delusion and Dream. An Interpretation in the Light of Psychoanalysis of W. Jensen's 'Gradiva', St. Edn.*, Vol. IX, pp. 1-95).

——, 'Der Dichter und das Phantasieren', *Die neue Revue*, 1st Year (1908); republ. in *Sammlung kleiner Schriften zur Neurosenlehre*, 2nd ser.; cf. *G.W.*, Vol. VII, pp. 213-233 (English translation, 'Creative writers and day-dreaming', *St. Edn.*. Vol. IX, pp. 141-153).

——, *Über Psychoanalyse fünf Vorlesungen* (1909); cf. *G.W.*, Vol. VIII, pp. 3-60

(English translation, 'Five lectures on psycho-analysis', *St. Edn.*, Vol. XI, pp. 1-55).

——, *Eine Kindheitserinnerung des Leonardo da Vinci*, Leipzig, F. Deuticke, 1910; cf. *G.W.*, Vol. VIII, pp. 128-211 (English translation, *Leonardo da Vinci and a Memory of Childhood*, *St. Edn.*, Vol. XI, pp. 57-137).

——, 'Formulierungen über die zwei Prinzipien des psychischen Geschehens', *Zeitschrift für Psychoanalysis*, 1911; cf. *G.W.*, Vol. VIII, pp. 230-238 (English translation, 'Formulations on the two principles of mental functioning', *St. Edn.*, Vol. XII, pp. 213-226).

——, *Zur Geschichte der psychoanalytischen Bewegung*, Leipzig, Internationaler psychoanalytischer Verlag, 1914; cf. *G.W.*, Vol. X, pp. 44-113 (English translation, *On the History of the Psycho-analytic Movement*, *St. Edn.*, Vol. XIV, pp. 1-66).

——, 'Das Unbewusste', *Internationale Zeitschrift für Psychoanalyse*, No. III, 1915; cf. *G.W.*, Vol. X, pp. 264-303 (English translation, 'The unconscious', *St. Edn.*, Vol. XIV, pp. 159-215).

——, 'Mitteilung eines der psychoanalytischen Theorie widersprechenden Falles von Paranoia' (1915); cf. *G.W.*, Vol. X, pp. 234-246 (English translation, 'A case of paranoia running counter to the psycho-analytic theory of the disease', *St. Edn.*, Vol. XIV, pp. 261-272).

——, *Vorlesungen zur Einführung in die Psychoanalyse* (1916-17); cf. *G.W.*, Vol. XI (English translation, *Introductory Lectures on Psychoanalysis, St. Edn.*, Vols. XV-XVI).

——, 'Das Unheimliche', *Imago*, Vol. V (1919); republ. in *Sammlung kleiner Schriften zur Neurosenlehre*, 5th ser.; cf. *G.W.*, Vol. XII, pp. 229-268 (English translation, 'The uncanny', *St. Edn.*, Vol. XVII, pp. 217-256).

——, 'Ein Kind wird geschlagen', *Zeitschrift für Psychoanalysis*, 1919; cf. *G.W.*, Vol. XII, pp. 197-226 (English translation, 'A child is being beaten', *St. Edn.*, Vol. XVII, pp. 175-204).

——, 'Das Ich und das Es' (1923); cf. *G.W.*, Vol. XIII, pp. 237-289 (English translation, 'The ego and the id', *St. Edn.*, Vol. XIX, pp. 1-59).

——, *Hemmung, Symptom und Angst* (1926); cf. *G.W.*, Vol. XIV, pp. 113-205 (English translation, *Inhibitions, Symptoms and Anxiety, St. Edn.*, Vol. XX, pp. 75-174).

——, *Neue Folge der Vorlesungen zur Einführung in die Psychoanalysis* (1932); cf. *G.W.*, Vol. XV (English translation, *New Introductory Lectures on Psychoanalysis, St. Edn.*, Vol. XXII, pp. 1-182).

——, *Aus den Anfängen der Psychoanalyse: Briefe an Wilhelm Fliess, Abhandlungen und Notizen aus den Jahre 1887-1902*, edited by Marie Bonaparte, Anna Freud & Ernst Kris, London, Imago Publ. Co., 1950 (English version: *The Origins of Psychoanalysis: Letters to Wilhelm Fliess, Drafts and Notes 1887-1902*, authorized translation by Eric Mosbacher & James Strachey, Introduction by Ernst Kris, London, Imago / New York, Basic Books, 1954).
[See also *Imago*.]

FREY, D., *Englisches Wesen im Spiegel seiner Kunst*, Stuttgart-Berlin, Kohlhammer, 1942.

FRIDLENDER, G. M., 'Osnovnye ètapy sovetskogo literaturovedenija' (= Essential stages in Soviet literary science), in *Sovetskoe literaturovedenie za 50 let* (= 50 Years of Soviet Literary Science), Leningrad, Izd. Nauka, 1968.

FRIEDERICH, Werner Paul (ed.), *Comparative Literature. Proceedings of the 2nd ICLA Congress at the University of North Carolina, Sept. 8-12, 1958*, Chapel Hill, University of North Carolina Press, 1959, N.C. University Studies in Comparative Lit., No. 23).

FRIEDMANN, Georges, 'Sociologie des communications. Introduction aux aspects sociologiques de la radio-télévision', in *Atti della Ia Conferenza internazionale di informazione visiva, op. cit.* (1961).

FRIEDRICH, Hugo, *Die Struktur der modernen Lyrik. Von Baudelaire bis zur Gegenwart*, Reinbek bei Hamburg, Rowohlt, 1956, Rowohlts deutsche Enzyklopädie, No. 25 (English translation by Joachim Neugroschel, *The Structure of Modern Poetry*, Evanston (Ill.), Northwestern University Press, 1974).

FROMM, Erich, *The Forgotten Language. An Introduction to the Understanding of Dreams, Fairy Tales and Myths*, New York, Rinehart, 1951.

FRY, Philip, 'Arts indiens et esquimaux du Canada', *Revue d'Esthétique*, XXII (4), 1969, pp. 441-447.

FRYE, Northrop, *The anatomy of criticism*, Princeton (N.J.), Princeton University Press, 1957 (French translation by Guy Durand, *Anatomie de la critique*, Paris, Gallimard, 1969, Bibliothèque des Sciences humaines).

——, *The Well-Tempered Critic*, Bloomington, Indiana University Press, 1963.

——, *The Modern Century*, Toronto, Oxford University Press, 1967 (French translation by François Rinfret, *La culture face aux media*, 1969).

——, 'The critical path. An essay on the social context of literary criticism', in *Theory in Humanistic Studies, op. cit.* (*Daedalus*, Spring 1970), pp. 268-342.

FUCKS, Wilhelm, *Mathematische Analyse von Sprachelemente, Sprachstil und Sprachen*, Cologne-Opladen, Westdeutscher Verlag, 1955, Arbeitsgemeinschaft für Forschung des Landes Nordrhein-Westfalen, Nos. 124 and 34a.

——, *Mathematische Analyse der Formalstruktur von Musik*, Cologne-Opladen, Westdeutscher Verlag, 1958, Forschungsberichte des Wirtschafts- und Verkehrsministeriums Nordrhein-Westfalen, No. 357.

——, 'Mathematische Musikanalyse und Randomfolgen', *Gravesaner Blätter*, 6, 1962.

——, *Nach allen Regeln der Kunst*, Stuttgart, Deutsche Verlags-Anstalt, 1968.

—— & LAUTER, Josef, *Exaktwissenschaftliche Musikanalyse*, Cologne-Opladen, Westdeutsche Verlags-Anstalt, 1965, Forschungsberichte des Landes Nordrhein-Westfalen, No. 1519.

FÜGEN, Hans Norbert, *Die Hauptrichtungen der Literatursoziologie und ihre Methoden. Ein Beitrag zur Literatursoziologische Theorie*, Bonn, Bouvier, 1964.

FÜGEN, Hans Norbert (ed.), *Wege der Literatursoziologie*, Neuwied am Rhein-Berlin, Luchterhand, 1968.

FULCHIGNONI, Enrico, *La moderna civiltà dell' immagine*, Rome, Armando Armando, 1964 (French translation by Giuseppe Crescenzi, *La civilisation de l'image*, Paris, Payot, 1969).

FURET, François, 'La "Librairie" du Royaume de France au XVIIIe siècle', in BOLLÈME, EHRARD, FURET, ROCHE, ROGER and DUPRONT, *Livre et société dans la France du XVIIIe siècle, op. cit.* (1965).

GADAMER, Hans-Georg, *Wahrheit und Methode. Grundzüge einer philosophischen Hermeneutik*, Tübingen, J. C. B. Mohr, 1960.

GAFFRON, Mercedes, *Die Radierungen Rembrandts*, Mainz, 1950.

——, 'Right and left in pictures', *Art Quarterly*, Vol. XIII, 1950, pp. 312-331.

GALINSKY, Hans, 'Literary criticism in literary history', *Comparative Literary Studies*, 1964, No. 2.

GALLI, Giorgio & ROSITI, Franco, *Cultura di massa e comportamento collettivo. Società e cinema negli anni precedenti il New Deal e il nazismo*, Milan-Bologna, Edizioni Il Mulino, 1967.

GAMBERINI, Italo, *Introduzione al primo corso di elementi di architettura e rilievo dei monumenti (Gli elementi dell' architettura come parole dell' linguaggio architettonico)*, Florence, Tip. B. Coppini e C., 1959.

GANDELSONAS, Mario, 'On reading architecture', *Progressive Architecture*, Mar. 1972.

GARAUDY, Roger, *D'un réalisme sans rivages*, Paris, Plon, 1963; new edn., with 'Pour un réalisme du XXe siècle' (1968) and an original introduction, under the title:

Esthétique et invention du futur, Paris, Union générale d'Editions, 1971, '10/18' ser.
——, Reply to the article by Sučkov, 'K sporu o realizme' (*op. cit.*), *Inostrannaja literatura* (= Foreign Literature) (Moscow), 1965, No. 4.
[See also *sub* 'Débats sur les problèmes idéologiques et culturels'.]
GARDNER, Helen L., *The Business of Criticism*, Oxford, Clarendon Press, 1963.
GARELLI, Jacques, *La gravitation poétique*, Paris, Mercure de France, 1966.
GARNICH, Rolf, *Konstruktion, Design, Ästhetik. Allgemeine mathematische Methode zur objektiven Beschreibung ästhetischer Zustände im analytischen Prozess und zur generativen Gestaltung im synthetischen Prozess von Design-Objekten*, Esslingen am Neckar, Erschienen im Selbstverlag Rolf Garnich (publ. by the author), 1968.
GARRONI, Emilio, *La crisi semantica delle arti*, Rome, Edizione Officina, 1964.
——, *Semiotica ed estetica. L'eterogeneità del linguaggio e il linguaggio cinematografico*, Bari, Laterza, 1968.
GARVIN, Paul L. (ed.), *A Prague School Reader on Aesthetics, Literary Structure and Style* (selected and translated from the original Czech), Washington (D.C.), Georgetown University Press, 1964.
GATZ, F. M., *Musik-Ästhetik in ihren Hauptrichtungen*, Stuttgart, 1929.
GEHLEN, Arnold, *Zeit-Bilder. Zur Soziologie und Ästhetik der modernen Malerei*, Frankfurt am Main-Bonn, Athenäum Verlag, 1960; 2nd edn., 1965.
GEIGER, Moritz, *Beiträge zur Phänomenologie des ästhetischen Genusses*, 1st publ. in *Jahrbuch für Philosophie und phänomenologische Forschung*, 1922, etc.
——, *Zugänge zur Ästhetik*, 1928.
GENETTE, Gérard, *Figures I*, Paris, Seuil, 1966.
——, *Figures II*, Paris, Seuil, 1969.
——, *Figures III*, Paris, Seuil, 1972.
[See also *sub Linguistique et littérature*.]
GERBRANDS, A. A., 'Kunststijlen in West Nieuw-Guinea' (= Artistic Styles in Western New Guinea), *Indonesië*, Vol. IV, 1951, pp. 251-283.
——, *Art as an Element of Culture, especially in Negro-Africa*, Leiden, Mededelingen van het Rijksmuseum voor Volkenkunde, Vol. XII, 1957.
——, *Wow-ipits, Eight Woodcarvers from Amanamkai*, The Hague, Mouton, 1966.
GERSTNER, Karl, *Programme Entwerfen*, Niederteufen-Appenzell, Arthur Niggli, 1963.
GETTO, Giovanni, *Letteratura e critica nel tempo*, Milan, Marzorati, 1968.
——, *Storia delle storie letterarie* (new edn., rev.), Florence, Sansoni, 1969.
GETZELS, Jacob W. & JACKSON, Philip W., *Creativity and Intelligence. Explorations with Gifted Students*, New York, Wiley, 1962.
GIBSON, James Jerome, *The Perception of the Visual World*, Boston, Houghton Mifflin, 1950; London, Allen & Unwin, 1952.
——, 'What is form?', *Psychological Review*, Vol. LVIII, 1951.
GIEDION, Sigfried, *Space, Time and Architecture*, Cambridge (Mass.), Harvard University Press, 1941 (French translation, *Espace, temps et architecture*, Brussels, Editions La Connaissance, 1969).
——, *Mechanisation Takes Command*, Cambridge (Mass.), Harvard University Press, 1950.
GIFFORD, J. V., *The Nature of the Cities as a System*, mimeographed, San Francisco, Department of City Planning, City and County of San Francisco, 1962.
GILSON, Étienne, *Painting and Reality* (U.S. National Gallery of Art, A. W. Mellon Lectures in the Fine Arts, 1955, Vol. IV), Princeton (N.J.), Princeton University Press, 1957; London, Routledge, 1958; French version, *Peinture et réalité*, Paris, Vrin, 1958.
——, *Introduction aux arts du beau*, Paris, Vrin, 1963 (English translation, *The Arts of the Beautiful*, New York, Scribner, 1965).

——, *Matières et formes. Poiétiques particulières des arts majeurs*, Paris, Vrin, 1964 (English translation by Salvator Attanasio, *Forms and Substances in the Arts*, New York, Scribner, 1966).

——, *La société de masse et sa culture*, Paris, Vrin, 1967 (1st publ., in a slightly different version, as 'L'industrialisation des arts du beau', in NARDI (ed.), *Arte e cultura nella civiltà contemporanea, op. cit.* (1966), pp. 77-140). [See also *sub Art et philosophie.*]

GIUDICI, Giovanni, 'In principio era il comunicato', *Sipradue*, 1967, No. 1.

GŁOWIŃSKI, Michał, OKOPIEŃ-SŁAWIŃSKA, Aleksandra & SŁAWIŃSKI, Janusz, *Zarys teorii literatury* (= Outline of a Theory of Literature), Warsaw, Państw. Zakł. Wydawn. Szkoln., 1962.

GODOY, Hernan, *El oficio de las letras*, Santiago, Editorial Universitaria, 1970.

GOLDMANN, Lucien, *Le dieu caché. Etude sur la vision tragique dans les 'Pensées' de Pascal et dans le théâtre de Racine*, Paris, Gallimard, 1956.

——, *Recherches dialectiques*, Paris, Gallimard, 1959.

——, *Pour une sociologie du roman*, followed by 'Structuralisme génétique et création littéraire', Paris, Gallimard, 1964; republ. (paperback), *ibid.*, 'Idées' ser., 1965.

——, 'La sociologie de la littérature: situation actuelle et problèmes de méthode', in *Sociologie de la création littéraire (Revue internationale des Sciences sociales), op. cit.* (1967), pp. 531-554 (parallel publication of English version, 'The sociology of literature: status and problems of method', in *Sociology of Literary Creativity (International Social Science Journal), op. cit.* (1967), pp. 493-516); original French text reproduced in GOLDMANN, *Marxisme et sciences humaines, op. cit.* (1970), pp. 54-93.

——, *Marxisme et sciences humaines* (collected essays), Paris, Gallimard, 1970, 'Idées' ser.

——, *Structures mentales et création culturelle*, Paris, Anthropos, 1970. [See also *Critique sociologique et critique psychanalytique*; ELSBERG; *Psychanalyse et sociologie comme méthodes*]

GOLDSCHEIDER, Ludwig (ed.), *Towards Modern Art, or King Solomon's Picture Book: Art of the New Age and Art of Former Ages Shown Side by Side*, London, Phaidon Press, 1951.

GOLDWATER, Robert, *Senufo Sculpture from West Africa*, New York, The Museum of Primitive Art, 1964.

GOMBRICH, Ernst H., 'Psycho-analysis and the history of art' (The Ernest Jones Lecture read before the British Psycho-Analytical Society, 19 Nov. 1953), *The International Journal of Psycho-Analysis*, Vol. XXXV, Pt. 4, 1954, pp. 401-441, ill.

——, *Art and Illusion. A Study in the Psychology of Pictorial Representation*, Washington (D.C.), Trustees of the National Gallery of Art / London, Phaidon Press, 1959; 2nd edn., rev., 1962 (French translation by Guy Durand, *L art et l'illusion. Psychologie de la représentation picturale*, Paris, Gallimard, 1971, Bibliothèque des Sciences humaines).

——, *Meditations on a Hobby Horse, and Other Essays on the Theory of Art*, London, Phaidon Press, 1963.

——, *The Story of Art*, London, Phaidon Press, 1965 (French translation by Edith Combe, *L'art et son histoire*, Paris, Le livre de poche, 1967).

——, *Norms and Forms*, London, Phaidon Press, 1966.

——, *In Search of Cultural History* (The Philip Maurice Deneke Lecture 1967), Oxford, Clarendon Press, 1969.

GOODMAN, Nelson, *Languages of Art. An Approach to a Theory of Symbols*, Indianapolis (Ind.)-New York, Bobbs-Merrill, 1968; London, Oxford University Press, 1969.

GORDON, P., 'Individual differences in the evaluation of art and the nature of art standards', *J. Educat. Res.*, No. 50, 1956, pp. 17-30.

GOTTMANN, Jean, *La politique des Etats et leur géographie*, Paris, A. Colin, 1952.
——, SESTINI, Aldo, TULIPPE, O., WILLATTS, E. C. & VILA, A., *L'aménagement de l'espace: planifciation régionale et géographie*, Paris, A. Colin, 1952.
GOUHIER, Henri, *L'essence du théâtre*, preceded by 'Quatre témoignages', Paris, Plon, 1943, 'Présences' ser.; new edn., Paris, Aubier-Montaigne, 1968.
——, *L'œuvre théâtrale*, Paris, Flammarion, 1958, Bibliothèque d'Esthétique.
[See also *sub Théâtre et collectivité*.]
GOULD, Murray, 'A keypunchable notation for the *Liber usualis*', in HECKMANN (ed.), *Elektronische Datenverarbeitung in der Musikwissenschaft, op. cit.* (1967), pp. 25-40.
GOURFINKEL, N., 'La théâtrologie soviétique', *Cahiers du Centre d'Etudes théâtrales de Louvain*, No. 6, 1968-69.
GRAF, G., *Geschichte der christlichen arabischen Literatur*, Vatican City, Bibl. Apost. Vat., 1944-53, 5 vols.
GRAMSCI, Antonio, *Letteratura e vita nazionale*, Turin, Einaudi, 1952.
GRANGER, Gilles-Gaston, *Essai d'une philosophie du style*, Paris, A. Colin, 1968.
GRAUMANN, Carl-F., 'Zur Psychologie des kritischen Verhaltens', *Studium generale*, XII, 1959.
GREEN, André, *Un œil en trop. Le complexe d'Œdipe dans la tragédie*, Paris, Minuit, 1969.
[See also *sub Critique sociologique et critique psychanalytique*.]
GREENBERG, Joseph H. (ed.), *Universals of Language*, Cambridge (Mass.), The M.I.T. Press, 1963; paperback edn., *ibid.*, 1966.
GREENOUGH, Horatio, *Form and Function. Remarks on Art*, Berkeley-Los Angeles, University of California Press, 1967; Cambridge, Cambridge University Press, 1948.
GREGOTTI, Vittorio, 'Kitsch e architettura', in DORFLES (ed.), *Il Kitsch. Antologia del cattivo gusto, op. cit.* (1968) (English translation, 'Kitsch and architecture', in DORFLES (ed.), *Kitsch, The World of the Bad Taste, op. cit.* (1969)).
GREIMAS, Algirdas Julien, *Linguistique structurale. Recherche de méthode*, Paris, Larousse, 1966, 'Langue et langage' ser.
——, 'Structure et histoire', in *Problèmes du structuralisme, op. cit.* (*Les Temps modernes*, 1966), pp. 815-827; reproduced in GREIMAS, *Du sens, op. cit.* (1970), pp. 103-115.
——, 'Les relations entre la linguistique structurale et la poétique', *Revue internationale des Sciences sociales* XIX (1), 1967, 'Linguistique et communication', pp. 8-17 (parallel publication of English translation, 'The relationship between structural linguistics and poetics', *International Social Sciences Journal*, same ref., 'Linguistics and communication', pp. 8-16).
——, *Du sens. Essais sémiotiques*, Paris, Seuil, 1970.
—— et al., *Essais de sémiotique poétique*, Paris, Larousse, 1972, 'L' ser.
GRIAULE, Marcel, *Arts de l'Afrique Noire*, Paris, Editions du Chêne, 1947.
GRIFF, Mason, 'Conflicts of the artist in mass society', *Diogenes*, No. 46, Summer 1964, pp. 54-68 (parallel publ. of French version, 'Les conflits intérieurs de l'artiste dans une société de masse', translation by Robert Champomier, *Diogène*, No. 46, Apr.-June 1964, pp. 59-74).
——, 'Advertising. The central institution of mass society', in *Mass Communication and Culture, op. cit.* (*Diogenes*, 1969), pp. 120-137 (parallel publication of French version, 'La publicité, institution centrale de la société de masse', translation by Marguerite Derrida, in *Communication et culture de masse, op. cit.* (*Diogène*, 1969), pp. 128-146).
[See also ALBRECHT, BARNETT & GRIFF (eds.).]
GRIFFIN, W. J., 'The uses and abuses of psychoanalysis in the study of literature', *News Letter of the Conference of Literature and Psychology of the Modern Language Association of America*, 1951.

GRUBER, Howard E., TERRELL, Glenn & WERTHEIMER, Michael (eds.), *Contemporary Approaches to Creative Thinking*, New York, Atherton Press (a division of Prentice-Hall), 1962.

GRUBER, R. I., *Istorija muzikal'noj kul'tury* (= History of Musical Culture), Moscow-Leningrad, 1941-53, 3 vols.

GUÉRARD, Albert Léon, *Literature and Society*, New York-Boston, Lothrop, Lee & Shepard, 1935.

GUIART, Jean, *Océanie*, Paris, Gallimard, 1963, 'L'univers des formes' ser.

GUICHARD, Léon, *La musique et les lettres en France au temps du wagnérisme*, Paris, Presses Universitaires de France, 1963, Publications de la Faculté des Lettres et Sciences humaines de Grenoble, Vol. XXIX.

GUIRAUD, Pierre, *Problèmes et méthodes de la statistique linguistique*, Paris, Presses Universitaires de France, 1960.

GUNZENHAUSER, Rul, *Ästhetisches Mass und ästhetische Information: Einführung in die Theorie G. D. Birkhoffs und die Redundanztheorie ästhetischer Prozesse*, Quickborn-Hamburg, Schnelle Verlag, 1968; rev. edn., *ibid.*, 1971.

GUYARD, Marius-François, *La littérature comparée*, Preface by Jean-Marie CARRÉ, Paris, Presses Universitaires de France, 1951, 'Que sais-je?' ser., No. 499; 5th edn., updated (without J. M. Carré's Preface), *ibid.*, 1969.

GUYAU, J.-M., *L'art au point de vue sociologique*, Paris, 1889.

HAGEN, Oskar, *Patterns and Principles of Spanish Art*, Madison, University of Wisconsin Press, 1936, Studies in Language and Literature, No. 38.

HALL, Edward T., *The Silent Language*, New York, Doubleday, 1959.

——, *The Hidden Dimension*, New York, Doubleday, 1966 (French translation by Amélie Petita with a Postface by Françoise CHOAY, *La dimension cachée*, Paris, Seuil, 1971, 'Intuitions' ser.).

HALLIDAY, M. A. K., 'Categories of the theory of grammar', *Word*, XVII (3), 1961.

HAMANN, Richard, *Geschichte der Kunst*, Berlin, Akademie Verlag, 1955, 2 vols.

——, *Allgemeine Geschichte der Kunst*, Dresden-Leipzig, Akademie der Künste der U.d.S.S.R., 1957-69, 6 vols.

HAMPSHIRE, Stuart, *Thought and Action*, London, Chatto & Windus, 1959; New York, Viking Press, 1960.

HANDSCHIN, Jacques, 'Musicologie et musique', in *Kongress Bericht, Internationale Gesellschaft für Musikwissenschaft, Basel, 1949, op. cit.*, pp. 10 sqq.

——, 'Der Arbeitsbereich der Musikwissenschaft', in *Gedenkschrift J. Handschin*, Bern-Stuttgart, P. Haupt, 1957, pp. 23-28.

HARDING, Denys W., *Experience into Words. Essays on Poetry*, London, Chatto & Windus, 1963.

HARDISON, Osborne Bennett, *Modern Continental Literary Criticism*, New York, Appleton-Century-Crofts, 1962; London, Peter Owen, 1964.

HARMON, L. D. & KNOWLTON, E. C., 'Picture processing by computer', *Science*, No. 163, Apr. 1969, pp. 19-29.

HARRISON, Frank Ll., HOOD, Mantle and PÁLISCA, Claude V., *Musicology*, Englewood Cliffs (N.J.), Prentice-Hall, 1963, 'Humanistic Scholarship in America. The Princeton Studies' ser.

HASKELL, Francis, *Patrons and Painters. A Study in the Relations between Italian Art and Society in the Age of the Baroque*, London, Chatto & Windus / New York, Knopf, 1963.

HATZFELD, Helmut Anthony, *A Critical Bibliography of the New Stylistics Applied to Romance Literatures, 1900-1952*, Chapel Hill, University of North Carolina Press, 1953, North Carolina Studies in Comparative Literature ser., No. 5; republ., New York, Johnson Reprint Corporation, 1971.

——, *A Critical Bibliography of the New Stylistics Applied to Romance Literatures, 1953-1965*, Chapel Hill, University of North Carolina Press, 1966; republ., New York, Johnson Reprint Corporation, 1966.

HAUG, Wolfgang Fritz, *Kritik der Warenästhetik*, Frankfurt am Main, Suhrkamp, 1971.

HAUSER, Arnold, *Sozialgeschichte der Kunst und Literatur*, Munich, Beck, 1953, 2 vols. (English translation by Stanley Godman in collab. with the author, *The Social History of Art*, New York, Knopf, 2 vols.; republ. in paperback, New York, Random House, 4 vols.).

——, *Philosophie der Kunstgeschichte*, Munich, Beck, 1958 (English translation, *Philosophy of Art History*, New York, Knopf, 1959).

HAZARD, Paul, *La crise de la conscience européenne, 1680-1715*, Paris, Boivin, 1935; republ., Paris, Fayard, 1961 (English translation by J. Lewis May, *The European Mind. The Critical Years: 1680-1715*, New Haven (Conn.), Yale University Press / London, Hollis & Carter, 1953).

HÉCAEN, Henry & ANGELERGUES, René, *La cécité psychique. Etude critique de la notion d'agnosie*, Paris, Masson, 1963.

HECKMANN, Harald (ed.), *Elektronische Datenverarbeitung in der Musikwissenschaft*, Regensburg, G. Bosse, 1967.

HEIDEGGER, Martin, *Erläuterungen zu Hölderlins Dichtung*, Frankfurt am Main, Klostermann, 1951 (French translation by Henri Corbin *et al.*, *Approche de Hölderlin*, Paris, Gallimard, 1962).

——, 'Der Ursprung des Kunstwerkes' and 'Wozu Dichter?', in HEIDEGGER, *Holzwege*, Frankfurt am Main, Klostermann, 1952 (French translation by Wolfgang Brockmeier, edited by François Fédier, 'L'origine de l'œuvre d'art' and 'Pourquoi des poètes?', in HEIDEGGER, *Chemins qui ne mènent nulle part*, Paris, Gallimard, 1962, pp. 11-68 and 220-261).

——, '... *Dichterisch wohnt der Mensch* ...', *Akzente*, I, 1954, pp. 57 sqq.; reproduced in HEIDEGGER, *Vorträge und Aufsätze*, Pfullingen, Neske, 1954 (French translation by André Préau, '... *L'homme habite en poète* ...', in HEIDEGGER, *Essais et conférences*, with a Preface by Jean Beaufret, Paris, Gallimard, 1958, pp. 224-245).

HEIMANN, Paula, 'A contribution to the problem of sublimation and its relation to the process of internalization', *International Journal of Psychoanalysis* XXXIII (1), 1952.

HEINEMANN, Rudolf, *Untersuchungen zur Rezeption der seriellen Musik*, Regensburg, G. Bosse, 1966.

HELLER, Ágnès, 'Lukács's aesthetics', *The New Hungarian Quarterly* VI (18), Summer 1965, pp. 33-46.

——, 'L'esthétique de György Lukács' (communication presented at the symposium on Sociology of Literature held at Royaumont on 12 Jan. 1968), *L'homme et la société* (Paris), No. 9, July-Sept. 1968, pp. 221-231.

HELMHOLTZ, Hermann von, *Die Lehre von den Tonempfindungen als physiologische Grundlage für die Theorie der Musik*, Brunswick, 1863.

HENDEL, Charles W., Introduction to CASSIRER, *The Philosophy of Symbolic Forms*, English translation, *op. cit.* (1953).

HERSKOVITS, Melville J., *The Backgrounds of African Art*, Denver (Colorado), Denver Art Museum, 1945, Cooke-Daniels Lecture ser.

HEYL, Bernard C., *New Bearings in Aesthetics and Art Criticism*, New Haven (Conn.), Yale University Press / London, H. Milford, 1943.

HILĀL, Mohammed Ghunaymi, *Al Adab al Muqâran* (= Comparative Literature), Cairo, Maktabat al Anglo – al Misriya, 1953; 3rd edn., *ibid.*, 1962.

——, *The Role of Comparative Literature in Contemporary Arabic Literature Study*, Cairo, 1965.

HILER, H., 'Some associative aspects of color', *Journal of Aesthetics and Art Criticism*, Vol. IV, 1946, pp. 203-217.

HILL, Anthony, 'Programme, paragramme, structure', in HILL (ed.), *DATA – Directions in Art* ..., *op. cit.* (1968).

HILL, Anthony (ed.), *DATA – Directions in Art, Theory and Aesthetics. An Anthology*, New York, New York Graphic Society / London, Faber & Faber, 1968.

HILLER, Lejaren A. & BEAN, Calvert, 'Information theory analyses of four sonata expositions', *Journal of Music Theory*, X, 1966, pp. 96-137.

—— & ISAACSON, L. M., *Experimental Music*, New York-Toronto-London, McGraw-Hill, 1959.

HIMMELHEBER, Hans, *Negerkünstler*, Stuttgart, Strecker & Schröder, 1935.

——, *Eskimokünstler*, Stuttgart, 1939.

——, 'Les masques Bayaka et leurs sculpteurs', *Brousse*, No. 1, 1939, pp. 19-39.

——, *Negerkunst und Negerkünstler*, Brunswick, Klinkhardt & Biermann, 1960.

Histoire et urbanisation = *Annales. Economies, Sociétés, Civilisations*, 25th Year, No. 4, July-Aug. 1970.

History of the theatre (proceedings of international congresses and conferences): see *Atti del IIo Congresso internazionale* ...; *The Transactions of the International Conference*

HITCHCOCK, H. Wiley (ed.), *The Prentice-Hall History of Music Series* (volumes by Albert SEAY, Claude V. PALISCA, Reinhard G. PAULY, Rey M. LONGYEAR, Eric SALZMAN, Bruno NETTL, William P. MALM, H. Wiley HITCHCOCK, other vols. in preparation), Englewood Cliffs (N.J.), Prentice-Hall.

HJELMSLEV, Louis, *Omkring sprogteoriens grundlæggelse* (English translation by F. J. Whitfield, *Prolegomena to a Theory of Language*, Madison, University of Wisconsin Press, 1963).

HOFFMAN, Frederick John, *Freudianism and the Literary Mind*, New York, Grove Press, 1959, Evergreen Book.

HOGG, James (ed.), *Psychology and the Visual Arts*, Harmondsworth (Middx.), Penguin Books, 1969.

HOGGART, Richard, *The Uses of Literacy. Aspects of Working-class Life, with special reference to Publications and Entertainments*, London, Chatto & Windus, 1957; republ., Harmondsworth (Middx.), Penguin Books, 1958, Pelican ser. (French translation by F. & J. C. Garcias & J. C. Passeron, Introduction by J. C. PASSERON, *La culture du pauvre*, Paris, Minuit, 1970).

——, 'Literature and society', in Norman MACKENZIE (ed.), *A Guide to the Social Sciences*, London, G. Weidenfeld & Nicolson, 1966; republ., New York, The New American Library, 1968, Mentor Books.

——, 'Humanistic studies and mass culture', in *Theory in Humanistic Studies, op. cit.* (= *Daedalus*, Spring 1970), pp. 451-472.

HÖLDERLIN, Friedrich, *Remarques sur Oedipe. Remarques sur Antigone*, French translation by François Fédier, Paris, Union générale d'éditions, 1965, '10/18' ser.

HOLLAND, Norman N., *Psychoanalysis and Shakespeare* (bibliography), New York, McGraw-Hill, 1966.

——, *The Dynamics of Literary Response*, London, Oxford University Press, 1968.

HONIGSHEIM, Paul, 'Soziologie der Kunst, Musik und Literatur', in Gottfried EISERMANN (ed.), *Die Lehre von der Gesellschaft*, Stuttgart, Enke, 1958, pp. 338-373.

HORNBOSTEL, E. M. von, 'Psychologie der Gehörserscheinungen', in *Handbuch der normalen und pathologischen Physiologie*, Vol. XI, edited by von BETHE *et al.*, Berlin, 1926.

HUACO, George A., *The Sociology of Film Art*, with a Foreword by Leo LÖWENTHAL, New York, Basic Books, 1965.

HUIZINGA, Johan H., *Wege der Kulturgeschichte*, Munich, Drei Masken Verlag, 1930.

——, *Homo ludens*, German edition revised by the author, Amsterdam, Pantheon Akademische Verlagsanstalt, 1939 (1st publ. in Dutch in 1938) (English translation by R. F. C. Hull, *Homo Ludens. A Study of the Play Element in Culture*, London, Routledge, 1949; New York, Roy Pubs, 1950; republ., paperback, Boston, Beacon Press, 1955; rev. edn., London, Paladin Press, 1970).

HUNGERLAND, Helmut, 'Consistency as a criterion in art criticism', *Journal of Aesthetics and Art Criticism* VII (2), Dec. 1948, pp. 93-112.

HUNGERLAND, Isabel Payson (Creed), *Poetic Discourse*, Berkeley, University of California Press, 1958.

HUNTER, Samuel, *Modern French Painting*, New York, Dell, 1956.

HUSSERL, Edmund, *Logische Untersuchungen*, Halle an der Saale, Niemeyer, 1st edn., 1901; 2nd edn., recast, 1913 for *Untersuchungen* 1-5, 1921 for Untersuchung 6 (English translation from the 2nd German edn. by J. N. Findlay, *Logical Investigations*, London, Routledge / New York, Humanities Press, 1970, 2 vols.).

——, 'Die Philosophie als strenge Wissenschaft', *Logos*, 1910 (English translation by Quentin Lauer, 'Philosophy as rigorous science', in HUSSERL, *Phenomenology and the Crisis of Philosophy*, New York, Harper & Row, 1965).

HYMAN, Stanley Edgar, *The Armed Vision. A Study in the Methods of Modern Literary Criticism* (rev. edn. abr. by the author), New York, Random House, 1955, Vintage Books.

Imago. Zeitschrift für Anwendung der Psychoanalyse auf die Geisteswissenschaften, ed. Sigmund FREUD, 1912-37, 26 vols.; reprintings: *American Imago*, 1944 sqq.; Nendeln, 1969.

INGARDEN, Roman, *Das literarische Kunstwerk*, Halle an der Saale, Niemeyer, 1931; 3rd edn., followed by *Von den Funktionen der Sprache im Theaterschauspiel*, Tübingen, Niemeyer, 1965 (see also *sub* INGARDEN, *O poznawaniu dzieła literackiego*).

——, *O poznawaniu dzieła literackiego* (= On the Knowledge of the Literary Work), Lwow, Ossolineum, 1937; reproduced in *Studia z estetyki*, Vol. I, pp. 1-268 (German translation, *Das literarische Kunstwerk, mit einem Anhang von den Funktionen der Sprache im Theaterschauspiel*, 3rd edn. rev., Tübingen, Niemeyer, 1965; French translation of Chap. I, 'De la connaissance de l'œuvre littéraire', *Archives de Philosophie*, Vol. XXIII, Fasc. 2, Apr.-June 1968, pp. 202-263).

——, *Studia z estetyki* (= Studies in Aesthetics), Warsaw, PWN, 1957-58, 2 vols.; 2nd edn., 1966.

——, *Untersuchungen zur Ontologie der Kunst: Musikwerk – Bild – Architektur – Film* (collected essays), German translation by the author, Tübingen, Niemeyer, 1962.

——, *Przezycie, dzieło, wartosc* (= Lived Experience, Work of Art, Value) (collected essays), Cracow, Wydawnictwo literackie, 1966 (German translation, *Erlebnis, Kunstwerk und Wert. Vorträge zur Ästhetik*, Tübingen, Niemeyer, 1969).

INGLIS, Frederick, *An Essential Discipline – An Introduction to Literary Criticism*, New York, Barnes & Noble / London, Methuen, 1968.

International Congresses of Comparative Literature (*Proceedings*): see *Actes du Ve Congrès* . . .; FRIEDERICH (ed.), *Comparative Literature*

International Congresses of Libraries and Museums of the Performing Arts/Congrès internationaux des Bibliothèques-Musées des Arts du Spectacle (International Section for Performing Arts Libraries and Museums of the International Federation of Library Associations/Section internationale des Bibliothèques-Musées des Arts du Spectacle de la Fédération internationale des Associations de Bibliothécaires): Vth Congress, Paris, 23-25 June 1961; VIth Congress, Munich, 28-30 Nov. 1963; VIIth Congress, Amsterdam, 6-9 Sept. 1965; VIIIth Congress, Budapest, 19-24 Sept. 1967; IXth Congress, Genoa, 5-10 Apr. 1970; *Proceedings/Actes* obtainable from Librairie Garnier-Arnoul, 39, rue de Seine, Paris, VIe.

International Congresses of Literary History (*Proceedings*): see *IIe* [Deuxième] *Congrès*

International Congresses of Musicology (*Proceedings*): see *Kongress Bericht* ...
(for IVth and IXth Congresses); *Report of the Eighth Congress*

International Congresses of Theatre History (*Proceedings*): see *Atti del IIo Congresso* ...; *The Transactions of the International Conference*

Interrelations of Cultures. Their Contribution to International Understanding (collection of studies), Paris, Unesco, 1953 (parallel publication of French version, *L'originalité des cultures. Leur rôle dans la compréhension internationale, ibid.*, 1953).

Isaacs, Susan, 'The nature and function of phantasy', in Joan Rivière (ed.), *Developments in Psychoanalysis*, London, Hogarth Press, 1952 (French translation by Willy Baranger, 'Nature et fonction du phantasme', in Joan Rivière (ed.), *Développements de la psychanalyse*, Paris, Presses Universitaires de France, 1966, pp. 64-114).

Ivanov, P. L., 'O dvuh formah èstetičeskogo v ob"ektivnoj dejstvitel'nosti' (= On the two forms of esthetic quality in objective reality), *Voprosy filosofii*, No. 12, 1962.

Ivanov, V., *U sučnosti socialističeskogo realizma* (= On the Essence of Socialist Realism), Moscow, 1963.

Jacobs, Jane, *The Death and Life of Great American Cities*, New York, Random House, 1961.

——, *The Economy of Cities*, New York, Random House, 1969.

Jacobs, Norman (ed.), *Culture for the Millions?* (essays by H. Arendt, *op. cit.*, E. Shils, *op. cit., et al.*), New York, D. Van Nostrand, 1961 (1st publ. with the title: *Mass Culture and Mass Media = Daedalus, Journal of the American Academy of Arts and Sciences* 89 (2), Spring 1960, pp. 269-418 and 429-430).

Jakobson, Roman, 'Two aspects of language and two types of aphasic disturbances' = Pt. II (pp. 53-82) of Roman Jakobson & Morris Halle, *Fundamentals of Language*, The Hague, Mouton, 1956 (French translation by Nicolas Ruwet, 'Deux aspects du langage et deux types d'aphasies', in Jakobson, *Essais de linguistique générale, op. cit.* (1963), pp. 43-67).

——, 'On linguistic aspects of translation', in Brower (ed.), *On Translation, op. cit.* (1959), pp. 232-239 (French translation by Nicolas Ruwet, 'Aspects linguistiques de la traduction', in Jakobson, *Essais de linguistique générale, op. cit.* (1963), pp. 78-86).

——, 'Linguistics and poetics' ('Concluding statement: From the viewpoint of linguistics'), in Sebeok (ed.), *Style in Language, op. cit.* (1960), pp. 350-377 (French translation by Nicolas Ruwet, 'Linguistique et poétique', in Jakobson, *Essais de linguistique générale, op. cit.* (1963), pp. 209-248).

——, *Essais de linguistique générale*, selected essays, translated into French by Nicolas Ruwet, Paris, Minuit, 1963.

——, 'Implications of language universals for semantics', in Greenberg (ed.), *Universals of Language, op. cit.* (1963), pp. 263-278.

——, 'Quest for the essence of language', in *Problems of Language, op. cit.* (*Diogenes*, 1965), pp. 21-37 (parallel publication in French, translation by Jacques Havet, 'A la recherche de l'essence du langage', in *Problèmes du langage, op. cit.* (*Diogène*, 1965; republ. in volume form, 1966), pp. 22-38).

——, 'Vers une science de l'art poétique', Preface to *Théorie de la littérature, op. cit.* (1965), pp. 9-13.

——, 'Linguistics', in *Main Trends of Research in the Social and Human Sciences, Part I: Social Sciences, op. cit.* (1970), pp. 419-463 (parallel publication in French, 'La linguistique', in *Tendances principales de la Recherche dans les Sciences sociales et humaines, Partie I: Sciences sociales, op. cit.* (1970), pp. 504-556).

—— & Halle, Morris, 'Phonology and phonetics' = Pt. I of the same authors' *Fundamentals of Language*, The Hague, Mouton, 1956, 'Janua Linguarum',

No. 1, pp. 1-51 (French translation by Nicolas Ruwet, 'Phonologie et phoné-tique', in JAKOBSON, *Essais de linguistique générale, op. cit.* (1963), pp. 103-149).

—— & LÉVI-STRAUSS, Claude, ' "Les chats" de Baudelaire', *L'homme* II (1), 1962, pp. 5-21.

[See also BOGATYREV & JAKOBSON; *Linguistique et littérature*; *Poetics . . ., Second Congress of Work-in-Progress . . .*; TYNJANOV & JAKOBSON.]

JASPERS, Karl, *Strindberg und Van Gogh. Versuch einer pathographischen Analyse unter vergleichender Heranziehung von Swedenborg und Hölderlin*, Bremen, J. Storm, 1949 (French translation by Hélène Naef, *Strindberg et Van Gogh, Swedenborg, Hölderlin*, preceded by a study by M. BLANCHOT, 'La folie par excellence', *op. cit.*, Paris, Minuit, 1953).

JAUSS, Hans Robert, *Literaturgeschichte als Provokation*, Frankfurt am Main, Suhr-kamp, 1970.

JAUSS, Hans Robert (ed.), *Die nicht mehr schönen Künste. Grenzphänomene des Ästhetischen*, Munich, W. Fink, 1968.

JENCKS, Charles, 'Semiology and architecture', in JENCKS & BAIRD (eds.), *Meaning in Architecture, op. cit.* (1969), pp. 10-25.

——, *Architecture 2000: Methods and Predictions*, New York, Praeger, 1970; London, Studio Vista, 1971.

——, Communication presented at the International Congress of Architectural Semi-otics (Barcelona, Mar. 1972), in *Proceedings of the Congress, op. cit.* (publ. forthcoming).

JENCKS, Charles & BAIRD, George (eds.), *Meaning in Architecture*, New York, Braziller, 1969; London, Barrie & Rockliff, The Cresset Press, 1970 (partial French translation by Jean-Paul Martin, *Le sens de la ville*, Paris, Seuil, 1972).

JEUNE, Simon, *Littérature générale et littérature comparée. Essai d'orientation*, Paris, Lettres modernes (Minard), 1968, 'Situation' ser., No. 17.

JOANNIS, H., *De l'étude de motivation à la création publicitaire et à la promotion des ventes*, Paris, Dunod, 1965.

JOHANSEN, John M., 'Johansen declares himself', *Architectural Forum* CXXIV (1), Jan. 1966, pp. 64-67.

——, 'The Mummers Theater: a fragment, not a building', *Architectural Forum* CXXVIII (4), May 1968, pp. 65-68.

JONES, Ernest, *Hamlet and Oedipus*, London, Gollancz, 1949 (last edn. published during the author's lifetime) (French translation by Anne-Marie Legall, *Hamlet et Œdipe*, Preface by J. STAROBINSKI, Paris, Gallimard, 1967).

KAGAN, M. S., *Lekcii po marksistko-leninskoj èstetikoj* (= Lessons in Marxist-Leninist Aesthetics), Leningrad, Izdatel'stvo Leningradskogo Univ., 1963-64-66, 3 vols. (German translation, *Vorlesungen zur marxistischen-leninistischen Ästhetik*, Berlin, Dietz, 1969).

——, *Bibliografičeskij ukazatel' k leksijam po marksistsko-leninskoj èstetike* (= Bibliographical Repertory for Lectures on Marxist-Leninist Aesthetics), Lenin-grad, Izd. Leningradskogo Univ., 1966.

——. 'I tak, "strukturalizm" i "antistrukturalizm"' (= And so, 'structuralism' and 'antistructuralism'), *Voprosy literatury*, 1969, No. 2.

——, RUNIN, B. & KONDRATENKO, F., 'Obsuždaem stat'ju A. Nujkina o prirode krasoty' (= Discussion of A. Nujkin's article on the nature of beauty), *Voprosy literatury*, 1966, No. 8.

KALINOWSKI, Georges, 'Ontologie et esthétique chez Roman Ingarden', *Archives de Philosophie*, Vol. XXXI, Fasc. 2, Apr.-June 1966, pp. 281-287.

——, 'Les thèses principales de l'esthétique ingardénienne', *Archives de Philosophie*, Vol. XXXIII, Fasc. 4, Oct.-Dec. 1970, pp. 945-950.

KANDEL, L. & MOLES, A. A., 'Adaptation de l'indice de Flesch à la langue française', *Cahiers d'Etudes de Radio-Télévision*, No. 20, 1958.

KANDINSKY, Wassili, *Über das Geistige in der Kunst, insbesondere in der Malerei*,

1912 (English translation, *Concerning the Spiritual in Art, and Painting in particular*, New York, George Wittenborn, 1972, paperback edn.).

KARBUSICKY, Vladimir, 'The interaction between "Reality – Work of art – Society" ' (translation from the Czech), in *The Arts in Society, op. cit.* (1968), pp. 644-655.

KATZ, David, *Gestaltpsychologie*; English translation by Robert Tyson, *Gestalt Psychology. Its Nature and Significance*, New York, Ronald, 1950; London, Methuen, 1951.

KAUFMANN, Emil, *Architecture in the Age of Reason: Baroque and Post-Baroque in England, Italy and France*, Cambridge (Mass.), Harvard University Press, 1955 (French translation by O. Bernier, *L'architecture au siècle des Lumières: baroque et post-baroque en Angleterre, France et Italie*, Paris, Julliard, 1963).

KAUFMANN, Pierre, *L'expérience émotionnelle de l'espace*, Paris, Vrin, 1967.

KAYSER, Wolfgang, *Das sprachliche Kunstwerk. Eine Einführung in die Literaturwissenschaft*, Bern, 1948; 13th edn., Bern-Munich, Francke, 1968.

KEPES, Gyorgy, *Langage of Vision*, Chicago, Theobald, 1944.

KEPES, Gyorgy (ed.), *Structure in Art and in Science*, London, Studio Vista / New York, Braziller, 1965, 'Vision and Value' ser.

KERENYI, Carl and MANN, Thomas, *Romandichtung und Mythologie. Ein Briefwechsel*, Zurich, Rhein-Verlag, 1945, 'Albae Vigiliae', N.S. 2; 2nd edn., 1956.

KERMAN, Joseph, 'A profile for American musicology', *Journal of the American Musicological Society*, XVIII, 1965, p. 61-69.

KESTELOOT, Lilyan, *Ecrivains noirs de langue française. Naissance d'une littérature*, Brussels, Institut de Sociologie de l'Université Libre de Bruxelles, 1962, 'Etudes africaines' ser.

KIBÉDI VARGA, A., *Les constantes du poème. A la recherche d'une poétique dialectique*, The Hague, Van Goor Zonen, 1963.

KIELL, Norman, *Psychiatry and Psychology in the Visual Arts and Aesthetics. A Bibliography*, Madison-Milwaukee, University of Wisconsin Press, 1965.

—, *Psychoanalysis, Psychology and Literature. A Bibliography*, Madison-Milwaukee, University of Wisconsin Press, 1965.

KIEMLE, Manfred, *Ästhetische Probleme der Architektur unter dem Aspekt der Informations Ästhetik*, Quickborn-Hamburg, Schnelle Verlag, 1957.

KINDERMANN, Heinz, *Theatergeschichte Europas*, Salzburg, Otto Müller, 1957-68, 8 vols.

'K itogam diskussii *Èstetika i žizn'* ' (= For an appraisal of the discussion 'Aesthetics and life'), *Voprosy literatury*, 1962, No. 7.

KLANICZAY, T., 'Styles et histoire du style', in *Littérature hongroise et littérature européenne*, Budapest, Akadémiai Kiadó, 1964. [See also *La littérature comparée en Europe orientale*.]

KLEE, Paul, *Das bildnerische Denken* (posthumous collection of theoretical essays, edited by Jürg Spiller), Basel, Benno Schwabe, 1956 (English translation by Ralph Manheim, with a Preface by G. C. ARGAN, *The Thinking Eye. Notebooks of Paul Klee*, New York, George Wittenborn / London, Lund Humphries, 1961; rev. edn., New York, *ibid.*, 1969).

KLEIN, Melanie, 'Infantile anxiety situations reflected in a work of art and the creative impulse' (1929), reproduced in M. KLEIN, *Contributions to Psychoanalysis*, London, Hogarth Press, 1948.

KNELLER, George Frederick, *The Art and Science of Creativity*, New York, Holt, Rinehart & Winston, 1965.

KNEPLER, Georg, *Musikgeschichte des XIX. Jahrhunderts*, Berlin, Henschel, 1961, 2 vols.

KNEUTEN, J., 'Eine Musikform und ihre biologische Funktion', *Zeitschr. f. exp. u. angew. Psychol.*, 16, 1969.

'K obsuždeniju voprosa o suščnosti èstetičeskogo' (= Contribution to the question of the essence of aesthetic quality), *Voprosy filosofii*, 1963, No. 5.

KOCH, Helmuth, *Marxismus und Ästhetik*, Berlin, Dietz, 1962.

KOENIG, Giovanni Klauss, 'Il linguaggio dell' architettura: notazione di "linguaggio comune"', *Criteri*, No. 9-10, 1960.

——, *Lezioni del corso di plastica*, Florence, Editrice Universitaria, 1961.

——, *L'invecchiamento dell' architettura moderna*, Florence, Libreria editrice fiorentina, 1963.

——, *Analisi del linguaggio architettonico*, Florence, Libreria editrice fiorentina, 1964.

KOESTLER, Arthur, *The Act of Creation*, New York, Macmillan, 1964 (German translation. *Der göttliche Funke*, Bern-Munich, 1966).

KOFMAN, Sarah, *L'enfance de l'art. Une interprétation de l'esthétique freudienne*, Paris, Payot, 1970.

KÖHLER, Wolfgang, *Gestalt Psychology. An Introduction to New Concepts in Modern Psychology*, New York, Liveright, 1947 (French translation by Serge Bricianer, *Psychologie de la forme. Introduction à de nouveaux concepts en psychologie*, Paris, Gallimard, 1964, 'Idées' ser.).

—— & HELD, R., 'The cortical correlate of patterns vision', *Science*, Vol. CX, 1949.

KOLINSKY, Mieczyslaw, 'Recent trends in ethnomusicology', *Ethnomusicology*, Vol. XI, 1967, pp. 1-24.

Kongress Bericht, Internationale Gesellschaft für Musikwissenschaft, Basel, 1949 (Proceedings of the IVth International Congress of Musicology, Basel, 1949), Basel, Bärenreiter Verlag, undated.

Kongress Bericht, Internationale Gesellschaft für Musikwissenschaft, Salzburg, 1964 (Proceedings of the IXth International Congress of Musicology, Salzburg, 1964), Kassel, Bärenreiter Verlag, 1964-65, 2 vols.

KÖNIG, René, *Kleider und Leute. Zur Soziologie der Mode*, Frankfurt am Main, Fischer Bücherei, 1967 (English translation by T. Bradley, *A la Mode. René König on the Social Psychology of Fashion*, New York, Seabury Press, 1973).

KONRAD, N., 'Oktjabr' i filologičeskie nauki' (= October and the philological sciences), *Novyj Mir*, 1971, No. 1, pp. 208-218.

KOOIJMAN, S., *Ornamented Bark-cloth in Indonesia*, Leiden, Mededelingen van het Rijksmuseum voor Volkenkunde, Vol. XVI, 1963.

KÖPECZI, Béla, 'Socialist realism – The continuing debate', *The New Hungarian Quarterly* VII (24), Winter 1966, pp. 95-106.

——, 'Balzac and the Human Comedy', *The New Hungarian Quarterly* VIII (3), 1968.

——, 'L'histoire des idées – histoire de la littérature?' *Acta Litteraria Academiae Scientiarum Hungaricae* (Budapest), Vol. XI, 1969.

——, 'Le réalisme socialiste en tant que courant littéraire international', in *Actes du Ve Congrès de l'Association internationale de Littérature comparée/ Proceedings of the Vth Congress of the International Comparative Literature Association (Belgrade 1967)*, Amsterdam, Swets & Zeilinger, 1969, pp. 371-377.

——, 'Réalisme socialiste: légende et vérité', *Acta Litteraria Academiae Scientiarum Hungaricae* (Budapest), XIII (1-4), 1971, pp. 325-348.

——, 'A Marxist view of form in literature', *New Literary History*, Vol. III, 1971-72, pp. 355-372.

KÖPECZI, Béla & JUHÁSZ, P. (eds.), *Littérature et réalitié*, Budapest, Akadémiai Kiadó, 1966.

KORNIENKO, V. S., 'K voprosu a prirode èstetičeskogo' (= Contibrution to the question of the nature of aesthetic quality), *Voprosy filosofii*, 1961, No. 6.

KORTE, Werner F., 'Struktur und Modell als Information in der Musikwissenschaft', *Archiv für Musikwissenschaft*, Vol. XXI, 1964, pp. 1-22.

KRESTOVSKY, Lydia, *Le problème spirituel de la beauté et de la laideur*, Paris, Presses Universitaires de France, 1948.

KRIEG, Walter, *Materialen zu einer Entwicklungsgeschichte der Bücher-Preise und des Autoren-Honorars vom 15. bis zum 20. Jahrhundert*, Vienna, Bad Bocklet/ Zurich, Stubenrauch, 1953.

KRIS, Ernest, *Psychoanalytic Explorations in Art*, New York, International Universities Press, 1952.

KRISTEVA, Julia, 'Bakhtine, le mot, le dialogue et le roman', *Critique*, No. 239, Apr. 1967, pp. 438-465.

——, 'Pour une sémiologie des paragrammes', *Tel Quel*, No. 29, 1967; reproduced in KRISTEVA, *Σημειωτικη-Recherches pour une sémanalyse, op. cit.* (1969), pp. 174-207.

——, 'Le geste, pratique ou communication?', *Langages*, No. 10, June 1968; reproduced in KRISTEVA, *Σημειωτικη-Recherches pour une sémanalyse, op. cit.* (1969), pp. 90-112.

——, 'Linguistique et sémiologie aujourd'hui en U.R.S.S.', introductory essay for 'La sémiologie aujourd'hui en U.R.S.S.', *op. cit.* (1968), pp. 3-8.

——, 'Le productivité dite texte', *Communications* (Paris), No. 11, 1968; reproduced in KRISTEVA, *Σημειωτικη-Recherches pour une sémanalyse, op. cit.* (1969), pp. 208-245.

——, *Σημειωτικη-Recherches pour une sémanalyse*, Paris, Seuil, 1969, 'Tel Quel' ser.

——, 'La mutation sémiotique', *Annales. Economies. Sociétés. Civilisations*, 25th Year, No. 6, Nov.-Dec. 1970, pp. 1497-1522.

[See also *sub* BAHTIN, *Problemy poetiki Dostoevskogo*; *Linguistique et littérature*.]

KULTERMANN, Udo, *Geschichte der Kunstgeschichte. Der Weg einer Wissenschaft*, Vienna-Düsseldorf, Econ Verlag, 1966.

KUNO, Ulaza & SUGA, Yayoi, 'Multidimensional mapping of piano pieces', *Japanese Psychological Research*, 8, 1966.

KUPKA, K., *Un art à l'état brut*, Lausanne, 1962.

KUPPER, H., 'Computer und Musikwissenschaft', *IBM Nachrichten* (Verlag IBM, Sindelfingen), No. 180, Dec. 1966.

KURTH, Ernst, *Musikpsychologie*, Berlin, 1931; 2nd edn., Bern, 1947.

KUTSCHER, Artur, *Grundriss der Theaterwissenschaft*, 2nd edn., Munich, Desch, 1949.

LABASSE, Jean, *L'organisation de l'espace. Eléments de géographie volontaire*, Paris, Hermann, 1966, Actualités scientifiques et industrielles, No. 1326.

LABORIT, Henri, *L'homme et la ville*, Paris, Flammarion, 1971.

LACAN, Jacques, 'Le séminaire sur "la Lettre volée" ', *La Psychanalyse* (Paris), Vol. II, 1957, pp. 1-44; reproduced in LACAN, *Ecrits, op. cit.* (1966), pp. 11-61.

——, *Ecrits* (collected essays), Paris, Seuil, 1966.

LAFARGUE, Paul, *Critiques littéraires*, Introduction by J. FRÉVILLE, Paris, Editions sociales internationales, 1936.

LAIBLIN, Wilhelm (ed.), *Märchenforschung und Tiefenpsychologie*, Darmstadt, Wissenschaftliche Buchgesellschaft, 1969, 'Wege der Forschung', No. 102.

LALO, Charles, *L'art et la vie sociale*, Paris, 1921.

LANG, Paul H., 'Editorial', *Musical Quarterly*, Vol. L, 1964, pp. 215-226.

LANGE-EICHBAUM, Wilhelm & KURTH, Wolfram, *Genie, Irrsinn und Ruhm*, 6th edn., Munich-Basel, 1967.

LANGER, Susanne K., *Philosophy in a New Key*, Cambridge (Mass.), Harvard University Press, 1942; republ., New York, The New American Library, undated, Mentor Books.

——, 'Abstraction in science and in art', in HENLE, Paul, KALLEN, Horace M. & LANGER, Susanne K. (eds.), *Structure, Method and Meaning. Essays in Honor of Henry M. Scheffler*, New York, The Liberal Arts Press, 1951.

——, *Feeling and Form. A Theory of Art Developed from Philosophy in a New Key*, London, Routledge/New York, Scribner/Toronto, Saunders, 1964.

——, *Philosophical Sketches*, Baltimore (Md.), The Johns Hopkins Press, 1962;

republ., New York, The New American Library of World Literature, 1964, Mentor Books.

LANGER, Susanne K. (ed.), *Reflections on Art. A Source Book of Writings by Artists, Critics and Philosophers*, Baltimore, The Johns Hopkins Press, 1958.

LAPLANCHE, Jean, 'La recherche psychanalytique', *Revue de l'Enseignement supérieur* (Paris), 1966, No. 2-3, special issue = *La Psychologie*, pp. 147-153.

——, *Hölderlin et la question du père*, Paris, Presses Universitaires de France, 1967.

——, 'Interpréter [avec] Freud', *L'Arc*, No. 34 (special issue: *Freud*), 1968.

—— & PONTALIS, J.-B., 'Fantasme originaire, fantasmes des origines, origine du fantasme', *Les Temps modernes*, 19th Year, No. 215, Apr. 1964, pp. 1833-1868.

——, *Vocabulaire de la psychanalyse*, Paris, Presses Universitaires de France, 1967.

LaRUE, Jan & COBIN, Marian W., 'The Ruge-Seignolay catalogue: an exercise in automated entries', in HECKMANN (ed.), *Elektronische Datenverarbeitung in der Musikwissenschaft, op. cit.* (1967), pp. 41-56.

LASCAULT, Gilbert, 'L'art contemporain et la "vieille taupe"', in *Art et contestation, op. cit.* (1968).

——, 'Esthétique et psychanalyse', in J. C. SEMPE *et al.*, *La psychanalyse*, Paris, S.G.P.P., 1969, 'Le point de la question' ser., pp. 217-272.

——, 'Pour une psychanalyse du visible', in TEYSSÈDRE *et al.*, *Les sciences humaines et l'œuvre d'art, op. cit.* (1969).

LAUDE, Jean, *Les arts de l'Afrique noire*, Paris, Librairie générale française, 1966, 'Le livre de poche' ser.
[See also TEYSSÈDRE, LASCAULT, LAUDE, GORSEN *et al.*]

LAUFER, R., 'La bibliographie matérielle dans ses rapports avec la critique textuelle, l'histoire littéraire et la formalisation', in *Méthodologies, op. cit.* (*Rev. d'Hist lit. de la France*, 1970), pp. 776-783.

LAWALL, S., *Critics of Consciousness*, Cambridge (Mass.), Harvard University Press, 1968.

LAWLOR, M., 'Cultural influences on preferences for designs', *J. Abnorm. Soc. Psychol.*, No. 61, 1955, pp. 690-692.

LAWRENSON, T. E. & PURKIS, Hélène, 'Les éditions illustrées de Térence dans l'histoire du théâtre', in *Le lieu théâtral à la Renaissance*, Paris, Editions du C.N.R.S., 1964.

LAZARSFELD, Paul F., *Communications in Modern Society*, Urbana, University of Illinois Press, 1948.

——, 'Tendances actuelles de la sociologie des communications et comportement du public de la Radio-Télévision américaine', *Cahiers d'Etudes de Radio-Télévision*, No. 23, Sept. 1959, pp. 243-256 (with a brief summary in English).

LEAVIS, Queenie Dorothy, *Fiction and the Reading Public*, London, Chatto & Windus, 1932.

LE BOT, Marc, 'Machinisme et peinture', *Annales. Economies, Sociétés, Civilisations*, 22nd Year, No. 1, Jan. 1967.

——, 'Art, sociologie, histoire', *Critique*, No. 239, Apr. 1967, pp. 475-491.

——, *Peinture et machinisme*, Paris, Klincksieck, 1973, 'Collection d'Esthétique'.

LEENHARDT, Jacques, 'La sociologie de la littérature. Quelques étapes de son histoire', in *Sociologie de la création littéraire* (*Revue internationale des Sciences sociales*), *op. cit.* (1967), pp. 555-572 (parallel publication of English translation, 'The sociology of literature. Some stages in its history', in *Sociology of Literary Creativity* (*International Social Science Journal*), *op. cit.* (1967), pp. 517-533).

——, 'Sémantique et sociologie de la littérature', in *Sociologie de la littérature. Recherches récentes et discussions, op. cit.* (1969, 1970), pp. 99-111.

——, 'Pour une esthétique sociologique. Essai de construction de l'esthétique de Lucien Goldmann', *Revue d'Esthétique*, XXIV (2), 1971, pp. 113-128.

——, *Lecture politique du roman:* LA JALOUSIE *d'Alain Robbe-Grillet*, Paris, Minuit, 1973.

[See also *sub Psychanalyse et sociologie ...*]

LEENHARDT, Maurice, *Les arts de l'Océanie*, photographs by Emmanuel Sougez, Paris, Editions du Chêne, 1948, 'Arts du monde' ser.

LEFEBVRE, Henri, *Le droit à la ville*, Paris, Anthropos, 1968.

——, *La révolution urbaine*, Paris, Gallimard, 1970.

——, 'Réflexions sur la politique de l'espace', *Espaces et sociétés* (periodical, Paris), 1970.

LENIN, Vladimir Ilič, *Sočinenija* (= Complete Works), 4th edn. in Russian, Moscow, 1941-50, 35 vols.

—— (LÉNINE, Vladimir Ilitch), *Ecrits sur la littérature et l'art*, selected texts in French translation, with a study by Jean FRÉVILLE, 'L'action de Lénine sur la littérature et la culture', Paris, Editions sociales, 1957, 'Classiques du marxisme' ser.

——, 'The organization of the Party and Party literature', Russian original in *Novaja Žizn'* (= New Life), 13 (26), Nov. 1905 (*Complete Works* in Russian, *op. cit.*, Vol. X, pp. 26-31) (quoted in French translation in LÉNINE, *Ecrits sur la littérature et l'art, op. cit.*, p. 87).

——, 'Leo Tolstoy', Russian original in *The Social Democrat* of 16 (29) Nov. 1910 (*Complete Works* in Russian, *op. cit.*, Vol. XVI, pp. 293-297) (quoted in French translation in LÉNINE, *Ecrits sur la littérature et l'art, op. cit.*, p. 129).

LE RICOLAIS, Robert, 'Introduction à la notion de forme' (1966), in HILL (ed.), *DATA – Directions in Art ..., op. cit.* (1968).

LE ROY LADURIE, Emmanuel & COUPERIE, Pierre, 'Le mouvement des loyers parisiens de la fin du Moyen Age au XVIIIe siècle', in *Histoire et urbanisation, op. cit.* (*Annales*, 1970), pp. 1002-1023.

LESURE, François, 'The employment of sociological methods in musical history (Pour une sociologie historique des faits musicaux)', in *Report of the Eighth Congress, International Musicological Society, New York, 1961, op. cit.* (1961), Vol. I, pp. 333-346.

——, Article 'Musicologie', in MICHEL (ed.), *Encyclopédie de la musique, op. cit.* (1961), Vol. III, pp. 268 sqq.

LEVIN, Harry, *Contexts of Criticism*, New York, Atheneum, 1963.

——, *Refractions. Essays in Comparative Literature*, London-New York, Oxford University Press, 1966.

——, *Why Literary Criticism Is not an Exact Science*, Cambridge (Mass.), Harvard University Press, 1967.

LEVIN, Samuel R., *Linguistic Structures in Poetry*, The Hague, Mouton, 1962, 'Janua Linguarum', No. XXIII.

LÉVI-STRAUSS, Claude, *Tristes Tropiques*, Paris, Plon, 1955 (English translation by John Russell, *World on the Wane*, London, Hutchinson, 1961).

——, *Anthropologie structurale* (collected essays), Paris, Plon, 1958 (English translation by Claire Jakobson & Brooke Grundfest Schoepf, *Structural Anthropology*, New York-London, Basic Books, 1963).

——, *Mythologiques*: Le cru et le cuit*, Paris, Plon, 1964 (English translation by John & Doreen Weightman, *The Raw and the Cooked. Introduction to a Science of Mythology: I*, London, Jonathan Cape, 1970).

——, 'La structure et la forme. Réflexions sur un ouvrage de Vladimir Propp', *Cahiers de l'Institut de Science économique appliquée* (Paris), 99, ser. M, No. 7, Mar. 1960, pp. 3-36; another edn., with the title 'L'analyse morphologique des contes russes', *International Journal of Slavic Linguistics and Poetics*, No. 3, 1960; reproduced with the original title in Cl. LÉVI-STRAUSS, *Anthropologie structurale deux*, Paris, Plon, 1973, pp. 139-173.
[See also JAKOBSON & LÉVI-STRAUSS.]

LHOTE, André, *Traité du paysage et de la figure* (originally published as two separate treatises, Paris, Floury, 1939 and 1950), new edn. (as one work), Paris, Grasset, 1963.

LICHTHEIM, George, *Lukács*, London, Collins, 1971, Fontana Modern Masters ser. (French translation by Sylvie Dreyfus, *Lukács*, Paris, Seghers, 1971, 'Les maîtres modernes' ser.).

LIFŠIC, Mihail, *K voprosu o vzgljadah Marksa na iskusstvo* (= Contribution to the Question of Marx's Views on Art), Moscow-Leningrad, 1933.

LIHAČEV (LIKHATSCHOW), D. S., *Die Kultur Russlands während der osteuropäischen Frührenaissance vom 14. bis zum Beginn des 15. Jahrhunderts*, Dresden, Verlag der Kunst, 1962.

LINCOLN, Harry, 'Some criteria and techniques for developing computerized thematic indices', in HECKMANN (ed.), *Elektronische Datenverarbeitung in der Musikwissenschaft, op. cit.* (1967), pp. 57-62.

Linguistique et littérature (articles by Roland BARTHES, Roman JAKOBSON & Luciana STEGAGNO PICCHIO, Gérard GENETTE, Jean COHEN, Solomon MARCUS, Nicolas RUWET, Steen JANSEN, Tzvetan TODOROV, Julia KRISTEVA and Mihail BAKHTIN) = *Languages* (Paris), No. 12, Dec. 1968.

LINTON, Ralph & WINGERT, Paul S., *Arts of the South Seas*, with colour illustrations by Miguel Covarrubias, New York, Museum of Modern Art, 1946.

LIPPARD, Lucy, *Pop Art*, New York, Praeger, 1966.

Liste des acquisitions de la Bibliothèque, Paris, Hôpital Ste Anne, Centre international de documentation concernant les expressions plastiques (Dr. Claude Wiart).

Literature and Psychology, 'a quarterly journal of literary criticism as informed by depth psychology' (since 1951), ed. first Leonard MANHEIM, then Morton N. KAPLAN, Teaneck (N.J.), Fairleigh Dickinson University.

La littérature comparée en Europe orientale. Conférence de Budapest, 26-29 octobre 1962, prepared by I. SÖTER with K. BOR, T. KLANICZAY, Gy. M. VAJDA (in French), Budapest, Akadémiai Kiadó, 1963.

Littérature et société. Problèmes de méthodologie en sociologie de la littérature (colloquium), Brussels, Editions de l'Institut de Sociologie, Université Libre de Bruxelles, 1967.

'Littérature et stylistique', *Cahiers de l'Association internationale des Etudes françaises* (Paris), No. 16, Mar. 1964, pp. 7-108.

Littérature hongroise – Littérature européenne. Etudes de littérature comparée publiées par l'Académie des Sciences de Hongrie à l'occasion du IVe Congrès de l'Association internationale de Littérature comparée (SÖTÉR, István & SÜPEK, Ottó, eds.), Budapest, Akadémiai Kiadó, 1964.

Littérature, idéologies, société = *Littérature* (Paris), No. 1, Feb. 1971.

LOCHER, Gottfried Wilhelm, *The Serpent in Kwakiutl Religion. A Study in Primitive Culture*, Leiden, Brill, 1932.

Logique et linguistique = *Langages* (Paris), No. 2, June 1960 (articles by Oswald DUCROT, BAR-HILLEL, Noam CHOMSKY, W. v. O. QUINE, etc.).

LORENZ, Konrad Z., 'The role of *Gestalt* perception in animal and human behavior', in WHYTE (ed.), *Aspects of Form, op. cit.* (1951).

—, *Über tierisches und menschliches Verhalten*, Munich, R. Piper, 1965.

LOSONCZI, Agnès, 'Le changement d'orientation sociale dans la musique de tous les jours', in *Etudes sociologiques*, edited by A. HEGEDÜS, Budapest, Corvina, 1969.

LOTMAN, Iuri M., *Lekcii po struktural'noj poetike* (= Lectures in Structural Poetics), Tartu, University, 1964, Trudy po znakovym sistemam, No. I.

—, *Tezisy k probleme v rjadu modelirujuščih sistem* (= Theses relative to the Problem of Model-productive Systems), Tartu, University, 1967.

—, 'Le nombre dans la culture' (French translation), in 'La sémiologie aujourd'hui en URSS', *op. cit.* (1968), pp. 24-27.

—, *Struktura hudožestvennogo teksta*, Moscow, Izdatel'stvo' 'Iskusstvo', 1970 (French translation under the general editorship and with a Preface by Henri Meschonnic, *La structure du texte artistique*, Paris, Gallimard, 1973, Bibliothèque des Sciences humaines).

LOVEJOY, Arthur O., *Essays in the History of Ideas*, Baltimore (Md.), Johns Hopkins Press, 1948.

LÖWENFELD, Viktor, *Creative and Mental Growth. A Textbook on Art Education*, New York, Macmillan, 1947.

LÖWENTHAL, Leo, *Literature and the Image of Man. Sociological Studies of the European Drama and Novel, 1600-1900*, Boston, Beacon Press, 1957.

—, *Literature, Popular Culture, and Society*, Englewood Cliffs (N.J.), Prentice-Hall, 1961.

—, *Literatur und Gesellschaft. Das Buch in der Massenkultur*, Neuwied, Luchterhand, 1964.

—, 'Literature and society' (annotated bibliography), in J. THORPE (ed.), *Relations of Literary Study*, Modern Language Association of America, 1967, pp. 89-110. [See also *sub* HUACO, *The Sociology of Film Art*.]

LOWINSKY, Edward E., *Tonality and Atonality in Sixteenth-Century Music*, Berkeley-Los Angeles, University of California Press, 1961.

—, 'Character and purposes of American musicology. A reply to Joseph Kerman', *Journal of the American Musicological Society*, XVIII, 1965, pp. 222-234.

LOWRY, I. S., *Seven Models of Urban Development*, Palo Alto (Calif.), The Rand Corporation, 1967.

LUCAS, Frank L., *Literature and Psychology*, London, Cassell, 1951; republ. (paperback), Ann Arbor, University of Michigan Press, 1957.

LUKÁCS, György, *Gesammelte Werke*, Berlin, Luchterhand, 1962- , 12 vols.

—, *Die Theorie des Romans*, Berlin, Cassirer, 1920 (French translation, *La théorie du roman*, Paris, Gonthier, 1963).

—, *A történelmi regény*, Budapest, Hungaria, undated (1947; this work was originally published in Russian in 1938); German version, *Der historische Roman*, Berlin, Aufbau-Verlag, 1955, and in LUKÁCS, *Gesammelte Werke, op. cit.*, Vol. 6, *Probleme des Realismus III* (1965) (English translation, *The Historical Novel*, Boston, Beacon Press, 1963).

—, *K. Marx und Fr. Engels als Literaturhistoriker*, Berlin, Aufbau-Verlag, 1948.

—, *Adalékok az esztétika történetéhez*, Budapest, Akadémiai Kiadó, 1953; German version, *Beiträge zur Geschichte der Ästhetik*, Berlin, Aufbau-Verlag, 1954.

—, *Probleme des Realismus* (2nd edn. of *Essays über Realismus*), Berlin, Aufbau-Verlag, 1955.

—, *Die Gegenwartsbedeutung des kritischen Realismus*, publ. under the title *Wider den missverstandenen Realismus*, Hamburg, Claassen, 1958; reproduced with its original title in the collection *Probleme des Realismus*, I, Berlin, Luchterhand, 1971 (French translation by M. de Gandillac, *La signification présente du réalisme critique*, Paris, Gallimard, 1960).

—, *A különösség, mint esztétikai kategória*, Budapest, Akadémiai Kiadó, 1957 (Italian translation, *Prolegomeni a un'estetica marxista. Sulla categorie particolarità*, Rome, 1957; French translation, *Prolégomènes à une esthétique marxiste*, Paris, F. Maspero, for later publ.).

—, *Die Eigenart des Ästhetischen*, in LUKÁCS, *Gesammelte Werke, op. cit.*, Vols. 11-12, *Ästhetik I* (1963); Hungarian version, *Az esztétikum sajatossàga*, Budapest, Akadémiai Kiadó, 1965, Vols. 1-2.

—, *Művészet és társadalom* (= Art and Society), Budapest, Gondolat, 1968. [See also Goldmann *et al., Problèmes d'une sociologie du roman*.]

LUNAČARSKIJ, A. V., *Osnovi pozitivnoj èstetiki* (= Basic Principles of Positivist Aesthetics), Moscow, 1923.

—, *Sobranie sočinenij* (= Selected Works), Moscow, Hudožestvennaja literatura, 1963-67, 8 vols.

LUNDIN, Robert Wm., *An Objective Psychology of Music*, Cardiff-London, George Ronald, 1953.

LUTHE, Heinz Otto, 'Recorded music and the record industry. A sector neglected

by sociological research' (translated from German), in *The Arts in Society*, *op. cit.* (*International Social Science Journal*, 1968), pp. 656-666 (parallel publication of French translation in *Les arts dans la société*, *op. cit.*, pp. 712-724).

LYNCH, Kevin, *The Image of the City*, Cambridge (Mass.), The M.I.T. Press, 1960 (French translation, *L'image de la cité*, Paris, Dunod, 1968).

——, *A Classification System for the Analysis of Urban Patterns*, mimeographed, Cambridge (Mass.), The M.I.T. Press, 1964.

LYOTARD, Jean-François, 'La travail du rêve ne pense pas', *Revue d'Esthétique*, XXI (1), 1968.

——, 'Œdipe juif', *Critique*, No. 277, June 1970, pp. 530 sqq.

——, *Discours, figure*, Paris, Klincksieck, 1971, 'Collection d'Esthétique'.

MACA, J. (ed.), *Sovetskoe iskusstvo za 15 let* (= 15 Years of Soviet Art), documents, Moscou-Leningrad, 1953.

MACDONALD, Dwight, 'A theory of mass culture', *Diogenes*, No. 3, Summer 1953, pp. 1-17 (parallel publication of French translation, 'Culture de masse', *Diogène*, No. 3, July-Sept. 1953, pp. 3-30).

MACGOWAN, Kenneth & MELNITZ, William, *The Living Stage. A History of the World Theatre*, Englewood Cliffs (N.J.), Prentice-Hall/London, Bailey, 1955.

MACHEREY, Pierre, 'L'analyse littéraire, tombeau des structures', in *Problèmes du structuralisme*, *op. cit.* (*Les Temps modernes*, 1966), pp. 907-928.

——, *Pour une théorie de la production littéraire*, Paris, Maspero, 1966, 'Théorie' ser., No. 4.

MACKINNON, Donald W., 'The creativity of architects', in TAYLOR (ed.), *Widening Horizons in Creativity*, *op. cit.* (1964), pp. 359-378.

MACKSEY, Richard Alan & DONATO, E. U. (eds.), *The Languages of Criticism and the Sciences of Man. The Structuralist Controversy*, Baltimore (Md.), The Johns Hopkins Press, 1970.

McLAUGHLIN, Terence, *Music and Communication*, London, Faber & Faber/New York, St. Martin's Press, 1971.

McLUHAN, Marshall, *The Gutenberg Galaxy. The Making of Typographic Man*, Toronto, University of Toronto Press/London, Routledge, 1962 (French translation by Jean Paré, *La galaxie Gutenberg*, Tours (France), Mame, 1967).

——, *Understanding Media. The Extensions of Man*, London, Routledge/New York, McGraw-Hill, 1964 (French translation by Jean Paré, *Pour comprendre les média. Les prolongements technologiques de l'homme*, Tours, Mame/Paris, Seuil, 1968).

—— & FIORE, Quentin, *The Medium is the Message. An Inventory of Effects*. Harmondsworth (Middx.), Allen Lane, The Penguin Press, 1967 (French translation, *Message et massage*, Paris, J. J. Pauvert, 1968).

McNEAL, James U., *Dimension of Consumer Behavior*, New York, Appleton-Century-Crofts, 1965.

Main Trends of Research in the Social and Human Sciences, Part I. Social Sciences, Paris-The Hague, Mouton/Unesco, 1970 (parallel publication in French, *Tendances principales de la recherche dans les sciences sociales et humaines, Partie I: Sciences sociales*, *op. cit.*).

MALDONADO, Tomas, 'Beitrag zur Terminologie der Semiotik', *Ulm* (periodical), 1961.

——, *Training for the Future* (Lethaby Lectures), London, Royal College of Arts, 1965.

MALLARMÉ, Stéphane, *Divagations* (collected essays), Paris, Bibliothèque Charpentier, 1897 (republication of the various essays, replaced at their dates among the works in prose, in *Œuvres complètes*, Paris, Gallimard, 1945, Bibliothèque de la Pléiade).

MALRAUX, André, *Le musée imaginaire*, Paris, Gallimard, 1947, 'La galerie de la

Pléiade' ser.; new edn., recast, *ibid.*, 1965, 'Idées/Arts' ser. (English translation, *Museum without Walls*, New York, Doubleday, paperback, undated).

——, *Psychologie de l'art*, Paris, Gallimard, 1947-50, 3 vols. (cf. English translations: *Voices of Silence*, New York, Doubleday, 1953, and *Metamorphosis of the Gods, ibid.*, 1964).

MANDROU, Robert, *De la culture populaire en France aux XVIIe et XVIIIe siècles, Bibliothèque bleue de Troyes*, Paris, Stock, 1964.

——, 'Histoire littéraire et histoire culturelle', in *Méthodologies, op. cit.* (1970), pp. 861-869.

MANHEIM, Leonard F., *Hidden Patterns. Studies in Psychoanalytic Criticism*, New York, Macmillan, 1966.

——, 'Psychopathia literaria', in James D. PAGE (ed.), *Approaches to Psychopathology*, New York, Columbia University Press, 1966.

MANN, Thomas: see KERENYI and MANN.

MANNONI, Olivier, 'Le théâtre du point de vue de l'imaginaire', *La psychanalyse*, No. 5, 1969; reproduced in MANNONI, O., *Clés pour l'imaginaire, ou l'autre scène*, Paris, Seuil, 1969.

MARCH, Lyonel, 'Homes beyond the fringe', *Riba Journal*, Aug. 1967.

MARCUSE, Herbert, *Eros and Civilization. A Philosophical Inquiry into Freud*, Boston, Beacon Press, 1955 (French translation by J. G. Neny & B. Fraenkel, rev. by the author, *Eros et Civilisation. Contribution à Freud*, Paris, Minuit, 1963, 'Arguments' ser.).

MARDEKAR, M., *Arts and Man*, Bombay, Popular Prakashan, 1960.

MARGOLIS, Joseph Z. (ed.), *Philosophy Looks at the Arts. Contemporary Readings in Aesthetics*, New York, Scribner, 1962.

MARIN, Louis, 'Eléments pour une sémiologie picturale', in TEYSSEDRE, LASCAULT, LAUDE, GORSEN *et al., Les sciences humaines et l'œuvre d'art, op. cit.* (1969).

——, 'Récit mythique, récit pictural – A propos de Poussin', in *Actes du Colloque d'Urbino sur l'analyse du récit, Université d'Urbino, juillet 1968*, Urbino, publ. by the University, 1969.

——, *Etudes sémiologiques*, Paris, Klincksieck, 1972, 'Esthétique' ser.

[See also *sub* RADCLIFFE-BROWN, *Structure and Function in Primitive Society.*]

MARINO, A., *Introducere in critica literara*, Bucharest, Editura Tineretului, 1968.

MARINOW, A., 'Der malende Schizophrene und der schizophrene Maler', *Zeitschrift für Psychotherapie und medizinische Psychologie*, Nov. 1967.

MARITAIN, Jacques, *Art et scolastique*, Paris, Rouart, 1927; 3rd edn., *ibid.*, 1955 (English translation by J. F. Scanlan, *Art and Scholasticism, with other Essays*, New York, Scribner, 1930; facsimile reprod., Freeport (N.Y.), BFL (Books for Libraries) Communications).

——, *Frontières de la poésie*, Paris, Rouart, 1935.

——, *Creative Intuition in Art and Poetry*, New York, Pantheon Books, 1953.

—— & Raïssa, *Situation de la poésie*, Paris, Desclée de Brouwer, 1938 (English translation by Marshall Suther, *The Situation of Poetry. Four Essays on the Relations between Poetry, Mysticism, Magic and Knowledge*, New York, Philosophical Library, 1955; facsimile reprod., Millwood (N.Y.), Kraus Reprints, 1968).

MARIX-SPIRE, Thérèse, *Les Romantiques et la musique. Le cas George Sand (1804-1838)*, Paris, Nouvelles Editions Latines, 1955.

MARÓTHY, János, *Zene és polgár, zene és proletár* (= Music and the Bourgeois, Music and the Proletarian), Budapest, Akadémiai Kiadó, 1966.

MARTINEAU P., *Motivation et publicité*, Paris, Editions Hommes et Techniques, 1969.

MARTINET, André, *Eléments de linguistique générale*, Paris, A. Colin, 1961.

——, *A Functional View of Language*, Oxford, Clarendon Press, 1962 (French translation by Henriette & Gérard Walter, *Langue et fonction*, Paris, Gonthier/Denoël, 1969, 1971, Bibliothèque 'Mediations').

MARTINI, Francesco di Giorigio, *Trattati di architettura in ingegneria e arte militare*, a cura di C. MALTESE, transcrizione di L. MALTESE DEGRASSI, Milan, Edizione Il Profilo, 1967.

MARX, Karl, *Contribution to the Critique of Political Economy*, new English translation, New York, International Publishers Company, 1970.

—— and ENGELS, Friedrich, *Sur la littérature et l'art*, selected writings in French translation, edited by Jean FRÉVILLE, Paris, Editions sociales internationales, 1936; new edn., augm., with a study by FRÉVILLE 'La littérature et l'art dans l'œuvre de Marx et d'Engels', Paris, Editions sociales, 1954, 'Classique du marxisme' ser.

—— & – *The German Ideology* (English translation), New York, International Publishers Company, 1947 (original German text in MARX-ENGELS, *Gesamtausgabe* (MEGA), Vol. V, Moscow, 1932; integral French translation by Gilbert Badia *et al.*, presented and annotated by Gilbert Badia, *L'idéologie allemande*, Paris, Editions sociales, 1968).

MASCAGNI, Andrea, 'L'insegnamento della musica in Italia', *Nuova rivista musicale italiana*, III, 1969, pp. 55-78.

Mask und Kothurn (Vienna), No. III, 1957.

Mass Communication and Culture (articles by Raoul ERGMANN, René BERGER (*op. cit.*), Ulrich SAXER, Edmond RADAR, J. BENSMAN & R. LILIENFELD, Mason GRIFF (*op. cit.*), and Rolf MEYERSON) = *Diogenes*, No. 68, Winter 1969 (parallel publ. in French, *Communication et culture de masse* = *Diogène*, No. 68, Oct.-Dec. 1969).

Mass Culture and Mass Media (*Daedalus*, Spring 1960): see JACOBS, N. (ed.).

MATHEWS, Max V. *et al.*, *The Technology of Computer Music*, Cambridge (Mass.), The M.I.T. Press, 1969.

MATTIL, E. L. *et al.*, 'The effect of a "depth" vs. a "breadth" method of art instruction at the ninth grade level', *Studies in Art Education* III (1), 1961, pp. 75-87.

MAURON, Charles, 'L'art et la psychanalyse' (1949), *Psyché* (Paris), No. 63, 1952.

——, *Introduction à la psychanalyse de Mallarmé*, Neuchâtel (Switzerland), La Baconnière, 1950; new edn., augm., *ibid.*, 1968; English version, *Introduction to the Psychoanalysis of Mallarmé*, Berkeley-Los Angeles, University of California Press/Cambridge, Cambridge University Press, 1963.

——, 'Note sur la structure de l'inconscient chez Van Gogh', *Psyché*, Nos. 75, 76 and 77-78, 1953.

——, *Des métaphores obsédantes au mythe personnel. Introduction à la psychocritique*, Paris, José Corti, 1963.

[See also *Critique sociologique et critique psychanalytique*.]

MAURY, Paul, *Art et littératures comparés*, Paris, Les Belles Lettres, undated (1934).

MAUZI, Robert, *L'idée du bonheur dans la littérature et la pensée françaises du XVIIIe siècle*, 3rd edn., Paris, A. Colin, 1967.

MEAD, Margaret, 'Bringing up children in the space age', *Space Digest* II (2) (Supp. to *Air Force. The Magazine of Aerospace Power* XLII (2), Feb. 1959, pp. 70-73).

MEDAM, Alain, *La ville censurée*, Paris, Editions Anthropos, 1971.

MEHLMAN, J., 'Entre psychanalyse et psychocritique' (with selective bibliography), *Poétique* (periodical, Paris, Seuil), No. 3, 1970, pp. 365-385.

MEHNERT, Klaus, *Aktuelle Probleme des sozialistischen Realismus*, Berlin, Dietz, 1968.

MEHRING, Franz, *Die Lessing-Legende*, Stuttgart, Dietz, 1893.

——, *Gesammelte Schriften*, Berlin, Dietz, 1961- , 16 vols.

MEILAH, V., *Lenin i problemy russkoj literatury*, 3rd edn., Leningrad, Lenizdat, 1956 (French translation by Ducroux & S. Mayret, V. MEILAKH, *Lénine et les problèmes de la littérature russe*, Paris, Editions sociales, 1956).

MELETINSKIJ, Elizar M., 'Strukturno-tipologičeskie izučenie skazki', postface to the 2nd edn. of PROPP, *Morfologija skazki, op. cit.* (1969) (French translation by

Claude Kahn, 'L'étude structurale et typologique du conte', with Propp, *Morphologie du conte*, translation from the 2nd edn., *op. cit.*, 1970).
— (Meletinsky, Ye.), 'The structural-typological study of folklore', *Social Sciences (U.S.S.R. Academy of Sciences)*, Vol. 3 [No. 1], 1971, pp. 64-81.
— (Meletinsky, E.) & Segal, Dimitri M., 'Structuralism and semiotics in the U.S.S.R.' (translated from Russian by Nicolas Slater), *Diogenes*, No. 73, Spring 1971, pp. 88-115.
Memmi, Albert, 'Cinq propositions pour une sociologie de la littérature', *Cahiers internationaux de Sociologie*, VI (26), 1959, pp. 149-163.
—, 'Problèmes de la sociologie de la littérature', in Georges Gurvitch (ed.), *Traité de Sociologie*, Paris, Presses Universitaires de France, 1960, Vol. II, pp. 299-314.
Mendel, Arthur, 'The services of musicology to the practical musician', in A. Mendel et al., *Some Aspects of Musicology*, New York, The Liberal Arts Press, 1957, pp. 3-18.
—, 'Evidence and explanation', in *Report of the Eighth Congress, International Musicological Society, New York, 1961*, Vol. II, *op. cit.* (1962), pp. 3-18.
Merleau-Ponty, Maurice, 'Le doute de Cézanne', first published in *Fontaine* (periodical, Paris), No. 47, Dec. 1945, pp. 80-100; reproduced in Merleau-Ponty, *Sens et non-sens*, Paris, Nagel, 1948, 'Pensées' ser., pp. 15-49 (English translation in *Sense and Non-Sense*, translated by Hubert L. & Patrice Dreyfus, Evanston (Ill.), Northwestern University Press, 1964).
—, *Phénoménologie de la perception*, Paris, Gallimard, 1945, Bibliothèque des Idées (English translation by G. Smith, *Phenomenology of Perception*, New York, Humanities Press, 1962).
—, *Signes* (collected essays), Paris, Gallimard, 1960 (English translation by Richard C. McGleary, *Signs*, Evanston (Ill.), Northwestern University Press, 1964).
—, 'L'œil et l'esprit' (dated July-Aug. 1960), first published in the yearly periodical *Art de France* (Paris), No. 1, 1961; reproduced in *Les Temps modernes* XVII (184-185), 1961, pp. 193-227; posthumous republication in booklet form, *L'œil et l'esprit*, Paris, Gallimard, 1964.
—, *Le visible et l'invisible*, followed by 'Notes de travail' (posthumous work: materials for the work which the author was preparing when he died in 1961, edited by Claude Lefort), Paris, Gallimard, 1963, Bibliothèque des Idées (English translation by Alphons Lingis, *The Visible and the Invisible*, Evanston (Ill.), Northwestern University Press, 1969).
Méthodologies (presentation by René Pomeau, papers by R. Laufer, J. Proust and others = *Revue d'Histoire littéraire de la France*, 70th Year, No. 5-6 (double issue), Sept.-Dec. 1970, pp. 769-1063.
Metz, Christian, 'Le cinéma: langue ou langage?', in *Recherches sémiologiques* (= *Communications*, No. 4), *op. cit.* (1964), pp. 52-90; reproduced in Metz, *Essais sur la signification au cinéma*, *op. cit.* (1968), pp. 39-94.
—, 'La grande syntagmatique du film narratif', in *Recherches sémiologiques. L'analyse du récit* (= *Communications*, No. 8), *op. cit.* (1966), pp. 120-124; reproduced, in a recast version, in Metz, 'Problèmes de dénotation dans le film de fiction', *op. cit.* (1968).
—, 'Problèmes actuels de théorie du cinéma', *Revue d'Esthétique*, XX (2-3) (double issue), 1967.
—, 'Les sémiotiques ou sémies', *Communications*, No. 7, 1966.
—, *Essais sur la signification au cinéma*, Paris, Klincksieck, 1968, 'Collection d'Esthétique', No. 3.
—, 'Problèmes de dénotation dans le film de fiction', in Metz, *Essais sur la signification au cinéma, op. cit.* (1968), pp. 111-148 (essays resulting from the merging of three studies: 'Problèmes de dénotation dans le film de fiction: contribution à une sémiologique du cinéma', a report presented at the International Preparatory Conference on the Problems of Semiotics, Kazimierz, Poland, Sept.

1966; 'Un problème de sémiologie du cinéma', article published in *Image et son*, Jan. 1967; and 'La grande syntagmatique du film narratif', *op. cit.* (1966)).

——, *Langage et cinéma*, Paris, Larousse, 1971.

——, *Essais sur la signification au cinéma*, Vol. II, Paris, Klincksieck, 1972, 'Collection d'Esthétique'.

MEYER, Leonard B., *Emotion and Meaning in Music*, Chicago, University of Chicago Press, 1956.

——, 'On rehearing music', *Journal of the American Musicological Society*, 14, 1961.

MEYER-EPPLER, Werner, *Grundlagen und Anwendung der Informationstheorie*, Berlin, Springer, 1959.

MEZEI, L. & ROCKMAN, A., 'The electronic computer as an artist', *Canadian Art* XXI (6), 1964, pp. 365-367.

MICHEL, François (ed.), *Encyclopédie de la musique*, Paris, Fasquelle, 1961, 3 vols.

MIERINDORFF, M., *Lebt das Theater? Der Wiclair-Test*, Bad Ems, Institut für Kunstsoziologie, 1960.

MIKO, František, *Estetika výrazu* (= Aesthetics of Expression), Bratislava, 1969.

MILIC, Louis T., *Style and Stylistics. An Analytical Bibliography*, New York, The Free Press, 1967.

MILLER, Edwin Haviland, *The Professional Writer in Elizabethan England. A Study of Non-Dramatic Literature*, Cambridge (Mass.), Harvard University Press, 1959.

MILLER, James G., 'Living systems. Basic concepts', *Behavioral Science* X (3), July 1965, pp. 193-237.

——, 'Living systems. Structure and process' and 'Living systems. Cross-level hypotheses', *Behavioral Science* X (4), Oct. 1965, pp. 337-379 and 380-411.

MILNER, Max, *Le diable dans la littérature française depuis Cazotte jusqu'à Baudelaire, 1772-1861*, Paris, José Corti, 1960, 2 vols.

MINDER, Robert, *Dichter in der Gesellschaft*, Frankfurt am Main, Insel Verlag, 1966.

MITRY, Jean, *Esthétique et psychologie du cinéma*, Paris, Presses Universitaires de France, 2 vols.: Vol. I. *Les structures*, 1963; Vol. II. *Les formes*, 1965.

——, 'D'un langage sans signes', *Revue d'Esthétique*, XX (2-3) (double issue), 1967.

MITSCHERLICH, Alexander, *Die Unwirtlichkeit unserer Städte, Anstiftung zum Unfrieden*, Frankfurt am Main, Suhrkamp, 1965 (French translation, *Psychanalyse et urbanisme. Réponse aux planificateurs*, Paris, Gallimard, 1970).

——, *Thesen zur Stadt der Zukunft*, Frankfurt am Main, Suhrkamp, 1972.

MITTENZWEI, Werner, 'Die Brecht-Lukács Debatte', *Sinn und Form*, Feb. 1967.

——, 'Brecht et la tradition littéraire' (translated from German), *La Pensée*, No. 167, Jan.-Feb. 1973, pp. 80-95.

MJASNIKOV, A., 'Sovremennye spori po voprosam socialističeskogo realizma' (= The current debate on the subject of socialist realism), *Inostrannaja literatura* (= Foreign Literature) (Moscow), 1968, No. 3.

MOLES, Abraham A., *Théorie de l'information et perception esthétique*, Paris, Flammarion, 1958; republ., Paris, Denoël/Gonthier, 1972, 'Médiations – Grand Format' ser. (English translation by Joel E. Cohen, *Information Theory and Esthetic Perception*, Urbana, University of Illinois Press, 1966).

——, *Les musiques expérimentales* (French translation by Daniel Charles), Paris-Zurich, Editions du Cercle d'Art contemporain, 1960.

——, 'Structures du message poétique et niveaux de la sensibilité', *Médiations* (Paris), 1961, pp. 161-175.

——, 'Die Permutations Kunst', *Rot* (Stuttgart), No. 6, 1962.

——, 'Cybernétique et œuvre d'art', *Revue d'Esthétique*, XVIII (2), 1965, pp. 163-182.

——, *Sociodynamique de la culture*, The Hague, Mouton, 1967.

——, *L'affiche dans la société urbaine*, Paris, Dunod, 1969.

——, 'Création artistique et mécanismes de l'esprit', published in Romanian translation, 'Creatia artistică şi mecanismele spiritului', *Revista de filozofie* (Academia

Republicii Socialiste România, Bucarest), XVII (2), 1970, pp. 173-183; unpublished in French in its present form (see, however, a partial preliminary version, in *Ring, Cercle d'Art contemporain* (Zurich), No. 1, 1960, pp. 37-47).

——, *Art et ordinateur*, Paris, Casterman, 1971.

[See also: SCHAEFFER & MOLES; RONGE (ed.); KANDEL & MOLES.]

MOLNAR, François, *Sur l'art abstrait*, Zagreb, Galeria Grada, 1963.

——, 'Towards science in art' (1965), in HILL (ed.), *DATA – Directions in Art ...*, *op. cit.* (1968).

MONDRIAN, Piet, 'Réalité naturelle et réalité abstraite', a dialogue translated from Dutch by Michel Seuphor, in SEUPHOR, Michel, *Piet Mondrian. Sa vie, son œuvre*, Paris, Flammarion, 1957.

MORAWSKI, Stefan, 'Les péripéties de la théorie du réalisme socialiste. Une petite leçon d'histoire qui n'est pas à dédaigner', *Diogène*, No. 36, Oct.-Dec. 1961, pp. 120-142 (parallel publication of English version, 'Vicissitudes ni the theory of socialist realism. A little lesson in history not to be igonred', translation by S. Alexander, *Diogenes*, No. 36, Winter 1961, pp. 110-136).

——, 'Le réalisme comme catégorie artistique', *Recherches internationales*, No. 38, 1963.

MORETTI, Luigi, 'Form as structure', *Arena*, June 1966.

MORGAN, D. N., 'Psychology and art today', *Journal of Aesthetics and Art Criticism*, Vol. IX, 1950.

MORIN, Edgar, ' "Matérialité" et "magie" de la musique à la radio', *in: Radio, musique et société, op. cit.* (1955), pp. 483-487.

——, *Le cinéma ou l'homme imaginaire. Essai d'anthropologie*, Paris, Minuit, 1958; new edn., Geneva-Paris, Gonthier, 1965, Bibliothèque 'Médiations'.

——, *L'esprit du temps. Essai sur la culture de masse*, Paris, Grasset, 1962, 'La galerie' ser.

MORIN, Violette, 'Erotisme et publicité', *Communications*, No. 13, 1969.

MORPURGO TAGLIABUE, Guido, *L'esthétique contemporaine*, Milan, Marzorati, 1960. [See also *sub Art et philosophie.*]

MORRIS, Charles, 'Science, art and technology', *Kenyon Review*, Vol. I, 1939.

——, *Signs, Language and Behavior*, Englewood Cliffs (N.J.), Prentice-Hall, 1946.

MORRISON, Claudia C., *Freud and the Critic. The Early Use of Depth Psychology in Literary Criticism*, Chapel Hill, University of North Carolina Press, 1968.

MORSY, Zaghloul, 'Profils culturels et conscience critique au Maroc', *Cahiers d'Histoire mondiale / Journal of World History* (Unesco), XII (4), 1970, pp. 588-602.

MOSSE, E. P., 'Psychological mechanisms in art production', *Psychoanalytic Review*, Vol. XXXVIII, 1951.

MOULIN, Raymonde, *Le marché de la peinture en France*, Paris, Minuit, 1967.

MOUNIN, Georges, 'Les systèmes de communication non linguistiques et leur place dans la vie du XXe siècle', *Bulletin de la Société de Linguistique de Paris*, Vol. LIV, Fasc. 1, 1959, pp. 176-200; reproduced in MOUNIN, *Introduction à la sémiologie, op. cit.* (1970), pp. 17-39.

——, 'Communication linguistique humaine et communication non linguistique animale', *Les Temps modernes*, April-May 1960; reproduced in MOUNIN, *Introduction à la sémiologie, op. cit.* (1970), pp. 41-56.

– —, *Poésie et société*, Paris, Presses Universitaires de France, 1962.

——, *Introduction à la sémiologie*, Paris, Minuit, 1970, 'Le sens commun' ser.

MOUTARD, Nicole, 'L'articulation en musique', *La Linguistique* VII (2), Feb. 1972, pp. 5-19.

MUELLER, John Henry, *The American Symphony Orchestra. A Social History of Musical Taste*, London, J. Calder, 1958.

—— & HEVNER, Kate, *Trends in Musical Taste*, Bloomington, Indiana University Press, 1943, Humanities Series, No. 8.

MÜHLE, Günthèr, *Entwicklungspsychologie des zeichnerischen Gestaltens. Grund-*

lagen, Formen und Wege in der Kinderzeichnung, Munich, J. A. Barth, 1955; 2nd edn., 1967.

——— & WELLEK, Albert, 'Ausdruck, Darstellung, Gestaltung', *Studium generale*, Vol. V, 1952.

MUKAŘOVSKÝ, Jan, *Kapitoly z české poetiky* (= Chapters from Czech poetry), Prague, Svoboda, 1948.

———, 'Kunst als semiotisches Faktum', *Neues Forum*, Vol. XV, 1968.

MUKERJEE, Radkakamal, *The Social Function of Art*, Bombay, Hind Kitabs, 1948, Lucknow University Studies, Faculty of Arts.

MÜLLER-VOLLMER, Kurt, *Towards a Phenomenological Theory of Literature: A Study of W. Dilthey's Poetik*, The Hague, 1963.

MUMFORD, Lewis, *Sticks and Stones*, New York, Boni & Liveright, 1924.

———, *The Culture of Cities*, New York, Harcourt-Brace, 1938.

———, *The Highway and the City*, New York, Harcourt-Brace, 1953.

MUNRO, Thomas, 'Methods in the psychology of art', *Journal of Aesthetics and Art Criticism*, Vol. VI, 1948.

———, *The Arts and Their Inter-Relations. An Outline of Comparative Aesthetics*, Cleveland (Ohio), The Press of Case Western Reserve University, 1949; new edn., rev. and augm., *ibid.*, 1967.

———, 'The Marxist theory of art history', *Journal of Aesthetics and Art Criticism*, Vol. XVII, No. 4, 1959; reproduced in Thomas MUNRO, *Evolution in the Arts and Other Theories of Culture History*, Cleveland (Ohio), The Press of Case Western Reserve University, 1963.

———, *Form and Style in the Arts. An Introduction to Aesthetic Morphology*, Cleveland (Ohio), The Press of Case Western Reserve University in collab. with the Cleveland Museum of Art, 1970.

Music Centre of the University of Ghent, 'Seminarie voor muziekgeschiedenis', *Jaarboek, Rijksuniversiteit Gent*, No. 2, I.P.E.M., 1967.

Musicology (*Proceedings* of international congresses): See *Kongress Bericht* ... (IVth and IXth Congresses); *Report of the Eighth Congress*

'Musicology and music education', *Current Musicology* II (2), 1966.

Musiques nouvelles = *Revue d'Esthétique* (Paris), XXI (2-3-4) (triple issue), 1968.

MYERS, Bernard Samuel, *Problems of the Younger American Artist. Exhibiting and Marketing in New York City. A Pilot Survey*, New York, Arco Publ., 1957, City College, New York Area Research Council, Studies in the New York Area, No. 2.

NARDI, Pietro (ed.), *Arte e cultura nella civiltà contemporanea* = *Quaderni di San Giorgio* (Milan, Sansoni), Vol. XXIX, 1966.

NASH, D. J., 'The socialisation of an artist: the American composer', *Social Forces* XXXV (4), 1957, pp. 307-313.

NATTIEZ, J. J. (ed.), *Sémiologie de la musique* = *Musique en jeu* (Paris, Seuil), No. 5, 4th quarter, 1971.

NAVRATIL, Leo, *Schizophrenie und Kunst. Ein Beitrag zur Psychologie des Gestaltens*, Munich, Deutscher Taschenbuch Verlag, 1965.

NEDOŠIVIN, G. A., *Očerki teorii iskusstva* (= Essays on the Theory of Art), Moscow, Iskusstvo, 1963.

[See also BERESTNEV & NEDOŠIVIN (eds.).]

NEDZVEČKIJ, V., ASTAHOV, I., NUJKIN, A., MJASNIKOV, A., 'Obsuždaem stat'ju A. Nujkina o prirode krasoty' (= Discussion of A. Nujkin's article on the nature of beauty), *Voprosy literatury*, 1966, No. 12.

NEGROPONTE, Nicholas, *The Architecture Machine. Toward a More Human Environment*, Cambridge (Mass.), The M.I.T. Press, 1970.

NEU, D. Morgan, 'A critical review of the literature on "absolute pitch" ', *Psychological Bulletin*, XLIV, 1947.

———, 'Absolute pitch – A reply to Bachem', *Psychological Bulletin*, XLV, 1948.

Neue Bauhaus Bücher, series of republications, ed. by H. M. WINGLER, Mainz, Kupferberg, 1965-

NEUMANN, John von *et al.*, 'The general and logical theory of automata', in *Cerebral Mechanisms*, Hixon Symposium, New York, Wiley, 1951, pp. 1-41.

NEUPOKOEVA, I G., 'Metodologija komparativizma S.Š.A. i ee svjaz' s reakcionnoj sociologiej i èstetikoj' (= The method of comparativism in the U.S.A. and its relation to reactionary sociology and aesthetics), in NEUPOKOEVA, I. G., *Problemy vzaimodejstvija sovremennyh literatur* (= Problems of the Cooperation of Contemporary Literatures), Moscow, Izd. Akademii Nauk S.S.S.R., 1963.

New literary History, A Journal of Theory and Interpretation I (1), Oct. 1969. [See also *A Symposium on Periods.*]

NEWTON, Douglas, *Art Styles of the Papuan Gulf*, New York, The Museum of Primitive Art, 1961.

NICHOLS, Stephen G., Jr. & VOWLES, Richard B. (eds.), *Comparatists at Work. Studies in Comparative Literature*, Waltham (Mass.), Blaisdell Publ. Co., 1968.

NOLL, A. M., 'Computers and the visual arts', in *Computers in Design = Design and planning*, 1967, No. 2 (special issue).

NORBERG-SCHULZ, Christian, *Intentions in Architecture*, Oslo, 1963.

——, 'Meaning in architecture', in JENCKS & BAIRD (eds.), *Meaning in Architecture, op. cit.* (1969), pp. 214-229.

——, *Existence, Space and Architecture*, London, Studio Vista, 1971.

The Norton History of Music (volumes by Curt SACHS, Gustav REESE, Manfred BUKOFZER, Alfred EINSTEIN and William W. AUSTIN), New York, W. W. Norton, 1940-66.

La notion de structure = *Revue internationale de philosophie*, No. 73-74, 1965, Fasc. 3-4.

NUJKIN, A., 'Eščë raz o prirode krasoty' (= Once more on the nature of beauty), *Voprosy literatury*, 1966, No. 3.

'Of Socialist realism – A basis for further discussion' (conclusions of the Panel on Cultural Theory attached to the Central Committee of the Hungarian Socialist Workers' Party, published *in extenso* in the periodical *Társadalmi Szemle*), *The New Hungarian Quarterly* VII (19), Autumn 1965, pp. 52-71.

OGDEN, Robert Morris, *The Psychology of Art*, New York, Scribner, 1938.

OLBRECHTS, Frans M., *Les arts plastiques du Congo belge*, Brussels-Antwerp-Amsterdam, Editions Erasme/S.A. Standaard Boekhandel, 1959.

OLÉRON, Pierre, *Les activités intellectuelles*, Paris, Presses Universitaires de France, 1964, 'La psychologie' ser., No. 17.

'On the artist and politics', discussion, *Marxism Today* (London), Vol. IV, 1960: No. 1, Jan., pp. 28-32 (statements by Ruscoe CLARKE, T. D. SMITH and David CRAIG); and No. 2, Feb., pp. 61-64 (statement by Arnold KETTLE).

OSGOOD, Charles *et al.*, *The Measurement of Meaning*, Urbana, University of Illinois Press, 1957.

Oxford Companion to the Theatre, London, Oxford University Press, 2nd edn., 1967.

PALISCA, Claude V., 'American scholarship in Western music', in HARRISON, HOOD and PALISCA, *Musicology, op. cit.* (1963), pp. 87-213.

PANDAY, K. C., *Comparative Aesthetics*, Varanasi (Benares), Chowkhamba Sanskrit Series, Post Box 8, 1957.

PANOFSKY, Erwin, *'Idea'. Ein Beitrag zur Begriffsgeschichte der älteren Kunsttheorie*, Leipzig-Berlin, Idea Verlag, 1924; 2nd edn., rev., Berlin, 1960 (Italian translation and presentation by Edmondo Cione with a new preface by the athor, *'Idea'. Contributo alla storia dell' estetica*, Florence, La Nuova Italia Editrice, 1952, Biblioteca di Cultura, No. 40).

——, 'Über das Verhältnis des Kunstgeschichte zur Kunsttheorie. Ein Beitrag zu der

Erörtung über die Möglichkeit "kunstwissenschaftlicher Grundbegriffe" ', *Zeit-schrift für Ästhetik und allgemeine Kunstwissenschaft*, Vol. XVIII, 1925, pp. 129-161.

——, 'Zum Problem der Beschreibung und Inhaltsdeutung von Werken der bilden-den Kunst', *Logos*, Vol. XXI, 1932, pp. 103-119; reproduced in English version in *Studies in Iconology, op. cit.* (1939).

——, 'Iconography and iconology. An introduction to the study of Renaissance art', 1st publ. as 'Introductory' in PANOFSKY, *Studies in Iconology, op. cit.* (1939); reproduced in PANOFSKY, *Meaning in the Visual Arts, op. cit.* (1955), pp. 26-54 (French translation as 'Introduction', in *Essais d'iconologie, op. cit.* (1967), pp. 13-45).

——, *Studies in Iconology. Humanistic Themes in the Art of the Renaissance*, Lon-don-New York, Oxford University Press, 1939; republ. with a new preface, New York-Evanston (Ill.), Harper, 1962, Torchbooks (French translation by Claude Herbette & Bernard Teyssèdre, *Essais d'iconologie. Les thèmes huma-nistes dans l'art de la Renaissance*, Paris, Gallimard, 1967, Bibliothèque des Sciences humaines).

——, 'Abbot Suger of St.-Denis', 1st publ. as 'Introduction' in *Abbot Suger on the Abbey Church of St.-Denis and Its Art Treasures*, edited, translated and an-notated by Erwin PANOFSKY, Princeton (N.J.), Princeton University Press, 1946; reproduced in PANOFSKY, *Meaning in the Visual Arts, op. cit.* (1955), pp. 108-145 (French translation by Pierre Bourdieu, 'L'abbé Suger de Saint-Denis', with *Architecture gothique et pensée scolastique, op. cit.* (1967)).

——, *Gothic Architecture and Scholasticism*, Latrobe (Pa.), The Archabbey Press, 1951 (French translation by Pierre Bourdieu, *Architecture gothique et pensée scolastique*, preceded by 'L'abbé Suger de Saint-Denis', and followed by a Postface by Pierre BOURDIEU, Paris, Minuit, 1967, 'Le sens commun' ser.; 2nd edn., rev., *ibid.*, 1970).

——, *Meaning in the Visual Arts. Papers in and on Art History*, Garden City (N.Y.), Doubleday, 1955 (French translation of a slightly different selection of essays by Marthe & Bernard Teyssèdre, *L'œuvre d'art et ses significations. Essais sur les 'arts visuels'*, Paris, Gallimard, 1969, Bibliothèque des Sciences humaines).

——, *Aufsätze zu Grundfragen der Kunstwissenschaft*, Berlin, Hessling, 1964.

PARAIN, Charles, 'Structuralisme et histoire', *La Pensée*, No. 135, Oct. 1967 (special issue, *Structuralisme et marxisme*), pp. 38-52.

PAREYSON, Luigi, *Estetica. Teoria della formatività*, Bologna, Zanichelli, 2nd edn., 1960.

PASOLINI, Pier-Paolo, 'Il cinema di poesia', *Filmcritica* (Rome), No. 156-157, 1965.

——, 'Per una definizione dello stile nelle opere cinematografiche: la lingua scritta dell'azione', *Nuovi Argomenti*, No. 1, 1966.

——, 'In calce al cinema di poesia', *Filmcritica*, No. 163, 1966.

PAULME, Denise, *Les sculptures de l'Afrique Noire*, Paris, Presses Universitaires de France, 1956.

PAVLOV, T., *Osnovni vyprosi na estetikata* (= Basic Problems of Aesthetics), Sofia, Bilgarski Pisatel', 3rd edn., 1958.

PAŽITNOV, L. & ŠRAGIN, B., 'Kak že svjazat' èstetiku s žizn'ju?' (= How then can we unite aesthetics with life?), *Voprosy literatury*, 1961, No. 12.

PEIRCE, Charles Sanders, *Collected Papers*, ed. by C. Hartshorne, P. Weiss & A. Burks, Cambridge (Mass.), Harvard University Press, 1931-35 and 1958. [See also BUCHLER (ed.), *The Philosophy of Peirce. Selected Writings*.]

PEPPER, Stephen Coburn, *Principles of Art Appreciation*, New York, Harcourt, Brace & Co., 1949. [See also *sub Art et philosophie*.]

PERLOFF, Harvey S., 'Modernizing urban development', in BELL (ed.), *Toward the Year 2000, op. cit.* (*Daedalus*, 1967), pp. 789-800.

PHILLIPS, William (ed.), *Art and Psychoanalysis*, New York, Criterion Books, 1957.

PIAGET, Jean & INHELDER, Bärbel, *Le représentation de l'espace chez l'enfant*, Paris, Presses Universitaires de France, 1948 (English translation by F. J. Langdon & J. L. Lunzer, *The Child's Conception of Space*, London, Routledge, 1956, International Library of Psychology; new edn., New York, Humanities Press, 1963; paperback edn., New York, Norton, 1967).

PICARD, Raymond, *Nouvelle critique, ou nouvelle imposture*, Paris, Pauvert, 1965, 'Libertés' ser., No. 27.

PICHOIS, Claude & ROUSSEAU, A. M., *La littérature comparée*, Paris, A. Colin, 1967.

PICKFORD ,Ralph W., 'The psychology of ugliness', *British Journal of Aesthetics*, 9, 1969.

—, 'Factorial studies of aesthetic judgments', in A. A. ROBACK (ed.), *Present-day Psychology*, New York, 1955; 2nd edn., 1968.

PIERCE, John Robinson, *Symbols, Signals and Noise. The Nature and Process of Communication*, New York, Harper, 1961.

—, 'Communication', in BELL (ed.), *Toward the Year 2000, op. cit. (Daedalus*, 1967), pp. 909-921.

PIGUET, Jean-Claude, *Découverte de la musique*, Neuchâtel, 1948.

PINGAUD, Bernard, 'L'œuvre et l'analyste', *Les Temps modernes*, 21st Year, No. 233, Oct. 1965, pp. 638-646.
[See also BACKÈS, PINGAUD *et al.*]

PLEHANOV, G. V. (PLÉKHANOV, G. W.), *L'art et la vie sociale*, French translation by Mrs G. Batault-Plékhanov, Mrs Alix Guillain & Jean Fréville, preceded by two studies by Jean FRÉVILLE, Paris, Editions sociales, 1950.

— (PLEKHANOV, G. V.), *Art and Society*, New York, 1953.

—, *Art and Social Life*, London, 1953.

— (PLEKHANOW, G. W.), *Kunst und Literatur*, Berlin, Dietz, 1955.

PLENGE, Johannes, 'Die China Rezeption des Trecento und die Franciskaner-Mission', in *Forschungen und Fortschritte. Nachrichtenblatt der deutschen Wissenschaft und Technik*, Leipzig, J. A. Barth, 1929, hrsg. im Auftrage der Deutschen Akademien der Wissenschaften.

Poetics / Poetyka / Poétika, First International Congress of Work-in-Progress Devoted to Problems of Poetics, Warszawa, 1960 (editorial committee: D. DAVLE and others), Warsaw, Państ. Wyd. Nauke/The Hague, Mouton, 1961.

Poetics / Poetyka / Poétika, Second International Congress of Work-in-Progress Devoted to Problems of Poetics, Warszawa, 1964 (editorial committee: Roman JAKOBSON and others), The Hague-Paris, Mouton/Warsaw, Polish Scient. Publ., 1966.

La politique culturelle = Communications (Paris), No. 14, 1970.

POMEAU, René, 'L'histoire de la littérature et les méthodologies' (texte de présentation), in *Méthodologies, op. cit. (Revue d'Histoire littéraire de la France*, 1970), pp. 769-775.

PONTALIS, J.-B., *Après Freud*, Paris, Julliard, 1965, 'Les Temps modernes' ser.; new edn., augm., Paris, Gallimard, 1968; republ., *ibid.*, 1971, 'Idées' ser.
[See also LAPLANCHE & PONTALIS.]

PORTUONDO, José Antonio, 'Critique marxiste de l'esthétique bourgeoise contemporaine' (translated from Spanish), *Cahiers d'Histoire mondiale / Journal of World History* (Unesco), XII (4), 1970, pp. 655-669.

POSPELOV, G. N., 'Literature and sociology' (translated from Russian), in *Sociology of Literary Creativity, op. cit. (International Social Science Journal*, 1967), pp. 534-549.

—, 'Metodologičeskoe razvitie sovetskogo literaturovedenija' (= Methodological development of Soviet literary science), in *Sovetskoe literaturovedenie za 50 let* (= 50 Years of Soviet Literary Science), Moscow, Izd. Moskovskogo Univ., 1967.

POULENC, Francis, *Journal de mes Mélodies*, Paris, Grasset, 1965, Société des Amis de Francis Poulenc.

POULET, Georges, *Etudes sur le temps humain*, Paris, Plon, 1951-68, 4 vols.

——, 'Réponse', *Lettres nouvelles*, 24 June 1959.

——, *L'espace proustien*, Paris, Gallimard, 1963.

—— *et al.*, *Les chemins actuels de la critique* ('décade' held from 2 to 12 Sept. 1966 at the Centre culturel international of Cerisy-la-Salle, France, under the direction of George Poulet; contributions edited by Jean Ricardou, with an annotated bibliography by Dominique Noguez), Paris, Plon, 1967, 'Faits et thèmes' ser.; republ., Paris, Union générale d'Editions, 1970, '10/18' ser.

POUSSEUR, Henri, *Fragments théoriques sur la musique expérimentale*, Brussels, Université Libre de Bruxelles, Editions de l'Institut de Sociologie, 1970.

——, *Musique, sémantique, société*, Paris, Casterman, 1972, 'Mutations. Orientations' ser., No. 19.

POUZYNA, I. V., *La Chine, l'Italie et les débuts de la Renaissance (XIIIe-XIVe siècles)*, Paris, Editions d'Art et d'Histoire, 1935.

POWELL, John Walker, *Channels of Learning. The Story of Educational Television*, Washington (D.C.), Public Affairs Press, 1962.

PRACHT, E., 'Sozialistischer Realismus und ästhetische Masstäbe' (= Socialist realism and aesthetic criteria), *Deutsche Zeitschrift für Philosophie*, 1966, No. 1.

PRAMPOLINI, Giacomo, *Storia universale della letteratura*, Turin, Unione tipografica, 1938.

PRICE, Cedric, 'Potteries Thinkbelt', *Architectural Design* XXXVI (10), Oct. 1966, pp. 484-497.

PRICKMANN, J., 'The nature of ugliness and the creative impulse', *International Journal of Psychoanalysis* XXI (3), 1940.

PRIEBERG, Fred K., *Musica ex Machina*, Berlin-Frankfurt, Ullstein Verlag, 1960.

PRIETO, Luis J., *Principles de noologie*, The Hague, Mouton, 1964, 'Janua Linguarum', No. XXXV.

——, *Messages et signaux*, Paris, Presses Universitaires de France, 1966.

Problèmes du langage (= *Diogène*, No. 51, 1965; republ. 1966): see *Problems of Language*.

Problèmes d'une sociologie du roman (contributions by Lucien GOLDMANN, Nathalie SARRAUTE, Alain ROBBE-GRILLET, Georges LUKÁCS *et al.*) = *Revue de l'Institut de Sociologie* (Brussels), 1963, No. 2; 2nd edn., Brussels, Université Libre de Bruxelles, Editions de l'Institut de Sociologie, 1963, 'Etudes de sociologie de la littérature' ser.

Problèmes du structuralisme = *Les Temps modernes* (Paris), 22nd Year, No. 246, Nov. 1966: presentation by Jean POUILLON, articles by Marc BARBUT, GREIMAS (*op. cit.*), Maurice GODELIER, BOURDIEU (*op. cit.*), MACHEREY (*op. cit.*), EHRMANN, pp. 769-960.

Problems of Language = *Diogenes*, No. 51, Fall 1965 (parallel publication in French, *Problèmes du langage* = *Diogène*, No. 51, July-Sept. 1965; republished in volume form with the same title, Paris, Gallimard, 1966).

Problemy socialističeskogo realizma (= Problems of socialist realism) (collection of essays), Moscow, Hudožestvennaja literatura, 1961.

Proceedings of the AIA/ACSA Teachers' Seminar in Montreal, Washington (D.C.), AIA (American Institute of Architects), 1969.

Proceedings of the International Congress of Architectural Semiotics (Barcelona, March 1972), to be published later through the agency of the Colegio Oficial de Arquitectos de Cataluña y Baleares, Barcelona.

PROPP, Vladimir Ja., *Morfologija skazki*, Leningrad, Akademija, Gosudarstvennyj Institut istorii iskusstva, 1928, 'Voprosy poetiki' ser., No. 12; 2nd edn., corr. and suppl., with a Postface by E. M. MELETINSKIJ, 'Strukturno-tipologičeskie izučenie skazki' (= Structural-typological study of the folktale), Leningrad, Izd. Nauka, 1969 (English translation from the 1st edn. by Laurence Scott, ed. with an Introduction by Svatava Pirkova-Jakobson, *Morphology of the Folktale*, Bloomington, Indiana University Research Center in Anthropology, Folk-

lore and Linguistics, 1958, publ. No. 10, and *International Journal of American Linguistics* XXIV (4), Pt. III, Oct. 1958; new edn., rev. and edited with a Preface by Louis A. Wagner, new Introduction by Alan Dundes, Austin-London, University of Texas Press, 1968) (French translations: from the 1st edn. by Claude Ligny, *Morphology du conte*, Paris, Gallimard, 1970, Bibliothèque des Sciences humaines; and from the 2nd edn. by Marguerite Derrida, same title, followed by PROPP's essay, 'Les transformations des contes merveilleux' ['Transformacii volšebnyh skazok', *op. cit.*, 1928], and by MELETINSKIJ's Postface, 'L'étude structurale et typologique du conte', Paris, Seuil, 1970, 'Points' ser.).

——, 'Transformacii volšebnyh skazok', *Poetika Vremennyh Otdela Slovesnyh Iskusstv*, IV, 1928, pp. 70-89 (French translation by Tzvetan Todorov, 'Les transformations des contes merveilleux', in *Théorie de la littérature, op. cit.* (1965); reproduced also with the French translation of PROPP's *Morfologija skazki* from the 2nd edn., *op. cit.*, 1970).

——, *Istoričeskie korni volšebnoj skazki* (= The Historical Roots of the Fairy Tale), Leningrad, Izd. Leningradskogo Univ., 1946.

PROSHANSKY, H. M., ITTELSON, W. H. & RIVLIN, L. G. (eds.), *Environmental Psychology: Man and His Physical Setting* (anthology), New York, Holt, Rinehart & Winston, 1970.

PROUST, Jacques, 'De l'usage des ordinateurs dans l'édition des grands écrivains français du XVIIIe siècle', in *Méthodologies, op. cit.* (*Revue d'Histoire littéraire de la France*, 1970), pp. 784-797.

PRUETT, James W. (ed.), *Studies in Musicology*, with a Foreword by Charles SEEGER, Chapel Hill, University of North Carolina Press, 1969.

Psychanalyse et sociologie comme méthodes d'étude des phénomènes historiques et culturels (= Vol. II of *Critique sociologique et critique psychanalytique, op. cit.* (1970); joint publication of the Institut de Sociologie of Brussels Free University and the Ecole pratique des Hautes Etudes (6th Section) of Paris, with the assistance of Unesco: contributions by Jacques LEENHARDT, Janine CHASSE-GUET-SMIRGEL, Christian DAVID, Annette LAVERS, Marthe ROBERT, Lucien GOLDMANN, Alain BESANÇON, Jean CASSOU, Georges DEVEREUX, Jane W. DEVE-REUX, Dominique FERNANDEZ, M. Masud R. KHAN), Brussels, Editions de l'Université Libre de Bruxelles, 1973, 'Etudes de sociologie de la littérature' ser.

Pubblicità e televisione, essays by Francesco ALBERONI, BARTHES (*op. cit.*), Raymond A. BAUER, DORFLES (*op. cit.*), ECO (*op. cit.*) and Renato SEGURTA, Rome, ERI (Edizioni RAI Radiotelevisione Italiana), 1968-69.

PUZIN, M., *Simulation of Cellular Patterns by Computer Graphics*, Toronto, University of Toronto, May 1969, Technical Report No. 10.

Quatre conférences sur la nouvelle critique = Supplement to No. 34 of *Studi francesi* (Turin), Jan.-Apr. 1968.

QUENEAU, Raymond, *Bâtons, chiffres et lettres*, Paris, Gallimard, 1950; new edn., augm., *ibid.*, 1965, 'Idées' ser.

QUENEAU, Raymond (ed.), *Histoire des littératures*, Paris, Gallimard, 1956 (Vols. 1 and 2) and 1959 (Vol. 3), Encyclopédie de la Pléiade.

RADCLIFFE-BROWN, A. R., *Structure and Function in Primitive Society*, London, Cohen & West, 1952 (French translation by Françoise & Louis Marin, *Structure et fonction dans la société primitive*, presentation by Louis MARIN, Paris, Minuit, 1969).

Radio, musique et société (Proceednigs of the International Congress on the Sociological Aspects of Music on the Radio, Paris, 27-30 Oct. 1954) = *Cahiers d'études de radio-télévision* (Paris), 1955, Nos. 3-4 (double issue), pp. 259-575.

RAIMONDI, Ezio, 'L'industrializzazione della critica letteraria', in NARDI (ed.), *Arte e cultura nella civiltà contemporanea, op. cit.* (1966), pp. 141-172.

——, *Techniche della critica letteraria*, Turin, Einaudi, 1967.

RANSOM, John Crowe, *The New Criticism*, Norfolk (Conn.)-New York, New Directions, 1941.

RAPOPORT, Amos, *House Form and Culture*, Englewood Cliffs (N.J.), Prentice-Hall, 1969 (French translation by A. M. Meistersheim, *Pour une anthropologie de la maison*, Paris, Dunod, 1972, 'Aspects de l'urbanisme' ser.).

RASER, John R., *Simulations and Society. An Exploration of Scientific Gaming*, New York, Allyn & Bacon, 1969.

RASHEVSKY, Nicolas, 'Perception of visual patterns and visual aesthetics', in *Mathematical Biophysics*, Chicago, University of Chicago Press, 1948; Cambridge, Cambridge University Press, 1949.

RASSERS, Willem Huibert, *Panji, the Cultural Hero. A Structural Study of Religion in Java*, The Hague, Martinus Nijhoff, 1959, Koninklijk Inst. voor Taal-, Landen Volkenkunde, Transl. ser. No. 3.

RAVAR, Raymond & ANRIEU, Paul, *Le spectateur au théâtre. Recherche d'une méthode d'enquête sociologique*, Brussels, Editions de l'Institut de Sociologie, Université Libre de Bruxelles, 1964.

RAYMOND, Marcel, *Etre et dire*, Neuchâtel (Switzerland), La Baconnière, 1970.

Recherches sémiologiques = *Communications* (Seuil, Paris), No. 4, Nov. 1964.

Recherches sémiologiques. L'analyse structurale du récit = *Communications*, No. 8, Nov. 1966.

RECKZIEGEL, Walter & MIX, Roland, *Theorien zur Formalanalyse mehrstimmiger Musik*, Cologne-Opladen, Westdeutscher Verlag, 1967, Forschungsberichte des Landes Nordrhein-Westfalen, No. 1768.

REITLINGER, Gerald Roberts, *The Economics of Taste, 1760-1960*, London, Barrie & Rockliff, 1963, 2 vols.

REMAK, Henry H. H., 'Comparative literature at the crossroad. Diagnosis, therapy and prognosis', *Yearbook of Comparative and General Literature* (Chapel Hill, North Carolina), No. 9, 1960.

Report of the Eighth Congress, International Musicological Society, New York, 1961, Kassel, Bärenreiter Verlag, 1961-62, 2 vols.

REVAULT D'ALLONNES, Olivier, *La création artistique et les promesses de la liberté*, Paris, Klincksieck, 1972, 'Collection d'Esthétique'.

RÉVÉSZ, Géza, *Zur Grundlegung der Tonpsychologie*, Leipzig, 1913.

——, 'Prüfung der Musikalität', *Zeitschrift für Psychologie*, 85, 1920.

——, 'Gibt es einer Hörraum?', *Acta Psychologica* (The Hague), No. 3, 1937.

——, *Inleiding tot de muziekpsychologie*, Amsterdam, 1944; 2nd edn., 1946; German version, *Einführung in die Musikpsychologie*, Bern, 1946.

RICHARD, Jean-Pierre, *L'univers imaginaire de Mallarmé*, Paris, Seuil, 1962.

RICOEUR, Paul, *De l'interprétation. Essai sur Freud*, Paris, Seuil, 1965, 'L'ordre philosophique' ser. (English translation by Denis Savage, *Freud and Philosophy. An Essay on Interpretation*, New Haven (Conn.), Yale University Press, 1969, Terry Lectures ser.).

——, 'Une interprétation philosophique de Freud', *La Nef*, No. 31, July-Oct. 1967.

——, *Le conflit des interprétations. Essais d'herméneutique*, Paris, Seuil, 1969, 'L'ordre philosophique' ser.
[See also BERGE, CLANCIER, RICOEUR, RUBINSTEIN *et al.*; *Critique sociologique et critique psychanalytique*.]

RIEGL, Alois, *Historische Grammatik der bildenden Künste* (posthumous work edited by Karl M. Swoboda & Otto Pächt), Graz-Cologne, H. Böhlau, 1966.

RIEMANN, Hugo, *Grundriss der Musikwissenschaft*, 1908.

RIFFATERRE, Michel, *Essais de stylistique structurale*, Paris, Flammarion, 1970, Nouvelle Bibliothèque scientifique.

RIGHTER, William, *Logic and Criticism*, London, Routledge, 1963.

RITCHIE, Andrew C., *Matisse. His Art and His Public*, New York, Museum of Modern Art, 1951.

ROBACK, Abraham Aaron, 'The psychology of literature', in A. A. ROBACK (ed.), *Present-day Psychology*, New York, Greenwood Press, 1955; 2nd edn., 1968.

ROBERT, Marthe, *L'ancien et le nouveau. De Don Quichotte à Franz Kafka*, Paris, Grasset, 1963.

——, 'Vincent Van Gogh. Le génie et son double', *Preuves*, No. 204, Feb. 1968.

——, 'Raconter des histoires', *L'Ephémère*, No. 13, Spring 1970.

——, *Roman des origines et origines du roman*, Paris, Grasset, 1972.

ROCHE, D., 'Milieux académiques provinciaux', in BOLLÈME, EHRARD, FURET, ROCHE, ROGER and DUPRONT, *Livre et société dans la France du XVIIIe siècle*, op. cit. (1965).

RODER, M., 'Art and history', *Journal of Aesthetics and Art Criticism*, Vol. XXVI, 1967.

ROHWER, Jens, *Neueste Musik*, Stuttgart, Klett, 1964.

ROLAND-MANUEL (ed.), *Histoire de la musique*, Paris, Gallimard, 1960, 1963, 2 vols., Encyclopédie de la Pléiade.

ROMANENKO, V., 'Real'nost' krasoty v prirode' (= The reality of beauty in nature), *Voprosy literatury*, 1962, No. 1.

ROMANO, Dario, *L'esperienza cinematografica. Un' analisi dello stimolo cinematografico e dei corrispondenti processi perceptivi*, Florence, G. Barbera, 1965.

RONGE, Hans (ed.), *Kunst und Kybernetik* (a report on 3 colloquia held at Recklinghausen in 1965, 1966 and 1967, with contributions by RONGE, MOLES, NAKES, BENSE, OTTO, etc.), Cologne, DuMont, 1968.

ROSENBERG, Bernard & WHITE, David M. (eds.), *Mass Culture: The Popular Arts in America*, Glencoe (Ill.), The Free Press, 1960.

ROST, G. & SCHULZE, H., 'Der sozialistische Realismus', in *Kunst und Literatur* (bibliography), Leipzig, Verlag für Kunst und Literatur, 1960.

ROUSSET, Jean, *Forme et signification*, Paris, José Corti, 1962.

RUDOFSKY, Bernard, *Architecture without Architects. A Short Introduction to Non-Pedigreed Architecture*, New York, Museum of Modern Art, 1965; republ. (paperback), New York, Doubleday, 1969.

RUSH, Richard H., *Art as an Investment*, Englewood Cliffs (N.J.), Prentice-Hall, 1961 (French translation by M. Cl. Prévost, *La peinture, valeur de placement*, Paris, Editions du Tambourinaire, 1966).

RUSSELL, L., 'Cinema, code and image', *New Left Review*, No. 49, 1968, pp. 65-81.

RUWET, Nicolas, 'L'analyse structurale de la poésie', *Linguistics* (The Hague), Dec. 1963, pp. 38 sqq.

——, 'Analyse structurale d'un poème français', *Linguistics*, Jan. 1964.

——, 'Musicologie et linguistique', *Revue internationale des Sciences sociales* XIX (1), 1967, 'Linguistique et communication', pp. 85-93 (parallel publication of English translation, 'Musicology and linguistics', *International Social Science Journal*, same ref., 'Linguistics and communication', pp. 79-87).
[See also *Linguistique et littérature*.]

RYKWERT, Joseph, 'The sitting position – A question of method', 1st publ. in Italian, *Edilizia Moderna*, No. 86, 1965; publ. in English, *Arena*, June 1967; reprod. in JENCKS & BAIRD (eds.), *Meaning in Architecture*, op. cit. (1969), pp. 232-243.

——, *On Adam's House in Paradise. The Idea of the Primitive Hut in Architectural History*, New York, Museum of Modern Art, 1973 (French translation, *La maison d'Adam au Paradis*, Paris, Seuil, 1976).
[See also ALBERTI, *Ten Books on Architecture*.]

SACHS, Hanns, *The Creative Unconscious. Studies in the Psychoanalysis of Art*, Cambridge (Mass.), Science-Art Publishers, 1942.

SADER, Manfred, *Lautheit und Lärm. Gehörpsychologische Fragen der Schall-Intensität* (= Sound level and Noise. Psychological Issues of Hearing related to Sound Intensity), Göttingen, Verlag für Psychologie, Dr. J. C. Hogrefe, 1966.

SADOUL, Georges, *Histoire du cinéma mondial, des origines à nos jours*, Paris, Flammarion, 8th edn., 1966.

SÁNCHEZ RUPHUY, Rodrigo, *Witzverständnis bei Psychotikern und Normalen*. Mainz, Naturwissenschaft Dissertation (Thesis), 1967.

SÁNCHEZ VÁSQUEZ, Adolfo, *Las ideas estéticas de Marx*, Mexico City, Editorial ERA, 1965; Havana, Edición Revolucionaria, 1966.

SANDER, Friedrich & VOLKELT, Hans, *Ganzheitpsychologie. Grundlagen, Ergebnisse, Abhandlungen*, Munich, Beck, 1962; 2nd edn., *ibid.*, 1967.

SAPORTA, Sol & DE CHASCA, E., *Stylistics, Linguistics and Literary Criticism*, New York, Hispanic Institute, 1961.

SARTRE, Jean-Paul, *L'imaginaire. Psychologie phénoménologique de l'imagination*, Paris, Gallimard, 1940, Bibliothèque des Idées; republ., *ibid.*, 'Idées' ser., 1968 (English translation, *The Psychology of Imagination*, New York, Philosophical Library, 1948).

——, *L'être et le néant. Essai d'ontologie phénoménologique*, Paris, Gallimard, 1943, Bibliothèque des Idées (English translation by Hazel E. Barnes, *Being and Nothingness*, paperback edn., New York, Washington Square Press, undated).

——, *Baudelaire*, Paris, Gallimard, 1947; republ., *ibid.*, 1963, 'Idées' ser. (English translation by Martin Turnell, London, Hamish Hamilton, 1964; republ. (paperback), New York, New Directions, undated).

——, 'Qu'est-ce que la littérature?', 1st publ., *Les Temps modernes*, 2rd Year, Nos. 17 to 22, March to July 1947; reproduced in SARTRE, *Situations, II*, Paris, Gallimard, 1948, pp. 55-330; republ. in volume form, *Qu'est-ce que la littérature?*, *ibid.*, 1970, 'Idées' ser. (English translation by Bernard Frechtman, *What Is Literature?*, New York, Philosophical Libary, 1949; London, Methuen, 1950; republ., with a new Introduction by Wallace Fowlie, New York, Harper & Row, 1965).

——, 'Questions de méthode', 1st publ., *Les Temps modernes*, 12th Year, Nos. 139 and 140, 1957; constitutes the first part of *Critique de la raison dialectique*, *op. cit.* (1960); republ. in volume form, *Questions de méthode*, Paris, Gallimard, 1967, 'Idées' ser. (English translation by Hazel E. Barnes, *Search for a Method*, New York, Random House, 1968, Vintage Books).

——, *Critique de la raison dialectique*, Paris, Gallimard, 1960, Bibliothèque des Idées.

——, *Les mots*, Paris, Gallimard, 1964 (English translation by Bernard Frechtman, *Words*, New York, Braziller, 1964; republ. (paperback), New York, Fawcett World Library, 1972).

——, Interview, *Le nouvel Observateur du monde* (Paris), No. 272, 26 Jan.-1 Feb. 1970 (first publ. in English in *New Left*); reproduced with the title 'Sartre par Sartre' in SARTRE, *Situations, IX*, Paris, Gallimard, 1972, pp. 99-134.

——, *L'idiot de la famille* (a study on Flaubert), Paris, Gallimard, Bibliothèque de Philosophie: Vols. I and II, 1971; Vol. III, 1972.

SAUSSURE, Ferdinand de, *Cours de linguistique générale*, eds. Charles Bally & Albert Sechehaye (1915), 5th edn., Paris, Payot, 1955 (English translation by Wade Baskin, *Course in General Linguistics*, New York, Philosophical Library, 1959).

SAYCE, Richard A., *Style in French Prose. A Method of Analysis*, Oxford, Clarendon Press, 1953; 2nd edn., London, Oxford University Press, 1958.

SCALVINI, Maria Luisa, *Spazio come campo semantico*, Vol. 7 of 'Collana di Studi di Architettura e di Urbanistica', Naples, University of Naples, Istituto di Architettura e di Urbanistica, 1968.

——, 'Über das Signifikat in der Architektur', in *Die Aussage der Architektur, op. cit.*, 2nd pt. (*Werk*, June 1971), pp. 390-393.
[See also DE FUSCO & SCALVINI.]

Scénographie nouvelle, Boulogne sur Seine (France), Editions Aujourd'hui, 1963.

ŠČERBINA, V., 'O prirode literaturnyh zakonomernostej' (= On the nature of literary regularities), *Voprosy literatury*, 1966, No. 1.

SCHAEFFER, Pierre, *Traité des objets musicaux*, Paris, Seuil, 1966.
—, *La musique concrète*, Paris, Presses Universitaires de France, 1967, 'Que sais-je?' ser., No. 1287.
—— & MOLES, Abraham A., *A la recherche d'une musique concrète*, Paris, Seuil, 1952.
SCHAPIRO, Meyer, 'Style', in A. L. KROEBER (ed.), *Anthropology Today*, Chicago, University of Chicago Press, 1953, pp. 287-312.
—, 'The Joseph scenes on the Maximianus throne', in *Essays in Honour of Hans Tietze*, Paris-New York, Editions de la Gazette des Beaux-Arts, 1958.
—, 'On some problems of the semiotics of visual arts: field and vehicle in image signs', in *Conférence internationale préparatoire sur les problèmes de la sémiologie, Kazimierz, Pologne, 1966* (typescript); reproduced, *Semiotica* I (3), 1969, pp. 223-243.
SCHÄRER, Hans, *Die Gottesidee der Ngadju Dajak in Süd-Borneo*, Leiden, 1946 (English translation by Rodney Needham, Preface by P. F. de Josselin de Jong, *Ngaju Religion. The Conception of God among a South Borneo People*, The Hague, Martinus Nijhoff, 1963).
SCHEFER, Jean-Louis, 'Lecture et système du tableau', *Information sur les sciences sociales / Social Science Information* VII (3), June 1968, pp. 150-170.
SCHEFOLD, R., *Versuch einer Stilanalyse der Aufhängehaken vom Mittleren Sepik in Neu-Guinea = Basler Beiträge zur Ethnologie*, Vol. IV, 1966.
SCHEIN, Ionnel, 'Ledoux et notre temps', in *L'œuvre et les rêves de Ledoux*, Paris, Editions du Chêne, 1971.
SCHIØDT, Nanna & SVEJGAARD, Bjarner, 'Application of computer techniques to the analysis of Byzantine Sticherarion-melodies', in HECKMANN (ed.), *Elektronische Datenverarbeitung in der Musikwissenschaft*, op. cit. (1967), pp. 187-201.
SCHIRMUNSKI, Viktor: see ŽIRMUNSKIJ, Viktor Maksimovič.
SCHLOEZER, Boris de, *Introduction à J. S. Bach. Essai d'esthétique musicale*, Paris, Gallimard, 1947, Bibliothèque des Idées.
SCHMITZ, Carl August, *Wantoat. Art and Religion of the Northeast New Guinea Papuans* (English translation by Mrs G. E. van Baaren-Pape), The Hague, Mouton/New York, Humanities Press, 1963.
SCHNEIDER, Daniel Edward, *The Psychoanalyst and the Artist*, New York, International Universities Press, 2nd edn., 1954; republ., New York, The New American Library, 1962, Mentor Books.
SCHRAMM, Wilbur Lang (ed.), *Mass Communications. A Book of Readings*, Urbana, University of Illinois Press, 1960.
SCHRICKEL, H. G., 'Psychology of art', in A. A. ROBACK (ed.), *Present-day Psychology*, New York, Philosophical Library, 1955; 2nd edn., New York, Greenwood Press, 1968.
SCHÜCKING, Levin Ludwig, *Die Soziologie der literarischen Geschmacksbildung*, Leipzig, Teubner, 1931 (English translatioh from the 3rd German edn. by Brian Battershaw, *The Sociology of Literary Taste*, Chicago, University of Chicago Press, 1966).
SCHULTZ, W., 'Epistemology, science and structures', in *Transformation* (New York), 3, 1952.
SCOTT BROWN, Denise, 'Il "pop" insegna' / 'Learning from Pop' and 'Risposta per Frampton' / 'Reply to Frampton' (Italian and English texts in succession), *Casabella* (Milan), No. 359-360, Dec. 1971 (special issue: *The City as an Artifact*), pp. 14-23 and 39-45.
SCOTT-JAMES, Rolfe Arnold, *The Making of Literature. Some Principles of Criticism Examined in the Light of Ancient and Modern Theory*, London, Heinemann, 1963.
SCULLY, Vincent, 'L'ironie en architecture', in *L'Architecture actuelle dans le monde, op. cit.* (*Revue d'Esthétique*, 1962), pp. 254-263.
[See also *sub* VENTURI, R., *Complexity and Contradiction in Architecture*.]

SEASHORE, Carl E., *The Measurement of Pitch Discrimination*, Psychological Monograph No. 53, 1910.
——, *The Psychology of Musical Talent*, Boston, 1919.
——, 'A base for the approach to quantitative studies in the aesthetics of music', *American Journal of Psychology*, 39, 1927.
SEBAG, Lucien, *Marxisme et structuralisme*, Paris, Payot, 1964.
SEBEOK, Thomas A. (ed.), *Style in Language* (being the outcome of a conference grouping linguists, anthropologists, psychologists and literary critics, held at the University of Indiana in the Spring of 1958: in particular, contributions by JAKOBSON, *op. cit.*, VOEGELIN, *op. cit.* and WELLEK, R., *op. cit.*), Cambridge (Mass.), The M.I.T. Press, 1960.
SÉCHAN, Louis, *Etudes sur la tragédie grecque dans ses rapports avec la céramique*, Paris, Champion, 1926.
SEEGER, Charles, 'Versions and variants of the tunes of "Barbara Allen"', in *Reports, Institute of Ethnomusicology, University of California, Los Angeles*, I, 1966, pp. 120-167.
——, 'Foreword', in PRUETT (ed.), *Studies in Musicology, op. cit.* (1969).
SEGAL, Hanna, 'A psychoanalytical approach to aesthetics', *International Journal of Psychoanalysis* XXXIII (1), 1952.
SEGRE, Cesare, *I segni e la critica*, Turin, Einaudi, 1969.
'La sémiologie aujourd'hui en U.R.S.S.' (presentation by Julia KRISTEVA (*op. cit.*), text by Viatcheslav Vs. IVANOV, series of studies on 'Le nombre dans la culture' issued from the work of the Colloquium on Semiotics organized from 10 to 20 May 1968 at the University of Tartu, by I. M. LOTMAN (*op. cit.*), A. I. SYRKINE & V. N. TOPOROV, B. L. OGUIBENINE, V. V. IVANOV, E. S. SEMEKA), *Tel Quel* (Paris), No. 35, Autumn 1968, pp. 3-41.
SERENI, Emilio, *Storia del paesaggio agrario italiano*, Bari, G. Laterza, 1961 (French translation by Louise Gross, *Histoire du paysage rural italien*, Paris, Julliard, 1964, 'Les Temps modernes' ser.).
SHANNON, Claude E. & WEAVER, Warren, *The Mathematical Theory of Communication*, Urbana, University of Illinois Press, 1949.
SHARPE, Ella, 'Certain aspects of sublimation and delusion', *International Journal of Psychoanalysis*, XI, 1930.
——, 'Similar and divergent unconscious determinants underlying the sublimation of pure art and pure science', *International Journal of Psychoanalysis*, XVI, 1935.
SHILS, Edward, 'Mass society and its culture', in JACOBS, N. (ed.), *Culture for the Millions?, op. cit.* (1961) (1st publ. in *Mass Culture and Mass Media = Daedalus*, Spring 1960, pp. 288-314).
SHKLOVSKY, V.: see ŠKLOVSKIJ, V.
SHUMAKER, Wayne, *Elements of Critical Theory*, Berkeley-Los Angeles, California University Press, 1952; republ., Cambridge, Cambridge University Press, 1964.
SIDDIQI, Jawaid A., *Experimentelle Untersuchungen über den Zusammenhang von Sprachgestalt und Bedeutung*, Meisenheim, Anton Hain Verlag, 1969.
—— & THIEME, Thomas, 'Die verlorenen Botschaften. Über die Urteilsstruktur bei Künstlern . . .', *Zeitschrift für experimentelle und angewandte Psychologie*, 16, 1969.
SILBERMANN, Alphons, *La musique, la radio et l'auditeur. Etude sociologique*, Paris, Presses Universitaires de France, 1954, Bibliothèque internationale de Musicologie (German version, *Musik, Rundfunk und Hörer. Die soziolog. Aspekte d. Musik am Rundfunk*, Cologne-Opladen, Westdeutscher Verlag, 1959 – constitutes Vol. I of the series *Kunst und Kommunikation*, edited by A. SILBERMANN).
——, *Introduction à une sociologie de la musique*, Paris, Presses Universitaires de France, 1955, Bibliothèque internationale de Musicologie.
——, 'Kunst', in René KÖNIG (ed.), *Soziologie*, Frankfurt am Main, Fischer Taschenbuch Verlag, 1958.

——, 'A definition of the sociology of art' (translated from German), being the introduction to *The Arts in Society, op. cit. (International Social Science Journal,* 1968), pp. 567-588.

SIMON, H. A., 'The architecture of complexity', in *Proceedings of the Amer. Phil. Soc.,* 106, 1962.

——, *Patterns in Music,* Pittsburgh, Carnegie Institute of Technology, June 1967, Complex Information Processing Paper No. 104.

SITTE, Camillo, *City Planning according to Artistic Principles,* first complete and critical translation by G. R. & C. C. Collins, London, Phaidon Press/New York, Random House, 1965.

SKINNER, Burrhus F., *Verbal Behavior,* New York, Appleton-Century-Crofts, 1957.

ŠKLOVSKIJ (CHKLOVSKI), V., 'L'art comme procédé' (1917), in a French translation in *Théorie de la littérature, op. cit.* (1965), pp. 76-97.

——, *Hudožestvennaja proza* (= Literary Prose), Moscow, Sovetskij Pisatel', 1959.

SŁAWIŃSKI, Janusz *et al.* (eds.), *Z dziejów form artystycznych w literaturze polskiej* (= On the Evolution of Artistic Forms in Polish Literature), series of works, Warsaw, 1963-
[See also GŁOWIŃSKI, OKOPIEŃ-SŁAWIŃSKA & SŁAWIŃSKI.]

SMITH, Marian Wesley (ed.), *The Artist in Tribal Society* (Symposium, Royal Anthropological Institute), London, Routledge, 1961; New York, The Free Press, 1962.

Socialist\u010deskij realizm i problemy èstetiki (= Socialist Realism and the Problems of Aesthetics), collection of studies, Moscow, 1967.

Sociologie de la littérature. Recherches récentes et discussions (articles by J. ELSBERG, *op. cit.,* Lucien GOLDMANN, George HUACO, Jacques LEENHARDT, *op. cit., et al.)* = *Revue de l'Institut de Sociologie* (Brussels), 1969, No. 3, 2nd edn., Brussels, Université libre de Bruxelles, Editions de l'Institut de Sociologie, 1970, 'Etudes de Sociologie de la Littérature' ser.

Sociology of Literary Creativity (articles by L. GOLDMANN, *op. cit.,* J. LEENHARDT, *op. cit.,* G. N. POSPELOV, *op. cit.,* U. ECO, G. LUKÁCS, G. MOUILLAUD and M. WALTZ) = *International Social Science Journal* (Unesco), XIX (4), 1967, pp. 491-613 (parallel publication of French version, *Sociologie de la création littéraire* = *Revue internationale des Sciences sociales,* same reference, pp. 529-657).

SOLLERS, Philippe, *Logiques,* Paris, Seuil, 1968.

SOLOV'EV, G., 'Po zakonam krasoty' (= On the laws of beauty), *Voprosy literatury,* 1961, No. 11.

SOMMER, Robert, *Personal Space. The Behavioral Basis of Design,* Englewood Cliffs (N.J.), Prentice-Hall, 1969.

SOULIER, Gustave, *Influences orientales dans la peinture toscane,* Paris, thesis, 1925.

SOURIAU, Étienne, *La correspondance des arts. Eléments d'esthétique comparée,* Paris, Flammarion, 1947; republ., *ibid.,* 1969.

——, 'Le sublime', *Revue d'Esthétique,* XIX (3-4) (double issue), 1966.
[See also *Architecture et dramaturgie.*]

Sovetskoe literaturovedenie za 50 let (= 50 Years of Soviet Literary Sciences), Leningrad, Izd. Nauka, 1968 (contains a systematic bibliography of Soviet works concerning the history of literature).

Sovremennye problemy realizma i modernizm (= Current Problems of Realism and Modernism), collection of studies, Moscow, Izd. Nauka, 1965.

SPADOLINI, Pierluigi, *Dispense del corso di progettazione artistica per industrie,* Florence, Editrice Universitaria, 1960.

SPARSHOTT, Francis Edward, *The Structure of Aesthetics,* Toronto, University of Toronto Press, 1963.

SPEARMAN, Diana, *The Novel and Society,* New York, Barnes & Noble/London, Routledge, 1966.

SPILLER, Robert Ernest (ed.), *The American Literary Revolution, 1783-1837*, New York, New York University Press, 1967.

SPINGARN, Joel Elias, *Creative Criticism and Other Essays*, Port Washington (N.Y.), Kennikat, 1964.

SPITZER, Leo, *Linguistics and Literary History*, Princeton (N.J.), Princeton University Press, 1948; 2nd edn., New York, Russell & Russell, 1962.

——, 'A new synthetic treatment of contemporary Western lyricism' (about Hugo Friedrich), *Modern Language Notes*, 72, 1957.

——, 'Les études de style et les différents pays', in *Actes du IIIe Congrès de l'Association internationale de Littérature comparée, Utrecht, août 1961*, Paris–The Hague, Mouton, 1963, pp. 23-39.

——, *Etudes de style* (a selection of essays translated from English and German into French by Eliane Kaufholz, Alain Coulon and Michel Foucault), preceded by 'Leo Spitzer et la lecture stylistique', by Jean STAROBINSKI, Paris, Gallimard, 1970, Bibliothèque des Idées.

STAIGER, Emil, *Grundbegriffe der Poetik*, 8th edn., Zurich, Atlantis Verlag, 1968.

——, *Stilwandel. Studien zur Vorgeschichte der Goethezeit*, Zurich, Atlantis Verlag, 1963.

STALLKNECHT, Newton P., 'Aesthetics in English-speaking countries', in Raymond KLIBANSKY (ed.), *Contemporary Philosophy. A Survey / La philosophie contemporaine. Chroniques*, Vol. IV, Florence, La Nuova Italia Editrice, 1971, pp. 68-87 (with bibliography).

STAROBINSKI, Jean, *Jean-Jacques Rousseau. La transparence et l'obstacle*, Paris, Plon, 1957; new edn., followed by 'Sept essais sur Rousseau', Paris, Gallimard, 1971.

——, 'Psychanalyse et critique littéraire', *Preuves*, No. 181, Mar. 1966.

——, Preface to the French translation of JONES, *Hamlet and Oedipus* (*op. cit.*, 1949): *Hamlet et Œdipe*, 1967.

——, *L'œil vivant, II. La relation critique*, essay, Paris, Gallimard, 1970, 'Le chemin' ser.

——, 'Considérations sur l'état présent de la critique littéraire', *Diogène*, No. 74, Apr.-June 1971, pp. 62-95 (parallel publication of English version, 'Considerations on the present state of literary criticism', translated by Valérie Brasseur, *Diogenes*, No. 74, Summer 1971, pp. 57-88).

[See also *sub* Spitzer, *Etudes de style*.]

STEARN, Gerald Emanuel (ed.), *McLuhan Hot and Cool. A Primer for the Understanding of and a Critical Symposium with Responses by McLuhan* (contributions by A. ALVAREZ, Frank KERMODE, Jonathan MILLER, Susan SONTAG George STEINER, Raymond WILLIAMS *et al.*), New York, Dial Press, 1967; new edn., Harmondsworth (Middx.), Penguin Books, 1968.

STEIN, Rolf A., *Recherches sur l'épopée et le barde au Tibet*, Paris, Imprimerie Nationale, 1959.

STEPHEN, Sir Leslie, *English Literature and Society in the Eighteenth Century* (London, 1904), new edn., London, Methuen, 1963.

STERBA, R., 'The problem of art in Freud's writings', *Psychoanalytic Quarterly*, Vol. IX, 1940.

STEVENS, Stanley Smith & DAVIS, Hallowell, *Hearing. Its Psychology and Physiology*, New York, Wiley, 1938; 3rd edn., *ibid.*, 1948.

STEVENSON, Charles Leslie, *Ethics and Language*, New Haven (Conn.), Yale University Press, 1945.

——, 'Interpretation and evaluation in aesthetics', in Max BLACK (ed.), *Philosophical Analysis*, Ithaca (N.Y.), Cornell University Press, 1950.

——, 'On the analysis of a work of art', *Philosophical Review*, No. 77, 1958.

STIRLING, James, 'Functional tradition and expression', *Perspecta*, 6, 1960.

STOLNITZ, Jerome, *Aesthetics and Philosophy of Art Criticism. A Critical Introduction*, Boston, Houghton Mifflin, 1960.

STOLOVIČ, L. N., *Èstetičeskoe v dejstvitel'nosti i iskusstve* (= The Aesthetic Quality in Reality and in Art), Moscow, 1959.

——, 'O dvuh koncepcijah èstetičeskogo' (= On the two conceptions of aesthetic quality), *Voprosy filosofii*, 1962, No. 2.

STRICH, Fritz, *Deutsche Klassik und Romantik, oder Vollendung und Unendlichkeit*, Munich, Meyer & Jessen, 2nd edn., 1924.

Structuralism (Jacques EHRMANN, ed.), = *Yale French Studies* (New Haven, Conn., Yale University Press), No. 36-37 (double issue), Oct. 1966; republ., with bibliographical additions, Garden City (N.Y.), Doubleday, 1970, Anchor Books.

Strukturno-tipologičeskie issledovanija (= Structuro-typological research), Moscow, Izd. Akademii Nauk S.S.S.R., 1962-63.

SUČKOV, B., 'K sporu o realizme' (= On the debate over realism), *Inostrannaja literatura* (= Foreign Literature) (Moscow), 1965, No. 1.

——, *Istoričeskie sudby realizma* (= The Historical Fate of Realism), Moscow, Izdatel'stvo Sovetskij Pisatel', 1967.

SUTTON, Walter, *Modern American Criticism*, Englewood Cliffs (N.J.), Prentice-Hall, 1963, 'Humanistic Scholarship in America. The Princeton Studies' ser.

SUTTON, Walter & FOSTER, R. (eds.), *Modern Criticism. Theory and Practice*, New York, Odyssey Press, 1963.

SYCHRA, Antonin, *Intervento alla Tavola Rotonda della Mostra Internazionale del Nuovo Cinema a Pesaro*, 1967, mimeographed.

A Symposium on Periods = *New Literary History*, Winter 1970.

SZABOLCSI, M., 'Possibilité d'une unité des méthodes génétiques et structuralistes dans l'interprétation des textes', *Acta Litteraria* (Budapest, Hungarian Academy of Sciences), 1968, No. 1-2.

SZIGETI, József, *Bevezetés a marxista-leninista esztétikába* (= Introduction to Marxist-Leninist Aesthetics), Budapest, Kossuth, 1964-66, 2 vols.

SZONDI, P., *Theorie des modernen Dramas*, Frankfurt am Main, Suhrkamp, 1959.

TAFURI, Manfredo, *Teorie et storia dell'architettura*, Bari, G. Laterza, 1968.

TAGLIAVINI, Luigi Ferdinando, 'Prassi esecutiva e metodo musicologico', in *Kongress Bericht, Internationale Gesellschaft für Musikwissenschaft, Salzburg, 1964*, Vol. I, *op. cit.* (1964), pp. 19-24.

TAGORE, Rabindranath, *Rabindranath Tagore on Art and Aesthetics*, ed. by Pritish NEOGY, New Delhi, Orient Longman's, 1961.

TAINE, Hippolyte, *Philosophie de l'art*, Paris, 1885.

TASALOV, V., 'Stroitel'stvo kommunizma i tvorčestvo krasoty' (= The building up of communism and the creation of beauty), *Voprosy literatury*, 1961 No. 8.

TAYLOR, Calvin Walker (ed.), *Widening Horizons in Creativity. Proceedings of the Utah Creativity Research Conference, 1962*, New York, Wiley, 1964.

TAYLOR, John L., *Instructional Planning Systems. A Gaming Simulation Approach to Urban Problems*, Cambridge, Cambridge University Press, 1971.

TEESING, Hubert Paul Hans, *Das Problem der Perioden in der Literaturgeschichte*, Groningen, 'Batavia' Wolters Verlag, 1949.

Tendances principales de la recherche dans les sciences sociales et humaines, Partie I: Sciences sociales, Paris-The Hague, Mouton/Unesco, 1970 (parallel publication in English, *Main Trends of Research in the Social and Human Sciences, Part I: Social Sciences, op. cit.*).

TERRACINI, Benvenuto, *Analisi stilistica. Teoria, storia, problemi*, Milan, Feltrinelli, 1966.

TEYSSÈDRE, Bernard, 'Présentation' [of WÖLFFLIN, *Renaissance et baroque*, French translation, *op. cit.*], 1967.

——, LASCAULT, Gilbert, LAUDE, Jean, GORSEN, Peter *et al.*, *Les sciences humaines et l'œuvre d'art*, Brussels, Editions La Connaissance/Paris, Weber, 1969, 'Témoins et témoignages' ser.

Théâtre et collectivité (texts by Francis AMBRIÈRE, Marie CHAPEAU, Jean DARCANTE,

Georges FRIEDMANN, Lise GAUTHIER-FLORENNE, Henri GOUHIER, etc.), Paris, Flammarion, 1953.

Le Théâtre tragique, Work of the Groupe d'Etudes théâtrales of the Centre national de la Recherche scientifique (France) on tragedy, Paris, Editions du C.N.R.S., 1962.

Théorie de la littérature: Textes des formalistes russes, réunis, présentés et traduits par Tzvetan TODOROV [texts by B. EIKHENBAUM (= EJHENBAUM, *op. cit.*), V. CHKLOVSKI (= ŠKLOVSKIJ, *op. cit.*), R. JAKOBSON, V. V. VINOGRADOV, J. TYNIANOV (*op. cit.*), O. BRIK, B. TOMACHEVSKI, V. PROPP (*op. cit.*); Preface by Roman JAKOBSON, 'Vers une science de l'art poétique' (*op. cit.*)], Paris, Seuil, 1965, 'Tel Quel' ser.

Théorie d'ensemble: see FOUCAULT, BARTHES, DERRIDA *et al.*

Theory in Humanistic Studies (articles by M. W. BLOOMFIELD, P. DE MAN, N. FRYE (*op. cit.*), E. D. GENOVESE, G. HARTMAN, E. D. HIRSCH Jr., R. HOGGART (*op. cit.*), J. H. MILLER, T. PARSONS, R. H. PEARCE, and E. WEIL) = *Daedalus, Journal of the American Academy of Arts and Sciences* (Cambridge, Mass.), XCIX (2), Spring 1970 (pp. I-VIII and 237-525).

THERNSTROM, Stephan, 'Reflections on the new urban history', *Daedalus, Journal of the American Academy of Arts and Sciences*, C (2), Spring 1971 (special issue: *The Historian and the World of the Twentieth Century*), pp. 359-375.

THIBAUDET, Albert, *Physiologie de la critique*, Paris, Editions de la Nouvelle Revue Critique, 1930.

THIEL, M. (ed.), *Enzyklopädie der geisteswissenschaftlichen Arbeitsmethoden*, Munich-Vienna, 1969, 7 vols.

THIEME, Ulrich & BECKER, Felix, *Allgemeines Lexicon der bildenden Künstler*, Leipzig, W. Engelman, 1907-50.

THODY, Philip, 'The sociology of literary creativity. A literary critic's view', *International Social Science Journal* (Unesco), XX (3), 1968, pp. 487-498 (parallel publication of French version, 'La sociologie de la création littéraire. Le point de vue d'un critique littéraire', *Revue internationale des Sciences sociales*, Unesco, same ref., pp. 533-545).

THOMPSON, Denys (ed.), *Discrimination and Popular Culture*, Harmondsworth (Middx.), Penguin Books, 1964.

TODOROV, Tzvetan, 'L'héritage méthodologique du formalisme', *L'Homme* (Paris), V (1), Jan.-Mar. 1965, pp. 64-83; reproduced in TODOROV, *Poétique de la prose, op. cit.* (1971), pp. 9-31.

——, 'Présentation', in *Théorie de la littérature, op. cit.* (1965).

——, 'Procédés mathématiques dans les études littéraires', *Annales. Economies, sociétés, civilisations*, 20th Year, No. 3, May-June 1965, pp. 503-512.

——, 'Les anomalies sémantiques', *Langages* (Paris), No. 1, Mar. 1966, pp. 100-123.

——, *Littérature et signification*, Paris, Larousse, 1968, 'Langue et langage' ser.

——, 'Poétique', in WAHL (ed.), *Qu'est-ce que le structuralisme?, op. cit.* (1968), pp. 97-166.

——, *Introduction à la littérature fantastique*, Paris, Seuil, 1970.

——, *Poétique de la prose* (collected essays), Paris, Seuil, 1971, 'Poétique' ser.

[See also *Linguistique et littérature*.]

TODOROV, Tzvetan (ed.): see *Théorie de la littérature. Textes des formalistes russes*.

TOEPLITZ, Jerzy, 'Le cinéma et l'éclatement du système des arts', *Diogène*, No. 72, Oct.-Dec. 1970, pp. 122-141 (parallel publication of English version, 'On the cinema and the disruption of the arts system', translated by Valérie Brasseur, *Diogenes*, No. 72, Winter 1970, pp. 112-133).

TOFFLER, Alvin, *The Culture Consumers*, Harmondsworth (Middx.), Penguin Books, 1965.

TORRANCE, Ellis Paul, *Rewarding Creative Behavior. Experiences in Classroom Creativity*, Englewood Cliffs (N.J.), Prentice-Hall, 1965.

TORRE, Guillermo de, 'Diálogo de literaturas', in FRIEDRICH (ed.), *Comparative*

Literature. Proceedings of the ICLA 1958 Congress at the University of North Carolina, op. cit. (1959), Vol. I, pp. 79-88.

TORT, Michel, 'De l'interprétation, ou la machine herméneutique', *Les Temps modernes*, No. 237, Feb. 1966, pp. 1461-1493 and No. 238, Mar. 1966, pp. 1629-1652.

The Transactions of the International Conference on Theatre History (*1955*), London, Society for Theatre Research, 1957.

TRÂN VAN KHÊ, Les tendances actuelles de l'ethnomusicologie', *Cahiers d'Histoire mondiale / Journal of World History* (Unesco), XII (4), 1970, pp. 682-690.

Travaux du Cercle linguistique de Prague, 1: *Mélanges linguistiques dédiés au Premier Congrès des Philologues slaves*, Prague, 1929.

TREITLER, Leo, 'Music analysis in an historical context', *College Music Symposium*, Vol. VI, 1966, pp. 75-88.

——, 'On historical criticism', *Musical Quarterly*, Vol. LIII, 1967, pp. 188-205.

TRILLING, Lionel, *The Liberal Imagination. Essays on Literature and Society*, London, Secker & Warburg/New York, Viking Press, 1951; 3rd edn., *ibid.*, 1964.

TROUSSON, Raymond, *Le thème de Prométhée dans la littérature européenne*, Geneva, Droz, 1964, 2 vols.

TUGARINOV, B., *O cennostjah žizni i kul'tury* (= On Values in Life and Culture), Leningrad, Izd. Leningradskogo Univ., 1960.

TURNER, John F. C., *Uncontrolled Urban Settlement. Problems and Policies* (a report prepared at the request of the United Nations Centre for Housing, Building and Planning for the interregional seminar held at Pittsburgh, Pa., from 24 Oct. to 7 Nov. 1966 on the theme: 'Development Policies and Planning in relation to Urbanization'), Pittsburgh (Pa.), 1966; abridged version: 'Uncontrolled urban settlement. Problems and policies', *Ekistics* XXIII (135), Feb. 1967 (special issue: *Human Settlements. Challenge and Response*), pp. 120-122.

——, 'Architecture of democracy', *Architectural Design*, Aug. 1968.

TYNIANOV (= TYNJANOV), J., 'La notion de construction' (1923), in a French translation in *Théorie de la littérature, op. cit.* (1965), pp. 114-119.

——, *Archaïstes et novateurs*, 1929, partly quoted in French translation, *Change*, II, 1968.

—— & JAKOBSON, Roman, 'Les problèmes des études littéraires et linguistiques' (1928), in a French translation in *Théorie de la littérature, op. cit.* (1965), pp. 138-140.

UITTI, Karl D., *Linguistics and Literary Theory*, Englewood Cliffs (N.J.), Prentice-Hall, 1969, 'Humanistic Scholarship in America. The Princeton Studies' ser.

ULLMANN, Stephen, *Semantics. An Introduction to the Science of Meanings*, Oxford, Basil Blackwell, 1964.

——, *Language and Style*, Oxford, Basil Blackwell, 1964.

VALÉRY, Paul, 'Le cimetière marin', 1st publ., *La Nouvelle Revue Française*, No. 81, 1 June 1920; reproduced in VALÉRY, *Charmes*, Paris, Editions de la N.R.F., 1922, 1926; included in VALÉRY, *Œuvres*, Bibliothèque de la Pléiade, Vol. I, *op. cit.* (1957), pp. 147-151.

——, 'Le coup de dés' (1920), reproduced in VALÉRY, *Variété II*, Paris, Gallimard, 1930, pp. 193-202; included in VALÉRY, *Œuvres*, Bibliothèque de la Pléiade, Vol. I, *op. cit.* (1957), pp. 622-630.

——, 'L'enseignement de la poétique au Collège de France' (Feb. 1937), 1st publ. in booklet form, Paris, 1937; reproduced in VALÉRY, *Introduction à la poétique*, Paris, Gallimard, 1938, pp. 7-16, then in his *Variété V, ibid.*, 1944; included in VALÉRY, *Œuvres*, Bibliothèque de la Pléiade, Vol. I, *op. cit.* (1957), pp. 1438-1443.

——, *Œuvres*, Paris, Gallimard, 1957-60, 2 vols., Bibliothèque de la Pléiade.

VAN BAAREN, Th. P., *Korwars and Korwar-Style*, The Hague, Mouton, 1966.

VANDENHOUTE, P. J. L., *Classification stylistique du masque Dan et Guéré de la Côte d'Ivoire occidentale*, Leiden, 1948, Mededelingen van het Rijksmuseum voor Volkenkunde, Vol. IV.

VÁNDOR, Tamás, *Zeichnungen und Malereien von in Hypnose hervorgerufenen visuellen Erlebnissen* (Phil. Diss., Mainz, 1965), Meisenheim, 1970.

VANSLOV, V., *Problema prekrasnogo* (= The Problem of Beauty), Moscow, 1957.

VAN TIEGHEM, Paul, 'La question des méthodes en histoire littéraire', in *Actes du Premier Congrès international d'Histoire littéraire (Budapest 1931)*, Paris, 1932.

——, *La littérature comparée*, Paris, A. Colin, 4th edn., rev., 1951.

VAN TIEGHEM, Philippe, *Technique du théâtre*, Paris, Presses Universitaires de France, 1960.

VEINSTEIN, André, 'Ex libris de notre théâtre', in *Encyclopédie du Theâtre contemporain*, Vol. II, Paris, O. Perrin, 1959.

——, 'Metodologia della ricerca teatrale nei diversi paesi', in *Atti del IIo Congresso internazionale di Studio del Teatro, a cura del Centro Italiano di Ricerche teatrale, Venezia, Luglio, 1957*, Rome, De Luca, 1960, pp. 78-85 (text in French).

——, *Le théâtre expérimental*, Brussels, La Renaissance du Livre, 1968.

——, 'Dix-neuf des raisons qui font du théâtre un sujet privilégié pour l'esthétique', in *Actes du VIe Congrès international d'Esthétique, Upsal, 1968*.

VENTURI, Robert, *Complexity and Contradiction in Architecture*, Introduction by Vincent SCULLY, New York, Museum of Modern Art, 1966 (French translation, *De l'ambiguïté en architecture*, Paris, Dunod, 1971).

VIEFHAUS-MILDENBERGER, M., *Film und Projectionen auf der Bühne*, Ems, Lechte Verlag, 1961.

VERNANT, Jean-Pierre, *Mythe et pensée chez les Grecs. Etudes de psychologie historique*, Paris, François Maspero, 1965, 'Les textes à l'appui' ser., No. 13.

VIANU, T., 'Materialismul istoric şi dialectic în studiul istoriei literare' (= Historical and dialectical materialism in the study of literary history), in *Teorie si metode în ştiinţe sociale*, Bucharest, Ed. Academiei, 1965.

VIGOTSKIJ, L. S., *Psihologija iskusstva* (= The Psychology of Art), Preface by A. N. LEONT'EV (LEONTIEV), Moscow, Iskusstvo, 1965.

VINOGRADOV, V. V., *Problema avtorstva i teorija stilej* (= The Problem of Authorship and the Theory of Styles), Moscow, Goslitizdat, 1962.

——, *Sjužet i stil'* (= Subject and Style), Moscow, Izd. Akademii Nauk S.S.S.R., 1963.

——, *Stilistika. Teorija poetičeskoj reči* (= Stylistics. The Theory of Poetic Language), Moscow, Izd. Akademii Nauk S.S.S.R., 1963, 'Poetika' ser.

[See also *Théorie de la littérature*.]

VINTON, John (ed.), *Dictionary of 20th-Century Music*, New York, Dutton (in course of preparation for later publ.).

'Les Visages de la critique depuis 1920', *Cahiers de l'Association internationale des Etudes françaises* (Paris), No. 16, Mar. 1964, pp. 181-284.

VOEGELIN, C. F., 'Casual and noncasual utterances within unified structure', in SEBEOK (ed.), *Style in Language, op. cit.* (1960), pp. 57-68.

VOLPICELLI, L., 'Alfabetizzazione e mezzi audiovisivi', *Comunicazioni di massa*, No. 7, 1965.

Voprosy literatury (Moscow), Nos. 3, 4, 5 and 6 of 1957 (series of studies on realism in literature).

WACHTEL, N., 'Structuralisme et histoire', *Annales. Economies, sociétés, civilisations*, 21st Year, No. 1, 1966.

WAGENFÜHR, Horst, *Kunst als Kapitalanlage*, Stuttgart, Forkel, 1965 (French translation by L. Mézeray, Preface by Maurice Rheims, *L'art, valeur de placement*, Paris, Buchet-Chastel, 1967).

WAHL, François (ed.), *Qu'est-ce que le structuralisme?*, Paris, Seuil, 1968.

WALLIS, Mieczislaw, 'La notion de champ sémantique et son application à la théorie de l'art', *Sciences de l'art* (special issue), 1966, pp. 3 sqq.

414 Mikel Dufrenne et al.

——, 'Mediaeval art as a language', in *Actes du Ve Congrès international d'Esthétique, Amsterdam, 1964*, The Hague, Mouton, 1968, pp. 427 sqq.

WALZEL, Oskar, *Gehalt und Gestalt des Dichters*, Darmstadt, Gentner, 1929; new edn., *ibid.*, 1957.

WATSON, Bruce, 'On the nature of art publics', in *The Arts in Society, op. cit.* (*Int. soc. Sc. J.*, 1968), pp. 667-680 (parallel publication of French translation, 'Les publics d'art', in *Les arts dans la société, op. cit.* (*Rev. int. des Sc. soc.*, 1968), pp. 725-740).

WATSON, George, *The Literary Critics. A Study of English Descriptive Criticism*, new edn., London-New York, Chatto & Windus, 1964.

WATT, Ian, *The Rise of the Novel*, London, Chatto & Windus/Berkeley, University of California Press, 1957.

WEBB, Robert Kiefer, *The British Working Class Reader 1790-1848. Literary and Social Tension*, London, Allen & Unwin/New York, Columbia University Press, 1955.

WEBBER, Melvin M., 'The urban place and the non-place urban realm', in WEBBER (ed.), *Explorations into Urban Structure*, Philadelphia, University of Pennsylvania Press, 1964.

WEBER, Jean-Paul, *Néo-critique et paléo-critique, ou Contre Picard*, Paris, J. J. Pauvert, 1966, 'Libertés' ser., No. 42.

WEINREICH, Uriel, 'On the semantic structure of language', in GREENBERG (ed.), *Universals of Language, op. cit.* (1963), pp. 142 sqq.

WEINRICH, Harald, *Tempus. Besprochene und erzählte Welt*, Stuttgart, Kohlhammer, 1964.

WEISS, Paul, *Nine Basic Arts*, Carbondale, Southern Illinois University Press, 1961.

——, *The World of Art*, Carbondale, Southern Illinois University Press, 1961.

WEISSTEIN, Ulrich, *Einführung in die vergleichende Literaturwissenschaft*, Stuttgart, Kohlhammer, 1968 (English translation by William Riggan, *Comparative Literature and Literary Theory. Survey and Introduction*, Bloomington, Indiana University Press, 1974).

WEITZ, Morris, 'Aesthetics in English-speaking countries', in Raymond KLIBANSKY (ed.), *Philosophy in the Mid-Century / La philosophie au milieu du XXe siècle*, Vol. III, Florence, La Nuova Italia Editrice, 1958.

WELLEK, Albert, *Das absolute Gehör und seine Typen*, Leipzig, J. A. Barth, 1938; 2nd edn., Bern-Munich, 1969.

——, 'Gefühl und Kunst', *Neue psychologische Studien* XIV (1), 1939.

——, *Typologie der Musikbegabung im deutschen Volke. Grundlegung einer psychologischen Theorie der Musik und Musikgeschichte*, Munich, Beck, 1939; 2nd edn., *ibid.*, 1969.

——, *Ganzheitspsychologie und Strukturtheorie. Zwölf Abhandlungen zur Psychologie und philosophischen Anthropologie*, Bern-Munich, Francke, 1955; 2nd edn., rev., *ibid.*, 1969.

——, *Der Rückfall in die Methodenkrise der Psychologie und ihre Überwindung*, Göttingen, Verlag für Psychologie, Dr. C. J. Hogrefe, 1959; 2nd edn., *ibid.*, 1969.

——, 'The relationship between music and poetry', *Journal of Aesthetics and Art Criticism*, Vol. XXI, 1962.

——, 'Grösse in der Musik', *Archiv für Musikwissenschaft*, 19/20, 1963 [1964]; discussion, *ibid.*, 23, 1966.

——, *Musikspychologie und Musikästhetik, Grundriss der systematischen Musikwissenschaft*, Frankfurt am Main, Akademische Verlagsgesellschaft, 1963.

——, 'Das Genie', Chap. V of A. WELLEK, *Psychologie*, Bern-Munich, Francke, 1963; 3rd edn., *ibid.*, 1971.

——, 'Die Struktur der modernen Lyrik. Betrachtungen ... zu Grundsatzfragen einer Literaturkritik und systematischen Literaturwissenschaft', *Studium generale*, Vol. XVI, 1963.

——, 'Expériences comparées sur la perception de la musique tonale et de la musique dodécaphonique', in *Esthétique expérimentale, Ier Colloque international, op. cit. (Sciences de l'Art*, 1966), pp. 156-162 (with discussion).

——, 'Das Farbenhören und seine Bedeutung für die bildende Kunst', *Palette* (Basel), No. 23, 1966, and *Exakte Ästhetik* (Frankfurt am Main), No. 3-4, 1966.

——, *Die Polarität im Aufbau des Charakters. System der konkreten Charakter- kunde*, 3rd edn., rev., Bern-Munich, Francke, 1966.

——, *Witz – Lyrik – Sprache. Beiträge zur Literatur- und Sprachtheorie*, Bern- Munich, Francke, 1970.

[See also MÜHLE & WELLEK, A.]

WELLEK, René, *The Rise of English Literary History*, Chapel Hill, University of North Carolina Press, 1941.

——, *A History of Modern Criticism, 1750-1950*, New Haven (Conn.), Yale Uni- versity Press, 1955- , 4 vols., published to date, a 5th vol. forthcoming.

——, 'The crisis of comparative literature', in FRIEDERICH (ed.), *Comparative Liter- ature. Proceedings of the ICLA 1958 Congress at the University of North Carolina, op. cit.* (1959), Vol. 1, pp. 149-160.

——, 'From the viewpoint of literary criticism – Closing statement', in SEBEOK (ed.), *Style in Language, op. cit.* (1960), pp. 408-419.

——, 'Literaturkritik und Literaturwissenschaft', in *Herders Lexicon der Weltlite- ratur*, Freiburg, Herder, 1961.

——, *Concepts of Criticism*, New Haven (Conn.)-London, Yale University Press, 1963.

——, 'Comparative literature today', *Comparative Literature* XVII (4), Fall 1965, pp. 325-337.

——, 'The name and nature of comparative literature', in NICHOLS & VOWLES (eds.), *Comparatists at Work, op. cit.* (1968), pp. 3-27.

——, *Discriminations. Further Concepts of Criticism*, New Haven (Conn.)-London, Yale University Press, 1970.

—— & WARREN, Austin, *Theory of Literature*, New York, Harcourt-Brace, 1949, numerous re-editions (French translation by J. P. Audigier & J. Cattegno, *La théorie littéraire*, Paris, Seuil, 1971, 'Poétique' ser.).

[See also *sub* ERLICH, *Russian Formalism.*]

WERTHEIMER, M., '*Gestalt* theory', *Social Research*, Vol. II, 1944, pp. 78-99.

WESTRICH, Edmund, 'Die Entwicklung des Zeichnens während der Pubertät', *Archiv für gesamte Psychologie* (Frankfurt am Main), Supp. to No. 8, 1968.

WESTRUP, Jack Allan, *An Introduction to Musical History*, London, Hutchinson's University Library, 1955.

WESTRUP, Jack Allan *et al.* (eds.), *The New Oxford History of Music*, London, Oxford University Press, 1957-

WHEELWRIGHT, Philip E., *Metaphor and Reality*, Bloomington, Indiana University Press, 1961.

WHORF, Benjamin Lee, *Language, Thought and Reality* (edited by J. B. Carroll), Cambridge (Mass.), The M.I.T. Press, 1956 (French translation by Claude Carme, *Linguistique et anthropologie*, Paris, Denoël/Gonthier, 1971, Biblio- thèque 'Médiations').

WHYTE, Lancelot Law (ed.), *Aspects of Form. A Symposium on Forms in Nature and Art*, London, Lund Humphries/New York, Pellegrini & Cudahy (Farrar, Strauss & Young), 1951.

WILDENSTEIN, Georges, 'Le goût pour la peinture dans le cercle de la bourgeoisie parisienne autour de 1700', *Gazette des Beaux-Arts*, July-Aug. 1956.

WILLIAMS, Raymond, *Culture and Society. 1780-1950*, London, Chatto & Windus, 1958.

——, *The Long Revolution*, Harmondsworth (Middx.), Penguin Books, 1965; New York, Harper, 1966.

——, *Communications*, 2nd edn., rev., London, Chatto & Windus, 1966; New York,

Barnes & Noble, 1967 (1st edition issued in 1962 with the title: *Britain in the Sixties: Communications*).

WILSON, Edmund, *The Intent of the Critic* (edited by Donald Alfred Stauffer), Gloucester (Mass.), Peter Smith, 1963.

WILSON, Robert N. (ed.), *The Arts in Society*, Englewood Cliffs (N.J.), Prentice-Hall, 1964.

WIMMER, Erich, *Maria im Leid. Die Mater dolorosa, insbesondere in der deutschen Literatur und Frömmigkeit des Mittelalters*, Würzburg, 1968.

WIMSATT, William Kurtz, *The Verbal Icon. Studies in the Meaning of Poetry, and Two Preliminary Essays written in collab. with* Monroe C. BEARDSLEY, Lexington, University of Kentucky Press, 1954.

—— & BROOKS, Cleanth L., *Literary Criticism. A Short History*, London, Routledge/New York, Knopf, 1957.

WINCKEL, Fritz, 'Musik – VI. Informationstheorie', in BLUME (ed.), *Die Musik in Geschichte und Gegenwart, op. cit.*, Vol. IV (1961), cols. 967-970.

WIND, Edgar, *Ästhetischer und kunstwissenschaftlicher Gegenstand*, Diss. Phil. (thesis), Hamburg, 1923; parlty reproduced in 'Zur Systematik der künstlerischen Probleme', *Zeitschrift für Ästhetik und allgemeine Kunstwissenschaft*, Vol. XVIII, 1925, pp. 438 sqq.

——, 'Some points of contact between history and natural science', in Raymond KLIBANSKY & H. J. PATON (eds.), *Philosophy and History*, Oxford, Oxford University Press, 1936.

——, *Art and Anarchy*, The Reith Lectures 1960, rev. and enl., London, Faber & Faber, 1963.

WINGERT, Paul Stover, *American Indian Sculpture. A Study of the Northwest Coast*, Locust Valley (N.Y.), J. J. Augustin, 1949 (by spec. arr. with the Amer. Ethnol. Society).

——, *Primitive Art. Its Traditions and Styles*, London, Oxford University Press, 1962.

[See also LINTON & WINGERT.]

WINKLER, Walter, *Psychologie der modernen Kunst*, Tübingen, Alma Mater Verlag, 1949.

WINNICOT, D. W., 'Critical notice on J. Field', *British Journal of Medical Psychology* XXXIII (2), 1950.

——, 'Transitional objects and transitional phenomena. A study of the first not-me possession', *International Journal of Psychoanalysis* XXXIV (2), 1953.

WITTGENSTEIN, Ludwig, *Philosophische Untersuchungen / Philosophical Investigations*, English translation by G. E. M. Anscombe, Oxford, Basil Blackwell, 1953; 3rd edn., 1967 (French translation by Pierre Klossowski in WITTGENSTEIN, *Tractatus logico-philosophicus*, followed by *Investigations philosophiques*, Paris, Gallimard, 1961, Bibliothèque des Idées).

——, *Lectures and Conversations on Aesthetics, Psychology and Religious Belief (1938-1946)*, edited by C. Barrett, Oxford, Basil Blackwell, 1966 (French translation by Jacques Fauve, *Leçons et conversations*, followed by *Conférence sur l'éthique*, Paris, Gallimard, 1971).

WITTKOWER, Rudolf, *Architectural Principles in the Age of Humanism*, London, Tiranti, 1961.

WOLFF, Erwin, *Der englische Roman des 18. Jahrhunderts: Wesen und Formen*, Göttingen, Vandenhoeck & Ruprecht, 1964; 2nd edn., *ibid.*, 1968.

WÖLFFLIN, Heinrich, *Die Kunst A. Dürers*, Munich, Bruckmann, 1905 (English translation by A. & H. Grieve, edited by Kurt Gerstenberg, *The Art of Albrecht Dürer*, London, Phaidon, 1971).

——, *Kunstgeschichtliche Grundbegriffe: das Problem der Stilentwicklung in der neueren Kunst* (1915), 8th edn., Munich, Bruckmann, 1943 (English translation, *Principles of Art History: the Problem of the Development of Style in Later Art*, paperback edn., New York, Peter Smith/London, G. Bell, undated).

——, *Renaissance und Barock* (1888), new edn., Basel, Schwabe & Co., 1961 (English translation by Kathrin Simon, with an Introduction by Peter Murray, *Renaissance and Baroque*, London, Fontana-Collins, 1964; French translation by Guy Ballangé, *Renaissance et Baroque*, presentation by Bernard TEYSSÈDRE (*op. cit.*), Paris, Le livre de poche, 1967).

WOLLHEIM, Richard, *Art and Its Objects. An Introduction to Aesthetics*, New York, Harper, 1968.

[See also *sub Art et philosophie*.]

Wort in der Zeit (Graz, Austria), issues of 1966: discussions on the relations between literature and art and politics.

XENAKIS, Iannis, *Musiques formelles. Nouveaux principes formels de composition musicale = Revue musicale* (Richard Masse, Paris), No. 253-254 (special issue), 1963.

ZALOSCER, Hilde, *Quelques considérations sur les rapports entre l'art copte et les Indes*, Cairo, Institut français d'Archéologie orientale, Cahier No. 6, 1947.

ZEITLER, R., 'Kunstgeschichte als historische Wissenschaft', *Figure*, No. 6, 1967.

ZELINSKIJ, K., 'O krasote' (= On beauty), *Voprosy literatury*, 1960, No. 11.

ZERAFFA, Michel, *Roman et société*, Paris, Presses Universitaires de France, 1971, 'SUP-Le sociologue' ser.

ZEVI, Bruno, 'Alla ricerca di un "codice" per l'architettura', *L'Architettura*, No. 145, Nov. 1967.

ŽIRMUNSKIJ (SCHIRMUNSKI), Viktor Maksimovič, *Vergleichende Epenforschung*, Vol. I, Berlin, Akademie Verlag, 1961.

——, *J. G. Herder*, Berlin, 1963.

[See also CHADWICK & ZHIRMUNSKY.]

ZOLTAI, Dénes, *Ethos und Affekt. Geschichte der philosophischen Musikästhetik*, Budapest, Akadémiai Kiadó, 1970.

ZUMTHOR, Paul, *Essai de poétique médiévale*, Paris, Seuil, 1972, 'Poétique' ser.

II. BIBLIOGRAPHICAL TOOLS

A. MAIN PERIODICAL BIBLIOGRAPHIES

1. *Literature:*
 Bulletin signalétique No. 523, Histoire et science de la littérature (quarterly), Centre national de la Recherche scientifique (CNRS), Paris.
 LEHMANN, J. (ed.), *The Year's Work in Literature*, London, since 1949.

2. *Visual arts:*
 Bulletin signalétique No. 526, Art et archéologie (Proche-Orient, Asie, Amérique) (quarterly), Centre national de la Recherche scientifique (CNRS), Paris.
 Répertoire d'art et d'archéologie, Paris, since 1910.

3. *Music:*
 Acta musicologica, Leipzig, since 1928 (in particular, systematic listing of works in all languages on music from 1930 to 1952).
 Ethnomusicology, Journal of the Society for Ethnomusicology, since 1953 (listing of works and articles in the rubric 'Current Bibliography').
 Music Library Association Notes, Second series, since 1948 (international listing of recently published works about music, arranged by languages; lists also new recordings).
 Musikforschung, Gesellschaft für Musikforschung.

Nuova rivista musicale italiana, ERI, Edizioni RAI, Radiotelevisione Italiana, since 1967 (analyses the content of musical periodicals).

RILM (Répertoire international de la littérature musicale), Abstracts of Music Literature, 1967 et seq. (experimental indexing by computer of all publications, periodical and others, in all languages in the field of music, founded by the International Musicological Society and the International Association of Music Libraries, and sponsored by the American Council of Learned Societies (editor: Barry S. BROOK): publication by quarterly fascicles grouped by two).

4. *Theatre:*

International Theatre Informations (information organ of the International Theatre Institute, quarterly, Paris): each number contains a bibliographical selection of works in various languages on the theatre.

B. WORKS CITED CONTAINING IMPORTANT BIBLIOGRAPHIES

See in particular, under I. LIST OF WORKS CITED, the following works:
CORTI, M. & SEGRE, C. (eds.), *I metodi attuali della critica* . . .;
DUNCAN, H. D., *Language and Literature in Society*;
HATZFELD, H. A., *A Critical Bibliography of the New Stylistics* . . .;
HOLLAND, N. N., *Psychoanalysis and Shakespeare*;
KAGAN, M. S., *Bibliografičeskij ukazatel' k leksijam po marksistsko-leninskoj èstetike*;
KIELL, N., *Psychiatry and Psychology in the Visual Arts* . . .;
——, *Psychoanalysis, Psychology and Literature* . . .;
KRIS, E., *Psychoanalytic Explorations in Art*;
LASCAULT, G., 'Esthétique et psychanalyse';
Liste des acquisitions de la Bibliothèque, Centre international de Documentation concernant les Expressions plastiques, Hôpital Ste Anne, Paris.
LÖWENTHAL, L., 'Literature and society';
MILIC, L. T., *Style and Stylistics*;
MOULIN, R., *Le marché de la peinture en France*;
NEGROPONTE, N., *The Architecture Machine*;
Sovetskoe literaturovedenie za 50 let,
STERBA, R., 'The problem of art in Freud's writings';
Structuralism (J. EHRMANN, ed.).